New Visuals and Examples Throughout the Book

With hundreds of images, *The Film Experience* visually reinforces all the major techniques, concepts, and film traditions discussed in the text with eye-catching examples. New part-opening and chapter-opening images cover films from cinema's early years to today. Contemporary additions include *Moonlight, La La Land, Mad Max: Fury Road, Star Wars: The Force Awakens, Creed, Ex Machina, Birdman, Straight Outta Compton, Suicide Squad*, and more, alongside classics like *Touch of Evil, Midnight Cowboy, The Shining, In the Mood for Love*, and many more.

CHAPTER 1

ENCOUNTERING FILM
From Preproduction to Exhibition

Between 2013 and 2015, Ryan Coogle directed two very different kinds of films—*Fruitvale Station* (2013), a small but intense drama about an African American man mistakenly shot and killed by a transit policeman on a subway platform, and *Creed* (2015), the seventh film in the *Rocky* franchise, about the bond between Rocky Balboa and Apollo Creed's son as he prepares for a championship fight. Although both feature rising star Michael B. Jordon, the production, distribution, and exhibition of the two films illustrate how films, even by the same director, can be shaped by extremely different institutional histories that in turn shape our understanding of them.

Based on actual events that occurred in 2008 in California, Ryan Coogler's *Fruitvale Station* generated extensive buzz at both the Sundance and Cannes film festivals. When its theatrical release in July 2013 coincided with the acquittal of accused murderer George Zimmerman for his "Stand your ground" shooting of a young, unarmed African American in Florida, *Fruitvale Station* became not just an emotionally searing film but also part of larger conversations, still ongoing, about justice in the streets of America.

Coogler's 2015 *Creed* traveled a different path. This franchise film inherits the whole history of the *Rocky* series, which focused on star Sylvester Stallone's character as a boxer from the working-class neighborhoods of Philadelphia. In *Creed*, Rocky is an older and wiser man asked to train the son (Jordon) of his old rival. It's a more crowd-pleasing, formulaic film than *Fruitvale Station*, and a bigger box office success, but they both appeal to African American and broader audiences.

As these two disparate films suggest, film production, distribution, and exhibition shape our encounters with movies, and these aspects of film are in turn shaped by how movies are received by audiences.

Top: © Warner Bros./Courtesy Everett Collection. Bottom: © The Weinstein Company/Courtesy Everett Collection

17

Proven Learning Tools That Foster Critical Viewing and Analysis

The Film Experience offers a great array of learning tools that have been updated for this edition, including new Viewing Cues in every chapter, in-depth Film in Focus essays on films like *Gone Girl* and *Minority Report*, Form in Action boxes with analysis of multiple films, and the very best coverage of writing about film.

3.38a

3.38b

3.38c

FORM IN ACTION

Mise-en-Scène in *Hugo* (2011)

Martin Scorsese's *Hugo* (2011) begins with a sequence that, for over five minutes, is virtually without focused dialogue and thus concentrates on exploring an elaborate mise-en-scène. The opening shot rushes through a bustling platform in the Gare Montparnasse railway station in Paris of the 1930s and ends with a dramatic close up of the station clock, out of which the young boy Hugo peers [Figure 3.38a].

Two primary and several secondary spaces appear in this mise-en-scène—the public spaces of the station and the interior spaces behind the clock face. With the first, the film follows Hugo's perspective through the mise-en-scène of the station as he spies on the comings and goings in the station—observing a café, a flower cart, a newspaper stand, the entry of a bookstore, and the threatening stationmaster—all of which become important places in the film [Figure 3.38b]. The film then cuts to the interior spaces behind the clock face and follows Hugo with a long tracking shot through a maze of interior rooms full of large mechanical gears, steam pipes, and secret passageways with slides and ladders [Figure 3.38c], ending with Hugo peeking through another clock [Figure 3.38d] across from the toy shop of Georges Méliès. With lighting that remains foreboddingly low-key and shadowy, this divided mise-en-scène emphasizes a key motif in the film: behind the everyday world of history and society lies the more secretive and mysterious vision of youthful imagination.

As part of this motif, props play an especially complex role across this opening mise-en-scène. Along with 1930s costumes and Parisian locations, the film uses a pervasive presence of mechanical objects. From the gears in the clock tower to the toys of Méliès's shop [Figure 3.38e], these mechanisms describe not just how this world works but how the human imagination can express itself in this modern world. Meanwhile, the two large clocks that bracket the sequence call theatrical attention to both "clockwork mechanisms" (here from automatons to movies) and the movement of history itself

ADMIT ONE

FIFTH EDITION

THE FILM EXPERIENCE
An Introduction

Timothy Corrigan
University of Pennsylvania

Patricia White
Swarthmore College

bedford/st.martin's
Macmillan Learning
Boston | New York

For Bedford/St. Martin's

Vice President, Editorial, Macmillan Learning Humanities: Edwin Hill
Program Director for Communication: Erika Gutierrez
Marketing Manager: Kayti Corfield
Director of Content Development: Jane Knetzger
Senior Developmental Editor: Jesse Hassenger
Senior Content Project Manager: Peter Jacoby
Senior Workflow Manager: Lisa McDowell
Production Supervisor: Robert Cherry
Media Project Manager: Sarah O'Connor
Editorial Services: Lumina Datamatics, Inc.
Composition: Cenveo® Publisher Services
Photo Editor: Terri Wright and Kerri Wilson, Lumina Datamatics, Inc.
Photo Researcher: Terri Wright
Senior Art Director: Anna Palchik
Text Design: Jerilyn Bockorick
Cover Design: William Boardman
Cover Art: Arrival © Paramount Pictures Corp. All Rights Reserved. *Arrival* © Xenolinguistics,
 LLC. All Rights Reserved. Photo courtesy The Everett Collection.
Printing and Binding: LSC Communications

Manufactured in the United States of America.

2 1 0 9 8 7
f e d c b a

For information, write: Bedford/St. Martin's, 75 Arlington Street, Boston, MA 02116

ISBN 978-1-319-05951-4 (paperback)
ISBN 978-1-319-09359-4 (loose-leaf edition)

Acknowledgments

Art acknowledgments and copyrights appear on the same page as the art selections they
cover.

This book is dedicated to Kathleen and Lawrence Corrigan and Marian and Carr Ferguson and to Max Schneider-White.

About the Authors

Courtesy Timothy Corrigan

Timothy Corrigan is a professor of English and cinema studies at the University of Pennsylvania. His other books include *New German Film: The Displaced Image* (Indiana UP); *The Films of Werner Herzog: Between Mirage and History* (Routledge); *Writing about Film* (Longman/Pearson); *A Cinema without Walls: Movies and Culture after Vietnam* (Routledge/Rutgers UP); *Film and Literature: An Introduction and Reader* (Routledge); *Critical Visions in Film Theory: Classical and Contemporary Readings* (Bedford/St. Martin's), with Patricia White and Meta Mazaj; *American Cinema of the 2000s* (Rutgers UP); and *The Essay Film: From Montaigne, After Marker* (Oxford UP), winner of the 2012 Katherine Singer Kovács Award for the outstanding book in film and media studies. He has published essays in *Film Quarterly*, *Discourse*, and *Cinema Journal*, among other collections, and is also an editor of the journal *Adaptation* and a former editorial board member of *Cinema Journal*. In 2014, he received the Society for Cinema and Media Studies Award for Outstanding Pedagogical Achievement.

Courtesy Cynthia Schneider

Patricia White is Eugene Lang Research Professor of Film and Media Studies at Swarthmore College. She is the author of *Women's Cinema/World Cinema: Projecting Twenty-first Century Feminisms* (Duke UP) and *Uninvited: Classical Hollywood Cinema and Lesbian Representability* (Indiana UP). Her essays have appeared in journals including *Camera Obscura*, *Cinema Journal*, *Film Quarterly*, and *Screen*, and in books including *A Feminist Reader in Early Cinema*, *Out in Culture*, and *The Routledge Companion to Cinema and Gender*. She is coeditor with Timothy Corrigan and Meta Mazaj of *Critical Visions in Film Theory: Classic and Contemporary Readings* (Bedford/St. Martin's). She is a member of the editorial collective of the feminist film journal *Camera Obscura*. She serves on the board of the feminist distributor and media organization Women Make Movies and the editorial board of *Film Quarterly*.

In our culture, movies have become a near-universal experience, even as their delivery methods have expanded and changed. Whether watching the newest *Star Wars* adventure with a packed crowd or Academy Award–winner *Moonlight* (2016) at a downtown arthouse, or catching up with classics or old favorites on a state-of-the-art TV set or portable tablet, we all have experienced the pleasures that movies can bring. The film experience can begin with journeying to imaginary worlds, witnessing re-creations of history, observing stars in familiar and unfamiliar roles, and exploring the laughter, thrills, or emotions of different genres. Understanding the full depth and variety of these experiences, though, requires more than just initial impressions.

This book aims to help students learn the languages of film and synthesize those languages into a cohesive knowledge of the medium that will, in turn, enhance their movie watching. *The Film Experience: An Introduction* offers readers a serious, comprehensive introduction to the art, industry, culture, and *experience* of movies—along with the interactive, digital tools and examples to bring that experience to life.

As movie fans ourselves, we believe that the complete film experience comes from understanding both the formal and cultural aspects of cinema. Knowing how filmmakers use the familiarity of star personas, for example, can be as valuable and enriching as understanding how a particular editing rhythm creates a specific mood. *The Film Experience* builds on formal knowledge and cultural contexts to ensure that students gain a well-rounded ability to engage in critical analysis. The new fifth edition is better equipped than ever to meet this challenge, with the best art program in this course, a newly revised chapter about film history and accompanying History Close-Up boxes, and new video clips and discussion questions that bring a variety of cinematic concepts to life. The learning tools we have created help students make the transition from movie fan to critical viewer, allowing them to use the knowledge they acquire in this course to enrich their movie-watching experiences throughout their lives.

The Best Coverage of Film's Formal Elements

We believe that comprehensive knowledge of film practices and techniques allows students a deeper and more nuanced understanding of film meaning. Going beyond mere descriptions of the nuts and bolts of film form, *The Film Experience* highlights how formal elements like cinematography, editing, and sound can be analyzed and interpreted within the context of a film as a whole—formal studies made even more vivid by our suite of online film clips.

In choosing our text and video examples, we draw from the widest variety of movies in any introductory text, demonstrating how individual formal elements can contribute to a film's larger meaning. We understand the importance of connecting with students through films they may already know, and we have

added new examples referring to recent films like *La La Land*, *Hidden Figures*, *Ex Machina*, *Creed*, *Moonlight*, *Gone Girl*, and *Star Wars: The Force Awakens*. We also feel that it is our responsibility to help students understand the rich variety of movies throughout history, utilizing classics like *The Jazz Singer*, *Citizen Kane*, *Touch of Evil*, *Bonnie and Clyde*, *The Godfather*, and *Chinatown*, as well as a wealth of experimental, independent, and international films.

Fully Encapsulating the Culture of Film

In addition to a strong foundation in film form, knowledge of the nature and extent of film culture and its impact on our viewing experiences is necessary for a truly holistic understanding of cinema. One of the pillars of *The Film Experience* story has always been its focus on the relationship among viewers, movies, and the industry. Throughout, the book explores how these connections are shaped by the social, cultural, and economic contexts of films through incisive discussions of such topics as the influence of the star system, the marketing strategies of indies versus blockbusters, and the multitude of reasons that we are drawn to some films over others. That discussion continues in this new edition with additional emphasis on how the medium's history informs the ways we watch movies today.

New to This Edition

Thanks to the valuable feedback from our colleagues and from our own students, in this new edition we have enhanced *The Film Experience's* coverage of film history. As ever, *The Film Experience* continues to be the best at representing today's film culture—with cutting-edge inclusion of topics like 3-D technology, digital distribution, and social media marketing campaigns.

A Heavily Revised Chapter 2 on History

Our chapter on history and historiography has been reconfigured and relocated in the text, now placed in Part 1 so that it can better provide valuable background for the chapters that follow. The history coverage has been updated, streamlined, and made more relevant to the chapters that follow, providing an overview that deepens when the book later introduces historical information about editing, cinematography, sound, and other elements of film form.

History Close Up Boxes Highlight Underrepresented Groups

Several chapters now include History Close Up boxes that continue the conversation about how film history interacts with contemporary film culture, spotlighting women and people of color, as well as films and practices that have been underacknowledged in more traditional historical narratives. These boxes remind students that not every important figure in the development of this medium is well known and that diversity and inclusion continue to be major issues in today's film landscape.

LaunchPad Solo for *The Film Experience* with More Text and Video Than Ever

The Film Experience goes further with LaunchPad Solo, our online platform and home to numerous movie clips, video essays, discussion questions, and more—perfect for interactive learning. Bringing print and digital together, the Viewing Cue feature in the margins of each chapter directs students to film clips of both classic and contemporary films available online in LaunchPad Solo for *The*

Film Experience. More than a dozen new clips have been added for the fifth edition, all accompanied by thought-provoking discussion questions. LaunchPad Solo also includes many additional, exclusive Film in Focus and Form in Action boxes not available in the print edition, including boxes written especially for this new edition online. The LaunchPad Solo platform makes it easy to assign the videos, readings, and questions, and because all students will have access to the same clips and activities, classroom conversations can start from a common ground. Access to LaunchPad Solo for *The Film Experience* can be packaged with the book or purchased on its own.

New Examples Enhance the Strongest Art Program Available

Each generation of students that takes the introductory course (from eighteen-year-old first-year students to returning adults) is familiar with its own recent history of the movies. Hence, we have updated this edition with a number of new examples that reflect the diverse student body—Hollywood blockbusters such as *Deadpool*, *Inside Out*, and *Furious 7*; independent fare like *Ex Machina*, *Carol*, and *Moonlight*; and popular international films like *Persepolis*, *PK*, and *Oldboy*.

Proven Learning Tools That Foster Critical Viewing and Analysis

The Film Experience transforms students from movie buffs to critical viewers by giving them the help they need to translate their movie experiences into theoretical knowledge and analytical insight. Our host of learning tools includes the following:

- **Chapter-opening vignettes place students inside a film.** Each compelling vignette, many of them new to this edition, draws from actual scenes in a real movie to connect what students know as movie fans to key ideas in the chapter's discussion. For example, Chapter 1 opens with a contrast between filmmaker Ryan Coogler's projects *Fruitvale Station* and *Creed*, illustrating the different scopes, scales, and frames of reference for contemporary filmmaking.

- **Film in Focus essays in each chapter provide close analyses of specific films,** demonstrating how particular techniques or concepts inform and enrich those films. For example, a detailed deconstruction in Chapter 4 of the editing patterns in *Bonnie and Clyde* shows how they create specific emotional and visceral effects.

- **Form in Action boxes with image-by-image analyses in the nine chapters on form and organization** give students a close look at how the formal concepts they read about translate onscreen. With several new additions—including a look at the mise-en-scène of a Martin Scorsese film, an analysis of a recent movie trailer, and an examination of the internationally acclaimed *In the Mood for Love*—each Form in Action essay brings key cinematic techniques alive and teaches students how to read and dissect a film formally.

- **Marginal Viewing Cues adjacent to key discussions in the chapter highlighting key concepts** prompt students to consider these concepts while viewing films on their own or in class—and to visit our online clip library for some specific examples.

- **The best instruction on writing about film and the most student writing examples** of any introductory text are offered throughout. Praised by instructors and students as a key reason they love the book, Chapter 12, "Writing a Film Essay: Observations, Arguments, Research, and Analysis," is a step-by-step guide to writing papers about film—taking notes, choosing a topic, developing an argument, incorporating film images, and completing a polished

essay. It includes several annotated student essays and new coverage of creating video essays, exploring a popular new format for film analysis.

Resources for Students and Instructors

To find more information on the student resources or to learn more about package options, please visit the online catalog at **macmillanhighered.com/filmexperience/catalog.**

- For students and instructors: **LaunchPad Solo** for *The Film Experience* at **bedfordstmartins.com/filmexperience**
 Available packaged with *The Film Experience* or purchased separately, LaunchPad Solo features a collection of short videos, including both film clips and unique annotated video essays designed to give students a deeper look at important film concepts covered in the text. The videos further the discussions in the book and bring them vividly to life. The videos are great as in-class lecture launchers or as motivators for students to explore key film concepts and film history further.

- For instructors: the **Online Instructor's Resource Manual** by John Bruns, College of Charleston
 The downloadable Instructor's Resource Manual recommends methods for teaching the course using the chapter-opening vignettes, the Viewing Cues, and the Film in Focus and Form in Action features. In addition, it offers teaching aids like chapter overviews, questions to generate class discussion, ideas for encouraging critical and active viewing, sample test questions, and sample syllabi. Instructors who have adopted LaunchPad Solo for *The Film Experience* can find a full instructor section within LaunchPad Solo that includes the Instructor's Resource Manual and PowerPoint presentations.

Print and Digital Formats

For more information on these formats and packaging information, please visit the online catalog at **macmillanhighered.com/filmexperience/catalog.**

LaunchPad Solo is a dynamic new platform that dramatically enhances teaching and learning. LaunchPad Solo for *The Film Experience* collects videos, activities, quizzes, and instructor's resources on a single site and offers a student-friendly approach, organized for easy assignability in a simple user interface. Instructors can create reading, video, or quiz assignments in seconds, as well as embed their own videos or custom content. A gradebook quickly and easily allows instructors to review the progress for a whole class, for individual students, and for individual assignments, while film clips and videos enhance every chapter of the book. LaunchPad Solo can be packaged with *The Film Experience* or purchased on its own. Learn more at **LaunchPadWorks.com.**

The Film Experience **is available as a print text.** To get the most out of the book and gain access to the extensive video program, consider packaging LaunchPad Solo with the text.

The loose-leaf edition of *The Film Experience* **features the same print text in a convenient, budget-priced format, designed to fit into any three-ring binder.** Consider packaging LaunchPad Solo with the loose-leaf edition.

The e-book for *The Film Experience* **includes the same content as the print book and provides an affordable, tech-savvy PDF e-book option for students.** Instructors can customize the e-book by adding their own content and deleting or rearranging chapters.

Acknowledgments

A book of this scope has benefited from the help of many people. A host of reviewers, readers, and friends have contributed to this edition, and Timothy Corrigan is especially grateful to his students and his University of Pennsylvania colleagues Karen Redrobe, Peter Decherney, Nicola Gentili, and Meta Mazaj for their hands-on and precise feedback on how to make the best book possible. Patricia White thanks her colleagues in Film and Media Studies at Swarthmore, Bob Rehak and Sunka Simon; Helen Lee and the many colleagues and filmmakers who have offered feedback; and her students and assistants, especially Robert Alford, Mara Fortes, Willa Kramer, Brandy Monk-Payton, and Natan Vega Potler.

Instructors throughout the country have reviewed the book and offered their advice, suggestions, and encouragement at various stages of the project's development. For the fifth edition in particular, we would like to thank Brooke Belisle, Stony Brook University; David A. Brewer, The Ohio State University; Bryan Brown, Northern Virginia Community College; Leslie Chilton, Arizona State University; Janet Cutler, Montclair State University; Isabelle Freda, Hofstra University; Kristen Hatch, University of California, Irvine; Hugh Manon, Clark University; John MacKay, Yale University; Alice Maurice, University of Toronto — Scarborough; Lucinda McNamara, Cape Fear Community College; Joshua Shepperd, The Catholic University of America; and Lisa Stokes, Seminole State College of Florida.

At Bedford/St. Martin's, we thank Erika Gutierrez, senior program director for communication, for her belief in and support of this project from the outset, as well as senior development manager Susan McLaughlin and vice president for humanities Edwin Hill for their support as we developed the fifth edition. We are especially grateful to senior developmental editor Jesse Hassenger for guiding us with patience and good humor throughout multiple editions of this project. His great knowledge of and passion for the movies has benefited the book immensely. We are indebted to photo researchers Kerri Wilson and Terri Wright and to Tayarisha Poe and Logan Tiberi-Warner for all their work capturing images: the art program was a tremendous undertaking, and the results are beautiful. Thanks to Peter Jacoby, senior content project manager, and Lisa McDowell, senior workflow manager, for their diligent work on the book's production. We also thank Jerilyn Bockorick for overseeing the design and Billy Boardman for a beautiful new cover. Thanks also go to Kayti Corfield, marketing manager; Sarah O'Connor, media project manager; and Mary Jane Chen, assistant editor.

We are especially thankful to our families — Marcia Ferguson and Cecilia, Graham, and Anna Corrigan; George and Donna White, Cynthia Schneider, and Max Schneider-White. Finally, we are grateful for the growth of our writing partnership and for the rich experiences this collaborative effort has brought us. We look forward to ongoing projects.

Timothy Corrigan
Patricia White

Brief Contents

Contents

(Top, Bottom) © Warner Bros./Courtesy Everett
Collection

(Top) Everett Collection, inc; (Center) Universal/
Photofest; (Bottom) Everett Collection, Inc

Everett Collection, Inc

PART 3
ORGANIZATIONAL STRUCTURES:
from stories to genres 240

Everett Collection, Inc

Everett Collection, Inc

Beyoncé appears courtesy of Parkwood
Entertainment/Columbia

(Top, Center, Bottom) Everett Collection, Inc

PART 4

CRITICAL PERSPECTIVES:
reading and writing about film 374

Everett Collection, Inc

Columbia/REX/Shutterstock.com

THE FILM
EXPERIENCE

CULTURAL CONTEXTS
watching, studying, and making movies

The staggering worldwide box-office success of *Star Wars: The Force Awakens* (2015) was fueled by a nostalgia for the original series that was felt by multiple generations of viewers, the marketing synergy of Lucasfilm and new owner Walt Disney Studios, and state-of-the-art visual effects that recreated the original *Star Wars* (1977) aesthetic.

Another science fiction film released the same year, the British *Ex Machina*, targeted specialized audiences. Instead of appealing through spectacle and action sequences, the film poses existential questions about artificial intelligence's challenges to the definition of what is human. Yet beneath its cutting-edge style, its fantasy of a male-created female android takes clear inspiration from the ancient story of Pygmalion and Galatea, with cinematic antecedents in *Metropolis* (1927) and *Blade Runner* (1982). In contrast, *Star Wars: The Force Awakens* reflects the changing consciousness of its broad-based audience by including a white woman and an African American male alongside a white male as heroes.

Despite differences of scale, complexity, and impact, the films were both measured by box-office success and critical and awards recognition. Although *Ex Machina* earned a fraction of the blockbuster's take, it was a success given its comparatively modest $15 million production budget—and it beat *Star Wars* in the Oscar race for best visual effects. Social and institutional forces shaped these two films in very different ways—from their production through their promotion, distribution, and exhibition.

Part 1 of this book identifies institutional, cultural, and historical contexts that shape the film experience, showing us how to connect our personal movie preferences with larger critical perspectives on film. The Introduction examines how and why we study film as part of a wider cultural phenomenon; Chapter 1 introduces the movie production process as well as the mechanisms and strategies of film distribution, promotion, and exhibition; and Chapter 2 gives an overview of film history as well as strategies for organizing historical information. Understanding these different contexts will help us to develop a broad and analytical perspective on the film experience.

Top: Courtesy ZUMAPRESS.com/Moviestills/AGE Fotostock. Bottom: Everett Collection, Inc.

STUDYING FILM
Culture and Experience

--

The documentary *Room 237* (2012), directed by Rodney Ascher, is named after a room in the isolated resort hotel where Stanley Kubrick's *The Shining* (1980) takes place. The interviewees do exactly what the film's characters are warned against — explore Room 237 — and their often far-fetched interpretations of the horror classic structure the documentary. Allowing participants to exercise their interpretive imaginations to the fullest, *Room 237* is a commentary on the extent to which viewers may invest in their viewing and interpretation of films as well as a call for a disciplined practice of criticism. By over-reading the labels on products in the hotel pantry to expound a theory claiming the film is about the genocide of Native Americans, the subjects of *Room 237* make a mockery of close analysis as a method. The juxtaposition of multiple theories about Kubrick's film — one connecting it to faking the moon landing — is an indictment of the claim that a critic can make a text mean anything he or she wants. But at the same time, the enthusiasm of these viewers for their object of study, their animation when speaking of it, and their unshakable belief in the director's authority speak to the powerful hold of the film experience over our critical imagination.

For more than a century, the movies have been an integral part of our cultural experience, and most of us already know a great deal about them. We may know which beloved comic book character will be featured in the next big-screen adaptation or which director will have a new project in competition at the Cannes Film Festival. We anticipate summer releases, pick front-runners for major awards, and get ideas for Halloween costumes from horror franchises. Our encounters with and responses to motion pictures are a product of the diverse attitudes, histories, practices, and interests that we, the viewers and the fans, bring to the movies. These factors contribute to the culture that frames our overall film experience.

Film culture is the social and historical environment that shapes our expectations, ideas, and understanding of movies. In addition to individual films, film culture encompasses the practices, institutions, and communities surrounding film production, publicity, and appreciation—anything people say and do that is related to the movies. Our tastes and habits inform film culture, and in turn, film culture transforms how we watch, understand, and enjoy movies in a variety of rapidly expanding ways. We can view parodic trailers of new releases on the Internet, catch a showing of *The Philadelphia Story* (1940) on cable television, join those camped out to see *Star Wars: The Force Awakens* in IMAX **[Figure I.1]**, watch a documentary streaming on Netflix, or attend a screening of the silent vampire film *Nosferatu* (1922) with organ accompaniment. Our encounters with and responses to these films—how and why we select the ones we do, why we like or dislike them, and how we understand or are challenged by them—are all part of film culture and, by extension, objects of film study.

I.1 ***Star Wars* fans in line.** Experiencing the premiere of a movie becomes a singular social event with friends and other fans. Hector Mata/Getty Images

KEY OBJECTIVES

- Define the scope of film culture and film studies.
- Describe the role and impact of film viewers, and note how viewers' movie experiences have both personal and public dimensions.
- Understand this textbook's approach to film culture and the film experience.

Why Film Studies Matters

As students, you bring to the classroom a lifetime of exposure to the movies. For example, your opinions about casting certain actors in the film *The Fault in Our Stars* (2014) may reflect your understanding of how characters from a novel should appear onscreen. Your mesmerized attraction to the special effects and stunts of

Furious 7 (2015) may pique your curiosity about new cinematic technology. Your expectations of genre formulas, such as those found in the classic horror movie *The Exorcist* (1973), may provoke an outburst when a character heads down a darkened alley. The discipline of film studies builds on your knowledge about and appreciation for the movies, helping you to think about film form and context more analytically and precisely.

Film studies is a discipline that reflects critically on the nature and history of movies and the place of film in culture. It is part of a rich and complex history that overlaps with critical work in many other fields, such as art history, communications, literary studies, philosophy, and sociology. Since the origin of the medium, scientists, politicians, and writers have attempted to make sense of the film experience. A film's efforts to describe the world, impose its artistic value, or shape society have long been the subject of both scholarly and popular debates. In the decades before the first public projection of films in 1895, scientists Étienne-Jules Marey and Eadweard Muybridge adapted photographic technology to study human and animal motion, laying the groundwork for the invention of cinema as we know it. In the early twentieth century, poet Vachel Lindsay and Harvard psychologist Hugo Münsterberg wrote books on the power of movies to change social relationships and the way people perceive the world. By the 1930s, the Payne Fund Studies and Margaret Farrand Thorp's *America at the Movies* (1939) offered sociological accounts of the effect of movies on young people and other social groups. Soon courses about the art of the movies began to appear in universities, journals devoted to the new aesthetic form appeared around the world, and in 1935 the Museum of Modern Art in New York City began collecting films.

After World War II, new kinds of filmmaking emerged in Europe that sparked passionate, well-informed criticism about the history and art of the movies, including Hollywood genre films and the accomplishments of particular directors. Such criticism fueled film studies journals and courses, and by the 1970s the discipline had attained a firm foothold in North American universities. Today the study of film represents a wide spectrum of approaches and points of view, including accounts of different historical periods or national cinemas, analyses of economic and technological developments, studies of how race and gender are depicted in movies and affect audiences' responses to them, and explications of particular aesthetic or formal features of films, including experimental, documentary, and genres of narrative cinema. Film studies provides a strong background for the study of television and digital media, especially as the production and consumption of these forms becomes less distinct.

One sign of the interaction between contemporary film culture and film studies is the DVD supplement. As downloading and streaming movies becomes common practice, DVD and Blu-ray editions of films distinguish themselves with extra features that may include commentary tracks from the filmmakers, scholars, or other experts; additional scenes deleted from the final cut; "making-of" videos; or historical background. These practices, such as preservation of original promotional materials or on-set documentation, are often of direct value to film studies. With research on movies and the movie business facilitated by DVD supplements, as well as podcasts, blogs, and the Internet, the complexities and range of films and film cultures may now be more available to viewers than ever before. The formal study of film gives shape and direction to such inquiry.

The Film Experience provides a holistic perspective on the formal and cultural dynamics of watching and thinking about movies. It does not privilege any one mode of film study over another but rather introduces critical tools and perspectives that allow readers to approach film study according to their different needs, aims, and interests. Crucially, it supplies the vocabulary needed to understand, analyze, and discuss film as industry, art, and practice.

At the same time, *The Film Experience* raises theoretical questions that stretch common reactions. These questions include psychological ones about perception, comprehension, and identification; philosophical ones about the nature of the image and the viewer's understanding of it; and social and historical ones about what meanings and messages are reinforced in and excluded by a culture's films. Far from destroying our pleasure in the movies, studying them increases the ways that we can enjoy them thoughtfully.

Film Spectators and Film Cultures

I.2 Poster for public screening of early films by the Lumière brothers. This poster shows the short comic sketch *L'Arroseur arrosé (The Waterer Watered, 1895)*. In the advertisement, the audience's reaction shows the novelty of the experience, which is as important as the image onscreen. Ronald Grant Archive/Alamy

I.3 *Avatar* (2009). Many viewers responded favorably to Sigourney Weaver's strong female character in the film; others joined an Internet campaign against the film's depiction of smoking.

Movies are always both private and public affairs. Since the beginning of film history, the power of the movies has derived in part from viewers' personal and sometimes idiosyncratic responses to a particular film and in part from the social and cultural contexts that surround their experience of that film. Viewers present at the first projections of the Lumière brothers' *Train Arriving at a Station* (1894) were rumored to have fled their seats to avoid the train's oncoming rush. New interpretations of such first-encounter stories suggest that audiences were seeking precisely such a visceral entertainment not found in their normal social lives **[Figure I.2]**. In a more contemporary example, some individuals reacted on a personal level to *Avatar* (2009), breathlessly absorbed in a love story that harks back to *Romeo and Juliet* and overwhelmed by breathtaking visual movements that recall the visceral experience of amusement park rides. Other viewers dismissed the film because it offered what they saw as a simplistic political parable about corporate greed, terror, and exploitation and disguised its bland characters and predictable story with jazzy special effects **[Figure I.3]**.

Some approaches in film studies look first at a film's formal construction and others at the historical background of its production; *The Film Experience* begins with an emphasis on movie spectators and the ways that individuals respond to films. Our different viewing experiences determine how we think about a particular movie—why it excites or disappoints us. The significance of movies may lie primarily not in how they are made but rather in how we, as viewers,

engage with and respond to them. As movie spectators, we are not passive audiences who simply absorb what we see on the screen. We respond actively to films, often in terms of our different ages, backgrounds, educational levels, interests, and geographical locations. The richness and complexities of these factors make film viewing and film study a profoundly cultural experience. In short, our engagement with a movie goes beyond determining whether we like or dislike it. As **active viewers**, we engage with a film in energetic and dynamic ways that *The Film Experience* aims to encourage and direct.

Our reactions are not only personal but also have important public and social dimensions. For instance, the film *Selma* (2015) commemorates the fiftieth anniversary of a pivotal event in the struggle for equal voting rights by depicting the marches from Selma to Montgomery, Alabama, as a successful example of community activism. Martin Luther King Jr. is an important part of the story, but so are the local leaders, ordinary citizens, and the four young girls killed by a bomb planted by Ku Klux Klan members in a Birmingham church. Movies inspired by real-life events often have as much to say about the historical moment in which they are made as they do about the one they depict. *Selma* allowed commentators to draw parallels with contemporary community organizing in response to police violence and the importance of women's voices in such struggles. Controversies over historical inaccuracies in the film's depiction of President Lyndon B. Johnson and director Ava DuVernay's failure to receive a nomination for the Academy Award for best director hit on political issues of access to historical narratives and race and gender equity in the film industry. In this way, discussions of the film's dramatic images and events effectively connected emotional responses with wider social dynamics.

At the intersection of these personal and public experiences, each of us has developed different tastes—cultural, emotional, intellectual, and social preferences or interests—that influence our expectations and lead us to like or dislike particular movies. Some tastes vary little from person to person; most people prefer good characters to bad ones and justice served to justice foiled. Yet many tastes in movies are unique products of our experiential circumstances or experiential histories. **Experiential circumstances** are the material conditions that define our identity at a certain time and in a certain place—such as our age, gender, race, linguistic and socioeconomic background, and the part of the country or world in which we live. For example, children are drawn to animated features with cuddly creatures and happy resolutions, whereas adults may have more patience for complicated plotlines or films with subtitles. Audiences who have been underrepresented in mainstream cinema may object when a role in a film goes to an actor of a different race than the character as written in a novel. Tastes shaped by experiential circumstances have social significance.

Experiential histories are the personal and social encounters through which we develop our identities over time and can include our education, relationships, travels, and even the films we have seen. These histories help determine individual as well as cultural tastes. For example, a World War II veteran, because of his experiential history, might have a particular taste for WWII films **[Figure I.4]**, ranging from such sentimental favorites as *Mrs. Miniver* (1942) to the

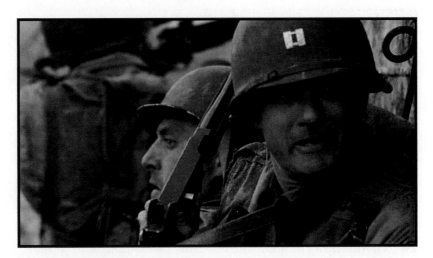

I.4 *Saving Private Ryan* (1998). Based on their experiential histories, veterans hailed Spielberg's hard-hitting film as a realistic depiction of what American combat troops encountered during the invasion of Normandy.

I.5 *Into the Woods* (2014). Musical adaptations often draw their fan base from audiences familiar with the Broadway productions or fans of the stars, like Emily Blunt or James Corden, who sing in the film version.

harder-hitting dramas *Saving Private Ryan* (1998) and *Flags of Our Fathers* (2006). Early years spent watching Turner Classic Movies with an older relative might predispose a college-age viewer to seek out Hollywood revivals. An audience's taste in films is often tied to historical events, drawing viewers to see films about lived-through experiences such as the NASA space missions in *Hidden Figures* (2016) or the September 11, 2001, terrorist attacks on the United States dramatized in Oliver Stone's *World Trade Center* (2006).

But experiential influences are not limited to public history. American college students may be drawn to Wes Anderson's *Fantastic Mr. Fox* (2009) as fans of the director's debut film *Rushmore* (1998) or because they read Roald Dahl's books as children. A big-screen **adaptation**—the process of turning a book, television show, play, or other artistic work into a film—attracts the fans from the original medium. For example, *Into the Woods* (2014) appeals to Broadway fans familiar with the original musical, fans eager to see their favorite movie stars attempting a musical role, or family audiences interested in the fairy-tale aspect of the story **[Figure I.5]**.

Our experiential circumstances and histories may predispose us to certain tastes and responses, but these are activated when we actually watch a film by two psychological processes that come into play simultaneously—identification and cognition. **Identification**—the complex process through which we empathize with or project feeling onto a character, action, or setting—is commonly associated with our emotional responses. Both adolescent and adult viewers can respond empathetically to the portrayal of the social electricity and physical awkwardness of teenage sexuality in *American Graffiti* (1973), *The Breakfast Club* (1985), or *Superbad* (2007), although different generations might find the music of one movie or the fashions of another more resonant, and male viewers are presumed to relate more easily—or uneasily—than female viewers to the high school boys at the center of *Superbad* **[Figure I.6]**. Each of us may identify with different minor

I.6 *Superbad* (2007). In this Judd Apatow production, the main characters are two male adolescents who spend most of the movie in search of alcohol to impress girls. Identification with the characters based on gender is an important, although not necessarily predictable, aspect of the viewer's experience of film.

characters (such as the nerd Brian or the prom queen Claire in *The Breakfast Club*), but the success of a film often depends on eliciting audience identification with one or two of the main characters (such as Curt and Steve, the two boys who are about to leave for college in *American Graffiti*). Identification is sustained as the main characters face conflict and choices. Using another example, while watching the musical *An American in Paris* (1951) [**Figure I.7**], one viewer may instantly relate to the carefree excitement of the opening scenes by identifying with the street life of the artistic Montmartre neighborhood where she had lived as a college student. Another viewer who has never been to Paris may participate vicariously because the film effectively creates an atmosphere of romance with which he can identify. Sometimes our preference for a particular film genre aids — or detracts from — the

I.7 *An American in Paris* (1951). The setting of a film may be a source of identification.

process of identification. Viewers who favor the adrenaline rush of horror films may have less interest and enthusiasm when faced with the bright colors and romantic plotlines associated with American musicals of the 1940s and 1950s.

Cognition, or the aspects of comprehension that make up our rational reactions and thought processes, also contributes to our pleasure in watching movies. At the most basic cognitive level, we process visual and auditory information indicating motion, the passing of time, and the organization of space as we watch movies. At another level, we bring assumptions about a given location or setting to most films, we expect events to change or progress in a certain way, and we measure characters against similar characters encountered elsewhere. Thus, watching a movie is not only an emotional experience that involves identifying through processes of participation and empathy but also a cognitive process that involves the intellectual activities of comparison and comprehension. Involved through our emotional identification with the terrors or triumphs of Russell Crowe's character in *Gladiator* (2000), for example, we also find ourselves engaged cognitively with other aspects of the film [**Figure I.8**]. We recognize and distinguish the Rome in the movie through particular visual cues (such as the Colosseum and other Roman monuments) that are known perhaps from studying world history or viewing pictures or other movies. We expect we know who will win the battles and fights because of what we have learned about such skirmishes. Because of other experiences, we arrive at the film with certain assumptions about Roman tyrants and heroes, and we appreciate and understand characters like the emperor Commodus or the gladiator Maximus as they successfully balance our expectations with surprises. At the same time, our prior knowledge does not necessarily prepare us for the extreme and graphic violence depicted in the film.

VIEWING CUE

What types of films do you identify with most closely? Are they from a particular country, era, or genre? Do they feature certain stars or a particular approach to music or settings?

I.8 *Gladiator* (2000). Viewers cognitively process historical knowledge, narrative cues, and their own visceral responses when watching historical scenes such as the ones seen in *Gladiator*.

I.9a

I.9b

I.9c

FORM IN ACTION

Identification, Cognition, and Film Variety

The processes of identification and cognition that underlie how viewers interact with films are engaged in different ways across the breadth of film culture. Some films elicit identification through action, special effects, or stars, while other films produce more cognitive relationships with their audiences by referring to current events or encouraging witty and ironic perspectives on characters or their circumstances.

Hollywood blockbusters like *Mission: Impossible—Rogue Nation* (2015) attract large audiences who expect to be entertained by action, spectacle, and special effects without having to think too deeply about plot, character, or realism **[Figure I.9a]**. *Ponyo* (2008), a Japanese animated fantasy about a surprising friendship, appeals to family audiences in the United States (by using well-known English-speaking actors to voice the characters) as well as to anime enthusiasts (through its visual daring) **[Figure I.9b]**. The documentary *The Look of Silence* (2014) is an engrossing exploration of government-sanctioned mass killings in Indonesia in the mid-1960s that appeals to audiences interested in documentaries as a tool for exposing human rights abuses. The director uses real-life figures and footage from his previous film on the subject, *The Act of Killing* (2012), to confront those responsible for these horrific crimes **[Figure I.9c]**. Independently produced films like *Whiplash* (2014), which tells an unusual story of an abusive music teacher and his driven student, solicit a demographic with access to art-house cinemas that is comfortable with unlikable characters, lesser known actors, and small-scale narratives **[Figure I.9d]**.

📹 FORM IN ACTION
🎬 LaunchPad Solo
To watch a clip from *Whiplash* (2014) showing how identification is solicited through performance, see LaunchPad Solo.

I.9d

Even as we are drawn to and bond with places, actions, and characters in films, we must sometimes reconsider how those ways of identifying develop and change as part of our intellectual or cognitive development. Indeed, this process of cognitive realignment and reconsideration determines to a large degree our reaction to a movie. Leonardo DiCaprio's reputation as a sensitive if conflicted hero in previous movies made his manic turn as the vicious slaveholder Calvin Candie in *Django Unchained* (2012) a startling change of pace. Viewers were confronted with the questions of what attracted them to the actor and how the challenge to their expectations affected their experience of the film and its violence. Thus, what we like or dislike at the movies often relates to the simultaneous and evolving processes of identification and cognition.

The Film Experience

What a movie looks and sounds like is at the heart of any film experience, and much of *The Film Experience* is devoted to exploring in detail the creation of those many visual, audio, narrative, and formal features and forces that we see on the screens around us. But viewers ultimately process those images and sounds, and they do so in diverse ways that bring meaning to film culture and to their lives. The cinematic complexities of *Citizen Kane* (1941), for example, are technically the same for each viewer, but they provoke different responses **[Figure I.10]**. Hardly a typical viewer, newspaper tycoon William Randolph Hearst reacted negatively to the film, claiming it was an inflammatory portrait of himself and refusing to allow his papers to carry ads for it. In the 1950s, French writers and filmmakers hailed the film as auteur cinema, evidence of the power of the filmmaker to create a personal vision of the world. In recent decades, the film's consistent ranking at or near the top of critics' polls has influenced the teaching and viewing of *Citizen Kane*, thus illustrating how viewers respond to both the movie and its prestigious place in film history. With any film, some viewers may find importance in the technological or economic features, others may highlight the aesthetic or formal innovations, and still others may emphasize a film's historical or social significance as its most meaningful quality. The same film, in fact, could lead different moviegoers to any one of these (or other) critical pathways, and the most important way to engage the film is the one that provides the most productive encounter for each individual viewer.

Viewers' experiences of the movies—their shared exposure to film culture and their individual interpretations guided by identification, cognition, and their experiential circumstances and histories—are the starting point of *The Film Experience*. Part 1 examines both how processes and patterns of production, distribution, and exhibition present a film in particular ways and how the history of film form and culture shapes our

I.10 *Citizen Kane* (1941). Even canonized films offer multiple entryways and the possibility of various responses for careful viewers. Courtesy Everett Collection

understanding of the medium and its social role. This approach foregrounds the social contexts in which audiences encounter the movies. Part 2 presents the four formal systems that structure films—mise-en-scène, cinematography, editing, and sound—showing how viewers derive meaning from familiar as well as innovative forms and patterns. Part 3 introduces and analyzes the primary modes through which viewers' encounters with the movies are shaped—narrative, nonfiction, and experimental organizations—as well as film genres. Part 4 offers critical perspectives on film, including an account of major questions and positions in film theory and a guide to writing a film essay and enhancing writing with audiovisual tools.

The Film Experience encourages readers to choose and explore different pathways into a film and into film culture more generally. This is not to say that studying film allows a movie to mean anything one wants; indeed, this book insists on a precise understanding of film forms, practices, and terminologies. Rather, having the tools and awareness to measure how and why a film engages us and provokes us in many different ways ultimately makes clear how rich and exciting films and film cultures are and, at the same time, how important and rewarding it is to think carefully, accurately, and rigorously about both.

Critical and scholarly interest in the movies is an outcome of—and an input into—the values and ideas that permeate our social and cultural lives. Not only are cultural values and ideas *reflected in* the films and media that surround us, but values and ideas are also *generated by* them. Both inside and outside the classroom, movies engage us, and we them. Public debates about violence in the movies, the crossover of movie stars into positions of political power, the technological and economic shifts that have led to widespread participation in moving image production, the vigorous marketing of new formats and playback devices, and the recycling of plots and characters across media are only some of the constant reminders of how movies are spread throughout the fabric of our everyday experiences. To think seriously about film and to study it carefully is therefore to take charge of one of the most influential forces in our lives. Expanding our knowledge of the cinema—its formal grammar, its genres, and its historical movements—connects our everyday knowledge to the wider sociocultural patterns and questions that shape our lives.

CONCEPTS AT WORK

Viewing movies is more complex than it at first seems. As fans and students of the movies, most of us experience films from a variety of personal and cultural positions and angles. Our histories, circumstances, and tastes may draw us to different films for different reasons: one person may be an expert on *Star Wars* lore and enjoy the future world of *Ex Machina*, while others may be drawn to the music of *Into the Woods* or the history lessons of *Gladiator*. In some cases, we identify primarily with the film and its characters, as when adults view *The Breakfast Club* nostalgically. In others, our experience may be more of cognitive or intellectual engagement, as when we reflect on a documentary such as *The Look of Silence*. In almost every case, it can be rewarding and exciting to examine how and why we view and respond to movies in certain ways.

- How would you describe the film culture that situates you today? How does it position you to enjoy certain films or kinds of films?
- What kinds of tastes, histories, and circumstances inform viewers' understanding of a historical film like *Selma*?
- Describe two different viewing positions for a big summer movie like a *Mission: Impossible* or *Avengers* movie—one viewing position that is primarily about identification and another that has a more cognitive engagement with the film. Try to be specific.
- Make the case for studying a war film like *Saving Private Ryan*. How might that film be studied, and how would that activity add to both the understanding and the enjoyment of that film?

LaunchPad Solo

Visit the LaunchPad Solo for *The Film Experience* to view movie clips, read additional Film in Focus pieces, and reflect more upon your film experiences.

ENCOUNTERING FILM
From Preproduction to Exhibition

Between 2013 and 2015, Ryan Coogle directed two very different kinds of films —
Fruitvale Station (2013), a small but intense drama about an African American man
mistakenly shot and killed by a transit policeman on a subway platform, and *Creed*
(2015), the seventh film in the *Rocky* franchise, about the bond between Rocky Balboa
and Apollo Creed's son as he prepares for a championship fight. Although both feature
rising star Michael B. Jordon, the production, distribution, and exhibition of the two films
illustrate how films, even by the same director, can be shaped by extremely different insti-
tutional histories that in turn shape our understanding of them.

Based on actual events that occurred in 2008 in California, Ryan Coogler's *Fruitvale
Station* generated extensive buzz at both the Sundance and Cannes film festivals. When
its theatrical release in July 2013 coincided with the acquittal of accused murderer
George Zimmerman for his "Stand your ground" shooting of a young, unarmed African
American in Florida, *Frutivale Station* became not just an emotionally searing film but
also part of larger conversations, still ongoing, about justice in the streets of America.

Coogler's 2015 *Creed* traveled a different path. This franchise film inherits the whole
history of the *Rocky* series, which focused on star Sylvester Stallone's character as a
boxer from the working-class neighborhoods of Philadelphia. In *Creed*, Rocky is an older
and wiser man asked to train the son (Jordon) of his old rival. It's a more crowd-pleasing,
formulaic film than *Fruitvale Station*, and a bigger box office success, but they both
appeal to African American and broader audiences.

As these two disparate films suggest, film production, distribution, and exhibition
shape our encounters with movies, and these aspects of film are in turn shaped by how
movies are received by audiences.

Top: © Warner Bros./courtesy Everett Collection. *Bottom:* © The Weinstein Company/courtesy Everett Collection

Whether we follow movie news or not, we know that a great deal has taken place before we as viewers experience a film. The varied practices that go into moviemaking are artistic and commercial but also cultural and social, and they anticipate the moment of viewing, at which meaning and value are generated. Understanding the process that takes a film from an idea to its final form deepens an appreciation for film form and the labor and craft of filmmakers and reveals ways that culture and society influence filmmaking itself.

This chapter describes the process of production as well as the fate of a finished film as it is distributed, promoted, and exhibited. Such extrafilmic processes describe events that precede, surround, or follow the actual images we watch and are inseparable from the film experience.

As viewers, our response, enjoyment, and understanding are shaped by where and when we see a movie as much as by the film's form and content. The film experience now encompasses ever smaller viewing devices (including computers, iPads, and smartphones), changing social environments (from IMAX to home theaters), and multiple cultural activities designed to promote interest in individual films (reading about films, directors, and stars; playing video games; watching special DVD editions; or connecting to social media that support a film franchise). Waiting in line with friends for a Thursday night premiere and half-watching an edited in-flight movie are significantly different experiences that lead to different forms of appreciation and understanding. Overall, it is helpful to think of production and reception as a cycle rather than a one-way process: what goes into making and circulating a film anticipates the moment of viewing, and viewing tastes and habits influence film production and dissemination.

KEY OBJECTIVES

- List the stages of filmmaking, from preproduction through production to postproduction, and explain how each stage informs what we see on the screen.
- Describe how the mechanisms of film distribution determine what films we can see as well as when and how we can see them.
- Analyze how film promotion may predispose us to see certain films and to see them in certain ways.
- Evaluate the ways in which film exhibition both structures and is influenced by audience reception.
- Explain the ways in which media convergence and rapid technological advances are affecting virtually all aspects of the film experience from production to consumption.

Production: How Films Are Made

The aim at each step of filmmaking is to create an artistic and commercial product that will engage, please, or provoke viewers. In short, film **production** is a multi-layered activity in which industry, art, technology, and imagination intertwine. It

describes the different stages—from the financing and scripting of a film to its final edit and, fittingly, the addition of production **credits** naming the companies and individuals involved—that contribute to the construction of a movie. Production may not seem like a central part of our film experiences as viewers, but the making of a film anticipates an audience of one sort or another and implies a certain kind of viewer. Does the film showcase the work of the director or the screenwriter? The cinematographer or the composer of the musical score? How does the answer to this question affect our perspective on the film? Understanding contemporary filmmaking in its many dimensions contributes to our appreciation of and ability to analyze films.

Preproduction

Although the word *production* is used to define the entire process of making a film, a great deal happens—and often a long time passes—before a film begins to be shot. **Preproduction** designates the phase when a film project is in development, involving preparing the script, financing the project, casting, hiring crew, and securing locations. In **narrative** filmmaking (scripted films), the efforts of the screenwriter, producer, and sometimes director, often in the context of a studio or an independent production company, combine at this stage to conceive and refine an idea for a film in order to realize it onscreen. Funds are raised, rights are secured, a crew is assembled, casting decisions are made, and key aspects of the film's design, including location scouting and the construction of sets and costumes, are developed during the preproduction phase. Documentary filmmakers might conduct archival or location research, investigate their subject, and conduct interviews during this period.

Screenwriters

A **screenwriter** (or scriptwriter) is often the individual who generates the idea for a narrative film, either as an original concept or as an adaptation of another source (such as a novel, true story, or comic book character). The screenwriter presents that early concept or material in a **treatment**, a short prose description of the action of a film and major characters of the story, written before the screenplay. The treatment is then gradually expanded to a complete **screenplay** (or script)—the text from which a movie is made, including dialogue and information about action, settings, shots, and transitions. This undergoes several versions, from the temporary screenplay submitted by the screenwriter to the final shooting script that details exact scenes and camera setups. As these different scripts evolve, one writer may be responsible for every version, or different writers may be employed at each stage, resulting in minor and sometimes major changes along the way. Even with a finished and approved script, in the studio context an uncredited **script doctor** may be called in to do rewrites. From *Sunset Boulevard* (1950), about a struggling screenwriter trapped in the mansion of a fading silent film star, to *Adaptation* (2002), about (fictional) screenwriter Charlie Kaufman's torturous attempt to adapt Susan Orlean's book *The Orchid Thief*, numerous films have found drama in the process of screenwriting itself **[Figure 1.1]**. One reason may be

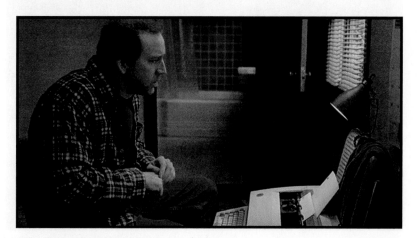

1.1 *Adaptation* (2002). As its title indicates, screenwriting is the topic of this inventive film, in which Charlie Kaufman, played by Nicolas Cage, is both a fictionalized character and the actual credited writer.

the dramatic shifts and instabilities in the process of moving from a concept to a completed screenplay to a produced film, a process that highlights the difficulties of trying to communicate an individual vision to an audience.

Producers and Studios

The key individuals in charge of movie production and finances are a film's producers. A **producer** oversees each step of a film project, especially the financial aspects, from development to postproduction and a distribution deal. At times, a producer may be fully involved with each step of film production from the selection and development of a script to the creation of an advertising campaign for the finished film. At other times, a producer may be an almost invisible partner who is responsible principally for the financing of a movie. Producers on a project also sometimes include filmmakers who are working on other areas of the film, such as the director, screenwriter, or actors.

Producers were extremely powerful in the heyday of the **studio system**, a term that describes the industrial practices of large production companies responsible for filmmaking in Hollywood or other national film industries. The Hollywood studio era extended from the 1920s through the 1950s. MGM was identified with the creative vision of the supervisor of production, Irving B. Thalberg, who as production head worked closely with studio mogul Louis B. Mayer from the mid-1920s until Thalberg's premature death in 1936. After leaving MGM to found his own studio, producer David O. Selznick controlled all stages of production, beginning with the identification of the primary material for the film. For instance, he acquired *Gone with the Wind* as a property even before the novel was published. Selznick supervised every aspect of the 1939 film version of the best-seller, even changing directors during production—a process documented in his famous production memos.

Since the rise of the independent film movement in the 1990s, independent producers have worked to facilitate the creative freedom of the writer and director, arranging the financing for the film as well as seeing the film through casting, hiring a crew, scheduling, shooting, **postproduction** (the period in the filmmaking process that occurs after principal photography has been completed, usually consisting of editing, sound, and visual effects work), and distribution sales. For example, producer James Schamus first worked with Ang Lee on the independent film *Eat Drink Man Woman* (1994) and cowrote the screenplays of *Sense and Sensibility* (1995), *Crouching Tiger, Hidden Dragon* (2000), and *Lust, Caution* (2007). As vice president of Focus Features (a specialty division of Universal), Schamus shepherded Lee's *Brokeback Mountain* (2005) through all stages of production.

Regardless of the size or type of film being made, distinctions among the tasks and roles of types of producers exist. An **executive producer** may be connected to a film primarily in name, playing a role in financing or facilitating a film deal and having little creative or technical involvement. On a documentary, an executive producer might work with the television channel commissioning the program. A coproducer credit may designate an investor or an executive with a particular production company partnering in the movie, someone who had no role in its actual

1.2 *The Kids Are All Right* (2010). A modestly budgeted independent production usually requires name stars to attract financing. Even with cast members committed, however, Lisa Cholodenko's comedic drama about lesbian parents took years to produce.

production. The **line producer** is in charge of the daily business of tracking costs and maintaining the production schedule of a film, while a **unit production manager** is responsible for reporting and managing the details of receipts and purchases.

The budget of a film, whether big or minuscule, is handled by the producers. In budgeting, **above-the-line expenses** are the initial costs of contracting the major personnel, such as directors and stars, as well as administrative and organizational expenses in setting up a film production. **Below-the-line expenses** are the technical and material costs—costumes, sets, transportation, and so on—involved in the actual making of a film. **Production values** demonstrate how the quality of the film's images and sounds reflects the extent of these two expenses. In both subtle and not-so-subtle ways, production values often shape viewers' expectations about a film. High production values suggest a more spectacular or more professionally made movie. Low production values do not necessarily mean a poorly made film. In both cases, we need to adjust our expectations to the style associated with the budgeting.

Financing Film Production

Financing and managing production expenses is a critical ingredient in making a movie. Traditionally, studios and producers have worked with banks or large financial institutions to acquire this financing, and the term *bankable* has emerged as a way of indicating that a film has the necessary ingredients—such as a famous star or well-known literary source—to make that investment worth the risk. A mainstream action movie like *Suicide Squad* (2016), starring Will Smith, might cost well over $100 million to produce and over $50 million to market—a significant investment that assumes a significant financial return. Developed alongside the conception of a film, therefore, is a plan to find a large enough audience to return that investment and, ideally, a profit.

Some films follow a less typical financing path. Kevin Smith made *Clerks* (1994) by charging expenses to various credit cards. The 1990s saw a rise in independent film as financing strategies changed. Instead of relying on a single source such as a bank or a studio, independent filmmaking is financed by organized groups of individual investors or presales of distribution or broadcast rights in different markets. In the absence of studio backing, an independent film must appeal to potential investors with a known quantity, such as the director's reputation or the star's box-office clout. Although major star Julianne Moore was attached to Lisa Cholodenko's project *The Kids Are All Right* (2010) for five years, raising the film's $4 million budget was difficult **[Figure 1.2]**. Filmmakers as successful as Spike Lee (*Do the Right Thing*, 1989) and Zach Braff (*Garden State*, 2004) have turned to the Kickstarter Web site to raise funding for recent projects.

Nonfiction films also require financing. Documentaries may be sponsored by an organization, produced by a television channel, or funded by a combination of individual donors and public funds. For instance, Jonathan Caouette's *Tarnation* (2003) recounts the filmmaker's childhood and adolescence through a collage of snapshots, Super-8 footage, answering machine messages, video diaries, and home movies **[Figure 1.3]**. It does not use a conventional screenplay, and it was edited on a home

1.3 *Tarnation* (2003). As Jonathan Caouette's debut film shows, even an ultra-low-budget independent production can be released theatrically if it lands an adequate distribution deal.

computer with an alleged production budget of about $200. With John Cameron Mitchell and Gus Van Sant as executive producers, the film screened at the Sundance Film Festival. The publicity led to other festival invitations, a distribution deal for a limited theatrical release, and considerable critical attention.

Casting Directors and Agents

With the increasing costs of films and the necessity of attracting money with a bankable project, the roles of casting directors and agents have become more important. Traditionally the work of a **casting director**, the practice of identifying the actors who would work best in particular scripted roles emerged during the advent of the star system around 1910. Around this time, Florence Lawrence, the exceedingly popular star of Biograph Studio who was known as the "Biograph Girl," first demanded to be named and given a screen credit. Often in consultation with directors, producers, and writers, casting directors have since become bigger and more widely credited players in determining the look and scale of films as they revolve around the cast of stars and actors in those films.

Representing actors, directors, writers, and other major individuals in a film production, **agents** negotiate with writers, casting directors, and producers and enlist different personnel for a movie. The significance and power of the agent extends back at least to the 1930s, when talent agent Lew Wasserman, working as a publicist for the Music Corporation of America (MCA), began to create independent, multiple-movie deals for Bette Davis, Errol Flynn, James Stewart, and many others. By the mid-1950s, Wasserman and others had established a **package-unit approach** to film production whereby the agent, producer, and casting director determine a script, stars, and other major personnel as a key first step in a major production, establishing the production model that would dominate after the demise of the traditional studio system. By the mid-1970s, so-called superagents would sometimes predetermine a package of stars and other personnel from which the film must be constructed.

Locations, Production Design, Sets, and Costumes

In narrative films, the interaction between characters and the physical location of the action is often a central dimension of a film; hence, choices about location and set design are critical. Likewise, documentary filmmaking depends on location as well—from the record of a strike in *Harlan County, U.S.A.* (1976) to nature documentaries like *Planet Earth* (2006)—but it also uses sets for interviews.

Location scouts became commonplace in the early twentieth century. These individuals determine and secure places that provide the most suitable environment for shooting different movie scenes. Choosing a location is often determined by a series of pragmatic questions: Does the place fit the requirements of the script, and how expensive would it be to film at this location? Many films rely on constructed sets that re-create a specific place, but the desire for movie realism often results in the use of actual locations to invigorate a scene. Thus the *Lord of the Rings* (2001–2003) and *Hobbit* trilogies (2012–2014) take advantage of the lush and wild location filming in New Zealand, while *Only Lovers Left Alive* (2013) **[Figure 1.4]** makes the ravaged and vacated urban landscape of nighttime Detroit an important backdrop for its tale about two emotionally impoverished and disenchanted vampires. In recent decades, the cinematic task of re-creating real-seeming environments has shifted to computer-graphics technicians. These technicians design the models to be digitally transferred onto film, becoming, in a sense, a new kind of location scout.

The **production designer** determines the film's overall look. **Art directors** are responsible for supervising the conception and construction of the physical environment in which actors appear, including sets, locations, props, and costumes. The **set decorators** complete the look of a set with the details. For example, in a movie set in a particular historical period and place, such as *Argo* (2012), the art department

1.4 *Only Lovers Left Alive* (2013). Cities like Tangiers and a decaying Detroit become distinctive backgrounds for Jim Jarmusch's moody, mordantly funny vampire story.

coordinated to create sets and locations that accurately reflect Tehran in 1980 and that also highlighted the suspenseful atmosphere surrounding the rescue of six Americans.

The role of **costume designers**, those who plan and prepare how actors will be dressed as their characters, greatly increased as the movie business expanded in the 1930s. Costume designers ensure the splendor, suitability, and sometimes the historical accuracy of the movie characters' appearances. Indeed, for those films in which costumes and settings are central to the story—films set in fantasy worlds or historical eras, such as *Pan's Labyrinth* (2006), which uses both kinds of settings—one could argue that the achievement of the film becomes inseparable from the decisions made about the art and costume design. In the end, successful films integrate all levels of the design, from the sets to the costumes, as in *The Grand Budapest Hotel* (2014), where the costumes re-create the 1930s in a luxurious hotel in Eastern Europe but have a zany excess and decadence that mirrors the plot and themes **[Figure 1.5]**.

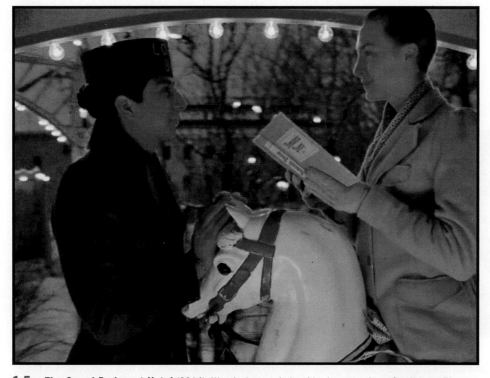

1.5 *The Grand Budapest Hotel* (2014). Wes Anderson clothes his characters in outfits that recall a 1930s sensibility but exaggerates those outfits to the point that they sometimes seem surreal.

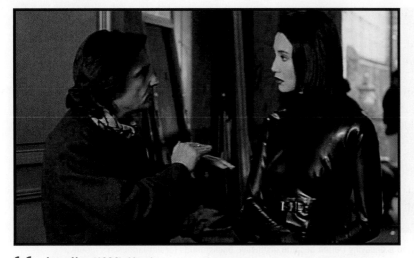

1.6 *Irma Vep* (1996). Maggie Cheung stars in a film about making a film—starring Maggie Cheung.

Production

Most mythologized of all phases of moviemaking is production itself or **principal photography**, which is the majority of footage that is filmed. The weeks or months of actual shooting, on set or on location, are also known as a **film shoot**. Countless films, from *The Bad and the Beautiful* (1952) and *Irma Vep* (1996) to *Hitchcock* (2012), dramatize inspired or fraught interactions among cast, crew, and the person in charge of it all, the director **[Figure 1.6]**. The reality of production varies greatly with the scale of the film and its budget, but the director, who has often been involved in all of the creative phases of preproduction, must now work closely with the actors and production personnel—most notably, the camera units headed by the cinematographer—to realize a collaborative vision.

The Director

The earliest films of the twentieth century involved very few people in the process of shooting a film, with the assumption that the cameraman was the de facto director. By 1907, however, a division of labor separated production roles, placing the director in charge of all others on the film set. Today the **director** is commonly regarded as the chief creative presence or the primary manager in film production, responsible for and overseeing virtually all the work of making a movie—guiding the actors, determining the position of the camera, and selecting which images appear in the finished film.

Directors have different methods and degrees of involvement. Alfred Hitchcock claimed he never needed to see the action through the camera viewfinder because his script directions were so precise that there would be only one way to compose the shot. Others are comfortable relinquishing important decisions to their assistant director (AD), cinematographer, or sound designer. Still others, like Woody Allen and Barbra Streisand, assume multiple roles (screenwriter, actor, and editor) in addition to that of director **[Figures 1.7a and 1.7b]**. In Hollywood during the studio era, when directors' visions often were subordinated to a "house style" or a

(a) (b)

1.7a and 1.7b Barbra Streisand. Stardom as a singer and actor gave Streisand the opportunity to turn to directing. In *Yentl* (1983), her first film as a director, her protagonist dresses as a boy to study the Torah. Everett Collection, Inc.

producer's vision, directors worked so consistently and honed their craft with such skilled personnel that critics can detect a given director's signature style across routine assignments. This has elevated directors like Howard Hawks (*Bringing Up Baby*, 1938, and *His Girl Friday*, 1940) and Nicholas Ray (*Rebel Without a Cause*, 1955) to the status of **auteurs** — directors who are considered "authors" of films in which they express their own individual vision and experiences.

Today a company backing a film will choose or approve a director for projects that seem to fit with his or her skills and talents. For example, Mexican director Alfonso Cuarón's success with films like *A Little Princess* (1995) and *Great Expectations* (1998) led to his early involvement with *Harry Potter and the Prisoner of Azkaban* (2004). Because of the control and assumed authority of the director, contemporary viewers often look for stylistic and thematic consistencies in films by the same director, and filmmakers like Quentin Tarantino have become celebrities. This follows a model prevalent in art cinema made outside Hollywood in which the vision of a director like Jean-Luc Godard or Tsai Ming-liang (*What Time Is It There?*, 2001) is supported by the producer and made manifest in virtually every aspect of the film.

The Cast, Cinematographer, and Other On-Set Personnel

The director works with the actors to bring out the desired performance, and these collaborations vary greatly. Because film scenes are shot out of order and in a variety of shot scales, the cast's performance must be delivered in bits and pieces. Some actors prepare a technical performance; others rely on the director's prompting or other, more spontaneous inspiration. Daniel Day-Lewis, the star of *Lincoln* (2012) and *There Will Be Blood* (2007), is known for immersing himself in every role to such an extent that he stays in character throughout the entire production, even when the cameras are not rolling. David Fincher's exacting directorial style requires scores of **takes**, or different versions of a shot, a grueling experience for *Zodiac* (2007) actors Jake Gyllenhaal and Robert Downey Jr. Some directors gravitate to particularly sympathetic and dynamic relations with actors — Tim Burton with Johnny Depp, Pedro Almodóvar with Penelope Cruz, and Martin Scorsese with Robert De Niro and Leonardo DiCaprio.

The **cinematographer**, also known as the director of photography (DP), selects the cameras, film stock, lighting, and lenses to be used as well as the camera setup or position. In consultation with the director, the cinematographer determines how the action will be shot, the images composed, and, later, the kind of exposure needed to print the takes. The cinematographer oversees a **camera operator** (who physically manipulates the camera) and other camera and lighting crew. Many films owe more to the cinematographer than to almost any other individual in the production. The scintillating *Days of Heaven* (1978) profits as much from the eye of cinematographer Néstor Almendros as from the direction of Terrence Malick, and the consistently stunning work of cinematographer Michael Ballhaus on films such as Rainer Werner Fassbinder's *The Marriage of Maria Braun* (1979) and Martin Scorsese's *The Departed* (2006) arguably displays the artistic singularity and vision that are usually assigned to film directors **[Figure 1.8]**.

Other personnel are also on the set — including the **production sound mixer** (who is the sound engineer on the production set) and other sound crew, including the boom operator; the **grips** who install

1.8 *The Departed* (2006). Cinematographer Michael Ballhaus suggests interpretations of the characters' motives through shot composition and lighting.

lighting and dollies; the special effects coordinator; the scenic, hair, and make-up artists; and the catering staff. A production coordinator helps this complex operation run smoothly. During the shoot, the director reviews **dailies** (footage shot that day) and begins to make **selects** (takes that are chosen to use in editing a scene). After principal photography is completed, sets are broken down, and the film "wraps," or completes production. A film shoot is an intense, concentrated effort in which the contributions of visionary artists and professional crew mesh with schedule and budget constraints.

Postproduction

Some of the most important aspects of a finished film—including editing, sound, and visual effects—are achieved after principal photography is completed and production is over. How definitive or efficient the process is depends on many factors. A documentary may be constructed almost entirely during this phase, or a commercial feature film may have to be recut in response to test screenings or the wishes of a new executive who has assumed authority over the project.

Editing and Sound

The director works closely with the editor and his or her staff during **editing**—the process of selecting and joining film footage and shots into a finished film with a distinctive style and rhythm. This process now is largely carried out with digital footage and computer-based editing. Editing is anticipated during preproduction of fiction films with the preparation of a shooting script, and in production it is recognized in the variety and number of takes provided. Only a fraction of the footage that is shot is included in the finished film, however, making editing crucial to its final form. In documentary production, editing may be the most important stage in shaping the film. When the editing is completed, the picture is said to be *locked*.

Postproduction also includes complex processes for editing sound and adding special effects. A sound editor oversees the work of **sound editing**—combining music, dialogue, and effects tracks to interact with the image track. Less apparent than the editing of images, sound editing can create noises that relate directly to the action of the image (such as matching the image of a dog barking), underpin those images and actions with music (such as the pounding beats that follow an army into battle), or insert sounds that counterpoint the images in ways that complicate their meanings (such as using a religious hymn to accompany the flight of a missile). In the **sound mixing** process, all of the elements of the soundtrack—music, effects, and dialogue—are combined and adjusted to their final levels.

Special Effects

Special effects are techniques that enhance a film's realism or surpass assumptions about realism with spectacle. Whereas some special effects are prepared in preproduction (such as the building of elaborate models of futuristic cities), others can be generated in production (with special camera filters or setups) or created on set (for example, by using pyrotechnics).

Today most special effects are created in postproduction and are distinguished by the term **visual effects**—imagery combined with live action footage by teams of computer technicians and artists. In the contemporary digital age, computer technicians have virtually boundless postproduction capabilities to enhance and transform an image. Fantastical scenes and characters (such as Andy Serkis as Gollum in *Lord of the Rings*) can be acted out using **green-screen technology**, in which actors

1.9 *Star Wars: Episode III—Revenge of the Sith* (2005). Although the original *Star Wars* films used multiple sets, models, and props, much of the prequel series was generated using state-of-the-art computer technology.

perform in front of a plain green background, and **motion-capture technology**, which transfers the actors' physical movements to **computer-generated imagery (CGI)**. The settings of the *Star Wars* prequel trilogy (1999–2005) were generated largely in postproduction **[Figure 1.9]**. All of the personnel who work behind the scenes on these many levels of filmmaking are acknowledged when the titles and credits are added in the final stage of postproduction.

Distribution: What We Can See

The completed film reaches its audience through the process of **distribution**, in which films are provided to venues in which the public can see them. These include theaters and video stores, broadcast and cable television, Internet streaming and **video on demand (VOD)**, libraries and classrooms — even hotels and airlines. Despite these many outlets for distribution, many worthy films never find a distributor and are never seen. As avenues of distribution multiply, new questions about the role of film culture in our individual and collective experience arise. Our tastes, choices, and opportunities are shaped by aspects of the industry of which we may be unaware, and we, in turn, influence what we can see in the future.

The discussion that follows, which emphasizes the U.S. feature-film distribution system since it often controls even foreign theaters, addresses how viewers and views of movies are prepared by the social and economic machinery of distribution.

Distributors

A **distributor** is a company or an agency that acquires the rights to a movie from the filmmakers or producers (sometimes by contributing to the costs of producing the film) and makes the movie available to audiences by renting, selling, or licensing it to theaters or other exhibition outlets. Top-grossing distributors include Walt Disney, Warner Bros., Sony Pictures, 20th Century Fox, Universal, Paramount Pictures, and Lionsgate. Smaller companies include the Weinstein Company, Magnolia Pictures, and divisions of both Netflix and Amazon.

The supply of films for distribution depends on the films that are produced, but the inverse of that logic is central to the economics of mainstream movie culture: what is produced depends on what Hollywood and many other film cultures assume can be successfully distributed. Film history has accordingly been marked with regular battles and compromises between filmmakers and distributors about what audiences are willing to watch. United Artists was formed in 1919 by four prominent Hollywood stars—D. W. Griffith, Charlie Chaplin, Mary Pickford, and Douglas Fairbanks—to distribute their independently produced films and became a major company. Decades later, in 1979, the independent distributor Miramax used aggressive promotional campaigns to make foreign-produced and independent movies viable in wide theatrical release, thus changing the distribution landscape.

Evolution of the Feature Film

Consider the following examples of how the prospects for distributing and exhibiting a film can influence and even determine its content and form, including decisions about its length. From around 1911 to 1915, D. W. Griffith and other filmmakers struggled to convince movie studios to allow them to expand the length of a movie from roughly fifteen minutes to over 100 minutes. Although longer films imported from Europe achieved some success, most producers felt that it would be impossible to distribute longer movies because they believed audiences would not sit still for more than twenty minutes. Griffith persisted and continued to stretch the length of his films, insisting that new distribution and exhibition patterns would create and attract new audiences—those willing to accept more complex stories and to pay more for them. Griffith's controversial three-hour epic, *The Birth of a Nation* (1915), was distributed as a major cultural event comparable to a legitimate theatrical or operatic experience and was an enormous commercial and financial success **[Figure 1.10]**. The film became a benchmark in overturning one distribution formula, which offered a continuous program of numerous short films, and establishing a new one, which concentrated on a single **feature film**, a longer narrative movie that is the primary attraction for audiences.

After 1915, most films were distributed with ninety- to 120-minute running times rather than in their previous ten- to twenty-minute lengths, and this pattern for distribution has proved durable. The recent trend toward longer running times, especially for "prestige" or "epic" films, acknowledges the flexible contexts in which films are now viewed.

Our experience of a movie—its length, its choice of stars (over unknown actors, for example), its subject matter, and even its title—is determined partly by decisions made about distribution even before the film becomes available to viewers. Most movies are produced to be distributed to certain kinds of audiences. Distribution patterns—whether a movie is available everywhere for everyone at the same time, is released during the holiday season, or is available only in specialty video stores or on Internet sites—bring expectations that a particular film either fulfills or frustrates.

1.10 **Advertisement for *The Birth of a Nation*** (1915). The ambitious nature of D. W. Griffith's controversial epic was apparent in its advertisements and unprecedented three-hour running time. Everett Collection, Inc.

Release Strategies

As one of its primary functions, distribution determines the number of copies of a film that will be available and the number of locations at which the movie will be seen. During the heyday of the Hollywood studio system, studios either showed their films in their own theater chains or sold them to theaters in packages, a practice known as **block booking.** An exhibitor was required to show cheaper, less desirable films as a condition of booking the star-studded A pictures. This practice was the target of antitrust legislation and finally was outlawed in the 1948 *United States v. Paramount* decision, which divorced the studios from their theater chains and required that films be sold individually. Typically, a distribution strategy kicks off with a **premiere** — a red carpet event celebrating the opening night of a movie that is attended by stars and attracts press attention. A film's initial opening in a limited number of **first-run theaters** (theaters that show recently released movies) as exclusive engagements gradually was expanded, allowing for a series of premieres.

In 1975, Steven Spielberg's *Jaws* introduced the practice of **wide release,** opening in hundreds of theaters simultaneously. Since then, a film with a mass circulation of premieres — sometimes referred to as **saturation booking** or a saturated release — is screened in as many locations as possible in the United States (and increasingly abroad) as soon as possible. For a potential blockbuster such as *X-Men: Apocalypse* (2016), the distributors immediately release the movie in a maximum number of locations and theaters to attract large audiences before its novelty wears off **[Figure 1.11].** In these cases, distribution usually promises audiences a film that is easy to understand and appeals to most tastes (offering action sequences, breathtaking special effects, or a light romance rather than controversial topics).

A **limited release** may be distributed only to major cities — the cult comedy *Wet Hot American Summer* (2001) never played in more than thirty theaters — and then expand its distribution, depending on the film's initial success. Audience expectations for films following a limited release pattern are generally less fixed than for wide releases. They usually will be recognized in terms of the previous work of the director or an actor but will offer a certain novelty or experimentation (such as a controversial subject or a strange plot twist) that presumably will be better appreciated as the film is publicly debated and understood through the reviews

1.11 *X-Men: Apocalypse* (2016). As a major studio release and entry in the hugely successful Marvel series, the film received a saturated release, opening on around ten thousand screens in more than four thousand theaters.

1.12 *I'm Not There* (2007). Todd Haynes's experimental Bob Dylan biopic built up critical attention through a limited release pattern.

and discussions that follow its initial release. The Weinstein Company's decision to limit the release of Todd Haynes's experimental biopic of Bob Dylan, *I'm Not There* (2007), to major cities was a strategic bid to maximize critical attention to the film's daring and the intriguing premise of its star performances, which include Cate Blanchett playing the 1960s Dylan [**Figure 1.12**].

As part of these general practices, distribution strategies have developed over time to shape or respond to the interests and tastes of intended audiences. **Platforming** involves releasing a film in gradually widening markets and theaters so that it slowly builds its reputation and momentum through reviews and word of mouth. The strategy for expanding a release depends on box-office performance: if a film does well in its opening weekend, it will open in more cities on more screens. When the low-budget supernatural horror film *Paranormal Activity* (2007) was acquired and released by Paramount, audiences became directly involved in determining where the film would open by voting on director Oren Peli's Web site. A movie also can be distributed for special **exclusive release**, premiering in only one or two locations. A dramatic example of this strategy was seen with the restored version of Abel Gance's silent classic *Napoléon*, an epic tale of the life of the French emperor that periodically presents the action simultaneously on three screens. The original film premiered in April 1927. In 1981, the exclusive release of the restored film toured to one theater at a time, accompanied by a full orchestra; seeing it became a privileged event.

Target Audiences

Since the late twentieth century, movies also have been distributed with an eye toward reaching specific target audiences—viewers whom producers feel are most likely to want to see a particular film. Producers and distributors aimed *Shaft* (1971), an action film with a black hero, at African American audiences by distributing it primarily in large urban areas. Distributors positioned *Trainspotting* (1995), a hip tale of young heroin users in Edinburgh, to draw art-house and younger audiences in cities, some suburbs, and college and university towns. The *Nightmare on Elm Street* movies (1984–1994), a violent slasher series about the horrific Freddy Krueger, were aimed primarily at the male teenage audience who frequented cineplexes and, later, video stores.

1.13 *Driving Miss Daisy* (1989). Platforming this modestly budgeted film cultivated audiences and critical responses.

The various distribution strategies all imply important issues about how movies should be viewed and understood. First, by controlling the scope of distribution, these strategies determine the quality and importance of an audience's interactions with a film. As a saturated release, the 2015 attempt to restart the *Fantastic Four* series aimed for swift gratification with a focus on special effects and action, before disappointed word of mouth could spread. Platformed gradually through expanding audiences, *Driving Miss Daisy* (1989) benefited from critical reflections on the relationship it depicts between an older white woman and her black chauffeur [**Figure 1.13**].

1.14 *Inside Out* (2015). This computer-animated film is aimed principally at families, but childless audiences may still find plenty to identify with.

Second, in targeting audiences, distribution can identify primary, intended responses to the film as well as secondary, unexpected ones. Movies from the Pixar animation studio might resonate the most with children and their parents, with stories in *Inside Out* (2015) **[Figure 1.14]**, *Finding Dory* (2016), and *Toy Story 3* (2010) that address both childhood and the process of parenting, layering the animated adventures with inside jokes and references for adults. But as Pixar has established itself as a source of high-quality animation, their adult following has grown — including some former kids who may have grown up on the company's early movies and now will see follow-ups with their favorite characters even as they age out of the target audience. Awareness of these strategies of targeting indicates how our identification with and comprehension of films are as much a product of our social and cultural locations as they are a product of the film's subject matter and form.

Ancillary Markets

Commercial cinema's reach has been expanding ever since studios began to take advantage of television's distribution potential in the mid-1950s. New technologies for watching movies continue to proliferate, and distribution has increasingly taken advantage of television, video, DVD, Blu-ray, and forms of video on demand (VOD). Today more of a film's revenue is generated by such **ancillary markets** than by its initial theatrical release.

Television Distribution

Historically, the motion picture industry competed with broadcasting, which distributed entertainment directly to the home through radio and later television. As television became popular in postwar America, the studios realized that the new medium provided an unprecedented distribution outlet. With the rise of cable television, studios were provided with even more lucrative opportunities to sell their vast libraries of films. Home video and the launch of dedicated movie channels like Turner Classic Movies (founded by Ted Turner to showcase his acquisition of MGM's collection) were a boon to cinema lovers as well.

With viewing options ranging from network to premium channels and from on-demand to subscription plans, more and more movies are presented through

television distribution—the selection and programming, at carefully determined times, of films made for theaters and exclusively for television. Historically, there was a specific lag time between a theatrical release in a cinema and a cable or network release, but these relationships are changing. Some movies are distributed directly to video or cable, such as the ongoing series of follow-ups to *Bring It On* (2000). Whether a movie is released after its theatrical run or is made expressly for video and television, this type of distribution usually aims to reach the largest possible audience and thus to increase revenues. In an attempt to reach specialized audiences through subscription cable, distributors like IFC Films have made critically acclaimed foreign and U.S. independent films available on demand the same day they are released in art-house theaters in major cities, allowing television audiences in markets outside large cities access to such works as the Romanian *4 Months, 3 Weeks, 2 Days* (2007), winner of the Cannes Film Festival's top prize. Although the traditional wisdom is that such access will hurt the theatrical box office, the strategy allows such films to reach wider audiences, and positive word of mouth, for both the film and the distributor's "brand," might enhance overall theatrical revenue.

Guaranteed television distribution can reduce the financial risk for producers and filmmakers and thus, in some situations, allow for more experimentation or filmmaker control. In a fairly new trend, the flow between television and theatrical distribution is reversed. Premium (subscription) cable channels such as HBO increasingly produce their own films that include riskier subjects. Even though these films are presented on their networks, a theatrical window for the film to receive reviews and become eligible for awards is sometimes allowed.

Television distribution has both positive and negative implications. In some cases, films on television must adjust their style and content to suit constraints of both time and space: scenes might be cut to fit a time slot or be interrupted with commercial breaks (breaking up movies into miniseries events is less common today than it was in the past). For many years, the size and ratio of a widescreen film was changed to fit the traditionally square shape of the television monitor, thus altering the picture to suit the format. Now, widescreen ratios tend to be the default, sometimes distorting those films or other programming originally produced in the standard square format. In other cases, television distribution may expand the ways movies can communicate with audiences and experiment with different visual forms. *The Singing Detective* (1986) uses the long length of a television series watched within the home as the means to explore and think about the passage of time, the difficulty of memory, and the many levels of reality and consciousness woven into our daily lives.

VIEWING CUE

Was the movie recently screened for class likely to have been shown on television? If so, in what way? How might such distribution have significantly changed the look or feel of it?

Home Video, VOD, and Internet Distribution

Each new format for the public or private consumption of media—VHS (video home system), LaserDisc, DVD (digital video disk), Blu-ray—offers a new distribution challenge for media makers and a potential new revenue model for rights holders. Independent producers may find it difficult to transfer existing media to new formats or to make enough sales for a particular avenue of distribution to be viable. The home video era began with competition between Sony's Beta format and VHS. The VHS format won out, and with the widespread use of videocassette recorders (VCRs) in the 1980s, studios quickly released films in the VHS home video format, first for rental and increasingly for sales. There have been similar dueling interests in recent years, such as that between high-definition DVD (HD-DVD) and Blu-ray.

One of the most significant challenges to distributors posed by new formats is **piracy**, the unauthorized duplication and circulation of copyrighted material. Despite anti-copying software, the circulation of pirated films is widespread and can bypass social, cultural, and legal controls, bringing banned films to viewers in China, for example, or building subcultures and networks around otherwise hard-to-access films.

As with film distribution through cinema and television, distribution of consumer formats like video, DVD, and Blu-ray determines the availability of particular titles to audiences. A film may be made available for rental or purchase in stores, received by mail from companies like Netflix, or ordered from independent distributors such as Kino International.

Before the closing of many video stores caused by the shift to subscriber and on-demand services in the 2000s, the video store was a significant site of film culture. Because the selection in rental stores was based on a market perspective on local audiences as well as the tastes of individual proprietors, some films were distributed to certain cities or neighborhoods and excluded from other locations. The dominant chains (such as Blockbuster, which filed for bankruptcy in 2010) were likely to focus on high-concentration family-oriented shopping sites, offering numerous copies of current popular mainstream movies and excluding daring subject matter or older titles. Some local independent video stores specialized in art films, cult films, or movie classics (such as those released on DVD by the Criterion Collection). Still other local stores depended on X-rated films or video game rentals for their primary revenue. Sometimes distribution follows cultural as well as commercial logic. Bollywood films, available in video and even grocery stores in neighborhoods with large South Asian populations, provided a tie to cultural traditions and national stars and songs before access to such films became widespread.

For viewers, there were two clear consequences to these patterns of video distribution. The first is that video distribution can control and direct—perhaps more than theatrical distribution does—local responses, tastes, and expectations. As part of a community anchored by a particular video store, we see and learn to expect only certain kinds of movies when the store makes five or six copies of one blockbuster film available but only one or none of a less popular film. The second consequence highlights the sociological and cultural formations of film distribution. As a community outlet, video stores become part of the social fabric of a neighborhood. Viewers are consumers, and video stores can become forums in which the interests of a community of viewers—in children's film or art-house cinema, for instance—can determine which films are distributed. Michel Gondry's *Be Kind Rewind* (2008) shows an urban community coming together around the films made available at its locally owned video store after its employees begin to produce their own versions of rental titles to replace their demagnetized inventory **[Figure 1.15]**. Such ties are less likely to be forged around recent alternatives to dedicated stores, such as DVD kiosks in grocery stores.

The innovation in distribution of DVDs that was probably most responsible for the decline of the local video store is the rental-by-mail model launched by Netflix and followed by other companies. As part of a subscription system that offers viewers a steady stream of DVDs, Netflix members can select and return films as rapidly or as slowly as they wish. Because the DVDs arrive and are returned through the mail, this distribution arrangement emphasizes the rapidity of contemporary consumption of movies. And because a subscriber preselects DVDs that are then sent automatically, this kind of distribution lacks the kind of social interaction that used to exist in video stores.

But such models still involve a material object that is literally distributed to viewers. As high-speed Internet made downloading movies and live

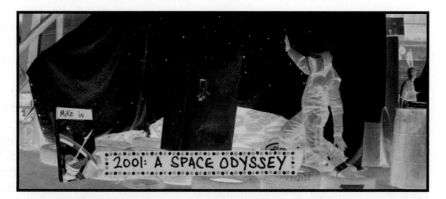

1.15 *Be Kind Rewind* (2008). The employees at a neighborhood video store attract a loyal local audience with their do-it-yourself inventory, like this re-created scene from Stanley Kubrick's *2001: A Space Odyssey* (1968).

streaming a consumer option, many sites began to provide such opportunities, and distribution confronted yet another set of challenges. If a movie is rented on demand, how many times can it be watched? On how many different devices? Unauthorized downloading and sharing became even more difficult for distributors to regulate. At the same time, new opportunities for viewing and for forming social relations around cinema were generated. Netflix updated its own model to allow subscribers to stream titles to both computers and televisions—by far its largest section of the market today. With the success of streaming and downloading, viewers may feel that they finally have overcome the limits set by distribution, even though economic decisions still shape the circulation of film.

This new ease of film consumption raises different questions about changing viewing patterns and their implications, however. Do these new paradigms undermine the social and communal formations of the overall film experience? Does increased ease of access to film traditions remote in time or location make for a richer film culture? Do more platforms actually result in more viewing options, or do many of these services redivide smaller slices of the same pie? Finally, how might these patterns influence and change the kinds of movies that are made? The answers to these questions are not clear or certain. Indeed, these new viewing patterns may simply offer different ways for audiences to create different kinds of communities based on their own interests. Similarly, the more open access to periods of film history or foreign film cultures may broaden our sense of both but also may require more work and research into those discovered times and places.

Many kinds of films—such as artists' films, activist documentaries, alternative media, and medical or industrial films—are made without the intention of showing them for a profit. Although many of these films are shown publicly, they are not shown in a traditional theatrical context and do not necessarily have access to commercial video or Internet distribution methods. Some of these works serve a specific training or promotional purpose and are distributed directly to their intended professional or target audience. Others may find television or educational distributors from PBS to Women Make Movies. Still others may be uploaded to the Internet.

◄ VIEWING CUE

How might the distribution of a film that was released in the last year have been timed to emphasize certain responses? Was it a seasonal release?

Distribution Timing

Distribution timing—when a movie is released for public viewing in certain locations or on certain platforms—is another prominent and changing feature of distribution. Adding significantly to our experience of movies, timing can take advantage of the social atmosphere, cultural connotations, or critical scrutiny associated with particular seasons and calendar periods. The summer season and the December holidays are the most important in the United States because audiences usually have more free time to see thrill rides like *Speed* (1994) **[Figure 1.16]**.

Offering a temporary escape from hot weather, a summer release like *Jurassic World* (2015) offers the visual thrills and fun of rampaging dinosaurs, a bit like an old-fashioned sci-fi movie and a bit like the amusement park that the film's plot depicts. The Memorial Day release of *Pearl Harbor* (2001) immediately attracts the sentiments and memories that Americans have of World War II and other global conflicts. The film industry is calculating releases ever more carefully—for example, by holding a promising film for a November release so that it can vie for prestigious (and business-generating) award nominations.

1.16 *Speed* (1994). Action movies intended as summer amusements have become central to the release calendar.

1.17　*The Shallows* (2016). Just a few weeks before the scheduled June 2016 release of the shark thriller *The Shallows*, the studio moved its date up by five days to capitalize on rising excitement over the film.

Mistiming a film's release can prove to be a major problem, as was the case in the summer of 2013, when the DreamWorks cartoon *Turbo* followed too close on the heels of *Monsters University* and *Despicable Me 2* to gain much traction with the family audience that all three were targeting. Avoiding unwanted competition can be a key part of a distributor's timing. Recently, distributors moved up the opening of *The Shallows* (2016) to capitalize on positive buzz and avoid Fourth of July weekend competition **[Figure 1.17]**.

Multiple Releases

Of the several other variations on the tactics of timing, movies sometimes follow a first release or first run with a second release or second run. The first describes a movie's premiere engagement, and the second refers to the redistribution of that film months or years later. After its first release in 1982, for example, Ridley Scott's *Blade Runner* made a notable reappearance in 1992 as a longer director's cut **[Figure 1.18]**. Although the first release had only modest success, the second (supported by a surprisingly large audience discovered in the home video market) appealed to viewers newly attuned to the visual and narrative complexity of the movie. Audiences wanted to see, think about, and see again oblique and obscure details in order to decide, for instance, whether Deckard, the protagonist, was a replicant or a human.

For *Blade Runner*'s twenty-fifth anniversary in 2007, a final cut was released theatrically but catered primarily to DVD customers. With multiple releases, financial reward is no doubt a primary goal, as the trend to reissue films in anticipation of or following major awards like the Oscars indicates.

With a film that may have been unavailable to viewers during its first release or that simply may not have been popular, a re-release can lend it new life and reclaim viewers through a process of rediscovery. When a small movie achieves unexpected popular or critical success or a major award, for example, it can be redistributed with a much wider distribution circuit and to a more eager, sympathetic audience that is already prepared to like the movie. In a version of this practice,

1.18　*Blade Runner* (1982, 1992, 2007). Although its initial opening was disappointing, Ridley Scott's dystopian "future noir" was an early success on home video. Theatrical releases of a director's cut for its tenth anniversary and a final cut for its twenty-fifth make the question of the film's definitive identity as interesting as the questions of human versus replicant identity posed by its plot.

1.19 *It's a Wonderful Life* (1946). A box-office disappointment when it initially was released, Frank Capra's film became a ubiquitous accompaniment to the holiday season on television. In recent years, NBC's broadcast restrictions attempted to restore the film's status as an annual family viewing event.

Mira Nair's *Salaam Bombay!* (1988) was re-released in 2013 to commemorate the twenty-fifth anniversary of the stunning debut by this now-celebrated Indian filmmaker. A re-release also may occur in the attempt to offer audiences a higher-quality picture or a 3-D repackaging of an older film or to clarify story lines by restoring cut scenes, as was done in 1989 with Columbia Pictures' re-release of the 1962 Academy Award–winning *Lawrence of Arabia*.

Similarly, television distribution can retime the release of a movie to promote certain attitudes toward it. *It's a Wonderful Life* did not generate much of an audience when it was first released in 1946. Gradually (and especially after its copyright expired in 1975), network and cable television began to run the film regularly, and the film became a Christmas classic shown often and everywhere during that season **[Figure 1.19]**. In 1997, however, the NBC television network reclaimed the exclusive rights to the film's network broadcast in order to limit its television distribution and to try to make audiences see the movie as a special event.

Day-and-Date Release

The **theatrical release window** of a film — the period of time before its availability on home video, video on demand, or television platforms, during which it plays in movie theaters — has traditionally been about three to six months to guarantee box-office revenue. This period is becoming shorter and shorter. **Day-and-date release** refers to a simultaneous-release strategy across different media and venues, such as a theatrical release and VOD availability. This practice is now routine for many smaller distributors. Sometimes films from Magnolia Pictures, like the recent *High-Rise* (2015) **[Figure 1.20]**, will debut on VOD platforms before their theatrical release. In the future, day-and-date release may go further. Napster cofounder Sean Parker has discussed the introduction of a device that would play brand-new wide releases in customers' homes as soon as they are available in movie theaters. Some filmmakers such as Christopher Nolan and James Cameron have denounced this idea, while others like Steven Spielberg and Martin Scorsese have encouraged it.

Whether or not this kind of distribution strategy actually announces a radical change in film distribution, it does signal the kinds of experimentation that digital production and distribution can allow and the inevitable changes and adjustments that will occur in the future in response to shifting markets, tastes, and technologies. Across the division between Nolan and Spielberg, it also suggests larger concerns about how these changes can affect our responses to films and the kinds of films that will be made.

1.20 *High-Rise* (2015). Ben Wheatley's dystopian satire follows the inhabitants of an apartment building that is organized by class. Magnolia Pictures made the movie available both in select theaters and through video-on-demand outlets.

Marketing and Promotion: What We Want to See

Why and how we are attracted to certain movies is directly shaped by the marketing and promotion that accompany distribution. A film might be advertised online as the work of a great director, for example, or it might be described as a steamy love story and illustrated with a sensational poster. A film trailer might emphasize the comedic aspect of an unusual or disturbing film like *The Lobster* (2016). Although these preliminary encounters with a film might seem marginally relevant to how we experience the film, promotional strategies, like distribution strategies, prepare us in important ways for how we will see and understand a film.

VIEWING CUE

Name a movie you believe has had a strong cultural and historical influence. Investigate what modes of promotion helped highlight particular themes in and reactions to the film.

Generating Interest

Marketing and promotion aim to generate and direct interest in a movie. Film **marketing** identifies an audience for a specific product (in this case, a movie) and brings the product to its attention for consumption so that buyers will watch the product. Film **promotion** refers to the aspect of the industry through which audiences are exposed to and encouraged to see a particular film. It includes advertisements, trailers, publicity appearances, and product tie-ins. No doubt the **star system** is the most pervasive and potent component of the marketing and promotion of movies around the world. One or more well-known actors who are popular at a specific time and within a specific culture act as the advertising vehicle for the movie. The goal of the star system, like that of other marketing and promotional practices, is to create specific expectations that will draw an audience to a film. These marketing and promotional expectations—that Leonardo DiCaprio stars or that indie filmmaker Sarah Polley directs, for example—often become the viewfinders through which an audience sees a movie.

The methods of marketing and promotion are many and creative. Viewers find themselves bombarded with newspaper and billboard advertisements, previews shown before the main feature, tie-in games featured on the official movie Web site, and trailers that appear when browsing the Internet. Stars make public appearances on radio and television talk shows and are profiled in fan magazines, and media critics attend early screenings and write reviews that are quoted in the ads for the film. All these actions contribute to movie promotion. In addition, although movies have long been promoted through prizes and gifts, modern distributors are especially adept at marketing films through **tie-ins**—ancillary products (such as soundtracks, toys, and other gimmicks made available at stores and restaurants) that advertise and promote a movie. *Minions* (2015), for example, was anticipated with an extensive line of toys and games that generated interest in the movie and vice versa.

Marketing campaigns for blockbuster films have become more and more extensive in recent years, with the promotion budget equaling and often even exceeding the film's production budget. A marketing blitz of note accompanied *Independence Day* (1996). Given its carefully timed release on July 3, 1996, following weeks of advertisements in newspapers and on television, it is difficult to analyze first-run viewers' feelings about this film without taking into account the influence of these promotions. Defining the film as a science fiction thriller, the advertisements and reviews drew attention to its status as the film event of the summer, its suitability for children, and its technological wizardry. Promoted and released to coincide with the Fourth of July holiday, *Independence Day* ads emphasized its patriotic American

text continued on page 40 ▶

FILM IN FOCUS

![camera icon] **FILM IN FOCUS**

LaunchPad Solo

To watch a clip from *Killer of Sheep* (1977),
see the *Film Experience* LaunchPad.

Distributing *Killer of Sheep* (1977)

See also: *Bless Their Little Hearts* (1983);
Daughters of the Dust (1991)

Distribution is almost invisible to the public and hence much less glamorous than film production or exhibition, but it determines whether a film will ever reach an audience. Independent filmmakers often bring new perspectives to mainstream, formulaic filmmaking, but their visions need to be shared. African American filmmakers, who have historically been marginalized within the industrial system of production, often encounter additional challenges in getting their films distributed. The career of Charles Burnett, considered one of the most significant African American filmmakers despite his relatively small oeuvre, is marked by the vicissitudes of distribution. The successful limited release of his first feature, *Killer of Sheep* (1977), in 2007, more than thirty years after it was made, not only illuminates black American filmmakers' historically unequal access to movie screens but also illustrates the multiple levels on which current distribution campaigns function. The way the film's distributor, Milestone Films, handled the film's theatrical, nontheatrical, and DVD release in order to maximize critical attention and gain significant revenue serves as a model for similar endeavors [**Figure 1.21**].

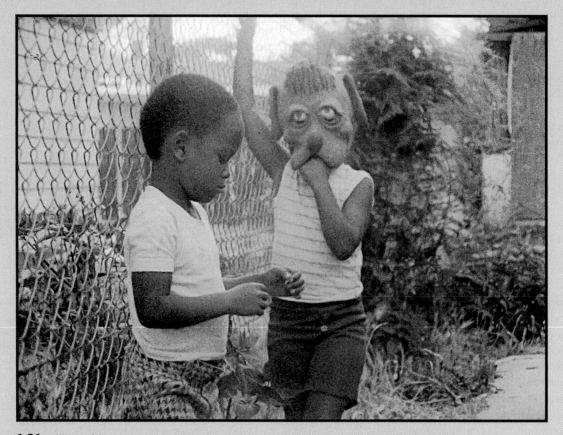

1.21 *Killer of Sheep* (1977). Charles Burnett's legendary independent film about an African American family in Los Angeles's Watts neighborhood infuses its realism with poetic images, like the child wearing a mask. The film was finally distributed theatrically thirty years after it was made. Courtesy of Milestone Film & Video

Produced in the early 1970s as a master's thesis film, Burnett's *Killer of Sheep* emerged amid a flowering of African American filmmaking talent at the University of California, Los Angeles, film school. In place of the two-dimensional stereotypes of past classical Hollywood films, the almost-too-good-to-be-true characters played by Sidney Poitier in the 1960s, or the often cartoonish, street-wise characters of the low-budget **blaxploitation** films that Burnett saw on urban screens in the early 1970s, he depicted his protagonist, Stan, as the father of a black family living in the impoverished Watts neighborhood in Los Angeles. A decent man whose slaughterhouse job and daily struggles have numbed and depressed him, Stan nevertheless gets by, and his bonds with his family and community, depicted in grainy, beautifully composed black-and-white images, are profoundly moving. In one poignant scene, Stan and his wife slow dance to a song by Dinah Washington, getting through another day.

Killer of Sheep was never distributed theatrically before its restoration. Essential to the mood and meaning of the film is its soundtrack, composed of blues and rhythm and blues music by Paul Robeson, Dinah Washington, and Earth, Wind & Fire. Without the resources to clear the music rights for public presentation, Burnett circulated his film over the years in occasional festivals and museum and educational settings. His artistic reputation became firmly established. In 1990, the film was among the first fifty titles named to the National Film Registry by the Library of Congress. But audiences never got to see the film. Only when Burnett was able to complete *To Sleep with Anger* in 1990, due to the participation of actor Danny Glover and Burnett's receipt of a prestigious MacArthur Fellowship, did one of his films receive theatrical distribution. But even *To Sleep with Anger*, a family drama that lacked violence and clear resolutions, was overlooked amid the media's attention to more sensationalized depictions of ghetto culture set to hip-hop soundtracks, such as John Singleton's *Boyz N the Hood* (1991).

Eventually Burnett's critical reputation helped secure the restoration of *Killer of Sheep* by the UCLA Film & Television Archive just when its original 16mm elements were in danger of disintegrating beyond repair. The restoration, one of several planned for independent films of historical significance, was funded by Turner Classic Movies and filmmaker Steven Soderbergh, whose own debut feature, *sex, lies, and videotape* (1989), changed the landscape for the distribution of independent film. In March 2007, the specialty, or "boutique," distributor Milestone Films, whose founders (Dennis Doros and Amy Heller) have long been in the business of releasing important classic and contemporary films theatrically, opened *Killer of Sheep* in a restored 35mm print in New York. Excellent reviews that positioned the film in relation both to African American history and to filmmaking movements like **Italian neorealism** (a film movement that began in Italy during World War II and lasted until about 1952, depicting everyday social realities using location shooting and amateur actors) and the grassroots support of the Harlem-based organization Imagenation, made the opening a record-breaking success, and the film soon opened in art cinemas around the country. The next phase was release on DVD to institutions such as universities that did not have the facilities to show *Killer of Sheep* on 35mm but wanted the rights to have a public screening. Later, the film was released on DVD for the consumer market, packaged with another unreleased early feature by Burnett, *My Brother's Wedding* (1983), along with a commentary track and other features. Thus an experienced "niche" distributor helped a thirty-year-old film win a place on critics' top-ten lists, a special prize from the New York Film Critics Circle, and a place in public memory.

1.22 *Independence Day* (1996). The film's massive promotional campaign for its Fourth of July weekend opening drew on blatant and subtle forms of patriotism, such as the multicultural appeal of its cast. Photofest, Inc.

themes **[Figure 1.22]**. In that light, many posters, advertisements, and publicity stills presented actor Will Smith together with Bill Pullman or Jeff Goldblum, not only to promote the film's stars but also to draw attention to the racial harmony achieved in the film and its appeal to both African American and white audiences. During the first month of its release, when U.S. scientists discovered a meteorite with fossils that suggested early life on Mars, promotion for the movie responded immediately with revised ads: "Last week, scientists found evidence of life on another planet. We're not going to say we told you so. . . ." In contrast, the 2016 sequel *Independence Day: Resurgence* never found a strong marketing hook and made far less money twenty years later.

Some Hollywood promotions and advertisements emphasize the realism of movies, a strategy that promises audiences more accurate or more expansive reflections of the world and human experience. In *Silver Linings Playbook* (2012), a Bradley Cooper and Jennifer Lawrence film about a young man released from a mental institution, the struggle to cope with his bipolar disorder while living with his Philadelphia family was a reality that the film's promotions claimed had rarely before been presented in movies. A related marketing strategy is to claim textual novelty in a film, drawing attention to new features such as technical innovations, a rising star, or the acclaimed book on which the film is based. With early sound films like *The Jazz Singer* (1927), *The Gold Diggers of Broadway* (1929), and *Innocents of Paris* (1929), marketing advertisements directed audiences toward the abundance and quality of the singing and talking that added a dramatic new dimension to cinematic realism **[Figure 1.23]**. Today promotions and advertisements frequently exploit new technologies. *Avatar*'s (2009) marketing campaign emphasized its new three-dimensional (3-D) technology. Marketers also can take advantage of current political events, as when they advertised the plot of Kathryn Bigelow's *Zero Dark Thirty* (2012), which told the story of the long international search for Osama bin Laden after September 11, 2001, by noting its timely encounter with debates and concerns around the use of torture and the killing of Osama bin Laden **[Figure 1.24]**.

1.23 *Innocents of Paris* (1929). The marquee for the movie promotes the novelty of sound and song and this early musical's singing star.

As official promotion tactics, stars are booked to appear on talk shows and in other venues in conjunction with a film's release, but they may also bring unofficial publicity to a film. Brad Pitt and Angelina Jolie boosted audiences for the film *Mr. and Mrs. Smith* (2005) when they became a couple during its filming. Conversely, unwelcome publicity can cause an actor's contract to be canceled or raise concerns about the publicity's effect on ticket sales. Mel Gibson, for example, encountered difficulty finding big-studio work in Hollywood after his well-publicized personal troubles in 2010.

Independent, art, revival, and foreign-language films have less access to the mechanisms of promotion than do current mainstream films, and social media

1.24 *Zero Dark Thirty* (2012). Topical interest in the hunt for Osama bin Laden, as well as the director's success with the similarly current *The Hurt Locker* (2008), fueled interest in Kathryn Bigelow's film.

have afforded new opportunities to spread the word to specialized audiences. In addition, audiences for these films are led to some extent by what we might call "cultural promotion" — academic or journalistic accounts that discuss and frequently value films as aesthetic objects or as especially important in movie history. A discussion of a movie in a film history book or a university film course thus could be seen as an act of marketing, which confirms that promotion is about urging viewers not just to see a film but also to see it with a particular point of view. Although these more measured kinds of promotion are usually underpinned by intellectual rather than financial motives, they also deserve our consideration and analysis.

How does a specific film history text, for instance, prepare you to see a film such as *Bonnie and Clyde* (1967)? Some books promote it as a modern gangster film. Others pitch it as an incisive reflection of the social history of the turbulent 1960s. Still other texts and essays may urge readers to see it because of its place in the oeuvre of a major U.S. director, Arthur Penn **[Figure 1.25]**. Independent movies promote the artistic power and individuality of the director; associate themselves with big-name film festivals in Venice, Toronto, and Cannes; or call attention, through advertis-

ing, to what distinguishes them from mainstream Hollywood films. For a foreign film, a committed publicist can be crucial to its attaining distribution by attracting critical mention. Documentaries can be promoted in relation to the topical subject matter or controversy. In short, we do not experience any film with innocent eyes; consciously or not, we come prepared to see it in a certain way.

Advertising

Advertising is a central form of promotion that uses television, billboards, film trailers or previews, print ads, images and videos on Web sites, and other forms of display to bring a film to the attention of a potential

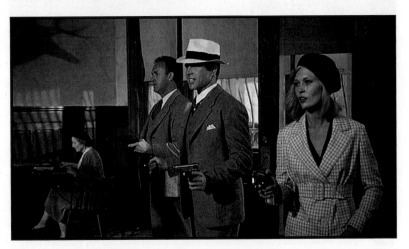

1.25 *Bonnie and Clyde* (1967). Critical accounts may position this film as an updated gangster film or as social commentary on the turbulent 1960s.

1.26 *The Kid* (1921). Unlike posters for his well-known slapstick comedies, this poster shows Charlie Chaplin displaying a demeanor that suggests the serious themes of his first feature film.
Courtesy Everett Collection

audience. Advertising can use the facts in and issues surrounding a movie in various ways. Advertising often emphasizes connections with and differences from related or similar films or highlights the presence of a particularly popular actor or director. The poster for Charlie Chaplin's *The Kid* (1921), for example, proudly pronounces that it is "the great Film he has been working on for a whole year" **[Figure 1.26]**. For different markets, *Prometheus* (2012) was promoted as a star vehicle for Sweden's Noomi Rapace or as the latest film from Ridley Scott, the director of *Alien* (1979), *Blade Runner* (1982), *Thelma & Louise* (1991), and *Black Hawk Down* (2001). It is conceivable that these two promotional tactics created different sets of expectations about the movie — one more attuned to tough female protagonists and the other to lavish sets and technological landscapes. As this example reveals, promotion tends both to draw us to a movie and also to suggest what we will concentrate on as a way of understanding its achievement.

Trailers

One of the most carefully crafted forms of promotional advertising is the **trailer** — a form of promotional advertising that previews edited images and scenes from a film in theaters before the main feature film, in television commercials, or on Web sites. In just a few minutes, the trailer provides a compact series of reasons that a viewer should see that movie. A trailer for Stanley Kubrick's *Eyes Wide Shut* (1999) is indicative of this form of advertising: it moves quickly to large bold titles announcing separately the names of Tom Cruise, Nicole Kidman, and Kubrick, foregrounding the collaboration of a star marriage and a celebrated director of daring films. Then, against the refrain from Chris Isaak's soundtrack song "Baby Did a Bad Bad Thing," a series of images condenses the progress of the film, including shots of Kidman

1.27 *Eyes Wide Shut* (1999). Advertisements and trailers for Stanley Kubrick's last film emphasized the film's director, its stars—Tom Cruise and Nicole Kidman, who were married at the time—and its sexual content.

undressing, Cruise sauntering with two beautiful women, the two stars sharing a passionate kiss, two ominous-looking men standing at the gate of an estate, and Cruise being enticed by a prostitute. Besides the provocative match of two, then-married star sex symbols with a controversial director, the trailer underlines the dark erotic mysteries of the film within an opulently decadent setting. It introduces intensely sexual characters and the alternately seedy and glamorous atmosphere of the film in a manner meant to draw fans of Cruise, Kidman, Kubrick, and erotic intrigue **[Figure 1.27]**. That this promotion fails to communicate the stinging irony in the movie's eroticism may account for some of the disappointed reactions that followed its eager initial reception. The availability of trailers on the Internet has increased the novel approaches to this format, and trailers are now rated and scrutinized like theatrical releases.

1.28a

1.28b

1.28c

1.28d

1.28e

1.28f

FORM IN ACTION

The Changing Art and Business of the Film Trailer

The film has become a central form of movie marketing, positioned before the feature and subject to its own conventions. Throughout the 1950s, onscreen text was used to advertise a film's key features, including its stars, genre, plot mysteries, even the latest film technology. Later, voiceover narration and scoring helped make a coherent message from a montage of images arranged in a three-act structure. In the era of the Internet, the movie trailer has become an online experience that studios use to build expectations and engage viewers.

A trailer for the 2015 adaptation *Pride and Prejudice and Zombies* is a clever example of the succinct art of this form of promotion. The title itself rides the wave of the many Jane Austen adaptations that have appeared since the 1990s (such as the 1995 *Clueless* and the 2016 *Love and Friendship*), and the trailer signals the conventions of this genre by beginning with a handsome horseman riding toward an eighteenth-century English country house, followed by a close-up of an elegant drawing room where men and women in Regency evening clothes dance to classical music. The precisely accented voiceover of a woman remarks that "To succeed in polite society, a young woman must be many things" **[Figure 1.28a]**. Then an **intertitle** (printed text inserted between film images) announces "Based on the Jane Austen Classic"—again underlining tradition. There is a montage of sophisticated social activities and rituals, while the voiceover enumerates the typical Austen virtues: "be kind, well read, and accomplished" **[Figure 1.28b]**. The last image of this montage—of a well-dressed gentleman diving into a pond—however, oddly disrupts the sequence **[Figure 1.28c]**, as the voiceover concludes her sentence with the phrase "to survive in the world as we know it," which transforms audience expectations. The next image, both shocking and ridiculous, shows one of the proper ladies turning to see the grotesque bloody face of a zombie (dressed in a Regency gown) **[Figure 1.28d]**. At this point, the trailer suddenly switches to a driving contemporary soundtrack and hilariously cuts to introduce the ironic new dimension of this Austen world where to survive women will now "need other qualities" **[Figure 1.28e]**. A rapid montage then turns the opening dance into a violent and bloody showdown between the Regency ladies and an onslaught of vampires, as knives are pulled from under gowns and the heroines march forward as a fierce band **[Figure 1.28f]**. In about sixty seconds, this preview trailer draws in fans of Austen adaptations, comically and satirically overturns their expectations, and opens a new viewing space for contemporary fans of zombie films.

43

VIEWING CUE

LaunchPad Solo

Watch a clip of the trailer for *Suicide Squad* (2016). What kinds of messages does the trailer send about the film and its tone?

Media Convergence

Movie advertising has always targeted consumers' changing habits and has adapted strategies for this era of **media convergence** — the process by which formerly distinct media (such as cinema, television, the Internet, and video games) and viewing platforms (such as television, computers, and cell phones) become interdependent. A viewer might find and play an online game set in a film's fictional world on the film's Web site, read a comic-book tie-in, and watch an online promotion with the films' stars, all before viewing the movie in a theater. Indeed, the enormous sums spent on marketing a film's theatrical release are deemed worthwhile because they relate directly to the promotion of other media elements within the brand or franchise, such as video games, books, music, and DVD releases. Viewers understand these tactics and may participate in this convergence: a viewer who enjoys a film and its soundtrack might download a ringtone for her cell phone and place the title in her Netflix queue in anticipation of its release on DVD months later. But viewers may also decide to skip the theatrical release altogether and catch the film later on video on demand or DVD.

The enormous popularity of social networking sites has fostered the technique of **viral marketing** — a process of advertising that relies on existing social networks to spread a marketing message by word of mouth, electronic messaging, or other means. Because viral marketing works through networks of shared interest, it is less dependent than conventional promotional techniques on market research and can be a highly effective and informative indicator of audience preferences. Yet it is also less easily controlled than deliberately placed ads that are based on target demographics. In many ways, media convergence has allowed today's viewers to affect how films are understood and produced more than viewers did in years past.

The Hollywood studios made a production distinction between an **A picture** (a feature film with a large budget and prestigious source material or actors that has been historically promoted as a main attraction receiving top billing) and a **B picture** (a low-budget, nonprestigious movie that usually played on the bottom half of a double bill). Just as today the term **blockbuster** (a big-budget film intended for wide release, whose large investment in stars, special effects, and advertising attracts large audiences and big profits) prepares us for action, stars, and special effects, and **art film** (a film produced primarily for aesthetic rather than commercial or entertainment purposes, whose intellectual or formal challenges are often attributed to the vision of an auteur) suggests a more visually subtle, perhaps slower-paced or more intellectually demanding movie, the terminology used to define and promote a movie can become a potent force in framing our expectations.

The Rating System

Rating systems, which provide viewers with guidelines for movies (usually based on violent or sexual content), are a similarly important form of advertising that can be used in marketing and promotion. Whether they are wanted or unwanted by viewers, ratings are fundamentally about trying to control the kind of audience that sees a film and, to a certain extent, about advertising the content of that film.

In the United States, the current Motion Picture Association of America (MPAA) ratings system classifies movies as G (general audiences), PG (parental guidance suggested), PG-13 (parental guidance suggested and not recommended for audiences under thirteen years old), R (persons under age seventeen must

1.29 *Ghostbusters* (2016). A PG-13 rating can suggest a certain edge to a film that makes it attractive to preteens without alienating older viewers.

be accompanied by an adult), and NC-17 (persons under age seventeen are not admitted). Films made outside the major studios are not required to obtain MPAA ratings, but exhibition and even advertising opportunities are closely tied to the system.

Other countries, as well as some religious organizations, have their own systems for rating films. Great Britain, for instance, uses these categories: U (universal), A (parental discretion), AA (persons under age fourteen are not admitted), and X (persons under age eighteen are not admitted). The age limit for X-rated films varies from country to country, the lowest being age fifteen in Sweden.

A project like *The Peanuts Movie* (2015), an animated adaptation of the famous comic strip, depends on its G rating to draw large family audiences, whereas sexually explicit films like Steve McQueen's *Shame* (2011), rated NC-17 for its explicit sexual content, and Nagisa Oshima's *In the Realm of the Senses* (1976), not rated and confiscated when it first came to many countries, can use the notoriety of their ratings to attract curious adult viewers. An NC-17 rating can damage a film's box-office prospects, however, because many outlets will not advertise such films. Many mainstream movies eagerly seek out a middle ground. Movies like *Ghostbusters* (2016) prefer a PG-13 rating because it attracts a young audience of eight-, nine-, and ten-year-olds who want movies with some adult language and action **[Figure 1.29]**.

Word of Mouth and Fan Engagement

Our experiences when viewing a movie are shaped in advance in less evident and predictable ways as well. Word of mouth—the oral or written exchange of opinions and information sometimes referred to as the "buzz" around a movie—may seem to be an insignificant or vague area of promotion, yet our likes and dislikes are formed and given direction by the social groups we move in. Social networking sites that allow us to list or indicate our likes and dislikes with a click have expanded these social groups exponentially. We know that our friends like certain kinds of films, and we tend to enjoy and promote movies according to the values of our particular age group, cultural background, or other social determinant. When marketing experts promote a movie to a target audience, they intend to do so through word of mouth or "virally," knowing that viewers communicate with

(a) **(b)**

1.30a and 1.30b *Titanic* (1997). Word of mouth anticipating the release of James Cameron's film focused on special effects. After the film's release, word of mouth among young female fans was appreciative of its star Leonardo DiCaprio and its romance plot.

one another and recommend films to people who share their values and tastes **[Figures 1.30a and 1.30b]**.

Consider, for instance, how friends who enjoyed the novel might have discussed the making of the film *The Hunger Games* (2012). Would they be excited about the casting of rising star Jennifer Lawrence as the tough young heroine? About the genre of science fiction films set in a dystopian future and the potential for interesting visual effects? About other books by Suzanne Collins with which they are familiar? What would each of these word-of-mouth promotions indicate about the social or personal values of the person promoting the movie and the culture of taste influencing his or her views?

Fan magazines were an early extension of word of mouth as a form of movie promotion and have consistently shed light on the sociology of taste. Emerging in the 1910s and widely popular by the 1920s, such "fanzines" brought film culture home to audience members. Posing as objective accounts, many stories were actually produced by the studios' publicity departments. Those print fan magazines have evolved into Internet discussion groups, promotional and user-generated Web sites, social media accounts, and other fan activities, which have become an even bigger force in film promotion and culture. In fact, Web sites, often set up by a film's distributor, have become the most powerful contemporary form of the fanzine, allowing information about and enthusiasm for a movie to be efficiently exchanged and spread among potential viewers. Notoriously, the title *Snakes on a Plane* (2006) was so resonant with viewers in its very literalness that the Web activity around the film (even before its release) prompted changes to make the film more daring and campier. The subsequent box-office disappointment may have been a measure of viewers' reaction to marketing manipulations.

To encourage and develop individual interest in films, these fanzines and Web sites gather together readers and viewers who wish to read or chat about their ongoing interest in movies like the *Star Trek* films (1979–2016) or cult favorites like *Casablanca* (1942) or who wish to share fan productions. Here tastes about which movies to like and dislike and about how to see them are supported and promoted on a concrete social and commercial level. Information is offered or exchanged about specific movies, arguments are waged, and fan fiction or user-generated videos are developed around the film. Magazines may provide information about the signature song of *Casablanca*, "As Time Goes By," and the actor who sings it, Dooley Wilson. Message board participants may query each other about Mr. Spock's Vulcan history or fantasize about his personal life. The Internet promotes word of mouth about a film by offering potential audiences the possibility of some participation in the making of the film, an approach that is increasingly common today.

As they proliferate, promotional avenues like these deserve attention and analysis to try to determine how they add to or confuse our understanding of a film. Our different experiences of the movies take place within a complex cultural terrain where our personal interest in certain films intersects with specific historical

VIEWING CUE

Consider a recent film release that you've seen, and identify which promotional strategies were effective in persuading you to watch it. Was anything about the promotion misleading? Was there anything about the film you feel was ignored or underplayed in the promotion?

and social forces to shape the meaning and value of those experiences. Here, too, the film experience extends well beyond the big screen.

Movie Exhibition: The Where, When, and How of Movie Experiences

Exhibition is the part of the industry that shows films to a paying public, usually in movie theaters. It may involve promotional elements like movie posters and publicity events in a theater lobby or be related to distribution through the calendar of film releasing. But exhibition, which is closely tied to **reception**—the process through which individual viewers or groups make sense of a film—is at the heart of the film experience. **Exhibitors** own individual theaters or theater chains and make decisions about programming and local promotion. They are responsible for the actual experience of moviegoing, including the concessions that make a night out at the movies different from one spent watching films at home and that bring in an estimated 40 percent of theater owners' revenue. Like distribution and promotion, we may take exhibition for granted, forgetting that the many ways we watch movies contribute a great deal to our feelings about, and our interpretations of, film. We watch movies within a cultural range of exhibition venues—in theaters, at home on video monitors, or on a plane or train on portable devices. Not surprisingly, these contexts and technologies anticipate and condition our responses to movies.

The Changing Contexts and Practices of Film Exhibition

Very different kinds of film response can be elicited by seeing the same movie at a cineplex or in a college classroom or by watching it uninterrupted for two hours on a big screen or in thirty-minute segments over four days on a computer. A viewer watching a film on an airplane monitor may be completely bored by it, but watching it later at home, he or she may find the film much more compelling and appreciate its visual surprises and interesting plot twists.

Movies have been distributed, exhibited, and seen in many different contexts historically. At the beginning of the twentieth century, movies rarely lasted more than twenty minutes and often were viewed in small, noisy **nickelodeons**—store-front theaters or arcade spaces where short films were shown continuously for a five-cent admission price to audiences passing in and out—or in carnival settings that assumed movies were a passing amusement comparable to other attractions. By the 1920s, as movies grew artistically, financially, and culturally, the exhibition of films moved to lavish **movie palaces** like Radio City Music Hall (which opened in 1932), with sumptuous seating for thousands amid ornate architecture. By the 1950s, city centers gave way to suburban sprawl, theaters lost their crowds of patrons, and drive-ins and widescreen and 3-D processes were introduced to distinguish the possibilities of film exhibition from its new rival, television at home. Soon television became a way to experience movies as special events in the flow of daily programming. In the 1980s, VCRs gave home audiences access to many movies and the ability to watch them when and how they wished, and the **multiplex**, a movie theater complex with many screens, became increasingly important as a way to integrate a choice of moviegoing experiences with an outing to the mall.

Today we commonly view movies at home on a disc player or computer screen, where we can watch them in the standard ninety- to 120-minute period, extend our viewing over many nights, or rewatch favorite or puzzling portions of them. Portable devices such as laptops, smartphones, and tablet computers give a new mobility to our viewing. As theaters continue to compete with home screens, film exhibitors have countered with so-called megaplexes—theaters with twenty or more screens,

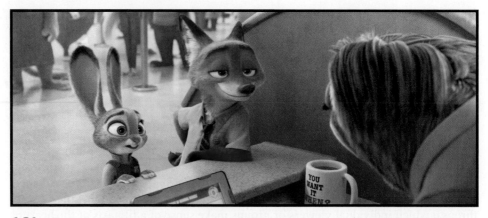

1.31 *Zootopia* (2016). Family films are distributed widely to theater chains and exhibited in early time slots, although some become crossover hits.

more than six thousand seats, and over a hundred showtimes per day. These new entertainment complexes may feature not just movies but also arcade games, restaurants, and coffee bars. Home exhibition has responded in turn with more elaborate digital picture and sound technologies and convergence between devices such as game consoles and television screens for streaming movies.

Technologies and Cultures of Exhibition

Viewing forums—the locations where we watch a movie—contribute to the wider culture of exhibition space and the social activities that surround and define moviegoing. Theatrical exhibition highlights a social dimension of watching movies because it gathers and organizes individuals as a specific audience at a specific place and time. Further, our shared participation in that social environment directs our attention and shapes our responses.

A movie such as *Zootopia* (2016) will be shown as a Saturday matinee in suburban theaters (as well as other places) to attract families with children to its talking-animal adventure **[Figure 1.31]**. The time and place of the showing coordinate with a period when families can share recreation, making them more inclined to appreciate this empowering tale of societal harmony and self-confidence. Conversely, Peter Greenaway's *The Pillow Book* (1996), a complex film about a woman's passion for calligraphy, human flesh, poetry, and sex, would likely appear in a small urban theater frequented by individuals and young couples or groups of friends who also spend time in the theater's coffee bar **[Figure 1.32]**. This movie probably would appeal to an urban crowd with experimental tastes and to those who like to watch intellectually stimulating and conversation-provoking films. Reversing the exhibition contexts of these two films would indicate how those contexts could generate wildly different reactions. The technological conditions of exhibition—that is, the industrial and mechanical vehicles through which movies

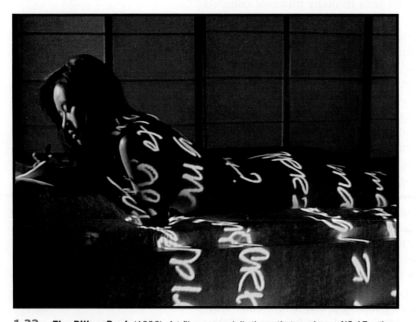

1.32 *The Pillow Book* (1996). Art films, especially those that receive an NC-17 rating, are likely to be distributed primarily to specialty cinemas in urban locations.

are shown—shape the viewer's reaction as well, with screen sizes and locations varying widely from experience to experience.

Different technological features of exhibition are sometimes carefully calculated to add to both our enjoyment and our understanding of a movie. Cecil B. DeMille's epic film *The Ten Commandments* (1923) premiered in a movie palace, where the plush and grandiose surroundings, the biblical magnitude of the images, and the orchestral accompaniment supported the grand spiritual themes of the film. Thus the conditions for watching a film may parallel its ideas or formal practices. With the special projection techniques and 3-D glasses worn for *Creature from the Black Lagoon* (1954), the creature's appearance becomes even more startling. 3-D technology is an excellent example of changing exhibition technologies and cultures **[Figure 1.33]**. Long regarded nostalgically as a gimmick of the 1950s, it made a comeback with state-of-the-art digital movie production and exhibition with the technology developed for *Avatar* (2009). Theater owners worldwide converted screens in order to show the film and to attract local audiences with the novelty of the spectacle. As a result, digital projection is now more prevalent than 35mm film.

1.33 **3-D exhibition.** Viewers enjoy a screening with special 3-D glasses in the 1950s, the first heyday of the technology. As a technological innovation, 3-D brings the focus to exhibition contexts and offers a chance for theater owners to increase revenue. Bettmann/Getty Images

In contrast to viewing technologies that attempt to enhance the spectacular nature of the big-screen experience are those that try to maximize (sometimes by literally minimizing) the uniquely personal encounter with the film image. Consumers have adapted quickly as distinct media (such as cinema, television, the Internet, and video games) and viewing platforms (such as television, computers, and cell phones) have become commercially, technologically, and culturally interdependent.

The Timing of Exhibition

Whereas distribution timing determines when a film is made available and in what format, the timing of exhibition is a more personal dimension of the movie experience. When and for how long we watch a film can shape how it affects us and what our attitude toward it is as much as where we see the film and with whom. Although it is common to see movies in the early evening, either before or after dinner, audiences watch movies of different kinds according to numerous rituals and in various time slots. Afternoon matinees, midnight movies, or in-flight movies on long plane rides give some indication of how the timing of a movie experience can vary and how that can influence other considerations about the movie. In each of these situations, our experience of the movies includes a commitment to spend time in a certain way. Instead of spending time reading, talking with others, sleeping, or working on a business project, we watch a movie. That time spent with a movie accordingly becomes an activity associated with relaxing, socializing, or even working in a different way.

Leisure Time

Traditionally, movie culture has emphasized film exhibition as leisure time, a time that is assumed to be less productive than time spent working and that reinforces assumptions about movies as the kind of enjoyment associated with play and pleasure. To some extent, leisure time is a relatively recent historical development. Since the nineteenth

VIEWING CUE

Consider how viewing the movie you most recently watched in class on a large screen versus a laptop would affect your response.

text continued on page 52 ▶

FILM IN FOCUS

FILM IN FOCUS

LaunchPad Solo

To watch a clip from *Citizen Kane* (1941), see the *Film Experience* LaunchPad.

Exhibiting *Citizen Kane* (1941)

The tale of a man obsessed with power and possessions, *Citizen Kane* (1941) is often considered one of the greatest films ever made. It is usually hailed for Orson Welles's portrayal of Charles Foster Kane, Welles's direction of the puzzle-like story, and the film's complex visual compositions. It also is a movie that ran into trouble even before its release because of its thinly disguised and critical portrayal of U.S. media mogul William Randolph Hearst [Figure 1.34]. Less often is *Citizen Kane* seen and understood according to its dramatic exhibition history, one that has colored or even decided the changing meanings of the film.

As the first film of a twenty-five-year-old director already hailed as a "boy genius" for his work as a theater actor and director, *Citizen Kane* was scheduled to open with appropriate fanfare at the spectacular Radio City Music Hall in New York City, where RKO premiered its top films. Besides highlighting the glamorous and palatial architecture of this building, exhibiting the film in New York first would take advantage of the fact that Welles's career and reputation had been made there. The physical and social context for this opening exhibition would combine the epic grandeur of the Radio City building and a New York cultural space attuned to Welles's artistic experimentation. Already offended by rumors about the film, however, Hearst secretly moved to block the opening at Radio City Music Hall. After many difficulties and delays, the film's producer and distributor, RKO, eventually premiered the film simultaneously at an independent theater in Los Angeles and at a refurbished vaudeville house in New York City. The film's wider release was detrimentally affected by Hearst's attack on the film. Hearst newspapers were banned from running ads for it, directly affecting its box-office potential. When major theaters such as the Fox and Paramount chains were legally forced to exhibit the film, they sometimes booked *Citizen Kane* but did not actually screen it for fear of vindictive repercussions from Hearst. Where it was shown, the controversy overshadowed the film itself, making it appear for many audiences strange and unnecessarily confrontational, resulting in a box-office failure.

1.34 *Citizen Kane* (1941). William Randolph Hearst objected to the film's thinly veiled portrayal of his life and blocked it from opening at Radio City Music Hall. The film's wider release was negatively affected as well. Major theater chains did not want to screen it for fear of incurring Hearst's wrath.

Changing sociological and geographical contexts for exhibition have continued to follow *Citizen Kane* as its reputation has grown through the years. After its tumultuous first exhibition in the United States, the film was rediscovered in the 1950s by the art-house cinemas of France. There it was hailed as a brilliantly creative expression of film language. Today many individuals who see *Citizen Kane* watch it in a classroom—in a college course on American cinema, for example. In the classroom, we look at movies as students or as scholars, and we are prepared to study them. In this context, viewers may feel urged to think more about the film as an art object than as entertainment or exposé. In the classroom, we may focus more on the serious aspects of the film (such as Kane's real and visual alienation from his best friends) than on the comic interludes (such as the vaudevillian dance number). Someone watching *Citizen Kane* in an academic situation can see and think about it in other ways, but exhibition contexts suggest certain social attitudes through which we watch a movie. The exhibition history of *Citizen Kane* likewise describes

significant differences in how the film is experienced through different technologies. Its original 35mm exhibition showed off the imagistic details and stunning deep-focus cinematography that made the film famous. The visual magnitude of scenes such as Susan Alexander's operatic premiere and Kane's safari picnic at Xanadu or the spatial vibrancy and richness of Kane and Susan's conversation in one of Xanadu's vast halls arguably require the size and texture of a large theatrical image. Since its first theatrical exhibition, the film has circulated to film societies and colleges on 16mm film and later appeared on the successive consumer technologies of video, laserdisc, DVD, and Blu-ray. The content of the film remains the same, but the different technologies have sometimes muted the visual power of its images and scenes because of lower quality or smaller image size. Digital formats enhance the image, perhaps redirecting our understanding to visual dynamics rather than the events of the story.

The shift in the exhibition context may also affect our level of concentration from focused to distracted attention. A viewing experience on television may be broken up because of commercials, and on a digital format we can affect the duration of the experience when we start and stop the movie ourselves. Whereas the large images in the theater may direct the viewer more easily to the play of light and dark as commentaries on the different characters, a DVD player might instead allow the viewer to replay dialogue in order to note levels of intonation or wordplay. Consumer editions of *Citizen Kane* give viewers the added opportunity to supplement the film with rare photos, documents from the advertising campaign, commentaries by filmmaker Peter Bogdanovich and critic Roger Ebert, and a documentary, *The Battle over Citizen Kane* (1996), that describes the history of its script and its exhibition difficulties. To whatever degree these supplemental materials come into play, it is clear that a DVD exhibition of *Citizen Kane* offers possibilities for significantly enriching an audience's experience of the film. Viewers taking advantage of these materials would conceivably watch *Citizen Kane* prepared and equipped with certain points of view. They might be attuned to Welles's creative innovation and influence on later filmmakers like Bogdanovich or interested in how the film re-creates the connections between Hearst and Kane that are detailed in the documentary supplement. That the DVD provides material on "alternative ad campaigns" for the original release of the film even allows viewers to investigate the way different promotional strategies can direct their attention to certain themes and scenes.

The fame of *Citizen Kane* among critics as the best film ever made (remaining at the top of the *Sight and Sound* poll taken each decade since 1962 until 2012, when it dropped to number two) and its frequent invocation as the effort of a "boy wonder" contribute to yet another exhibition context. Fans post excerpts on the Internet in video-sharing sites such as YouTube, and would-be filmmakers compare their efforts to Welles's or remix parts of his film, introducing new generations to the classic.

VIEWING CUE

Think of a movie you've watched as a "leisure time" versus a "productive time" activity. How might the film be viewed differently in a classroom versus during a long airplane flight? How might your film choice be affected by the timing and context in which you view the movie?

century, when motion pictures first appeared, modern society has aimed to organize experience so that work and leisure could be separated and defined in relation to each other. We generally identify leisure time as an "escape," "the relaxation of our mind and body," or "the acting out of a different self." Since the early twentieth century, movie exhibition has been associated with leisure time in these ways. Seeing a comedy on a Friday night promises relaxation at the end of a busy week. Playing a concert film on a DVD player while eating dinner may relieve mental fatigue. Watching a romantic film on television late at night may offer the passion missing from one's real life.

Productive Time

Besides leisure time, however, we can and should consider film exhibition as productive time—time used to gain information, material advantage, or knowledge. From the early years of the cinema, movies have been used to illustrate lectures or introduce audiences to Shakespearean performances. Educational films like those shown in health classes or driver education programs are less glamorous versions of this use of film. Although less widely acknowledged as part of film exhibition, productive time continues to shape certain kinds of film exhibition. For a movie reviewer or film producer, an early-morning screening may be about "financial value" because this use of time to evaluate a movie will presumably result in certain economic rewards. For another person, a week of films at an art museum represents "intellectual value" because it helps explain ideas about a different society or historical period. For a young American, an evening watching *Schindler's List* (1993) can be about "human value" because that film aims to make viewers more knowledgeable about the Holocaust and more sensitive to the suffering of other human beings.

The timing of exhibitions may frame and emphasize the film experience according to certain values. The Cannes Film Festival introduces a wide range of films and functions both as a business venue for buying and selling film and as a glamorous showcase for stars and parties. The May timing of this festival and its French Riviera location ensure that the movie experience will be about pleasure and the business of leisure time. In contrast, the New York Film Festival, featuring some of the same films, has a more intellectual or academic aura. It occurs in New York City during September and October, at the beginning of the academic year and the calendars of arts organizations, which associates this experience of the movies more with artistic value and productive time.

Classroom, library, and museum exhibitions tend to emphasize understanding and learning as much as enjoyment. When students watch films in these kinds of situations, they are asked to attend to them somewhat differently from the way they may view films on a Friday night at the movies. They watch more carefully, perhaps; they may consider the films as part of historical or artistic traditions; they may take notes as a logical part of this kind of exhibition. These conditions of film exhibition do not necessarily change the essential meaning of a movie; but in directing how we look at a film, they can certainly shade and even alter how we understand it. Exhibition asks us to engage and think about the film not as an isolated object but as part of the expectations established by the conditions in which we watch it.

CONCEPTS AT WORK

Behind virtually every movie is a complex range of decisions, choices, and aims about how to make, distribute, market, and exhibit a film. In this chapter, we have highlighted some of the most important parts of that work as they anticipate and position viewers. We have seen how production methods, distribution strategies, marketing techniques, and exhibition places respond to and

create different kinds of movie experiences. Films as different as Ryan Coogler's *Fruitvale Station* and *Creed* represent, for example, extremely different paths from production to marketing and so attract and position viewers in very different ways. James Schamus and Ang Lee create a dynamic and unique working relationship as producer and director that generates a number of films—such as *Crouching Tiger, Hidden Dragon* (2000) and *Brokeback Mountain* (2005)—that bear both their signatures and elicit certain audience expectations. Because of legal complications, *Killer of Sheep* struggles with distribution and exhibition, while *Zero Dark Thirty* benefits enormously from buzz about its controversial depiction of torture. Examine how these and other issues discussed in this chapter inform other films you wish to evaluate and analyze:

- How do the different stages of preproduction inform what we ultimately see on the screen in films such as *The Lord of the Rings* trilogy or *Life of Pi* (2012)?
- Consider how the strategies of film distribution determine what we see as well as when and how we can see movies such as *Paranormal Activity* or *X-Men: Apocalypse* (2016).
- Evaluate the ways in which different venues for exhibition both shape and influence how an audience responds to that movie.
- In which ways have media convergence and rapid technological advances created different relationships and dynamics with audiences? How, for example, has the day-and-date release strategy pioneered by *Bubble* (2006) changed our ways of watching films? Has easier access to repeat viewings changed the way movies tell their stories?

LaunchPad Solo

Visit the LaunchPad Solo for *The Film Experience* to view movie clips, read additional Film in Focus pieces, and learn more about your film experiences.

HISTORY AND HISTORIOGRAPHY
Hollywood and Beyond

Three films retell a similar story at different points over nearly fifty years of film history — *All That Heaven Allows*, a Hollywood melodrama made in 1955 by German émigré director Douglas Sirk; *Ali: Fear Eats the Soul*, directed in 1974 by German filmmaker Rainer Werner Fassbinder; and *Far from Heaven*, made in 2002 by American independent Todd Haynes. The first, starring Rock Hudson and Jane Wyman in a romance between a middle-class widow and her gardener, is a glossy Technicolor tale of social prejudice in small-town USA. The second, concentrating on the love affair between an older cleaning woman and a young Arab worker, is a grittier story about age, race, class, and immigration in modern Germany. The third juxtaposes a husband's desire for men with his wife's developing interracial intimacy with their gardener, critiquing the facade of a typical 1950s family. Although these are very different films — a product of the Hollywood studio system, a low-budget film by an acclaimed German filmmaker of the 1970s, and an independent art-house film — they are deeply connected, an original and two remakes that use a central love story as social critique at a particular historical place and time. They represent threads in the rich tapestry of films past, which can be approached as a series of partial histories and particular viewpoints.

Every year, Hollywood's greatest spectacle, the Academy Awards nominations and ceremony, attracts media attention and global audiences as Academy voters determine the "best" work in twenty-four categories. Interested viewers can watch marathons of previous winners on cable television to educate themselves in the history of great movie art. But awards—perhaps especially the Oscars—can be influenced by the critical profile of a film, its genre, advertising campaign, production values, or the prominence of its personnel within the industry. Other influential lists of "greatest" films give top honors to Hollywood productions—*Citizen Kane* (1941), *Vertigo* (1958), *Singin' in the Rain* (1952), *The Searchers* (1956), for example—that were passed over for the Oscar for best picture in their time. Conversely, some Academy Award winners are not included on the Library of Congress's National Film Registry, a list of films of historical significance that admits additional films each year after a public nomination process. Certainly, looking only at Oscar winners is not the most unbiased or comprehensive approach to the global history of cinema; foreign-language films are grouped in one Academy Award category, to which each country is allowed to submit only a single film.

Movie history can take many shapes and forms beyond "best of" lists. How we look at film history is the product of certain formulas and models. For example, industrial histories look at the technologies, business practices, and policies that shape filmmaking and the distribution and exhibition of films. Social histories relate film genres, stars, and filmgoing habits to larger social contexts. Formal histories analyze prevalent stylistic choices. Genealogies look at how power relations operating during a certain period influence one particular historical development over another. In our discussion of film history, we aim not only to present key facts, names, and events but also to direct attention to how history is written.

Since the first days of moving pictures, movies themselves have attempted to write history. The first movies, with their remarkable ability to present people and events as living images, began to record actual historical happenings (such as the 1900 Paris Exposition) and to re-create historical moments (such as the assassination of President William McKinley in 1901). Cinema quickly became one of the most common ways that people encounter the figures of the past. Some historical movies—such as the tale of the eighteenth-century Russian monarch Catherine the Great in *The Scarlet Empress* (1934), the story of John Reed and the Greenwich Village leftist movement in *Reds* (1981), and the 1965 voting rights march led by Martin Luther King Jr. and other civil rights leaders in *Selma* (2015) **[Figure 2.1]**—have so powerfully and convincingly reconstructed the past that they have become the dominant framework through which many of us see and understand history.

The study of the methods and principles through which the past is viewed according to certain perspectives and priorities is called **historiography**. Just as the movies construct visions of history for us, so too do written accounts shape our view of film history in particular ways. Attention to historiography gives us a broader perspective on the kinds of historical narratives available to us, allowing us to understand the many stories that constitute the movie past rather than to take a singular perspective as given.

It has been nearly 125 years since films were first exhibited to paying audiences, and those first exhibitions were the culmination of long efforts of invention and imagination. We have selected **periodization** as the most useful historiographic tool to give readers a broad overview of film history that can serve as background for the concepts to be introduced in the book. Periodization is a method of organizing film history by periods that are defined by historical events or that produced

2.1 *Selma* (2015). History in the movies: David Oyelowo portrays Martin Luther King Jr. in Ava DuVernay's drama about a crucial moment in the U.S. civil rights era.

movies that share thematic and stylistic concerns. Although different periodizations are possible, this survey is divided into the following broad periods—silent (1894–1929), classical (1929–1945), post–World War II (1945–1975), globalization (1975–2000), and digital (2000–present). For each era, we reference key social events that define film histories and highlight formal and stylistic features that are tied to industrial and technological developments.

Inevitably, writing film history involves interpretation and making choices about what to include and what to leave out. The commonly accepted list of great works in a field of study is called the **canon.** In this chapter, we introduce canonical film and filmmakers as an essential orientation to film history, while recognizing that the very concept of a film canon confers cultural weight on certain movies over others. We have therefore also highlighted undervalued contributions and traditions that help reveal the antecedents of some of today's diverse film practices and drive changes in the canon.

Although Hollywood has achieved a dominant economic and stylistic position in world film history, any view of film history would be incomplete if it ignored the rich traditions of filmmaking beyond Hollywood. Film arose as an international medium and in its first decades even transcended language barriers. A variety of factors internal and external to the film industry led to the rise of Hollywood's storytelling and commercial models. This chapter examines film cultures from around the world—some as old as Hollywood and some just beginning to emerge—without attempting to be comprehensive.

This chapter concludes with attention to the issue of preserving our rich and diverse film history. The Film Foundation, founded by director Martin Scorsese, estimates that more than 50 percent of films made worldwide before 1950 are no longer extant. How can we tell the full story of cinema with this many gaps in the record? These losses encourage the writing of film histories that go beyond the films themselves to consider institutions like archives and practices like public memories of filmgoing.

Indeed, every aspect of the film experience can be woven into the history of the medium. While this chapter offers a broad overview, later chapters also include historical material explaining technical and stylistic developments as well as the evolution of modes and genres of filmmaking.

Silent Cinema

The silent cinema period, from 1895 until roughly 1929, was characterized by rapid development and experimentation in film technology, form, and culture and the establishment of successful film industries around the world. After World War I (1914–1918), Hollywood achieved dominance as it established the practices and formulas that carried into the classical period after the incorporation of synchronized sound technology. This period saw the development of the major film genres, the star system, the studio system, and the theatrical exhibition of feature-length narrative films. A technological development was not the only thing that brought the silent period to a close, however. Along with the coming of sound, the 1929 stock market crash plunged the nation and much of the world into economic insecurity.

Around the turn of the twentieth century in the United States, massive industrialization attracted large numbers of immigrants and rural Americans to urban centers, shifting traditional class, race, and gender lines as the country experienced economic prosperity. Industrialization also fostered the growth of leisure time and commercialized leisure activities, allowing popular culture to compete with high culture as never before. These patterns of modernization—including the invention of cinema and its rapid integration into the life of the masses—were international phenomena.

For many historians, the beginning of cinema history proper is the first screening of August and Louis Lumière's *Workers Leaving the Lumière Factory* on March 22, 1895, followed by the public screening of this and other films by the brothers in Paris on December 18, 1895. Seeking the shock of the new, viewers in major cities all over the world flocked to see demonstrations of the new medium in films like R. W. Paul's 1896 racing film *The Derby* [**Figure 2.2**]. Soon commercial and theatrical venues for showing movies to the general public arrived in the form of **nickelodeons**—storefront theaters and arcade spaces where short films were showed continuously for a five-cent admission price to audiences passing in and out. The early development of film technology, technique, subject matter, and exhibition practices took place on many fronts. In part to control this growth, the major film companies in the United States standardized practices by forming the Motion Picture Patents Company (known as "the Trust") in 1908.

This period of rapid change in how films were made and seen is known as **early cinema**, which stretches from 1895 to the rise of the feature film form around 1915. In early cinema,

2.2 ***The Derby*** (1896). The finish of the annual Epsom Derby horse race, captured by British filmmakers Robert W. Paul and Birt Acres, stands at the beginning of cinema's evolution.

the impulse was less to tell a story than to provide an exciting spectacle for audiences. The first movies encompassed trick films, comic sketches, travelogues, and scenes of everyday life. Stylistically, early cinema was characterized by the shift from single to multiple shots and the early elaboration of narrative form. From simple scenes like *Fred Ott's Sneeze* (1896), movies quickly evolved to dramatize real or fictional events using multiple shots that were logically connected in space and time. Released in 1903, Edwin S. Porter's *Uncle Tom's Cabin* presented fourteen shots introduced by intertitles to depict the highlights of the famous novel and play. By 1911, D. W. Griffith's *The Lonedale Operator*, a short film about burglars threatening a telegraph operator, used around one hundred shots and parallel editing to build suspense. The kind of cutting and variations in camera distance that Griffith employed eventually characterized the influential American narrative style, whereas narrative styles in other film-

2.3 **Alice Guy Blaché in 1915.** The earliest and most prolific woman director in history has barely been acknowledged in mainstream film histories. Fort Lee Public Library, Silent Film Collection, Fort Lee, New Jersey

producing countries like Denmark and Russia relied on a more presentational, tableau format.

The early film era was an entrepreneurial period that attracted women caught up in rapid changes in gender roles and expectations. Although they have only recently been restored to the historical record, women participated as directors and producers as well as assistants, writers, editors, and actors. Alice Guy Blaché made what some consider the first fiction film, *La fée aux choux* (*The Cabbage Fairy*) in 1896 in France and later turned out hundreds of films from her New Jersey studio **[Figure 2.3]**. Lois Weber, a director in the 1910s who was nearly as well-known as fellow filmmakers Cecil B. DeMille and D. W. Griffith, made a film about birth control, *Where Are My Children?* (1916) **[Figure 2.4]**, and at least eleven women were credited with directing movies at Universal in the 1910s. As the Hollywood mode of production began to solidify in the 1920s, all of these women were driven out of the industry.

Another sign of the promise of filmmaking before the standard practices and economic interests of the studio system pushed out different approaches can be seen in early African American film culture. In the first decades of the twentieth century, black filmmakers like Oscar Micheaux (see the History Close Up later in this chapter), produced work for African American audiences confronting the realities of racism and segregation. Opposition to the inflammatory depictions of blacks in Griffith's *The Birth of a Nation* (1915) was a significant impetus for claiming film as a medium for self-representation. So-called **race movies** — early-twentieth-century films that featured all–African American casts — were circulated to African American audiences, sometimes at segregated, late-night screenings known as "midnight rambles". Some race movies were produced by white entrepreneurs, but several prominent production companies were owned by African Americans. In 1910, for example, Bill Foster founded the Foster Photoplay Company in Chicago, and in 1916, actor Noble Johnson formed the all-black Lincoln Motion Picture Company in Los Angeles with his brother and other partners.

2.4 *Where Are My Children?* (1916). This film by Lois Weber deals with the controversial social issues of birth control and abortion.

Throughout the 1910s, French and American studios churned out films for export in genres including slapstick comedy and literary adaptations. The characters in these short films were originally anonymous actors and actresses, but the emergence of the star system enhanced the cultural power of film. By 1911, Biograph Studios' most popular actress, Florence Lawrence, was known as the "Biograph Girl," and celebrities like Mary Pickford ("America's Sweetheart") became the focus of wildly popular fan magazines and collectables. In Japan, film production flourished, and a unique film culture developed, with storytellers called **benshi** who narrated and interpreted silent films. In the 1910s, epic films produced in Italy challenged the standards of film length set in the United States by the Trust, which was finally dissolved in 1918. American movie production advanced in length and complexity, and Hollywood extended its reach around the world, producing half the films made worldwide in 1914 on the cusp of World War I.

Silent Features in Hollywood

Hollywood came of age with three major historical developments—the standardization of film production, the establishment of the feature film, and the cultural and economic expansion of movies throughout society. As the industry grew, standardized formulas for film production took root, and the studios created efficient teams of scriptwriters, producers, directors, camera operators, actors, and editors and established the longer feature-film model with a running time of approximately 100 minutes. The movies also found more sophisticated subject matter and more elegant theaters for distribution, reflecting their rising cultural status and their ability to attract audiences from all corners of society. Internationally, Hollywood continued to extend its reach. While World War I wreaked havoc on European economies, Hollywood increased its exports fivefold and its overseas income by 35 percent. The most pronounced and important aesthetic changes during this period included the development of narrative realism and the integration of the viewer's perspective into the editing and narrative action. Narrative realism came to the forefront of movie culture as the movies sought legitimization. From D. W. Griffith's *The Birth of a Nation* (1915) and *Intolerance* (1916) **[Figure 2.5]** through King Vidor's *The Big Parade* (1925), films learned to explore simultaneous actions, complex spatial geographies, and the psychological interaction of characters through narrative—with camera movements, framing, and editing that situated viewers *within* the narrative action rather than at a theatrical distance.

With these aesthetic developments came the refinement of genres. During this time, comedians and prominent silent film directors Charlie Chaplin and Buster Keaton drew audiences in with their slapstick vignettes and early narratives, defining the art of the comedy in 1920s Hollywood. Although Chaplin and Keaton each created distinct styles and stories, both replaced the clownish and chaotic gymnastics of early film comedies (such as Mack Sennett's Keystone comedies) with nuanced and acrobatic gestures that dramatized serious human and social themes. Providing a bombastic counterpoint to silent comedies and dramas, Cecil B. DeMille's *The Ten Commandments* (1923) was an expensive and technically advanced spectacle that marked another direction in silent film history **[Figure 2.6]**. Perhaps the most interesting balancing act in *The Ten Commandments* is its portrayal of lurid sex and violence in scenes that are

2.5 *Intolerance* (1916). D. W. Griffith intertwines stories set in four different historical periods in this landmark in the evolution of narrative film form.

continually reframed by a strong moral perspective. A similar contradiction characterized American attitudes toward the movies more generally. The early 1920s saw a series of sex and drug scandals involving Hollywood stars, and calls for censorship became widespread.

By 1920, comedies, lavish spectacles, and thrilling melodramas attracted fifty million weekly moviegoers, and attendance continued to soar during that decade as audiences followed the offscreen lives of their favorite stars in fan magazines. Technological experiments with sound fostered competition among the studios, culminating in Warner Bros.' successful exhibition of *The Jazz Singer* (1927), the first feature-length film with synchronized speech.

German Expressionist Cinema

By the end of the 1930s, the aesthetic movements and national film industries that had developed in Europe

2.6 *The Ten Commandments* (1923). Cecil B. DeMille's first version of the biblical story was a silent movie spectacular.

during the silent and early sound eras were shaken by the threat of military conflict. But the internationalism of the first decades of cinema meant that the aesthetic influences of these movements were still considerable and lasting. Expressionism (in film, theater, painting, and other arts) turned away from realist representation and toward the unconscious and irrational sides of human experience. **German expressionist cinema** (1918–1929) veered away from the movies' realism by representing such dark forces through lighting, sets, and costume design.

After a national film industry was centralized toward the end of World War I, German films began to compete successfully with Hollywood cinema. The postwar Weimar Republic was a period in which culture, science, and the arts flourished, and social norms were relaxed and modernized. The first LGBT activist movie, *Anders als die Andern* (*Different from the Others*), was produced in Germany in 1919 in the socially tolerant Weimar era between the two world wars. Dramatizing the risk of blackmail to a prominent citizen because of his sexual preference, the film advocates the decriminalization of male homosexuality (no statute specifically prohibited lesbianism) and features a lecture by German sexologist Magnus Hirschfeld.

Weimar-era cinema differed from Hollywood models in that it successfully integrated an explicit commitment to artistic expression into studio production through the giant national Universal Film AG (UFA). The most famous achievement of the expressionist trend in film history is Robert Wiene's *The Cabinet of Dr. Caligari* (1920), a dreamlike story of a somnambulist who, in the service of a mad tyrant, stalks innocent victims **[Figure 2.7]**. Along with its story of obsessed and troubled individuals, the film's shadowy atmosphere and strangely distorted artificial sets became trademarks of German expressionist cinema. G. W. Pabst was a master of the more realistic "street film" genre of the Weimar period. In *The Joyless Street* (1925), the realities of city streets become excessive, morbid, and emotionally twisted.

Two of the most important filmmakers at UFA were Fritz Lang, director of *Dr. Mabuse: The Gambler* (1922), *Metropolis* (1927), and *M* (1931), and F. W. Murnau, director of *Nosferatu* (1922) and *The Last Laugh* (1924).

2.7 *The Cabinet of Dr. Caligari* (1920). Expressionist sets make this one of the most visually striking films in history.

Lang, the most prominent director in pre-Nazi Germany, created the first science fiction blockbuster with *Metropolis* and later had a successful Hollywood career where he enriched film noir pictures like *The Woman in the Window* (1944) with expressionist style and themes. In *Nosferatu*, Murnau re-creates the vampire legend within a naturalistic setting, one that lighting, camera angles, and other expressive techniques infuse with a supernatural anxiety. Murnau, too, emigrated to Hollywood, where he made one of the masterpieces of silent cinema, *Sunrise* (1929).

Soviet Silent Films

Soviet silent films from 1917 to 1931 represent a break from the entertainment history of the movies. The Soviet cinema of this period developed out of the Russian Revolution of 1917, suggesting its distance from the assumptions and aims of the capitalist economics of Hollywood. This resulted in an emphasis on documentary and historical subjects and a political concept of cinema that was centered on audience response.

Dziga Vertov, a seminal theoretician and practitioner in this movement, established a collective workshop—the Kinoki or "cinema-eyes"—to investigate how cinema communicates both directly and subliminally. He and his colleagues were deeply committed to presenting everyday truths rather than distracting fictions, yet they also recognized that cinema elicits different ideas and responses according to how images are structured and edited. Thus they developed a montage aesthetic suited to the modern world into which the people of the Soviet Union were being catapulted. In the spirit of these theories, Vertov's creative nonfiction film *Man with a Movie Camera* (1929) records not only the activity of the modern city but also how its energy is transformed by the camera recording it. By moving rapidly from one subject to another; using split screens, superimpositions, and variable film speeds; and continually placing the camera within the action, this movie does more than describe or narrate the city [**Figure 2.8**].

Although Soviet cinema at this time produced many exceptional films, Sergei Eisenstein's *Battleship Potemkin* (1925) quickly became the most renowned outside the Union of Soviet Socialist Republics (USSR). This film about an uprising of oppressed sailors that heralded the coming revolution retains its place in film history because of its brilliant demonstration of Eisenstein's theories of montage. The film's extraordinary international and critical success enabled Eisenstein to travel throughout Europe and even to Hollywood, before beginning a project in Mexico. Eventually he returned to the Soviet Union, where, under Joseph Stalin, socialist realism became the official program in filmmaking. Consequently, the careers of Eisenstein, Vertov, and the other major experimental filmmakers of the revolutionary period declined, with Eisenstein developing an influential body of writing on film.

2.8 *Man with a Movie Camera* (1929). The image of the cameraman looms over the city, implying the central role that cinema plays in modern life.

French Cinema

Alongside the Lumière brothers at the very origin of cinema, magician George Méliès took film art in the direction of the fantastical, producing hundreds of trick films like *The Vanishing Lady* (1986) for export all over the world. The French film industry was the world's most successful before World War I, fueled by successful genre films and thrilling serials like *Les Vampires* (1915), produced by Louis Feuillade for the powerful Gaumont studio.

HISTORY CLOSE UP

Oscar Micheaux

One of the most important rediscovered figures in film history is the African American novelist, writer, producer-director, and impresario Oscar Micheaux (right), who in 1918 directed his first feature film, *The Homesteader*, an adaptation from his own novel. Micheaux owned and operated an independent production company from 1918 to 1948, producing more than forty feature films on extremely limited budgets, most of which have been lost. Reusing footage and working with untrained actors, he fashioned a distinctly non-Hollywood style whose "errors" can be interpreted as an alternative aesthetic tradition. His most controversial film, *Within Our Gates* (1920) (discussed later in this chapter), realistically portrayed the spread of lynching and was threatened with censorship in a period of race riots. Later, in *Body and Soul* (1925), Micheaux teamed up with actor, singer,

Photofest, Inc.

and activist Paul Robeson in a powerful portrait of a corrupt preacher. Paradoxically, efforts made in the 1940s to persuade Hollywood to produce more progressive representations of African Americans helped put an end to the independent tradition of "race movies" and Micheaux released his last film, *The Betrayal*, in 1948.

In the 1920s, cinema as an art form was championed by avant-garde artists and intellectuals in new journals and ciné clubs, and artists and filmmakers conducted radical experiments with film form. Parallelling contemporaneous visual arts like impressionist painting, **French impressionist cinema** was a 1920s avant-garde film movement that aimed to destabilize familiar or objective ways of seeing and to revitalize the dynamics of human perception. Representative of the early impressionist films are Germaine Dulac's *The Seashell and the Clergyman* (1928), Jean Epstein's *The Fall of the House of Usher* (1928), Marcel L'Herbier's *L'Argent* (1928), and Abel Gance's three daring narrative films—*I Accuse* (1919), *The Wheel* (1923), and *Napoleon* (1927). Dulac's surrealist film illustrates the daring play between subject matter and form that was typical of these films. *The Seashell and the Clergyman* barely concentrates on its story (a priest pursues a beautiful woman), focusing instead on the memories, hallucinations, and fantasies of the central character, depicted with split screens and other strange imagistic effects **[Figure 2.9]**. Equally lyrical but very different in form, Danish director Carl Theodor Dreyer's *The Passion of Joan of Arc* (1928) focuses on the expressivity of the human face in close-up in what many consider the pinnacle of silent film as an art form.

2.9 *The Seashell and the Clergyman* (1928). In a surreal image from the film collaboration between Germaine Dulac and Antonin Artaud, the main character sees his own head in the seashell.

Classical Cinema in Hollywood and Beyond

The introduction of synchronized sound in 1927 inaugurated a period of Hollywood consolidation that lasted until the end of World War II in 1945. The Great Depression, triggered in part by the stock market collapse of 1929, defined the American cultural experience at the beginning of the 1930s. Franklin D. Roosevelt's New Deal became the political antidote for much of the 1930s, pumping a determined spirit of optimism into society. The catastrophic conflict of World War II then defined the last four years of the classical period, in which the country fully asserted its global leadership and control.

The film industry followed the turbulent events with dramatic changes of its own. The "Big Five" studios (20th Century Fox, Metro-Goldwyn-Mayer, Paramount, Warner Bros., and RKO) along with the "Little Three" (Columbia, Universal, and United Artists) dominated the industry by controlling distributors and theater chains and exerting great industrial and cultural power. With social issues more hotly debated and the movies gaining more influence than ever, the messages of films came increasingly under scrutiny.

Formed in 1922, the Motion Picture Producers and Distributors Association of America (MPDAA, now the MPAA) enlisted former postmaster general William H. Hays to regulate movies' moral content through what became known as the "Hays Office." The Motion Picture Production Code, adopted in 1930, was at first widely ignored, but in 1934 the MPDAA set up the Production Code Administration, headed by Joseph I. Breen, to enforce it strictly. The code's conservative list of principles governed primarily the depiction of crime and sex and kept censorship efforts within the industry rather than under government regulation.

Sometimes the Code's provisions led to distortions of original source material. Lillian Hellman's hit Broadway play *The Children's Hour* [Figure 2.10] dealt with the consequences of a malicious child's lies about the lesbian relationship between the headmistresses of her school. But because under the Code, "homosexuality and any inference to it are prohibited," the 1936 movie version, *These Three*, implied that the child's gossip was about one teacher's affair with the other's fiancé, a change that puzzled audiences familiar with the play.

At this time, Hollywood films followed these industry shifts with two important stylistic features—the elaboration of movie dialogue and the growth of characterization in films and the prominence of generic formulas in constructing film narratives. Sound technology opened a whole new dimension to film form that allowed movies to expand their dramatic capacity. Accomplished writers flocked to Hollywood, literary adaptations flourished, and characters became more psychologically complex through the use of dialogue. Popular music often was featured, and African American performers were included even as they remained barred from central dramatic roles. Meanwhile, generic formulas, like musicals and westerns, became the primary production and distribution standard. In fact, genres sometimes superseded the subject matter and actors in defining a film and expectations about it.

During Hollywood's golden age in the 1930s and 1940s, an exceptional number and variety of studio classics emerged. Frank Capra's *It Happened One Night* (1934) is perhaps one of the best representations of the energy that was making its way from the New York theatrical stage to

2.10 *The Children's Hour* (1961). Lillian Hellman's 1936 play was eventually faithfully adapted to the screen after the Production Code was relaxed in the 1960s, but by then its depiction of the main character's suicide was dated and damaging.

the Hollywood screen after the arrival of synchronized dialogue. The film's social allegory about common people correcting the greed and egotism of the rich defined Capra's vision throughout this decade and into the 1940s [**Figure 2.11**]. Similarly, veteran director John Ford elevated the western with *Stagecoach* (1939)—a film widely considered one of the finest examples of classical Hollywood style. It depicted the tense journey of a mismatched group of passengers through the spectacular landscape of Monument Valley and established Ford's long-lasting partnership with John Wayne and working relationship with the Navajo. In 1939, *Stagecoach* joined *Gone with the Wind*, *The Wizard of Oz*, *Wuthering Heights*, and *Mr. Smith Goes to Washington* as a contender for the year's best picture Oscar (Capra's *You Can't Take It with You* won the honor), making it a banner year for classical Hollywood.

Although 65 percent of Americans attended the movies weekly in 1930, many kinds of Americans were not represented in them. Stereotypes of racial and ethnic minorities and the casting of white actors to portray people of color were endemic to this period. Hattie McDaniel won the first Oscar awarded to an African American performer for her portrayal of Mammy in *Gone with the Wind* even as the film met with criticism in the black press for glorifying the slaveholding South. By 1942, many African American men were serving in the U.S. military, and the studios reached an agreement with National Association for the Advancement of Colored People (NAACP) leader Walter White to monitor the representation of African Americans in films. Also during the war, representations of Latin Americans were encouraged, and monitored, under the Roosevelt administration's official Good Neighbor policy.

Employment behind the scenes in Hollywood was also limited, with few people of color working in key creative positions, one of these, Chinese American cinematographer James Wong Howe, was nominated for ten Academy Awards and won two. Women were restricted by the studios to specific production roles such as script supervisor or editor. The most prominent and, for a considerable period, the only active female director in sound-era Hollywood was Dorothy Arzner [**Figure 2.12**]. Her films *Christopher Strong* (1933) and *Dance, Girl, Dance* (1940) feature strong heroines played by top stars Katharine Hepburn and Lucille Ball, and they portray significant bonds between women within their more traditional storylines of heterosexual romance.

European Cinema in the 1930s and 1940s

The introduction of synchronized sound presented a challenge to cinema's internationalism even as rising nationalism in Europe used cinema to define linguistic and cultural heritage. Weimar cinema shows these tensions in the early sound film *The Blue Angel* (1930), which was filmed simultaneously in German, French, and English. Marlene Dietrich plays her breakthrough role as a cabaret singer who seduces an aging professor. During the rise of Nazism, Dietrich and much of the Weimar cinema's

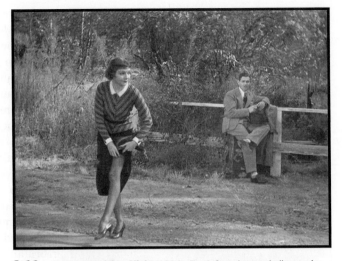

2.11 *It Happened One Night* (1934). Frank Capra's screwball comedy—about a rebellious socialite (Claudette Colbert) who flees her wealthy father and takes up, reluctantly, with a reporter (Clark Gable) who hopes to use her scandalous behavior as a news scoop—is a quintessential 1930s Hollywood film.

2.12 **Dorothy Arzner.** Arzner was the only woman to direct Hollywood films in the 1930s, the heyday of the studio system. Photofest, Inc.

2.13 *Mädchen in Uniform* (1931). This Weimar-era film about a student's crush on her teacher features an all-female cast and was written and directed by women. Photofest, Inc.

creative personnel emigrated to the United States. Another Weimar film, *Mädchen in Uniform* (1931), written by lesbian author Christa Winsloe and based on her own play **[Figure 2.13]**, depicts a young woman's boarding-school crush on a sympathetic teacher. Featuring an all-female cast and directed by a woman, Leontine Sagan, the film cautions against repressive hierarchies that would soon become omnipresent in Nazi Germany and itself was subject to censorship.

Socially conscious directors René Clair, Jean Vigo, Marcel Carné, and Jean Renoir integrated artistic innovations into traditional narrative in **poetic realism**—a film movement in 1930s France that incorporated a lyrical style and a fatalistic view of life. Renoir's *The Rules of the Game* (1939) **[Figure 2.14]** is on one level a realistic account of social conflict and disintegration. A tale of aristocrats and their servants gathered for a holiday in the country, the film is a satirical and often biting critique of the hypocrisy and brutality of this microcosm of decadent society. The film's insight and wit come from lighting, long takes, and framing that draw out dark ironies not visible on the surface of the relationships. One of the film's most noted sequences features a hunting expedition in which the editing searingly equates the slaughter of birds and rabbits with the social behavior of the hunters toward each other.

Jean Vigo's *Zero for Conduct* (1933) takes up the themes of rebellion and social critique by depicting tyranny at a boys' boarding school. The boys' spirit of rebellion is conveyed in a combination of realistic narrative and lyrical, sometimes fantastical, images. These images dramatize the wild and anarchic vision of the young boys: at one point a pillow fight erupts in the dormitory, and the whirlwind of pillow feathers transforms the room into a paradise of disorder. The spirit of poeticism and critique that informed these directors' visions, although not impossible to convey in Hollywood films of the period, was discouraged by the industrial and commercial orientation of filmmaking in Hollywood.

Golden Age Mexican Cinema

In the mid-1930s, the Mexican film industry entered its own Golden Age with films like Fernando de Fuentes's drama *Vamonos con Pancho Villa!* (*Let's Go with Pancho Villa*) (1936), celebrating the revolutionary leader. With European production directly affected by war and Hollywood focusing on wartime genres, Mexican studios became a center of film production for national and international markets.

2.14 *The Rules of the Game* (1939). Jean Renoir's masterwork of poetic realism is known for its fluid style and critique of bourgeois society.

Successful melodramas, comedies, and musicals featured beloved stars such as Pedro Infante. Dolores del Rio returned from a successful career in Hollywood to her native Mexico to star in prolific director Emilio "El Indo" Fernandez's *Maria Candelaria* (1944). The director also guided Maria Félix in *Enamorada* (1946). Perhaps most iconic of all was the comic actor Cantinflas, the persona of actor Mario Moreno, who became a symbol of the Mexican people. Although the film industry was eclipsed in the postwar period, a resurgence of auteurism in an industrial context took place at the end of the century.

Postwar Cinemas (1945–1975)

World War II indelibly altered the map of world politics and culture, and cinema, already a mature art form and social force, became an important barometer of these changes. The Hollywood studio system faced legal, economic, and cultural challenges at home and artistic and political ones from the many new wave cinemas emerging around the world, which were catalyzed by new ideas and alliances in the postwar period. As new media technologies and leisure options began to vie with cinema, the movies attempted to consolidate their hold on the public.

Postwar Hollywood

Unrest characterized postwar America. The start of the Cold War with the Soviet Union and the Communist bloc began an extended period of tension and anxiety about national identity and security. Traditional institutions—such as the family unit, sexual relationships, and established social relations—stood on the brink of tremendous change. In the 1950s and 1960s, the civil rights movement and women's liberation began to mobilize to challenge social injustice. Changes within the film industry dismantled some of the power of the studios, opening American cinema to many of these social and political changes. The end of the studio era led to two important shifts—the recognition and eventual dominance of youth audiences and the increasing influence of European art films.

The most notorious ideological conflict in Hollywood history occurred immediately after the war, when the film industry came under congressional investigation for alleged Communist infiltration. The movie colony was a sensational target for the House Un-American Activities Committee (HUAC) hearings, held as part of the Red Scare instigated by Senator Joseph McCarthy.

Ten writers and directors who refused to answer the committee's question, "Are you now or have you ever been a member of the Communist Party?" were cited for contempt of Congress and eventually served prison terms **[Figure 2.15]**. Others served as "friendly witnesses," naming acquaintances, friends, and colleagues who sympathized with the Communist Party. Although HUAC's charges remained unconfirmed, its intimidation tactics were influential. Accusations of present or past Communist Party affiliation devastated Hollywood's creative pool and led to the blacklisting of more than three hundred screenwriters, directors, actors, and technical personnel.

A number of other events greatly affected Hollywood during the postwar period. After the U.S. Supreme Court's 1948 *United States v. Paramount* decision, the studios were ordered to divest their theater chains, effectively ending their control of the industry. This decline in studio power was accompanied by the arrival of television and its rapid spread in the 1950s. Finally, in 1968, the Production Code era officially ended, and the ratings system was introduced. Movies grew more daring and darker as they loosened or challenged the formulas of classical Hollywood and explored controversial themes and issues. Competing with television, they also developed a more self-conscious and exaggerated sense of image composition and narrative structure.

Beginning with *The Best Years of Our Lives* (1946) and its layered tale of postwar trauma in small-town America, films delved into such subjects as family betrayal, alcoholism and drug abuse, sexuality, racial

2.15 The Hollywood Ten. Refusing to answer HUAC's questions, these ten directors, screenwriters, and producers were jailed for contempt of Congress. Bettmann/Getty Images

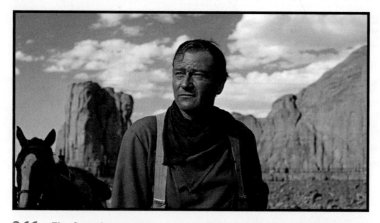

2.16 *The Searchers* (1956). John Ford's late western uses lead actor John Wayne and the Monument Valley settings familiar from their long collaboration to bring out dark themes of racist violence in the settling of the West. The film's structure and hero profoundly affected the New Hollywood directors of the 1970s.

2.17 *Gilda* (1946). Set in a casino in Argentina at the end of World War II, this film indirectly represents fears about shifting gender roles on the home front.

2.18 *Rebel Without a Cause* (1955). Teenage angst and juvenile delinquency are on display in Nicholas Ray's CinemaScope classic.

injustice, and psychological breakdowns. African American actor Sidney Poitier took on a symbolic role for a nation coming to terms with racial division in films like *The Defiant Ones* (1958) and *In the Heat of the Night* (1967). These new topics introduced more unpredictable characters and narratives as well as sometimes subversive and violent visual styles, exemplified in Orson Welles's *Touch of Evil* (1958) and Alfred Hitchcock's shocking *Psycho* (1960). John Ford's westerns can be seen as historical barometers of this transitional and turbulent period in Hollywood. *My Darling Clementine* (1946), the prototypical western, is a meditation on the power of nature and communal individualism to overcome evil, while *The Searchers* (1956) is a morally ambivalent tale about where violence and racism reside, featuring an older John Wayne as a racist cowboy **[Figure 2.16]**.

As examples of the film noir cycle, Charles Vidor's *Gilda* (1946) and Howard Hawks's *The Big Sleep* (1946) both reflect the postwar period's social and personal instability and explore the perceived threat of female sexuality and autonomy. As if reflecting their troubled characters and actions in their form, film noir narratives seem to lose their direction, and their visual styles are overwhelmed with gloom. Rita Hayworth's performance in *Gilda* transforms the femme fatale into a sympathetic character, however, appealing to female audiences who were confronting the conflicted roles of women in the 1940s, when their new freedoms in the workforce were perceived as a threat to job-seeking veterans **[Figure 2.17]**.

As the studio mode of production loosened its hold, more independent producers came forward. Ida Lupino, a well-known actress, began directing hard-hitting, low-budget independent films such as *Hard, Fast and Beautiful* (1951), about a mother who pushes her daughter to succeed in a tennis career. Lupino later had a successful directing career in television, an arena that offered more opportunities for women to create in the postwar period.

By the late 1950s and 1960s, younger audiences came to the forefront of movie culture. Drive-ins and teenage audiences are one example. Another is the college and urban audiences for art films and other alternative cinemas that proliferated after 1960. Nicholas Ray's *Rebel Without a Cause* (1955) gives what was a shocking depiction of a generational crisis in America in which teenagers drift aimlessly beyond parental guidance **[Figure 2.18]**. Roger Corman's American International Pictures made even more blatant attempts to exploit young audiences with work like *Attack of the Crab Monsters* (1957) and a series of 1960s films based on the stories of Edgar Allan Poe. At the same time, with films like Ingmar Bergman's *The Seventh Seal* (1957) and Federico Fellini's *8½* (1963)—two

very different meditations on existential questions—movies shown in new art-house theaters came to be considered complex artistic objects that justified aesthetic appreciation and academic study.

Postwar prosperity and the growth of the suburbs led audiences to new consumption patterns exemplified by the rapid adoption of television into American life. Hollywood answered with spectacular color and widescreen technologies that could not be duplicated at home. When the studios were ordered to divest their theater holdings, independent cinema owners were able to court new urban demographics. Both foreign art cinema and exploitation cinema found audiences among nonconforming youth, with depictions of sexuality and violence prohibited in mainstream filmmaking. Although the studio system produced one of its last and highest-budgeted family films in 1965, *The Sound of Music*, classical Hollywood's reign was waning as the civil rights movement, political violence, and the war in Vietnam heated up.

2.19 *Sweet Sweetback's Baadasssss Song* (1971). Melvin Van Peebles's militant blaxploitation film became a hit.

Younger filmmakers influenced by the rebellious energy of new European films ironically showed Hollywood its survival path. The unprecedented violence and irreverent tone of Arthur Penn's *Bonnie and Clyde* (1967), made at Warner Bros. with the support of star Warren Beatty, challenged mainstream sensibilities. But it was a box-office hit, turning Hollywood's attention to youth audiences for decades to come.

In the early 1970s, Hollywood also targeted an urban market with a genre of low-budget films about streetwise African American protagonists, known as **blaxploitation**. Although the term cynically suggests the economic exploitation of black film audiences, the genre was made possible in part by the black power movement, and some African American filmmakers turned the genre to their own purposes. The studio-produced and immensely successful *Shaft* (1971) was directed by noted photographer Gordon Parks. And Melvin Van Peebles wrote, directed, scored, and starred in *Sweet Sweetback's Baadasssss Song* (1971), which incorporates revolutionary rhetoric in a kinetic tale of a black man pursued by racist cops **[Figure 2.19]**.

An independent New American Cinema was emerging in New York, exemplified by John Cassavetes's *Faces* (1959), made on low-budget, 16mm film. At the same time, Hollywood was doing its best to incorporate new voices into the system, hiring younger, often film-school-trained directors. Francis Ford Coppola's Oscar-winning *The Godfather* (1972) **[Figure 2.20]** defined the convergence of directorial and marketing talent characteristic of the era of the New Hollywood.

International Art Cinema

In the aftermath of World War II, new filmmaking styles and fresh voices emerged in Europe and quickly spread around the world. Studio filmmaking was either compromised by its alliance with defeated government powers or seemed old-fashioned in the face of emerging

2.20 *The Godfather* (1972). Perhaps the key example of the New Hollywood, Francis Ford Coppola's film was an economic and artistic success.

youth culture and prosperity. These new currents in cinema served an important political role in the immediate postwar period, with major European film festivals in Cannes, Venice, and Berlin establishing their prominence in defining cultural worth. Highlighting the work of particular directors, they cultivated an auteurist approach to film art and, by including directors from outside of Europe, emphasized the internationalism of the medium as part of a hoped-for new order of peace and prosperity.

Italian Neorealism

One of the most profound influences in international postwar art cinema was **Italian neorealism**, a film movement that began in Italy during World War II and lasted until approximately 1952. Neorealism shed light on everyday social realities, often using location shooting and nonprofessional actors. Its relatively short history belies its far-reaching effects. At a critical juncture of world history, Italian cinema revitalized film culture by depicting postwar social crises and using a stark, realistic style clearly different from the glossy entertainment formulas of Hollywood and other studio systems.

Earlier in the century, Italian film spectacles such as *Quo Vadis?* (1913) and *Cabiria* (1914) had created a taste for lavish epics. The films produced at the Cinecittà ("cinema city") studios under Benito Mussolini's fascist regime (1922–1943) were similarly glossy, decorative entertainments. During wartime in 1942, screenwriter Cesare Zavattini set the stage for neorealism, calling for a new cinema that would forsake entertainment formulas and promote social realism instead. Luchino Visconti responded with *Ossessione* (1943), and Vittorio De Sica directed Zavattini's screenplays to produce such classics as *Bicycle Thieves* (1948). Perhaps the best example of the accomplishments and contradictions of this movement is Roberto Rossellini's *Rome, Open City* (1945), shot under adverse conditions at the end of the war **[Figure 2.21]**. Set during the Nazi occupation of Rome (1943–1944), the film intentionally approximates newsreel images to depict the strained and desperate street life of the war-torn city. (The phrase *open city* refers to a city that has agreed not to defend itself against invaders, who then agree not to bomb or destroy buildings.) The plot tells of a community that protects a resistance fighter who is being hunted by the German Gestapo/SS and that experiences the tragic deaths of people caught in between, sounding a note that reverberated throughout postwar movie cultures. Subsequent Italian cinema—including the work of directors Pier Paolo Pasolini, Michelangelo Antonioni, Vittorio and Paolo Taviani, Marco Bellocchio, Bernardo Bertolucci, and even Federico Fellini—follows from this neorealist history even when it introduces new forms and subjects.

2.21 *Rome, Open City* (1945). Roberto Rossellini's film exemplifies Italian neorealism in its use of war-ravaged locations, nonprofessional actors, and contemporary subject matter.

French New Wave

A particularly rich period of cinema history occurred in the wake of Italian neorealism, from the 1950s through the 1970s, when numerous daring film movements, often designated as new waves, appeared in Brazil, Czechoslovakia, France, Germany, Japan, and the United Kingdom. Despite their exceptional variety, these different new waves share two common postwar interests that counterpoint their often nationalistic flavor—the use of film to express a personal vision and a break with past filmmaking institutions and genres.

The first and most influential new wave cinema, the Nouvelle Vague or **French New Wave**, came to prominence in the late 1950s and 1960s in France in opposition to the conventional studio system. These films often were made with low budgets and young actors on location, used unconventional sound and editing patterns, and addressed the struggle for personal expression. These exceptionally rich and varied films were influenced by filmmakers as diverse as the minimalist Robert Bresson and the comedic genius Jacques Tati. Within a little more than a year, three definitive films appeared—François Truffaut's *The 400 Blows* (1959), Jean-Luc Godard's *Breathless* (1960), and Alain Resnais's *Hiroshima mon amour* (1959). Although the style and subject matter of these films are extremely different, they each demonstrate the struggle for personal expression and the formal investigation of film as a communication system.

The vitality of these films broke with the past and immediately affected international audiences. Indeed, this vitality often was expressed in memorable stylistic innovations, such as the freeze frame on the boy protagonist's face that ends *The 400 Blows*, the jump cuts that register the restlessness of the antihero of *Breathless*, and the time-traveling editing of *Hiroshima mon amour*.

Much of the inspiration for the French New Wave filmmakers sprang from the work of film critic and theoretician André Bazin. In 1951, Bazin helped establish the journal *Cahiers du cinéma*, many of whose contributors would become some of the most renowned directors of the movement, including Eric Rohmer, Claude Chabrol, Truffaut, and Godard. The revitalization of film language occurred in conjunction with the journal's policy of auteurism (*la politique des auteurs*) or **auteur theory**, which emphasized the role of the director as an expressive author. Writing and directing their own films, paying tribute to the important figures emerging around the world (like Michelangelo Antonioni, Ingmar Bergman, and Akira Kurosawa), and reevaluating the work of Hollywood directors, the young French filmmaker-critics helped shape the perspective and culture that elevated film to the art form it is considered to be today. Figures less directly associated with *Cahiers du cinema*, such as Chris Marker and Agnès Varda [**Figure 2.22**] brought a similar spirit and a more political focus to documentaries and other personal films.

Many French filmmakers took up political positions as the war for Algeria's independence from France unfolded (1954–1962) and as student and worker strikes swept the nation in May 1968. Among them, Godard was the most formally experimental, collaborating under the name Dziga Vertov Group on films like *Vent d'Est* (*Wind from the East*) (1969). Other new waves in the 1960s and 1970s were influenced by the Nouvelle Vague's use of amateur actors, improvised dialogue, street locations, and increasing politicization. Although the spirit of these movements and the formal innovations of the films challenged entrenched state- and commercially dominated national film industries, they were still largely identified with the concept of the nation.

Catalyzed by the neorealism of the Nouvelle Vague, new wave cinemas burst out across the globe. A brief efflorescence of often absurdist films like Věra Chytilová's *Daisies* (1966) constituted the politically subversive **Czech New Wave**. This movement came to prominence in 1960s Czechoslovakia and used absurdist humor, nonprofessional actors, and improvised dialogue to express political dissent. It ended with the Soviet invasion in 1969.

VIEWING CUE

LaunchPad Solo

View the online clips of *Gilda* (1946) and *Rome, Open City* (1945), which were produced at roughly the same time. What makes them identifiable by period? Can you identify contrasts between classical Hollywood and Italian neorealist style?

2.22 **Agnès Varda in *The Gleaners and I*** (2000). With the feature film *Cléo from 5 to 7* (1962), Varda became the only woman director celebrated in the French New Wave. She also made documentaries like *Salut les Cubains (Hello to the Cubans)* (1963), a practice to which she later returned.

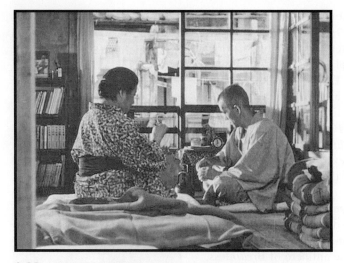

2.23 *Tokyo Story* (1953). Yasujiro Ozu is known for carefully composed images taken from a low height and stories that capture the rhythms of everyday life.

New German Cinema was a film movement launched in West Germany in 1962 by a group of young filmmakers willing to confront Germany's recent history, and grew into a larger moment in the decades that followed. They declared a new agenda for German film in a film festival document called the Oberhausen Manifesto. The **Cinema Novo** movement (1960s–1970s) in Brazil emphasized social equality and intellectualism and broke with studio gloss, and director Glauber Rocha embraced an "aesthetics of hunger" in the violent and mystical *Black God, White Devil* (1964).

Japanese Cinema

The Golden Lion awarded at the 1951 Venice International Film Festival to Akira Kurosawa's *Rashomon* (1950) marked a new era of visibility for Japanese cinema in the West. Japan is one of the world's largest film-producing nations and has a long and varied tradition of using distinct perceptual and generic forms and drawing on a range of cultural and artistic traditions. After World War II and the subsequent Allied occupation, Japanese films increasingly incorporated Hollywood forms and styles, yet still emphasized the contemplative aspect of images and placed character rather than action at the center of the narrative.

Kenji Mizoguchi, Yasujiro Ozu, Akira Kurosawa, and Nagisa Oshima are among the most celebrated names in Japanese cinema, with the long careers of the first two beginning in the silent period (which lasted into the 1930s in Japan). Ozu's midcareer masterpiece, *Tokyo Story* (1953), highlights his exquisite sense of the rhythms of everyday life, conveyed through carefully composed frames, long takes, and a low camera height **[Figure 2.23]**.

The energies of postwar cinema are especially evident in *Rashomon*, which uses multiple, contradictory narrations of the same crime from characters' differing points of view. Recognition at European film festivals—such as the Silver Lion won by Mizoguchi's ghost story *Ugetsu* (1950) at Venice—established Japanese cinema's centrality to postwar art cinema and helped Japanese auteurs achieve international notoriety. Later Oshima helped define Japan's new wave with the violent erotic masterpiece *In the Realm of the Senses* (1976).

Going beyond art cinema, many distinctly Japanese genres produced for national audiences eventually earned international followings. The first of dozens of films featuring the monster Godzilla was produced in 1954 **[Figure 2.24]**, and Japanese animation, or **anime**, which was first launched following World War II, received international attention through 1960s television exports.

2.24 *Godzilla* (1954). The seminal Japanese monster movie spawned a series that continues to this day. *Shin Godzilla* was released in 2016.

Indian Cinema

The first Indian movie premiered in 1913, but the golden age of Indian cinema came after independence in 1948 with the ascendance of the Bombay-based industry with its stars, songs, and spectacular successes. During the same period, Parallel Cinema, centered mainly in Calcutta and exemplified by the films of renowned director Satyajit Ray, arose

as an alternative to India's commercial cinema. Ray's modest black-and-white film *Pather Panchali* (1955) has been heralded internationally as a masterpiece of realist style. This film, together with the two subsequent features in the "Apu trilogy" (named after their main character), is rooted in Bengali literature, landscape, and culture. Both traditions — popular blockbusters and realist, regional dramas — continue to thrive in contemporary Indian cinema.

In the 1970s, India overtook Hollywood as the world's largest film producer, driven largely by the hundreds of Hindi-language films produced annually in Mumbai. Often referred to as **Bollywood** films, they are a dominant cultural form notable for rootedness in Hindu culture and mythology and for elaborate song-and-dance numbers.

With an episodic narrative form based in theatrical traditions that accommodate musical numbers, many Hindi films highlight star performances. Nargis plays the title role of Mehboob Khan's *Mother India* (1957) **[Figure 2.25]**, and the phenomenally successful action star Amitabh Bachchan was featured in one of the most popular Bollywood films of all time, *Sholay* (1975).

Indian cinema remains the world's most prolific film industry, with the subcontinent's large population served by films produced in a number of languages of India, besides Hindi — including Bengali, Marathi, and Tamil. Indian diasporan audiences in South and Southeast Asia, the Middle East, and the West contribute to the industry's increasingly global success and influence.

Third Cinema

Inspired by the politicized atmosphere of Third World decolonization in the 1960s, Argentine filmmakers Fernando Solanas and Octavio Getino championed revolutionary filmmaking in Latin America in their 1969 manifesto "Towards a Third Cinema." Their populist vision arose in opposition to Hollywood and to commercial film cultures elsewhere (which they dubbed "first cinema") and in response to the elitist aesthetics of auteur films (or "second cinema"). The term **Third Cinema** has been used to unite films from many countries under one political and formal rubric, including some made by Europeans, such as *The Battle of Algiers* (1966), directed by Italian Marxist Gillo Pontecorvo in cooperation with the victorious Algerian revolutionary government. In Latin America, Solanas and Getino's *The Hour of the Furnaces* (1968) incited political opposition and cultural renewal in Argentina.

For advocates of Third Cinema, the creation of the Cuban Institute of Cinematographic Art and Industry in postrevolutionary Cuba provided the ideal testing ground for the role of film within an emerging nation's cultural identity. Tomás Gutiérrez Alea's *Memories of Underdevelopment* (1968) about a middle-class intellectual contemplating the changes in postrevolutionary society is among the best-known examples of Cuban cinema **[Figure 2.26]**.

The very term "Third Cinema" evokes its particular era in world politics — one that was dominated by First

2.25 *Mother India* (1957). Legendary Indian actress Nargis (born Fatime Rashid) in the iconic role of a mother who withstands hardship and becomes an allegorical figure of an independent India.

VIEWING CUE

Scan local film and television listings, noting how many different countries are represented. If the range is limited, why do you think this is so? If you have located foreign films, what kinds of venues or channels show them?

2.26 *Memories of Underdevelopment* (1968). Tomás Gutiérrez Alea's film paints an ambivalent portrait of a disaffected intellectual who grapples with the survival of traditional culture in postrevolutionary Cuba.

and Second World superpowers preoccupied with the Cold War and that witnessed sometimes-violent nation-building struggles in the Third World. As the global contours of politics and culture shifted, Third Cinema became an aesthetic catalyst for a transnational filmmaking culture.

Cinematic Globalization (1975–2000)

The last quarter of the twentieth century saw significant economic, political, and technological changes that consolidated U.S. dominance in global film markets and fostered an efflorescence of film art around the world. In the United States, new cultural pressures followed the end of the Vietnam War in 1975. The globalization of financial markets and the dissolution of the Soviet bloc in the 1990s redistributed global power. Postcolonial migrations continued to transform European societies and global cities, and international debt policies affected developing nations. The rise of new nationalisms and fundamentalisms ignited violent conflicts and prolonged wars. Cinema and other kinds of cultural production became crucial to mediating individuals' experiences of these events and transformations.

It is impossible to be fully inclusive of the world's film culture in this period. New cinemas came to prominence on the global scene, and international coproductions increased. In addition to the story of New Hollywood in the era of blockbusters and franchises, we have selected a few examples of national and regional cinemas to illuminate important histories and trends. European, Indian, Chinese, African, and Iranian cinemas illustrate different developments of cinema and globalization, but many other national and regional cinemas, directors, aesthetic movements, and institutions would be equally deserving of attention.

New Hollywood in the Blockbuster Era

With Steven Spielberg's *Jaws* (1975) **[Figure 2.27]**, the commercial movie industry in the United States introduced economic strategies that guided blockbuster and franchise production and releases through the end of the century, consolidating

2.27 *Jaws* (1975). Widely considered the first summer blockbuster, Steven Spielberg's shark thriller was the highest-grossing movie of all time until it was surpassed by *Star Wars* a few years later.

Hollywood power and media ownership in a small number of companies. As has been seen, at the end of the 1960s, Hollywood turned some of its power over to young filmmakers, who began to address the teenage audiences that made up larger and larger portions of the moviegoing public. The success of *The Godfather* (1972) at the beginning of the decade ushered in a remarkable series of New Hollywood films. Influenced by European art cinemas, films such as *The Godfather Part II* (1974), *Taxi Driver* (1976) (see the Film in Focus feature later in this chapter), and *The Deer Hunter* (1978) took imaginative risks in form and subject matter and pushed the representation of violence well beyond what classical Hollywood had permitted.

New Hollywood's strategy for courting youth audiences changed significantly, however, when global conglomerate enterprises began to assimilate and shape the industry. Corporate Hollywood redirected youthful energy toward more commercial blockbusters and global markets. As the first film to be released simultaneously on hundreds of screens and promoted though national television advertising, *Jaws* (1975) ushered in the era of aggressively marketed summer blockbusters. *Jaws* was soon topped at the box office by George Lucas's *Star Wars* (1977), which ushered in the now prevalent franchise formula with its sequels, reissues, and tie-ins. Film critic Robin Wood characterizes the films of the Reagan era as a "cinema of reassurance," with films like *Raiders of the Lost Ark* (1981) expressing nostalgia for an era of clearly defined heroes and bad guys. During this same period, technological innovations and market innovations (including home video and cable television) disseminated movies in new ways, offering viewers more variety and control while increasing media companies' profits from ancillary markets.

Amid so many cataclysmic changes in film culture, two trends characterize the last quarter of the twentieth century in film—the elevation of spectacles featuring special effects and the fragmentation and reflexivity of narrative constructions. Both were facilitated by the introduction of digital technologies that would come to fully define the commercial cinema and new media alternatives after 2000.

On the one hand, movies began to drift away from a traditional focus on engrossing narrative and instead emphasized sensational mise-en-scène or dramatic manipulations of the film image. In this context, conventional realism gave way to intentionally artificial and spectacular representations of characters, places, and actions. Playful films like *Who Framed Roger Rabbit* (1988) **[Figure 2.28]** allowed cartoon characters to interact with human ones. Computer-generated imagery (CGI) was used to introduce spectacular effects in *Tron* (1982) and, beginning with Pixar's *Toy Story* (1995), to generate entire films.

On the other hand, movies that emphasized narrative engagement often intentionally fragmented, reframed, or distorted the narrative in ways that challenged its coherence. Movies like Quentin Tarantino's *Pulp Fiction* (1994) and Paul Thomas Anderson's *Magnolia* (1999) interlocked story lines across different timelines and locations. Christopher Nolan's *Memento* (2000) reconstructed narrative through its continually changing retrospective perspectives, all subject to the narrator/protagonist's lack of short-term memory. The result is a series of overlapping episodes that eventually leads back to the murder that started the film.

2.28 *Who Framed Roger Rabbit* (1988). Cartoon characters interacting with actors exemplifies a contemporary interest in spectacle and a self-consciousness about film form.

FILM IN FOCUS

LaunchPad Solo

To watch a clip from *Taxi Driver* (1976),
see the *Film Experience* LaunchPad.

Taxi Driver and New Hollywood (1976)

See also: *The Graduate* (1967); *Chinatown* (1974)

One reason that Martin Scorsese's *Taxi Driver* (1976) remains such a powerful and rich film today is its keen self-consciousness about its place in film history and the complex historical references it puts into play. *Taxi Driver* is suffused with the historical events that colored and shaped U.S. society in the 1970s and shares many characteristics with other films of the era. At the same time, it echoes and recalls Hollywood's classical and postwar periods, suggesting that one of the defining features of New Hollywood film is its awareness of past cinematic traditions. For instance, Scorsese commissioned the film's haunting score from composer Bernard Herrmann, best known for his collaborations with Orson Welles on *Citizen Kane* (1941) and Alfred Hitchcock on *Vertigo* (1958), *Psycho* (1960), and other films. The darkness lurking in these films is fully embraced in *Taxi Driver* and resonates in Herrmann's music.

The story, written by filmmaker Paul Schrader, focuses on a New York cabdriver, Travis Bickle (played by Scorsese regular Robert De Niro), and his increasing alienation from the city in which he lives and works. As he cruises New York locked in the isolated compartment of his cab, his voiceover narration rambles and meditates on his entrapment in a world that has lost its innocence and seems to be progressing only toward its own destruction. Travis decries the filth and decadence of the city and considers violent and apocalyptic solutions like assassinating a politician. Attempting to break out of the bitter routines of his existence, he imagines himself the savior of Iris (played by a thirteen-year-old Jodie Foster), a young prostitute, and attracts the ire of her pimp. The film ends with a ghastly bloodbath in which Travis murders the pimp, followed by the unsettling announcement that Travis has become a media hero.

The issues and atmosphere of 1970s U.S. society pervade *Taxi Driver*. Flagged by Travis's veteran's jacket and the traumatized personality associated with young soldiers returning from the Vietnam War, the specter of that war haunts the film. Travis's violent personality echoes a decade of U.S. violence—the assassinations of John F. Kennedy (1963) and Martin Luther King Jr. (1968)

and, as an explicit source for the film, Arthur Bremer's attempted assassination of Alabama governor George Wallace (1972). The violence in *Taxi Driver* associates it with many other films made since the 1970s. From films such as *A Clockwork Orange* (1971) to *Natural Born Killers* (1994), modern life and identity are tied to the psychological and social prevalence of violence, and graphic, often unmotivated violence becomes a desperate means of expression for lost souls. Five years after its release, *Taxi Driver* remained a barometer of modern America. When John Hinckley Jr. tried to assassinate President Ronald Reagan in 1981, he claimed to have been inspired by *Taxi Driver* and had hoped, in killing a president, to "effect a mystical union with Jodie Foster."

As a part of its consciousness about the burdens of the past, the film's plot explicitly recalls John Ford's *The Searchers* (1956) and implicitly recalls other classical westerns, such as Ford's *Stagecoach* (1939) via the Mohawk haircut that Travis acquires midway through the film and the Native American look of the pimp that Travis kills. Like Ford's Ethan Edwards (John Wayne) in *The Searchers*, Travis becomes alienated from most social interaction, yet he yearns, through his determination to "save" Iris, to restore some lost form of family and community. He wants to be a hero in an age when there is little possibility for heroic action. Yet the recollection of earlier periods of Hollywood history and their plots and characters only highlights the historical differences of this film. Travis is a fully modern antihero, one with no frontier to explore and only imaginary heroics to motivate him. New York is not the Wild West, and Travis clearly lacks the proud, clear vision and the noble purpose of a western hero like the Ringo Kid in the classic *Stagecoach*. That a younger, more cynical audience was the primary target of and the vehicle for the success of *Taxi Driver* indicates that the changing social tastes and attitudes of audiences play a large part in determining the variations among films of different historical periods.

Stylistically, *Taxi Driver* consistently suggests a high degree of self-consciousness about its narrative

organization and images. Scorsese employs two formal patterns typical of New Hollywood films—exaggerated or hyperrealistic cinematography and an often interiorized narrative perspective. Both of these patterns suggest the influence of French New Wave directors on Scorsese and on other films of this period, such as *Apocalypse Now* (1979). *Taxi Driver* paints New York City through hyperrealistic images that seem to be the product of either a strained mind or a strained society. Shots of New York at night gleam and swirl with flashing colors, creating a carnivalesque atmosphere of neon and glass. Frames (like those of the cab window and its rearview mirror) constantly call attention to a subjective, partial point of view **[Figure 2.29]**. This attention to the frames through which we see and understand the world then crystallizes in one of the most renowned shots of the movie. Midway through the film, Travis equips himself with various guns, and while he poses before a mirror, he repeatedly addresses himself with the famous line "You talkin' to me?" As he watches himself in the mirror, identity appears to split, one image of self violently confronting the other **[Figure 2.30]**. This line could be an epigraph for contemporary movies on divided identity.

Similarly, the first-person narration of *Taxi Driver* provides an almost psychotic staging of Travis's personal desires and anxieties. "One day, indistinguishable from the next, a long continuous chain," Travis rambles on through the private voiceover. This drifting interior narrative jumps from one psychological state and illogical action to another. Travis tries, for instance, to court a woman by taking her on a date at a pornographic movie, and later, for no apparent reason, he plans to assassinate her employer, a politician running for office. When Travis initiates his final bloody attack on Iris's pimp, the narrative takes its most unpredictable turn. Despite the bizarre motivation for this event (to rescue a young woman who does not wish to be rescued) and the shockingly graphic slaughter that leaves a trail of shredded bodies, Travis becomes a community hero who is celebrated in newspapers for his rescue of Iris. At this moment of anticipated closure, narrative logic becomes strained to the point of fracturing. A "happy ending" to a narrative motivated and shaped by a narcissistic and unbalanced mind seems to subvert the possibility of a traditional narrative logic in *Taxi Driver*—and possibly even in this world.

Taxi Driver acts out the signs of its times, socially and artistically. However, this film demonstrates that cinema also bears the burden of its past. Being true to its present requires unusual awareness of the dramatic changes and fissures that distinguish the film from its historical heritage.

2.29 *Taxi Driver* (1976). The windshield functions as a frame for Travis Bickle's limited point of view.

2.30 *Taxi Driver* (1976). The famous scene in which the main character, Travis Bickle, confronts his mirror image demonstrates a divided and shifting identity.

2.31 *Pulp Fiction* (1994). The running commentary of the hit men played by John Travolta and Samuel L. Jackson marks this as a Quentin Tarantino film.

The Commercial Auteur

The combination of the New Hollywood's recognition of the auteur and its commercial orientation resulted in a relatively new formation in Hollywood moviemaking—the idea of the auteur, most often the director, as a brand. We can pinpoint three signature films of this period as evidence of this phenomenon—Ridley Scott's *Blade Runner* (1982), David Lynch's *Blue Velvet* (1986), and Quentin Tarantino's *Pulp Fiction* (1994). Each of these films is a dramatic visual and narrative experiment that investigates the confusion of human identity, violence, and ethics at the end of the twentieth century. In *Blade Runner*, Deckard (played by Harrison Ford) hunts down androids in a dark and visually complex dystopia where technology creates beings who are "more human than human." With *Blue Velvet*, Lynch fashions a nightmarish version of small-town America in which Jeffrey, the protagonist, discovers violence seething throughout his everyday community and his own naive soul. In *Pulp Fiction*, where violence is also a measure of human communication, the narrative follows the unpredictable actions and reflections of two hit men who philosophically meditate out loud about the Bible, loyalty, and McDonald's hamburgers **[Figure 2.31]**. These exceptional films demonstrate great imaginative quality, professional skill, and innovation.

These filmmakers are able to produce such daring and disturbing projects and successfully distribute them within mainstream film culture in part because their own personae become part of what is marketed. The prominence of the director in driving movie commerce has taken on even higher financial stakes as studio film budgets have soared. This is nowhere more evident than in the career of James Cameron. Although its huge budget, innovative technology, and massive promotional campaign helped make *Titanic* (1997) one of the highest-grossing films in both United States and worldwide box-office history, Cameron's "brand" was also key to the film's success and helped pave the way for the even more grandiose *Avatar* (2009).

American Independent Cinema

The promotion of a director's unique vision also helped independently financed films to gain visibility in the 1980s, opening up pathways to female and nonwhite filmmakers. New York-based writer-directors committed to their own visions—like

2.32 *Malcolm X* (1992). Spike Lee argued that a big-budget biographical film about the slain leader should be directed by an African American.

Susan Seidelman (*Desperately Seeking Susan*, 1985) and Spike Lee (*She's Gotta Have It*, 1986)—earned critical praise and audience attention. Seidelman's film featured Madonna just as her career took off, and Lee's stylish and engaging film announced an important voice in American cinema and catalyzed a wave of African American films in the 1990s. Working through his production company, 40 Acres and a Mule, Lee addressed important moments in American history in the biopic *Malcolm X* (1992) **[Figure 2.32]** and the documentary *4 Little Girls* (1997), chronicled race relations in *Do the Right Thing* (1989), and promoted the careers of young women of color like Darnell Martin, who directed *I Like It Like That* (1994).

In 1989, the success of Steven Soderbergh's *sex, lies, and videotape* at both the Cannes and Sundance film festivals marked a new era of American independent filmmaking, with Sundance successes attracting industry interest. Independent feature films—such as Todd Solondz's *Welcome to the Dollhouse* (1995) and Mary Harron's *American Psycho* (2000)—are often noted for controversial subject matter and dark tone. Distributors like Miramax developed an aggressive marketing model for these edgy films, and the expansion of art-house cinemas outside university towns helped build a viable independent sector in the 1990s. Stars were drawn to independent films for challenging roles and awards prospects. Some observers lamented the incorporation of the movement into business as usual, as Hollywood studios began to distribute and develop films through specialty divisions.

But with their low budgets and openness to first-time directors, independent films offered many opportunities for marginalized groups. Chinese American Wayne Wang launched his significant filmmaking career with *Chan Is Missing* (1982), and playwright and director Luis Valdez looked at Chicano history in *Zoot Suit* (1981) and *La Bamba* (1987). The first feature film by and about Native Americans, *Smoke Signals* (1998), directed by Chris Eyre and written by Sherman Alexie, provided a gently funny picture of the contradictions of contemporary Native American life.

Women filmmakers also carved out a place in independent filmmaking. Allison Anders connected with audiences in films based on her own experiences, such as *Gas Food Lodging* (1992), and films based on the experiences of other girls and women, such as *Mi Vida Loca* (1993). Julie Dash's *Daughters of the Dust* (1991) became the first feature by an African American woman to be released nationally in theaters. A prize winner for its cinematography at Sundance, it later inspired Beyoncé Knowles's *Lemonade* (2016). Independent feature film producer Christine Vachon was central to the 1990s phenomenon known as New Queer Cinema. This efflorescence of feature films, daring in form and subject matter, proved there was a viable theatrical market for work by and about lesbians and gay men. Vachon's company Killer Films brought to the screen Rose Troche and Guinevere Turner's lesbian romance *Go Fish* (1994); Kimberly Peirce's debut drama based on the murder of young transman Brandon Teena, *Boys Don't Cry* (1999); and numerous features by Todd Haynes, including the critically acclaimed *Far from Heaven* (2002) and *Carol* (2015).

A diversity of voices emerged in independent filmmaking during these decades, energized by politics (including AIDS activism) and the affordability of video technology. The audiences most receptive to these voices were incorporated into an increasingly specialized view of the filmgoing public—corresponding to developments in cable "narrowcasting" in the 1990s.

From National to Transnational Cinema in Europe

As Hollywood blockbusters pushed local films off movie screens in many countries, European film industries focused on what makes their products aesthetically distinctive, at the same time enacting funding, import and export, and distribution policies to keep them competitive. State-subsidized film industries sustained the work of auteur directors through movies made for national television and through international coproduction agreements. An increasingly efficient circuit of film festivals offered outlets for exhibition and exposure to critical attention, and awards and prizes distinguished such films from their Hollywood counterparts.

New German Cinema

A unique mix of government subsidies, international critical acclaim, domestic television broadcast, and worldwide film festival exposure established **New German Cinema** as an integral product of West Germany's national culture.

2.33 *The Marriage of Maria Braun* (1979). Rainer Werner Fassbinder made forty feature films in a short career as one of the most celebrated representatives of New German Cinema. This historical drama featuring frequent Fassbinder star Hanna Schygulla was one of his most commercially successful films.

Although extraordinarily vital and stylistically diverse, this cinema often confronts Germany's Nazi and postwar past, approached directly or through an examination of the contemporary political and cultural climate, and emphasizes the distinctive, often maverick, visions of individual directors.

Alexander Kluge, one of the political founders of New German Cinema, used modernist film practices to question the interpretation of history in *Yesterday Girl* (1966). Before his death at age thirty-six, Rainer Werner Fassbinder, perhaps the movement's most celebrated and its most prolific director, made more than forty feature films. The first and best known among his influential trilogy about postwar Germany, *The Marriage of Maria Braun* (1979), adapts the Hollywood melodrama to tell of a soldier's widow who builds a fortune in the aftermath of the war **[Figure 2.33]**. By 1984, Edgar Reitz's sixteen-hour television series *Heimat* (1984), in part a response to the American television miniseries *Holocaust* (1978), demonstrated that the cultural silence about the Nazi era had definitively been broken.

On the international stage, however, the hallmark of New German Cinema was less its depiction of historical, political, and social questions than the distinctive personae and filmic visions of its most celebrated participants. The visionary Wim Wenders, the driven Werner Herzog, and the enormously productive, despotic, and hard-living Fassbinder were easily packaged as auteurs with outsized personalities. Wenders's films, including *Alice in the Cities* (1974) and *Wings of Desire* (1987), are philosophical reflections on the nature of the cinematic image and the encounter between Europe and the United States. Herzog's *Aguirre: The Wrath of God* (1972) and *Fitzcarraldo* (1982) are bold depictions of extreme cultural encounters set in Latin American jungles. As these and other successful directors began to work abroad, and as wider social shifts and changes in cultural policy took place in Germany, the heyday of New German Cinema came to an end. In the 1980s, domestic audiences welcomed comedies like Doris Dörrie's *Men* (1985). The industry underwent changes after the fall of the Berlin Wall and the establishment in 1992 of the European Union. With Tom Tykwer's hit *Run Lola Run* (1998), German films again achieved wide international recognition.

African Cinema

African cinema encompasses an entire continent and many languages, cultures, and nations, each with varying levels of economic development and infrastructure. An initial distinction can be made between the longer history of North African cinema and the more recent emergence of sub-Saharan African cinema.

North Africa was more smoothly integrated into international film culture. The Lumière brothers' Cinématographe debuted in Egypt in 1896, and after the introduction of sound, a commercial industry developed in Egypt that still dominates the movie screens of Arab countries. Youssef Chahine, working both in popular genres and on more political and personal projects (in which he sometimes appeared), was a cosmopolitan presence in Egyptian cinema from the 1950s to his death in 2008. His autobiographical trilogy, beginning with *Alexandria . . . Why?* (1979),

is notable for its humor, frank approach to sexuality, and inventive structure. In recent Tunisian production, art films predominate, several of which are directed by or tell the stories of women. Moufida Tlatli's *The Silences of the Palace* (1994) opens in the postindependence period and follows a young woman singer as she remembers her girlhood as a palace servant. Many prominent filmmakers from Tunisia, Morocco, and Algeria have received training or financing from France, which allows for high production values and distribution abroad but also depends on their countries' colonial past.

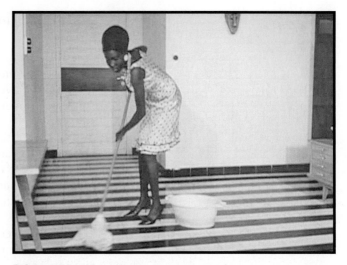

2.34 *Black Girl* (1966). Simple long shots and a stark mise-en-scène depict the young woman's sense of entrapment and alienation.

Taking shape in the 1960s after decolonization and often linked to the political and aesthetic precepts of Third Cinema, sub-Saharan African cinema encompasses the relatively well-financed francophone, or French-language, cinema of West Africa; films from a range of anglophone, or English-speaking, countries; and films in African languages such as Wolof and Swahili. Although it is difficult to generalize about this rapidly expanding film culture, some of its most influential features and shorts have been united by a focus on social and political themes rather than commercial interests and by an exploration of the conflicts between tradition and modernity.

At the forefront of this vital development is the most respected proponent of African cinema, Senegalese filmmaker Ousmane Sembène, who in 1966 directed sub-Saharan Africa's first feature film, *Black Girl*, with extremely limited technical and financial resources. The film, based on Sembène's own novel, follows a young woman who travels from Dakar, Senegal, to Monte Carlo, France, to work with a white family as a nanny. She soon becomes disillusioned with her situation, which leaves her trapped in the home, cooking and cleaning. Her French voiceover records her alienation and her increasing despair. Simply composed long shots depict her as enclosed and restricted by her surroundings **[Figure 2.34]**. Although he made only eight features before his death in 2007, Sembène's films are remarkable for their moral vision, accessible storytelling, and range of characters. His protagonists represent aspects of traditional and modern African life without becoming two-dimensional symbols.

Internationally known francophone filmmakers include Idrissa Ouedraogo from Burkina Faso (*Tilai*, 1990) and Souleymane Cissé (*Finye*, 1982; *Yeelen*, 1987) and Abderrahmane Sissako (*Life on Earth*, 1998; *Bamako*, 2006) from Mali. Sissako's films have been hailed as exquisite commentaries on the effects of globalization on Africa.

Chinese Cinema

Chinese cinema poses its own challenge to models of national cinema because it includes films from the "three Chinas" — the People's Republic of China (Communist mainland China); the island of Hong Kong, which reverted to Chinese sovereignty in 1997 after being under British control since 1842; and the Republic of China (the island of Taiwan, settled by nationalists at the Communist Party takeover of China in 1949). Each of these areas developed under a different social and political regime, so the industries vary greatly in terms of commercial structure, degree of government oversight, audience expectations, and even language. Yet they are all culturally united and increasingly economically interdependent.

2.35 *Raise the Red Lantern* (1991). Gong Li became an international art-film star in the films of Fifth Generation Chinese director Zhang Yimou.

Film in the People's Republic of China

In mainland China after the 1949 Communist Revolution, cinema production was nearly halted and limited to propaganda purposes. It was further disrupted during the Cultural Revolution in the 1960s, when leader Mao Zedong referred to American films as "sugar-coated bullets." It was not until the 1980s that a group of filmmakers emerged, the so-called Fifth Generation (referring to their class at the Beijing Film Academy), who were interested both in the formal potential of the medium and in critical social content. Two characteristics stood out—ordinary protagonists and an emphasis on rural or historical subjects filmed with great beauty.

The enthusiastic reception given *Yellow Earth* (1985) at international film festivals made director Chen Kaige and cinematographer Zhang Yimou the most acclaimed filmmakers of this movement. With Zhang's directorial turn came a series of lush, sensuous films featuring Gong Li, an unknown actress who became an international film star. Zhang's films *Ju dou* (1990) and *Raise the Red Lantern* (1991) **[Figure 2.35]** were the targets of censorship at home and the recipients of prizes abroad. The strong aesthetic vision of Fifth Generation films, stemming from the filmmakers' experiences growing up as marginalized artists during the Cultural Revolution, made a critical statement in its own right.

After the violent suppression of protests in Tiananmen Square in 1989, a new underground film movement emerged in the People's Republic of China. The work of the so-called Sixth Generation was characterized by the exploration of controversial themes in contemporary urban life and by production without official approval. For example, Zhang Yuan's *East Palace, West Palace* (1996) was mainland China's first film about gay life.

VIEWING CUE

Compare at least two films from the same movement (such as New German Cinema or Hong Kong New Wave). Do the characteristics discussed in this chapter apply?

Hong Kong Cinema

After the phenomenal international success of low-budget Hong Kong kung-fu films in the 1970s, the sophisticated style of the Hong Kong New Wave led by producer-director Tsui Hark exploded on the scene. These Hong Kong films were known for expensive production methods and a canny use of Western action elements. Director John Woo became internationally known for his technical expertise and visceral editing of violent action films like *The Killer* (1989). Along with legendary stunt star Jackie Chan, Woo brought the Hong Kong style to Hollywood in such films as *Face/Off* (1997).

The stylish, even avant-garde work of Wong Kar-wai told quirky stories of marginal figures moving through a postmodern, urban world, photographed and edited in a distinctive style that finds beauty in the accidental and the momentary. *Happy Together* (1997) is the ironic title of a tale of two men drifting in and out of a relationship, set in a Buenos Aires that is not so different, in its urban anxiety, from the men's home of Hong Kong. Wong's *In the Mood for Love* (2000) is set in the 1960s among cosmopolitan former residents of Shanghai who are trying to establish a pattern of life in Hong Kong **[Figure 2.36]**.

2.36 *In the Mood for Love* (2000). In this film by Hong Kong auteur Wong Kar-wai, stylish characters make chance connections amid the urban alienation of Hong Kong.

Taiwan Cinema

Two contemplative family sagas by acclaimed auteurs of the new Taiwan cinema—Hou Hsiao-hsien's *A City of Sadness* (1989) and Edward Yang's *Yi yi* (2000)—reflect

on the identity of contemporary Taiwan. Influenced by mainland China (where much of its population and nationalist government come from), Japan (which ruled the island from 1895 to 1945), and the West (with which it trades), Taiwan cinema had little chance to explore indigenous culture on screen before the lifting of martial law in 1987. Although these directors were heralded by international critics, their films often were less successful at home than U.S. and Hong Kong films.

Iranian Cinema

Although many Chinese films have achieved strong commercial as well as critical success internationally, Iranian cinema is especially notable for receiving festival prizes and critical acclaim abroad. The art films of this Islamic nation are characterized by spare pictorial beauty, often of landscapes or scenes of everyday life on the margins, and an elliptical storytelling mode that developed in part as a response to state regulation. Meanwhile, the thriving domestic industry favors more populist melodramas.

Following the 1979 Islamic Revolution in Iran, cinema was attacked as a corrupt Western influence and movie theaters were closed, but by the 1990s, both a popular cinema and a distinctive artistic film culture developed. The latter became a way to enhance Iran's international reputation, especially during the more moderate rule of Mohammad Khatami from 1997 to 2005. Films by such directors as Abbas Kiarostami and Mohsen Makhmalbaf became the most internationally admired and accessible expressions of contemporary Iranian culture as well as some of the most highly praised examples of global cinema. In Kiarostami's *Taste of Cherry* (1997), beautiful, barren landscapes are the settings for wandering characters' existential conversations. Jafar Panahi's popular *The White Balloon* (1995) depicts a little girl's search for a goldfish. Rural settings and child protagonists helped filmmakers avoid the censorship from religious leaders that contemporary social themes would attract. These strategies also evaded strictures forbidding adult male and female characters from touching—a compromise that at least avoided offering a distorted picture of domestic and romantic life.

More recently, however, filmmakers have used the international approval accorded Iranian films to tackle volatile social issues such as drugs and prostitution in portrayals of contemporary urban life. Panahi's *The Circle* (2000), banned in Iran, focuses on the plight of women, some of whom find prison a refuge. Makhmalbaf's *Kandahar* (2000) depicts the situation of neighboring Afghanistan just before that country became the focus of international attention and the target of a U.S.-led military campaign [**Figure 2.37**]. These depictions of controversial issues have tested the limits of the government's tolerance. In December 2010, Panahi was sentenced to a six-year jail term and banned from making films for twenty years by Mahmoud Ahmadinejad's regime. Released from prison but with the threat still looming, he has defined the ban by making modest films like *Taxi* (2015), shot in his car as he impersonates a cab driver and discusses his situation with family members (see Chapter 8).

One of the most interesting apparent contradictions in Iranian cinema is the success of women filmmakers. Strict religious decrees require that female characters be portrayed with their heads covered and forbid a range of onscreen behaviors, including singing. Nevertheless, many Iranian women filmmakers have achieved prominence

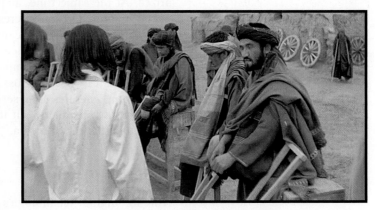

2.37 *Kandahar* (2000). Mohsen Makhmalbaf's film explores the volatile social issues in Afghanistan just prior to the U.S.-led military campaign there.

2.38 *Persepolis* (2007). Marjane Satrapi's autobiographical graphic novels satirize the Islamic Revolution in Iran, and the film adaptation, made with Vincent Paronnaud in France, was not looked on favorably in the country of her birth.

behind the camera. The prolific Tahmineh Milani was arrested for her film *The Hidden Half* (2001), and Samira Makhmalbaf (daughter of Mohsen Makhmalbaf), made her first feature film, *The Apple* (1998), when she was only eighteen. Perhaps the most visible example of Iranian feminist perspectives is the French animated film *Persepolis* (2007) by Vincent Paronnaud and Marjane Satrapi, based on the latter's graphic novel about her girlhood in Iran **[Figure 2.38]**.

In each of these examples of film cultures at the end of the twentieth century, we can see the role played by cinema's powerful images and narratives in defining and challenging national and regional identities. With the further incorporation of digital technologies in the twenty-first century, cinema continues to define and be defined by globalization.

Cinema in the Digital Era (2000–present)

Cinema in the twenty-first century has built on many trends that emerged in the late twentieth century, with some key new features tied to the adoption of digital technology at the largest and smallest scales. The year 2000 saw the introduction of industry standards for the commercial exhibition of films digitally, and by 2016, 98 percent of the world's screens had been digitized. Moreover, nearly 80 percent of top-grossing Hollywood films were shot on digital formats. At the other end of the scale, new technology made some productions far more affordable. Independent filmmaker Sean Baker used an iPhone to make his award-winning theatrical feature *Tangerine* (2015), and a vast range of media producers and cultures overcame distances and format differences to circulate entertainment, political media, and artwork over global networks.

Rapidly changing technologies that were developed in the late twentieth century reshaped film viewing and audience engagement. Starting in the 1980s, home video, DVD, and Blu-ray sales made it possible for viewers to own and watch films repeatedly and selectively, piecing together narrative strands of complex works and forming communities with like-minded viewers. Cable and streaming services made the viewing experience both more intentional and more fragmented. Because of these changing habits, marketing tactics became increasingly particularized. At the same time, audiences could drive more diverse representations by making their tastes and interests known. Most significantly, the 2000s ushered in a rapid process of **media convergence** – the process by which formerly distinct media (such as cinema, television, the Internet, and video games) and viewing platforms (such as TV, computers, and cell phones) become interdependent. As media content is linked across platforms through digitization, convergence allows media conglomerates and service providers to maximize and profit from their contact with consumers, but it also engages audiences directly in the circulation and recombination of media.

Global Hollywood

Evolving digital technologies are on constant display in high-budget, visual effects-driven franchises. Sequels, animation, and superhero films have become formulas for Hollywood success abroad, including in the rapidly expanding

Chinese market. Corporations like Disney now earn more revenue internationally than from the U.S. theatrical release of their films, creating a pervasive brand presence. Reboots of popular properties like *The Amazing Spider-Man* (2012) play to built-in audiences and increasingly vocal fandoms, minimizing risk for unprecedentedly expensive productions and maximizing audience awe with special-effects innovations.

Technological progress has indeed been rapid. In 1968, Stanley Kubrick's *2001: A Space Odyssey* used no computerized visual effects, and by 2001, the first photorealistic all-digital movie (*Final Fantasy: Spirits Within*) had appeared. Innovations followed rapidly with motion capture in *The Polar Express*

2.39 *Beyond the Lights* (2014). Gina Prince-Bythewood's romantic drama looks at a budding romance through the lens of music industry pressures and prejudices.

(2004) and the 3-D effects and facial capture of *Avatar* (2009). One sign of how the blockbuster franchises of the late 1970s are repurposed in the sequel-dominated, fan-engaging productions of the early twenty-first century is the documentary *Raiders! The Story of the Greatest Fan Film Ever Made* (2016) about a homemade version of *Raiders of the Lost Ark* started by eleven-year-olds in 1982 and finally finished in 2015.

Diversifying Screens

Despite its record box-office take and the worldwide conversion to digital projection launched by James Cameron's *Avatar* (2009), the Academy Award for best director that year went to Kathryn Bigelow, the first woman to receive the honor. Conversations about diversity and inclusion familiar in independent sectors increasingly targeted mainstream films, where women and people of color remain underrepresented both on- and offscreen. Women directed only 7 percent of the 250 top-grossing films in the United States in 2016, for example. Wide protests against all-white slates of Oscar acting nominees prompted the Academy of Motion Picture Arts and Sciences to invite hundreds of new members to help diversify the voting pool, which nevertheless remained 89 percent white and 73 percent male in 2016.

In contrast to the edgy, action-oriented films of Bigelow, women directors' successes often remained tied to genres considered typically female. Screenwriter turned director Nora Ephron mastered the romantic comedy formula in *Sleepless in Seattle* (1993) and continued to focus on women's themes in *Julie & Julia* (2009). Nancy Meyers (*It's Complicated*, 2009; *The Intern*, 2015) was well established as a writer and producer before turning to directing, making films aimed comfortably at female audiences.

Independent women directors such as Mira Nair (*The Namesake*, 2006) and Sofia Coppola (*The Bling Ring*, 2013) established the critical and commercial success needed to sustain high-profile careers, and many more are making their mark, including women of color like Gina Prince-Bythewood (*Love & Basketball*, 2000; *Beyond the Lights*, 2014) **[Figure 2.39]** and Karyn Kusama (*Jennifer's Body*, 2009; *The Invitation*, 2016). Palestinian American director Cherien Dabis, whose *Amreeka* (2009) **[Figure 2.40]** is a modest immigration tale about a Palestinian mother working at a Midwestern fast-food place, examines the merging and clashing of two cultures.

2.40 *Amreeka* (2009). A Palestinian American family experiences life in suburban Chicago.

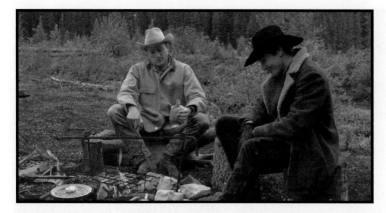

2.41 *Brokeback Mountain* (2005). An appealing cast and new take on the traditional western made a gay male love story a mainstream success.

◢◣ VIEWING CUE

View the clip from Gina Prince-Bythewood's *Beyond the Lights* (2014). How do dialogue and form position the black woman protagonist? How do you think this relates to the unique perspective of a black woman director behind the camera?

Director Lisa Cholodenko's incisive comedy about lesbian parenting, *The Kids Are All Right* (2010), appealed to crossover audiences with prominent stars in the main roles, building on the success of Ang Lee's cowboy love story *Brokeback Mountain* (2005) **[Figure 2.41]**. The films' success corresponded to unprecedented changes in American public opinion on LGBT issues in the 2000s, culminating in the 2015 Supreme Court decision legalizing marriage between same-sex couples.

The first decades of the 2000s saw commercial and political gains in black cinema. Playwright-producer-actor-director Tyler Perry's comedies achieved spectacular success with African American audiences. *Diary of a Mad Black Woman* (2005) introduced his signature character, no-nonsense grandmother Madea (played by a cross-dressing Perry), to the screen. More than a dozen films have followed, grossing half a billion dollars at the box office. Perry and Oprah Winfrey also helped promote a very different kind of black story: Lee Daniels's drama *Precious: Based on the Novel Push by Sapphire* (2009), a devastating and yet soaring story of an overweight young woman's life of physical, emotional, and sexual abuse. Ava DuVernay became one of the most high-profile black women directors within the industry with the historical drama *Selma* (2015) and the first to receive an Oscar nomination with the documentary *13th* (2016). Several films—*Selma*; *Lee Daniels' The Butler* (2013), about an African American man's career in the White House; Steve McQueen's Oscar-winning *12 Years a Slave* (2013), the harrowing of a free black man who was kidnapped into slavery in 1841; and Nate Parker's cinematic telling of the Nat Turner slave rebellion, *The Birth of a Nation* (2016)—contributed to important shifts in the national conversation about the country's racial past that occurred under the Barack Obama presidency.

Proliferating social media platforms (like Twitter) and television formats (like reality television) stoked public interest in celebrity culture. Although this type of convergence serves media conglomerates in influencing markets and consumer options, its innovations allow audiences to communicate and make connections between media representations and social movements and invite artists to experiment with different forms of expression and outreach. One example is HBO's hour-long film *Lemonade* (2016), which coincided with the surprise Internet launch of Beyoncé Knowles's album of the same name. A collaboration with multiple visual and musical artists, the film explores black women's cultural heritage. The scope and ambition of the project were matched in its release strategy. Publicity and clips spread the visual and musical elements rapidly through social media, and the film was released on streaming services after its debut on cable television and packaged with the music for download and physical purchase. Such innovations in media genres and modes of consumption and distribution urge new definitions of film and the film experience.

Global Film Culture in the Age of Streaming

Providing alternatives to Hollywood, world film culture in the twenty-first century depends increasingly on international financing and the circulation of films through networks of festivals, where prizes and reviews help publicize the films, their directors, and the cultures from which they originate. Extensive coverage of festivals through online blogs and media outlets increases public awareness of the diversity of film culture, and digital media allows for the widespread accessibility of films and film history via the Internet. Both auteurs and national and regional film movements come to the fore in this context, giving access to viewers worldwide.

Transnational Europe

From Europe, Fatih Akin's films, including *The Edge of Heaven* (2007) **[Figure 2.42]**, explore the cultural interpenetration of Germany and Turkey, and Florian Henckel von Donnersmarck's Academy Award–winning *The Lives of Others* (2006) shows life under state surveillance in the former East Germany. Austrian director Michael Haneke's often-disturbing films, including *Caché* (2005) and *The White Ribbon* (2009) make the conflicts and tensions of the recent European past resonate in the present.

Originating with a group of Danish filmmakers, the Dogme movement is a keen example of the branding and transnational flow of film culture in this period. Announced at a 1995 Paris film festival, the Dogme 95 manifesto included a list of rules for a new realism and authenticity in filmmaking. The first film to receive a Dogme certificate, Thomas Vinterberg's *The Celebration* (1998), used low-end digital cameras for a visceral immediacy, and the aesthetic was embraced by filmmakers around the world. At the same time, Danish films—ranging from Lars von Trier's controversial *Antichrist* (2009) and *Melancholia* (2011) to Susanne Bier's Academy Award–winning drama *In a Better World* (2010), about a Danish doctor who works in Africa and his son's rebellion at home—received exposure unusual for a small country. As Bier's film illustrates, globalization is reflected in both the subject matter and the model of financing of much of European cinema today. After the founding of the European Union in 1993, trans- and supranational film production structures became prominent. For example, the collaborative Ibermedia fund, originating in Spain, has facilitated the completion of hundreds of Latin American films since its founding in 1996, including the Claudia Llosa's Oscar-nominated *The Milk of Sorrow* (2009), a stylistically innovative exploration of the legacy of violence against indigenous women in postconflict Peru **[Figure 2.43]**.

2.42　*The Edge of Heaven* (2007). Several of Fatih Akin's films address the German-Turkish culture clash in the lives of their characters.

2.43　*The Milk of Sorrow* (2009). Claudia Llosa's drama became the first Peruvian film to be nominated for the Foreign Language Film Academy Award in the U.S.

East Asian Cinemas

Many of the most celebrated directors and national movements in world cinema in the 2000s originated in East Asia. As China emerged as the most important export market for film, it also stepped up production and collaborations with filmmaking talent in Hong Kong, like auteur Wong Kar-wai's martial arts epic *The Grandmaster* (2013). More modest in scale and critical of rapid development in China, the work of the "urban generation" of mainland Chinese filmmakers was made possible by digital cameras and incorporates documentary aesthetics. The most internationally acclaimed filmmaker of this group, Jia Zhangke, was granted state approval for the first time to make his fourth feature, *The World* (2004), which depicts the uprooted lives of young employees at a Beijing theme park in heartbreaking, wry visual compositions. Taiwan auteur Tsai Ming-liang produced *Café Lumière* (2003) in Japan. The director's formal precision, such as very long takes often deployed to convey a

2.44 *Snowpiercer* (2014). Made in English with Korean funds, this science-fiction film about rebellion aboard a globe-spanning train exemplifies the transnational dynamics of twenty-first century cinema.

2.45 *PK* (2014). This Bollywood-produced science-fiction comedy became one of India's biggest-ever box office hits in 2014—and became the first Indian movie to gross over $10 million in North America.

2.46 *Arugbá* (2010). Veteran Nigerian filmmaker Tunde Kelani's film, which depicts the issues facing an accomplished young woman selected to participate in the annual community festival, was embraced by critics and audiences but economically undermined by video piracy.

pervasive melancholy, is indebted to Japanese director Yasujiro Ozu. Alongside the international reputations of its auteurs, Taiwan saw domestic audiences return to locally made films, responding to the pop star cast of *Cape No. 7* (2008). In Korea, a cinema renaissance in the 2000s saw domestic films regularly outperform Hollywood, with directors like Park Chan-wook (*Oldboy*, 2003; *The Handmaiden*, 2016) and Bong Joon-ho (*The Host*, 2006; *Snowpiercer*, 2014) **[Figure 2.44]** becoming cult figures and making forays into English-language production.

Global Bollywood

In the 2000s, film production and distribution in India continued to operate outside of Hollywood influence, and the Internet allowed Indian cinema's global reach to reach a massive South Asian diasporan audience and convert new viewers to Bollywood-style entertainments. Shah Rukh Khan skyrocketed to popularity in such films as *Dilwale Dulhania Le Jayenge* (1995) and *Om Shanti Om* (2007), with a fan base numbering in the billions. The cricket film *Lagaan: Once upon a Time in India* (2001) capitalized on the international popularity of Indian cinema to bid for attention from more mainstream critics and audiences in North America and the United Kingdom. This strategy became more successful throughout the decade with international hits like *PK* (2014) **[Figure 2.45]**. The transnational dimension of Indian film also can be seen in movies directed by filmmakers of the Indian diaspora. For example, Gurinder Chadha's *Bride & Prejudice* (2004), an adaptation (with musical numbers) of Jane Austen's *Pride and Prejudice*, and Mira Nair's award-winning *Monsoon Wedding* (2001) borrow some of the visual and narrative tropes of Bollywood cinema. In 2008, when *Slumdog Millionaire*, British director Danny Boyle's film about a Mumbai street kid turned game-show contestant, won the Oscar for best picture, the international influence of Indian cinema could not be contested.

African Film in the Age of Video

Also able to counter Hollywood with domestic audiences is the Nigerian film industry, known as **Nollywood**, which witnessed a stunning boom beginning in the 1990s. Driven by the hunger of audiences for African-produced images that are relevant to their lives, Nollywood produces popular genre films such as Tunde Kelani's *Arugbá* (2010) **[Figure 2.46]**. The films are shot and distributed on video, essential on a continent that lacks film studios and movie theaters. In 2006, Nollywood overtook Hollywood in terms of the number of films released annually.

Because of the limited financial and technical resources for film production, distribution, and exhibition, the Pan-African Film and Television Festival of Ouagadougou (FESPACO) in Burkina

Faso has been a vital spur to African film culture. Filmmakers from all over the continent and the African diaspora meet at the festival, held every other year, to show and view others' work and to strategize about how to extend the cinema's popular influence. The shift to digital production has significantly affected undercapitalized industries in Ghana, Congo, Zimbabwe, South Africa, and elsewhere in Africa.

The World Wide Web makes information about films, filmmakers, institutions, festivals, and history much more accessible all over the globe. Distribution remains a challenge, with uneven access, insufficient bandwidth for streaming film content, and piracy and copyright concerns. But new technologies allow students to research film culture and expand their film experience like never before.

Film Preservation and Archives

This chapter's overview of global film history mentions only a tiny fraction of the films that have been produced over 125 years. Of those films, many no longer exist. Films were considered an ephemeral entertainment in the early days of the medium, heavy and costly to ship back to their producers and bulky to store. Moreover, they were dangerous. The nitrate base of the film stock used on virtually all films made before the 1950s was extremely flammable and susceptible to decomposition. Many films were lost to the ages. Today, preserving the material history of cinema requires skills and resources in film preservation, storage, access, and information science that are provided by a network of moving image archives worldwide.

Digital technologies allow for the transfer, storage, and circulation of original film in formats that do not decay. Digital formats have enabled studios and other commercial interests to retrieve material for which there is a market interest "from the vaults." But this is not a solution to the challenges of preserving the breadth and variety of our movie past. For one thing, digital storage also can degrade over time. Historians and audiences need to have access to materials in their original format both as viewing experiences and as artifacts.

The importance of archives and preservation is especially vital to silent film history because 80 percent of our silent film heritage is believed to be lost. Kevin Brownlow and David Gill's 1981 restoration of Abel Gance's epic *Napoléon* (1927) is a complex and particularly sensational example of restoration. Frustrated with the tattered versions of this silent French classic that were in circulation in his youth, Brownlow pursued the confused history of the film, searching out different versions from private and public archives and eventually patching together an accurate reproduction of the film for a highly publicized tour in 1981. In 2016, Brownlow's ongoing efforts resulted in a definitive digital version of Gance's over five-hour film.

The preservation movement may highlight films that have been neglected by canonical film histories and need to be recovered materially as well as critically, such as Dorothy Arzner's *Working Girls* (1931), restored by the UCLA Film and Television Archives, or Micheaux's *Within Our Gates* (1920) (see the Film in Focus in this chapter). In 1990, Martin Scorsese established The Film Foundation with a group of fellow filmmakers to support restoration efforts for American films. Hundreds of projects have been completed, including a restoration of *The Night of the Hunter* (1955)—a dark, offbeat tale of a religious con man pursuing his two stepchildren and a hidden stash of money **[Figure 2.47]**. In 2007, the World Cinema

2.47 *The Night of the Hunter* (1955). This dark fable was restored with the support of Martin Scorsese and The Film Foundation.

text continued on page 92 ▶

FILM IN FOCUS

FILM IN FOCUS

LaunchPad Solo

To watch a clip from *Within Our Gates* (1920), see the *Film Experience* LaunchPad.

Rediscovering *Within Our Gates* (1920)

See also: *Where Are My Children?* (1916) and *Salomy Jane* (1914)

Oscar Micheaux's *Within Our Gates* (1920) is a crucial film in the counterhistory of American cinema because of its content, its circumstances of production and reception, and its fate **[Figure 2.48]**. Produced independently in 1919 and released in 1920, it is the earliest surviving feature film by an African American filmmaker. Despite its historical significance, however, the film was lost for decades. Greeted with controversy on its initial release, it came back into circulation in the 1990s after the Library of Congress identified a print titled *La Negra* in a film archive in Spain as Micheaux's lost film and then restored it. The film's recovery was part of the efforts of film historians and black cultural critics to reinvestigate the vibrant world of early-twentieth-century race movies and the remarkable role that Micheaux played in this culture. The film's long absence from the historical record deprived generations of viewers and cultural producers of a picture of African American life and politics in the North and South during that era and of awareness of the audience that Micheaux addressed.

Within Our Gates is important to an alternative film history because it offers a corrective view of a devastating historical phenomenon—the lynching of African Americans, which had reached epidemic proportions in the first decades of the twentieth century. When the film was returned to circulation in the 1990s, viewers immediately saw it as a countervision to D. W. Griffith's *The Birth of a Nation*, which boldly uses cinematic techniques like parallel editing to tell the inflammatory story of a black man pursuing a white virgin, who commits suicide rather than succumb to rape. The Klan is formed to avenge her death, and the would-be rapist is captured and punished in what the film depicts as justified vigilante justice.

Micheaux offers an equally visceral story that counters the myth of lynching as a reaction to black male violence by presenting a testament to white racist mob violence against African Americans. After an African American tenant farmer, Jasper Landry, is unjustly accused of shooting the wealthy landowner Girdlestone (the guilty party is actually an angry white tenant), a lynching party attacks Landry's family. *Within Our Gates*

2.48 Poster for *Within Our Gates* (1920). Oscar Micheaux's rediscovered film about the lives and philanthropic work of middle-class African Americans provoked controversy for its dramatic scenes of lynching.
Courtesy Oscar Micheaux Society, Duke University, with thanks to Jane Gaines

poignantly depicts the lynching of the mother and father and the last-minute escape of their small son as a public spectacle attended by the townspeople, including women and children. This powerful sequence stands as perhaps the strongest cinematic rebuttal to *The Birth of a Nation*'s racist distortion of history. It uses the power

of the visual to make history, just as Griffith's film does. Finally, as a director, Micheaux offers an important contrast to Griffith. Whereas Griffith has long been heralded as a father of American cinema, Micheaux's diverse talents, his unique approach to film language, his business savvy, and his modernity have waited decades for full recognition.

The structure of Micheaux's film also rewards historical inquiry because it requires viewers to think about how certain modes of storytelling become naturalized. Although *Within Our Gates*'s treatment of lynching is its most noted feature, this controversial material, which threatened to prevent the film's exhibition in Chicago where racial tensions had recently erupted in rioting, is buried in an extensive flashback. The flashback fills in the past of Sylvia Landry, described by a title card as someone "who could think of nothing but the eternal struggle of her race and how she could uplift it." The language of racial uplift directly addresses the racially conscious, middle-class black audiences for Micheaux's film. Sylvia's quest to raise funds for a black school in the South, her romance with the politically active Dr. Vivian, and several side plots featuring less noble characters, make the lynching story at the film's heart feel even closer to the historical record **[Figure 2.49]**. The story serves a didactic purpose in the film—demonstrating the racial injustice that propels Sylvia's struggle.

But the film does not spare melodramatic detail. The inclusion of white male violence against black women is another rebuttal of the distortions in *The Birth of a Nation*. We learn that Sylvia, the Landrys' adopted daughter, escapes the lynch mob only to be threatened with rape by landowner Girdlestone's brother **[Figure 2.50]**. The attack is diverted when the would-be rapist notices a scar that reveals she is actually his daughter. The improbability of the rescue scenario can be understood as the use of melodramatic coincidence to right wrongs that cannot easily receive redress in other ways. In other words, Micheaux uses the form of the movies to imagine social reality differently.

Micheaux's films were made with extreme ingenuity on low budgets. When Micheaux's affecting melodrama of African American hardship and determination disappeared from film history, a great deal was lost. The film's subject matter was not undertaken in mainstream cinema. The perspective of African American filmmakers was absent in Hollywood, and black audiences were marginalized by Hollywood films. The title *Within Our Gates* speaks to the film's own status—a powerful presence within American film history that was too long unacknowledged. Preserved by the Library of Congress Motion Picture Conservation Center and contextualized by the scholarship of black film historians like Pearl Bowser, *Within Our Gates* will remain a touchstone of American cultural history.

2.49 *Within Our Gates* (1920). In the framing story of Oscar Micheaux's film, Dr. Vivian hears the story of Sylvia Landry's past. Courtesy Oscar Micheaux Society, Duke University, with thanks to Jane Gaines

2.50 *Within Our Gates* (1920). In the flashback, a last-minute coincidence saves the heroine from assault by a white man who is revealed to be her biological father. Courtesy Oscar Micheaux Society, Duke University, with thanks to Jane Gaines

Foundation expanded this effort. The foundation has preserved crucial films from India, the Philippines, Mexico, and Senegal since its first project, the documentary *Trances* (1981) by Moroccan filmmaker Ahmed El Mannouni.

A good deal of progress has been made in considering films not only as documents of history but also as pieces of history that are worth preserving. Film archives, which are key to the efforts of film preservation, became central institutions beginning in the 1930s. Today more than 120 archives dedicated to the preservation and proper exhibition of films and their study constitute the International Federation of Film Archives (FIAF). Among the most prominent are at the Cinémathèque Française, identified with longtime archivist Henri Langlois, and New York's Museum of Modern Art. Several DVD initiatives such as Natural Film Preservation Foundation's ongoing series, *Treasures from American Film Archives,* and Kino Lorber's five-disc collection of race movies, "Pioneers of African American Cinema," have resulted in the distribution of rare movies that viewers previously had not been able to see. Different versions of older films—such as Fritz Lang's *Metropolis* (1927) or Orson Welles's *Touch of Evil* (1958)—have been pieced together from materials found in archives and collections, and they generate debates among aficionados about which is the authoritative version. A film's history includes not only the definitive version reconstructed by archivists but also the vicissitudes of its exhibition and audience reception over time.

◄ VIEWING CUE

View an "ephemeral film" on the Internet Archive at www.archive.org/details/ephemera. What does it tell us about history?

Orphan Films

The term **orphan films** (films that do not have copyright holders, including amateur films, training films, documentaries, censored materials, commercials, and newsreels) has been adopted by preservationists for surviving ephemeral or noncommercial films that may lack traditional cultural value but often yield fascinating glimpses of the past. Orphan films are in the public domain, or they have been abandoned by their owners or copyright holders and have no commercial interests to pay the costs of their preservation.

Orphan films function like time capsules. For example, a 1952 informational film about biological warfare conveys the anxieties of the government and citizens of the United States during the Cold War **[Figure 2.51]**. Newsreels offer glimpses of past events just as the people of that era saw them—fleeting moments in history that only film can record. Preserving such material is useful to documentary filmmakers and artists because material records of the past can be incorporated into new historical interpretations or artistic expressions. Looking carefully at the variety of forms, styles, and uses of orphan films helps us understand how central and how taken for granted film was to the twentieth century.

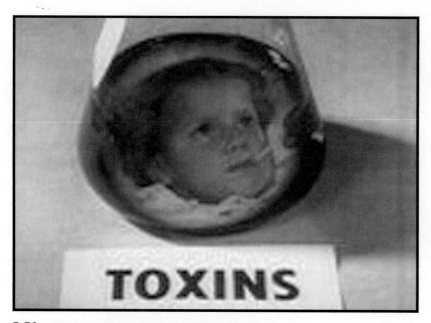

2.51 *What You Should Know about Biological Warfare* (1952). The U.S. government instructs citizens in Cold War protocol. Courtesy Prelinger Archives

CONCEPTS AT WORK

We have learned to watch movies for their formal composition and their organizational structure. Placing movies in historical context enriches our understanding of how these elements create meaningful experiences for viewers. *Far from Heaven* imitates the stylization of *All That Heaven Allows* to provide insights into the construction of gender roles and racial stratification in the 1950s and to reveal how those legacies can still be felt in the 2000s. With a historical perspective on 1970s America, we understand *Taxi Driver* as a challenge to studio filmmaking and storytelling motivated by the disruptions of the Vietnam War and related social upheaval.

By looking, however cursorily, at global histories, we have attempted to move beyond a single progression to multiple sites on the map and beyond stylistic periods to a more dynamic sense of the interaction of national history and film. Finally, learning about films like *Within Our Gates* changes conceptions about the dominant histories of and in cinema.

- Consider how World War II affected films of the 1940s in two different national contexts.
- How does *Taxi Driver* draw on and challenge Hollywood film traditions?
- In what ways is a film like *The White Balloon* (1995) indebted to the Italian neorealism of *Bicycle Thieves* (1948)? How are the aesthetic choices in these films related to cultural and historical contexts, such as Iranian censorship and the occupation of Rome during World War II?
- What is lost when women filmmakers are excluded from the traditional Hollywood-centered histories? What is gained when those films are examined and reshown?
- What is the importance of archiving and preserving films from the past?

LaunchPad Solo

Visit the LaunchPad Solo for *The Film Experience* to view movie clips, read additional Film in Focus pieces, and learn more about your film experiences.

FORMAL COMPOSITIONS
film scenes, shots, cuts, and sounds

To some extent, every movie mimics how we commonly use our senses to experience the real world. Film studies examines the ways that movies manage to activate our senses through the use of specific formal systems — mise-en-scène, cinematography, editing, and sound. In *Broken Blossoms* (1919), D. W. Griffith uses composition to create the claustrophobic sensations of being physically trapped in a small room. In George Miller's *Mad Max: Fury Road* (2015), desert landscapes, outrageous costumes, rapid editing, and a pounding soundtrack create a mesmerizing postapocalyptic world. By invigorating and manipulating the senses, film images and sounds create experiences viewers recognize and respond to — physically, emotionally, and intellectually.

The next four chapters identify the formal and technical powers associated with four different categories of film form. Chapter 3 on mise-en-scène explores the roles played by sets, props, and other onscreen elements. Chapter 4 examines cinematography — the art of how films are shot. Chapter 5 looks at film editing, and Chapter 6 focuses on film sound. Chapters begin with a short historical overview of the element and then detail the properties and strategies associated with each of these aspects of film form. Chapters conclude with an examination of how some of the scenes, shots, cuts, and sounds are used to guide our reactions to and interpretations of movies.

VILLAGE ROADSHOW/Album Photo Press/Newscom

CHAPTER

3

MISE-EN-SCÈNE
Exploring a Material World

Ridley Scott's *The Martian* (2015) could be described as a film about the desperate need to explore and reconstruct an adequate mise-en-scéne. A sci-fi tale of an astronaut mistakenly assumed dead and abandoned on Mars in 2035, this film presents Matt Damon as the astronaut who must find a way to survive in a barren climate that lacks enough oxygen or resources to sustain human life. A botanist by training, Damon responds by ingeniously constructing a sustainable home from the shelter and materials left behind on the planet. He builds a survival set where he can artificially manufacture food and air and later travels to a former Mars probe, where he modifies its windows, nose cone, and panels in order to fly it to a dangerous rendezvous in space. In an unaccommodating outer space, the film explores and celebrates one man's heroic ability to create another material space and mise-en-scéne as a reconstructed world that allows him to survive.

A French term meaning literally "placement in a scene" or "onstage," **mise-en-scène** (pronounced *meez-on-sen*) refers to all the elements of a movie scene that are organized, often by the director, to be filmed and that are later visible onscreen. It includes actors, lighting, sets, costumes, make-up, and other features of the image that exist independently of the camera and the processes of filming and editing. Cinema orchestrates a rich and complex variety of formal and material elements inherited from theater, using principles of composition derived from painting and photography.

Outside the movies, our surroundings function like a mise-en-scène. The architecture of a town might be described as a public mise-en-scène. How a person arranges and decorates a room could be called a private mise-en-scène. Courtrooms construct a mise-en-scène that expresses institutional authority. The placement of the judge above the court, of the attorneys at the bar, and of the witnesses in a partially sequestered area expresses the distribution of power. The flood of light through the vast and darkened spaces of a cathedral creates an atmospheric mise-en-scène aimed at inspiring contemplation and humility. The clothes, jewelry, and make-up that a person chooses to wear are, in one sense, the functional costuming all individuals don as part of inhabiting a particular mise-en-scène: businessmen wear suits, clergy dress in black, and service people in fast-food restaurants wear uniforms with company logos. This chapter describes how mise-en-scène organizes and directs much of our film experience by putting us in certain places and by arranging the people and objects of those places in specific ways.

KEY OBJECTIVES

- Define mise-en-scène, and identify how theatrical and other traditions affect the history of cinematic mise-en-scène.
- Describe how settings and sets relate to a film's story.
- Summarize the ways props, costumes, and make-up shape our perception of a character.
- Explain how lighting is used to evoke particular meanings and moods.
- Explain how actors and performance styles contribute to mise-en-scène.
- Compare and contrast the various ways in which mise-en-scène directs our interpretation.

3.1 *The Elephant Man* (1980). In many films, make-up accentuates features of the character. Here it complicates that character and challenges the viewer to recognize the human being beneath his distorted features.

We respond to the sensations associated with physical settings and material surfaces and objects in many ways. Whether we actually touch the materials or simply imagine their texture and volume, this tactile experience of the world is a continual part of how we engage with and understand the people and places around us. This is also the case with the movies. Characters attract or repulse us through the clothing and make-up they wear. In *Some Like It Hot* (1959), Marilyn Monroe's eroticism is inseparable from her slinky dresses. In *The Elephant*

Man (1980), the drama hinges on Joseph Carey Merrick's deformed appearance (achieved through the magic of make-up) and the recognition that he is a sensitive human being inside a hideous shape [**Figure 3.1**].

Actions set in open or closed spaces can generate feelings of potency or hopelessness. In *Lawrence of Arabia* (1962), the open desert shimmers with possibility and danger, whereas in *127 Hours* (2010), a rock climber becomes trapped in a crevasse from which there seems to be no escape, and the viewer experiences his claustrophobia [**Figure 3.2**]. In *Vertigo* (1958), viewers share the perspective of the protagonist when he relives again and again the dizzying fear of heights that he first experiences when he watches a partner fall from a roof. These feelings can be culturally modified, influenced, or emphasized in very different ways by specific films.

The artistic precedent for cinematic mise-en-scène is the theatrical stage, where the sensual and tactile engagement of audience members is based on the presence of real actors performing in real time on a physical stage. Film engages us in a different way. A film's material world may be actual objects and people set in authentic locations, like the stunning wilderness vistas captured in *The Revenant* (2015). Or it may include objects and settings constructed by set designers to appear realistic or fantastic,

3.2 ***127 Hours*** (2010). The film's confined setting becomes a formal structure and a visceral experience because the protagonist is trapped in a crevasse in the wilderness for the greater part of this film's running time. Everett Collection, Inc.

3.3 ***Alice in Wonderland*** (2010). Production designer Robert Stromberg worked with a team of art directors, costume designer Colleen Atwood, and an extensive make-up department to accomplish the Red Queen's distinctive look in this Disney reimagining.

as in Tim Burton's *Alice in Wonderland* (2010) with its living cards and unusual creatures [**Figure 3.3**]. In all its variation, mise-en-scène — a film's places and spaces, people and objects, lights and shadows — is a key dimension of our movie experience.

A Short History of Mise-en-Scène

The first movies were literally "scenes." Sometimes they were quaint public or domestic scenes, such as pioneer filmmakers Auguste and Louis Lumière's films of a baby being fed or a pillow fight. Often they were dramatic scenes re-created on a

3.4 *Intolerance* (1916). The film's massive Babylonian set became a Los Angeles tourist attraction until it was dismantled in 1921.

stage for a movie camera. Soon movies like *The Automobile Thieves* (1906) and *On the Stage; or, Melodrama from the Bowery* (1907) began to coordinate two or three interior and exterior settings, using make-up and costumes to create different kinds of characters and exploiting the stage for visual tricks and gags. In D. W. Griffith's monumental *Intolerance* (1916), the sets that reconstructed ancient Babylon were, in many ways, the main attraction **[Figure 3.4]**. In the following section, we sketch some of the historical paths associated with the development of cinematic mise-en-scène throughout more than a century of film history.

Theatrical Mise-en-Scène and the Prehistory of Cinema

The clearest heritage of cinematic mise-en-scène lies in the Western theatrical tradition that began with early Greek theater around 500 BCE and evolved through the nineteenth century. Stages served as places where a community's religious beliefs and truths could be acted out, and during the Renaissance of the late sixteenth and early seventeenth centuries, the addition of sets, costumes, and other physical elements reflected a secular world of politics and personal relationships. Through these elements of mise-en-scène, individuals and communities fashioned their values and beliefs.

By the beginning of the nineteenth century, lighting and other technological developments rapidly altered the nature of mise-en-scène and set the stage apart from the audience, anticipating the cinema. In contrast to the drawing-room interiors that had prevailed before, lighting grew more elaborate and professional, and stages and sets grew much larger and more spectacular, sometimes with massive panoramic scenery and machinery. In the nineteenth century, an emphasis on individual actors, such as Fanny and John Kemble and Ellen Terry in England, influenced the rising cult of the star, who became the center of the mise-en-scène. Non-Western theatrical traditions such as Sanskrit dramas in India and Japanese kabuki featured recognizable characters in familiar plots.

1900–1912: Early Cinema's Theatrical Influences

The subjects of the first films were limited by their dependence on natural light. But by 1900, films revealed their theatrical influences. *The Downward Path* (1901), a melodrama familiar from the popular stage, used five tableaux—brief scenes presented by sets and actors as "pictures" of key dramatic moments—to convey the plight of a country girl who succumbs to the wickedness of the city. Further encouraging this theatrical direction in mise-en-scène was the implementation of mercury-vapor lamps and indoor lighting systems around 1906 that enabled studio shooting. By 1912, one of the most famous stage actors of all time, Sarah Bernhardt, was persuaded to participate in the new medium and starred in the films *Queen Elizabeth* (1912) and *La dame aux camélias* (1912). Besides legitimate theater, other aspects of nineteenth-century visual culture influenced the staging of early films. The famous "trick" films of Georges Méliès, with their painted sets and props, were adapted from magicians' stage shows. In the United States, Edwin S. Porter's *Uncle Tom's Cabin* (1903) imitated the staging of familiar scenes from the "Tom shows," seemingly ubiquitous regional adaptations for the stage of Harriet Beecher Stowe's antislavery novel.

1915–1928: Silent Cinema and the Star System

The 1914 Italian epic *Cabiria*, which included a depiction of the eruption of Mount Etna, established the public's taste for movie spectaculars. Feature-length films soon became the norm, and elaborately constructed sets and actors in carefully designed costumes defined filmic mise-en-scène **[Figure 3.5]**. By 1915, art directors or set designers (at the time, called *technical directors* who did *interior decoration*) became an integral part of filmmaking. The rapid expansion of the movie industry in the 1920s was facilitated by the rise of studio systems in Hollywood, Europe, and Asia. Studios had their own buildings and lots on which to construct expansive sets and their own personnel under contract to design and construct them. Erich Kettelhut's famous futuristic set designs for Fritz Lang's film *Metropolis* (1927), constructed on the soundstage of the German UFA studios, were influenced by the modernist architecture of the Manhattan skyline.

3.5 *The Sheik* (1921). The charismatic power of silent film star Rudolph Valentino is often linked to the romanticized Western notions of North Africa and the Middle East that were created through set and costume design. Everett Collection, Inc.

1930s–1960s: Studio-Era Production

The rapid introduction of sound at the end of the 1920s was facilitated by the stability of the studio system, in which a company controlling film production and distribution had sufficient capital to invest in production facilities and systems. **Soundstages** were large soundproofed buildings designed to house the construction and movement of sets and to capture sound and dialogue during filming. Art directors were essential to a studio's signature style. During his long career at MGM, Cedric Gibbons was credited as art director on fifteen hundred films, including *Grand Hotel* (1932), *Gaslight* (1944), and *An American in Paris* (1951). He supervised a large number of personnel charged with developing each film's ideal mise-en-scène from the studio's resources. Producer David O. Selznick coined the title *production designer* for William Cameron Menzies's central role in creating the look of the epic *Gone with the Wind* (1939), from its dramatic historical sets, décor, and costumes to the color palette that would be highlighted by the film's Technicolor cinematography.

Studio backlots enabled the construction of entire worlds—the main street of a western town or New York City's Greenwich Village, for example. Other national cinemas invested considerable resources in central studios. Cinecittà ("cinema city") was established by Italian dictator Benito Mussolini in 1937, bombed during World War II, then rebuilt and used for Italian and international productions. The expense lavished on mise-en-scène during the heyday of the studio system shapes contemporary expectations of "movie magic."

1940–1970: New Cinematic Realism

Photographic realism and the use of exterior spaces and actual locations—identifiable neighborhoods and recognizable cultural sites—complement cinema's theatrical heritage. Although the Lumières' earliest films were of everyday scenes and their operatives traveled all over the world to record movies, location shooting did

not influence mainstream filmmaking until World War II. Italian neorealist films were shot on city streets to capture the immediacy of postwar lives (and because refugees were housed in the Cinecittà studios). Ever since, fiction and documentary filmmaking have come to depend on location scouting for suitable mise-en-scène. *Naked City* (1948) returned U.S. filmmaking to the grit of New York's crime-ridden streets. Realistic mise-en-scène was central to many of the new cinema movements of the 1970s that critiqued established studio styles, including in the postrevolutionary cinema in Cuba and the emergence of feature-filmmaking in sub-Saharan Africa in such films as Ousmane Sembène's *Xala* (1975).

1975–Present: Mise-en-Scène and the Blockbuster

Since the mechanical shark (nicknamed "Bruce") created for Steven Spielberg's *Jaws* in 1975, the economics of internationally marketed blockbuster filmmaking have demanded an ever more spectacular emphasis on mise-en-scène. The cinematic task of re-creating realistic environments and imagining fantastical mise-en-scène alike has shifted to computerized models and computer-graphics technicians, who design the models to be digitally transferred onto film. *Pan's Labyrinth* (2006) portrays the internal world of its lonely child heroine in a rich mise-en-scène constructed from actual sets, costumes, prosthetics, and computer-generated imagery **[Figure 3.6]**. Films may benefit from the technical capacity of computers to re-create the exact details of historical eras, such as the nineteenth-century New York streets of Scorsese's *Gangs of New York* (2002). Many contemporary audiences look for and many contemporary movies provide an experience that is "more real than real," to adapt the motto of the Tyrell Corporation in *Blade Runner* (1982).

3.6 *Pan's Labyrinth* (2006). A girl's fantasy life is rendered in a combination of computer-generated imagery and constructed mise-en-scène.

The Elements of Mise-en-Scène

📽 VIEWING CUE

Describe, with as much detail as possible, one of the sets or settings in a movie you watch for class. Other than the actors, which features of the film seem most important? Explain why.

In this section, we identify the elements of mise-en-scène and introduce some of the central terms and concepts underpinning the notion of mise-en-scène. These include settings and sets, props, actors, costumes, and lighting — and the ways that all of these important elements contribute to scenic and atmospheric realism and are coordinated through design and composition.

Settings and Sets

Settings and sets are the most fundamental features of mise-en-scène. The **setting** is a fictional or real place where the action and events of the film occur. The **set** is, strictly speaking, a constructed setting, often on a studio soundstage, but both the setting and the set can combine natural and constructed elements. For example, one setting in *Citizen Kane* (1941) is a Florida mansion, which, in this case, is a set

3.7 *Interstellar* (2014). Location shooting and visual effects together create the mise-en-scène of a desolate, distant planet.

constructed on an RKO soundstage and based on the actual Hearst estate in San Simeon, California.

Working within the production designer's vision, members of the art department construct sets and arrange props within settings to draw out important details or to create connections and contrasts across the different places in a film. An especially complex example is *Birdman* (2015), which shifts between the stage sets and rooms inside a New York theater and the streets outside the theater in a manner that may indicate a realistic setting or a setting marked as fantasy.

Historically and culturally, sets and settings have changed regularly. The first films were made either on stage sets or in outdoor settings, using the natural light from the sun. Films gradually began to integrate both constructed sets and natural settings into the mise-en-scène. Today's cinematic mise-en-scène continues to use constructed sets, such as the studio creation of the detective's residence for *Sherlock Holmes* (2009), as well as actual locations, such as the Philadelphia streets and neighborhoods of *The Sixth Sense* (1999) or the deserts and dusty streets of Jordan (standing in for Iraq) in *The Hurt Locker* (2008). Models and computer enhancements of mise-en-scène are used increasingly, notably in science fiction and fantasy films like *Interstellar* (2014), which uses a mixture of practical and digital effects to depict space and time travel **[Figure 3.7]**.

Scenic Realism and Atmosphere

Settings and sets contribute to a film's mise-en-scène by establishing scenic realism and atmosphere. **Realism** is an artwork's quality of conveying a truthful picture of a society, person, or some other dimension of everyday life. It is the term most viewers use to describe the extent to which a movie creates a truthful picture. The word *realism* – one of the most common, complicated, and elusive yardsticks for the cinema – can refer to psychological or emotional accuracy (in characters), recognizable or logical actions and developments (in a story), or convincing views and perspectives of those characters or events (in the composition of the image).

The most prominent vehicle for cinematic realism, however, is the degree to which mise-en-scène enables us to recognize sets and settings as accurate evocations of actual places. A combination of selection and artifice, **scenic realism** is the physical, cultural, and historical accuracy of the backgrounds, objects, and other figures in a film. For example, *Glory* (1989), a Civil War film telling the story of the first African American regiment of the U.S. Army, drew on the expertise of historian Shelby Foote for the physical, historical, and cultural verisimilitude of

VIEWING CUE

LaunchPad Solo

Watch the clip from *Life of Pi* (2012) without sound. What is communicated through the elements of the mise-en-scène alone?

3.8 *Glory* (1989). The scenic realism of this Civil War drama enhances the effect of its story of the first African American regiment's bravery.

the sets and setting **[Figure 3.8]**. Recognition of scenic realism frequently depends on the audience's historical and cultural point of view. *The Blind Side* (2009), for example, set in an affluent American suburb, may seem realistic to many Americans but could appear to be a fantastic other world to farmers living in rural China.

In addition to scenic realism, the mise-en-scène of a film creates atmosphere and connotations, those feelings or meanings associated with particular sets or settings. The setting of a ship on the open seas might suggest danger and adventure; a kitchen set may connote comfortable, domestic feelings. Invariably these connotations are developed through the actions of the characters and developments of the larger story. The early kitchen set in *Mildred Pierce* (1945) creates an atmosphere of bright, slightly strained warmth. In *E.T.: The Extra-Terrestrial* (1982), a similar set describes the somewhat chaotic space of a modern, single-parent family. In *Marie Antoinette* (2006), the opulence of Versailles conveys the heroine's loneliness as well as her desires **[Figure 3.9]**.

Props, Costumes, and Lights

As we have seen, unlike other dimensions of film form such as editing and sound, mise-en-scène was in place with the first films, so the early decades of film history were explorations in how to use the materials of mise-en-scène. Here we examine the multiple physical objects and figures that are the key ingredients in a cinematic mise-en-scène, moving from inanimate objects and human figures to the accentuation of those figures and objects with costumes and lighting.

3.9 *Marie Antoinette* (2006). A scenic background of extravagance creates an atmosphere in which the character's discontent, desire, and duty come into sharp relief.

Props

A **prop** – short for *property* – is an object that functions as a part of the set or as a tool used by the actors. Props acquire special significance when they are used to express characters' thoughts and feelings, their powers and abilities in the world, or the primary themes of the film. In *Singin' in the Rain* (1952), when Gene Kelly transforms an ordinary umbrella into a gleeful expression of his new love, an object that normally protects a person from rain is expressively used in a dance: the pouring rain makes little difference to a man in love **[Figure 3.10]**. In Alfred Hitchcock's *Suspicion* (1941), a glass of milk, brought to a woman who suspects her husband of murder, suddenly crystallizes the film's unsettling theme of malice hiding in the shape of innocence. Even natural objects or creatures can become props that concentrate the meanings of a movie. In *E.T.: The Extraterrestrial,* a flower withers and then revives when the alien does. When E.T. takes the flower with him on the spaceship, it signals an ongoing connection with the children who gave it to him.

Props appear in movies in two principal forms. Instrumental props are objects displayed and used according to their common function. Metaphorical props are those same objects reinvented or employed for an unexpected, even magical, purpose – like Gene Kelly's umbrella – or invested with metaphorical meaning. The distinction is important because the type of prop can characterize the kind of world surrounding the characters and the ability of those characters to interact with that world. In *Babette's Feast* (1987), a movie that uses the joys and generosities of cooking to bridge cultural and other differences in a small Danish village, a knife functions as an instrumental prop for preparing a meal **[Figure 3.11]**. In *Psycho* (1960), that same prop (a knife) is transformed into a hideous murder weapon and a ferocious sexual metaphor **[Figure 3.12]**. *The Red Shoes* (1948) might be considered a film about the shifting status of a prop, red dancing slippers. At first, these shoes appear as an instrumental prop serving Victoria's rise as a great ballerina, but by the conclusion of the film, they have been transformed into a darkly metaphorical prop that magically dances the heroine to her death.

In addition to their function within a film, props may acquire significance in two other prominent ways. Cultural props, such as a type of car or a piece of furniture, carry meanings associated with their place in a particular society. In *Brooklyn* (2015), the use of the simple prop of spaghetti on a plate becomes a humorous and dramatic moment in the

3.10 *Singin' in the Rain* (1952). An ordinary umbrella is transformed into a dancing prop, expressing how Gene Kelly's new love can transform a rainy world and all its problems into a stage for an exuberant song and dance.

3.11 *Babette's Feast* (1987). In this movie about the joys and generosities of cooking, a kitchen knife is a simple instrumental prop.

3.12 *Psycho* (1960). In contrast to the knife used in *Babette's Feast*, this prop also can be a murder weapon associated metaphorically with male sexuality.

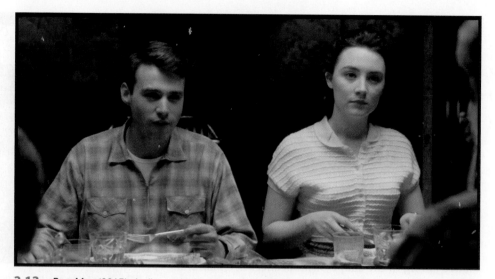

3.13 *Brooklyn* (2015). At dinner with her Italian boyfriend's family, a young Irishwoman proves herself by eating spaghetti with a spoon.

courtship between two cultures — those of an Irish woman and an Italian man **[Figure 3.13]**.

Contextualized props acquire a meaning through their changing place in a narrative. *The Yellow Rolls-Royce* (1964) and *The Red Violin* (1998) focus on the changing meaning of the central prop. In the first film, three different romances are linked through their connection to a beautiful Rolls-Royce. The second film follows the path of a Nicolò Bussotti violin from seventeenth-century Italy to an eighteenth-century Austrian monastery, to nineteenth-century England, to the Chinese Cultural Revolution in the twentieth century, and finally to a contemporary shop in Montreal, Canada **[Figure 3.14]**.

Some films play with the meaning that a contextual prop comes to acquire. In *Ronin* (1998), a mysterious briefcase unites a group of mercenaries in a plot about trust and betrayal, but its secret becomes ultimately insignificant. Alfred Hitchcock's famous "McGuffins" are props that are important only at first — like the stolen money in *Psycho* and the uranium in *Notorious* (1946). They move a plot forward but contribute little to the primary drama of love, danger, and desire.

3.14 *The Red Violin* (1998). The changing significance of a violin dramatizes how different contexts make meaning of objects.

Costumes and Make-Up

Costumes are the clothing and related accessories worn by a character that define the character and contribute to the visual impression and design of the film overall. These can range from common fashions, like a dark suit or dress, to historical or more fantastic costumes. Cosmetics, or make-up, applied to the actor's face or body highlight or even disguise or distort certain aspects of the face or body.

How actors are costumed and made up can play a central part in a film, describing tensions and changes in the character and the story. Sometimes a character becomes fully identified with one basic look or costume. Through his many movie incarnations, James Bond has always appeared in a tuxedo at some point in the action. In *Legally Blonde* (2001), much of the humor revolves around the disjuncture between

(a) **(b)**

3.15a and 3.15b *My Fair Lady* (1964). Cecil Beaton's costumes and set designs transformed a flower seller into a refined member of society.

Elle's bright pink Los Angeles fashions and accessories and the staid environment of Harvard Law School. The dynamic of costuming also can be highlighted in a way that makes the clothes the center of the movie. *Pygmalion* (1938) and its musical adaptation as *My Fair Lady* (1964) are essentially about a transformation of a girl from the street into an elegant socialite. Along with language and diction, that transformation is indexed by the changes of costume and make-up from dirt and rags to diamonds and gowns [**Figures 3.15a and 3.15b**].

Costumes and make-up function in films in four different ways. First, when costumes and make-up support scenic realism, they reproduce, as accurately as possible, the clothing and facial features of people living in a specific time and place. Thus Napoleon's famous hat and jacket, pallid skin, and lock of hair across his brow are a standard costume and the basic make-up for the many films featuring this character, from Abel Gance's 1927 *Napoléon* to Sacha Guitry's 1955 *Napoléon*. Increasingly sophisticated **prosthetics** – artificial facial features or body parts used to alter actors' appearances – enhance realism in performance, as with Leonardo DiCaprio as J. Edgar Hoover in *J. Edgar* (2011).

Second, when make-up and costumes function as character highlights, they draw out or point to important parts of a character's personality. Often these highlights are subtle, such as the ascot a pretentious visitor wears. Sometimes they are pronounced, as when villains in silent films wear black hats and twirl their moustaches. In William Wyler's film *Jezebel* (1939), Bette Davis's character shocks southern society when she appears in a red dress. Even though the film is in black and white, her performance and the blocking of her entrance convey the tensions created by the dress's scandalous color. Movies with multiple superheroes like *The Avengers* (2012) or *Captain America: Civil War* (2016) depend on recognition of each of the Marvel superheroes by costume and props [**Figure 3.16**].

◄ VIEWING CUE

Identify the single most important prop in the last film you watched for class. In what ways is it significant? Does the prop function as an instrumental prop, a metaphorical prop, or both? Explain.

3.16 *Captain America: Civil War* (2016). Iconic costumes distinguish the heroes of this comic-book adaptation.

(a) **(b)**

3.17a and 3.17b *Lee Daniels' The Butler* (2013). Oprah Winfrey wears costumes designed by Ruth Carter to reflect her social status and the historical changes swirling around her character and her husband during his long career as the White House butler.

VIEWING CUE

Describe the ways that costuming and make-up add scenic realism, highlight character, or mark the narrative development in the film viewed for class.

Third, when costumes and make-up act as narrative markers, their change or lack of change becomes a crucial way to understand and follow a character and the development of the story. Often a film chronicles the story through the aging of the protagonist: gradually the hair is whitened and the face progressively lined. *The Curious Case of Benjamin Button* (2008) juxtaposes the aging of Cate Blanchett's character with the regression of the protagonist played by Brad Pitt, augmenting the illusions of make-up with computer-generated imagery (CGI). The use of more modern styles of clothing also can advance the story. In *Lee Daniels's The Butler* (2013), the main character played by Forest Whitaker works in the White House for three decades, during eight presidential administrations. Although his job and uniform remain the same through convulsive historical changes, history registers in the changing costumes Oprah Winfrey wears in the role of his wife **[Figures 3.17a and 3.17b]**. In the *Lord of the Rings* trilogy (2001–2003), the dark corruption of Gollum appears most powerfully in the changes in his physical appearance, measured in a dramatic flashback to his origins as the hobbit Smeagol at the beginning of *The Return of the King* (2003) **[Figures 3.18a and 3.18b]**.

Finally, make-up, prosthetics, and costuming can be used as a part of overall production design to signify genre, as they do in the fantasy world of the *Lord of the Rings* trilogy.

Costumes and make-up that appear natural or realistic in films carry important cultural connotations as well. The desire to define her own gender and sexuality guides the teenager Alike's choice of clothes in *Pariah* (2011); she does not feel like herself in the pink top her mother buys for her. In *The Devil Wears Prada* (2006), the maturation of the naive Andy Sachs (Anne Hathaway) becomes literally apparent in the changes in her outfits, which evolve from college frumpy to designer fashionable.

(a) **(b)**

3.18a and 3.18b *The Lord of the Rings: The Return of the King* (2003). Viewers waited until the trilogy's last installment for a glimpse of Smeagol (Andy Serkis), the hobbit whose greed will deform him into the shape of the creature Gollum.

Lighting

One of the most subtle and important dimensions of mise-en-scène is **lighting**—which not only allows an audience to observe a film's action and understand the setting in which the action takes place but also draws attention to the props, costumes, and actors in the mise-en-scène. Our daily experiences outside the movies demonstrate how lighting can affect our perspective on a person or thing. Entering a dark, shadowed room may evoke feelings of fear, while the same room brightly lit may make us feel welcomed and comfortable. Lighting is a key element of cinematography, but because lighting choices affect what is visible onscreen and relate profoundly to our experience of mise-en-scène, they are discussed here in this context. Mise-en-scène lighting refers specifically to light sources located within the scene itself. This lighting may be used to shade and accentuate the figures, objects, and spaces of the mise-en-scène. As we discuss in more detail in Chapter 3, the primary sources of film lighting are usually not visible onscreen, but they nevertheless affect mise-en-scène.

The interaction of lighting, sets, and actors can create its own drama within the mise-en-scène. How a character moves through light or how the lighting on the character changes can signal important information about the character and story. In *Back to the Future* (1985), Marty McFly's face is suddenly illuminated from an unseen source, signaling a moment of revelation about the mysteries of time travel. More complexly, in *Citizen Kane*, the regular movement of characters, particularly of Kane, from shadow to light and then back to shadow suggests moral instability.

The mise-en-scène can use both natural and directional lighting. **Natural lighting** usually assumes an incidental role in a scene; it derives from a natural source in a scene or setting, such as the illumination from the sun, the moon, or a fire. Spread across a set before more specific lighting emphases are added, **set lighting** distributes an evenly diffused illumination throughout a scene as a kind of lighting base. **Directional lighting** is lighting coming from a single direction. It may create the impression of a natural light source but actually directs light in ways that define and shape the object or person being illuminated. As illustrated in the shots presented here from *Sweet Smell of Success* (1957) **[Figures 3.19–3.25]**, an even more specific technical grammar has developed to designate the various strategies used in lighting the mise-en-scène:

- **Three-point lighting** is a common lighting technique that uses three sources: key lighting (to illuminate the object), backlighting (to pick out the object from the background), and fill lighting (to minimize shadows) **[Figure 3.19]**.
- **Key light** is the main source of non-natural lighting in a scene. It may be balanced with little contrast between light and dark in the case of **high-key lighting** or the contrasts between light and dark may be stark, as in **low-key lighting**. These terms indicate the ratio of key to fill lighting: high-key lighting is even (low ratio of key to fill) and used for melodramas and realist films; low-key lighting is dramatic (high ratio of key to fill) and used in horror films and film noir **[Figures 3.20 and 3.21]**.
- **Fill lighting** is a technique that uses secondary fill lights to balance the key lighting by removing shadows or to emphasize other spaces and objects in the scene **[Figure 3.22]**.
- **Highlighting** describes the use of the different lighting sources to emphasize certain characters or objects **[Figure 3.23]**.
- **Backlighting** is a highlighting technique that illuminates the person or object from behind, tending to silhouette the subject **[Figure 3.24]**.
- **Frontal lighting, sidelighting, underlighting,** and **top lighting** are used to illuminate the subject from different directions in order to draw out features or create specific atmospheres around the subject **[Figure 3.25]**.

3.19 *Sweet Smell of Success* (1957). Cinematographer James Wong Howe's celebrated scathing tale of the newspaper business uses Hollywood's classic three-point lighting schema as a basic setup.

3.20 *Sweet Smell of Success* (1957). High-key lighting emphasizes the daytime glare of a crowded coffee shop.

3.21 *Sweet Smell of Success* (1957). Low-key lighting heightens the contrast between light and shadow in a dangerous encounter.

3.22 *Sweet Smell of Success* (1957). Fill lighting picks out press agent Sidney Falco (Tony Curtis) as he listens to J. J. Hunsucker (Burt Lancaster) twist the facts.

3.23 *Sweet Smell of Success* (1957). Highlighting picks out the powerful columnist from the background.

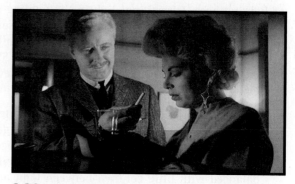

3.24 *Sweet Smell of Success* (1957). Backlighting foregrounds the illicit nature of an encounter.

3.25 *Sweet Smell of Success* (1957). Underlighting distorts a policeman's smile into a threat.

The mise-en-scène can use both **hard lighting** (a high-contrast lighting style that creates hard edges, distinctive shadows, and a harsh effect, especially when filming people) and **soft lighting** (diffused, low-contrast lighting that reduces or eliminates hard edges and shadows and can be more flattering when filming people). These lighting techniques, in conjunction with the narrative and other features of the mise-en-scène, elicit certain responses. Shading—the use of shadows to shape or draw attention to certain features—can explain or comment on an object or a person in a way the narrative does not. Hard and soft lighting and shading can create a variety of complex effects through highlighting and the play of light and shadow that enlighten viewers in more than one sense of the word.

3.26 ***Barry Lyndon*** (1975). In this example of chiaroscuro lighting, the soft glow of the candles creates areas of brightness (*chiaro*) as the background is engulfed in darkness (*scuro*). The murky color scheme contributes to the eerie atmosphere and the characters' ghostlike appearance.

In a movie like *Barry Lyndon* (1975), the story is conspicuously inseparable from the lighting techniques that illuminate it. Extraordinarily low and soft lighting, with sharp frontal light and little fill light on the faces, creates an artificial intensity in the expressions of the characters, whose social desperation hides their ethical emptiness **[Figure 3.26]**. One particular version of this play of light is referred to as **chiaroscuro lighting**, a dramatic, high-contrast lighting that emphasizes shadows and the contrast between light and dark. This pictorial arrangement of light and dark creates depth and contrast. In the opening scene of *The Godfather* (1972), the chiaroscuro lighting in Don Corleone's den contrasts with the brightly lit wedding party outdoors.

None of the elements of mise-en-scène—from props to costumes to lighting—can be assigned standard meanings because they are always subject to different uses in each film. They also carry different historical and cultural connotations at different times. Although the low-key lighting of German expressionist cinema, as in the 1924 horror film *Waxworks*, may be formally similar to that found in 1950s film noir, such as in *Kiss Me Deadly* (1955), the lighting has a very different significance, reflecting the distinctive perspective of each film and the cultural context that produced it. The metaphoric darkness that surrounds characters like Dracula and Jack the Ripper in the first film suggests a monstrous evil with psychological effects; in the second, that shadowy atmosphere describes a corruption that is entirely human, a function of brutal greed and sexualized violence. The contemporary independent film *Pi* (1998) uses high-contrast lighting and black-and-white film stock to evoke associations with these earlier film movements and connote both the psychological disturbance of the math-obsessed protagonist and the ruthless motives of those who seek to profit from his predictions.

Performance: Actors and Stars

At the center of the mise-en-scène is most often a flesh-and-blood **actor** who embodies and performs a film character through gestures and movements. A more intangible yet essential part of mise-en-scène, **performance** describes the actor's use of language, physical expression, and gesture to bring a character to life and to communicate important dimensions of that character to the audience. Because characters help us see and understand the actions and world of a film and because

text continued on page 114 ▶

◀ VIEWING CUE

Consider the role of lighting in this sequence from Richard Linklater's *Boyhood* (2014). Does it use low-key lighting or high-key lighting? Does the lighting dramatically add to the sequence's emotional impact? Or if you consider the lighting is unremarkable, how would you argue that it is still significant?

FILM IN FOCUS

FILM IN FOCUS

LaunchPad Solo

To watch a video about *Do the Right Thing* (1989) and a clip from the film, see the *Film Experience* LaunchPad.

Mise-en-Scène in *Do the Right Thing* (1989)

See also: *Crooklyn* (1994); *Summer of Sam* (1999); *25th Hour* (2002)

In Spike Lee's *Do the Right Thing* (1989), characters wander through Bedford-Stuyvesant, a gentrifying African American neighborhood in Brooklyn. Here life becomes a complicated negotiation between a private mise-en-scène (apartments, bedrooms, and businesses) and a public mise-en-scène (city streets and sidewalks crowded with people). With Lee in the role of Mookie, who acts as a thread connecting the various characters, stores, and street corners, the film explores the different attitudes, personalities, and desires that clash within a single urban place by featuring a variety of stages—rooms, stores, and restaurants—with personal and racial associations. On the hot summer day of this setting, lighting creates an intense and tactile heat, and this sensation of heat makes the mise-en-scène vibrate with energy and frustration. Working with his usual production designer, Wynn Thomas, and cinematographer, Ernest R. Dickerson, Lee transforms the neighborhood into a theatrical space for fraught encounters.

Lee's performance in the central role of Mookie draws on his then-emerging status as a star actor and a star filmmaker. In fact, this double status as star and director indicates clearly that what happens in the mise-en-scène is about him. Physically unimposing, restrained, and cautious throughout the film, Lee's performance seems to shift and adjust depending on the character he is responding to. As the central performer in a neighborhood of performers, Lee's Mookie is a chameleon, surviving by continually changing his persona to fit the social scene he is in. By the end of the film, however, Mookie must decide which performance will be the real self he brings to the mise-en-scène—how, that is, he will "act" in a time of crisis by taking responsibility for the role he is acting.

The costumes (by Ruth Carter) and make-up (by Matiki Anoff) in *Do the Right Thing* reflect the styles of dress in U.S. cities in the 1980s. Both contribute to a kind of scenic realism of the time, yet Lee also uses them to define and highlight each character's place in the film's narrative. Mookie's Brooklyn Dodgers shirt with the name and number of the legendary baseball player Jackie Robinson on the back symbolizes his hometown and African American pride **[Figure 3.27]**, whereas Pino (John Turturro), wears white, sleeveless T-shirts that signify his white working-class background. Jade (Joie Lee), Mookie's sister, stands out in her dramatic hats, skirts, and earrings and elegant make-up and hairstyles, calling attention perhaps to the individuality and creativity that allow her, uniquely here, to casually cross racial lines.

The central crisis of *Do the Right Thing* turns on the drama of instrumental props that become loaded with cultural meanings and metaphorical powers. Early in the film, Smiley (Roger Guenveur Smith) holds up a photograph of Martin Luther King Jr. and Malcolm X as a call to fight against racism with both nonviolence and violence. Shortly thereafter, Da Mayor (Ossie Davis) nearly instigates a fight because Sonny, the Korean grocer (Steve Park), has not stocked a can of his favorite beer, Miller High Life. But the walls of Sal's pizzeria contain photographs of famous Italian Americans—Frank Sinatra, Joe DiMaggio, Liza Minnelli, Al Pacino, and others **[Figure 3.28]**—and they are what ignites the film. When Buggin' Out (Giancarlo Esposito) complains

3.27 *Do the Right Thing* (1989). Mookie wears a Brooklyn Dodgers shirt with Jackie Robinson's number as a symbol of hometown and African American pride.

3.28 *Do the Right Thing* (1989). Nostalgic black-and-white photos of Italian Americans on the pizzeria wall illustrate the potential of props to serve as political flashpoints.

that there should be photos of African Americans on that wall because Sal's clientele is all black, Sal (Danny Aiello) angrily responds that he can decorate the walls of his pizzeria however he wishes. Later, when Radio Raheem (Bill Nunn) refuses to turn down his boom box (an object that has become synonymous with who he is), he and Buggin' Out again confront Sal with the cultural significance of the photos and the neighborhood residents' social rights within this mise-en-scène: why, they demand, are there no photographs of African Americans on the wall? Finally, at the climactic moment in the film, Mookie tosses a garbage can through the window of the pizzeria, sparking the store's destruction but saving the lives of Sal and his son.

Both social and graphic blockings become dramatic calculators in a film explicitly about the "block" and the arrangement of people in this neighborhood. In one scene, Pino, Vito (Richard Edson), and Mookie stand tensely apart in a corner of the pizzeria as Mookie calls on Vito to denounce his brother's behavior and Pino counters with a call for family ties. Their bodies are quietly hostile and territorial simply in their arrangement and in their movements around the counter that separates them. This orchestration of bodies climaxes in the final showdown at Sal's pizzeria. When Buggin' Out and Radio Raheem enter the pizzeria, the screaming begins with Sal behind the counter, while Mookie, Pino, Vito, and the neighborhood kids shout from different places in the room. As the fight begins, the bodies collapse on each other and spill onto the street in a mass of undistinguishable faces. After the police arrive and Radio Raheem is killed, the placement of his body creates a sharp line between Mookie, Sal, and his sons on one side and the growing crowd of furious blacks and Latinos on the other. Within this blocking, Mookie suddenly moves from one side of the line to the other and then calmly retrieves the garbage can to throw through the window. The riot that follows is a direct consequence of Mookie's decisions about where to position himself and how to shatter the blocked mise-en-scène that divides Sal's space from the mob.

Do the Right Thing employs an array of lighting techniques that at first may seem naturalistic, but over the course of the film, directional lighting becomes particularly dramatic. From the beginning, the film juxtaposes the harsh, full glare of the streets with the soft morning light that highlights the interior spaces of DJ Mister Señor Love Daddy's (Samuel L. Jackson) radio station, where he announces a heat wave for the coming day, and the bedroom where Da Mayor awakens with Mother Sister (Ruby Dee). Here the lighting of the interior mise-en-scène emphasizes the rich and blending shades of the dark skin of the African American characters, while the bright, hard lighting of the exterior spaces draws out distinctions in the skin colors of blacks, whites, and Asians. This high-key lighting of exteriors, in turn, accentuates the colors of the objects and props in the mise-en-scène as a way of sharply isolating them in the scene—for example, the blues of the police uniforms and cars, the yellows of the fruits in the Korean market, and the reds of the steps and walls of the neighborhood **[Figure 3.29]**.

Other uses of lighting in the film are more dramatic and complex. For example, the dramatic backlighting of Mookie as he climbs the stairs to deliver the pizza adds an almost religious and certainly heroic/romantic effect to the pizza delivery. When Pino confronts Vito in the storage room, the scene is highlighted by an overhead light that swings back and forth, creating a rocking and turbulent visual effect. In the final scene, Mookie walks home to his son on a street sharply divided between bright, glaring light on one side and dark shadows on the other.

More charged with the politics of mise-en-scène than many films, *Do the Right Thing* turns a relatively small city space into an electrified set where actors, costumes, props, blocking, and lighting create a remarkably dense, jagged, and mobile environment. Here the elements of mise-en-scène are always theatrically and politically in play, always about the spatial construction of culture in a specific time and place. To live here, people need to assume, as Mookie eventually does, the powers and responsibilities of knowing how and when to act.

3.29 *Do the Right Thing* (1989). The high-key lighting against a glaringly red wall adds to the intensity and theatricality of these otherwise casual commentators on the street.

3.30 ***The Blue Angel*** (1930). The voice, body, and eyes of Marlene Dietrich become the signature vehicles for her dramatic performances as an actor and character in her breakthrough role.

performance is an interpretation of that character by an actor, the success or failure of many films depends on an actor's performance. In a film like *Kind Hearts and Coronets* (1949), in which Alec Guinness plays eight different roles, the shifting performances of the actor may be its greatest achievement.

In a performance, we can distinguish two primary elements—voice, which includes the natural sound of an actor's voice along with the various intonations or accents he or she may create for a particular role, and bodily movement, which includes physical gestures and facial expressions and, especially important to the movies, eye movements and eye contact. (As in many elements of mise-en-scène, these features of performance also rely on other dimensions of film form, such as sound and camera positions.) Woody Allen has made a career of developing characters through the performance of a strident, panicky voice and bodily and eye movements that dart in uncoordinated directions. At the heart of such movies as *The Blue Angel* (1930) and *Shanghai Express* (1932) is Marlene Dietrich's sultry voice, complemented by drooping eyes and languid body poses and gestures [**Figure 3.30**].

Additionally, different acting styles define performances. With stylized acting, an actor employs emphatic and highly self-conscious gestures or speaks in pronounced tones with elevated diction. The actor seems fully aware that he or she is acting and addressing an audience. Much less evident today, these stylized performances can be seen in the work of Lillian Gish in *Broken Blossoms* (1919), in Joel Grey's role as the master of ceremonies in *Cabaret* (1972) [**Figure 3.31**], and in the comic performances seen in virtually any Monty Python movie.

More influential since the 1940s, naturalistic acting requires an actor to embody the role that he or she is playing fully and naturally in order to communicate that character's essential self, famously demonstrated by Marlon Brando as Stanley in *A Streetcar Named Desire* (1951), a role in which the actor and character seem almost indistinguishable [**Figure 3.32**].

3.31 ***Cabaret*** (1972). Joel Grey is the master of ceremonies whose own stylized performance introduces a film replete with stylized performances on and off the stage.

3.32 ***A Streetcar Named Desire*** (1951). Ever since this landmark adaptation, Marlon Brando's physical performance of Stanley has become difficult to distinguish from the essence of that fictional character.

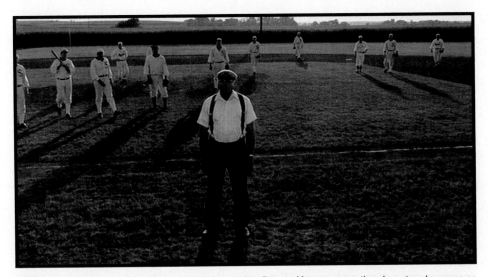

3.33 *Field of Dreams* (1989). James Earl Jones plays Terence Mann, a supporting character who serves as a parallel and counterpoint to the desires and choices of the character played by the leading actor, Kevin Costner.

Types of Actors

As part of the usual distribution of actors through mise-en-scène, **leading actors**—the two or three actors, often stars, who represent the central characters in a narrative—play the central characters. Recognizable actors who are associated with particular character types, often humorous or sinister, and often are cast in minor parts are sometimes referred to as **character actors**. They might play the role of the bumbling cook in a western. **Supporting actors** play secondary characters in a film, serving as foils or companions to the central characters. Supporting actors and character actors often add to the complexity of a film's plotline or emotional impact. They may involve us more thoroughly in the action or highlight a movie's themes. In the hands of a strong actor, such as James Earl Jones in a supporting role in *Field of Dreams* (1989) or Jennifer Lawrence in *American Hustle* (2014), these supporting roles frequently balance our perspective on the main characters, perhaps requiring us to rethink and reassess the main character's decisions and motivations. In *Field of Dreams*, the writer that Jones plays, Terence Mann, fulfills his fantasy of entering the field and joining the baseball game, while lead actor Kevin Costner's character must remain behind **[Figure 3.33]**. Finally, realism and spectacle are enhanced by **extras**—actors without speaking parts who appear in the background and in crowd scenes. Those relatively large groups of "background artists" provide character and sometimes personality to large crowd scenes.

Actors frequently are selected for parts precisely because of their association with certain **character types**—conventional characters typically portrayed by actors cast because of their physical features, their acting style, or the history of other roles they have played. Tom Hanks portrays "everyman" characters, while Helen Mirren played both Elizabeth I and Elizabeth II in the same year. To appreciate and understand a character can consequently mean recognizing this intersection of a type and an actor's interpretation or transformation of it. Arnold Schwarzenegger's large and muscular physical stature, clipped voice, and stiff acting style suit well the characters he plays in *The Terminator* (1984) and *Total Recall* (1990). The comedy of *Kindergarten Cop* (1990) arises from his tough character's attempt to act "against type" in his undercover role of a kindergarten teacher.

Stars

The leading actors in many films are movie stars—individuals who, because of their cultural celebrity, bring a powerful aura to their performance, making them the focal points in the mise-en-scène. Unlike less famous actors, star performers often

3.34 *Gravity* (2014). This lost-in-space thriller depends, in an unusually large way, on the performance and star persona of Sandra Bullock to balance the spectacular cinematography and special effects.

dominate the action and space of the mise-en-scène, bring the accumulated history and significance of their past performances to each new film appearance, and acquire a status that transforms their individual physical presence into more abstract or mythical qualities **[Figure 3.34]**. Stars thus combine the ordinary (they embody and play types audience members can identify with) and the extraordinary, bringing their distinct personality to their roles. Early in Hollywood history, the star-driven system often identified an actor with a particular genre that had a distinctive mise-en-scène. Douglas Fairbanks, for example, starred in swashbuckling adventure tales, and Charlie Chaplin's comic "Little Tramp" character was instantly recognizable by his costume.

A star's performance focuses the action of the mise-en-scène and draws attention to important events and themes in the film. In *Casablanca* (1942), several individual dramas about different characters trying to escape Casablanca are presented, but Humphrey Bogart's character Rick Blaine is, in an important sense, the only story. The other characters become important only as they become part of his life. In *Money Monster* (2016), George Clooney plays a wacky, histrionic financial adviser on an absurdly theatrical television show about investing. The show's producer is played by Julia Roberts, and the interactions between the two star performers overshadow the hostage crisis at the center of the film's plot. Johnny Depp's tongue-in-cheek performance as Jack Sparrow in *Pirates of the Caribbean: The Curse of the Black Pearl* (2003) contributed to the film's unexpected success and generated sequels highlighting the character's antics.

In all three of these films, much of the power of the characters is a consequence of the star status of the actors, recognized and understood in relation to their roles in other films—and in some cases, in relation to a life off the screen. Recognizing and identifying with Rick in *Casablanca* implies, especially for viewers in 1942, a recognition on some level that Rick is more than Rick, that this star character in *Casablanca* is an extension of characters Bogart has portrayed in such films as *High Sierra* (1941) and *The Maltese Falcon* (1941). A similar measuring takes place as we watch Clooney and Roberts. Clooney's performance in *Money Monster* impresses viewers because the character he plays is so unlike the characters he plays in more serious roles in *Syriana* (2005) and *The Descendants* (2011). Part of our appreciation and understanding of his role is the skill and range he embodies as a star. Depp's pirate captain builds on the actor's association with eccentric characters and on cultural recognition of the rock star persona of Keith Richards of the Rolling Stones. We understand these characters as an extension of or departure from other characters associated with the star.

Blocking

The arrangement and movement of actors in relation to each other within the physical space of a mise-en-scène is called **blocking**. Social blocking describes the arrangement

3.35 *The Imitation Game* (2014). In this example of social blocking, several mathematicians remain tensely at odds within the framework of a necessary cooperation.

of characters to accentuate relations among them. In *The Imitation Game* (2014), while working to break the German Enigma code, Alan Turing and his team gather together in scenes blocked to draw attention to the tension within the group **[Figure 3.35]**.

Graphic blocking arranges characters or groups according to visual patterns to portray spatial harmony, tension, or some other visual atmosphere. Fritz Lang, for instance, is renowned for his blocking of crowd scenes. In *Metropolis* (1927), the oppression of individuality is embodied in the mechanical movements of rectangles of marching workers **[Figure 3.36]**. In *Fury* (1936), a mob lynching in a small town is staged as graphic-blocked patterns whose directional arrow suggests a kind of dark fate moving against the lone individual. Both forms of blocking can become especially dynamic and creative in dance or fight sequences. In *Kill Bill: Vol. 2* (2004), the choreographed movement of bodies visually describes social relations and tensions as well as graphic patterns suggesting freedom or control.

3.36 *Metropolis* (1927). Fritz Lang's graphic blocking of workers in linear formation define a futuristic setting in which individuality itself is in doubt.

3.37 ***2001: A Space Odyssey*** (1968). The extremely influential production design of Stanley Kubrick's vision-
ary science fiction film could hardly contrast more with the eighteenth-century England of the same director's *Barry
Lyndon* (1975). Yet the attention to the composition of figures in space unites the director's work.

Space and Design

The overall look of a film is coordinated by its design team, which uses space and
composition to create a scene for the film's action. The set design of *2001: A Space
Odyssey* (1968) is characterized by futuristic design elements arranged sparsely
within the elongated widescreen frame **[Figure 3.37]**. The crowded warrens of *Fan-
tastic Mr. Fox* (2009) fill the frame but give the viewer little sense of depth, with
stop-motion figures and props jumbled together. The frontal orientation of *Marie
Antoinette* (2006) emphasizes the screens and drapes and wallpaper of Versailles,
giving the film a compositional style reminiscent of decorative arts. Even as most
designers would say their work is in the service of the story, the actors who move
through these spaces are picked out by lighting, carefully made up, and specifi-
cally costumed in palettes that integrate the work of all these departments into the
mise-en-scène.

Making Sense of Mise-en-Scène

The elements of mise-en-scène that we have designated are used together to create
the world of the film. Mise-en-scène describes everything visible within the frame.
Properties of cinematography that are discussed in the next chapter (including
framing, angle, and color) render the mise-en-scène in a particular way, but a
visual impression starts with what is in front of the camera or later placed in the
frame with special effects technology.

How do audiences interpret mise-en-scène? Whether a film presents authentic
places or ingeniously fabricates new worlds, its sets, props, acting styles, blocking,
and lighting create opportunities for audiences to find significance. From the minia-
turized reenactment of Admiral Dewey's naval victory in one of the first "newsreels,"
The Battle of Manila Bay (1898), to the futuristic ductwork located "somewhere on

text continued on page 120 ▶

3.38a

3.38b

3.38c

3.38d

3.38e

Mise-en-Scène in *Hugo* (2011)

Martin Scorsese's *Hugo* (2011) begins with a sequence that, for over five minutes, is virtually without focused dialogue and thus concentrates on exploring an elaborate mise-en-scène. The opening shot rushes through a bustling platform in the Gare Montparnasse railway station in Paris of the 1930s and ends with a dramatic close up of the station clock, out of which the young boy Hugo peers [**Figure 3.38a**].

Two primary and several secondary spaces appear in this mise-en-scène—the public spaces of the station and the interior spaces behind the clock face. With the first, the film follows Hugo's perspective through the mise-en-scène of the station as he spies on the comings and goings in the station—observing a café, a flower cart, a newspaper stand, the entry of a bookstore, and the threatening stationmaster—all of which become important places in the film [**Figure 3.38b**]. The film then cuts to the interior spaces behind the clock face and follows Hugo with a long tracking shot through a maze of interior rooms full of large mechanical gears, steam pipes, and secret passageways with slides and ladders [**Figure 3.38c**], ending with Hugo peeking through another clock [**Figure 3.38d**] across from the toy shop of Georges Méliès. With lighting that remains forebodingly low-key and shadowy, this divided mise-en-scène emphasizes a key motif in the film: behind the everyday world of history and society lies the more secretive and mysterious vision of youthful imagination.

As part of this motif, props play an especially complex role across this opening mise-en-scène. Along with 1930s costumes and Parisian locations, the film uses a pervasive presence of mechanical objects. From the gears in the clock tower to the toys of Méliès's shop [**Figure 3.38e**], these mechanisms describe not just how this world works but how the human imagination can express itself in this modern world. Meanwhile, the two large clocks that bracket the sequence call theatrical attention to both "clockwork mechanisms" (here from automatons to movies) and the movement of history itself.

Hugo's dramatic cinematography features camera movements that produce swirling visions across a variety of historical and material mise-en-scènes. That it is also one of the great achievements in contemporary 3-D filmmaking further enriches these spaces of the mise-en-scène as a depth of vision that first arrived in 1895 but, in this opening sequence, becomes rediscovered through the future perspective of a twenty-first century film technology.

🎥 FORM IN ACTION
📡 LaunchPad Solo

To watch a video about the mise-en-scène of *Hugo* (2011) and a clip from the film, see the *Film Experience* LaunchPad.

3.39 *Brazil* (1985). In this darkly comic film, a futuristic mise-en-scène of twisting and labyrinthine ductwork entangles the human actors in a disorienting present.

the Los Angeles–Belfast border" of *Brazil* (1985) **[Figure 3.39]**, to the winter light of the Swedish countryside in *The Girl with the Dragon Tattoo* (2011), mise-en-scène can produce specific meanings through views of real lands and landscapes as well as imaginatively designed settings. In this final section, we explore how different approaches to and cultural contexts for mise-en-scène help us identify and assign meaning.

Defining Our Place in a Film's Material World

For most movie viewers, recognizing the places, objects, and arrangements of sets and settings has never been simply a formal exercise. The mise-en-scène has always been the site where viewers measure human, aesthetic, and social values; recognize significant cinematic traditions; and, in those interactions, identify and assign meaning to the changing places of films.

The most fundamental value of mise-en-scène is that it defines where we are: the physical settings and objects that surround us indicate our place in the material world. Some people crave large cities with bright lights and active crowds; others find it important that their town have a church as the visible center of the community. Much the same holds true for cinematic mise-en-scène, in which the place created by the elements of the mise-en-scène becomes the essential condition for the meaning of the characters' actions. As part of this larger cultural context, cinematic mise-en-scène helps to describe the limits of human experience by indicating the external boundaries and contexts in which film characters exist (corresponding to our own natural, social, or imaginary worlds). On the other hand, how mise-en-scène is changed or manipulated in a film can reflect the powers of film characters and groups—and their ability to control or arrange their world in a meaningful way. Although the first set of values (conditions and limits) can be established without characters, the second (changing or manipulating those limits) requires the interaction of characters and mise-en-scène.

Mise-en-Scène as an External Condition

Mise-en-scène as an external condition indicates surfaces, objects, and exteriors that define the material possibilities in a place or space. The mise-en-scène may be a magical space full of active objects, or it may be a barren landscape with no borders. In *King Solomon's Mines* (1937) and *The African Queen* (1951), arid desert plains and dense jungle foliage threaten the colonial visitors, whereas films like *The Lady Vanishes* (1938) and *The Taking of Pelham 123* (2009), set in the interiors of trains and subways, feature long, narrow passageways, multiple windows, and strange, anonymous faces. An individual's movements are restricted as the world flies by outside. In each case, the mise-en-scène describes the material limits of a film's physical world. From those terms, the rest of the scene or even the entire film must develop.

Mise-en-Scène as a Measure of Character

Mise-en-scène as a measure of character dramatizes how an individual or a group establishes an identity through interaction with (or control of) the surrounding setting and sets. In *The Adventures of Robin Hood* (1938), the mise-en-scène of a forest becomes a sympathetic and intimate place where the outlaw-hero can achieve

justice and find camaraderie. In *Brokeback Mountain* (2005), the wide-open space of the mountain expands the horizons of the characters' sexual identities **[Figure 3.40]**. In the science fiction film *Donovan's Brain* (1953), the vision and the personality of a mad scientist are projected and reflected in a laboratory with twisted, mechanized gadgets and wires. Essentially, his ability to create new life forms from that environment reflects both his genius and his insane ambitions. The interactions between character and elements of the mise-en-scène may convey more meaning to viewers than even the interactions between the characters.

3.40 *Brokeback Mountain* (2005). In the expansive mountains and plains of the American West, two cowboys explore new sexual intimacies as the film confounds expectations associated with setting.

Keep in mind that our own cultural expectations about the material world determine how we understand the values of a film's mise-en-scène. To modern viewers, the mise-en-scène of *The Gold Rush* (1925) might appear crude and stagy, and the make-up and costumes might seem more like circus outfits than realistic clothing. For viewers in the 1920s, however, the fantastical and theatrical quality of this mise-en-scène made it entertaining. For them, watching the Little Tramp perform his balletic magic in a strange location was more important than the realism of the mise-en-scène.

Interpretive Contexts for Mise-en-Scène

Two prominent contexts for eliciting interpretations, or readings, of films include naturalistic mise-en-scène and theatrical mise-en-scène. Naturalistic mise-en-scène appears realistic and recognizable to viewers. Theatrical mise-en-scène denaturalizes the locations and other elements of the mise-en-scène so that its features appear unfamiliar, exaggerated, or artificial. Throughout their history, movies have tended to emphasize one or the other of these contexts, although many films have moved smoothly between the two. From *The Birth of a Nation* (1915) to *Bridge of Spies* (2015), settings, costumes, and props have been selected or constructed to appear as authentic as possible in an effort to convince viewers that the filmmakers had a clear window on a true historical place. The first movie re-creates the historical sites and events of the Civil War, even titling some of its shots "historical facsimiles," whereas the second reconstructs a variety of Cold War-era settings in the United States, Russia, and Germany. In other films, from *The Cabinet of Dr. Caligari* (1920) to the *Harry Potter* series (2001–2011), those same elements of mise-en-scène have exaggerated or transformed reality as most people know it. *Caligari* uses sets painted with twisted buildings and nightmarish backgrounds, and the fantastical settings of the *Harry Potter* films are inhabited by magical animals and animated objects.

The Naturalistic Tradition

Naturalism is one of the most effective — and most misleading — ways to approach mise-en-scène. If mise-en-scène is about the arrangement of space and the objects in it, as we have suggested, then naturalism in the mise-en-scène means that a place looks the way it is supposed to look. We can, in fact, pinpoint several more precise characteristics of a naturalistic mise-en-scène. Elements of the mise-en-scène follow assumed laws of nature and society and have a consistently logical relation to each other, and the mise-en-scène and characters mutually define each other.

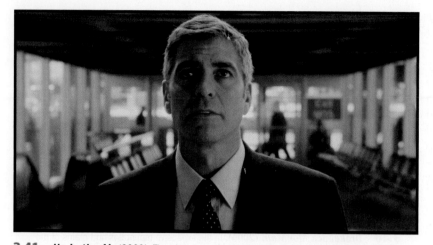

3.41 *Up in the Air* (2009). The airports and hotel bars encountered by frequent travelers become a self-enclosed, naturalistic mise-en-scène from which the character cannot escape.

Naturalistic mise-en-scène is consistent with accepted scientific laws and cultural customs. Thus, in a naturalistic setting, a person would be unable to hear whispers from far across a field, and a restaurant might have thirty tables and several waiters or waitresses. This kind of realistic mise-en-scène also creates logical or homogeneous connections among different sets, props, and characters. Costumes, props, and lighting are appropriate and logical extensions of the naturalistic setting, and sets relate to each other as part of a consistent geography. *The Battle of Algiers* (1966) uses location shooting in an attempt to re-create with documentary realism the revolution that was fought in the city's streets a decade earlier. Naturalism in the movies also means that the mise-en-scène and the characters mutually define or reflect each other. The gritty streets and dark rooms of a city reflect the bleak attitudes of thieves and femmes fatales in *The Killers* (1946). In *Up in the Air* (2009), the everyday world of airports, airlines, and hotel lobbies functions as a bleakly distorted home for a character unable to secure human companionship [**Figure 3.41**]. Two specific traditions have emerged from naturalistic mise-en-scène.

Historical Mise-en-Scène. A historical mise-en-scène re-creates a recognizable historical scene, highlighting those elements that call attention to a specific location and time in history. *All Quiet on the Western Front* (1930) can still stun audiences with its brutally accurate representation of trench warfare in World War I, and the setting and costumes of *The Last Emperor* (1987) capture the clash of tradition with Chinese Communist society.

Everyday Mise-en-Scène. By calling attention to the ordinary rather than the historical, an everyday mise-en-scène constructs commonplace backdrops for the characters and the action. In *Louisiana Story* (1948), a swamp and its rich natural life are the always-visible arena for the daily routines of a young boy in the Louisiana bayous. In *Winter's Bone* (2010), the struggles of the heroine to protect her family home are set against the stark beauty and sparse settlement of the Ozarks. In the Brazilian film *Central Station* (1998), a railroad station in Rio de Janeiro and a poor rural area in the Brazilian countryside are the understated stages in a touching tale of a woman's friendship with a boy in search of his father.

The Theatrical Tradition

In contrast, theatrical mise-en-scène creates fantastical environments that display and even exult in their artificial and constructed nature. In films in this tradition, elements of the mise-en-scène violate or bend the laws of nature and society, dramatic inconsistencies occur within or across settings, or the mise-en-scène takes on an independent life that requires confrontations between its elements and the characters.

Often violating the accepted laws of how the world functions, theatrical mise-en-scène can call attention to the arbitrary or constructed nature of that world. In movies from *Top Hat* (1935) to *Silk Stockings* (1957), Fred Astaire somehow finds a way to dance on walls and ceilings and transform spoons and brooms into magical partners. In several Wes Anderson films, including *The Life Aquatic* (2004),

3.42 *The Life Aquatic* (2004). This cut-away shot of the main ship in *The Life Aquatic* is clearly not life-sized but lends its introduction a handmade charm.

some sets are deliberately displayed in ways that make them resemble dollhouses or toy models **[Figure 3.42]**. Dramatic inconsistencies within a film's mise-en-scène indicate the instability of those scenes, costumes, and props—and the world they define. In a theatrical mise-en-scène, props, sets, and even bodies assume an independent (and sometimes contradictory) life that provokes regular confrontations or negotiations between the mise-en-scène and the characters. Two historical trends—expressive and constructive—are associated with theatrical mise-en-scène.

Expressive Mise-en-Scène. In an expressive mise-en-scène, the settings, sets, props, and other dimensions of the mise-en-scène assert themselves independently of the characters and describe an emotional or spiritual life permeating the material world. Associated most commonly with the German expressionist films of the 1920s, this tradition is also seen in surrealism, in horror films, and in the magic realism of Latin American cinema. Since Émile Cohl's *Fantasmagorie* (1908) depicted an artist surrounded by sketches and drawings whose life and activity are independent of him, expressive mise-en-scène has enlivened the terrifying, comical, and romantic worlds of many films, including *The Birds* (1963), in which birds become demonic; *Barton Fink* (1991), in which wallpaper sweats; and *The Hobbit: The Battle of Five Armies* (2014), which continues the fantastic landscapes and magical props of the franchise to create a material world infused with the metaphysics and ethics of good versus evil.

Constructive Mise-en-Scène. In a constructive mise-en-scène, the world can be shaped and even altered through the work or desire of the characters. Films about putting together a play or even a movie are examples of this tradition as characters fabricate a new or alternative world through their power as actors or directors. In François Truffaut's *Day for Night* (1973), for example, multiple romances and crises become entwined with the project of making a movie about romance and crises, and the movie set becomes a parallel universe in which day can be changed to night and sad stories can be made happy. Other films have employed constructive mise-en-scène to dramatize the wishes and dreams of their characters. In *Willy Wonka and the Chocolate Factory* (1971), the grim factory exterior hides a wonderland where, as one character sings, "You can even eat the dishes," whereas the mise-en-scène of *Being John Malkovich* (1999) constantly defies the laws of spatial logic, as Craig the puppeteer and his coworker Maxine struggle for the right to inhabit the body of the actor Malkovich.

We rarely experience the traditions of naturalistic and theatrical mise-en-scène in entirely isolated states. Naturalism and theatrics sometimes alternate

text continued on page 126 ▶

◢◣ VIEWING CUE

Describe why the mise-en-scène of the film you most recently watched fits best within a naturalistic or a theatrical tradition. Explain how this perspective helps you experience the film. Illustrate your position using two or three scenes as examples.

FILM IN FOCUS

FILM IN FOCUS

LaunchPad Solo

To watch a clip of *Bicycle Thieves* (1948), see the *Film Experience* LaunchPad.

Naturalistic Mise-en-Scène in *Bicycle Thieves* (1948)

The setting of Vittorio De Sica's *Bicycle Thieves* (1948) is post–World War II Rome, a mise-en-scène whose stark and impoverished conditions are the most formidable obstacle to the central character's longing for a normal life. Antonio Ricci, played by nonprofessional actor Lamberto Maggiorani, finds a job putting up movie posters, a humble but adequate way to support his wife and his son Bruno in an economically depressed city. When the bicycle he needs for work is stolen, he desperately searches the massive city on foot, hoping to discover the bike before Monday morning, when he must continue his work. The winding streets and cramped apartments of the actual Roman locations appear as bare, crumbling, and scarred surfaces. They create a frustrating and impersonal urban maze through which Ricci walks asking questions without answers, examining bikes that are not his, and following leads into strange neighborhoods where he is observed with hostile suspicion. In what was once the center of the Roman empire, masses of people wait for jobs, crowd onto buses, or sell their wares. The most basic materials of life take on disproportionate significance as props: the sheets on a bed, a plate of food, and an old bike are the center of existence. In the mise-en-scène, the generally bright lighting reveals mostly blank faces and walls of poverty.

Bicycle Thieves is among the most important films within the naturalistic tradition of mise-en-scène, which is associated specifically with the Italian neorealist movement of the late 1940s **[Figure 3.43]**. The laws of society and nature follow an almost mechanical logic that cares not at all for human hopes and dreams. Here, according to a truck driver, "Every Sunday, it rains." In a large city of empty piazzas and anonymous crowds, physical necessities reign: food is a constant concern, most people are strangers, a person needs a bicycle to move around town, and rivers are more threatening than bucolic. Ricci and other characters become engulfed in the hostility and coldness of the pervasive mise-en-scène, and their encounters with Roman street life follow a path from hope to despair to resignation. In the beginning,

3.43 *Bicycle Thieves* (1948). The unadorned street locations of postwar Rome and an ordinary bicycle are at the heart of this naturalistic mise-en-scène.

objects and materials, such as the bed linens Ricci's wife pawns to retrieve his bicycle, offer promise for his family's security in a barren and anonymous cityscape. However, the promise of these and other material objects turns quickly to ironic emptiness: the bicycle is stolen, the marketplace overwhelms him with separate bicycle parts that can never be identified, and settings (such as the church into which he pursues one of the thieves) offer no consolation or comfort. Finally, Ricci himself gets caught in this seemingly inescapable logic of survival when, unable to find his bike, he tries to steal another one. Only at the end of the day, when he discovers his son is not the drowned body pulled from the river, does he give up his search for the bicycle. Realizing that this setting and the objects in it will never provide him with meaning and value, he returns sadly home with the son he loves.

Bicycle Thieves's purpose is to accentuate the common and everyday within a naturalistic tradition. Ricci and his neighbors dress as the struggling working-class population from whom the actors were cast, and the natural lighting progresses from dawn to dusk across the

various locations that mark Ricci's progression through the day. This film's everyday mise-en-scène is especially powerful because without any dramatic signals, it remains permeated by the shadow of World War II. Even within the barest of everyday settings, objects, and clothing, *Bicycle Thieves* suggests the traces of history—such as Mussolini's sports stadium—that have created these impoverished conditions.

Along with these traces of history within its everyday mise-en-scène, we are reminded of a theatrical tradition that ironically counterpoints the film's realism. While performing his new duties in the first part of the film, Ricci puts up a glamorous poster of the U.S. movie star Rita Hayworth [**Figure 3.44**]. Later the sets and props change when Ricci wanders from a workers' political meeting to an adjacent theater where a play is being rehearsed.

In these instances, a poster prop and a stage setting become reminders of a world that has little place in the daily hardships of this mise-en-scène—a world where, as one character puts it, "movies bore me."

For many modern viewers, Rome might be represented by that other theatrical tradition—as a city of magnificent fountains, glamorous people, and romantic restaurants. But for Ricci and his son, glamorous Rome is a strange place and a fake set. A touching scene in which they eat at a restaurant brings out the contrast between their lives and that of the rich patrons before they return to the streets they know. For Europeans who lived through World War II (in Rome or other cities), the glaring honesty of the film's mise-en-scène in 1948 was a powerful alternative to the glossy theatrical tradition of Hollywood sets and settings.

3.44 *Bicycle Thieves* (1948). The glamour of Hollywood is evoked ironically in the protagonist's modest job putting up movie posters in the streets of postwar Rome.

3.45 *Sullivan's Travels* (1941). The opposition between the "real" world and Hollywood fantasy may not be as absolute as its director hero at first assumes.

3.46 *Cabiria* (1914). In perhaps the first movie spectacular, the eruption of Mount Etna begins a cinematic tradition using mise-en-scène to show disaster.

within the same film, and following the play and exchange between the two can be an exciting and productive way to watch movies and to understand the complexities of mise-en-scène in a film—of how place and its physical contours condition and shape our experiences. In this context, Preston Sturges's *Sullivan's Travels* (1941) is a remarkable example of how the alternation between these two traditions can be the heart of the movie **[Figure 3.45]**. In this film, the lead character is Hollywood director John L. Sullivan, who after a successful career making films with titles like *So Long, Sarong*, decides to explore the world of suffering and deprivation as material for a serious realistic movie he intends to title *O Brother, Where Art Thou?* He subsequently finds himself catapulted into a grimy world of railroad boxcars and prison chain gangs, where he discovers, ironically, the power that the movie fantasies he once created have to delight and entertain others. The theatrical mise-en-scène of Hollywood, he learns, is as important to human life as the ordinary worlds people must inhabit.

Indeed, there have been many movie "spectaculars" where the magnitude and intricacy of the mise-en-scène share equal emphasis with or even outshine the story, a tradition extending back to the 1914 Italian film *Cabiria* **[Figure 3.46]** and continued with films like *Gone with the Wind* (1939), *2001: A Space Odyssey* (1968), *Gangs of New York* (2002), and *Avatar* (2009). The spectacular elements of these films can still contribute to a narrative. Low-budget independent films usually concentrate on the complexity of character, imagistic style, and narrative, but movie spectaculars attend to the stunning effects of sets, lighting, props, costumes, and casts of thousands. Movie spectaculars exploit one of the primary motivations of film viewing—the desire to be awed by worlds that exceed our day-to-day reality.

CONCEPTS AT WORK

Mise-en-scène describes the interrelationship of all the elements onscreen—from sets to props, to actors, to composition. These relationships may vary by genre. The lighting of a horror film like *Psycho* would be out of place in a musical, and the method acting of Marlon Brando would seem too stylized in a contemporary independent film. But the way mise-en-scène supports the viewer's experience of a story's world can be surprisingly consistent. In both *Do the Right Thing* and *Bicycle Thieves*, a city's streets are far more than backdrop; they are shaped by history and define characters and destinies. Explore some of the objectives for this chapter in reference to mise-en-scène in particular films.

- What other artistic and media traditions are visible in the meticulous mise-en-scène of Wes Anderson's films?
- Pandora is imaged in *Avatar* in such detail that a language was developed for the Navi to speak. Think of several story events that are tied to specific elements in this mise-en-scène.
- Imagine a different actor portraying Mookie in *Do the Right Thing* or a memorable central character in another movie. What difference would it make?
- Watch the opening scene of *Psycho*. Does the costuming in this scene create expectations about characters and events?
- Even realist films orchestrate elements of mise-en-scène for particular meanings. Watch *Bicycle Thieves* carefully for moments that depart from naturalistic lighting. What are the effects?

LaunchPad Solo

Visit the LaunchPad Solo for *The Film Experience* to view movie clips, read additional Film in Focus pieces, and learn more about your film experiences.

Visual stimuli determine a significant part of our experience of the world around us. We look left and right for cars before we cross a busy street, we watch sunsets in the distance, we focus on a face across the room. Vision allows us to distinguish colors and light, to evaluate the sizes of things near and far, to track moving objects, or to invent shapes out of formless clouds. Vision also allows us to project ourselves into the world, to explore objects and places, and to transform them in our minds. In the cinema, we know the material world only as it is relayed to us through the filmed images and accompanying sounds that we process in our minds. The filming of those images is called **cinematography** – which means motion-picture photography (literally, "movement-writing").

This chapter describes the feature at the center of most individuals' experiences of movies – film images. Although film images may sometimes seem like windows on the world, they are purposefully constructed and manipulated. Here we detail the subtle ways that cinematography composes individual movie images in order to communicate feelings, ideas, and other impressions.

KEY OBJECTIVES

- Outline the development of the film image from a historical heritage of visual forms.
- Describe how the frame of an image positions our point of view according to different distances and angles.
- Explain how film shots use the depth of the image in various ways.
- Identify how the elements of cinematography – film stock, camera or lens type, color, lighting, and compositional features of the image – can be employed in a movie.
- Compare and contrast the effects of different kinds of camera movement and lens adjustment.
- Relate animation techniques to cinematography.
- Introduce the array of methods used to create special effects.
- Explore the impact of digital technology on the art and practice of cinematography.
- Describe prevailing concepts of the film image within different cinematic conventions.

A Short History of the Cinematic Image

We go to the movies to enjoy stimulating sights, share other people's perspectives, and explore different worlds through the details contained in a film image. In Ingmar Bergman's *Persona* (1966), a woman's tense and mysterious face suggests the complex depths of her personality. At the beginning of *Saving Private Ryan* (1998), we share the visceral experience of confused and wounded soldiers as bullets zip across the ocean surface during the D-Day invasion in France **[Figure 4.1]**. *The Hurt Locker* (2008) uses a different approach for a different combat context: brightly and starkly lit images capture both an arid desert landscape and the brittle tension that seems to electrify the light **[Figure 4.2]**.

Vision occurs when light rays reflected from an object strike the retina of the eye and stimulate our perception of that object's image in the mind. Photography (literally, "light writing") mimics vision in the way it registers light patterns onto

4.1 *Saving Private Ryan* (1998). The film uses visceral camera work to bring viewers close to dying soldiers on D-Day.

4.2 *The Hurt Locker* (2008). In a very different war, monochromatic cinematography conveys the tension that permeates the desert spaces.

film or codes them to be reproduced digitally. Yet whereas vision is continuous, photography freezes a single moment in the form of an image. Movies connect a series of these single moments and project them above a particular rate of frames per second to create the illusion of movement. **Apparent motion** is the psychological process that explains our perception of movement when watching films, in which the brain actively responds to the visual stimuli of a rapid sequence of still images exactly as it would in actual motion perception.

The human fascination with creating illusions is an ancient one. In *The Republic*, Plato writes of humans who are trapped in a cave and misinterpret shadows on the cave's wall for the actual world. Leonardo da Vinci describes how a light source entering a hole in a camera obscura (literally, "dark room") projects an upside-down image on the opposite wall, offering it as an analogy of human vision and anticipating the mechanism of the camera. One of the earliest technologies used to project images was the **magic lantern**—a device developed in the seventeenth century using a lens and a light source to project an image from a painted glass slide. In the eighteenth century, showmen used these to develop elaborate spectacles called *phantasmagoria*. The most famous of these were Étienne-Gaspard Robert's terrifying mobile projections of ghosts and skeletons on columns of smoke in an abandoned Paris crypt. These fanciful devices provided the basis for the technology that drives modern cinematography and the film image's power to control, explain, and entertain. In this section, we examine the historical development of some of the key features in the production and projection of the film image.

1820s–1880s: The Invention of Photography and the Prehistory of Cinema

The components that finally converged in cinema—a photographic recording of reality and the animation of images—were central to the visual culture of the nineteenth century. Combining amusement and science, the phenakistiscope (developed in 1832) and the zoetrope (developed in 1834), among other precinema contraptions, allowed people to view a series of images in a manner that creates the illusion of a moving image [**Figure 4.3**].

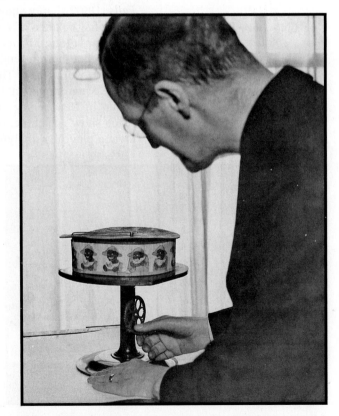

4.3 **Zoetrope.** An early precinema device that allowed people to view a series of images (here a series of racist caricatures) through a circular wheel, creating the illusion of movement. Hulton-Deutsch Collection/Getty Images

4.4 **Eadweard Muybridge's motion studies.** Experimenting with still photographs of figures in motion, Muybridge laid the groundwork for cinematography. Copyright by Eadweard Muybridge. From Eadweard Muybridge, *Animal Locomotion* (Philadelphia: Photogravure Company of New York, 1887), pl. 636. Library of Congress, LC-USZ62-102354.

In 1839, Louis-Jacques-Mandé Daguerre announced the first still photograph, building on the work of Joseph Nicéphore Niépce. Photography's mechanical ability to produce images of reality and make them readily available to the masses proved to be one of the most significant developments of the nineteenth century. In the 1880s, both Étienne-Jules Marey in France and Englishman Eadweard Muybridge, working in the United States, conducted extensive studies of human and animal figures in motion using **chronophotography**—a series of still images that record incremental movement **[Figure 4.4]**. Muybridge's Zoopraxiscope, a rotating glass disk introduced in 1879, enabled moving images to be projected for the first time.

1890s–1920s: The Emergence and Refinement of Cinematography

The official birth date of the movies is widely accepted as December 28, 1895, when the brothers Auguste and Louis Lumière debuted their Cinématographe at the Grand Café in Paris, showing ten short films, including a famous scene of workers leaving the Lumière factory. The Lumières successfully joined two key elements—the ability to record a sequence of images on a flexible, transparent medium and the capacity to project the sequence.

The first movies consisted of a single moving image. The Lumières' *Niagara Falls* (1897) simply shows the famous falls and a group of bystanders, but its compositional balance of a powerful natural phenomenon and the people on its edge draws on a long history of painting, infusing the film with remarkable energy and beauty that motion renders almost sublime **[Figure 4.5]**. In the United States, W.K.L. Dickson, working for Thomas Edison, developed a motion picture camera patented as the Kinetograph in 1891. The early Edison films were shot in the Black Maria studio in New Jersey and viewed individually by looking into a Kinetoscope or "peep show" machine. One such film, *The Kiss* (1896), titillated viewers by giving them a playfully analytical snapshot of an intimate moment **[Figure 4.6]**.

4.5 *Niagara Falls* (1897). One of the Lumière brothers' actualities, or nonfiction moving snapshots, shows the wonder and balance of a single moving image.

4.6 *The Kiss* (1896). From the Edison company, one of the most famous early films regards an intimate moment.

In the early years of film history, technical innovations in the film medium and in camera and projection hardware were rapid and competitive. Eastman Kodak quickly established itself as the primary manufacturer of **film stock**, a length of unexposed film consisting of a flexible backing or base such as celluloid and a light-sensitive emulsion. The standard **nitrate** film base of 35mm film stock was highly flammable, and its pervasive use is one reason that so much of the world's silent film heritage is lost. Nitrate film was not replaced by **safety film**, less flammable acetate-based film stock, until 1952.

After early competition among technologies, the width of the film stock, or **film gauge,** used for filming and exhibiting movies was standardized as 35mm in 1909. In the 1920s, 16mm film was introduced for amateur filmmakers, and higher resolution 70mm was experimented with for more spectacular effects. But 35mm remained the industry standard for film production and theatrical exhibition until challenged by digital formats at the end of the twentieth century **[Figures 4.7–4.9]**. By the 1920s, the rate at which moving images were recorded and later projected increased from sixteen frames to twenty-four frames per second (fps), offering more clarity and definition to moving images.

The silent film era saw major innovations in lighting and in mechanisms for moving the camera and varying the scale of shots. After 1926, **panchromatic** stock, which responded to a full spectrum of colors by rendering them as shades of gray, became the standard for black-and-white movies. Cameramen like Billy Bitzer, working with D. W. Griffith in the United States, and Karl Freund, shooting such German expressionist classics as *Metropolis* (1927), brought cinematographic art to a pinnacle of visual creativity. These visual achievements were adversely affected by the introduction of sound in 1927 because bulky and sensitive sound recording equipment created restrictions on outdoor and mobile shooting.

4.7 16mm film gauge drawn to scale. The lightweight cameras and portable projectors used with this format have been effective for documentary, newsreel, and independent film as well as for prints of films shown in educational and home settings.

4.8 35mm film gauge drawn to scale. The standard gauge for theatrically released films was introduced in 1892 by Edison and was the dominant format for both production and exhibition until the end of the twentieth century.

4.9 70mm film gauge drawn to scale. A wide, high-resolution gauge was in use since the early days of the film industry but was highlighted in feature films in the 1950s for spectacular effect. A horizontal variant of 70mm is used for IMAX formats.

(a)

(b)

(c)

4.10a–4.10c *The Wizard of Oz* (1939). **(a)** Viewers sometimes find the opening, sepia-tinted scenes of the film jarring. **(b)** When Dorothy first opens the door to Munchkinland, the drab tints of Kansas are left behind. **(c)** Technicolor's saturated primary colors are so important in the film that the silver slippers described in the book were changed to ruby slippers for the screen.

1930s–1940s: Developments in Color, Wide-Angle, and Small-Gauge Cinematography

Soon sound was recorded as an optical track directly on film, and technical innovations continued as the aesthetic potential of the medium was explored. By the 1930s, color processes had evolved from the individually hand-painted frames or tinted sequences of silent films, to colored stocks, and finally to the rich **Technicolor** process that dominated color film production until the 1950s. The Disney cartoon *Flowers and Trees* (1932) was the first to use Technicolor's three-strip process, which recorded different colors separately, using a dye transfer process to create a single image with a full spectrum of color. Although color promised a new realism, initially it often was used to highlight artifice and spectacle, notably in *The Wizard of Oz* (1939) **[Figures 4.10a–4.10c]**.

Meanwhile, the introduction of new **camera lenses** (pieces of curved glass that focus light rays in order to form an image on film) allowed cinematographers new possibilities. Wide-angle, telephoto, and zoom lenses use different **focal lengths** (the distance from the center of the lens to the point where light rays meet in sharp focus) that alter the perspective relations of an image. A wide-angle lens has a short focal length, a **telephoto lens** (a lens with a focal length of at least 75mm and capable of magnifying and flattening distant objects) has a long one, and a **zoom lens** has a variable focal length. The range of perspectives offered by these advancements allowed for better resolution, wider angles, more variation in perspective, and more **depth of field**—the range or distance before and behind the main focus of a shot within which objects remain relatively sharp and clear.

During the 1920s, filmmakers used gauzy fabrics and, later, special lenses to develop a so-called soft style that could highlight the main action or character. From the mid-1930s through the 1940s, the **wide-angle lens** was developed and used. This is a lens with a short focal length, typically less than 35mm, that allows cinematographers to explore a depth of field that can simultaneously show foreground and background objects or events in focus. Cinematographer Gregg Toland is closely associated with refinements in using wide-angle lenses for his dramatic, **deep-focus** cinematography on Orson Welles's *Citizen Kane* (1941) and William Wyler's *The Heiress* (1949) **[Figure 4.11]**.

Camera technology developed with the introduction of more lightweight **handheld cameras** that were widely used during World War II for newsreels and other purposes. These lightweight cameras could be carried by the operator rather than mounted on a tripod. Small-gauge production also expanded during this period, with 8mm film developed in 1932 for the amateur filmmaker and the addition of sound and color to the 16mm format. The portability and affordability of 16mm film encouraged its

use in educational films and other documentaries as well as in low-budget independent and avant-garde productions such as Maya Deren and Alexander Hammid's *Meshes of the Afternoon* (1943).

1950s–1960s: Widescreen, 3-D, and New Color Processes

The early 1950s witnessed the arrival of several **widescreen processes** that widened the image's **aspect ratio** (the width-to-height ratio of the film frame as it appears on a movie screen or television monitor). The dimensions of the movie screen changed from a square to a rectangular frame. The larger image was introduced in part to distinguish the cinema from the new competition of television. One of the most popular of these processes in the 1950s, CinemaScope, used an **anamorphic lens**—a camera lens that compresses the horizontal axis of an image onto a strip of 35mm film or a projector lens that "unsqueezes" such an image to produce a widescreen image. Other widescreen films, such as *Lawrence of Arabia* (1962), used a wider film gauge of 70mm **[Figure 4.12]**. This period, during which the popularity of television urged motion-picture producers to develop more spectacular displays, also saw a craze for 3-D movies such as *House of Wax* (1953). By now most movies were shot in color, facilitated by the introduction of Eastman color as an alternative to the proprietary, three-strip Technicolor process. In the 1960s, Hollywood began to court the youth market, and cinematographers experimented more aggressively with ways to distort or call attention to the image by using one or more of the following tools:

4.11 *The Heiress* (1949). Gregg Toland's cinematography uses wide-angle lenses and faster film stocks to create images with greater depth of field. Both foreground and background are in sharp focus.

4.12 *Lawrence of Arabia* (1962). The film's 70mm widescreen format is suited to panoramic desert scenes and military maneuvers.

- a **filter,** a transparent sheet of glass or gels placed in front of the lens to create various effects;
- a **flare,** a spot or flash of white light created by directing strong light directly at the lens;
- a **telephoto lens,** a lens that has a focal length of at least 75mm and is capable of magnifying and flattening distant objects; and
- **zooming,** rapidly changing focal length of a camera to move the image closer or farther away.

1970s–1980s: Cinematography and Exhibition in the Age of the Blockbuster

In the 1970s, the flexibility of **camera movement** was greatly enhanced with the introduction of the **Steadicam**. This camera stabilization system introduced in 1976 allows a camera operator to film a continuous and steady shot. It is responsible for the uncanny camera movements of *The Shining* (1980). Special effects technology

▶ VIEWING CUE

Think about the cinematography of a film you have seen in relation to the larger history of the image. Do certain shots seem like paintings, photographs, or other kinds of visual display? Explain how visual references within a specific shot or series of shots affect your understanding or interpretation of the film.

4.13 *Jaws* (1975). This Steven Spielberg film ushered in the blockbuster era with surprisingly modest special effects. A full glimpse of the mechanical shark, known on set as "Bruce," is not seen until ninety minutes into the film.

also developed rapidly in the era of the blockbuster ushered in by *Jaws* (1975) and *Star Wars* (1977), movies with expensive budgets that promised shocking, stunning, or simply wondrous images. Although the robotic shark in *Jaws* remained mostly unseen, George Lucas's Industrial Light & Magic used both traditional models and computer-based effects to characterize the *Star Wars* franchise and, in time, much of Hollywood film culture **[Figure 4.13]**.

The spectacular qualities of motion pictures are on display in the IMAX format and projection system developed in the 1970s. The IMAX large-format film system is projected horizontally rather than vertically to produce an image approximately ten times larger than the standard 35mm frame. The higher resolution is displayed in special venues featuring giant screens and stepped seating, although many theater chains have adopted a digital version of IMAX that allows them to project in this format without the system's original size and space requirements.

In the 1970s, documentary filmmakers and artists also began to shoot on **video** — an electronic recording medium initially used in television that captures and displays moving images — as a distinct alternative to filming on celluloid. Although the quality of a video image differed from a film image, the high costs and inconvenience of film stock and developing made the video process less expensive and more immediate. With the development of camcorders and video-cassette recorders (VCRs) in the 1980s, the format spread widely among consumers. Evolving broadcast and consumer video technologies (including Portapak, U-matic, Beta, and VHS) were analog formats (converting a continuous signal into one at an analogous speed in order to record on magnetic tape) that paved the way for the industrial and consumer embrace of even more lightweight and versatile digital video in the next decade.

1990s to the Present: The Digital Era

The shift to digital filmmaking is a critical transition in the history of cinematography. Rather than being recorded on film or magnetic tape, digital images are captured and stored as binary code on hard drives or other storage media. The format does not use film stock and thus does not require processing in a laboratory, physical editing, or postproduction effects. The process is less costly and allows for manipulation and exact reproduction of the image at various stages of the filmmaking and exhibition process. As early as the mid-1970s, the film industry developed digital technology to enhance visual effects. Animation, historically dominated by Walt Disney Studios, became an important sector of the film market with the advent of computer-generated imagery (CGI), especially in the productions of Pixar and DreamWorks studios.

The development of nonlinear editing systems greatly improved efficiency, and digital editing was quickly incorporated into studio filmmaking. Eventually, **digital cinematography** (shooting with a camera that records and stores visual information electronically as digital code) became a viable alternative to 35mm film in image quality. *Star Wars: Episode II — Attack of the Clones* (2002) was the first high-profile film to be shot in high-definition (HD) digital video. With increasing processing power and storage capacity, digital technology continues to transform cinematography, from the amateur to the blockbuster level. For

example, the feature film *Tangerine* (2015) was shot on the streets of Los Angeles on an iPhone 6.

Technically, the digital image offers advantages and disadvantages that have challenged the cinematographer's traditional role and led to innovations. With the economic advantage of lightweight and mobile cameras, digital moviemaking can be more intimate than 35mm cinematography, which involves large cameras and more crew members. Digital cinematography is not restricted by the length of a reel of film, allowing for longer takes. Initially, the quality of digital images suggested the immediacy of home movies or news footage. In independent filmmaker Rebecca Miller's *Personal Velocity* (2002), cinematographer Ellen Kuras films three women's stories with emotional texture and intimacy using miniDV (digital video) cassettes. With improvements in frame rate, resolution, and light sensitivity, digital cameras became attractive to studio filmmakers, with early adopters, like Robert Rodriguez, choosing them to shoot their films.

Digital cinematography also had several disadvantages when it was first introduced. Although a cinematographer could predict how a particular film stock responds to light, shooting digitally depends more on familiarity with the camera's capabilities. Digital images are recorded and displayed in pixels (densely packed dots) rather than the grain produced by the celluloid emulsion used for film. Innovations within the film industry — like the high-end Genesis camera, Peter Jackson's use of forty-eight frames per second in the *Hobbit* franchise, and better lenses — have attempted to surpass the quality of 35mm cinematography. In 2009, the first Hollywood features were shot using 4K resolution, roughly equivalent to 35mm, and digital cinematography eclipsed shooting on film as an industry standard. But both formats have their aesthetic champions, a debate explored in the 2012 documentary *Side by Side*.

Digital technology also changes the role played by the cinematographer, who traditionally was central only to the production phase of filmmaking. The convenience and aesthetic potential of scanning a film digitally to make a **digital intermediate (DI)** — a digitized version of a film that allows it to be manipulated — were soon recognized. This led to a new working relationship between the cinematographer and the visual effects supervisor as color and other elements of the image were manipulated in postproduction. On *O Brother Where Art Thou?* (2000), cinematographer Roger Deakins used the digital intermediate not only to enhance certain sequences but to adjust the entire film to a sepia tone. Such aesthetic decisions involve the cinematographer in more phases than only image capture.

Since *Avatar* (2009) ushered in a second era of 3-D spectaculars that now use digital technology, theaters have converted projection systems from 35mm to digital to accommodate these new films. In this rapid change, digital projection from a hard drive called a **digital cinema package (DCP)** (a collection of digital files that store and convey audio, image, and data streams) surpassed 35mm film exhibition in 2012. The debate between shooting on film and shooting on digital continues to have aesthetic currency, but economics has decided the question of exhibition in favor of digital.

As cinematography continues to develop, traces of its artistic past constantly resurface. Russian iconography permeates the images of Andrei Tarkovsky's *Andrei Rublev* (1969) **[Figures 4.14a and 4.14b]**. In Raoul Ruiz's *Time Regained* (1999), rich color tones re-create the vibrancy of magic lanterns. And the traditional animation of *The Secret of Kells* (2009) emulates the medieval illuminated manuscript known as the Book of Kells **[Figures 4.15a and 4.15b]**. In virtually every movie we see, our experience of its images is affected by the history of fine art, photography, and other movies.

(a)

(b)

4.14a and 4.14b A Russian icon painting from the sixteenth century and a scene from *Andrei Rublev* (1969). **(a)** Andrei Rublev's medieval art is invoked in **(b)** the composition and lighting of Tarkovsky's film about the great Russian icon painter. (a) Icon of St. John the Baptist (tempera on panel) by Rublev, Andrei (c. 1370–1430), Andrei Rublev Museum, Moscow, Russia/Bridgeman Images; (b) Photofest, Inc.

(a)

(b)

4.15a and 4.15b *The Secret of Kells* (2009). The Oscar-nominated animated feature *The Secret of Kells* uses traditional 2-D animation to reproduce the style of a medieval illuminated manuscript. Print Collector/Getty Images

The Elements of Cinematography

The basic unit of cinematography and the visual heart of cinema is the **shot**—a continuous point of view (or continuously exposed piece of film) between two edits. The shot runs across a series of individual, still film **frames**. The camera may move forward or backward, up or down, but the film does not **cut** to another point of view or image. A cinematographer shooting a high schooler's home the morning after a wild party may depict the scene in different ways. One version might show the entire room—with its broken window, a fallen chair, and a man slumped in the corner—as a single shot that surveys the wreckage from a calm distance. Another version might show the same scene in a rapid succession of shots—the window, the chair, and the man—creating a visual disturbance missing in the first version. What viewers see onscreen depends on the cinematographer's point of view, and creating, representing, and conveying meaning to an audience can be done within a remarkable range of options—including framing, depth, color, and movement. For the astute viewer, recognizing and analyzing how these options are used in a film can be one of the most satisfying ways to experience and understand that film.

Point of View

In cinematographic terms, **point of view** refers to the position from which a person, an event, or an object is seen or filmed. All shots have a point of view. A **subjective point of view** re-creates the perspective of a character as seen through the camera, whereas an **objective point of view** does not associate the impersonal perspective of the camera with that of a specific character. Scenes of the road ahead capture Furiosa's subjective point of view as she drives in *Mad*

4.16a–4.16d *Carrie* (1976). Brian De Palma utilizes different points of view in a single sequence: (a) an overhead shot that shows Sue's realization of the cruel trick about to be played on Carrie; (b) an objective shot that introduces a teacher's subjective point of view; (c) a shot from the perspective of the hidden perpetrators; and (d) the distorted perception of the victim.

Max: Fury Road (2015), whereas an establishing shot of the citadel from which she flees is objective.

A scene's point of view may be discontinuous. For instance, in the suspenseful climactic prom scene of *Carrie* (1976), as one of the protagonist's classmates, Sue, watches the crowning of the prom king and queen from backstage, she spots a rope leading above the curtain and follows it with her eyes before investigating where it leads **[Figure 4.16a–4.16d]**. The gym teacher watches but does not understand Sue's movements. A point-of-view shot from under the stage reveals where Chris and her boyfriend are hiding to play a cruel trick on Carrie. Finally, Carrie's humiliation leads to a distorted point-of-view shot of a laughing crowd of students, which incites her to punish them with her telekinetic powers.

In the spectacular, immersive opening attack of *The Revenant* (2015), the camera moves through a chaotic attack on the fur trappers by shifting from subjective to objective and then to another subjective point of view in one continuous take.

Four Attributes of the Shot

Every shot orchestrates four important attributes—framing, depth of field, color, and movement. The distance, angle, and height of the camera determines the portion of the filmed subject that appears within the borders of the frame, or **framing**. The range or distance before and behind the main focus of a shot within which

4.17 *Bend It Like Beckham* (2002). A mobile camera increases the viewer's excitement during the winning goal.

VIEWING CUE

LaunchPad Solo

Watch the clip from *Touch of Evil* (1958), and make a sketch or sketches of each shot. Describe how the framing and depth of field contribute to perception of the scene.

objects remain relatively sharp and clear is its **depth of field**.

Elements of cinematography such as choice of film stock and lighting give an image a particular visual quality. None is as prominent as color, which conveys aesthetic impressions as well as visual cues. Finally, a film image or shot may depict or incorporate movement. When the camera moves or the borders of the image are altered by a change in the focal length of the camera lens to follow an action or explore a space, it is called a **mobile frame**. For example, during the championship match in *Bend It Like Beckham* (2002), the mobile frame of the shot shows the protagonist as she darts down the field on her way to scoring the winning goal. The movement of the shot captures the strength and dexterity of her strides in a single motion [**Figure 4.17**].

Framing

Although we may not be accustomed to attending to every individual image in a movie, each involves careful construction by filmmakers and rewards close observation by viewers. In an early experiment with the power of framing, Abel Gance's *Napoléon* (1927) orchestrated three images to appear simultaneously side by side on different screens at the film's rousing climax, culminating in tinted images to recall the French flag [**Figure 4.18**]. Since then, filmmakers have experimented with and refined ways to manipulate the film frame. A **canted frame** is framing that is not level, creating an unbalanced appearance. It is produced by tilting the camera to the side. Such unbalanced framing famously recurs in *The Third Man* (1949) to indicate that things are not always what they appear to be [**Figure 4.19**]. But even when the shape or alignment of the frame itself is not altered, framing determines what we see. A director and cinematographer will use different set-ups to film a single scene; this **coverage** gives the editor enough footage to shape the scene in different ways. The three dimensions of the film image—the height and width of the frame and the apparent depth of the image—offer endless opportunities for representing the world and the ways we see it. Here we examine and detail the formal possibilities inherent in every shot that, when recognized, enrich our experience of the movies.

Aspect Ratio. Like the frame of a painting, the basic shape of the film image on the screen determines the composition. The **aspect ratio** is the width-to-height ratio of the film frame as it appears on a movie screen or television monitor. *Grand Illusion* (1937), *Citizen Kane*, and other classic films employ the **academy ratio** of 1.37:1—an aspect ratio of screen width to height that was adopted by the American Academy of Motion Picture Arts and Sciences in 1932 and used by most films until the introduction of widescreen ratios in the 1950s. These dimensions are closely

4.18 *Napoléon* (1927). The climax of Abel Gance's historical tour-de-force juxtaposed images on three screens, creating a visual connection between Napoleon and thoughts of his wife, Josephine, as he presses his army to victory. Sgf/Gaumont/REX/Shutterstock.com

approximated by the television screen and are rendered as 4:3 in digital formats. This almost-square image draws on associations between the film frame and a window or picture frame. **Widescreen ratios**, which have largely replaced academy ratio since the early 1950s, range from 1.66:1 to CinemaScope at 2.35:1. The widescreen ratio 1.85:1 is widely prevalent and corresponds to the digital aspect ratio 16:9 — the shape of widescreen television sets [**Figure 4.20**].

Aspect ratios often shape our experience to align with the themes and actions of the film. For example, CinemaScope, which uses an anamorphic (or compressed) lens to achieve a widescreen ratio of 2.35:1, was first used for religious epics and musicals. In Nicholas Ray's 1955 drama of teenage frustration and fear, *Rebel Without a Cause*, the elongated horizontal CinemaScope frame depicts the loneliness and isolation of Jim Stark (played by James Dean) in a potentially violent showdown with a high school rival and bully [**Figure 4.21**]. Outside the planetarium, Ray's cinematography conveys the city below as an unreachable place for these small-town youths who seem overwhelmed by social and psychological distances. Compared to the more confined frame of *Citizen Kane*, which depicts a man who is driven to control the world, the widescreen space in *Rebel Without a Cause* suits the fitful searching of restless teens. Both films use carefully composed frames that highlight their respective screen dimensions.

Although aspect ratio may not be a crucial determinant in every movie — both 1.85:1 and 2:35:1 are used widely today — it does not escape the consideration of the filmmaker. For instance, Stanley Kubrick shot his war film *Full Metal Jacket* (1987) in academy ratio rather than widescreen, which had become standard by the time he shot the film [**Figure 4.22**]. With this choice, Kubrick emphasizes a central theme — that the Vietnam War entered world consciousness through the box-like screen of television.

The changes in film ratios over the years have presented interesting challenges when movies appear on television or are recorded to tape or disc. For a long time, most television broadcasts and home video releases were reformatted to fit the TV screen through the **pan-and-scan process**, which is used to transfer a widescreen-format film to the standard television aspect ratio. A computer-controlled scanner determines the most important action in the image and then crops peripheral action and space or presents the

4.19 ***The Third Man*** (1949). Suspicions about Orson Welles's character Harry Lime are reinforced by the canted framing.

4.20 ***Hail, Caesar!*** (2016). The 1:85:1 ratio introduced in 1953 quickly became standard and is approximated in the 16:9 ratios of television and computer screens.

4.21 ***Rebel Without a Cause*** (1955). Nicholas Ray uses the exaggerated width of the CinemaScope frame to show Jim Stark (James Dean) cornered above the streets of Los Angeles.

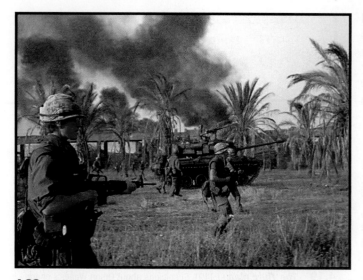

4.22 *Full Metal Jacket* (1987). Stanley Kubrick's use of academy ratio emphasizes the role played by television in transmitting the images of the Vietnam War to the American public.

4.23 *The Night of the Hunter* (1955). An iris-out emphasizes the threat of a figure of evil.

4.24 *Star Wars* (1977). The Star Wars franchise refers to the movie past through outdated cinematographic techniques such as this wipe used to transition between scenes—a stylistic touch that persists throughout the series' 40-year history.

original frame as two separate images. Reframing the image in these ways causes loss of elements of the picture. Wider aspect ratios are preserved by the **letterbox** format, in which the top and bottom strips of the frame are blacked out to accommodate a widescreen image.

DVDs, developed in 1995, made letterboxing much more common, and since the popularization of digital media about a decade later, television sets have been manufactured to display the horizontal proportions of widescreen cinema frames. This means it may be difficult to tell whether one is viewing a film in its original, or **native aspect ratio**. Wider aspect ratios are commonly slightly cropped to fill a flatscreen television, although some 2.35:1 features are now letterboxed. Blu-rays and DVDs tend to be more accurate, although even these formats can be adjusted slightly to fill a TV screen.

Masks. Besides the proportions determined by the aspect ratio, a film frame can be reshaped by various **masks**—attachments to the camera or devices added optically that cut off portions of the frame so that part of the image is black. Mostly associated with silent films like D. W. Griffith's *Intolerance* (1916), a masked frame may open only a corner of the frame, create a circular effect, or leave just a strip in the center of the frame visible. In an **iris** shot, the corners of the frame are masked in a black, usually circular, form. In Harold Lloyd's *The Freshman* (1925), a shot of a timid collegian first appears in an iris-in (a transition that expands the small circle to reveal the entire image) to show him surrounded by a crowd of hostile football players. Conversely, a full image may be reduced, as an iris-out (a transition that gradually obscures the whole image by decreasing the circle to focus on one object), to isolate and emphasize a specific object or action in that image, an effect that often is parodied in classic cartoons. In *The Night of the Hunter* (1955), an iris-out follows the demonic preacher as he walks toward the house of the children he threatens **[Figure 4.23]**. When such techniques are used in modern movies like the *Star Wars* franchise, it is often with self-conscious reference to an earlier filmmaking style. Masks also are used in special effects cinematography to leave part of the film unexposed. A second image is then filmed on that portion of the frame, and the two are combined in the printing or postproduction process **[Figure 4.24]**.

Composition. As with any visual medium, the arrangement of the pictorial elements within the frame is crucial in cinematography. **Onscreen space** refers to the space visible within the frame of the image, whereas **offscreen space** is the implied space or world that exists outside the film frame. Onscreen space is created by carefully framing mise-en-scène so that the position, scale, and balance of objects or lines within the frame direct our attention or determine our attitude toward what is being represented. Composition may make use of static vertical and horizontal lines or dynamic diagonals, or it may draw the eye into the image through depth cues. Wes Anderson's style is instantly recognizable in his frequent use of symmetrical compositions **[Figure 4.25]**.

◀ VIEWING CUE

Identify the original aspect ratio of the film you are studying in class. How is it appropriate or inappropriate to this film's themes and aims? If the film is exhibited in a different ratio, explain how that process affects certain scenes.

Some practices of composition are so widely adopted they are referred to as rules. For example, the **rule of thirds** is a technique that imagines the frame divided horizontally and vertically into thirds and dictates placing objects along these lines for maximum visual interest. Leaving **lead room**—the space in front and in the direction of an object being filmed—balances the viewer's tendency to look at that space. However, there are infinite ways to fill a film frame, and the distinctiveness of a director's collaboration with a cinematographer may lie in the exceptions that they make to these rules.

4.25 *The Grand Budapest Hotel* (2014). Director Wes Anderson's symmetrical compositions are an instantly recognizable feature of his film's distinctive style.

The action taking place in offscreen space is usually less important than the action occurring in the frame, as when a close-up focuses on an intimate conversation and excludes other people in the room. Offscreen space sometimes contains important information that will be revealed in a subsequent image, however, as when one person engaged in conversation looks beyond the edge of the frame toward a glaring rival shown in the next shot. Offscreen spaces in horror films like *Alien* (1979) seethe with a menace that is more terrifying because it is not visible **[Figure 4.26]**. In Robert Bresson's films, offscreen space suggests a spiritual world that exerts pressure on but eludes the fragmented and limited perspectives of the characters within the frame **[Figure 4.27]**.

4.26 *Alien* (1979). The horror genre makes significant use of offscreen space to generate suspense. What is Ripley (Sigourney Weaver) going to see?

Camera Distance. Another significant aspect of framing is the distance of the camera from its subject, which determines the **scale** of the shot, signals point of view, and contributes greatly to how we understand or feel about what is being shown. **Close-ups** are framings that show details of a person or an object, such as the face or hands or a flowerpot on a windowsill, perhaps indicating nuances of the character's feelings or thoughts or suggesting the special significance of the object. Breaking with

4.27 *L'Argent* (1983). The agency of characters in Robert Bresson's films often seems to be limited by external forces that are signified by the emphasis on offscreen space.

4.29 ***Requiem for a Dream*** (2000). An extreme close-up of a pupil dilated from drug use signals the film's unusual perspective.

4.28 ***The Passion of Joan of Arc*** (1928). Carl Theodor Dreyer captures the intensity of religious faith through close-ups of actress Renée Falconetti's portrayal of Joan of Arc.

traditions of establishing figures in space, Carl Theodor Dreyer's *The Passion of Joan of Arc* (1928) makes striking use of close-ups to depict religious fervor through the heroine's facial expressions **[Figure 4.28]**. An **extreme close-up** is a shot that is framed comparatively tighter than a close-up, singling out, for instance, an insect or a hand. *Requiem for a Dream* (2000) uses extreme close-ups inventively to render the perceptual distortions of drug addiction **[Figure 4.29]**.

At the other end of the compositional spectrum, a **long shot** places considerable distance between the camera and the scene, object, or person being filmed so that the object or person is recognizable but is defined by the large space and background. An **extreme long shot** is framed from a comparatively greater distance than a long shot; the surrounding space dominates human figures. The larger space of the image dwarfs objects or human figures, such as with distant vistas of cities or landscapes. Most films feature a combination of these long shots—sometimes to show distant action or objects, sometimes to establish a context for events, and sometimes, as with the introduction and conclusion of *Shane* (1953), to emphasize the isolation and mystery of a character in the distance **[Figures 4.30a and 4.30b]**.

 VIEWING CUE

Look for a pattern of framing distances in the next film you view for class. Do there seem to be a large number of long shots? Close-ups? Explain how this pattern reinforces themes of the film.

(a) (b)

4.30a and 4.30b ***Shane*** (1953). Barely seen, Shane approaches through an extreme long shot. Then the mysterious figure becomes more recognizable in a long shot.

4.31 *Ghostbusters* (2016). Physical comedy requires framing wide enough to allow for interaction between the characters and the mise-en-scène. A medium shot captures the scientist in the context of her lab.

Between close-ups and long shots, a **medium shot** is a middle-ground framing in which we see the body of a person from approximately the waist up. A medium shot of the scientist played by Kate McKinnon in *Ghostbusters* (2016) shows part of her laboratory behind her **[Figure 4.31]**. A **medium long shot** slightly increases the distance between the camera and the subject compared with a medium shot, showing a three-quarter-length view of a character (from approximately the knees up). This framing often is used in westerns when a cowboy's weapon is an important element of the mise-en-scène **[Figure 4.32]**.

A very common framing because of its use in conversation scenes, the **medium close-up** shows a character's head and shoulders. Melodramatic or romantic films about personal relationships may feature a predominance of medium close-ups and medium shots that capture the facial expressions of the characters. In *Ginger & Rosa* (2012), which focuses on a young woman's coming of age, the protagonist's view of the behavior of the people around her is frequently captured in medium close-up **[Figure 4.33]**. Open-air adventures—such as *The Seven Samurai* (1954), the tale of a sixteenth-century Japanese village that hires warriors for protection—tend to use more long shots and extreme

4.32 *Red River* (1948). The medium long shot was often used in westerns to keep weapons in view. French critics dubbed it the *plan américain* or "American shot."

4.33 *Ginger & Rosa* (2012). In this coming-of-age story set in the 1960s, the heroine's perspective is emphasized by frequent medium close-ups of her taking in what's happening around her.

4.34 *The Seven Samurai* (1954). An extreme long shot shows off the open-air battles in this epic.

4.35 *Tokyo Story* (1953). A camera placed low to the ground presents characters sitting on tatami mats.

4.36 *Far from Heaven* (2002). The height of the opening crane shot establishes the setting and introduces a sense of distance.

long shots in order to depict the battle scenes **[Figure 4.34]**. As these descriptions imply, framing is defined relatively; there is no absolute cut-off point between a medium shot and a medium long shot, for example. As we have seen, the most common reference point for the scale of the image is the size of the human figure within the frame, a measure that is not a universal element of the cinematic image.

Although many shots are taken from approximately eye level, the **camera height** also can vary to present a particular compositional element or evoke a character's perspective. Japanese director Yasujiro Ozu's signature camera level is low to the ground, an ideal position for filming Japanese interiors, where characters sit on the floor **[Figure 4.35]**. A camera might be placed higher to show large-scale objects, such as tall buildings or landscapes. The height of the opening shot of *Far from Heaven* (2002) mimics that of the opening of Douglas Sirk's *All That Heaven Allows* (1955); the distance sets up the films' vision of 1950s small-town repression **[Figure 4.36]**. When the camera is mounted on a crane to achieve such height, the shot is called a **crane shot**.

Camera Angles. Film shots are taken from a multitude of angles, from straight on to above or below. These often are correlated with camera height, as demonstrated by the series of shots from Jane Campion's *The Piano* (1993), a film about a mute Scottish woman who travels with her daughter to New Zealand to complete an arranged marriage. **High angles** are shots directed at a downward angle on individuals or a scene **[Figure 4.37]**, and **low angles** are shots from a position lower than its subject **[Figure 4.38]**. In either case, the exact angle of the shot can vary from very steep to slight. An **overhead shot** depicts the action from above, generally looking directly down on the subject from a crane or helicopter **[Figure 4.39]**. In the Czech film *The Shop on Main Street* (1965), a clever opening crane shot looking down on the town reflects the point of view of a stork nesting on a chimney. Shots can vary in terms of horizontal angles as well, with characters' faces more often shown in three-quarter view than in profile or frontally.

Shots change their angle depending on the physical or geographical position or point of view, so that a shot from a tall adult's perspective may be a high-angle shot, whereas a child's view may be seen through low angles. Such shots are often **point-of-view (POV) shots**, which are subjective shots that reproduce a character's optical point of view, often preceded or followed by shots of the character looking. They may incorporate camera movement or optical effects as well as camera height and angle in order to indicate point-of-view. Camera angles can sometimes indicate psychological, moral, or political meanings in a film, as when victims are seen from above and oppressors from below, but such interpretations must be made carefully. Formal features like these assume particular meanings in the context of the film's own patterns.

4.37 *The Piano* (1993). A high-angle long shot of the arrival on the beach.

4.38 *The Piano* (1993). An extreme low-angle shot, slightly canted, shows the farmer/husband as he furiously descends toward his unfaithful wife.

Depth of Field

In addition to the various ways an image can be framed to create perspectives and meanings, shots can be focused to create different layers of depth that subtly shape our understanding. As noted in the history section of this chapter, technological advances in camera lenses played a central role in allowing filmmakers to experiment with this element in a variety of ways. One of the most dramatic products of these developments is **deep focus**—a camera technique using a large depth of field in which multiple planes in the shot are all in focus simultaneously.

A film about three physically and psychologically brutalized veterans returning home from World War II, William Wyler's *The Best Years of Our Lives* (1946), shot by Gregg Toland, provides superior examples of

4.39 *The Piano* (1993). With this overhead shot, the film depicts a rare moment of contentment and harmony at the piano.

how deep focus can create relationships within a single image. In one image, the two grown children in the foreground frame the happy reunion of their parents in the background, all in harmonious balance and focus, with just a hint of the theme of isolation that will be developed after the homecoming **[Figure 4.40]**. In another image from the same film **[Figure 4.41]**, shallow focus, in which only a

4.40 *The Best Years of Our Lives* (1946). The deep focus and balanced composition indicate restored family harmony at a soldier's homecoming.

4.41 *The Best Years of Our Lives* (1946). The focused foreground of embracing lovers leaves the background of the veteran's artificial arms barely visible.

4.42 ***Still Alice*** (2014). The protagonist's sudden confusion with her surroundings is conveyed through shallow depth of field.

narrow range of the field is focused, is used. Here the choice of a depth of field indicates that what is significant in the image is the embracing lovers. With a **rack focus** (or **pulled focus**), there is a rapid change in focus from one object to another, such as refocusing from the face of a woman to the figure of a man approaching from behind her. The effect can emphasize depth of field or avoid cutting in a dialogue scene. Within the confined space of the bridge of the USS *Enterprise*, rack focus draws attention to the response of the aircraft carrier's crew to a command. The manipulation of focus also can be used to convey a subjective effect, as when the protagonist of *Still Alice* (2014), a professor at Columbia University suffering from early-onset Alzheimer's disease, becomes disoriented when running on what should be familiar campus terrain **[Figure 4.42]**.

Contrast and Color

Color profoundly affects our experience and understanding of a film shot. Even black-and-white films use contrast and gradations to create atmosphere or emphasize certain motifs. In F. W. Murnau's *Nosferatu* (1922), black and white and tones of gray create an ominous world where evil lives not in darkness but in shading **[Figure 4.43]**. Contemporary use of black and white can evoke a "lo-fi" or improvised aesthetic. In *Frances Ha* (2013), writer-director Noah Baumbach uses a digital version of monochrome to make his New York-set film recall French New Wave films **[Figure 4.44]**. *Computer Chess* (2013) goes so far as to use a vintage black-and-white tube camera to produce the soft look of analog video footage from the early 1980s **[Figure 4.45]**. *Pleasantville* (1998) was one of the first films to use digital processing to manipulate color in the service of the plot. In it, the world of a black-and-white 1950s television show switches to color as metaphor for the characters' emotional awakening.

Color can be described by **hue** (such as yellow or purple, discerned by detecting light of a particular wavelength), **value** (degree of lightness or darkness), and **intensity** (brightness or dullness). Beginning with the locations, set decoration, and actors' costumes and enhanced by lighting, color can be used to sharpen, mute, or balance the effects of the scene. For example, when used effectively, metallic blues, soft greens, and deep reds can elicit very different emotions from viewers **[Figure 4.46]**. Color film stocks allow a

4.43 ***Nosferatu*** (1922). Diffuse shadows and shades of gray create an atmosphere of dread.

4.44 *Frances Ha* (2012). This modest story of young New Yorkers uses black and white to recall both its French New Wave influences and Woody Allen's *Manhattan* (1979).

full range of colors to be registered on film, and digital cameras record red, green, and blue color values separately before combining them. After colors are recorded, they can be manipulated to create **color balances** – the adjustment of particular parts of the color spectrum to create realistic or unrealistic palettes. These may appear as either noncontrasting balances (sometimes called a monochromatic color scheme), which can create a more realistic or flat background against which a single color becomes more meaningful, or contrasting balances, which can create dramatic oppositions and tensions through color.

Color is a key element in the composition of the image. The spectacular nature of the Technicolor process was used for heightened emotional effect by masters of cinematography like Jack Cardiff in *The Red Shoes* (1948), in which a dancer's experience takes on the vividness of her red shoes. When color ceased to be a novelty, it was used for both realist and expressive purposes. For example, Néstor Almendros filmed Terrence Malick's *Days of Heaven* (1978) at the "magic hour" just before sunset to capture a particular quality of light for the historical setting in the Great Plains. The five sections of Zhang Yimou's martial arts epic *Hero* (2004), shot by Christopher Doyle, are correlated with five different colors to emphasize its prismatic narrative of betrayal.

4.45 *Computer Chess* (2013). Director Andrew Bujalski, whose previous features were shot with a handheld 16mm camera, uses an outdated black-and-white video technology for this film to evoke the milieu of early 1980s computing culture and the existential edge of machine intelligence.

4.46 *Pariah* (2011). Cinematographer Bradford Young and director Dec Rees designed their film's palette to reflect the heroine's search for identity.

4.47a

4.47b

4.47c

4.47d

4.47e

FORM IN ACTION

Color and Contrast in Film

The expressive use of color in film has evolved through artistic vision and technical innovation—from hand tinting to Technicolor experiments, faster stocks, and digital processing. Early silent films like *King Lear* (1910) created an impression of color film through its hand-tinted frames **[Figure 4.47a]**, an effect reconstructed by the British Film Institute's preservation of a print. Because of the time and labor involved, this practice never became a widespread phenomenon. Before releasing *Snow White and the Seven Dwarfs* (1937), Disney introduced the three-strip Technicolor process through a series of vibrant short films like *Flowers and Trees* (1932) **[Figure 4.47b]**. This short, part of the *Silly Symphonies* (1929–1939) series, became a sensation and was followed in 1935 by the first Technicolor feature. DeLuxe color and CinemaScope were advertised along with the stars of *The Girl Can't Help It* (1956), a Jayne Mansfield rock-and-roll farce that spoofs advertising culture, to attract audiences to the movie spectacle **[Figure 4.47c]**. The movie opens in black and white until an onscreen host reveals its "gorgeous, lifelike color." The advent of digital technology in the 1990s made possible the saturated visuals of computer-generated imagery in animated films like *Up* (2009) **[Figure 4.47d]**, as well as the altering of color in postproduction. A color script laid out the movie's moods and tones and guided animators through the transition into bright images when the elderly man, Carl, embarks on his adventure. Yet some filmmakers still favor the depth and richness of recording color on film, as in the 65mm format used to film most of *The Master* (2012) **[Figure 4.47e]**, which preserved more detail and color nuance than either 35mm or digital formats.

FORM IN ACTION

LaunchPad Solo

To watch a clip about color and contrast in *The Master* (2012), see the *Film Experience* LaunchPad.

Selection of film gauge and stock, which can vary in speed (a measure of a stock's sensitivity to light), manipulation of exposure, and choices in printing, can all affect the color and effects of a particular film. Cinematographer Rodrigo Prieto used different stocks, cameras, and lenses to achieve the looks of three interconnected stories that span the globe in *Babel* (2006). High-end digital cameras can now capture full resolution color data; **color grading** is the process of altering the image after capture, either digitally or photochemically.

Lighting, which is crucial to a film's palette and color effects, comes under the direction of the cinematographer during the production process. See Chapter 2 for a fuller discussion of lighting as an aspect of mise-en-scène.

Movement

Movement in movies re-creates a part of the human experience that could be represented only after the advent of film technology. In our daily lives, we anticipate these movements of a shot—for instance, when we focus on a friend sitting at a table and then refocus beyond that friend on another person standing at the door, when we stand still and turn our head from our left shoulder to our right, or when we watch from a moving car as buildings pass. As these adjustments within our field of vision do, the camera can move (by panning, tilting, or tracking) and then refocus (by adjusting the lens to zoom in or out).

Reframing refers to the process of moving the frame from one position to another within a single continuous shot. One extreme and memorable example of reframing occurs in the flashback to the protagonist's childhood in *Citizen Kane*. Here the camera pulls back from the boy in the yard to reframe the shot to include his mother observing him from inside the window. It then continues backward to reframe the mother as she walks past her husband and seats herself at a table next to the banker Thatcher, who will take charge of their son **[Figures 4.48a–4.48c]**. Often such reframings are much more subtle, such as when the camera moves slightly upward so that a character who is rising from a chair is kept centered in the frame.

Pans and Tilts. Pans and tilts are mobile frames in which the camera mount remains stationary. A **pan** (short for "panorama") is a left or right rotation of the camera, whose tripod remains in a fixed position. It produces a horizontal movement onscreen. In other words, the camera pivots on its vertical axis, as if a character is turning his or her head. For example, the long shot that scans the rooftops of San Francisco for a fugitive at the beginning of *Vertigo* (1958) is a pan, as are many similar establishing shots of a skyline. During the last scene of *Death in Venice* (1970), a slow pan leaves the main character, Gustav von Aschenbach, as he walks onto the beach and then swings past a jetty to settle the shot on the turbulent ocean and the glowing horizon. The movement of this pan suggests the romantic yearning and searching that characterize the

(a)

(b)

(c)

4.48a–4.48c *Citizen Kane* (1941). The camera movement reframes three planes of the image and four characters to condense a traumatic moment in Kane's lost childhood.

4.49 *Death in Venice* (1970). A pan starts from the protagonist, crosses the beach, and scans the horizon, suggesting his state of mind as he calmly embraces suicide.

entire film and that now culminate in von Aschenbach's death **[Figure 4.49]**.

Less common, **tilts** are upward or downward rotations of the camera, whose tripod or mount remains in a fixed position, producing a vertical movement onscreen, as when the frame swings upward to re-create the point of view of someone looking at a skyscraper starting at street level and moving upward into the clouds. In Wim Wenders's *Paris, Texas* (1984), a story about a father and son searching for the boy's mother, repeated tilt shots become a rhetorical action, moving the frame up a flagpole with an American flag, along the sides of Houston skyscrapers, and into the sky to view a passing plane. In this case, vertical tilts seem to suggest an ambiguous hope to escape or find comfort from the long quest across Texas.

Tracking Shots. A **tracking shot** is taken by a mounted camera moving through **space**. It can also be called a **dolly shot** when the camera is moved on a wheeled dolly. Elaborate camera movements can be achieved in this way through intricate planning. Max Ophüls was famous for using lengthy, fluid tracking shots in his films — for example, following a waltzing couple in *The Earrings of Madame de . . .* (1953). This feature distinguishes the films he made in four different countries over the course of his career. In the remarkable first shot of Jean-Luc Godard's *Contempt* (1963), a camera on tracks moves forward into the foreground of the image, following a woman reading. When it reaches the foreground, the camera turns and aims its lens directly at us, the audience. When moving camera shots follow an individual or object, they sometimes are called **following shots**. In *The 400 Blows* (1959), a single following shot tracks the boy, Antoine Doinel, for eighty seconds as he runs from the reformatory school to the edge of the sea. Cameras can be raised on cranes, mounted on moving vehicles, or carried in helicopters to follow a movie's action.

Handheld and Steadicam Shots. Even greater mobility is afforded when the camera is carried by the camera operator. Encouraged first by the introduction of lightweight 16mm cameras and later by the use of video formats, **handheld shots** are often-unsteady film images produced by an individual carrying the camera. They frequently are used in news reporting and documentary cinematography or to create an unsteady frame that suggests the movements of an individual point of view. The Dogme 95 manifesto issued by several Danish filmmakers in 1995 called for updating the language of cinema through the use of handheld cameras, among other "rules" for fostering immediacy in filmmaking. After the first Dogme film, *The Celebration* (1998), the movement spread, with filmmakers outside Denmark intrigued by the challenge. The restless energy of the fifteen-year-old protagonist of *Fish Tank* (2009) as she faces the limited options of her upbringing and class position are palpably conveyed by the rushing handheld shots **[Figure 4.50]**. In these cases, the handheld point of view involves the audience more immediately and concretely in the action.

4.50 *Fish Tank* (2009). The film uses a handheld camera to capture the protagonist's frustrated energy and, when she films herself within the film, her isolation.

To achieve the stability of a tripod mount, the fluidity of a tracking shot, and the flexibility of a handheld camera, cinematographers may wear the camera on a special stabilizing mount often referred to by the trademarked name Steadicam. In *Goodfellas* (1990), a film about mobster Henry Hill, a famous Steadicam shot, lasting several minutes, twists and turns with Hill and his entourage through a back door, across a kitchen, and into the main room of a nightclub, suggesting the bravura and power of a man who can go anywhere, who is both onstage and backstage [**Figure 4.51**]. In the restaurant scene in *Kill Bill: Vol. 1* (2003), Quentin Tarantino goes even further, incorporating a crane in a virtuoso Steadicam sequence.

4.51 *Goodfellas* (1990). The long and winding trail of power behind the scenes is depicted in a three-minute Steadicam shot.

Zooms. A zoom occurs not when a camera is moved but when adjustments are made to the camera lens during filming that magnify portions of the image. The kind of compositional reframing and apparent movement that is accomplished with **zoom lenses**, which employ a variable focal length of 75mm or higher, are different than the kind of movement accomplished by a moving camera used during a tracking shot. During a **zoom-in**, the lens's focal length is changed to narrow the field of view on a distant object, magnifying and reframing it, often in close-up, while the camera remains stationary. Less noticeable in films, a **zoom-out** reverses the action of a zoom-in so that objects that appear close initially are distanced and reframed as small figures. Although camera movements (such as tracking or Steadicam shots) and changes in the lens's focal length (zooms) may serve the same function of bringing the focus of a shot closer or relegating it to the distance, there are perceptible differences in the images. In a zoom-in, the image tends to flatten and lose its depth of field, whereas a tracking shot calls attention to the spatial depth that the camera moves through. They also can vary in their significance. Long lenses were first introduced in photojournalism in the 1940s. The use of the zoom lens in *The Battle of Algiers* (1966) evokes the newsreel technology through which the historical events were initially scene. Sometimes these techniques are used together. In *Vertigo* (1958), Hitchcock used a track-in while zooming out to suggest his main character's feeling of vertigo. The effect changes the focus of the image while the image stays the same size.

Animation and Special Effects: The Impact of Computer-Based Imaging

Our visual experience is not just naturalistic. It also is fantastical, composed of pictures from our dreams and imaginations. These kinds of images can be re-created in film through two important manipulations of the image – animation and special effects. Both can be used to make film seem even more realistic or completely unreal. Both practices have been employed since the earliest days of cinema, but the adoption of digital technologies since the 1990s has transformed the interrelated areas of animation and special effects and challenged the definition and practice of cinematography.

VIEWING CUE

LaunchPad Solo

Examine this clip from *Rear Window* (1954) and describe the moving camera (tracks, pans) and mobile framings (zooms) that are used. Why is a moving frame used here instead of a series of shots?

VIEWING CUE

LaunchPad Solo

Examine this clip from *The Battle of Algiers* (1967), and describe the cinematography. How do these choices contribute to the movie's effects?

4.52 *Coraline* (2009). Henry Selick's distinctive stop-motion animation blurs the line between the heroine's real world and the alternative world where the characters have button eyes.

Animation

Animation is the use of cinema technology to give the illusion of movement to individual drawings, paintings, figures, or computer-generated images. **Traditional animation** includes moving images drawn or painted on transparent sheets of celluloid known as **cels**, which are then placed on a painted background and photographed in sequence onto single frames of film. Beloved films from *Snow White and the Seven Dwarfs* (1937) to *The Little Mermaid* (1989) create graphic narratives through traditional frame-by-frame drawings, coloring, and filming. Both were made by Walt Disney Studios, the most prominent Hollywood studio producing animated shorts and features for much of movie history. But most major studios also had animation divisions that produced thousands of cartoons throughout the golden age of Hollywood. Warner Bros. was particularly well known for its Merrie Melodies and Looney Tunes series, which often mocked the conventions of **live action movies** (movies using photographic images). Building on a long tradition of graphic literature and animation in the Japanese context, director Hayao Miyazaki and his Ghibli Studios are celebrated for continuing the use of 2-D animation in films like *Ponyo* (2008).

Another traditional animation technique is **stop-motion photography**, used in Henry Selick's 3-D *Coraline* (2009) **[Figure 4.52]**. Stop-motion photography records inanimate objects or actual human figures in different positions in separate frames and then synthesizes them on film to create the illusion of motion and action. A specific form of stop-motion animation, **claymation**, uses stop-motion photography with clay figures to create the illusion of movement. It was revived to great acclaim by Aardman Studios' Nick Park in British films like *Chicken Run* (2000). Claymation accomplishes the effect of movement with clay or plasticine figures, while **pixilation** employs stop-motion photography to transform the movement of human figures into rapid, jerky gestures. Czech filmmaker Jan Švankmajer's *Alice* (1988) combines live action, pixilation, and puppets to re-create the dizzying events of Lewis Carroll's story.

Today animation is accomplished predominantly through **computer-generated imagery (CGI)** (still or animated images created through digital computer technology). **Computer animation** is a digital version of traditional animation. Computer animation technology was developed to create spectacular visual effects sequences in live-action films, and in the digital age, the lines between animation and mainstream filmmaking increasingly have blurred. In 1995, Pixar, the pioneering studio in computer animation, released *Toy Story*, directed by John Lasseter, the first feature-length film composed entirely of CGI **[Figure 4.53]**. Since then, striking technological advances have contributed to the resurgence of animation as a medium and a creative tool. Renewed

4.53 *Toy Story* (1995). Pixar's first feature was the first computer-animated feature film to be released. The exaggerated crayon colors leap from the more balanced, natural tones of the realistic background.

appreciation for the craft of animation was reflected in the introduction in 2002 of a new Academy Award category for feature-length animated films. The first winner was *Shrek* (2001), from Pixar's rival studio, DreamWorks.

Although studios like Pixar (owned by Disney since 2006), DreamWorks, and Illumination continue to produce CGI blockbusters for all ages—in the *Cars* (2006–2017), *Madagascar* (2005–2018), and *Despicable Me* (2010–2017) series—independent filmmakers also have engaged with animation. Richard Linklater's *Waking Life* (2001) and *A Scanner Darkly* (2006) employ **rotoscoping**—a technique using recorded real figures and action on video as a basis for painting individual animation frames digitally **[Figure 4.54]**. *Waltz with*

4.54 *A Scanner Darkly* (2006). For this Philip K. Dick adaptation, Richard Linklater had his actors filmed digitally and then animated using a rotoscope technique.

Bashir (2008), an Israeli film about the horrors of the 1982 Lebanon war, contributed to the emerging genre of **documentary animation**—animation that tells true stories with enhanced moving images.

Animation has a long history in the fine arts, where filmmakers have used color, line, and rhythm for abstract, lyrical, or fantastic effect. But within commercial filmmaking, animation often emulates dimensions of live-action cinematography, including conventional framing, camera motion, and editing, even when it mocks such conventions, as in cartoons like Chuck Jones's famous short *Duck Amuck* (1953) **[Figure 4.55]**. As computer imaging has become more pervasive, animation frequently is used without calling attention to itself, with technological development focusing on ever greater **photorealism**—the reproduction in animation of the details obtained in photography. **Virtual cinematography** is the process of image capture in a computer environment, which may be incorporated into live-action cinematography or other computer-generated imagery.

4.55 *Duck Amuck* (1953). Daffy Duck's attempts to get a cartoon started are thwarted by an unseen animator, who breaks every filmic convention, even the shape of the frame in this self-reflexive Warner Bros. classic.

HISTORY CLOSE UP

Floyd Norman

Animator Floyd Norman has worked in Hollywood since the 1950s, on Disney and Pixar classics from *Sleeping Beauty* (1959) to *Monsters, Inc.* (2001) as well as well-known TV cartoons like *The Smurfs* (1981–1990) and *Alvin and the Chipmunks* (1983–1990). His numerous and varied credits attest to the vast teams and talents that go into traditional and digital animation processes: he has worked as an "inbe-tweener," a layout artist, a storyboard artist, and a story edi-tor. Norman's work behind the scenes is important to Hollywood history in another way: he was the first African American animator on staff at Disney, a pioneer in an industry that was and remains lacking in diversity. Born in 1935 in Santa Barbara, California, Norman grew up passionate about drawing and did not regard race as a barrier to enter-ing his chosen profession. He came to Disney in 1956 with a diverse group of young artists and worked alongside Walt Disney himself on the latter's final film, *The Jungle Book* (1967). Interested in creating images for and about African American children, he and a partner founded an animation studio, working on the animated special *Hey, Hey, Hey, It's Fat Albert* (1969) and later establishing the Web site Afrokids.com. Nor-man found a place in the new world of digital animation on *Toy Story 2* (1999) and, valuing the camaraderie of the studio production process, remains a fixture at Walt Disney Studios even after retirement. New documentaries—like *Floyd Norman: An Ani-mated Life* (Michael Fiore and Erik Sharkey, 2016) and *Tyrus* (Pamela Tom, 2015) on Chinese American artist Tyrus Wong, an unsung background artist on Disney's *Bambi* (1942)—encourage viewers to look beyond the onscreen image to mine the richness of buried Hollywood histories.

From Special Effects to Visual Effects

Since the dawn of cinema, filmmakers have employed **special effects**—techniques that enhance a film's realism or surpass assumptions about realism with spec-tacle. In fact, for Georges Méliès, the foremost illusionist of early cinema, the cinematographic illusion of motion was one of many special effects that included background paintings, smoke and mirrors, and tinted images. **Mechanical effects** are produced on set, often with sets, props, costumes and make-up, and include pyrotechnics (fires and explosions), weather effects, and scaled models. The earliest films also used **optical effects**—special effects produced with the use of an optical printer, including visual transitions between shots such as dissolves, fade-outs, and wipes, or process shots that combine figures and backgrounds through the use of matte shots. Optical effects also include basic manipulations of the camera, such as **slow motion** (or **fast motion**)—a special effect that makes the action move at slower-than-normal (or faster-than-normal) speeds, achieved by filming the action at a high speed (or slow speed) and then projecting it at standard speeds. Examples of optical effects produced in-camera include **forced perspective**, which is cre-ated by positioning the camera to create illusions of scale; **color filters,** which are devices fitted to the camera lens to change the tones of the recorded image; and the **dolly zoom,** the famous effect in Hitchcock's *Vertigo,* (1958), in which the camera is moved to keep the object the same size.

Another common optical effect is a **process shot**—a special effect that combines two or more images as a single shot, such as filming an actor in front of a projected background. In a process shot, an image can be set up in different ways and manipulated during filming and then completed in postproduction. A process shot might be used to add a background to the action on screen; in **rear projection** a projector is positioned behind a screen in front of which the actors perform. Rear projection often was used to provide the view through the window behind characters in a moving car **[Figure 4.56]**.

A **matte shot** is a process shot that joins two or more pieces of film, one with the central action or object and the other with a painted or digitally produced background that would be difficult to create physically for the shot. Elaborate matte paintings are used to create atmosphere, background, and a sense of scale in films such as *King Kong* (1933). Traveling mattes are required when a figure moves in the foreground **[Figure 4.57]**.

A process shot may be used to compose an abstract image that juxtaposes two or more competing realities. In an example of the use of special effects in an art film, Hans-Jürgen Syberberg's epic *Our Hitler* (1977) shows Hitler quietly eating dinner while, in rear projection, Jews arrive at concentration camps. At other times, the film reduces Hitler to a puppet onstage.

Visual effects (VFX) are special effects created in postproduction through digital imaging. With the advent of computer-generated imagery, the technologies and artistry of cinematography, animation, and visual effects began to overlap more and more. Science fiction, superhero, and action films became more dominant in the market as visual effects made possible images that would be too costly, dangerous, or challenging to film. Some visual effects use a combination of cinematography and computer techniques, such as the celebrated "bullet time" in *The Matrix* (1999), in which images taken by a set of still cameras surrounding a subject are put together to create an effect of suspension or extreme slow motion. In *Inception* (2010), recognizable images of cityscapes and mountain fortresses are remade as the fragile and malleable virtual shapes of a dreamscape through a combination of in-camera effects and CGI **[Figure 4.58]**. The

4.56 *Vertigo* (1958). Rear projection of a moving landscape while actors sit in a car in the studio is an effect that appears clumsy to contemporary viewers.

4.57 *King Kong* (1933). The jungle matte painting provides a mysterious background for stop-motion animation by Willis O'Brien.

4.58 *Inception* (2010). Images of real and virtual worlds merge in the production and postproduction process, appropriate to a drama that takes place in the layers of a dream.

4.59 *Rise of the Planet of the Apes* (2011). The increasing sophistication of performance-capture technology, including Andy Serkis's work as Caesar, the leader of the ape rebellion, allowed this remake to avoid using actual apes in filming.

fantasy world of Peter Jackson's *Lord of the Rings* trilogy (2001–2003) was created through a range of special effects that include the use of simple forced perspective (to put hobbit, elven, and human characters in proper scale) and the imaginative work of the New Zealand-based Weta Digital. The company innovated **performance-capture technology**, generating computer models from data gathered from actor Andy Serkis's physical performance and facial expressions and incorporating them into the character Gollum. Weta and Serkis later collaborated to create Caesar in *Rise of the Planet of the Apes* (2011) **[Figure 4.59]** and its sequels.

Making Sense of the Film Image

From the desert expanses of *Lawrence of Arabia* (1962) to the dreamscapes of *Inception* (2010), movie images have been valued for their beauty, realism, or ability to inspire wonder. Often these qualities are found in their production values. But film images carry other values in what they preserve and say about the world. French filmmaker Jean-Luc Godard's remark that film is truth twenty-four frames per second is one way to describe the power and importance of the film image. Yet as Godard's many films themselves demonstrate, this "truth" is not just the truth of presentation but also the truth of representation. In short, film images are prized both for their accuracy in showing or presenting us with facts and for the ways they interpret or represent them.

Defining Our Relationship to the Cinematic Image

Images hold a remarkable power to capture a moment. Flipping through a photo album provides glimpses of past events. The morning newspaper collapses a day of war into a single poignant image. However, images can do far more than preserve the facts of a moment. They also can interpret those facts in ways that give them new meanings. A painting by Norman Rockwell evokes feelings of warmth and nostalgia, while the stained-glass windows lining a cathedral aim to draw our spiritual passions. When motion is added, the power of images to

4.60 *Everest* (2015). Location shooting at base camp in Nepal rendered in IMAX 3-D presents viewers with evidence of nature's might.

show and interpret information magnifies exponentially. A film image may be designed both to present (to show the visual truth of the subject matter realistically and reliably) and to represent (to color that truth with shades of meaning).

The Image as Presentation

The image as presentation reflects our belief that film communicates the details of the world realistically, even while showing us unrealistic situations. We prize the stunning images of the forbidding mountain in *Everest* (2015) **[Figure 4.60]** as well as the dynamic close-ups of a boxing match in *Creed* (2015) for their veracity and authenticity in depicting realities or perspectives. In pursuing this goal, cinematography may document either subjective images (which reflect the points of view of a person experiencing the events) or objective images (which assume a more general accuracy or truth). In *Little Big Man* (1970), images from the perspective of a 101-year-old pioneer raised by Native Americans succeed in both ways. They become remarkably convincing displays of known historical characters and events—such as General George Custer at the Battle of Little Bighorn—and they poignantly re-create the perspective of the pioneer as he lived through and now remembers those events.

The Image as Representation

The image also can influence or even determine the meaning of the events or people it portrays by *re*-presenting reality through the interpretive power of cinematography. The image as representation is an exercise in the power of visual stimuli. The way in which we depict individuals or actions implies a kind of control over them, knowledge of them, or power to determine what they mean. When we frame a subject, we capture and contain that subject within a particular point of view that gives it definition beyond its literal meaning. This desire to represent through control over an image permeates the drama of *Vertigo* (1958)—in which the main character, Scottie, tries desperately to define the woman he was hired to follow, Madeleine, through appearances—and the cinematography aids him by framing her as a painting. Representation as power over images can be found at the heart of films as diverse as *Blonde Venus* (1932) and *Pan's Labyrinth* (2006), which in different ways show the ability of the film image to capture and manipulate a person or reality in the service of a point of view. In *Blonde Venus*, as in many of the films directed by Josef von Sternberg and starring Marlene Dietrich, the heroine is depicted as a self-consciously erotic figure, whether in an outrageous costume as a showgirl or as a housewife and mother at home. In *Pan's Labyrinth*, a young girl escapes from the frightening reality of her father's

4.61 *Pan's Labyrinth* (2006). A lonely child's fantasy world is represented as real to the viewer.

brutality during the Spanish Civil War into a fantasy world rendered real for the spectator through artful cinematography and special effects **[Figure 4.61]**.

Part of the art of film is that these two primary imagistic values—presentation and representation—are interconnected and can be mobilized in intricate and ambiguous ways in a movie. When Harry Potter speaks in the language of snakes in *Harry Potter and the Chamber of Secrets* (2002), the cinematography highlights the fear and confusion among Harry's classmates. Is the image an objective presentation of the perspective of the Hogwarts students, or is it an interpretive representation on the part of the film itself, trying to make the viewer think Harry is deserving of fear? A perceptive viewer must consider the most appropriate meanings for the shot—whether it reflects the students' position or the film's position. Watching closely how images carry and mobilize values, we encounter the complexity of making meaning in a film and the importance of our own activity as viewers.

VIEWING CUE

In the clip from *Vertigo* (1958), contrast a shot that presents an objective situation with one or more shots that seem to represent Scottie's particular reality.

Interpretive Contexts for the Cinematic Image

Our encounters with the values embedded in the images we experience shape our expectations of subsequent films. For some kinds of movies, like documentaries and historical fiction films, we have learned to see the film frame as a window on the world and seek accuracy in its images. For others, such as avant-garde or art films, we learn to approach the images as puzzles, perhaps revealing secrets of life and society. Here we designate two conventions in the history of the film image—the convention of image as presence and the convention of image as text. In the first case, we identify with the image; in the second, we read it.

Presence

The compositional practices of the film image that we call the conventions of presence imply a close identification with the image's point of view, a primarily emotional response to that image, and an experience of the image as if it were a lived reality. Images in this tradition are able to fascinate us with a visual activity we participate in, overwhelm us with their beauty or horror, or comfort us with their familiarity. Although not entirely separable from the story and other elements of the film form, imagistic presence can be seen as what principally entertains us at

4.62 *Midnight Cowboy* (1969). Special effects and blurred, colored contrasts create a psychological representation of the cowboy's drug experience.

the movies, what elicits our tears and shrieks. A shot of horses and riders dashing toward a finish line or of a woman embracing a dear friend communicates an immediacy or truth that engages us and leads us through subsequent images. One variation on this convention is the **phenomenological image** – a film image that approximates the way we experience the physical world, like a shot that re-creates the dizzying perspectives from a mountaintop. In contrast, the **psychological image** is a film image that reflects a state of mind or emotion. For example, in *Midnight Cowboy* (1969), disorienting, blurry images at a party re-create Joe's mental and perceptual experience after taking drugs [**Figure 4.62**].

Textuality

The word textuality refers to a kind of film image that demands emotional and analytical distancing from the image, which is experienced as artifice or a construction to be interpreted. We stand back to look at textual images from an intellectual distance, and they seem loaded with signs and symbols for us to decipher. They impress us more for *how* they show the world than for *what* they show. So-called difficult, abstract, or experimental films – from Germaine Dulac's surrealist film *The Seashell and the Clergyman* (1928) to *Pi* (1998) – enlist viewers in this way, but many films integrate images that test our abilities to read and decipher. A canted framing of an isolated house or a family reunion shot through a yellow filter may stand out in an otherwise realistic movie as a puzzle image that asks for more reflection: How do we read this image? Why is this unusual composition included? In *The Seashell and the Clergyman* (1928), apparently about a priest in love with a beautiful woman, images resemble the cryptic language of a strange dream, requiring viewers to struggle to decipher them as a way of understanding the film's complex drama of repression and desire [**Figure 4.63**].

4.63 *The Seashell and the Clergyman* (1928). Extreme angles, shadows, and highlighted patterns in the pavement suggest a complex dream image in this surrealist collaboration between playwright Antonin Artaud and Germaine Dulac.

FILM IN FOCUS

FILM IN FOCUS

LaunchPad Solo

To watch a clip illustrating the cinematography of *Vertigo* (1958), see the *Film Experience* LaunchPad.

From Angles to Animation in *Vertigo* (1958)

See also: *Performance* (1970); *Run Lola Run* (1998); *Amélie* (2001)

In Alfred Hitchcock's suspense film *Vertigo* (1958), a wealthy businessman named Gavin Elster (Tom Helmore) hires Scottie (James Stewart), a retired police detective who suffers from acrophobia (fear of heights), to follow Elster's wife, Madeleine (Kim Novak). Elster claims that Madeleine is troubled by her obsession with Carlotta, a woman from the past. Scottie rescues Madeleine during an apparent suicide attempt and falls in love with her. After she dies when his acrophobia prevents him from stopping her leap from a mission tower, Scottie is plunged into a spiral of guilt. Later he believes he sees her on the streets of San Francisco, and his pursuit of a look-alike woman, Judy (also played by Kim Novak), entangles him in another twist. The film is a psychological murder mystery in which the central crisis involves distinguishing reality from fictive images of it.

Employing a particular brand of widescreen projection called VistaVision, the aspect ratio of *Vertigo* is one of its immediately recognizable and significant formal features. The widescreen frame becomes a fitting environment for Scottie and his anxious searches through the vistas of San Francisco and its environs.

Although *Vertigo* does not mask frames for emphasis in the artificially obvious way of older films, at times Hitchcock and cinematographer Robert Berks cleverly create masking effects by using natural objects within the frame. For instance, the film uses doors or other parts of the mise-en-scène to create masking effects that isolate and dramatize Scottie's intense gazing at Madeleine [**Figure 4.64**].

Like many other Hitchcock films, *Vertigo* continually exploits the edges of the frame to tease and mislead us with what we (and Scottie) cannot see. In Scottie's pursuit of Madeleine, she frequently evades his point of view, disappearing like a ghost beyond the frame's borders. The mystery of Madeleine's fall to her death is especially shocking because it occurs offscreen, revealed only as her blurred body flashes by the tower window, which acts as a second frame limiting Scottie's perception of what has happened [**Figure 4.65**].

4.64 *Vertigo* (1958). In this striking composition, Scottie's previously masked point of view becomes graphically juxtaposed with the mirror image of the woman he pursues.

The angles of shots are crucial in *Vertigo*. The hilly San Francisco setting naturally accentuates high and low angles as Scottie follows Madeleine through the streets, and the film's recurring motif about terror of heights informs even the most commonplace scenes, as high angles and overhead shots ignite Scottie's panic. Especially when these sharp angles reflect Scottie's point of view, they suggest complex psychological and moral concerns about power and control as well as about desire and guilt, dramatizing

4.65 *Vertigo* (1958). The window frames Scottie's uncertain view of a falling body.

those moments when Scottie's desires leave him in positions where he is most out of control and threatened.

Certainly among the more striking dimensions of *Vertigo* is its moving frame. One casual scene demonstrates how common shot movements describe events in a complex way and also subtly invest those events with nuance and meaning. In an early scene set in Elster's office, the wealthy man enlists Scottie's help to follow his wife. The scene begins with Elster sitting in his chair, but Scottie soon sits and Elster stands and moves around the room. A pan of Elster walking to a higher position in the room is followed by a low-angle shot of him and a complementing high-angle shot of Scottie. A backward track then depicts the more aggressive Elster as he moves to the front of the image toward the stationary Scottie **[Figure 4.66]**. As the moving frame continues to focus on Elster trying to convince Scottie to help him track his wife, the framing and its movement indicate that this is not quite a conversation between equals: the moving frame makes clear that Elster directs the image and controls the perspective.

A more clearly central series of camera movements takes place when Scottie finds Madeleine standing before a portrait of Carlotta in an art museum. Here the camera executes several complex moves that simulate Scottie's perspective: it simultaneously zooms in and tracks on the swirl in Madeleine's hair and then reframes by tracking and zooming out on the same hair design in the painting of Carlotta **[Figure 4.67]**. Indeed, these reframings in the museum resemble the opening sequence in which Scottie hangs from the gutter and his frightened glances at the street below are depicted through a quick, distorting combination of zooming in and tracking out that describes his intense panic and spatial disorientation. Entirely through these camera movements, the film connects Scottie's original trauma and guilt with his mysterious attachment to Madeleine.

Although *Vertigo* seems to be a realistic thriller, it employs—dramatically and disconcertingly—both animation and special effects as a part of its story and description of Scottie's state of mind. An eerie matte shot re-creates a tower that is missing from the actual church at San Juan Bautista. Its goal is largely to add a crucial element to the

4.67 *Vertigo* (1958). Restless camera movement combining zooms and tracking shots traces Scottie's gaze at the portrait.

4.68 *Vertigo* (1958). Scottie's animated nightmare sequence ends with a matte shot in which an abstracted black figure appears against the roof onto which another body had fallen.

setting where Scottie's fear of heights will be exploited. Yet along with the nightmarish significance of that tower, in the final scene the matted image appears as an eerily glowing surface and color as the surreal tower looms over yet another dead body. More obvious examples of special effects include the rear projections and animation when Scottie begins to lose his grip on one reality and become engulfed in another. In one scene, Scottie and Judy's kiss spins free of the background of the room. Earlier, during a nightmare triggered by his psychotic depression, an eruption of animation depicts the scattering of the mythical Carlotta's bouquet of flowers and a black abstract form of Scottie's body falling onto the roof of the church **[Figure 4.68]**. This "special sequence" credited to John Ferren echoes the spiraling animated shapes of the memorable title design by Saul Bass.

Rather than mimicking or supplementing reality, these instances of animation and special effects in *Vertigo* point out how fragile the photographic realism of the film shot can be. *Vertigo* describes the obsessions of a man in love with the image of a woman—Madeleine, who appears to revive Carlotta and then seemingly is reincarnated in Judy. The film contains long periods without any dialogue, almost as a way to insist that Scottie's (and Hitchcock's) interest is primarily in images in all their forms (from paintings to memories) and from many angles (high, low, moving, stationary, onscreen, and offscreen).

4.66 *Vertigo* (1958). A low-angle, backward tracking shot emphasizes the aggressive Gavin Elster.

Recognizing the dominance of images either of presence or of textuality within a film is one way to begin to appreciate and understand it. A romance like *Eat Pray Love* (2010) exudes the presence of location shooting in Italy, India, and Bali and invites audiences to share the heroine's emotional adventure through its exotic locales. A more dense and complex film about an underground gang of Nazi "werewolves," Lars von Trier's *Zentropa* (1991) asks us to decipher images constructed with special effects and mixed media, but part of its success lies in how it engages the complexities of a tradition of textuality.

We experience and process — and enjoy — film images by recognizing the concepts and contexts that underpin them and our expectations of them. The initial hostile reception of *Bonnie and Clyde* in 1967, for instance, turned to admiration several months later. One way of understanding the dynamics of this change is to note that viewers realized that the film's images belong not to a tradition of presence but to a tradition of textuality. Many viewers initially may have seen the film as glamorizing 1930s violence and only later recognized the distance of those images as an ironic commentary on 1960s violence. Film, like chance, favors the prepared mind.

CONCEPTS AT WORK

The experience and the art of the cinema are inseparable in cinematography — the moving image selected, framed, lit, explored, and manipulated through effects. The emergence of cinema at the end of the nineteenth century joined a long-standing impulse to create moving images with the technological capacity to make such images and present them to audiences. Since the end of the twentieth century, advances in digital technology have spurred renewed explorations of the spectacular through 3-D cinema and visual effects.

On the most basic level, films tell their stories through moving images, adding dimension to a flat screen and allowing viewers to locate themselves in the narrative, follow its action, decode significance, and experience emotion. As we have detailed in this and the previous chapter, the properties of the film shot are determined by the infinite range of possibilities of mise-en-scène and cinematography and their interactions. Explore the following questions that build on the key objectives introduced at the beginning of this chapter.

- Extend the analysis of *Vertigo* to the sequence in which Scottie follows Madeleine's car. How do camera distance and angle create point of view in a particularly important scene?
- Explore some of the effects of depth in field in a scene from *Citizen Kane*. Can you distinguish the use of the wide-angle lens? Does the use of deep-focus cinematography correlate with camera movement, and if so, why might this be the case?

- How do elements of cinematography such as film stock, color, and lighting establish mood in a scene from *The Hateful Eight*?
- Research several of the special effects shots used in an effects-heavy movie like *Inception*. Which ones were created digitally? Which ones were not? What is the impact of effects that were created without computer graphic imaging?

⫘ LaunchPad Solo

Visit the LaunchPad Solo for *The Film Experience* to view movie clips, read additional Film in Focus pieces, and learn more about your film experiences.

EDITING
Relating Images

The series of *Bourne* films — *The Bourne Identity* (2002), *The Bourne Supremacy* (2004), *The Bourne Ultimatum* (2007), *The Bourne Legacy* (2012), and, most recently, *Jason Bourne* (2016) — are justly celebrated for a high-speed, digital editing style that many contemporary movies aim to imitate. With different but sometimes overlapping narratives, these five films map a frenetic global espionage game in which a U.S. intelligence agency relentlessly pursues Jason Bourne, a former assassin who now has memory loss, by means of ubiquitous technological surveillance equipment that cuts quickly from one space to another around the world. This world is defined by and seen through flash pans, dramatic zooms, and rapid edits. Essentially, the editing approximates the barely-in-control perspective of a contemporary video game. At one point in *The Bourne Supremacy*, for instance, Bourne arranges a surreptitious meeting with a British journalist who claims to have classified information about Bourne's identity. As the encounter develops at a breathtaking pace in a crowded Waterloo Station in London, shots of computer screens and Bourne's anxious point of view provide images of cell phone communications, tracking data, visual surveillance cameras, and views of the station. For Bourne and most of us who live in the rapidly edited networks that surround us, rapidly edited images have become a dominant experiential shape, and learning to read those edits has become a crucial part of playing the game of today's film experience.

Top and bottom: Everett Collection, Inc. *Middle:* Universal/Photofest

Film **editing** is the process of selecting and joining film footage and shots. As we move through the world, we may witness images that are juxtaposed and overlapped in store windows, on highway billboards, on our desktop computers, or on television when we channel surf. But editing offers a departure from the way we normally see the world. In our everyday experience, discrete images are unified by our singular position and consciousness. And unless we consciously or externally interrupt our vision (such as when we blink), we do not see the world as separate images linked in selected patterns. There are no such limits in editing. Editing may emulate our ordinary ways of seeing or transcend them. The power and art of film editing lie in the ways in which the hundreds or thousands of discrete images that make up a film can be shaped to make sense or to have an emotional or a visceral impact. Many film theorists and professionals consider editing to be the most unique dimension of the film experience. This chapter explores in depth how film connects separate images to create or reflect key patterns through which viewers see and think about the world.

KEY OBJECTIVES

- Understand the artistic and technological evolution of editing.
- Examine the ways editing constructs different spatial and temporal relationships among images.
- Detail the dominant style of continuity editing.
- Identify the ways in which graphic or rhythmic patterns are created by editing.
- Discuss the ways editing organizes images as meaningful scenes and sequences.
- Summarize how editing strategies engage filmic traditions of continuity or disjuncture.

A Short History of Film Editing

Long before the development of film technology, different images were linked sequentially to tell stories. Ancient Assyrian reliefs show the different phases of a lion hunt, and the 230-foot-long Bayeux tapestry chronicles the 1066 Norman conquest of England in invaluable historical detail. In the twentieth and twenty-first centuries, comic strips and manga have continued this tradition in graphic art: each panel presents a moment of action in the story **[Figures 5.1a–5.1c]**. In cinema, a **storyboard** is a shot-by-shot representation of how a film or a film sequence will unfold.

Juxtaposed images that tell stories also have been used symbolically, sensationally, and educationally. Religious triptychs convey spiritual ideas via three connected images. The magic lantern was used by showmen to project successive images and create illusions of the supernatural. By the late nineteenth century, illustrated lectures using photographic slides became popular. Such practices have influenced film editing's evolution into its modern form.

5.1a–5.1c **Telling stories through images.** Different images linked sequentially—
(a) Ancient Assyrian reliefs, **(b)** the eleventh-century Bayeux tapestry, **(c)** and comics—can resemble story-
boards in cinema. (a) Roger Viollet Collection/Getty Images; (b) Erich Lessing/Art Resource, NY; (c) François PERRI/REA/Redux

1895–1918: Early Cinema and the Emergence of Editing

Films quickly evolved from showing characters or objects moving within a single image to connecting different images. Magician and early filmmaker Georges Méliès at first used stop-motion photography and, later, editing to create delightful tricks, like the rocket striking the moon in *Trip to the Moon* (1902) **[Figures 5.2a and 5.2b]**. In these early films appear the first creative uses of the edited **cut**—the transition between two separate shots or scenes. Although basic editing techniques were introduced by other filmmakers, Edwin S. Porter, a prolific employee of Thomas Edison, synthesized these techniques in the service of storytelling in *Life of an American Fireman* (1903) and other early films. One of the most important films in the historical development of cinema, Porter's *The Great Train Robbery* (1903) tells its story in fourteen separate shots, including a famous final shot of a bandit shooting his gun directly into the camera **[Figure 5.3]**. By 1906, the period now known as "early cinema" gave way to cinema dominated by narrative, a transition facilitated by more codified practices of editing.

(a) (b)

5.2a and 5.2b *Trip to the Moon* (1902). In a famous shock cut in his ambitious early science fiction film, Georges Méliès linked the launch of a rocket to its landing on the face of the moon.

D. W. Griffith, who began making films in 1908, is a towering figure in the development of the classical Hollywood editing style. Griffith is closely associated with the use of **crosscutting** (also called **parallel editing**)—an editing technique that cuts back and forth between actions in separate locations, often implying simultaneity—which he used in the rescue sequences that conclude dozens of his films. In *The Lonely Villa* (1909), shots of female family members isolated in a house alternate with shots of villains trying to break in and then with shots of the father rushing to rescue his family. The infamous climax of Griffith's *The Birth of a Nation* (1915) uses crosscutting to portray the film's white characters as victims of Reconstruction and the Ku Klux Klan as heroes. Griffith cuts from black soldiers breaking into a white family's isolated cottage, to a mixed-race politician threatening a white woman with rape, to the Ku Klux Klan riding to the rescue of both **[Figures 5.4a–5.4c]**. The controversial merging of technique and ideology exemplified in Griffith's craft is a strong demonstration of the power of editing. After the success of Griffith's *The Birth of a Nation*, feature filmmaking became the norm, and Hollywood developed the classical editing style that remains the basis for many films today.

1919–1929: Soviet Montage

Within a decade after *The Birth of a Nation* and in the wake of the 1917 Russian Revolution, Soviet filmmaker Sergei Eisenstein's first film, *Strike* (1925), influenced the craft of editing in a different, although equally dramatic fashion. Eisenstein's films and writings center on the concept of *montage*, editing that maximizes the effect of the juxtaposition of disparate shots. For example, to depict the mass shooting of workers in *Strike*, Eisenstein used a dramatic form of **intercutting**. He interposed images of gunfire and the fleeing and falling crowd with gruesome close-ups of a bull being butchered in a slaughterhouse **[Figures 5.5a and 5.5b]**. This juxtaposition of two or more unrelated actions or locations is an example

5.3 *The Great Train Robbery* (1903). Edwin S. Porter is credited with advancing the narrative language of editing in this and other early films. The film's last cut is used to enhance the shock effect of the final image rather than to complete the narrative.

(a)

(b)

(c)

5.4a–5.4c *The Birth of a Nation* (1915). In this sequence of images, Griffith's white supremacist views are advanced by the use of parallel editing, which encourages the viewer to root for the Ku Klux Klan to arrive in time to rescue the white people being threatened in two different locations. The last-minute rescue is a synthesis of the intercutting among different spaces.

(a)

(b)

5.5a and 5.5b *Strike* (1925). In contrast with classical editing, the Soviet style of editing emphasizes conflict. The workers' massacre is compared to the slaughter of a bull through the use of intellectual montage.

HISTORY CLOSE UP

Women in the Editing Room

In the first decades of the twentieth century, women looking for new opportunities during a period of rapid urbanization were attracted to the wide-open field of filmmaking. They found work as actors and also as writers, editors, producers, and directors. Dorothy Arzner, the most prominent female filmmaker of this era, worked on silent films as a script supervisor, then as a cutter, and finally as the main editor. Editing involves piecing together little bits of film with patience and refinement of movement. These qualities were associated with work traditionally performed by women, such as sewing, telegraph operating, and typing, which made editing one of the few filmmaking fields that remained open to women. Arzner's editing of such epics as *Blood and Sand* (1922) and *The Covered Wagon* (1923) impressed executives at Paramount, where she became a director. Before her 1943 retirement, she made a dozen feature films, many of which employed women editors such as Blanche Sewell.

One of the most exciting onscreen descriptions of the filmmaking process, the Soviet silent film *Man with the Movie Camera* (1929), features a woman at an editing table almost as prominently as the eponymous cameraman. Elizaveta Svilova (shown above in a frame from the film) appears seated at a flatbed, selecting and splicing strips of film, with the mechanical parts of the spinning reels of film linked in montage to the parts of a sewing machine. A close-up of a strip of images showing a child's face suddenly comes to life, a magical transformation that confirms the editor's art. The technique of montage, so central to Soviet cinema, is indebted to women like Svilova and Esfir Shub, whose film *The Fall of the Romanov Dynasty* (1927) innovated the genre of compilation documentary.

Despite these prominent examples in two different traditions, women editors do not have the reputations and opportunities they might have. The very invisibility that editing strives for echoes other forms of women's work that are effaced and unrecognized. Only 20 percent of the top 100 films produced in 2015 employed women on their editing teams, yet even these figures are slightly higher than women's participation in key creative roles on these films overall. Behind these numbers is an important legacy.

of what Eisenstein called **intellectual montage**. Rather than being unaware of the effects of editing on their ideas or emotions, a viewer forms an independent idea.

Eisenstein and filmmakers Lev Kuleshov, Vsevolod Pudovkin, and Dziga Vertov advanced montage (they used the French word for *editing*) as the key component of modernist, politically engaged filmmaking in the Soviet Union of the 1920s. One of the most fascinating self-reflexive sequences in film history is the editing sequence in Vertov's *Man with a Movie Camera* (1929) (see History Close Up box above). The film's own editor is shown cutting film that the cameraman has been shown gathering. Images shown on the strips of film seem to freeze before our eyes, only to be reanimated to startling effect. Other avant-garde movements in the 1920s and thereafter

continued to explore the more abstract and dynamic properties of editing employed by the Soviets.

1930–1959: Continuity Editing in the Hollywood Studio Era

With the full development of the Hollywood studio system, the movies refined the story-telling style known as **continuity editing**, which gives the viewer the impression that the action unfolds with spatiotemporal consistency. The introduction of synchronous sound posed new challenges, but by the early 1930s editors integrated picture and sound editing into the studio style.

Beginning in the 1940s, cinematic realism achieved new emphasis as one of the primary aesthetic principles in film editing. The influence of Italian neorealism, which

5.6 *In a Lonely Place* (1950). Postwar cinema tended to explore the depth of images, cutting less frequently between them to achieve a heightened realism.

used fewer cuts to capture the integrity of stories of ordinary people and actual locations, was evident in other new wave cinemas and even extended to classical Hollywood. For example, Nicholas Ray's *In a Lonely Place* (1950) emphasized imagistic depth and longer takes, cutting less frequently between images **[Figure 5.6]**. Incorporating these variations, the continuity editing style remained dominant at least until the decline at the end of the 1950s of the studio system, whose stable personnel, business models, and genre forms lent consistency to its products and techniques. In many ways, its principles still govern storytelling in film and television, even as the pace of that continuity editing has rapidly increased in recent films such as *Mission: Impossible — Rogue Nation* (2015) **[Figure 5.7]**.

5.7 *Mission: Impossible — Rogue Nation* (2015). The heritage of continuity editing has remained alive and well into the twenty-first century, although its pace has intensified, particularly in action films. The fifth *Mission: Impossible* film breaks from a fast pace to capture its star, Tom Cruise, performing a major stunt without a lot of cutting.

(a) **(b)**

5.8a and 5.8b *Breathless* (1960). Jump cuts between or in the middle of shots are a visual vehicle for conveying the distractions and disjunctions in a petty criminal's life. Michel's voiceover continues as we see Patricia from different angles.

1960–1989: Modern Editing Styles

Political and artistic changes starting in the 1960s affected almost every dimension of film form, and editing was no exception. Both in the United States and abroad, alternative editing styles emerged that aimed to fracture classical editing's illusion of realism. Anticipated to some extent by Soviet montage, these new more disjunctive styles reflected the feeling of disconnection of the modern world. Editing visibly disrupted continuity by creating ruptures in the story, radically condensing or expanding time, or confusing the relationships among past, present, and future.

The French New Wave produced some of the first and most dramatic examples of modern styles of editing. Jean-Luc Godard's *Breathless* (1960) innovated the use of **jump cuts**, edits that intentionally create gaps in the action **[Figures 5.8a and 5.8b]**. In the 1960s and 1970s, American filmmakers like Arthur Penn and Francis Ford Coppola incorporated such styles within classical genres to contribute to the New Hollywood aesthetic. In the 1980s, the fast-paced editing style used in commercials and music videos began to appear in mainstream films. Two popular and successful films, both made by former directors of television commercials, are indicative of this period—Adrian Lyne's *Flashdance* (1983), about a Pittsburgh woman who

(a) **(b)**

5.9a and 5.9b *Flashdance* (1983). Continuous music and discontinuous cutting characteristic of 1980s music videos energize this film about a young working-class woman who aspires to be a dancer.

5.10 *Transformers: Age of Extinction* (2014). This recent entry in the Michael Bay's *Transformer* franchise utilizes extremely quick cutting, especially in its action sequences. Shots like the one pictured above rarely last more than a couple of seconds.

doubles as a welder and exotic dancer, and Tony Scott's *Top Gun* (1986), about fighter pilots competing in flight school. Both combine an upbeat pop soundtrack with flashy, rapid editing to suggest the seductive energy of their protagonists' worlds **[Figures 5.9a and 5.9b]**.

1990s–Present: Editing in the Digital Age

Nonlinear digital editing ushered in perhaps the most significant changes in the history of film editing. Whereas for decades editors cut actual film footage by hand on a Moviola or flatbed editing table or in linear sequence on tape, in the 1990s editors began to use computer-based nonlinear digital editing systems. In nonlinear editing, film footage is stored as digital information on high-capacity computer hard drives. Individual takes can be organized easily and accessed instantaneously, sound-editing options can be explored simultaneously with picture editing, and optical effects such as dissolves and fades can be immediately visualized on the computer rather than added much later in the printing process. Feature films were soon edited with nonlinear computer-based systems regardless of whether they were shot on 35mm film or digital video.

The more rapid pace of contemporary films seems to correlate with digital editing. Average shot length has declined significantly, with shots in *Transformers: Age of Extinction* (2014) averaging around three seconds **[Figure 5.10]**, compared with the ten-second shots measured by scholars in *The Grapes of Wrath* (1940). However, digital filmmaking also can embrace the opposite aesthetic effect. On film, the length of a single take was limited by how much stock the camera could hold; on video, the duration of a shot is virtually limitless. Filmmaker Aleksandr Sokurov's *Russian Ark* (2002) is a virtuoso feature-length film with no cuts at all **[Figure 5.11]**.

5.11 *Russian Ark* (2002). Wandering through the Hermitage Museum in St. Petersburg and seeming to pass through historical eras, the digital camera is the vehicle for this film's meditation on art, politics, and Russian history, conveyed as a single ninety-six-minute shot.

The Elements of Editing

Film editing is the process through which different images or shots are linked together sequentially. A shot is a continuous image, regardless of the camera movement or changes in focus it may record, and editing can produce meaning by combining shots in an infinite number of ways. One shot is selected and joined to other shots by the editor to guide viewers' perceptions. For example, the opening sequence of *Crooklyn* (1994) depicts the Brooklyn block where the film is set by editing together a high-angle moving crane shot that provides an overview of the neighborhood and its inhabitants and a variety of shots of people and their activities **[Figures 5.12a–5.12c]**.

Film editing conveys multiple perspectives by linking individual shots (each presented from a single perspective) in various relationships. Some of these relationships mimic the way a person looks at the world—for example, by linking a shot of someone looking off in the distance to an extreme long shot of an airplane in the sky. But often these relationships exceed everyday perceptions, as in the shot from *The Birds* (1963) that shows birds flying over Bodega Bay, an inhuman perspective that, juxtaposed with shots on street level, adds to the film's uncanny effect. Edited images may leap from one location to another or one time to another and may show different perspectives on the same event. Editing is one of the most significant developments in the syntax of cinema because it allows for a departure from both the limited perspective and the continuous duration of a shot.

The Cut and Other Transitions

The earliest films consisted of a single shot, which ran only as long as the reel of film in the camera lasted. In his early trick films, pioneer Georges Méliès manipulated this limitation by stopping the camera, rearranging the mise-en-scène, and resuming filming to make objects and people seem to disappear or transform. It was a short step to achieving such juxtapositions by physically cutting the film. In Méliès's 1903 film *Living Playing Cards*, a magician, played by Méliès himself, seems to make his props come alive **[Figures 5.13a and 5.13b]**.

Even when they are intended to seem like magic, transitions between film shots and the technical labor of editing are often obscured. Rarely can viewers describe or enumerate the edits that make a particular film sequence memorable. Learning to watch for this basic element of film language gives the viewer insights into the art of the film.

The foundation for film editing is the **cut**—the join or splice between two pieces of film. This break in the image marks the physical connection between two shots from two different pieces of film. A single shot can depict a woman looking at a ship at sea by showing a close-up of her face and then panning to the right, following her glance to reveal the distant ship she is watching. A cut, on the other hand, renders this action in two shots, with the first showing the woman's face and the second showing the ship. The

(a)

(b)

(c)

5.12a–5.12c *Crooklyn* (1994). The credits sequence of Spike Lee's film juxtaposes a moving crane shot of a Brooklyn block with a series of short takes of daily activities to convey a sense of a tight-knit community.

(a) (b)

5.13a and 5.13b *Living Playing Cards* (1903). Pioneer George Méliès anticipated later editing techniques with magical transformations.

(a)

5.14a–5.14c *The Best Years of Our Lives* (1946). Director William Wyler uses composition in depth and editing to bring out developing tensions in the friendship of three returning veterans. **(a)** In the first shot, our attention is drawn to the figures in the foreground. **(b)** When Al turns to watch Fred make a difficult phone call in the background of the shot, **(c)** the film cuts to a second shot that emphasizes the relationship between these two figures.

(b)

(c)

facts of the situation remain the same, but the two approaches—the single-shot pan and the cut joining two shots—create different experiences of the scenario. The first might emphasize the distance that separates the woman from the object of her vision. The second might create a sense of immediacy and intimacy that transcends the distance. In a key scene from *The Best Years of Our Lives* (1946), we first see several characters occupying different spaces of the same shot **[Figure 5.14a]**. After the character on the right shifts his attention to the character in the background, we are presented with a cut isolating them **[Figures 5.14b and 5.14c]**.

VIEWING CUE

Count the shots in the scene from *Chinatown* (1974) available online. What is the motivation behind each cut? What overall pattern do these cuts create?

As these examples illustrate, the use of a cut usually follows a particular logic — in this case, emphasizing the significance of the character's gaze. The less frequently used **shock cut** juxtaposes two images whose dramatic difference creates a jarring effect, often accompanied by a jolt on the soundtrack, as in the shower murder sequence in *Psycho* (1960), emulated in countless subsequent horror films such as *The Visit* (2015) **[Figure 5.15]**. Later in this chapter, we investigate additional ways that editing may create logical or unexpected links among different images.

Edits can be embellished in ways that guide our experience and understanding of the transition. For example, a **fade-out** is an optical effect in which an image gradually darkens to black, and in a **fade-in** a black screen gradually brightens to a full picture (a fade-in often is used after a fade-out to create a transition between scenes). Alfred Hitchcock fades to black to mark the passing of time throughout *Rear Window* (1954). A **dissolve** briefly superimposes one shot over the next, which takes its place: one image fades out as another image fades in **[Figure 5.16]**. In studio-era Hollywood films, these devices were used to indicate a spatial or temporal break that is more definite than that done by straight cuts, and they often mark pauses between narrative sequences or larger segments of a film. A dissolve can take us from one part of town to another, whereas a fade-out (a more visible break) can indicate that the action is resuming the next day. The iris (discussed in Chapter 4) masks the corners of the frame with a black, usually circular form **[Figure 5.17]**, and a **wipe** is a transition used to join two shots by moving a vertical, horizontal, or sometimes diagonal line across one image to replace it with a second image that follows the line across the frame **[Figure 5.18]**. Wipes and irises are most often found in silent and early sound films.

Although editing can generate an infinite number of combinations of images, rules have developed within the Hollywood storytelling tradition to limit those possibilities (as we discuss later in this chapter). Other film traditions, most notably those of avant-garde and experimental cinema (see Chapter 8), can be characterized by their degree of interest in exploiting the range of editing possibilities as a primary formal property of film.

5.15 *The Visit* (2015). The shock cut has remained a staple of editing in horror films as a way of dramatically unsettling the comfort of continuity editing with the sudden appearance of a frightening or startling image.

5.16 *The Scarlet Empress* (1934). Extended dissolves were a favorite device in director Josef von Sternberg's very stylized filmmaking. The layering of a conversation and the approach of a carriage appear almost as an abstract pattern.

5.17 *Broken Blossoms* (1919). The iris often was used in films by D. W. Griffith to highlight objects or faces. Here it focuses our attention and emphasizes the vulnerability of Lillian Gish's character.

When watching movies, we make sense of a series of discontinuous, linked images by understanding them according to conventional ways of interpreting space, time, story, and image patterns. We understand the action sequences in *Furious 7* (2015) despite the improbable feats performed by the characters. Likewise, we make connections among the three separate narratives from three separate periods in *The Hours* (2002). Editing patterns also anticipate and structure narrative organizations. The next three sections explore the spatial and temporal relationships established by editing and introduce the rules of the Hollywood continuity editing system. Subsequent discussion examines patterns of editing images based on graphic, movement, and rhythmic connections in order to show how different techniques provide very different experiences.

5.18 *Desert Hearts* (1985). In a film set in the 1950s, a wipe creates a nostalgic reference to earlier editing techniques, but it also may suggest a certain kind of transience in the world of the characters.

VIEWING CUE

Look for other examples of transitional devices besides cuts. What spatial, temporal, or conceptual relationship is being set up between scenes joined by a fade, a dissolve, an iris, or a wipe?

VIEWING CUE

Estimate the number of shots in a scene from *Tangerine* (2015), then watch the scene, clapping with each cut. Were more shots used than you had imagined?

Continuity Style

In both narrative and non-narrative films, editing is a crucial strategy for ordering space and time. Two or more images can be linked to imply spatial and temporal relations to the viewer. **Verisimilitude** (literally, "the appearance of being true") is the quality of fictional representation that allows readers or viewers to accept a constructed world—its events, its characters, and their actions—as plausible. In cinematic storytelling, verisimilitude is enhanced by clear, consistent spatial and temporal patterns that—along with conventions of dialogue, mise-en-scène, cinematography, and sound—form part of Hollywood's overall **continuity style**. In the commercial U.S. film industry, spatial and temporal continuity are greatly enhanced through conventions of editing. Because its constructions of space and time are so codified and widely used, we devote special consideration to this style.

The basic principle of **continuity editing** (sometimes called *invisible editing*) is that each shot has a continuous relationship to the next shot. It uses cuts and other transitions to establish verisimilitude, to construct a coherent time and space, and to tell stories clearly and efficiently, requiring minimal mental effort on the part of viewers. Two particular goals constitute the heart of this style—constructing an imaginary space in which the action develops and approximating the experience of real time by following human actions.

In continuity editing, after the initial view of a scene, subsequent shots typically follow the logic of spatial continuity. If a character appears at the left of the screen looking toward the right in the establishing shot, he or she probably will be shown looking in the same direction in the medium shot that follows. Movements that carry across cuts also adhere to a consistent screen direction. A character exiting the right of a frame probably will enter a new space from the left. Similarly, a chase sequence covering great distances is likely to provide directional cues.

Continuity editing has developed and deployed these patterns so consistently that it has become the dominant method of treating dramatic material, with its own set of rules that narrative filmmakers learn early. Continuity or invisible editing minimizes the perception of breaks between shots. The argument between the lovers in *The Notebook* (2004) uses numerous invisible cuts to shift focus from character to character and to underscore the scene's emotional resonance as they move within the clearly delineated space between the front porch and a parked car.

Spatial patterns are frequently introduced through the use of an **establishing shot**—generally an initial long shot that establishes the location and setting and that orients the viewer in space to a clear view of the action. A scene in a western, as in *The Hateful Eight* (2015), might begin with an extreme long shot of wide-open space and then cut in to a shot that shows a stagecoach or saloon, followed by other, tighter shots introducing the characters and action.

A conversation usually is established with a relatively close shot of both characters (also known as a **two-shot**) in a recognizable spatial orientation and context. Then the camera alternates between the speaking characters, often using **over-the-shoulder shots** where the camera is positioned slightly behind and over the shoulder of one character, focusing on another character or object. It often is used when alternating between speaking characters. During an editing sequence that proceeds back and forth, the editor may insert **reestablishing shots** by periodically returning to the initial establishing shot to restore a seemingly objective view to spectators. Early in Howard Hawks's *The Big Sleep* (1946), when detective Philip Marlowe (played by Humphrey Bogart) is hired by General Sternwood, the scene opens with an establishing shot, and their conversation follows this pattern [**Figures 5.19a–5.19h**]. Although the conversation is presented by many shots that are edited together, the transitions

(a)

(b)

(c)

(d)

(e)

(f)

(g)

(h)

5.19a–5.19h *The Big Sleep* (1946). The simple interview, which provides a great deal of plot information, is broken down by many imperceptible cuts. After an initial establishing shot, alternating shots of the two characters in conversation cut in closer and closer and eventually focus our attention on the protagonist's face. Finally, the space is reestablished at the end of the interview.

5.20 *The Hunger Games: Catching Fire* (2013). An insert shows a close-up of the mockingjay pin kept by Katniss Everdeen.

remain largely invisible because the angle from which each character is filmed remains consistent and the dialogue continues over the cuts. Such editing practices are ubiquitous. We have learned to expect that film conversations will be coordinated with medium close-ups of characters speaking and listening, just as we expect that these figures will be situated in a realistic space.

Another device that is used in continuity editing is the **insert**—a brief shot, often a close-up, that points out details significant to the action. An insert might be a close-up of a hand slipping something into a pocket or a subtle smile that other characters do not see. The use of inserts helps overcome viewers' spatial separation from the action, pointing out details significant to the plot—for example, showing us an object of great meaning to a character **[Figure 5.20]** or making a comparison that transcends the characters' perspectives **[Figure 5.21]**.

Continuity editing minimizes disruptive effects and maximizes the viewer's ability to follow the action through practices that give a sense of spatial and temporal consistency. Some of these practices have become so codified that they are viewed as rules.

5.21 *Fury* (1936). Fritz Lang dissolves from one shot of women chatting to another of chickens clucking to illustrate the emptiness of gossip in a rare example of a nondiegetic insert in a classical film.

180-Degree Rule

The **180-degree rule** is the primary rule of continuity editing and one that many films and television shows consider sacrosanct. It restricts possible camera setups to the 180-degree area on one side of an imaginary line (the **axis of action**) drawn between the characters or figures of a scene. The two diagrams in **[Figure 5.22]** illustrate the 180-degree rule in the scene from *The Big Sleep* discussed earlier. Marlowe and the general are filmed as if the space were bisected by an imaginary line known as the **axis of action**. All of the shots illustrated by the still images from *The Big Sleep* in Figures 5.19a–5.19h were taken from one side of the axis. In general, any shot taken from the same side of the axis of action will ensure that the relative positions of people and other elements of mise-en-scène, as well as the directions of gazes and movements, will remain consistent. If the camera were to cross into

Diagram A

Diagram B

5.22 *The Big Sleep* (1946). **Diagram A** illustrates the 180-degree rule by depicting the imaginary axis of action, bisecting the conversation scene from *The Big Sleep*. All shots in **Diagram B**, which illustrates the editing of the conversation with reference to Figures 5.19b–5.19g, were taken from the white portion of Diagram A. Each character is depicted in tighter framings from a consistent camera angle. If the camera were to cross over to the shaded portion, the position of the characters onscreen would be reversed.

the 180-degree field on the other side of the line (represented by the shaded area in Figure 5.22, Diagram A), the characters' onscreen positions would be reversed. During the unfolding of a scene, a new axis of action may be established by figure or camera movement. Directors may break the 180-degree rule and cross the line, either because they want to signify chaotic action or because conventional spatial continuity is not their primary aim.

30-Degree Rule

The **30-degree rule** illustrates the extent to which continuity editing attempts to preserve spatial unity. This rule specifies that a shot should be followed by another shot taken from a position greater than 30 degrees from that of the first. In *Winter's Bone* (2010), when Ree shows her younger siblings how to skin a squirrel, an over-the-shoulder shot that emulates her point of view is followed by a medium shot in profile taken at a right angle to the action. The rule aims to emphasize the motivation for the cut by giving a substantially different view of the action. If a shot of the same subject is taken within 30 degrees of the previous shot, it will appear to jump in position onscreen.

(a) **(b)**

5.23a and 5.23b *The Silence of the Lambs* (1991). A shot of Clarice (played by Jodie Foster) followed by a reverse shot of her adversary Hannibal Lecter (Anthony Hopkins).

 VIEWING CUE

Does the film you watched most recently in class follow continuity patterns, such as the 180-degree rule? Locate an example, and identify other ways that spatial continuity is maintained.

Shot/Reverse Shot

One of the most common spatial practices within continuity editing, and a regular application of the 180-degree rule, is the **shot/reverse-shot** pattern (also called the shot/countershot). It begins with a shot of one character looking offscreen in one direction, followed by a shot of a second character who appears to be looking back. The effect is that the characters seem to be looking at each other. In the example from *The Big Sleep*, this pattern begins with a shot of Philip Marlowe taken from an angle at one end of the axis of action and continues with a shot of the general from the "reverse" angle at the other end of the axis, and proceeds back and forth. As can be seen in Figure 5.22, Diagram B, the camera distance changes from medium shot to close-up as the scene unfolds, but the angle on each character in the shot/reverse-shot pattern does not. The use of over-the-shoulder shots in shot/reverse-shot sequences increases the perception of viewer participation in a conversation. As Clarice Starling confronts the serial killer Hannibal Lecter in *The Silence of the Lambs* (1991), the 180-degree change in angle—known as cutting on the line—and symmetrical composition in the shot/reverse-shot sequence shows them to be equally matched adversaries, if not mirror images of each other **[Figures 5.23a and 5.23b]**.

Eyeline Match

Shot/reverse-shot sequences use characters' gazes to establish the continuous space of the conversation. A cut that follows a shot of a character looking offscreen with a shot of a subject whose screen position matches the gaze of the character in the first shot is called an **eyeline match [Figures 5.24a and 5.24b]**. If a character looks toward the left, the screen position of the character or object in the next shot will likely appear to match the gaze. Eyelines give the illusion of continuous offscreen space into which characters could move beyond the left and right edges of the frame.

Match on Action

To match images through movement means that the direction and pace of actions, gestures, and other movements are linked with corresponding or contrasting

(a)

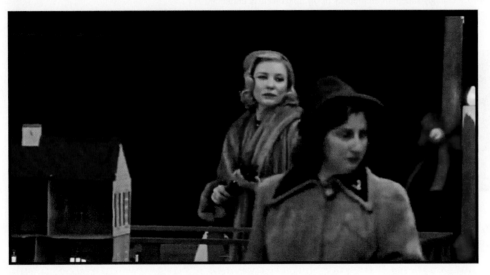

(b)

5.24a and 5.24b *Carol* (2015). In this early scene, an eyeline match directs our gaze to the protagonist's first vision of the woman with whom she will fall in love.

movements in one or more other shots. Leni Riefenstahl's extraordinary editing of athletes in motion in her documentary *Olympia* (1938) has become a model for sports montages **[Figures 5.25a and 5.25b]**. A common version of this pattern is the continuity editing device called a **match on action** — a cut between two shots continuing a visual action. In this technique, the direction of an action is picked up by editing to a shot depicting the continuation of that action, such as matching the movement of a stone tossed in the air to the flight of that stone as it hits a window. Often a match on action obscures the cut itself, such as when the cut occurs just as a character opens a door, and the next shot shows the character shutting the door from the other side.

Cutting on action — or editing during an onscreen movement — also quickens a scene or film's pace. Action sequences such as fights and chases exploit these possibilities by relying on the spatial consistency of continuity editing to convey what's happening and by using variation to increase the surprise and excitement **[Figures 5.26a and 5.26b]**.

(a) (b)

5.25a and 5.25b *Olympia* (1938). The seemingly superhuman mobility of Olympic divers is enhanced
by Leni Riefenstahl's editing.

(a) (b)

5.26a and 5.26b *Crouching Tiger, Hidden Dragon* (2000). A swordfight's tension is increased
through cutting on movement and matching on action.

Graphic Match

Formal patterns, shapes, masses, colors, lines, and lighting patterns within images
can link or define a series of shots according to graphic qualities [**Figures 5.27a and
5.27b**]. This is most easily envisioned in abstract forms: one pattern of images may
develop according to diminishing sizes, beginning with large shapes and proceed-
ing through increasingly smaller shapes; another pattern may alternate the graph-
ics of lighting, switching between brightly lit shots and dark, shadowy shots; yet
another pattern might make use of lines within the frame by assembling different
shots whose horizontal and vertical lines create specific visual effects. Many exper-
imental films highlight just this level of abstraction in the editing. A sequence of
Ballet mécanique (1924) (see Chapter 9) cuts rapidly between circles and triangles.
Commercials capitalize on graphic qualities to convey their message visually.

Although it may not be their organizing principle, narrative films edit accord-
ing to graphic qualities as well. This can have an aesthetic effect—by emphasiz-
ing sharp angles or soothing colors. Coherence in shape and scale often serves
a specific narrative purpose, as in the continuity editing device called a **graphic
match**—an edit in which a dominant shape or line in one shot provides a visual
transition to a similar shape or line in the next shot. One of the most famous
examples of a graphic match links the shape of a bone tossed in the air to the

shape of a spaceship in outer space in Stanley Kubrick's *2001: A Space Odyssey* (1968) **[Figures 5.28a and 5.28b]**.

Point-of-View Shots

Many of Alfred Hitchcock's most suspenseful scenes are edited to highlight the drama of looking. Often a character is shown looking, and the next shot shows the character's optical point of view, as if the camera (and hence the viewer) were seeing with the eyes of the character. Such point-of-view shots are often followed by a third shot in which the character is again shown looking, which reclaims the previous shot as his or her literal perspective. In a tense scene from *The Birds* (1963) in which the heroine, Melanie, sits on a bench outside a school as threatening crows gather on the playground behind her, Hitchcock uses both eyeline matches and point-of-view sequences. A bird flying high overhead catches Melanie's attention **[Figure 5.29a]**. When she turns her head to follow its flight, the shots are matched by her eyeline **[Figure 5.29b]**. Next comes a point-of-view sequence through which suspense is prolonged by showing Melanie's reaction before the sinister sight of congregating birds **[Figures 5.29c and 5.29d]**. The editing of this scene serves both to construct a realistic space and to increase our identification with Melanie by focusing solely on the act of looking.

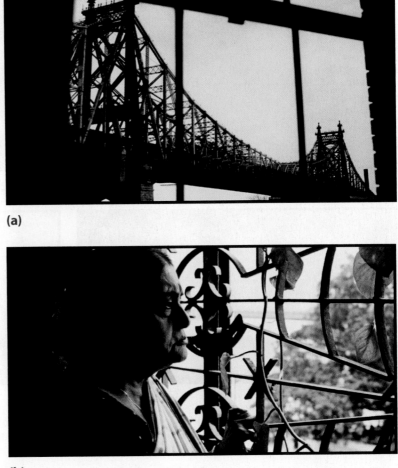

(a)

(b)

5.27a and 5.27b *The Namesake* (2006). A family drama set on two continents uses graphic elements to connect India and the United States.

Elsewhere in the film, the point of view of Melanie's romantic interest, Mitch, is conveyed by partially masking the frame as if we were looking along with him through his binoculars. Similarly, when a character wakes from a knock on the head, we may see a blurry image, foregrounding the subjective effect of the point-of-view construction.

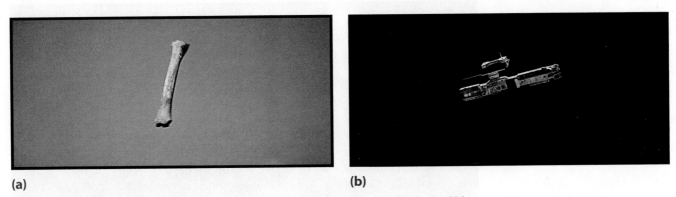

(a)

(b)

5.28a and 5.28b *2001: A Space Odyssey* (1968). Centuries are elided in a graphic match, which functions at the same time as a match on action.

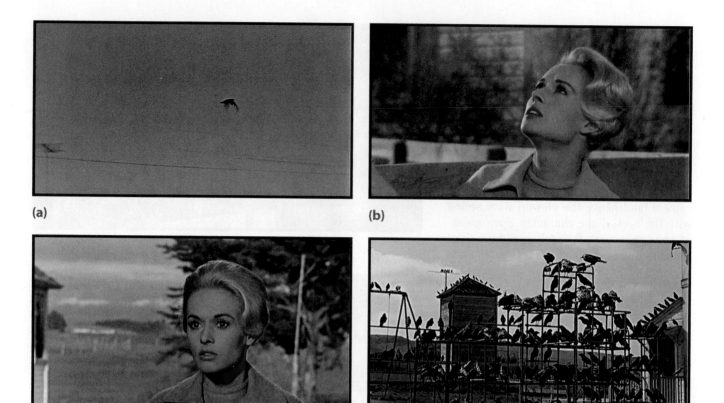

5.29a–5.29d *The Birds* (1963). **(a)–(b)** A low-angle shot of a flying bird is matched to Melanie's eye-line. **(c)–(d)** We see Melanie's shocked face and then a point-of-view shot of the gathering birds.

Reaction Shots

These components of the continuity system—which also include shot/reverse-shot patterns, eyeline matches, and point-of-view shots—construct space around the characters' behavior. The editing highlights human agency. A **reaction shot**, which depicts a character's response to something shown in a previous shot **[Figure 5.30]**, emphasizes human perspective in a way that can be seen as standing in for the audience's own response. The cut back to the character "claims" the view of the previous shot as subjective. A scene from *Clueless* (1995) in which the protagonist, Cher, and her friends, Dionne and Tai, converse in a coffee-shop booth shows a typical conversation edited for continuity. The scene begins with a tracking establishing shot

5.30 *The Way We Were* (1973). This reaction shot of Barbra Streisand's face registers her character's response to catching sight of her former lover.

(a)

(b)

(c)

(d)

5.31a–5.31d *Clueless* (1995). After **(a)** an establishing shot, this conversation alternates **(b and d)** shots of the heroine Cher's friends with **(c)** a reverse shot of Cher, maintaining spatial continuity.

that depicts the overall environment **[Figure 5.31a]**. Then the scene cuts back and forth across the booth in a shot/reverse-shot pattern using eyeline matches **[Figures 5.31b–5.31d]**. Cher sits alone and has most of the scene's shots, indicating that she is the focal point of our identification. In this way, continuity editing constructs spatial relationships to create a plausible and human-centered world onscreen.

Art Cinema Editing

Continuity editing strives for an overall effect of coherent space; however, many films, especially art films, use editing to construct less predictable spatial relations. For example, in Carl Theodor Dreyer's *The Passion of Joan of Arc* (1928), a series of close-ups against a white background conveys the psychological intensity of Joan's testimony before the inquisitors while never giving an overview of the space. The use of close-ups elevates the spiritual subject matter over the worldly space of her surroundings that establishing shots and eyeline matches would depict **[Figures 5.32a–5.32c]**. Japanese director Yasujiro Ozu often uses graphic elements to provide continuity across cuts. In *Early Summer* (1951), rather than editing to show optical point of view, he sets up his camera near the ground to balance his compositions around characters sitting on the floor. These directors provide significant challenges to the "rules" of Hollywood editing.

In postwar cinemas, directors explored characters' restlessness through editing that defied continuity. In Michelangelo Antonioni's film *L'Avventura* (1960), cuts join spaces that are not necessarily contiguous. The landscapes the characters move through express their psychological state of alienation in a way that a realistic use of space would not. Contemporary independent films may incorporate editing styles innovated in art cinema to convey a character's state of mind or a state of being that departs from the ordinary. In *Beasts of the Southern Wild* (2012), the editing

(a)

(b)

(c)

5.32a–5.32c *The Passion of Joan of Arc* (1928). The juxta-position of the inquisitors' faces with that of Renée Falconetti as Joan ignores spatial continuity but is freighted with power and significance.

contributes to a sense of enchantment and loss in a close-knit bayou community flooded during a storm **[Figures 5.33a and 5.33b]**. We discuss such alternatives in greater detail later in the chapter (see "Disjunctive Editing").

Editing and Temporality

Editing is one of the chief ways that temporality is manipulated in narrative film. A two-hour film may condense centuries in a story. Less frequently, it may expand story time, as in a prolonged rescue or a dream sequence. It is helpful to keep distinct the concepts of **plot time**, the length of time a movie depicts when telling its story; **story time**, the sequence of events inferred during the telling of a film story; and **screen time**, the actual length of time that a movie takes to tell its story. Film is a time-based medium, and editing strongly affects our experience of the temporal unfolding.

(a) (b)

5.33a and 5.33b *Beasts of the Southern Wild* (2012). Cutting between two views of the protagonist, Hushpuppy, conveys her magical, dreamlike experiences.

Flashbacks and Flashforwards

Through its power to manipulate **chronology**—the order according to which shots or scenes convey the temporal sequence of the story's events—editing organizes narrative time. A sequence of shots or scenes may describe the temporal development of events as one event or action follows another in progressive order, or it may order events and actions in a nonlinear fashion whereby the temporal order appears like pieces of a puzzle for the viewer to solve.

Editing may juxtapose events out of their temporal order in the story. When using continuity editing, any nonlinear time constructions tend to be introduced with strict cues about narrative motivation. For example, a **flashback**—a sequence that follows an image set in the present with an image set in the past—may be introduced with a dissolve conveying the character's memory or with voiceover narration indicating the shifting timeframe. A large number of flashbacks can blur the line between linear and nonlinear structure. In one sense, *Citizen Kane* (1941) follows a linear narrative, as a reporter conducts a series of interviews and investigations when he looks for an angle on a great man's death. However, the story of Kane's life is provided in a series of lengthy flashbacks that add complexity to the film's chronology. Certain events are narrated more than once, a manipulation of **narrative frequency**—the number of times a plot element is repeated throughout a narrative. In more recent films, such temporal shifts may not be signaled by external cues. *Blue Jasmine* (2013) shifts fluidly between the down-on-her-luck heroine's present existence and scenes of her extravagant lifestyle before her marriage ended **[Figure 5.34]**. Yet even in this case, the heroine's mental state serves as a motivation for the temporal play; the audience is given cues to follow the narrative's complexity.

The less common **flashforward** is a sequence that connects an image set in the present with one or more future images. Because it involves "seeing" the future, the technique usually is reserved for works that intentionally challenge our perceptions—movies focused on psychology or science fiction. In Nicolas Roeg's *Don't Look Now* (1973), for example, a couple is tormented by the recent death of their daughter, and haunting images of a small figure in a red rain slicker prove to be flashforwards to a revelatory encounter **[Figure 5.35]**. In *Memento* (2000), the chronology of scenes is completely reversed, but the maintenance of continuity within each scene allows us to follow the film.

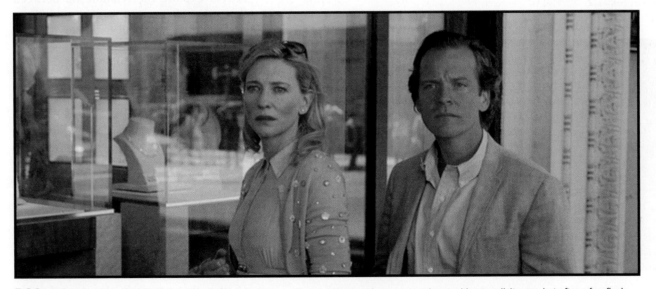

5.34 *Blue Jasmine* (2013). Woody Allen's film cuts between the lead character's present and past without explicit cues, but after a few flashbacks the time periods become easy to identify based on settings and other characters. In this shot, the San Francisco setting and the presence of actor Peter Sarsgaard indicate its setting in the present.

5.35 *Don't Look Now* (1973). Images of a small figure in red prove to be flashforwards to a horrifying encounter with the memories of a lost child.

(a)

(b)

5.36a and 5.36b *The Limey* (1999). Different shots of the protagonist (Terence Stamp) appear in the film without a clear sense of when they occurred.

Descriptive and Temporally Ambiguous Sequences

Certain edited sequences cannot be located precisely in time. The purpose of such a sequence is often descriptive, such as a series of shots identifying the setting of a film. As one character in *An American in Paris* (1951) describes the heroine to another, we see a series of shots depicting her different qualities (with different outfits to match). These vignettes are descriptive and do not follow a linear or other temporal sequence. Music videos also defy chronology in favor of associative editing patterns.

In art films and increasingly in commercial narrative films, the cinema can be prized for its ability to depict ambiguous temporality. Thus, editing may defy realism in favor of psychological constructions of time. Writer Marguerite Duras and director Alain Resnais make time the subject of their film *Hiroshima mon amour* (1959), which constantly relates the present-day story, set in Japan, to a character's past. An image of her lover's hand sparks the female protagonist's memory of being a teenager in France during World War II, and the flashback begins with a matching image of another hand. But temporality is such an important dimension of film narration that even more traditional narratives explore the relationship between the order of events onscreen and those of the story. Steven Soderbergh's *The Limey* (1999) ingeniously inserts shots of the activities of the protagonist, played by Terence Stamp, into the narrative but out of sequence, keeping us guessing about temporal relations [**Figures 5.36a and 5.36b**]. *Inception* (2010) complicates our sense of time by making us question whether entire sequences are dreams or events in the lives of the characters.

Duration

Narrative duration refers to the length of time used to present an event or action in a plot. This may not conform to the length of time that passes in the story. Editing is one of the most useful techniques for manipulating narrative duration; it can

contract or expand story time. Although actions may seem to flow in a continuous fashion, editing allows for **ellipsis**—an abridgement in time in the narrative implied by editing. Cutting strategies both within scenes and from scene to scene attempt to cover such ellipses. Grabbing a coat, exiting through the front door, and turning the key in the car ignition might serve to indicate a journey from one locale to the next. As we have seen, transitional devices such as dissolves and fades also manipulate the duration of narration. Without the acceptance of such conventions, time would be experienced in a disorienting fashion.

A continuity editing device that is used to condense time is the **cutaway**—a shot that interrupts an action to "cut away" to another image or action (for example, to a man trapped inside a burning building), often to abridge time, before returning to the first shot or scene at a point further along in time. We are so accustomed to such handling of the duration of depicted events that a scene in real time—such as the single shot of the central character's taking a bath in *Jeanne Dielman, 23 Quai du Commerce, 1080 Bruxelles* (1975)—seems unnaturally long **[Figure 5.37]**.

Less frequent than the condensation of time, the extension of time through **overlapping editing** occurs when an edited sequence presents two or more shots of the same action across several cuts. In *Battleship Potemkin* (1925), a sailor, frustrated with the conditions aboard ship, is shown repeatedly smashing a plate he is washing. Plot time in this scene is longer than that of the action. The effect is to emphasize this small moment's decisive importance in a heroic narrative of the sailors' mutiny.

Overlapping editing is a violation in a continuity system, and although it can be used for emphasis or for foreshadowing, it often appears strange or gimmicky. In a masterfully choreographed fight scene in John Woo's *Hard Boiled* (1992), shots of the hero's balletic leap are overlapped **[Figures 5.38a and 5.38b]**. Such instances of prolonging narrative duration emphasize editing's rhythm, pulse, and pattern over story event.

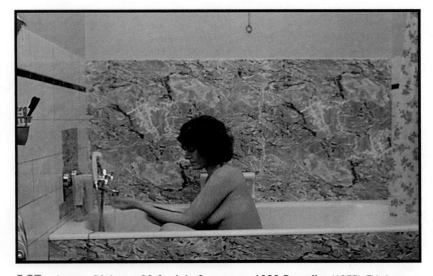

5.37 *Jeanne Dielman, 23 Quai du Commerce, 1080 Bruxelles* (1975). This long take records the protagonist's bath in real time. The film's pacing emulates the everyday routine of the housewife.

(a)

(b)

5.38a and 5.38b *Hard Boiled* (1992). The hero shoots up a restaurant without himself being hit. His leaps are prolonged through overlapping editing, which makes the scene even more spectacular.

(a)

(b)

5.39a and 5.39b *The Tree of Life* (2011). This film is paced with a measured editing style to capture the meditative perspectives of its characters.

Pace. The **pace** of a film is the tempo at which it seems to move, influenced by the duration of individual shots and the style of editing. The fast pace of a spy action movie like *Jason Bourne* (2016) contrasts with the more relaxed pace of a comedy like *School of Rock* (2003) or the slow elliptical editing of meditative films like *The Tree of Life* (2011) **[Figures 5.39a and 5.39b]** and *Melancholia* (2011). Chase scenes are likely to be cut more quickly than conversations. Pace may vary historically, culturally, and stylistically. There are no strict rules of pacing, although some editors may measure shot lengths exactly to achieve a desired rhythm.

Observers have noted that the **average shot length** (ASL) of narrative films has decreased over recent decades, and they correlate these measures to industry and narrative patterns as well as to processes of human perception. Rapid cutting of films whose average shot length may be less than two seconds has been enabled by digital technologies and driven by the prevalence of blockbuster action films.

A different way of controlling pace through editing is by using **long takes**, or shots of relatively long duration. Classical film theorist André Bazin is famous for his

advocacy of the long take in such post–World War II films as William Wyler's *The Best Years of Our Lives* (1946). Bazin especially championed the **sequence** shot, in which an entire scene is played out in space and time in a single shot, arguing that this type of filmmaking more closely approximates human perception and is thus more realistic than editing. Films that are cut with a preponderance of long takes use mise-en-scène—including blocking and acting—and camera movement instead of editing to focus viewers' attention.

Two different tests of Bazin's theories can be seen in contemporary uses of the long take. Shots that are sustained for what can seem an inordinate amount of time are prevalent in the styles of directors of contemporary international art films, prompting researchers to coin the term **slow cinema** for these works. *Flowers of Shanghai* (1998), by Taiwanese filmmaker Hou Hsiao-hsien, unfolds with only forty shots. The long takes evoke the city's past and vanished way of life. Minimal narrative incident, a contemplative or neutral camera, and a patient spectator are required of such films, in which editing's deliberate pace is one of the most defining aesthetic criteria.

Long takes and sequence shots are used by Quentin Tarantino and other contemporary directors not to promote Bazin's realism but to craft virtuoso displays of the kinetic possibilities of cinema. The spectacular unbroken shots in films like Tarantino's *Kill Bill: Vol. 2* (2004) keep pace with the film's otherwise rapid editing by the impressive choreography of characters, sets, and camera movement.

Most films use shot length to create a rhythm that relates to the particular aims of the film. One of the most influential examples of fast cutting, the infamous shower murder sequence from Hitchcock's *Psycho*, uses seventy camera setups for forty-five seconds of footage, with the many cuts launching a parallel attack on viewers' senses. In contrast, Alfonso Cuarón's *Children of Men* (2006) produces its uncanny mood in part through lengthy tracking shots. In these examples, pace is specific to the film and also a distinctive element of the director's style.

Rhythm. The early French avant-garde filmmaker Germaine Dulac defined film as "a visual symphony made of rhythmic images." Rhythm or **rhythmic editing** describes the organization of editing according to different paces or tempos determined by how quickly cuts are made. Like the tempos that describe the rhythmic organization of music, editing in this fashion may link a rapid succession of quick shots, a series of slowly paced long takes, or shots of varying length to modulate the time between cuts. A biopic about the hip-hop group N.W.A., *Straight Outta Compton* (2015), cuts many sequences to the rhythms of hip-hop and rap **[Figures 5.40a and 5.40b]**; the rhythm of the editing follows the music. Because rhythm is a fundamental property of editing, it often is combined with continuity aims or graphic patterns.

Without editing, a film's screen time would equal its plot time. Incorporating cuts shows the complexity of temporality in narrative film by organizing the order, frequency, and duration of events and descriptive information. Documentary and experimental films manipulate temporality through editing as well. Finally, editing is also integral to the viewer's physical experience of watching movies as they unfold in time: its rhythms can make us tense and fearful, calm and contemplative, or energized and euphoric.

Scenes and Sequences

The coordination of temporal and spatial editing patterns beyond the relationship between two shots results in a higher level of cinematic organization that is found in both narrative and non-narrative films. *Scene* and *sequence* are two terms for larger units of edited shots that are helpful to conceive of separately, even though they are not always strictly distinguished. In a narrative film, a **scene** is comprised of one or more shots that depict a continuous space and time—such as a conversation filmed following the 180-degree rule. A **sequence** is any number of shots that

VIEWING CUE

LaunchPad Solo

Time the shots of the sequence from *The General* (1927) available online. How does the rhythm of the editing in the sequence contribute to the film's mood or meaning?

(a)

(b)

5.40a and 5.40b *Straight Outta Compton* (2015). The rhythms of hip-hop and rap in the cutting of numerous sequences reflect the energy and anger of the town of Compton, California, in 1988.

VIEWING CUE

What is the temporal organization of the film you've just viewed for class? Does the film follow a strict chronology? How does the editing abridge or expand time?

are unified as a coherent action (such as a walk to school) or an identifiable motif (such as the expression of anger), regardless of changes in time and space. If the conversation ends with one character rising from the breakfast table and subsequent shots show the character driving, grabbing a coffee, and taking the elevator to work, the unit is a sequence. The editing bridges any changes of setting and covers ellipses of time, but the character continues one primary action, and no significant time passes. In a nonfiction film, a sequence could be defined by a topic or an aesthetic pattern. Editing combines and organizes a film's many scenes and sequences into patterns according to the logic of a particular story or mode of filmmaking.

One way to relate editing on the micro, shot-to-shot level to editing on a macro level is by **segmentation**—the process of dividing a film into large narrative units for the purpose of analysis. A classical film may have forty scenes and sequences but only ten large segments corresponding to the significant moves of the plot. In such films, locating editing transitions such as fades and dissolves can help point to these divisions, which occur at significant changes in narrative space, time, characters, or action. Tracing the logic of a particular film's editing on this level gives insight into how film narratives are organized. For example, the setting of a film's first scene may be identical to that of the last scene, or two segments showing the same characters may represent a significant change in their relationship. Although these structural units and relations may be dictated in the script, editing realizes them onscreen.

5.41a

5.41b

5.41c

5.41d

5.41e

5.41f

FORM IN ACTION

Editing and Rhythm in *Moulin Rouge!* (2001)

Editing gives a film its rhythm, and musical sequences often emphasize this dimension of editing over its ability to convey narrative information and spatiotemporal continuity. In the 1980s, commercials and music videos began to influence feature-film style strongly, and in the 1990s, the ease of digital editing facilitated a trend toward faster pacing. Today shot lengths average less than half those of studio-era Hollywood films. The frenetic editing of Baz Luhrmann's *Moulin Rouge!* (2001) contrasts markedly with the even pace of the classical *An American in Paris* (1951), for example. In contrast to the long takes of the Gene Kelly ballet sequence inspired by a Toulouse-Lautrec poster in the earlier classic, the frantic editing of *Moulin Rouge!* sucks Toulouse-Lautrec, among many other pleasure seekers, into a whirling world of mashed-up pop songs and dance moves.

Split-second shots of can-can dancers lip-syncing the disco song "Lady Marmalade" **[Figure 5.41a]** bewilder viewers as much as they do the naive hero Christian on his first visit to the notorious nightclub, the Moulin Rouge **[Figure 5.41b]**.

Incongruously, Nirvana's "Smells Like Teen Spirit" is introduced to the medley as the film cuts to the exterior of the club **[Figure 5.41c]** before a special-effects shot rapidly returns us to a montage of a tumult of bodies **[Figure 5.41d]** dancing to the can-can rap of Zidler, the master of ceremonies.

Cutting to the exterior again to highlight Zidler's direct solicitation of the audience **[Figure 5.41e]**, the film follows his superhuman dive back into the fray with jump cuts showing him commanding different stages.

Abruptly, Zidler signals for silence, and after this brief pause, the music and dance (and editing) resume at an even more accelerated pace **[Figure 5.41f]**. The rhythmic nature of the nineteenth-century music hall dance form and a postmodern pastiche of musical styles are echoed in and whipped into a frenzy by editor Jill Bilcock's cutting of a three-minute musical sequence with close to two hundred individual shots.

FORM IN ACTION

LaunchPad Solo

To watch a video about editing in *Moulin Rouge!* (2001),
see the *Film Experience* LaunchPad.

Making Sense of Film Editing

The editing styles we have discussed so far are not simply neutral ways of telling stories or conveying information. When they are applied in different contexts – Hollywood, art cinema, documentary, or the avant-garde – editing styles convey different perspectives. Cutting to a close-up in a silent film such as *The Cheat* (1912) was an innovative way of smoothly taking the viewer inside the film's world; it served the psychological realism of Hollywood storytelling. Documentary films have developed editing patterns whose logic is made clear by a continuous voiceover narration. Experimental films like *The Flicker* (1965) employ various patterns of alternation or accumulation to generate aesthetic experiences and reveal structural principles like those found in paintings or poetry.

Film editing serves two general aims – to generate emotions and ideas through the construction of patterns of seeing and also to move beyond normal temporal and spatial limitations. In John Ford's *Stagecoach* (1939), for instance, we experience the approach of pursuing Indians and the subsequent battle and escape from the perspective of the stagecoach's white passengers **[Figures 5.42a and 5.42b]**. Audience members almost involuntarily hope for the vanquishing of the pursuers, who are shown in long shots. We feel palpable relief, along with the surviving passengers, when their pursuers give up the chase. The editing breaks with the 180-degree rule, and the confusion builds feelings of tension. Because the point of view is not confined to the interior of the stagecoach, we see the initial threat and the close calls that the characters cannot see. Through logic and pacing, the editing does more than just link images in space and time; it also generates emotions and thoughts, and reinforces dominant social values.

These potential effects of editing are well illustrated in the legendary editing experiments conducted by Soviet filmmaker Lev Kuleshov in the 1910s and 1920s. A shot of the Russian actor Ivan Mozzhukhin's face followed by a bowl of soup signified "hunger" to viewers, while the identical footage of the face linked to a child's

(a) **(b)**

5.42a and 5.42b *Stagecoach* (1939). The editing of John Ford's classic *Stagecoach* uses humanizing close-ups of the passengers, medium long shots of the coach under siege, and long shots of the attackers to keep the viewers' sympathy with the stagecoach passengers.

coffin connoted "grief." In the absence of an establishing shot, viewers assumed these pairs of images to be linked in space and time and motivation—the so-called Kuleshov effect.

A magisterial example of how editing overcomes the physical limitations of human perception can be found in *2001: A Space Odyssey*. No individual character's consciousness anchors the film's journey through space and time. Instead, our experience of the film is governed largely by the film's editing—long-shot images that show crew members floating outside the spaceship, accompanied by Johann Strauss's *The Blue Danube* waltz,

5.43 *2001: A Space Odyssey* (1969). From beginning to end, the editing of this film defies the limits of human perception.

and a montage of psychedelic patterns that erases all temporal borders **[Figure 5.43]**. Our almost visceral response to these sequences is a result of the cinema's ability to defy our perceptual limits.

These two aims of film editing often overlap. The abstract images in *2001: A Space Odyssey* make us think about the boundaries of humanity and the vastness of the universe—and perhaps about cinema as a manipulation of images in space and time. Many of Alfred Hitchcock's climactic sequences generate emotions of suspense—achieved in *Saboteur* (1942) by suspending a character from the Statue of Liberty **[Figures 5.44a and 5.44b]**. The scene also transcends the confines of perception by showing us details that would be impossible to see without the aid of the movie camera.

Our responses to such editing patterns are never guaranteed. We may feel emotionally manipulated by a cut to a close-up or cheated by a cutaway. Additionally, across historical periods and in different cultures, editing styles can seem vastly different, and audience expectations vary accordingly. In a song-and-dance sequence from the Hindi film hit *Dilwale Dulhania Le Jayenge* (*The Big Hearted Will Take the Bride*) (1995), the editing uses flashbacks and costume changes on match cuts to

text continued on page 202 ▶

(a)

(b)

5.44a and 5.44b *Saboteur* (1942). Suspense is made literal—and visceral—as a man's fate hangs by a thread.

FILM IN FOCUS

Patterns of Editing in *Bonnie and Clyde* (1967)

See also: *Midnight Cowboy* (1969); *Fight Club* (1999)

Arthur Penn's *Bonnie and Clyde* (1967) represented a new kind of American filmmaking in the late 1960s, in part because its complex spatial and temporal patterns of editing departed from established norms. Based on the story of two famous outlaws from the 1930s, the film describes the meeting of the title characters and their violent but clownish crime wave through the Depression-era South. As their escapades continue, they are naively surprised by their notoriety. Soon the gaiety of their adventures gives way to bloodier and darker encounters: Clyde's accomplice/brother is killed, and eventually the couple is betrayed and slaughtered.

Frequently, Dede Allen's editing of scenes emphasizes temporal and spatial realism. The scene depicting the outlaw couple's first small-town bank robbery begins with a long shot of a car outside the bank. The next shot, from inside the bank, shows the car parked outside the window.

Spatially, this constructs the geography of the scene; temporally, it conveys the action that takes place within these linked shots. The scene creates verisimilitude.

At other points in *Bonnie and Clyde*, the logic of the editing emphasizes psychological or emotional effects over realism. When Bonnie (Faye Dunaway) is introduced, for example, the first image we see of her is an extreme close-up of her lips; the camera pulls back as she turns right to look in a mirror. This is followed by a cut on action as she stands and looks back over her shoulder to the left in a medium shot and then by another cut on action as she drops to her bed, her face visible in a close-up through the bedframe, which she petulantly punches. Here Bonnie's restless movements are depicted by a series of jerky shots, and through the editing, we sense her boredom and frustration with small-town life [**Figures 5.45a and 5.45b**].

(a) **(b)**

5.45a and 5.45b *Bonnie and Clyde* (1967). The lack of an establishing shot combines with the multiple framings to emphasize the claustrophobic mise-en-scène, taking us right into the character's psychologically rendered space.

(a)

(b)

(c)

5.46a–5.46c *Bonnie and Clyde* (1967). Clyde's famous death sequence uses slow-motion cinematography, cutting on movement, and overlapping editing.

Next Bonnie goes to her window and, in a point-of-view construction, spots a strange man near her mother's car. She comes downstairs to find out what he is doing, and her conversation with Clyde (Warren Beatty) is handled in a series of shot/reverse shots, starting with long shots as she comes outside and proceeding to closer pairs of shots. The two-shot of the characters together is delayed. The way this introduction is handled emphasizes the inevitability of their pairing.

The final scene is the film's most famous and influential, and the strategies used serve as an instructive summary of the patterns and logic of editing. Accompanied by the staccato of machine-gun bullets, Bonnie's and Clyde's deaths are filmed in slow motion, their bodies reacting with almost balletic grace to the gunshots and to the rhythm of the film's shots, which are almost as numerous. In nearly thirty cuts in approximately forty seconds, the film alternates between the two victims' spasms and the reestablishing shots of the death scene. Clyde's fall to the ground is split into three shots, overlapping the action **[Figures 5.46a–5.46c]**. The hail of bullets finally stops, and the film's final minute is comprised of a series of seven shots of the police and other onlookers gathering around, without a single reverse shot of what they are seeing. One of the more creative and troubling dimensions of the *Bonnie and Clyde* film is the striking combination of slow, romantic scenes and fast-paced action sequences, which culminate in this memorable finale.

For linking sex with violence, glamorizing its protagonists through beauty and fashion, and addressing itself to the antiauthoritarian feelings of young audiences, *Bonnie and Clyde* is among the most important U.S. films of the 1960s. Together with other countercultural milestones such as *The Graduate* (1967) and *Easy Rider* (1969), it heralded the end of studio-style production and the beginning of a new youth-oriented film market that revisited film genres of the past with a modern sensibility. However, as we have seen, it was not only the film's content that was innovative. *Bonnie and Clyde*'s editing and the climactic linkage of gunshots with camera shots also influenced viewers—from filmmakers to the American public.

(a)　　　　　　　　　　　　　　　　　　　　　　　　(b)

5.47a and 5.47b *Dilwale Dulhania Le Jayenge (The Big Hearted Will Take the Bride)* (1995). Editing transcends time and space within the film's song-and-dance sequences and resumes continuity as the narrative moves forward.

highlight the central couple's predestined romance **[Figures 5.47a and 5.47b]**. Audiences familiar with the conventions accept these ruptures in time and space; those less familiar may be surprised with the return to verisimilitude after the number.

Disjunctive Editing

As we have noted, continuity editing is so pervasive in narrative film and television that its basic tenets read as "rules" **[Figures 5.48a and 5.48b]**. But since the first uses of editing in the early twentieth century, continuity rules have been paralleled and sometimes directly challenged by various alternative practices. Here we refer to these practices collectively as *disjunctive editing* to distinguish these styles from continuity editing and to illuminate historical, cultural, and philosophical differences in editing styles. These traditions are not unified, however, and in modern filmmaking multiple editing methods sometimes converge in the editing style of a single film.

　Disjunctive editing is visible editing. It calls attention to the cut through spatial tension, temporal jumps, or rhythmic or graphic patterns and therefore makes a definitive break from cutting in the service of verisimilitude. Alternative editing practices based on oppositional relationships or other formal constructions can be traced back to early developments in film syntax in various countries and schools excited about the possibilities of film art. These practices confront viewers with juxtapositions and linkages that seem unnatural or unexpected with two main

(a)　　　　　　　　　　　　　　　　　　　　　　　　(b)

5.48a and 5.48b *Plan 9 from Outer Space* (1959). The principles of continuity editing are illustrated by their failed execution in a film by notorious B filmmaker Edward D. Wood Jr. When actor Bela Lugosi died before filming was complete on this low-budget sci-fi horror film, the director replaced him with another actor in a cape. Clearly, props alone do not create continuity.

purposes—to call attention to the editing for aesthetic, conceptual, ideological, or psychological purposes and to disorient, disturb, or affect viewers viscerally.

When the viewer notices a particular cut or cutting pattern because it is jarring, she or he may be led to reflect on its meaning or effect. Disjunctive editing is prominent in avant-garde and political film traditions, and some theorists argue that it leads the viewer to develop a critical perspective on the medium, the film's subject matter, or the process of representation itself. Other effects of disjunctive editing patterns may be more physical than rational. Editing may be organized around any number of different aspects, such as spatial tension, temporal experimentation, or rhythmic and graphic patterns.

Jump Cuts

One technique that is used many different ways in disjunctive editing is the **jump cut**—a cut that interrupts a particular action and intentionally or unintentionally creates discontinuities in the spatial or temporal development of shots. Used loosely, the term *jump cut* can identify several different disjunctive practices. Cutting a section out of the middle of a shot causes a jump ahead to a later point in the action. Sometimes the background of a shot may remain constant while figures shift position inexplicably. Two shots from the same angle but from different distances also creates a jump when juxtaposed. Although such jumps are considered grave errors in continuity editing, as noted previously, they were reintroduced into the editing vocabulary of narrative films by the French New Wave, notably Jean-Luc Godard's *Breathless* (1960). Jump cuts gave Godard's gangster narrative an outlaw energy. Contemporary films such as *The Big Short* (2015) have appropriated this technique to allow viewers to experience the disorientation and, in this case, the frightening lack of logic that propelled the 2008 housing collapse [**Figures 5.49a and 5.49b**].

(a)

(b)

5.49a and 5.49b *The Big Short* (2015). Hollywood films have increasingly appropriated jump cuts. Here, shots of Steve Carell's character convey his character's distracted state.

(a) **(b)**

5.50a and 5.50b *Happy Together* (1997). Here jump cuts draw attention to the restlessness and displacement of two men who have moved from Hong Kong to Buenos Aires.

Jump cuts illustrate the two primary aims of disjunctive editing. In Wong Kar-wai's *Happy Together* (1997), they contribute to the film's overall stylization. Jumps in distance and time are combined with changes in film stock within a supposedly continuous scene **[Figures 5.50a and 5.50b]**. Rather than simply taking in the action, the viewer notices *how* the action is depicted. The viewer may reflect on how the disjointed shots convey the characters' restless yet stagnant moods, recognize in them the film's theme of displacement, or appreciate the aesthetic effect for its own sake.

The jump cuts in Alain Resnais's *Last Year at Marienbad* (1961) are a central device that the film uses to play with space and especially time. The major conceit of this classic art film is the characters' different versions of the past. The protagonist (known only as X) insists that he met the heroine (A) at the same hotel one year before, and she denies it. This difference in point of view relates to the viewer's disorientation through editing. Numerous images show the female protagonist striking poses around the hotel and gardens **[Figures 5.51a and 5.51b]**. The temporal relationship among such shots is unclear (are they happening now, are they flashbacks, or are they X's version of events?), and differences in costume and setting are countered by similarities in posture and styling. Finally, the editing strategy becomes a reflection on the process of viewing a film. How can we assume that the action we are viewing is happening now, when recording, editing, projection, and viewing are all distinct temporal operations?

One principle behind the use of disjunctive edits like jump cuts for some filmmakers is the concept of **distanciation** introduced by German playwright Bertolt Brecht in his plays and critical writings of the 1920s. This artistic practice is intended to create an intellectual distance between the viewer and the work of art

(a) **(b)**

5.51a and 5.51b *Last Year at Marienbad* (1961). Delphine Seyrig strikes poses against various backgrounds, challenging our perception of time and place in the narrative and in cinematic viewing more generally. The technique was later adopted in music videos.

in order to reflect on the work's production or the various ideas and issues that it raises. When viewers are made aware of how the work is put together, they are encouraged to think as well as to feel. In *Two or Three Things I Know About Her* (1967), Jean-Luc Godard uses nondiegetic inserts (like numbered chapter headings, printed text, and advertising images) as distanciation devices.

Montage

As noted previously, the most important tradition in disjunctive editing is the Soviet theory of montage, which aims to grab viewers' attention through the collision between shots. Sergei Eisenstein developed his ideas in extensive writings, undertaken from the early 1920s to his death in 1945, that have secured him a place as one of the foremost theorists of cinema. At the same time, he illustrated these ideas in his films, starting with *Strike* in 1925. Eisenstein advocated **dialectical montage**—the cutting together of conflicting or unrelated images to generate an idea or emotion in the viewer. He argued that two contrasting or otherwise conflicting shots will be synthesized into a visual concept when juxtaposed. In *Battleship Potemkin* (1925), the shots of several stone lions juxtaposed in sequence suggest that one stone lion is leaping to life **[Figures 5.52a–5.52c]**. According to

(a)

(b)

(c)

5.52a–5.52c ***Battleship Potemkin*** (1925). Sergei Eisenstein rouses stone lions through montage.

(a)

(b)

(c)

5.53a–5.53c *San Francisco* (1936). Although continuity editing was the norm in studio-era Hollywood, montage sequences were created for special purposes, such as this spectacular earthquake scene.

Eisenstein, the concept of awakening, connected to revolutionary consciousness, is thus formed in viewers' minds even as they react viscerally to the lion's leap. Such an association of aesthetic fragmentation with a political program of analysis and action has persisted in many uses of disjunctive editing.

Recall that, strictly speaking, the word *montage* simply means "editing." As some of the techniques used by the Soviets were adapted elsewhere, the term **montage sequence** came to denote a series of thematically linked shots or shots meant to show the passage of time, joined by quick cuts or other devices, such as dissolves, wipes, and superimpositions. In studio-era Hollywood, the Soviet émigré Slavko Vorkapich specialized in creating memorable montage sequences such as the earthquake in *San Francisco* (1936) **[Figures 5.53a–5.53c]**.

Today the same term is used to emphasize the creative power of editing—especially the potential to build up a sequence and augment meaning—rather than simply the removal of the extraneous (as the term "cutting" implies). This principle of construction is behind abstract and animated films and videos that convey visual patterns through their editing (examples of which are explored in Chapter 8). It also informs films made from found footage, which date back at least to montage experiments like *The Fall of the Romanov Dynasty* (1927), cut from existing footage by Soviet filmmaker Esfir Shub when film stock was in short supply. One of the first explorations of the overabundance of images that saturated postwar consumer culture, Bruce Conner's *A Movie* (1958) is a rapid montage that creates humorous, sinister, and thought-provoking relationships among images culled from newsreels, pinups, war movies, and Hollywood epics. The introduction of consumer videos in the 1980s made the editing of found footage and the use of video effects accessible to artists as well as amateurs. Cecilia Barriga's low-budget analog video art piece *Meeting of Two Queens* (1991) is ingeniously constructed by recutting brief clips from the films of Hollywood icons Greta Garbo and Marlene Dietrich. The resulting video suggests a romance between the

two by using viewers' expectations of continuity editing and altering mise-en-scène through superimposition.

Converging Editing Styles

Given the influence of other traditions and styles, editing in mainstream films arguably no longer strives for invisibility. Certainly, it is no longer possible (if it ever was) to assign specific responses, such as passive acceptance or political awareness, to specific editing techniques.

Digital technology has revolutionized the craft and language of editing. Using footage from one hundred small digital video cameras, Lars von Trier in *Dancer in the Dark* (2000) breaks down actions much more minutely than through standard editing, and the arbitrariness of the cutting becomes apparent rather than remaining hidden. As the two formal traditions of continuity and disjunctive editing converge, the values associated with each tradition become less distinct. For Eisenstein, calling attention to the editing was important because it could change the viewers' consciousness. For contemporary filmmakers, omitting establishing shots, breaking the 180-degree rule, and using rapid montage may serve primarily to establish a stylish, eye-catching look.

Editing is perhaps the most distinctive feature of film form. Editing leads viewers to experience images viscerally and emotionally, and it remains one of the most effective ways to create meanings from shots. These interpretations can vary—from the almost automatic inferences about space, time, and narrative that we draw from the more familiar continuity editing patterns to the intellectual puzzles posed by the unfamiliar spatial and temporal juxtapositions of disjunctive editing practices.

VIEWING CUE

Does the editing of the film you've just viewed for class call attention to itself in a disjunctive fashion, setting up conflicts or posing oppositional values? If so, how and to what end?

CONCEPTS AT WORK

Distinctive to the medium of cinema, editing comprises an array of strategies to tell stories, juxtapose perspectives, and affect viewers' senses. The cinema of the silent era—including Griffith's experiments in the manipulation of time and space in crosscutting chase sequences, Eisenstein's thrilling Odessa steps sequence in *Battleship Potemkin*, and the modernist patterns of films like *Ballet mécanique*—developed a complex editing vocabulary. Classical Hollywood cinema's continuity editing in genre films like *The Big Sleep* constructed verisimilitude of time and space and allowed for brisk storytelling that was emulated all over the world. When postwar art cinema challenged the hero-driven linear narrative with more psychological constructions of space and time, Hollywood films like *Bonnie and Clyde* followed. Digital editing technologies have ushered in new forms of complex storytelling and combined disjunctive with continuity patterns in films like *The Big Short*. In all these traditions, viewers are called on to make sense of the infinite possibilities of combining images and sounds in sequence.

Considering these films more closely, attend to some of the objectives introduced at the beginning of this chapter.

- Watch a scene from *The Big Sleep* or another classical Hollywood film, and count the number of cuts. Are cuts used more often than you expected?
- Watch a scene from *The Big Short* or another current Hollywood film, and test whether the 180-rule, establishing shots, and eyeline matches govern the editing. What kinds of disjunctive editing are visible?
- Starting with the chapters on the DVD menu of *Bonnie and Clyde*, attempt a narrative segmentation of the film, and describe how the sequencing of two specific scenes relates to narrative.

LaunchPad Solo

Visit the LaunchPad Solo for *The Film Experience* to view movie clips, read additional Film in Focus pieces, and learn more about your film experiences.

FILM SOUND
Listening to the Cinema

Jane Campion's 1993 *The Piano* opens with its nineteenth-century heroine Ada McGrath's voiceover: "The voice you hear is not my speaking voice; it is my mind's voice." This is the first indication of the inventive uses to which the film will put sound—for Ada is mute, and we will not hear her "mind's voice" again until the film's final moments. She is about to emigrate from Scotland to New Zealand to marry a man whom she has never met, and the grand piano that she takes with her becomes her primary means of expression. Even when Ada is forced to leave the piano on the beach where she lands because it is too large to transport, the film's soundtrack acts as a link between her and the piano. Later the piano becomes an instrument of exchange and erotic expression, when she must barter for its return from the man who buys it from her husband. *The Piano* recognizes from the start that film sound does not simply play a supporting role and is not restricted to human speech. Rather, film sound—as dialogue, music, and sound effects—can create a drama as complex as mise-en-scène, cinematography, or editing.

The cinema is an audiovisual medium, one among many that saturate our contemporary media experience. Many of the visual technologies we encounter in daily life are also sound technologies: you choose your smartphone's ringtone, battle villains to the soundtrack of your favorite video game, or notice that your television's volume soars when a commercial interrupts a program. These devices use sound to encourage and guide interaction, to complement visual information, and to give rhythm and dimension to the experience. The cinema works similarly, using complex combinations of voice, music, and sound effects. Too often given secondary status, sound engages viewers perceptually, provides key spatial and story information, and affords an aesthetic experience of its own.

Sound is a sensual experience that in some cases makes an even deeper impression than a film's visuals. Viewers might cover their eyes during the infamous shower scene in *Psycho* (1960), but to lessen the scene's horror, they would have to escape from the shrieking violins that punctuate each thrust of the knife. To perceive an image, we must face forward with our eyes open, but sound can come from any direction. Listening to movies, just as much as watching them, defines the filmgoing experience, and advanced technologies have helped to make the sound experience more immersive than ever before. This chapter explores how speech, music, and sound effects are used in cinema and how they are perceived by a film's audience.

A Short History of Film Sound

The history of film sound might appear to begin with the talkies at the end of the 1920s, but in fact both the technical advances necessary to the invention of the cinema and its roots in other storytelling and entertainment practices are as tied to sound as they are to image. "Silent" films were accompanied by live music, sound effects, and human voices, and at most key moments of technological change, sound innovations paralleled advances in imaging.

Prehistories of Film Sound

The central role played by music in cinema arises from its theatrical predecessors. The practice of combining music with forms of visual spectacle in the Western tradition goes back at least as far as the use of choral odes in classical Greek theater. Perhaps most relevant to the use of sound in early cinema is the tradition of stage melodrama—a sensational narrative whose clearly identifiable moral types, coincidences, and reversals of fortune are dramatized by music. In eighteenth-century France, the word

mélodrame designated a theatrical genre that combined spoken text with music. In England, plays with music provided popular theatrical spectacles during a time when laws restricted "legitimate" theater to particular venues. Stage melodrama dominated the nineteenth-century American stage; its influence is seen in silent films like D. W. Griffith's *Way Down East* (1920), an adaptation of a nineteenth-century play.

In addition to music, cinematic predecessors such as magic lantern shows and travel lectures used sound effects and narration as aural accompaniment. As far back as the late eighteenth century, inventors were engaged in the problems of sound reproduction. Thomas Edison's introduction of the phonograph in 1877 greatly expanded the public's taste for technologically mediated entertainment; his laboratory developed film technology within a few decades.

6.1 Edison Studios' *Sound Experiment* (1895). A rare film fragment with synchronized sound from the dawn of cinema. Courtesy Edison Historic Site, NPS

1895–1920s: The Sounds of Silent Cinema

The dream of joining image and sound haunted the medium from its inception. Edison was a primary figure in the invention of the motion-picture apparatus, and one of the first films made by his studios in 1895 is a sound experiment in which Edison's chief inventor, W.L.K. Dickson, plays a violin into a megaphone as two other employees dance [**Figure 6.1**]. Sound cylinders provided a way of synchronizing image and sound very early in film history, and inventors continued to experiment with means of providing simultaneous picture and sound throughout the silent film era.

But before the successful development and widespread showing of films with synchronized sound, loudspeakers lured customers into film exhibitions that were accompanied by lecturers, pianos, organs, small ensembles, and eventually full orchestras. The so-called silent cinema used sound very intentionally. Often sound effects were supplied by someone standing behind the screen or by specially designed machines. Occasionally, actors even provided dialogue to go along with the picture. Moreover, in nickelodeons and other movie venues, audiences themselves customarily made noise, joining in sing-alongs between films [**Figures 6.2a and 6.2b**] and talking back to the screen.

(a)

(b)

6.2a and 6.2b Early nickelodeon slides. From 1905 to 1915, films were interspersed with sing-alongs, and slides like these provided the lyrics for an interactive experience. (a) From the collection of Joseph Yranski; (b) Marnan Collection/Minneapolis, Minnesota

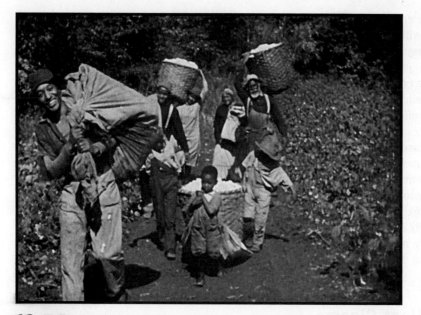

6.3 *Hallelujah!* (1929). With the coming of sound, musicals abounded, from backstage musicals to King Vidor's film, shot on location and highlighting an all-black cast.

From the music halls in Great Britain and vaudeville theaters in the United States, early cinema borrowed popular talents, proven material, formats (such as the revue), and audiences that had specific expectations about sound and spectacle. Because of the preexisting popularity of minstrel shows and vaudeville, African American and Jewish voices were heard in cinema when they might otherwise have been excluded from entertainment directed at mass audiences. For his sound film debut at MGM, director King Vidor chose to make *Hallelujah!* (1929), a musical with an all-black cast, capitalizing on the cultural associations of African Americans with the expressive use of song **[Figure 6.3]**. Both musical performers and stage performers with vocal training and experience were now in demand in Hollywood, and they soon displaced many of the silent screen's most beloved stars.

1927–1930: Transition to Synchronized Sound

No event in the history of Hollywood film was as cataclysmic as the rapid incorporation of synchronized sound in the period from 1927 to 1930. Many dynamics were at work in the introduction of sound, including the relationship of cinema to radio, theater, and vaudeville, the economic position of the industry as the United States headed into the Great Depression, and the popularity of certain film genres and stars. Yet exhibitors needed to be convinced to adopt the relatively untested new technology. Considerable expense was involved in converting a sufficient number of theaters to make the production of sound films feasible, and the studios had to be willing to make the investment.

In 1926 and 1927, two studios actively pursued competing sound technologies. Warner Bros. aggressively invested in sound and, in 1926, premiered its Vitaphone sound-on-disk system with a program of shorts, a recorded speech by Hollywood censor Will H. Hays, and the first feature film with a recorded score, *Don Juan*. Fox developed its Movietone sound system, which recorded sound optically on film. In 1928, Fox introduced its popular Movietone newsreels, which depicted everything from ordinary street scenes to exciting news (aviator Charles Lindbergh's takeoff for Paris was the first use of sound for a news item) and were soon playing in Fox's many theaters nationwide **[Figure 6.4]**. The new technology became impossible to ignore when it branched out from musical accompaniment and sound effects to include synchronous dialogue. Public response was enthusiastic.

Talking pictures, or "talkies," were an instant popular phenomenon. *The Jazz Singer*, Warner Bros.' second feature

6.4 Ad for the Fox Movietone Magic Carpet series in the exhibitor's journal *Motion Picture Herald* (1934). Fox Studios' theater holdings were equipped to show newsreels made with the studio's optical sound recording technology. The newsreels ran from 1928 to 1963 in the United States. Everett Collection, Inc.

film with recorded sound, released in October 1927, is credited with convincing exhibitors, critics, studios, and the public that there was no turning back. Starring vaudevillian Al Jolson—the country's most popular entertainer of the time, who frequently performed in blackface—the film tells a story, similar to Jolson's own, of a singer who must turn his back on his Jewish roots and the legacy of his father, a cantor in a synagogue, in order to fulfill his show-business dreams. Jolson introduces dialogue to the movies with a famous promise that came true soon thereafter: "You ain't heard nothing yet!" **[Figure 6.5]**. In the wake of *The Jazz Singer*'s remarkable success, the studios came together and signed with Western Electric (a subsidiary of AT&T) to adopt a sound-on-film system in place of the less flexible Vitaphone sound-on-disk process. The studios also invested in converting their major theaters and in acquiring new chains to show sound films.

6.5 *The Jazz Singer* (1927). Warner Bros.' Vitaphone sound-on-disk system became a sensation because of Al Jolson's singing and spontaneous dialogue.

1930s–1940s: Challenges and Innovations in Cinema Sound

The transition to sound was not entirely smooth. The troubles with exhibition technology were more than matched by the difficulties posed by cumbersome sound recording technology. Despite such problems, the transition was extremely rapid. By 1930, silent films were no longer being produced by the major studios, and only a few independent filmmakers, such as Charlie Chaplin, whose art grew from the silent medium, held out.

The ability of early films to cross national borders and be understood regardless of the local language, a much-celebrated property of the early medium, was also changed irrevocably by the addition of spoken dialogue in a specific language. Film industries outside the United States acquired national specificity, and Hollywood set up European production facilities. Exports were affected by conversion-standard problems and patent disputes. For a time, films were made simultaneously in different languages. Marlene Dietrich became an international star in *The Blue Angel* (1930), produced in Germany in French, English, and German versions.

By this period, the Radio Corporation of America had entered the motion-picture production business, joining with the Keith-Albee-Orpheum chain of vaudeville theaters. The new studio, RKO Radio Pictures, quickly became one of five studios known as the "majors" that dominated sound-era cinema. The score for RKO's *King Kong* (1933) was prolific composer Max Steiner's breakthrough. Also made at RKO, *Citizen Kane* (1941) was more adventurous in its use of sound, befitting Orson Welles's background in radio. The establishment of representational norms in sound recording and mixing practices proceeded rapidly after the introduction of sound. A complex division of labor arose for the recording and mixing of soundtracks. Continuous scoring was a norm, but so was the emphasis placed on making dialogue audible above all else.

1950s–1980s: From Stereophonic to Dolby Sound

The postwar period saw new attention being paid to the qualities and varieties of sound. Magnetic tape replaced the optical soundtrack as a recording medium, bringing greater clarity as well as new opportunities for creativity and new methods of both recording and mixing. The increased competition with other forms of entertainment including radio, television, and the recording industry encouraged innovations in film sound style and practice. Conventionally orchestral in style, scores began to incorporate jazz and popular music. **Stereophonic sound**—the

recording, mixing, and playback of sound on multiple channels to create audio perspective—was promoted in the 1950s along with widescreen technologies to lure audiences away from television through an immersive sensory experience at the movies. Spectacles like *The Sound of Music* (1965) were special events when seen and heard in properly equipped movie theaters.

In the 1960s and 1970s, portable sound recording technology helped break out of the studio model, and location sound used in independent cinema became part of the authenticity and artistry of the new Hollywood. Sound designer Walter Murch helped make Francis Ford Coppola's *Apocalypse Now* (1979) a new kind of sonic experience. Dolby Laboratories turned its attention to making the exhibition experience equal to the quality of film sound production, and its surround sound systems gave the blockbusters of the 1980s their powerful audio impact. The introduction of the MTV cable television channel in 1981 helped producers cross-promote the soundtrack albums for movies with popular music scores.

1990s–Present: Sound in the Digital Era

Changes in sound technologies and practices have corresponded with historical shifts in film's social role, and this continued as home video, cable, and video games became competitive entertainments. With digital technologies, these environments also began to converge.

Digital sound editing and mixing gave sound engineers greater flexibility during production and postproduction, and the sonic style of studio films became more dense and kinetic. Just as in the 1950s, when CinemaScope and stereophonic sound were used to lure customers back to the theaters, digital sound systems attracted audiences to theatrical exhibition. Audiophiles led the companion trend toward home theaters with digital sound systems and speakers configured like those of movie theaters to emulate surround sound. The perpetual quest for bigger and better-quality images and sounds confirms that one part of cinema's appeal is its ability to provide a heightened sensory experience that intensifies the ordinary.

The Elements of Film Sound

Sound is fully integrated into the film experience. In fact, one aspect of sound—human speech—is so central to narrative comprehension and viewer identification that we often can follow what happens even when the picture is out of sight. Sounds can interact with images in infinite ways, and strategies that combine the two can affect our understanding of film. In *Dr. Strangelove, or: How I Learned to Stop Worrying and Love the Bomb* (1964), the song "We'll Meet Again"—a nostalgic 1940s song used to boost troop morale during World War II—accompanies footage of hydrogen bombs dropping and detonating, making it impossible to read these images as noble or tragic. Instead, the song and images frame the film's view of war as dark satire **[Figure 6.6]**.

Sound effects of footsteps to accompany an image of a character walking are not really necessary; such an image is easily interpreted with the accompaniment. However, the sound of footsteps heightens the sense of immediacy and presence. In

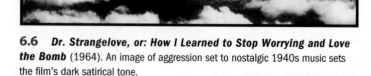

6.6 Dr. Strangelove, or: How I Learned to Stop Worrying and Love the Bomb (1964). An image of aggression set to nostalgic 1940s music sets the film's dark satirical tone.

the next section, we explore the relationship of sound and image and the often unperceived meanings of sound before considering more fully the technology and aesthetics of film sound.

Sound and Image

Any consideration of sound in film entails discussion of the relationship between sounds and images. Some filmmakers, such as the comic actor and writer-director Jacques Tati, have consistently given equal weight to the treatment and meaning of sound in their films. In *Playtime* (1967), comic gags take place in long shots, while sounds cue us where to look **[Figure 6.7]**. In his unique films, filmmaker Jacques Demy pursues a vision of film's musicality. In *The Umbrellas of Cherbourg* (1964), all of the dialogue is sung to Michel Legrand's music, while the candy-colored sets and costumes are designed to harmonize with this heightening of experience **[Figure 6.8]**. Derek Jarman's *Blue* (1993), made after the filmmaker had lost his vision due to an AIDS-related illness, combines an image track consisting solely of a rich shade of blue with a soundtrack featuring a complex mix of music, effects, and voices reading diaries and dramatic passages. Gazing into a vast blue screen allows viewers to focus more carefully on the soundtrack's ideas and the emotions they evoke.

For many filmmakers, however, as for viewers, sound functions more as an afterthought that exists to enhance the effect of the image. Many possible reasons exist for this disparity. Film is generally considered to be a predominantly visual medium rather than an aural one, following a hierarchy of vision over sound. The artistry of the image track is perceived to be greater because the image is more clearly a conscious rendering of the object being photographed than the recording is of the original sound. The fact that sound came later in the historical development of cinema also has been offered as an explanation of its secondary status. Yet the importance and variety of aural experiences at the movies were great even before the introduction of synchronized soundtracks.

Since the early years of sound cinema, certain directors and composers have struggled against a too-literal, and too-limited, use of sound in film, arguing that the infinite possibilities in image and sound combinations are germane to the medium and its historical development. French filmmaker René Clair feared that the introduction of sound would diminish the visual possibilities of the medium and reduce it to "canned theater." In his musical film *Le Million* (1931), he uses sound in a way that makes it integral to the film. Through scenes of characters and crowds singing songs essential to the plot, Clair demonstrates that sound's potential is more than additive. It transforms the film experience viscerally, aesthetically, and conceptually.

6.7 *Playtime* (1967). Jacques Tati's comic film emphasizes sound as much as image, often cueing the gag through sound effects.

📹 VIEWING CUE

Technologies of watching—and listening to—movies have changed rapidly in recent years. Characterize the audio experience of the last film you watched. How much of this experience was specific to the film's sound design, and how much was related to the format, platform, or venue through which you watched the film?

6.8 *The Umbrellas of Cherbourg* (1964). The musicality of Jacques Demy's lovely tale of a small-town romance is represented in everything from the dialogue, all in song, to the brightly colored costumes and sets.

Synchronous and Asynchronous Sound

Because sound and image always create meaning in conjunction, film theorists attentive to sound have looked for ways to talk about the possibilities of the combination of sound and image. In his book *Theory of Film* (1960), Siegfried Kracauer emphasizes a distinction between synchronous and asynchronous sound. **Synchronous sound** (also known as onscreen sound) is recorded during a scene or is synchronized with the filmed images and has a visible onscreen source, such as when dialogue appears to come directly from the speaker's moving lips. **Asynchronous sound** (also known as offscreen sound) is sound that does not have a visible onscreen source. For instance, although most film speech is synchronous, voiceovers are asynchronous because they do not coordinate with the action of the scene. A shot of an alarm clock accompanied by the sound of its ringing is synchronous. An asynchronous knock in a horror film might startle the characters with the threat of an offscreen presence.

Kracauer goes on to differentiate between **parallel sound** (which reinforces the image, such as synchronized dialogue or sound effects, or a voiceover that is consistent with what is displayed onscreen) and **contrapuntal sound** (which contrasts in meaning with the image that is displayed onscreen). In *Kill Bill: Vol. 2* (2004), as The Bride attempts to break out of a sealed coffin, the selections from Ennio Morricone's early scores for spaghetti westerns offer a counterpoint to this horrific situation **[Figure 6.9]**. Soon, the sound of The Bride's fist on the coffin lid, which parallels her methodical punching, combines with the music for heightened effect.

The two pairs of terms are distinct from each other and not mutually exclusive. A shot of a teakettle accompanied by a high-pitched whistle is both synchronous and parallel. The teakettle accompanied by an alarm bell would be a synchronous yet contrapuntal use of sound. A voiceover of a nature documentary may explain the behavior of the animals in a parallel use of asynchronous sound. Idyllic images accompanied by a narration stressing the presence of toxins in the environment and an ominous electronic hum would be a contrapuntal use of asynchronous sound.

A familiar example of how relationships between sound and image can achieve multiple meanings comes at the end of *The Wizard of Oz* (1939). The booming voice and sound effects synchronized with the terrifying image of the wizard are suddenly revealed to have been asynchronous sounds produced by an ordinary man behind the curtain. When we see him speaking into a microphone, the sound is in fact synchronous, and what was intended as a parallel is revealed to be a contrapuntal use of sound **[Figure 6.10]**.

Parallelism—the mutual reinforcing or even the redundancy of sound and image—is the norm in Hollywood. For

VIEWING CUE

Distinguish an example of synchronous sound (with an onscreen source) from an example of asynchronous sound (with an offscreen source) in the film you are studying. Are these sounds easy to distinguish?

6.9 *Kill Bill: Vol. 2* (2004). Spaghetti western music acts as a counterpoint to the horrific images of The Bride punching her way out of a sealed coffin.

6.10 *The Wizard of Oz* (1939). The source of the wizard's voice is revealed, interrupting the synchronous effect that frightened the travelers.

example, a shot of a busy street is accompanied by traffic noises, although viewers immediately understand the locale through the visuals. This parallelism is an aesthetic choice. In contrast, at the dawn of the sound era, Soviet theorists advocated a contrapuntal use of sound to maximize the effects of montage.

Diegetic and Nondiegetic Sound

One of the most frequently cited and instructive distinctions that is made in sound is between **diegetic sound** (which has its source in the narrative world of film) and **nondiegetic sound** (which does not have an identifiable source in the characters' world). Materially, the source of film sound is the actual soundtrack that accompanies the image, but diegetic sound implies an onscreen source. Diegesis is the world of the film's story (its characters, places, and events), including both what is shown and what is implied to have taken place. The word diegesis comes from the Greek word meaning "telling" and is distinguished from mimesis, meaning "showing." The implication is that mimetic representations imitate or mimic and diegetic ones use particular devices to tell about or imply events and settings.

6.11 *Little Miss Sunshine* (2006). Source music provides the soundtrack in this scene from *Little Miss Sunshine*.

One question offers a simple way to distinguish between diegetic and nondiegetic sound: can the characters in the film hear the sound? If not, the sound is likely to be nondiegetic. This distinction can apply to voices, music, and even sound effects. Examples of diegetic sounds include conversations among onscreen characters, the voice of God in *The Ten Commandments* (1956), a voiceover that corresponds to a confession a character is making to the police, and the song "Superfreak" accompanying the little girl's pageant dance routine in *Little Miss Sunshine* (2006) **[Figure 6.11]**. Nondiegetic sounds do not follow rules of verisimilitude. For example, the voiceover narration that tells viewers about the characters in *The Magnificent Ambersons* (1942), background music that accompanies a love scene or journey, or sound effects such as a crash of cymbals when someone takes a comic fall are all nondiegetic. Audio practitioners use the term **source music** to refer to diegetic music, such as a band performing at a party or characters listening to music on the radio.

The distinction between diegetic and nondiegetic sounds sometimes can be murky. Certain voiceovers, although not spoken aloud to other characters, can be construed as the thoughts of a character and thus as arising from the narrative world of the film. Film theorist Christian Metz has classified these as **semidiegetic sound** (they can also be referred to as internal diegetic sound). The uncertain status of the dead character's voiceover in *Sunset Boulevard* (1950) is an example of this. Diegetic music — such as characters singing "Happy Birthday" — is often picked up as a nondiegetic theme in the film's score. Such borderline and mixed cases, rather than frustrating our attempts to categorize, are illustrative of the fluidity and creative possibilities of the soundtrack as well as of the complex devices that shape our experience of a film's spatial and temporal continuity.

VIEWING CUE

Watch this clip from *Guardians of the Galaxy* (2014). What would the scene be like without the nondiegetic sound?

Sound Production

As early as the preproduction phase of a contemporary film, a **sound designer** may be involved to plan and direct the overall sound through to the final mix. During production, **sound recording** of dialogue and other sound takes place

text continued on page 220 ▶

FILM IN FOCUS

FILM IN FOCUS

LaunchPad Solo

To watch a video about sound and image in *Singin' in the Rain* (1952), see the *Film Experience* LaunchPad.

Sound and Image in *Singin' in the Rain* (1952)

See also: *42nd Street* (1933); *The Barkleys of Broadway* (1949); *The Artist* (2011)

Hollywood has furnished its own myth about the introduction of synchronized sound in *Singin' in the Rain* (1952). Directed by Stanley Donen and Gene Kelly, *Singin' in the Rain* demonstrates an escapist use of sound in film while also being *about* how sound in film achieves such effects. It addresses the relationship of sound to image, the history of film sound technologies, and the process of recording and reproducing sound.

Set in Hollywood at the end of the 1920s, *Singin' in the Rain* follows efforts at the fictional Monumental Pictures to make the studio's first successful sound film. Although the film's self-consciousness about the film-making process invites the audience into a behind-the-scenes perspective, the film itself continues to employ every available technique to achieve the illusionism of the Hollywood musical. One of the lessons of the film is that a "talking picture" is not just "a silent picture with some talking added," as the studio producer assumes it to be. The film shows that adding sound to images enhances them with all the exuberance of song and dance, comedy, and romance. It also suggests that a great deal of labor and equipment are involved in creating such effects.

From the very beginning of *Singin' in the Rain*, the technology responsible for sound reproduction—technology that usually is hidden—is displayed. The film opens outside a Hollywood movie palace where crowds have gathered for the premiere of the new Don Lockwood and Lina Lamont picture. Our first orientation is aural: "Ladies and gentlemen, I am speaking to you from" The asynchronous announcer's voice carries across the crowds and seems to address us directly. The second shot opens directly on a loudspeaker, underscoring the parallelism of image and soundtrack, and then begins to explore the crowd of listeners. When we first see the radio announcer, the source of the synchronous voice, the microphone is very prominent in the mise-en-scène **[Figure 6.12]**. Referring to the bygone days of radio and silent movies, the film celebrates its modern audience's

6.12 *Singin' in the Rain* (1952). A concern with sound recording technology is evident in the microphone's prominence in the first scene.

opportunity to watch sound and image combined in a sophisticated MGM musical.

Singin' in the Rain immediately begins to exploit the resources and conventions of studio-era sound cinema. When star Don Lockwood (Gene Kelly) tells the story of his past in a diegetic voiceover to the assembled crowds and the radio listeners at home, this is a contrapuntal use of sound because the series of flashback images contradict his words. When his onscreen image gives way to his off-screen voice speaking of studying at a conservatory, we see him and his buddy, Cosmo Brown (Donald O'Connor), performing a vaudeville routine instead. This scene shows that images and voices can be out of sync, a theme that becomes prominent in the film as a whole. It also shows the multiple ways the soundtrack can interact with the images. The comic vaudeville routine is, in turn, accompanied by lively music and humorous sound effects—the diegetic sound of the flashback world—encouraging our direct appreciation of the number. Next we hear the crowd's appreciative reactions to Lockwood's narration, a narration that we know to be phony. However, we do not experience these two

6.13 *Singin' in the Rain* (1952). The illusion of romance is visibly created on the soundstage, but the music that the characters dance to has no apparent source.

6.14 *Singin' in the Rain* (1952). The film's final reflexive moment is accompanied by an invisible chorus on the soundtrack.

different levels of sound—Don's self-serving narration and the debunking synchronized sound of the flashbacks—as confusing. It is clear that the film's unveiling of the mechanisms of sound technology will not limit its own reliance on the multiple illusions of sound-image relationships.

Later, when Don wants to express the depth of his feelings to Kathy Selden (Debbie Reynolds), he takes her to an empty soundstage. Ironically, his sincerity depends on the artifice of a sunset background, a wind machine, and a battery of mood lights, which together render the very picture of romance **[Figure 6.13]**. Yet the corresponding sound illusion is conjured without any visible sound recording or effects equipment, much less an onscreen orchestra. Indeed, each of Don's touches, such as switching on the wind machine, is synchronized with a nondiegetic musical flourish. It is possible to ask us to suspend our disbelief in this way because, in the film's world, music is everywhere.

Don's love interest Kathy is depicted as genuine because she can sing: her image and sound go together. In contrast, his onscreen leading lady, Lina Lamont (Jean Hagen), represents an image without the animating authenticity of sound. Although Lina is beautiful, she speaks with a comical accent. Ironically, the actress's hilarious performance is one of the greatest aural pleasures of the movie. In the course of the film, Don Lockwood must learn to incorporate his true self—the one who expresses himself by "singin' and dancin' in the rain"—into his onscreen persona.

Nothing illustrates the film's paradoxical acknowledgment of the sound-image illusions constructed by Hollywood and its indulgence in them better than the contrast between the disastrous premiere of the nonsinging *The Dueling Cavalier* and the film's final scene at the opening night of the musical *The Dancing Cavalier*, in which the truth of Lina's imposture comes out. In the former, a noisy audience laughs at and heckles the errors of poor synchronous sound recording. The actors' heartbeats and rustling costumes drown out their dialogue (for us, of course, the laughter and the heartbeats are both sound effects, the latter mixed at comically high levels). The film they have created fundamentally misunderstands the promise of "talking pictures."

At the premiere of the musical *The Dancing Cavalier*, in contrast, the film finally makes the proper match, not only between sound and image (thus correcting the humorous synchronization problems of the first version) but also between Don and Kathy. After she is forced to dub Lina "live" at the premiere and the hoax is exposed when the curtains are drawn for all the audience to see, the humiliated Kathy runs from the stage. Don gets her back by singing "You Are My Lucky Star" to her from the stage (thus demonstrating before the audience in the film that unlike Lina, he used his own singing voice during the film within a film). Cosmo conducts the conveniently present orchestra (the premiere is of a sound film that should not require accompaniment), and Kathy joins Don in a duet.

But we should not read the film as suggesting that the onscreen orchestra is more genuine than the romantic background music of the earlier scenes because it is synchronous. The film ends triumphantly with asynchronous music. A full, invisible chorus picks up "You Are My Lucky Star" as the camera takes us out into the open air, to pause on the billboard announcing the premiere of *Singin' in the Rain*, starring Lockwood and Selden (who are represented by images of the stars of the movie by the same name that we are watching, Gene Kelly and Debbie Reynolds) **[Figure 6.14]**. This patently fake chorus and the billboard advertising the film we are watching are the culmination of the film's effort to render Hollywood illusionism—so aptly represented by extravagant musicals such as *Singin' in the Rain*—natural. *Singin' in the Rain* dramatizes the arrival of sound in Hollywood as the inevitable and enjoyable combination of sound and image.

simultaneously with the filming of a scene. At the beginning of each take, the hinged clapstick on the **clapboard** is closed. This slate is marked with the scene and take numbers for the next take and is snapped to synchronize sound recordings and camera images. Microphones for recording sound may be placed on the actors, suspended over the action outside of the frame (on a long pole called a **boom**), or placed in other locations on set. The placement of microphones is often dictated by the desire to emphasize clarity and intelligibility of dialogue, especially the speech of the stars, in the final version of a film.

Direct sound is sound captured directly from its source, but some degree of **reflected sound** (recorded sound that is captured as it bounces from the walls and sets) may be desired to give a sense of space. The **production sound mixer** (or sound recordist) is the sound engineer on the production set who combines these different sources during filming, adjusting their relative volume or balance. In the multitrack sound recording process introduced in Robert Altman's *Nashville* (1975), as many as twenty-four separate tracks of sound can be recorded on twelve tracks. Besides adding an audio density to the realism of the image, both direct and reflected sound can be used to comment creatively on the characters and their environment—for instance, in Altman's films, emphasizing the complexity of communication.

When a cut of the film is prepared, the crucial and complex phase of work on **postproduction sound** (recorded sound added to a film in the postproduction phase) begins. **Sound editing** is combining music, dialogue, and effects tracks to interact with the image track. This creates rhythmic relationships, establishes connections between sound and onscreen sources, and smooths or marks transitions. When a sound is carried over a picture transition or belongs to the coming scene but is played before the image changes, it is termed a **sound bridge**. For example, music might continue over a scene change or montage sequence, or dialogue might begin before the speaking characters are seen by the audience. The director consults with the composer and the picture and sound editors to determine where music and effects will be added, a process called **spotting**.

Sound effects may be gathered, produced by sound-effects editors on computers, retrieved from a sound library, or generated by **foley artists**. Named for the legendary sound man Jack Foley, these are members of the sound crew who generate live synchronized sound effects—footsteps, the rustle of leaves, a key turning in a lock—while watching the projected film on what is called a foley stage. These effects eventually are mixed with the other tracks. The film's composer begins composing the score, which is recorded to synchronize with the film's final cut **[Figure 6.15]**. The composer may actually conduct the musicians in time with the film. **Postsynchronous sound**—recorded after the fact and then synchronized with onscreen sources—is often preferred for the dialogue used in the final mix. Natural sound recorded during production may be indistinct due to noise, perspective, or other problems, and much of the actor's performance will depend on intelligibility of dialogue.

During **automated dialogue replacement (ADR)**, actors watch the film footage and rerecord their lines to be dubbed into the soundtrack (this is also known

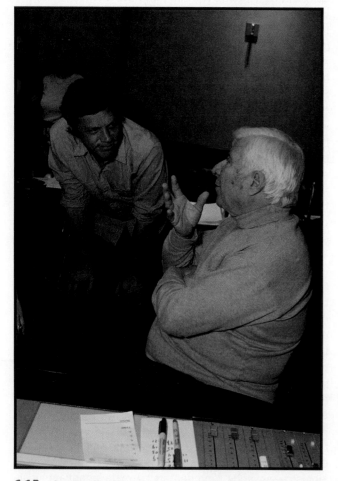

6.15 **Scoring *Far from Heaven*** (2002). Director Todd Haynes and composer Elmer Bernstein as they record the film's score, which re-creates the sound of 1950s Hollywood movies. Courtesy Salt Film Productions, Inc.

as **looping**, as a section of image track must be replayed while the new sound is recorded). Although dubbing can violate verisimilitude, in Italy and other countries it is used for all of a film's dialogue. Dubbing often replaces the original language of a film for exhibition in another country. Other common practices — such as **walla** (a nonsense word spoken by extras in a film to approximate the sound of a crowd during sound dubbing) or recording **room tone** (the aural properties of a location that are recorded and then mixed in with dialogue and other tracks to achieve a more realistic sound) — may be used to cover any patch of pure silence in the finished film. Such practices show the extent to which the sound unit goes to reproduce "real-seeming" sound.

Sound mixing (or re-recording) is the process by which all the elements of the soundtrack, including music, effects, and dialogue, are combined and adjusted to their final levels. It is an important stage in the postproduction of a film and can occur only after the image track, including the credits, is complete (that is, after the picture is "locked"). As multiple tracks are mixed, they are cut and extended, adjusted and "sweetened" by the sound editor with the input of the director and perhaps the sound designer and picture editor. There are no objective standards for a sound mix. Besides making sure it is complete and clear, the director and technicians will have specific ideas for the film's sound in mind. The final mix might place extra emphasis on dialogue, modulate a mood through the volume of the music, or punch up sound effects during an action sequence. In a film like *Barton Fink* (1991), much of the sense of inhabiting a slightly unreal world is generated by a sound mix that incorporates sounds such as animal noises into the effects accompanying creaking doors. At a film's final **mix**, a sound mixer combines separate soundtracks into a single master track that will be transferred onto the film print together with the image track to which it is synchronized. Optical tracks are "married" to the image track on the film print. Digital tracks may be printed on film or recorded for digital projection. **Sound reproduction** is sound playback during a film's exhibition. It is the stage in the process when the film's audience experiences the film's sound in a movie theater as signals converted back to sound waves by the sound system during projection.

Sound perspective enhances the impression of sound's presence and can be manipulated with great nuance in digital sound mixing. Sound systems use the placement of speakers in the three-dimensional space of the theater to suggest sounds emanating from the left or right of the depicted scene or from behind or in front of the audience.

The Social Network (2010) **[Figure 6.16]**, directed by David Fincher, is dominated by the sound of actors' voices reciting screenwriter Aaron Sorkin's distinctive dialogue. *The Terminator* (1984) keys us to events in its futuristic world by

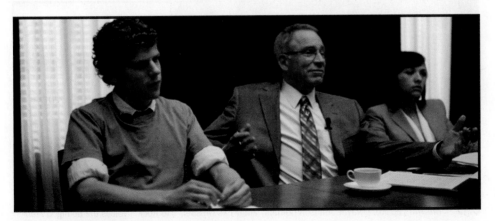

6.16 *The Social Network* (2010). Voices and dialogue describe and measure the complex action, relations, and emotions in this film about the founding of Facebook.

noises, and the title of *The Sound of Music* (1965) announces what one can expect to hear on its soundtrack. In the film **soundtrack** — audio recorded to synchronize with a moving image, including dialogue, music, and sound effects — these three elements often are present simultaneously. In some sense, a film's image track, composed of relatively discrete photographic images and text, is simpler and more unified. Nevertheless, although these three sound elements can all be present and combined in relation to any given image, conventions have evolved governing these relationships. Usually dialogue is audible over music, for example, and only in special cases does a piece of music dictate the images that accompany it. Here we examine each of the basic elements of the soundtrack and its potential to make meaning in combination with images and other sounds. We uncover conventional usages of soundtracks and discuss the ways that they have both shaped the film experience and given direction to theorists' inquiries into the properties and potential of film sound.

Voice in Film

Human speech, primarily in the form of dialogue, is often central to understanding narrative film. The acoustic qualities of the voices of actors make distinct contributions to films: Jimmy Stewart's drawl is relaxed and reassuring; a Sandra Bullock character can range between high and low acoustic tones to create a personality that is sometimes in control and then out of control. In animation, sound commonly is prepared in advance of the images — which is the reverse of live-action filmmaking. For many modern animated features, like *Moana* (2016) **[Figure 6.17]**, celebrities like Dwayne Johnson are hired to voice major characters. Johnson (as Maui) and newcomer Auli'I Cravalho (as the title character) recorded their parts separately in the studio rather than together.

Making an intelligible record of an actor's speech quickly became the primary goal in early film sound recording processes, although this goal required some important concessions in the otherwise primary quest for realism. For example, think about how we hear film characters' speech. Although the image track may cut from a long shot of a conversation, to a medium shot of two characters, and finally to a series of close-up, shot/reverse-shot pairings, the soundtrack does not reproduce these distances accurately through changes in volume or the relationship between direct and reflected sound. Rather, actors are miked so that what they say is recorded directly and is clear, intelligible, and uniform in volume throughout the dialogue scene. **Sound perspective**, which refers to the apparent location and distance of a sound source, remains close.

6.17 *Moana* (2016). Dwayne Johnson (formerly known as wrestler "The Rock") voices the demigod Maui in this Disney animated hit. Although his familiar face is not visible in the film, his name featured prominently in the film's advertisements.

Dialogue

But *what* actors say is crucial: speech establishes character motivation and goals and conveys plot information. Advances in recording technology have allowed filmmakers to experiment with how dialogue is used to tell their stories. Director Robert Altman's innovations in multitrack film sound recording in *Nashville* (1975), mentioned earlier in this chapter, allowed each actor to be miked and separately recorded. One stylistic feature of this technique is Altman's extensive use of **overlapping dialogue**—mixing characters' speeches to

6.18 *Nashville* (1975). Robert Altman's twelve-track recording process captures each character individually, and overlapping dialogue is used in the final mix.

imitate the rhythm of speech, a technique Orson Welles attempted with less sophisticated recording technology. In *Nashville*, characters constantly talk over each other **[Figure 6.18]**. This technique, which may make individual lines less distinct, is often used to approximate the everyday experience of hearing multiple, competing speakers and sounds at the same time.

Dialogue is also given priority when it carries over visual shifts, such as shot/reverse-shot patterns of editing conversations. We watch one actor begin a line and then watch the listener as the first actor continues speaking. Sound preserves temporal continuity as the scene is broken down into individual shots.

Voice-Off and Voiceover

A **voice-off** is a voice that originates from a speaker who can be inferred to be present in the scene but is not currently visible. This technique is a good example of the greater spatial flexibility of sound over image. Early in the film *M* (1931), the murderer's offscreen whistle is heard, followed by an onscreen shadow of a man, combining the expressive possibility of sound (recently introduced when the film was made) with that of lighting and mise-en-scène **[Figure 6.19]**. The opening shot of *Laura* (1944) follows a detective looking around an elegantly furnished apartment as a **narrator**—a character or other person whose voice and perspective describe the action of a film, usually in voiceover—introduces the film's events. Abruptly, the same voice addresses the detective from an adjacent room, telling him to be careful of what he touches. The unidentified narrator becomes a character in the film in a striking use of voice-off.

The use of the voice-off in a classical film is a strong tool in the service of film realism, implying that the mise-en-scène extends beyond the borders of the frame, but the illusion of realism can be challenged if the origins of the voice-off are not clear. The voice-off of HAL 9000, the computer in *2001: A Space Odyssey* (1968), is consistent with realism because the voice has a known source. However, the even level of volume makes it seem to pervade the spaceship even as it retains its intimate quality. The film's uncanny combination of humanity and technology shows how the voice-off can introduce distance into the customary match of sound and image.

A voice-off is distinguished from the familiar technique of **voiceover**—a voice whose source is neither visible in the frame nor implied to be offscreen and typically narrates the film's

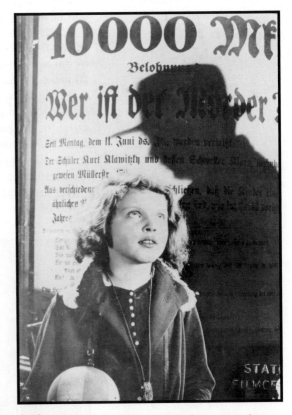

6.19 *M* (1931). An offscreen whistle first suggests the murderer's presence in Fritz Lang's masterpiece of early sound cinema. Coupling the whistle with the shadow of the man, Fritz Lang used both sound and lighting to heighten the suspense.

6.20 *Taxi to the Dark Side* (2007). The somber and matter-of-fact tone of the voiceover in this documentary makes the realities it describes seem even more disturbing than a more excited tone would. © Think Film / Photofest

VIEWING CUE

Identify specific uses of voice in the film you will screen next in class. Is dialogue abundant? If voiceovers are used, what are their function and diegetic status?

images—by the simple fact that voiceovers are nondiegetic sounds. Characters cannot hear the voiceover. The voiceover is an important structuring device in film: a text spoken by an offscreen narrator can act as the organizing principle behind virtually all of the film's images, such as in a documentary film, a commercial, or an experimental video or essay film. The unseen narrators of the classic documentaries *Night Mail* (1936) and *The Plow That Broke the Plains* (1936) offer a poem about the British postal service and an account of the U.S. government's agricultural programs, respectively, and the filmmaker's voiceover in Alex Gibney's *Taxi to the Dark Side* (2007) offers a somber description of contemporary torture in Afghanistan and Guantánamo Bay **[Figure 6.20]**. The voiceover device soon became the cornerstone of the documentary tradition, in which the voiceover "anchors" the potential ambiguity of the film's images. The sonic qualities of such voiceovers—usually male, resonant, and "unmarked" by class, regional, or foreign accent or other distinguishing features—are meant to connote trustworthiness (although today they can sound propagandistic). The traditional technique of directing our interpretation of images through a transcendent voiceover is sometimes referred to as the "voice of God." Confident male voices of this type are still heard in nature shows, commercials, and trailers seen in movie theaters.

Voiceovers can also render characters' subjective states. Much of the humor of the *Bridget Jones* series (2001–2016), for instance, comes from viewers' access to the heroine's internal (semidiegetic) comments on the situations she encounters **[Figure 6.21]**. But voiceover can also be an important structural device in narration, orienting viewers to the temporal organization of a story by setting up a flashback or providing a transition back to the film's present. For example, a voiceover narration in the present can accompany a scene from the past that uses both images and sounds from within the depicted world. Use of voiceovers to organize a film's temporality is prevalent in certain genres such as film noir, in which the voiceover imitates the hard-boiled, first-person investigative style of the literary works from which many of these stories are adapted. Sometimes, in keeping with the murky world of film noir or the limited perspective of the investigator, such voiceovers

6.21 *Bridget Jones's Baby* (2016). The subjective voiceover of this film humorously articulates the desires and anxieties of the heroine as she goes through pregnancy and childbirth.

6.22 **_Laura_** (1944). Shown writing in a bathtub, Waldo Lydecker (Clifton Webb) opens the film with a voiceover narration. His account of the heroine's death proves him to be unreliable when she is discovered to be alive.

6.23 **_Mildred Pierce_** (1945). The voiceover of Mildred (played by Joan Crawford) in the flashbacks increases our sympathy for her situation as a wife and mother.

prove unreliable, as we find out in *Laura* (1944) **[Figure 6.22]**.

The use of voiceover in Michael Curtiz's *Mildred Pierce* (1945) shows the clash of styles in the film between the film noir genre, which customarily has a male protagonist/narrator, and the **women's pictures** of the same period that featured female stars in romances or melodramas. In these films, the lead character faces exaggerated versions of the problems many women encounter. In the beginning of the film, Mildred (played by Joan Crawford) confesses to a crime she did not commit and begins her life story in a voiceover: "It seems as if I was born in a kitchen," she narrates **[Figure 6.23]**. However, the device is soon abandoned, and her voiceover's credibility is compromised as Mildred's version of events is discredited by the police; her voiceover ultimately confirms their point of view. Contemporary examples of female voiceovers, such as that of Sarah Connor in *The Terminator* (1984) and *Terminator 2: Judgment Day* (1991), give more credibility to the female narrator. The adult female narration that frames *Eve's Bayou* (1997) contrasts with the imperfect understanding of the child's point of view in the flashback. Together they represent an untold story of African American female experience **[Figure 6.24]**.

In an experimental film, voiceovers may lead the viewer/listener to think about different levels of the film's fiction. The soundtrack of Chantal Akerman's *News from Home* (1976) consists of the director's voice reading the letters that her mother back home in Belgium wrote to her in New York **[Figure 6.25]**. The images depict sparsely populated New York streets and lonely

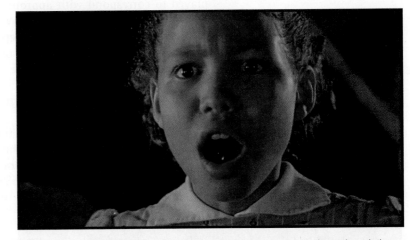

6.24 **_Eve's Bayou_** (1997). A little girl's version of events gains credence through the voiceover device.

6.25 **_News from Home_** (1976). Letters from home are read over images of a lonely New York City, creating a poetic disjunction across the spaces of the film.

subway platforms and cars. The disjunction between voice and image reinforces the distance mentioned in the correspondence.

Ever since "the talkies" were introduced, the human voice has organized systems of meaning in various types of film. Narrative films are frequently driven by dialogue, documentaries by voiceover, and experimental films often turn voice into an aesthetic element. Some writers suggest that a theory of "voice" can open up cinema analysis to more meanings than a model devoted to the image alone. Although we have stressed how frequently film sound is subordinated to the image, the realm of the voice shows us how central sound is to cinema's intelligibility.

Music in Film

Music is a crucial element in the film experience. Among a range of other effects, it provides rhythm and deepens emotional response. Music has rarely been absent from film programs, and many of the venues for early film originally hosted musical entertainments. The piano, an important element of public and private amusements at the turn of the twentieth century, quickly became a cornerstone of film exhibition. Throughout the silent film period, scoring for films steadily developed from the collections of music cues that accompanists and ensembles played to correspond with appropriate moments in films to full-length compositions for specific films. When D. W. Griffith's *The Birth of a Nation* premiered in 1915, a full orchestra, playing Joseph Carl Breil's score in which the Ku Klux Klan rallied to Richard Wagner's "Ride of the Valkyries," was a major audience attraction. The architecture of the large movie palaces constructed during this period was acoustically geared to audiences who listened to orchestral music in a concert setting. The introduction of dialogue presented problems of scale and volume in the movie palaces.

Although the term *talkies* for the new sound films soon took over, movies of every genre—including western, historical, disaster, crime, comedy, and science fiction films—relied on music from the beginning. Music contributes to categorizing such films *as* genre films. Vangelis's music for *Blade Runner* (1982), for example, distinctly marks it as a science fiction film. In contrast, Max Steiner's score for *Gone with the Wind* (1939) sets its nostalgic, romantic tone.

Narrative Music

Music is the only element of cinematic discourse besides credits that is primarily nondiegetic. Film music encourages us to let our barriers down and experience the movie as immediate and enveloping, easing our transition into the fictional world. Although overblown background music can jolt us out of a film, often we value the musical **score** (music composed to accompany the completed film) as a crucial element of our affective, or emotional, response to a film. The celebrated gag in Mel Brooks's *Blazing Saddles* (1974), in which the musical soundtrack turns out to be coming from Count Basie's jazz orchestra playing in the middle of the desert, shows how readily we accept the convention of nondiegetic music [**Figure 6.26**].

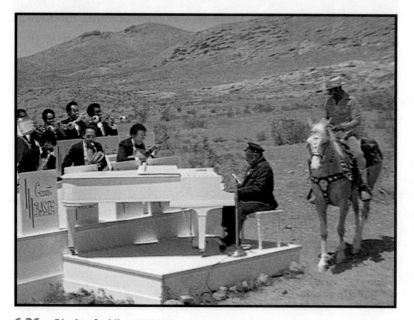

6.26 *Blazing Saddles* (1974). Soundtrack music finds its onscreen source in Count Basie's orchestra playing in a desert in Mel Brooks's western spoof.

Classical film music developed practices of composition and mixing that supported the aim of storytelling. The term **underscoring**, also referred to as background music (in contrast to diegetic **source music**), emphasizes this status. Much of classical Hollywood film music is derived from nineteenth-century, late-Romantic orchestral music. The work of such composers as Richard Wagner, Johann Strauss, and Richard Strauss relied on compositional principles such as motifs assigned to different characters, settings, or actions. This type of music conveyed to audiences particular associations and values that ranged from the high cultural status conferred on symphonic music of European origin (as opposed to the lower status of American jazz or pop) to the recognizable connotations of instrumentation, such as somber horns for a funereal mood, violins for romance, and a harp for an ethereal or heavenly mood.

A piece of music composed for a particular place in a film is referred to as a **cue**—a visual or aural signal that indicates the beginning of an action, line of dialogue, or piece of music. Often music reinforces story information through recognizable conventions. Action sequences in the *Indiana Jones* series (1981–2008) are introduced by the inescapable "dum da-dum dum" motif as a parody of and a tribute to these recognizable themes. Discontinuities in visual information represented by cuts and scene changes are frequently bridged by music. Various arrangements of the theme song of *High Noon* (1952) carry characters across space and help bridge transitions between scene changes.

Narrative cueing is the way that sound tells viewers what is happening in the plot. A few notes of "Deutschland über Alles" in the score of *Casablanca* (1942), for example, signify the looming Nazi threat. The most noticeable examples are **stingers**, which are sounds that force the audience to notice the significance of something onscreen—like the discordant blast in *The Shining* (1980) that marks the moment when Wendy, the mother, looks at her bedroom door through her mirror and sees the word "murder" scrawled on it **[Figure 6.27]**. Overillustrating the action through the score, such as by using plucked strings to accompany a character walking on tip-toe, is called **mickey-mousing**, in reference to the way cartoons often use the musical score to follow or mimic every action. Composer Mark Mothersbaugh incorporates a contemporary version of this practice in collaborations with Wes Anderson like *The Royal Tenenbaums* (2001).

Through the use of themes assigned to particular figures, music also participates in characterization. We know when the main character has entered the scene not only visually but also aurally. The presence of "bad girl" Marylee Hadley in *Written on the Wind* (1956) is signaled by a distinctive sultry theme. Composed by Jonny Greenwood of Radiohead, the music identified with Daniel Plainview in *There Will Be Blood* (2007) has a dissonant string arrangement that eerily complements this troubled and troubling character.

Music is a powerful way to express emotion in cinema. In Hitchcock's *Spellbound* (1945), for example, the mental state of the hero is conveyed by the sound of the theremin, an unusual electronic instrument that is played without physical contact and whose spooky sound is also used in science fiction films

6.27 *The Shining* (1980). When Wendy awakens and sees through the mirror what Danny has written on the door, a shocked look appears on her face. The stinger makes sure the audience doesn't miss the word *murder*.

text continued on page 229 ▶

6.28a *The Jazz Singer* (1927).

6.28b *The Graduate* (1967).

6.28c *Saturday Night Fever* (1977).

6.28d *Pulp Fiction* (1994).

6.28e *The Great Gatsby* (2013).

6.28f *Straight Outta Compton* (2015).

FORM IN ACTION

Popular Music in Film

Popular music can be used to develop characters, themes, and narrative structures in films. The film that introduced synchronized sound, *The Jazz Singer* (1927), allowed audiences familiar with Al Jolson's recordings to see the entertainer perform his standards [**Figure 6.28a**]. As one of the first films to merge prerecorded pop music with a film narrative, *The Graduate* (1967) weaves the songs of Paul Simon and Art Garfunkel through the social, sexual, and emotional crises of Benjamin Braddock (Dustin Hoffman). A major achievement of the film is the use of vocal tones and rhythms to create a world in which the aggressive and cold rhetoric of an adult generation contrasts with Benjamin's retreats into silence [**Figure 6.28b**].

With *Saturday Night Fever* (1977), John Travolta's performance as Tony Manero and the Bee Gees' music on the soundtrack create a now-classic merger of images and disco tunes, overlapping nondiegetic and diegetic songs to mimic Tony's movement between his blue-collar job in a Brooklyn paint store and his fantasy life in nightclubs [**Figure 6.28c**].

In 1994, Travolta appeared as a wildly different kind of character, hitman Vincent Vega, in Quentin Tarantino's *Pulp Fiction*. In this film, the bizarre and violent adventures of Vincent and his partner Jules Winnfield (Samuel L. Jackson) are frequently accompanied by an eclectic range of songs from different eras, recorded by singers like Dusty Springfield, Al Green, and Chuck Berry (in a dance sequence recalling Travolta's past films) [**Figure 6.28d**].

With far less irony, musical disjunctions communicate a very different vision in Baz Luhrmann's 2013 *The Great Gatsby*. This 3-D adaptation of F. Scott Fitzgerald's novel features contemporary jazz, pop, and hip-hop originals and covers from Jay-Z, Jack White, and Beyoncé, as well as classic compositions from Louis Armstrong and George Gershwin—music that captures youthful energy, longings, and illusions that link the 1920s and the 2010s [**Figure 6.28e**].

Sharing its title with the gangster rap record that made hip hop band N.W.A. famous, *Straight Outta Compton* [**Figure 6.28f**] is both biopic and music history. Its soundtrack album, released after the movie, combines funk and rap influences like George Clinton and Run-DMC with authoritative tracks by N.W.A. band members Ice Cube and Dr. Dre.

FORM IN ACTION

LaunchPad Solo

To watch a clip of pop music in *Saturday Night Fever* (1977), see the *Film Experience* LaunchPad.

[Figure 6.29]. The ambient score for David Fincher's *The Girl with the Dragon Tattoo* (2011) by Trent Reznor of the band Nine Inch Nails and Atticus Ross helps create a bleak and tense emotional landscape. Frequently, lush orchestration can ennoble specific events and make them feel timeless. In *War Horse* (2011), the lavish musical score adds an epic dimension to the boy's relationship to his horse **[Figure 6.30]**.

Although musical scoring conventions have evolved and changed since the classical era of studio filmmaking, in the orchestral scores of John Williams, the best-known composer of the past three decades, we can hear an homage to the romantic styles of the studio composers of earlier decades. Williams composes heroic, nostalgic scores that support and sometimes inflate the narrative's significance. He is known for scoring the *Star Wars* movies (from the 1977 original to the seventh film in 2015), the *Indiana Jones* (1981–2008) and *Harry Potter* (2001–2011) films, and many others. His five Academy Awards and fifty nominations suggest that the film industry recognizes his style's consistency with that of classical Hollywood.

6.29 *Spellbound* (1945). Gregory Peck's character is stricken by an episode of vertigo, signaled by the theremin on the soundtrack.

In Hollywood cinema of the studio era, nonclassical musical styles—such as jazz, popular, and dance music—might be used as source music and featured in musicals, but their incorporation into background music was gradual. One of the effects of the neglect of American musical idioms in favor of European influences was that African American artists and performers were rendered almost as inaudible as they were invisible in mainstream movies. African American performers frequently were featured in musicals, but they were there to provide entertainment and were rarely integrated into the narrative. Lena Horne's talent, for example, was underutilized because there were almost no leading roles for African American women in the 1940s and 1950s **[Figure 6.31]**.

As jazz music became more popular, jazz themes began to appear in urban-based film noirs of the 1940s. Henry Mancini's music for Orson Welles's *Touch of Evil* (1958) effectively connotes themes of crime, violence, and sexuality in the exaggerated border-town setting. With other changes in the U.S. film industry in the postwar period, musical conventions shifted as well. Modernist and jazz-influenced scores, such as Leonard Bernstein's score for *On the Waterfront* (1954), became more common as different audiences were targeted through more individualized filmmaking practices. At the end of the studio era, the great tradition of the

> **VIEWING CUE**
>
> As you watch the film assigned for your next class, pay particular attention to its music. Is the film's score drawn from the classical tradition? Is popular music used? How do scoring choices contribute to the film's meaning?

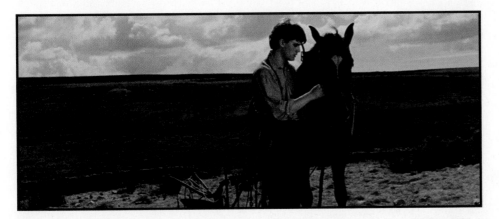

6.30 *War Horse* (2011). Composer John Williams's score helps intensify the emotion in this tale of a boy and his horse during World War I.

6.31 **Lena Horne.** Most of the actress's appearances in mainstream films were restricted to cameo numbers because the industry was unwilling to allow an African American to play a leading role. Courtesy Michael Ochs Archive/Getty Images

Hollywood musical also began to wane, but the persistence of the genre shows how central music is to the narrative film experience, even at the cost of verisimilitude.

Pop Music in Film

Popular songs have long had a place in the movies, promoting audience participation and identification by appealing to tastes shared by generations or ethnic groups. Sheet music and recordings sales were profitable tie-ins even before sound cinema. In the 1980s, however, the practice of tying the emotional (and commercial) response of the audience to popular music on a film's soundtrack was so well established that pop scores consisting of **prerecorded music** (previously recorded music, often popular songs, used on a film's soundtrack) began to rival originally composed music. *American Graffiti* (1973) helped inaugurate this trend with its soundtrack of nostalgic 1960s tunes, and *The Big Chill* (1983) also was influential in capturing the zeitgeist of a generation through popular songs. In the 1980s, the proliferation of the pop soundtrack drew the film experience outside the theater to the record store, and music videos began to include scenes from upcoming films. The centrality of prerecorded music is reflected in the rise of the **music supervisor**—the individual who selects and secures the rights for songs to be used in films. Sofia Coppola's movies are recognizable by the distinctive music selected by music supervisor Brian Reitzell. *The Bling Ring* (2013) features M.I.A., Sleigh Bells, Lil Wayne, and other contemporary musicians. In dance films such as *Step Up 3D* (2010), the soundtrack becomes a way for viewers to participate in the scene. Even superhero films draw effectively on the connotations of a pop song. Set in 1983, *X Men: Apocalypse* (2016) features "Sweet Dreams" by the Eurythmics, originally released in that year, and *Suicide Squad* (2016) uses a jukebox's worth of classic-rock hits, reportedly worked into

6.32 *Suicide Squad* (2016). Harley Quinn (Margot Robbie) is introduced with Lesley Gore's 1963 song "You Don't Own Me," a moment initially designed for a trailer that made it into the finished film.

the film itself after they played well in the movie's trailers [**Figure 6.32**]. Although theme songs have been composed for and promoted with films for decades (notably in the James Bond films), the contemporary movie and music industries have such close business relationships that even films without pop soundtracks often feature a tie-in song. "See You Again," the credits song from *Furious 7* (2015), was a tribute to one of the film's stars, Paul Walker, who died before the movie's release, and it became a hit in part because of fans' emotional response to that loss.

Sound Effects in Film

Much of the impression of film's realism comes from the use of sound effects, although, like other aspects of the soundtrack, viewers may not consciously notice these effects. Dialogue in film is deliberate; it tells a story and gives information. Background music is an enhancement that is "unrealistic" if we pay attention to it. But sound effects often appear natural. In daily life, we hardly notice ubiquitous sounds like fluorescent lights humming, crickets chirping, and traffic going by—sounds that might be added to a film to achieve a "realistic" sound mix.

In most films, every noise that we hear is selected, and these effects generally conform to our expectations of movie sounds. Virtually nothing appears onscreen that does not make its corresponding noise: dogs bark, babies cry. A spaceship that blows up in outer space will usually produce a colossal bang even though in fact there is no sound in space. If a recording of a .38 revolver sounds like a cap gun on film, it will be dubbed with a louder bang. These expectations vary according to film genre. Traffic noise will be loud in an action film, in which we remain alive to the possibilities of the environment. In a romance, the sound of cars will likely fade away unless traffic is keeping the lovers apart. Asynchronous sound effects, such as the hoot of an owl in a dark woods setting, both expand the sense of space and contribute to mood, often in very codified, even clichéd ways. Adding the clank of utensils and snatches of offscreen conversation to the soundtrack when two characters are shown at a table conjures a restaurant setting without having to shoot the scene in one.

Sound effects are one of the most useful ways of giving an impression of depth to two-dimensional images when they are reproduced in the three-dimensional space of the theater. A gunshot may come from the left-hand side of the screen, for example. At the same time that they serve a mimetic function, sound effects have become part of how the cinema experience is distinguished from the ordinary. THX is a standards system—devised by director George Lucas and named after his first feature film, *THX 1138* (1971)—for evaluating and ensuring the quality of sound presentation. THX theaters promise to deliver an intense aural experience that is identical in each certified venue.

The importance of a film's sound to the Hollywood illusion is marked in the relatively recent Academy Award category for sound-effects editing. The extraordinary density of contemporary soundtracks does not necessarily mean that they are more realistic than the less dense soundtracks of classical Hollywood. Instead, they more extensively use the particular properties of sound and new technologies to convey an increasingly visceral experience of the cinema.

The contemporary industry's attention to sound technologies and aesthetics creates audience expectations related to film genre. The distinctive soundtrack of *Jaws* (1975), for example, gave us both the now clichéd musical motif of the shark and a rich new standard for sound-effects use. The film acknowledges a predecessor in the genre when the death of the *Jaws*' shark is accompanied by a sound effect of a prehistoric beast's death from *King Kong* (1933). In these monster movies, sound effects can refer to familiar experiences but then take us far beyond everyday events.

Cartoons are excellent demonstrations of the ways that sound effects are synchronized to onscreen actions. Drawings do not "naturally" make sounds of their own, so every sound in an animated film is conventionalized. In *Frozen* (2013), for

VIEWING CUE

LaunchPad Solo

Watch this scene from Terrence Malick's *The Thin Red Line* (1998), and determine which sound seems especially responsible for conveying information to the spectator. How do voice, music, and sound effects work together?

6.33 *Frozen* (2013). The dramatic sounds of cracking ice match the grandeur of the animation.

example, a simple sound like the cracking of ice must be precisely engineered and calibrated for its effectiveness **[Figure 6.33]**.

Making Sense of Film Sound

Sounds are grounded in viewers' everyday activities and contribute to movies' immediacy and sensory richness. Film sound—whether the pathos of Louis Gottschalk's score for D. W. Griffith's *Broken Blossoms* (1919), the stimulating interactions between the musical quotations in *2001: A Space Odyssey* and Alex North's original music for the film, the indelible aural record of Laurence Olivier's performance of *Hamlet* (1948), or the comical sounds of Jacques Tati's *Playtime* (1967)—intensifies our viewing experience. Paradoxically, movie soundscapes often eschew realism and plausibility in order to heighten authenticity and emotion, like foregrounding actors' whispered conversation in a crowded room so we feel intimately connected to them.

The ways in which filmmakers choose to relate sound to image also distinctively affect our viewing experience. Some filmmakers rely on sound continuity to support the narrative aim and smooth over gaps in a story. In contrast, others use sound montage to act as a counterpoint to the image.

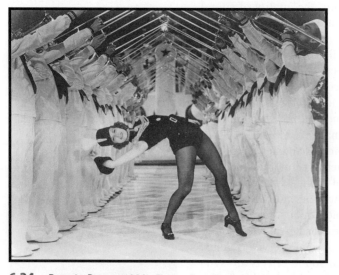

6.34 *Born to Dance* (1936). Eleanor Powell's tap dancing is a perfect display of synchronized sound.

Authenticity and Experience

Film sound, because it surrounds and permeates the body of the viewer in a way that images alone cannot, contributes to the authenticity and emotion we experience while viewing a film. Sound in film can indicate a real, multidimensional world and give the viewer/listener the impression of being present in a particular space. Additionally, sound encourages the viewer to experience emotion, depending on the kind of sound (such as a particular piece of music).

The impression of being present in space is supported by the preferences established in the standard techniques of sound recording, mixing, and reproduction. Hearing the taps on Eleanor Powell's shoes in *Born to Dance* (1936) makes us witnesses to her virtuosity **[Figure 6.34]**. Foregrounding actors' voices—through close miking, sound perspective, and mixing that

emphasizes dialogue — also authenticates our perception. We are "in on" the characters' most intimate conversations. The sense of presence at the dance contest in *Saturday Night Fever* (1977) is achieved through a sound mix that sacrifices background noise to focus on the Bee Gees' music.

Sound encourages the viewer to see the world in terms of particular emotions. When the lovers in *Now, Voyager* (1942) cannot really say what they mean to each other, the string section, performing Max Steiner's score, eloquently takes over. The zither theme of *The Third Man* (1949) makes us feel disoriented in the streets of postwar Vienna, just as the film's characters are. Excruciating suspense is generated in *Jurassic Park* (1993) when we hear the sound of the menacing *Tyrannosaurus rex* **[Figure 6.35]**. The acoustic environment in

6.35 *Jurassic Park* (1993). On the digital soundtrack, the *Tyrannosaurus rex*'s footsteps can be heard approaching the truck where the children are hiding, generating keen suspense.

film attempts to orient us in a way that feels genuine and genuinely gets us to *feel*.

Authenticity and emotion often are served by a subordination of sound to the cues given by the image in a practice of sound-image continuity. A competing approach explores the concrete nature of sounds and their potential independence of images and of each other.

Sound Continuity and Sound Montage

Sound continuity describes the process of furthering the aims of the narrative through scoring, sound recording, mixing, and playback processes that strive for the unification of meaning and experience. **Sound montage** is the collision or overlapping of disjunctive sounds in a film. It reminds us that just as a film is built up of bits and pieces of celluloid, a soundtrack is not a continuous gush of sound from the real world but is composed of separate elements whose relationship to each other can be creatively manipulated. Most assumptions, shared by technicians and viewers, about what constitutes a "good" soundtrack emphasize a continuity approach. However, since the introduction of sound, many filmmakers have used it as a separate element for a montage effect, a practice enhanced by the increasing sophistication of audio technology.

Sound Continuity

Matching up actors' voices with their moving lips and ensuring the words were intelligible were among the early goals of sound technology. Audiences were thrilled just to *see* the match. The degree of redundancy between image and sound in the continuity tradition still makes it difficult to analyze the soundtrack autonomously. From the priority granted to synchronization, we can define several compatible continuity practices:

- The relationship between image and sound and among separate sounds is motivated by dramatic action or information.
- With the exception of background music, the sources of sounds are identifiable.
- The connotations of musical accompaniment are consistent with the images (for example, a funeral march is unlikely to accompany a high-speed chase).
- The sound mix emphasizes what we should pay attention to.
- The sound mix is smooth and emphasizes clarity.

Attention is directed back to the characters, actions, and mise-en-scène by sound that supports it. In *The Big Sleep* (1946), a conversation in a car between the

VIEWING CUE

LaunchPad Solo

To what extent do sound effects add to a film's sense of realism? Watch this clip from Debra Granik's *Winter's Bone* (2010), and explain how sounds create a particular impression of location, action, or mood.

6.36 *Rocky Balboa* (2006). The *Rocky* film series' iconic theme song (Bill Conti's 1977 "Gonna Fly Now") ties together disparate images of Rocky doing pull-ups, jogging, and lifting weights.

6.37 *Alexander Nevsky* (1938). The editing of Sergei Eisenstein's first sound film was planned with the score in mind.

6.38 *L'Argent* (1983). Robert Bresson's films carefully select sound to explore themes of isolation.

two protagonists, Marlowe and Vivian, begins with engine noise in the background. We see that there is a dog on the porch in the opening scene of *The Searchers* (1956); when we hear it bark, the image comes alive. The relationship between image and sound and among separate sounds will also be motivated by dramatic action or information. In *The Big Sleep*, the engine noise will soon disappear so we can focus on the characters' avowal of love. The continuous use of music to cover a sequence of character activity draws our attention away from discontinuity in the image track. For example, continuous orchestral music links the "training montage" in *Rocky Balboa* (2006) **[Figure 6.36]**. Technology and techniques have developed in consort with these aims. Dolby noise-reduction technology improves frequency response and gives an almost unnatural clarity that serves the goal of continuity.

Sound Montage

In Chapter 5, we define montage in terms of images, but the term can also denote the infinite possibilities of interactions among images and sound. Often operating in opposition to the principles of sound continuity, sound montage calls attention to the fact that images and sounds communicate on two different levels.

Sergei Eisenstein, the primary theorist of montage, extended his ideas to sound even before synchronous sound technology was perfected. In his first sound film, *Alexander Nevsky* (1938), he experimented with what he called "vertical montage," which emphasized both the simultaneity of and the differences between image and sound **[Figure 6.37]**. In the early sound era, filmmakers such as Jean Vigo and René Clair in France and Rouben Mamoulian and King Vidor in the United States combined sound and image in lyrical and creative ways. In Mamoulian's *Applause* (1929), for instance, music and effects do not duplicate the image but create a more subjective and atmospheric setting.

In the post–World War II art cinema, sound experimentation was renewed. In spare films such as *Pickpocket* (1959) and *L'Argent* (1983), which explore themes of predestination and isolation through scrutiny of details, French director Robert Bresson achieves an uncanny presence of select sounds while refusing realistic indicators of space **[Figure 6.38]**. In the book *Notes on Cinematography* (1975), Bresson sums up his ideas: "what is for the eye must not duplicate what is for the ear." Without the use of room tone or other techniques to give spatial cues or to make sounds warmer, the minimalist sounds in his films become very concrete, a practice that has influenced many contemporary filmmakers in world cinema.

6.39 La Jetée (1962). The fluidity of a voiceover accompanying a montage of still images creates a reflective distance between the two elements.

6.40 Surname Viet Given Name Nam (1989). The qualities of the film's voices—they often are accented and seem to belong to nonactors reciting—convey information that cannot be gathered from images.

Like the disjunctive image-editing practices discussed in Chapter 5, sound montage does not smooth over juxtapositions. In sound montage, sound may "come first," and the borders between the nondiegetic and the diegetic may be difficult to establish. When motivated relationships (for example, the image of a dog motivates the sound effect of barking), are given up, we see and hear something onscreen that is different from an attempted extension of our natural world. The intention may be to critique, as in a disturbing sequence in *Natural Born Killers* (1994) when Mallory's life at home with her abusive father is presented as if it were a situation comedy, complete with laugh track, applause, and perky theme music, directly commenting on how the media use sound to manipulate emotion. In a very different use of sound montage, the succession of still images that constitutes Chris Marker's *La Jetée* (1962) is anchored by a voiceover that tells of the time experiments in which the protagonist is participating, identifying the film as science fiction **[Figure 6.39]**. Prioritizing sound makes us attend to the film's structure.

The use of the voice can be opened up to include direct address to the viewer or recitation or reading instead of naturalistic dialogue, as in Jean-Luc Godard's *Weekend* (1967) or Isaac Julien's *Looking for Langston* (1989). The sensual quality of sounds can be explored as it might be in a musical composition, or poetic effects can be achieved by combining different sound "images." Voices are layered in this way in Marguerite Duras's *India Song* (1975). A film can deliver ideas through multiple channels; the sound can contradict the image. Interview texts printed on the screen are read aloud with slight alterations by the voiceovers in Trinh T. Minh-ha's *Surname Viet Given Name Nam* (1989) **[Figure 6.40]**.

The expectation that every element of the mise-en-scène will make a naturalistic noise can also be frustrated with creative use of effects. German filmmaker Ulrike Ottinger's *Madame X: An Absolute Ruler* (1977) makes ingenious use of postsynchronous sound. Her film's motley crew of female pirates do not speak. Instead, their movements are "synchronized" with noises like animal growls or metallic clanking **[Figure 6.41]**.

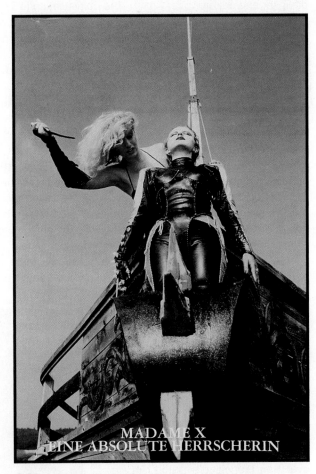

6.41 Madame X: An Absolute Ruler (1977). In Ulrike Ottinger's film, in lieu of dialogue, the character's movements are synchronized with a sound montage of noises like animal growls or metallic clanking. A Women Make Movies Release. Courtesy of Women Make Movies, www.wmm.com

text continued on page 238 ▶

FILM IN FOCUS

FILM IN FOCUS

LaunchPad Solo

To watch a clip from *The Conversation* (1974), see the *Film Experience* LaunchPad.

The Role of Sound and Sound Technology in *The Conversation* (1974)

See also: *Blow Out* (1981); *The Truman Show* (1998); *The Lives of Others* (2006)

Directed by Francis Ford Coppola in collaboration with sound designer and editor Walter Murch, *The Conversation* (1974) is notable because its very topic is the exploitation of sound technology. Although the film's sound conforms to the principles identified with the continuity tradition, it also—by its foregrounding of how sound is created and transmitted—illustrates the aims of sound montage practice.

The film, set in San Francisco, follows the activities of a surveillance expert, Harry Caul (played by Gene Hackman), as he goes about what seems to be a routine job—eavesdropping on a pair of lovers in the park. Harry's expertise and interest in technology leave little space for human contact and complement his rather paranoid character. Harry's hobby is playing the saxophone, and the warm sound of this instrument foreshadows his eventual awakening to the more human dimensions of the sounds he records for a living.

The first sequence of the film is a tour de force of sound and image counterpoint, which makes us partake in the activity of surveillance as we actively attempt to decode what is happening on the screen. Eavesdropping enhances the sound's quality of presence; we feel we are *right there* in the scene. Yet the activities of the on-camera sound recordists make us aware of those of the recordist, mixer, and director behind the scenes of the film we are watching.

The film opens with an aerial shot over San Francisco's Union Square; a slow zoom-in is accompanied by jazz music, while sound perspective remains constant. As the music shifts from an instrumental theme to the banter of two singers, and as the hubbub of the busy square and then the applause become audible,

we recognize that the music is diegetic—coming from the scene even though we cannot at first see the source. The music's festive and emotional connotations are immediately recognizable. Yet electronic interference comes in very early on. We begin to suspect that we are hearing the music through a device "within" the film as well as through the loudspeaker in the theater, and the emotional register turns slightly sinister.

In the next few shots, it remains difficult to tell who the object of the surveillance is and who the object of our attention should be, in part because the sound is not mixed to emphasize the action. Indeed, if we want to pick out Harry in the crowd in the first aerial shot, we must "listen" to the gestures of a mime, taunting through his mimicry a figure whose crumpled raincoat suggests a desire for anonymity. Harry, the silent stalker is stalked. Finally, when Harry enters a van where his assistant is stationed, we learn that the target is a young couple, Ann and Mark, played by Cindy Williams and Frederic Forrest **[Figure 6.42]**.

6.42 *The Conversation* (1974). We eavesdrop on characters that the plot never brings us to know better.

The sound mix in the scene is quite complicated. The cut to the first shot taken at ground level corresponds to a notable shift in sound perspective with an increase in the diegetic music volume. Quickly, a snatch of random conversation is heard and is followed by a snippet of another—this time, the targeted couple—but the succession has already identified for us the arbitrariness of continuity sound mixing practices that isolate immediately what we should pay attention to. The closeness of our sound perspective is then given technical justification when we see both Harry and a man with a hearing aid in close proximity to the couple. We stay with Ann and Mark as they continue a conversation about a drunk passed out on the park

6.43 *The Conversation* (1974). Audio technology becomes a pervasive presence in the film.

bench, and the volume of their conversation does not change as Harry climbs into the van. Here the continuity in sound perspective signals the importance of this apparently trivial conversation. And once again, what seemed like the film's sound—we hear the conversation—is revealed as sound produced within the story: what we hear is the recording of the conversation as we see the reel-to-reel tape recorder spinning [**Figure 6.43**].

In the next scene, Harry plays a few lines of recorded conversation over and over again, discovering in the captured sounds clues to a suspicious event. Is the "guilty" party the couple (presumably engaged in an affair) or those who pay to have them watched? And what is the ethical role of the "invisible" bystander (the hired sound recordist) and by extension the film viewer? The opening scene of *The Conversation* functions like a puzzle as Harry and the viewer strive to find the truth behind the sounds captured in the square.

Toward the end of the scene, a new sound element is introduced. A nondiegetic moody piano theme begins as the couple parts. The music continues, with some street noise in the mix, as Harry starts home. The piano carries over the dissolve to the next scene and ends just as Harry turns the key in his door, when it is abruptly replaced by a shrill sound effect—his alarm being set off. Our newly honed attention to the concrete nature of each sound element encourages us to evaluate this nondiegetic musical theme. Associated almost exclusively with long shots of Harry making his way around town, the wandering theme played on a single instrument underscores his alienation, inviting us as viewers to feel the emotion Harry attempts to keep at bay.

After Harry arrives home, we see him playing his saxophone. The sound of the sax is very solitary, and yet it connects Harry to the piano theme we have just heard as well as to the musicians in the park. Harry also plays his sax along with a record player, syncing up his own performance of the expressive qualities of music with prerecorded sound. This is emphasized by a shot of the record spinning. Such close-ups of sound technology are frequent in the film and remind us of the source of film voices, music, and effects. Often these cutaways are unmotivated by any character's specific attention to the sounds being emitted at that moment.

As the film progresses, Harry becomes increasingly suspicious of his employer's intentions, and he returns again and again to the evidence gathered in the first scene in the form of the tape. The film's theme of paranoia finds a perfect echo in its setting in the world of sound technology, eavesdropping, and surveillance. Because of the claims to presence of sound, the incriminating audiotape, with the accidental music and noises it captures, appears "real" and convincing, even in a film that is constantly showing off the paraphernalia of sound recording, mixing, and playback. By emphasizing that truth lies in the words spoken in that first conversation, the film upholds the privileged relationship between the voice and inner nature, while also facilitating Harry's (and the audience's) identification with other humans *through* technological mediation. Sound is used in service of narrative, but the narrative is about the uses of sound. Despite the period quaintness of the now-obsolete technologies the film lingers on—reel-to-reel tape recorders, oversized headphones, the squeaky sound of rewinding, and the mechanical click of old-fashioned buttons—*The Conversation* remains an apt commentary on the values and practices of sound technology.

6.44 *Wall-E* (2008). The "voices" of the animated robots in Pixar's *Wall-E* were created by sound designers—both as computer sound files and as technology-based voiceover artists.

Over a career spanning more than fifty years, Jean-Luc Godard has earned a reputation as probably the most exemplary practitioner of sound montage. Godard emphasizes music in the organization of many of his films; a favorite technique is to interrupt a music cue so that it literally cannot fade into the background. In *First Name: Carmen* (1983), we see a string quartet playing without knowing what its relationship to the story might be. The abrupt cessation of a soundtrack element may be extended to voices and effects as well. In the café scene in Godard's *Band of Outsiders* (1964), one of the characters suggests that if the friends in the group have nothing to say to each other, they should remain silent. This diegetic silence is conveyed by the complete cessation of sound on the soundtrack. By using non-authoritative or noncontinuous voiceovers as well as frequent voice-offs and by having on-camera characters address the camera, read, or make cryptic announcements, Godard challenges the natural role of the human voice in giving character and narrative information. Instead, language becomes malleable, an element in a collage of meaning.

But even in Hollywood films, sound montage can dominate, especially as soundtracks become more dense. Narratively motivated by the futuristic setting, the soundscape of Ridley Scott's *Blade Runner* (1982) resembles that of an experimental film. Sound is at least as responsible as the mise-en-scène and the story line for the theme of anxiety in a synthetic, syncretic world. In Terrence Malick's *The Tree of Life* (2011), a sound montage of whispering voices, voice-off commentary, and amplified noises from nature creates a vibrating and shifting world that his characters struggle to understand. In their richness, contemporary soundtracks draw more and more on montage traditions of layering sounds. Sound designer Ben Burtt used thousands of files for the soundscape for the animated film *Wall-E* and also "voiced" the title character **[Figure 6.44]**. The aim may not be, as it was in Godard's films, to encourage reflection in the viewer on the discrete aesthetic and ideological functions of sound and image, but there is no doubt that sound contributes key dimensions of the viewer's sense of wonder and immersiveness.

CONCEPTS AT WORK

From Thomas Edison's experiments and *The Jazz Singer* through *Singin' in the Rain* and *The Conversation*, films re-create sounds from the world around us and create new patterns of sound that construct or emphasize meanings and themes in the films. Listening carefully to films is a critical act that engages the films

we watch in an audio dialogue that involves, as *Singin' in the Rain* clearly dramatizes, film history and culture, as well as specific formal elements and strategies. In films like *Pulp Fiction* and *The Great Gatsby*, we listen — consciously or unconsciously — to a film with many layers of sound, from the dialogue to the background score and music soundtracks. Although film sound may represent the least visible of the formal and technical elements of the movies, listening to movies often provides the most insightful discoveries about a film. Indeed, in films like *The Piano*, sound becomes the primary motif through which we understand the characters. Listen carefully to the film you are examining, and reconsider two or three of these major objectives:

- What are some of the historical or cultural influences on its use of sound? Sound technology as in *Singin' in the Rain*? Contemporary music as in Quentin Tarantino's films?
- In which specific ways does the sound interact with the images? As narrative cues, such as those heard in movies like *Taxi Driver* (1976)? Or perhaps as ironic counterpoints to the action on the screen?
- Are there distinctive ways that voice or voices are used in the film?
- How does music function in relation to the story? As commentary on the action? As irony?
- Does the film creatively use sound effects in ways that make us understand the story and its world in specific ways?

LaunchPad Solo

Visit the LaunchPad Solo for *The Film Experience* to view movie clips, read additional Film in Focus pieces, and learn more about your film experiences.

ORGANIZATIONAL STRUCTURES
from stories to genres

We go to the movies not just to experience a film's elaborate scenes, brilliant images, dramatic cuts, and rich sounds. We also go for the gripping suspense of a murder mystery, the fascinating revelations of a documentary, the poetic voyage of a musical score set to abstract images and sounds, and the satisfying iconography of a western. The psychological thriller *10 Cloverfield Lane* (2016) keeps us tense with anticipation; the documentary *Amy* (2015) reveals new layers of Amy Winehouse's heartbreaking story; *The Lobster* (2016) intrigues with its bizarre premise that those who do not find a romantic mate will be turned into animals; and *La La Land* (2016) delights with its recasting of modern life in the entertainment capital as an old-fashioned musical.

Besides the stylistic details found in the mise-en-scène, cinematography, editing, and sound, movie experiences are also encounters with larger organizational structures and attractions. Some of us may look first for a good story; others may prefer documentary or experimental films. Some days we may be in the mood for a melodrama; other days we may feel like watching a horror film. Part 3 explores the principal organizations of movies—narrative, documentary, and experimental films, and movie genres—each of which, as we will see, arouses certain expectations about the movie we are viewing. Each shapes the world for us into a distinctive kind of experience, offering a particular way of seeing, understanding, and enjoying it.

Summit Entertainment/Photofest

NARRATIVE FILMS
Telling Stories

Based on the book series by L. Frank Baum, *The Wizard of Oz* has been one of the most adapted and ubiquitous narratives in American history, including a 1925 silent version, the famous 1939 Technicolor film with Judy Garland, updates like Sam Raimi's 2013 *Oz the Great and Powerful*, and the modernized musical *The Wiz* (1978), performed decades later on TV as the holiday special *The Wiz Live!* (2015). With a sepia-tone frame questioning Dorothy's place in Kansas farm life, the Technicolor narrative of the 1939 classic catapults the heroine into a strange world where she meets the Scarecrow, the Tin Man, and the Cowardly Lion, who then accompany her as she encounters and overcomes a series of obstacles along her way and finally defeats the Wicked Witch of the West. Despite its fantastical elements, the narrative follows a cause-and-effect structure propelled by the protagonist's goal and eventually concludes in her return to her home and family. Indeed, the basic outline of this narrative might describe the shape of many very different stories, from *Finding Nemo* (2003) to *The Hurt Locker* (2008). At the same time, this particular narrative is also a fine example of how some narratives can approach the status of a cultural myth, shared by many different audiences.

Movies have thrived on the art and craft of **narrative**, a story with a particular plot and point of view. At its core, narrative maps the different ways we have learned to make sense of our place in history and the world as well as to communicate with others. Narrative film developed out of a long cultural, artistic, and literary tradition of storytelling that shows characters pursuing goals, confronting obstacles to those goals, and ultimately achieving some kind of closure. In general, narrative follows a three-part structure consisting of a beginning, a middle, and an ending. An established situation is disrupted, and events in the middle of the narrative lead to a restoration of order in the ending.

Storytelling has always been a central part of societies and cultures. Stories spring from both personal and communal memories and reconstruct the events, actions, and emotions of the past through the eyes of the present. They also offer explanations for events and features of the world that may otherwise seem beyond comprehension. In this way, stories strengthen both the memory and the imagination of a society. Many stories—Bible stories, Hindu scriptures, Icelandic sagas, oral tales of indigenous cultures, and well-known stories of historical events (such as the Civil War) and people (such as Abraham Lincoln)—are all driven by these aims. In a sense, stories are both the historical center of a culture and the bonds of a community.

KEY OBJECTIVES

- Recognize the ubiquity of storytelling in film.
- Describe the different historical practices that create the foundations for film narratives.
- Explain how film narratives construct plots that can arrange the events of a story in different ways.
- Identify the ways that film characters motivate actions in a story.
- Break down the ways that plots create different temporal and spatial schemes.
- Describe how narration and narrative point of view determine our understanding of a story.
- Distinguish the differences between classical and alternative narrative traditions.

A Short History of Narrative Film

Over time, stories have appeared in a myriad of material forms and served innumerable purposes, many of which reappear in movie narratives. Some films, like *Little Big Man* (1970) and *Contempt* (1963), make explicit references to the narrative history that precedes them. *Little Big Man*, for instance, depicts the heritage of Native Americans gathered around the fire listening to storytellers recounting the history of their people. *Contempt*, in contrast, struggles with the narrative forms found in Homer's *Odyssey* and those demanded by commercial filmmaking—between telling a tale as an epic poem and as a Hollywood blockbuster [**Figures 7.1a–7.1c**].

To appreciate the richness of film narrative, viewers must keep in mind the unique cultural history of narrative itself. For example, oral narratives, which are spoken or recited aloud, represent a tradition that extends from the campfire to today's stage performance artists. Written narratives, such as Charles Dickens's *Bleak House* (1853), appear in printed form, while graphic narratives develop through a series of images, such as the stories told through lithographs in the eighteenth century and through modern comic books like *Deadpool* [**Figure 7.2**].

(a)

(b)

(c)

7.1a–7.1c *The Odyssey.* The history of narrative invariably reflects the historical pressures and conditions that determine how stories are told. **(a)** Ancient Greek epics, including the renowned *Odyssey*, often were depicted as visual narratives. **(b)** Since medieval times, the visual arts have incorporated stories and allegories into a single frame—for example, depicting multiple characters and events from the *Odyssey* in one sixteenth-century painting. **(c)** More modern visual arts, like Jean-Luc Godard's *Contempt*, have engaged directly with the history of narrative. Godard's film is about the struggle to adapt the *Odyssey* to the screen. (a) Erich Lessing/Art Resource, NY; (b) © National Gallery, London/Art Resource, NY

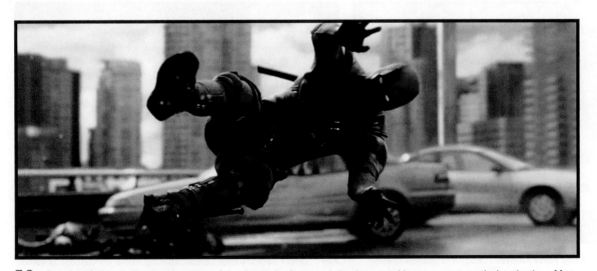

7.2 *Deadpool* (2016). The transformation of visual narrative from comic-book page to big screen captures the imagination of fans and new viewers alike.

In these and other examples, the form and material through which a story is told affect aspects of the narrative, facilitating some characteristics of expression and prohibiting others. Oral narratives provide more direct and flexible contact with listeners, allowing a story to be tailored to an audience and to change from one telling to another. A visual narrative shows the appearance of characters more concretely than a literary one, whereas a literary narrative is able to present characters' thoughts more seamlessly than a visual narrative. A film narrative commonly draws from and combines these and other narrative traditions, and attending to how a particular film narrative employs the strategies of, say, oral narratives or operatic narratives illustrates the broad and complex history of storytelling embedded in cinematic form.

1900–1920s: Adaptations, Scriptwriters, and Screenplays

Although the first movies usually showed only simple moving images (such as a train arriving at a station), these images often referred to a story behind them. As film form developed, adaptations of well-known stories were a popular choice of filmmakers, much like today's adaptations of comic books and remakes of previous movies. Audiences' familiarity with the characters and plot helped them to follow emerging motion-picture narrative techniques. As early as 1896, the actor Joseph Jefferson represented Rip van Winkle in a brief short. By 1903, a variety of similar film tableaux—a story told through a single image—assumed that audiences would know the larger story behind what was shown on the screen, including Shakespeare's *King John* (1899), *Cinderella* (1900), *Robinson Crusoe* (1902), and *Ali Baba and the Forty Thieves* (1905) **[Figure 7.3]**. *Uncle Tom's Cabin*, the most popular novel and stage play of the nineteenth century, was adapted for the screen numerous times in the silent film era, once by Edwin S. Porter in 1903 **[Figure 7.4]**. Porter's films were among the first to use editing to tell stories, and by 1906 the movies were becoming a predominantly narrative medium.

These early historical bonds between movies and stories served the development of what we call the *economics of leisure time*. In the first decades of the twentieth century, the budding movie industry recognized that stories take time to tell and that an audience's willingness to spend time watching stories makes money for

7.3 *Ali Baba and the Forty Thieves* (1905). The tableaux of early films rely on imagery that assumes the audience knows the larger story behind the image.

7.4 *Uncle Tom's Cabin* (1903). Edwin S. Porter directed one of numerous silent film adaptations of the most popular nineteenth-century novel and stage play.

the industry. In these early years, most individuals went to the movies to experience the novelty of "going to the movies" and spending an afternoon with friends or an hour away from work. By 1913, moviemakers recognized that by developing more complex stories they could attract larger audiences, keep them in their seats for longer periods, and charge more than a nickel for admission. Along with the growing cultural prestige of attending films that told serious stories, movies could now sell more time for more money through longer narratives. Quickly cinema established itself among the leading sources of cultural pleasures that included museums, art galleries, and traditional and vaudeville theaters. At the same time, cinema's own history came to be governed by the forms and aims of storytelling.

As narrative film developed, two important industrial events stand out—the introduction of screenplays and the advancement of narrative dialogue through sound. Whereas many early silent movies were produced with little advance preparation, the growing number and increasing length of movies from 1907 onward required the use of **screenwriters** (also called *scriptwriters*), who created the film's screenplay, either by beginning with an original treatment and developing the plot structure and dialogue over the span of several versions or by adapting short stories, novels, or other sources. As part of this historical shift, movies' narratives quickly became dependent on a **screenplay** (or film *script*), the text from which a movie is made, including dialogue and information about action, settings, shots, and transitions. It standardized the elements and structures of movie narratives. A copyright lawsuit regarding an early movie version of *Ben-Hur* (1907) immediately underlined the importance of scriptwriters who could develop original narratives.

■■ ▶ **VIEWING CUE**

For the film you recently watched in class, describe as much of the story as you can. What are the main events, the implied events, and the significant and insignificant details of the film's story?

1927–1950: Sound Technology, Dialogue, and Classical Hollywood Narrative

The introduction of sound technology and dialogue in the late 1920s proved to be one of the most significant advances in the history of film narrative. Sound affected the cinema in numerous ways, but perhaps most important was that it enabled film narratives to create and develop more intricate characters whose dialogue and vocal intonations added new psychological and social dimensions to film. More intricate characters were used to propel more complex movie plots. In many ways a product of the new narrative possibilities offered by sound, screwball comedies such as *Bringing Up Baby* (1938) feature fast-talking women and men whose verbal dexterity is a measure of their independence and wit **[Figure 7.5]**. Other films of this period use sound devices, such as a whistled tune in Alfred Hitchcock's *The Man Who Knew Too Much* (1934), to make oblique connections between characters and events and to build more subtle kinds of suspense within the narrative.

The continuing evolution of the relation between sound and narrative helped to solidify and fine-tune the fundamental shape of classical Hollywood narrative in the 1930s and 1940s. During this period, the structure of this increasingly dominant narrative form became firmly established according to three basic features: (1) the narratives focus on one or two central characters, (2) these characters move a linear plot forward, and (3) the action develops according to a realistic cause-and-effect logic. A trio of movies produced in 1939, often heralded as Hollywood's golden year—*Gone with the Wind*, *Stagecoach*, and *The Wizard of Oz*—illustrate

7.5 *Bringing Up Baby* (1938). The coming of sound allowed for the witty dialogue of the fast-talking, independent heroines of screwball comedies. Such characters are epitomized by Susan Vance (played by Katharine Hepburn), whose "baby" in this film is a pet leopard.

sound-era movie narratives as modern-age myths and, despite their many differences, describe narrative variations on this classical Hollywood structure. During these years, the Hollywood studio system grew in size and power, and it provided a labor force, a central producer system, and a global financial reach that created an extraordinarily efficient industrial system for storytelling. This system became increasingly identified with lucrative narrative genres, such as musicals and westerns (see Chapter 9).

Also during this period, the introduction and advancement of specific movie technologies — for example, deep-focus cinematography and Technicolor processes — offered ways to convey and complicate the narrative information provided by specific images. Although the plot structure of the classical narrative remained fully intact, these technologies allowed movies to explore new variations on narrative in the atmosphere of a scene or in the dramatic tensions between characters.

With growing pressure from the Motion Picture Producers and Distributors of America (headed by Will H. Hays from 1922 to 1945) — the U.S. organization that determined the guidelines for what was considered morally acceptable to depict in films and that adopted a strict Production Code in 1930 — film narratives during the 1930s turned more conspicuously to literary classics for stories that could provide adult plots acceptable to censors. These classics included *Pride and Prejudice* (1938) and *Wuthering Heights* (1939). For an industry that needed more verbal narratives, Hollywood looked increasingly to New York and other places where literary figures like F. Scott Fitzgerald could be lured into writing new stories and scripts.

World War II (1939–1945) significantly jolted classical Hollywood narratives. The stark and often horrific events that occurred during the war raised questions about whether the classic narrative formulas of linear plots, clear-headed characters, and neat and logical endings could adequately capture the period's far messier and more confusing realities. If the narrative of *The Wizard of Oz* followed the yellow brick road that led a character home, the war-scarred narrative of *The Best Years of Our Lives* (1946) poignantly questioned what path to follow and even doubted whether one could ever go home again **[Figure 7.6]**.

7.6 *The Best Years of Our Lives* (1946). This postwar narrative questions the happy ending and closure that a return home usually signifies.

1950–1980: Art Cinema

The global trauma of World War II not only challenged the formulaic Hollywood storytelling style of the time but also gave rise to an innovative art cinema that emerged in the 1950s and 1960s in Europe, Japan, India, Latin America, and elsewhere. This new form of cinema questioned many of the cultural perspectives and values that existed before the war. Produced by such directors as Ingmar Bergman, Federico Fellini, and Agnès Varda, European art cinema experimented with new narrative structures that typically subverted or overturned classical narrative models by featuring characters without direction, seemingly illogical actions, and sometimes surreal events. In *Cléo from 5 to 7* (1962), for instance, Varda restricts the narrative to two hours in the day of a singer, capturing the real-time

details of her life. Although the protago-
nist fears a cancer diagnosis, the narrative
eschews melodrama for the joys of wan-
dering through the everyday [Figure 7.7].

Influencing later new wave cinemas
such as the New German Cinema of the
1970s and the New Hollywood cinema
of the 1970s and 1980s, these films
intentionally subverted traditional narra-
tive forms such as linear progression of
the plot and the centrality of a specific
protagonist. In addition, these narratives
often turned away from the objective
point of view of realist narratives to cre-
ate more individual styles and tell stories
that were more personal than public.
Fellini's *8½* (1963), for instance, has an
unmistakable autobiographical dimension
as it recounts the struggles of a movie
director wrestling with his anxieties about
work and the memories that haunt him.

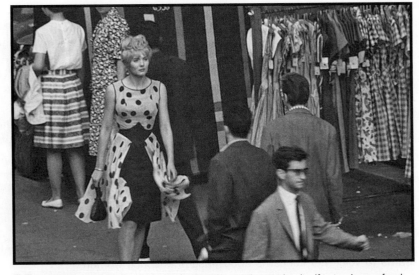

7.7 ***Cléo from 5 to 7*** (1962). Agnès Varda's narrative restricts itself to two hours of real time as it documents an afternoon in the life of a young woman in Paris.

1980s–Present: From Narrative Reflexivity to Games

Contemporary movies represent a wide variety of narrative practices, but three can
be identified as particularly significant and widespread in recent decades. Reflecting
different technological, artistic, and industrial influences, these three narratives often
reflect back on the process of making films, adapt the physical and psychological
excitement of amusement parks, or mimic the interactivity of video and digital games.

In the practice of narrative reflexivity, filmmakers still tell stories but now
call more attention to how they are telling those stories or how these stories are
a product of certain narrative techniques and perspectives. *Adaptation* (2002) is
thus a film about a screenwriter's struggles to adapt a *New Yorker* essay on orchids
to the formulas of a Hollywood narrative. Meanwhile, replete with references to
earlier films and narrative conventions, Quentin Tarantino's *Inglourious Basterds*
(2009) is a self-conscious film fantasy about the killing of Nazi leaders during the
screening of a film [Figure 7.8].

A second direction in movies of the last few decades is the appropria-
tion of roller coaster–like narratives with soaring effects similar to amusement
park rides and the physical and psychological thrills associated with them. The
Pirates of the Caribbean movie series
(2006–2017) is actually based on a Dis-
neyland ride. Similarly, although the
Harry Potter films (2001–2011) are based
on J. K. Rowling's children's books rather
than a theme park ride, they nonethe-
less seem to aspire, at least in part, to
the narrative-ride model, complete with
elaborate action sequences and IMAX-
ready spectacle. In 2010, the Universal
Studios theme parks opened extensive
attractions called The Wizarding World
of Harry Potter.

7.8 ***Inglourious Basterds*** (2009). Contemporary narratives like this film are highly self-conscious and reflexive about the historical sources and materials that construct their stories.

HISTORY CLOSE UP

Salt of the Earth

Turning actual events into a narrative often makes them more compelling. Characters with whom we can identify, sharply drawn conflict, and suspense about the outcome make *Salt of the Earth* (1954, right), based on a 1951 miners' strike in New Mexico, a gripping and deeply moving story. But despite these traditional narrative elements, the film broke with Hollywood convention in many ways. Shot on location with a mix of actors and Chicano/a community members, the story is told through the eyes of Esperanza, a young mother married to a striking miner. Initially meek, Esperanza learns to voice her concerns about issues affecting women in their company town, built on land that formerly belonged to Mexico. When the men are banned from picketing, the women walk the line instead. The story proceeds on both personal and political levels, as Esperanza and her husband, Juan, negotiate their roles and Esperanza takes a public role in the labor struggle. Both narrative threads rely on heroic acts by ordinary Americans about whom few Hollywood movies are made. Because the script was drafted in collaboration with the participants and directed by Herbert J. Biberman, one of the "Hollywood Ten" who were jailed for refusing to testify in congressional hearings into whether film industry professionals were current or former members of the American Communist Party, the film plays a role in another fraught narrative about American life—the history of censorship. The set was threatened while the film was in production, and anti-Communist unions blocked laboratories from printing it and projectionists from showing it. Not until many years after the film was made did it become recognized as a deeply American narrative.

As films move into the digital age of the new millennium, a third tendency is to structure stories with the effects of video and digital gaming, making films (and their marketing campaigns) a kind of interactive game for audiences. Movies are increasingly implicitly or explicitly constructing stories as interactive explorations of space. In Doug Liman's *Edge of Tomorrow* (2014), the hero dies combating an alien invasion over and over, waking to attempt his mission again [**Figure 7.9**]. Films

7.9 *Edge of Tomorrow* (2014). The looping narrative of this science fiction film exemplifies the increasing influence of gaming on film narrative.

no longer depict a linear plot that an audience simply follows in every instance. Indeed, as film narrative evolves in the twenty-first century, the convergences and exchanges between games and films may represent one of cinema's most interesting new directions.

The Elements of Narrative Film

Narrative is universal, but it also is infinitely variable. The origins of cinema storytelling in other narrative forms and texts, the evolution of narrative strategies across film history, and the distinct narrative traditions across cultures give a sense of this variety. However, we can identify the common elements of narrative and some of the characteristic ways the film medium deploys them.

Stories and Plots

The main features of any kind of narrative are the story, characters, plot, and narration. A **story** is the subject matter or raw material of a narrative. In a story, actions and events (usually perceived in terms of a beginning, a middle, and an end) are ordered chronologically and focus on one or more **characters**—the individuals who motivate the events and perform the actions of the story. Stories tend to be summarized easily, as in "the tale of a man's frontier life on the Nebraska prairie" or "the story of a woman confronting the violence of her past in Pakistan." In the next section, we discuss characters in detail.

The **plot** is the narrative ordering of the events of the story as they appear in the actual work, selected and arranged according to particular temporal, spatial, generic, causal, or other patterns. In one story, the plot may include the smallest details in the life of a character; in another story, it may highlight only major, cataclysmic events. One plot may present a story as progressing forward step by step from the beginning to the end, and another may present the same story by moving backward in time. One plot may describe a story as the product of the desires and drives of a character, whereas another might suggest that events take place outside the control of that character. Although the story of John F. Kennedy's life and death are well known, movies depicting these events feature very different plots. Oliver Stone's *JFK* (1991) focuses on New Orleans district attorney Jim Garrison's investigation of conspiracy theories around the death, using a bewildering array of footage to unsettle our historical certainties. *Thirteen Days* (2001) is a telescopic narrative covering the 1962 Cuban missile crisis, creating drama by focusing on a president's character under pressure, even though the outcome is already known to viewers. Finally, *Jackie* (2016) shifts emphasis to the first lady, covering her life in the days after the assassination.

From early films like Edwin S. Porter's *Life of an American Fireman* (1903), regarded as one of the first significant narrative films, to modern movies like Christopher Nolan's *Memento* (2000), with its reverse chronology, movies have relied on the viewer's involvement in the narrative tension between story and plot to create suspense, mystery, and interest. Even in the short and simple rescue narrative of Porter's film **[Figures 7.10a–7.10d]**, some incidental details are omitted, such as the actual raising of the ladders. To add to the urgency and energy of the narrative, the rescue is shown sequentially from two different camera setups, a practice that confused later audiences. In *Memento*, the tension between plot and story is more obvious and dramatic. This unusual plot, about a man without a short-term memory, begins with a murder and proceeds backward in time

(a) (b)

(c) (d)

7.10a–7.10d *Life of an American Fireman* (1903). This story proceeds from a fire alarm being sounded, to firefighters racing through the streets, to the rescue, with one event—the rescue of a woman via ladder—shown from two different perspectives. Photofest, Inc.

through a series of short episodes that unveil fragments of information about who the man is and why he committed the murder **[Figure 7.11]**. In other films, we know the story; what interests us is discovering the particular ways the plot constructs that story.

7.11 *Memento* (2000). A crisis of memory becomes a crisis of plot in Christopher Nolan's innovative reverse narrative.

Characters

The first characters portrayed in films were principally bodies on display or in motion—a famous actor posing, a person running, a figure performing a menial task. When movies began to tell stories, however, characters became the central vehicle for the actions, and with the advent of the Hollywood star system

around 1910, distinctions among characters developed rapidly. From the 1896 *Lone Fisherman* to the 1920 *Pollyanna* (featuring Mary Pickford), film characters evolved from amusing moving bodies to figures that had specific narrative functions and were portrayed by adored actors whose popularity made them nearly mythic figures. With the introduction of sound films in 1927, characters and their relationships were increasingly drawn according to traditions of literary realism and psychological complexity. Today the evolution of character presentation continues as the voices of real actors are adapted to animated figures and plots. Throughout all these historical incarnations, characters have remained one of the most immediate yet underanalyzed dimensions of the movies.

Character Roles

Characters are either central or minor figures who anchor the events in a film. They can propel the plot by fulfilling a particular character function, such as protagonist, antagonist, or helper—roles that recur across many plots. More complex characters motivate narrative events through specific situations or traits. Characters are commonly identified and understood through aspects of their appearance, gestures, actions, and dialogue; the comments of other characters; as well as such incidental but important features as their names or clothes.

In many narrative films, a character's inferred emotional and intellectual make-up motivates specific actions that consequently define that character. His or her stated or implied wishes and fears produce events that cause certain effects or other events to take place. Thus, the actions, behaviors, and desires of characters create the causal logic favored in classical film narrative, Hollywood's dominant style of narrative filmmaking in which characters' goals propel a linear plot toward closure. In *The Wizard of Oz* (1939), Dorothy's desire to "go home"—to find her way back to Kansas—leads her through various encounters and dangers that create friendships and fears, and these events, in turn, lead to others, such as Dorothy's fight to retrieve the witch's broom. In the end, she returns home joyfully. The character of Dorothy is thus defined first by her emotional desire and will to go home and then by the persistence and resourcefulness that eventually allow her to achieve that goal [Figure 7.12].

Most film characters are a combination of both ordinary and extraordinary features. This blend of fantasy and realism has always been an important movie formula: it creates characters that are recognizable in terms of our experiences and exceptional in ways that make them interesting to us. The complexities of certain film characters can be attributed to this blending and balancing. For example, the title characters of the biographical *Queen of Katwe* (2016), *Milk* (2008), and *Lincoln* (2012)—a young girl from one of Kampala's slums who became a chess champion, the activist who fought for gay rights in San Francisco, and the American president attempting to broker an antislavery legislation deal—all combine extraordinary and ordinary characteristics

7.12 *The Wizard of Oz* (1939). Narrative cause-and-effect logic finds Dorothy and her new companions on the yellow brick road, heading toward the Emerald City.

(a)

(b)

(c)

7.13a–7.13c **Biographical film characters.** These characters based on historical figures—from **(a)** *Queen of Katwe* (2016), **(b)** *Milk* (2008), and **(c)** *Lincoln* (2012)—represent a balance of the ordinary and the extraordinary.

[**Figures 7.13a–7.13c**]. Even when film characters belong to fantasy genres, as with the tough but vulnerable heroine of *Alien* (1979), understanding them means appreciating how that balance between the ordinary and the extraordinary is achieved.

Character Coherence, Depth, and Grouping

No matter how ordinary or extraordinary, unique or typical a character is, narrative traditions tend to require **character coherence**—consistency and coherence in a character's behaviors, emotions, and thoughts. Character coherence is the product of psychological, historical, or other expectations that see people (and thus characters in fictional narratives) as fundamentally consistent and unique. We usually evaluate a character's coherence according to one or more of the following three assumptions or models:

- *Values.* The character coheres in terms of one or more abstract values, such as when a character becomes defined through his or her overwhelming determination or treachery.
- *Actions.* The character acts out a logical relation between his or her implied inner or mental life and visible actions, as when a sensitive character acts in a remarkably generous way.
- *Behaviors.* The character reflects social and historical assumptions about normal or abnormal behavior, as when a fifteenth-century Chinese peasant woman acts submissively before a man with social power.

Defined within a realist tradition, the character Sergeant William James in Kathryn Bigelow's *The Hurt Locker* (2008) is part of a specialist bomb squad group in the Iraq War. His reckless behavior as he toys with mortal danger and death contrasts with his obsessive countdown of the days until he can return home. Questions about what drives and explains this character become part of the film's powerful depiction of war. When he finally returns home, only to quickly reenlist to return to Iraq, this complicated character seems revealed as one who coheres around a death wish of sorts or at least around the addictive excitement of risking death [**Figure 7.14**].

7.14 *The Hurt Locker* (2008). The contradictory behavior of Sergeant William James coheres around his addiction to danger and death.

Inconsistent, contradictory, or divided characters subvert one or more patterns of coherence. Although inconsistent characters occasionally may be the result of poor characterization, some films intentionally create an inconsistent or contradictory character as a way of challenging our sympathies and understanding. In films like *Desperately Seeking Susan* (1985) — about a bored suburban housewife, Roberta, who switches identities with an offbeat and mysterious New Yorker — characters complicate or subvert the expectation of coherence by taking on contradictory personalities. *Mulholland Dr.* (2001) dramatizes this instability when its two characters become mirror images of each other. In its tale of an amnesiac woman and a young actress who become entangled in a mysterious plot, fundamental notions about character coherence and stability are undermined [**Figure 7.15**].

Film characterization inevitably reflects certain historical and cultural values. The hero is overwhelmingly understood as male. In 2015, only 17 percent of the most successful Hollywood films had female leads. In Western cultures, movies promote the concept of the singular character, a unique individual distinguished by specific features and isolated from a social group. For example, the unique character of Jason Bourne in the series of *Bourne* films (2002–2016) is a product of a complex mixture of traits that reflect a modern notion of the advanced individual as one who is emotionally and intellectually complex and one of a kind. **Character depth** is the pattern of psychological and social features that distinguish a character as rounded and complex in a way that approximates realistic human personalities. It becomes a way of referring to personal mysteries and intricacies that deepen and layer the dimensions of a complicated personality. For example, the surface actions of Louise in *Thelma & Louise* (1991) — she refuses to drive through Texas to travel to Mexico — clearly hide a deep trauma (a presumed sexual assault) that she tries unsuccessfully to repress. The uniqueness of a character may be a product of one or two attributes — such as exceptional bravery, massive wealth, or superpowers — that separate him or her from all the other characters in the film. Sometimes we are led to question the value placed on singularity as a

7.15 *Mulholland Dr.* (2001). The double characters of the amnesiac and the young actress complicate character coherence.

7.16 *The Silence of the Lambs* (1991). Hannibal Lecter's dark depth of character is revealed.

VIEWING CUE

In the film you are watching for class, select a character that you might define as singular. Does that singularity indicate something about the values of the film? Does the character seem coherent? How?

product of a social system that prizes individuality and psychological depth. After all, Hannibal Lecter in *The Silence of the Lambs* (1991) and its prequel and sequel is one of the most singular and exceptional characters in film history [**Figure 7.16**]. Our troubling identification with him (at least in part) goes to the social heart of our admiration for such uniqueness.

Character grouping refers to the social arrangements of characters in relation to each other. Traditional narratives usually feature one or two **protagonists** (characters identified as the positive forces in a film) and one or two prominent **antagonists** (characters who oppose the protagonists as negative forces in a film). As with the sympathetic relationship between a German officer and a French prisoner in *Grand Illusion* (1937), this oppositional grouping of characters can sometimes be complicated or blurred.

In a film featuring an ensemble cast, such as *Crash* (2004), the conflicting relationships and competing interests among a group of interrelated characters provide much of the film's drama. Surrounding, contrasting with, and supporting the protagonists and antagonists, **minor characters** (also called *secondary characters*) are usually associated with specific character groups. In *Do the Right Thing* (1989), Da Mayor wanders around the edges of the central action throughout most of the film. Although he barely affects the events of the story, Da Mayor represents an older generation whose idealistic hopes have been dashed but whose fundamental compassion and wisdom stand out amid racial anger and strife.

Social hierarchies of class, gender, race, age, and geography, among other determinants, also come into play in the arrangements of film characters. Traditional movie narratives have focused on male protagonists and on heterosexual pairings in which males have claimed more power and activity than females. Another traditional character hierarchy places children and elderly individuals in subordinate positions. Especially with older or mainstream films, characters from racial minorities have existed on the fringes of the action and occupy social ranks markedly below those of the white protagonists. In *Gone with the Wind* (1939), for example, character hierarchy subordinates African Americans to whites. When social groupings are more important than individual characters, the collective character of the individuals in the group is defined primarily in terms of the group's action and personality. Sergei Eisenstein's *Battleship Potemkin* (1925) fashions a drama of collective characters, crafting a political showdown among czarist oppressors, rebellious sailors, and sympathetic civilians in Odessa. Modern films may shuffle those hierarchies noticeably so that groups like women, children, and the poor assume new power and position, as in *Winter's Bone* (2010), a story about a young female determined to find her lost father in a destitute Ozark Mountain region ravaged by a methamphetamine drug culture [**Figure 7.17**].

7.17 *Winter's Bone* (2010). The remarkable grit and determination of a young woman redefines both class and gender.

Character Types

Character types share distinguishing features with other similar characters and are prominent within particular narrative traditions such as fairy tales, genre films, and comic books. A single trait or multiple traits may define character types. These may be physical, psychological, or social traits. Tattoos and a shaved head may identify a character as a "skinhead" or punk, and another character's use of big words and a nasal accent may represent a New England socialite.

We might recognize the singularity of Warren Beatty's performance as Clyde in *Bonnie and Clyde* (1967), yet as we watch more movies and compare different protagonists, we can recognize him as a character type who—like James Cagney as gangster Tom Powers in *The Public Enemy* (1931) and Bruce Willis as John McClane in the *Die Hard* series (1988–2013)—can be described as a "tough yet sensitive outsider." By offering various emotional, intellectual, social, and psychological points of entry into a movie, character types include such figures as "the innocent," such as Elizabeth Taylor's Velvet Brown in *National Velvet* (1944); "the villain," such as Robert De Niro's Max Cady in Martin Scorsese's remake of *Cape Fear* (1991); and the "heartless career woman," such as the imperious fashion editor played by Meryl Streep in *The Devil Wears Prada* (2006) **[Figure 7.18]**. These and other character types can often be subclassified in even more specific terms—such as "the damsel in distress" or "the psychotic killer."

7.18 *The Devil Wears Prada* (2006). The "heartless career woman" character type is depicted by Meryl Streep in her role as imperious fashion editor Miranda Priestly.

Character types usually convey clear psychological or social connotations and imply cultural values about gender, race, social class, or age that a film engages and manipulates. In *Life Is Beautiful* (1997), the father (played by director Roberto Benigni) jokes and pirouettes in the tradition of comic clowns like Charlie Chaplin or Jacques Tati, outsiders whose physical games undermine the social and intellectual pretensions around them. In *Life Is Beautiful*, however, this comic type must live through the horrors of a Nazi concentration camp with his son, and in this context the character type becomes transformed into a different figure—a heroic type who physically and spiritually saves his child **[Figure 7.19]**.

Archetypes. Film characters also are presented as figurative types, characters so exaggerated or reduced that they no longer seem at all realistic and instead seem more like abstractions or emblems, like the white witch in *The Chronicles of Narnia: The Lion, the Witch, and the Wardrobe* (2006). In some movies, the figurative character appears as an **archetype**, a spiritual, psychological, or cultural model expressing certain virtues, values, or timeless realities—such as when a character represents evil or oppression. In *Battleship Potemkin* (1925), a military commander unmistakably represents

7.19 *Life Is Beautiful* (1997). The "comic" character type, depicted by Roberto Benigni in his role as a prisoner in a Nazi concentration camp, is transformed into the "hero" type.

7.20 *Imitation of Life* (1934). The "mammy" stereotype is identified by the black housekeeper's subservient role and dowdy costumes.

social oppression, and a baby in a carriage becomes the emblem of innocence oppressed. In different ways, figurative types present characters as intentionally flat, without the traditional depth and complexity of realistically drawn characters, and often for a specific purpose—to create a comic effect, as with the absent-minded professor in *Back to the Future* (1985); to make an intellectual argument, as in *Battleship Potemkin*; or to populate a world of superheroes, as in *Batman v. Superman: Dawn of Justice* (2016).

Stereotypes. Sometimes a film reduces an otherwise realistic character to a set of static traits that identify him or her in terms of a social, physical, or cultural category—such as the "mammy" character in *Imitation of Life* (1934) **[Figure 7.20]** or the vicious and inhuman Vietnamese in *The Deer Hunter* (1978). This figurative type becomes a **stereotype**—a character type that simplifies and standardizes perceptions that one group holds about another, often less numerous, powerful, or privileged group. Although Louise Beavers's role and performance as Annie Johnson in *Imitation of Life* are substantive enough to complicate the way the role is written, it is still an example of how stereotypes can offend even when not overtly negative because they tend to be applied to marginalized social groups who are not represented by a range of character types.

The relationship between film stars and character types has been a central part of film history and practice. For over a hundred years, the construction of character in film has interacted with the personae of recognizable movie stars. Rudolph Valentino played exotic romantic heroes in *The Sheik* (1921) and *Son of the Sheik* (1926), and his offscreen image was similarly molded to make him appear more exotic, with his enthusiastic female fans differentiating little between character and star. In *Meet the Parents* (2000) and its sequels, Robert De Niro's character draws on familiar aspects of the actor's tough-guy persona—for example, his role as a young Vito Corleone in *The Godfather: Part II* (1974) or as Travis Bickle in *Taxi Driver* (1976)—to humorous effect. Our experience of stars—garnered through publicity and promotion, television appearances, and criticism—resembles the process by which characters are positioned in narratives. Elements of characterization—clothing, personal relationships, perceptions of coherence or development—factor into our interest in stars and, in turn, into the ways that aspects of stars' offscreen images affect their film portrayals. One way to contemplate the effects of star image on character types is to imagine a familiar film cast differently. Would *Cast Away*'s (2000) story of everyman encountering his environment be the same if, instead of Tom Hanks, Jack Nicholson or Beyoncé Knowles played the lead?

Character Development

Finally, film characters usually change over the course of a realist film and thus require us to evaluate and revise our understanding of them as they develop. In a conventional story, characters are often understood or measured by the degree to which they change and learn from their experiences. Both the changes and a character's reaction to them determine much about the character and the narrative as a whole. We follow characters through this process of **character development**, which is shown in the patterns through which characters in a film move from one

7.21 *Creed* (2015). With a familiar plot about an underdog boxer, this new take on the *Rocky* series (1976–2015) engages the viewer through character development.

mental, physical, or social state to another. In Hitchcock's *Rear Window* (1954), the beautiful Lisa changes from a seemingly passive socialite to an active detective under the stress of investigating a murder mystery. In *Juno* (2007), the drama of a bright, sardonic sixteen-year-old's newly discovered pregnancy becomes less about a social or moral crisis in the community and more about her own self-discovery of the meaning of love, family, and friendship. The out-of-wedlock son of champion boxer Apollo Creed, Donnie Johnson, trains with and becomes a key support for his father's former rival Rocky Balboa, making a legacy for himself even as he is persuaded to take on his father's name **[Figure 7.21]**.

Character development follows four general schemes—external and internal changes and progressive and regressive development.

External Change. External change is typically a physical alteration, as when we watch a character grow taller or gray with age. Commonly overlooked as merely a realistic description of a character's growth, exterior change can signal other key changes in the meaning of a character. Similar to the female protagonist in *Pygmalion* (1938) and *My Fair Lady* (1964), the main character in *The Devil Wears Prada* (2006), Andy, is a naive recent college graduate who struggles with her first job at a fashion magazine, and her personal and social growth and maturation can be measured by her increasingly fashionable outfits.

Internal Change. Internal change measures the character's internal transformation, such as when a character slowly becomes bitter after experiencing numerous hardships or becomes less materially ambitious after gaining more of a spiritual sense of the world. In *Mildred Pierce* (1945), there is minimal external change in the appearance of the main character besides her costumes, but her consciousness about her identity dramatically changes—from a submissive housewife, to a bold businesswoman, and finally to a confused, if not contrite, socialite.

Progressive and Regressive Development. As part of these external and internal developments, progressive character development occurs with an improvement or advancement in some quality of the character. Regressive character development indicates a loss of or return to some previous state or a deterioration from the present state. For most viewers of *The Devil Wears Prada*, Andy grows into a more complex and more admirable woman. Mildred Pierce's path resembles for many a return to her originally submissive role.

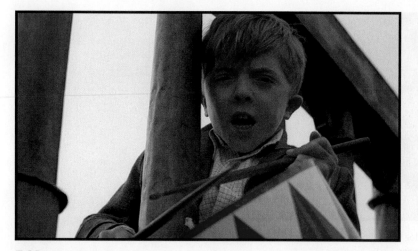

7.22 *The Tin Drum* (1979). Oskar's arrested character development is a symptom of the new Nazi society.

Using these four schemes to understand character development can be a complex and sometimes even contradictory process. Some characters may seem to progress materially but regress spiritually, for instance. Other characters may not develop at all or may resist development throughout a film. Character development is frequently symptomatic of the larger society in which characters live. When the boy Oskar in Volker Schlöndorff's *The Tin Drum* (1979) suddenly refuses to grow at all, his distorted physical and mental development reflects the new Nazi society that then was developing in Germany **[Figure 7.22]**.

Diegetic and Nondiegetic Elements

Most narratives involve two kinds of materials—those related to the story and those not related to the story. The film's **diegesis** is the world of the film's story (its characters, places, and events), including what is shown and what is implied to have taken place. The diegesis of Steven Spielberg's *Lincoln* (2012) includes characters and events explicitly revealed in the narrative, such as Abraham Lincoln's negotiations with lawmakers to pass an antislavery bill. However, the film's diegesis also includes viewers' knowledge of other unseen figures and events from American history, including the final battles of the Civil War and Lincoln's impending assassination. The extent to which we find the film realistic or convincing, creative or manipulative, depends on our recognition of the richness and coherence of the diegetic world surrounding the story.

The notion of diegesis is critical to our understanding of film narrative because it forces us to consider those elements of the story that the narration chooses to include or not include in the plot—and to consider *why* these elements are included or excluded. Despite the similarity of information in a plot and a story, plot selection and omission describe the exchange by which plot constructs and shapes a story from its diegesis. Consider a film about social unrest and revolution in Russia at the beginning of the twentieth century. Because the diegesis of that event includes a number of events and many characters, what should be selected, and what should be omitted? Faced with this question for his film on the 1905 revolution, Sergei Eisenstein reduced the diegesis to a single uprising on a battleship near the Odessa steps and called the film *Battleship Potemkin* (1925).

Information in the narrative can be nondiegetic. A **nondiegetic insert** is an insert that depicts an action, an object, or a title originating outside of the space and time of the narrative world. It includes material used to tell the story that does not relate to the diegesis and its world, such as background music and credits. These dimensions of a narrative indirectly add to a story and affect how viewers participate in or understand it. With silent films, nondiegetic information is sometimes part of the intertitles—those frames that usually print the dialogue of the characters but occasionally comment on the action—as when D. W. Griffith inserts a line from Walt Whitman ("Out of the cradle endlessly rocking") into his complex narrative *Intolerance* (1916).

Diegetic soundtracks include sound sources that can be located in the story, whereas nondiegetic soundtracks are commonly musical scores or other arrangements of noise and sound whose source is not found in the story. Most moviegoers are familiar with the ominously thumping soundtrack of *Jaws* (1975) that

VIEWING CUE

Describe the diegesis of the film you just watched in class. Which events are excluded or merely implied when that diegesis becomes presented as a narrative?

announces the unseen presence of the great white shark. In this way, the story punctuates its development to quicken our attention and create suspenseful anticipation of the next event [Figure 7.23].

Credits—a list at the end of a film of all the personnel involved in a film production, including cast, crew, and executives—are another nondiegetic element of the narrative. Sometimes seen at the beginning and sometimes at the end of a movie, credits introduce the actors, producers, technicians, and other individuals who have worked on the film. Hollywood movies today open with the names of famous stars, the director, and the producers, and their closing credits identify

7.23 *Jaws* (1975). In the opening sequence, Chrissie goes swimming during a late-night beach party. At first, all is tranquil, but the ominous thumping in the soundtrack foreshadows her violent death. This sound is used throughout the film to signal the presence of the shark.

the secondary players and technicians. How this information is presented, especially in the opening credits, can suggest ways of looking at the story and its themes. In *Se7en* (1995), for instance, the celebrated opening credits graphically anticipate a dark story about the efforts of two detectives to track down a diabolical serial killer. Filmed in a suitably grainy and fragmented style and set to the sounds of a pulsating industrial soundtrack, the opening credits depict the obsessive mind of a maniac as he crafts morbid scrapbooks, providing both atmosphere and expository narrative information [Figure 7.24].

VIEWING CUE

As you view the next film, identify the most important nondiegetic materials, and analyze how they might emphasize certain key themes or ideas.

Narrative Patterns of Time

Narrative films have experimented with new ways of telling stories since around 1900, the beginning of movie history. One of the first such films, Edwin S. Porter's *The Great Train Robbery* (1903), manipulated time and place by shifting from one action to another and coordinated different spaces by jumping between exterior and interior scenes. Since then, movie narratives have contracted and expanded times and places according to ever-varying patterns and well-established formulas, spanning centuries and traveling the world in *Cloud Atlas* (2012) or confining the tale to two hours in one town in Agnès Varda's *Cléo from 5 to 7* (1962). For more than a hundred years and through different cultures

7.24 *Se7en* (1995). The presentation of the credits in a film can suggest ways for viewing its story and its unfolding themes.

around the world, the art of storytelling on film has been developed and altered by intricate temporal organizations and spatial shapes that respond to changing cultural and historical pressures.

Linear Chronology

A narrative can be organized according to a variety of temporal patterns. Individuals and societies create patterns of time as ways of measuring and valuing experience. Repeating holidays once a year, marking births and deaths with symbolic rituals, and rewarding work for time invested are some of the ways we organize and value time. Similarly, narrative films develop a variety of temporal patterns as a way of creating meaning and value in the stories and experiences they recount.

Most commonly, plots follow a **linear chronology** – the arrangement of plot events and actions that follow each other in time. The logic and direction of the plot commonly follow a central character's motivation – that is, the ideas or emotions that make that person tick. In these cases, a character pursues an object, a belief, or a goal of some sort, and the events in the plot show how that character's motivating desire affects or creates new situations or actions. Put simply, past actions generate present situations, and decisions made in the present create future events. The narrative of *Little Miss Sunshine* (2006) has a linear structure. A family of offbeat and dysfunctional characters travels from New Mexico to California to participate in a beauty pageant, and on their drive toward this single goal, over the course of several days, they must overcome many sometimes hilarious predicaments, obstacles, and personalities in order to complete their narrative journey and ultimately discover themselves anew. Although journeys are obvious examples of linear plots, many film genres rely on this chronology. In a romantic comedy like *Trainwreck* (2015), the bad behavior of the heroine and the mistrust of her love interest lead to complications and misunderstandings, but these only delay the obvious resolution of the couple getting together **[Figure 7.25]**.

Linear narratives most commonly structure their stories in terms of beginnings, middles, and ends. As a product of this structure, the relationship between the narrative opening and closing is central to the temporal logic of a plot. How a movie begins and ends and what relationship exists between those two poles explain much about a film. Sometimes this relation can create a sense of closure or completion, as happens when a romance ends with a couple united or with a journey finally concluded. Other plots provide less certain relations between openings and closings.

7.25 *Trainwreck* (2015). The poor choices of Amy Schumer's character may seem to lead away from the desired goal but ultimately prove that the romantic pair are right for each other.

text continued on page 264 ▶

7.26a

7.26b

7.26c

7.26d

FORM IN ACTION

Nondiegetic Images and Narrative

Most moviegoers attend to the diegetic world of a film narrative—its characters, its story, and the world the characters inhabit. Punctuating, surrounding, and sometimes intruding on that diegetic world, however, are often important and illuminating nondiegetic actions and images.

During the silent era, films relied heavily on nondiegetic intertitles to describe actions in the story, provide the characters' dialogue, and add a perspective outside the narrative. An intertitle in D. W. Griffith's *Intolerance* (1916) offers a powerful poetic metaphor from a Walt Whitman poem about the course of human history [Figure 7.26a].

Although intertitles are no longer commonly used, opening credit sequences are still a typical nondiegetic element in narrative films. As the first images seen by audiences, they frequently anticipate some of the main themes of a film without actually using images from the story itself. The opening credits of *Vertigo* (1958) begin with Saul Bass's powerful close-up of an eye containing a vertiginous spiral—an abstract pattern that resurfaces in various iterations throughout the credits and the diegesis [Figure 7.26b], anticipating the complex themes of human vision trapped within the spirals of desire and fear in the film.

Closing credits offer other nondiegetic possibilities in a narrative film, including comic outtakes, bloopers, or images of the real people on whom fictional narratives are based. In *School of Rock* (2003), the end credits start to roll over a sequence depicting the characters playing in an after-school rock band [Figure 7.26c]. One of the kids acknowledges the shift from diegetic to nondiegetic with the lyric "The movie is over, but we're still on screen," riffing on the inclusivity of the creative process.

Another way in which modern films challenge and break open the closed fictional world of narrative diegesis is by "breaking the fourth wall"—directly addressing an audience outside the walls of the diegesis. In *Ferris Bueller's Day Off* (1986), the always inventive and troublesome Ferris turns to the audience to detail his strategies for scamming parents [Figure 7.26d].

FORM IN ACTION

LaunchPad Solo

To watch a video about the use of nondiegetic images, see the *Film Experience* LaunchPad.

7.27 ***Life of Pi*** (2012). In Ang Lee's magical film, the protagonist's fantastic adventure concludes with a dramatic ambiguity.

In Ang Lee's *Life of Pi* (2012), Pi Patel's story begins with his childhood in a zoo and a dramatic shipwreck that leaves him drifting the seas in a lifeboat with a zebra, an orangutan, a hyena, and a male Bengal tiger nicknamed Richard Parker. At the conclusion, the reality of what actually happened (and what was fantasy) is brought into question **[Figure 7.27]**.

Plot Chronologies: Flashback and Flashforward

Despite the dominance of linear chronologies in movie narratives, many films deviate, to some extent, to create different perspectives on events. Such deviations may lead viewers toward an understanding of what is or is not important in a story or disrupt or challenge notions of the film as a realistic re-creation of events. Plot order describes how events and actions are arranged in relation to each other. Actions may appear out of chronological order, as when a later event precedes an earlier one in the plot.

One of the most common nonlinear plot devices is the narrative flashback, whereby a story shifts dramatically to an earlier time in the story. When a flashback describes the whole story, it creates a retrospective plot that tells of past events from the perspective of the present or future. In *The Godfather: Part II* (1974), the modern story of mobster Michael Corleone periodically alternates with the flashback story of his father, Vito, many decades earlier. This comparison of two different histories draws parallels and suggests differences between the father's formation of his Mafia family and the son's later destruction of that family in the name of the Mafia business **[Figures 7.28a and 7.28b]**.

Conversely but less frequently, a film may employ a narrative flashforward, leaping ahead of the normal cause-and-effect order to a future incident. A film narrative may show a man in an office and then flash forward to his plane leaving an airport before returning to the moment in the plot when he sits at his desk. In *They Shoot Horses, Don't They?* (1969), the plot flashes forward to a time when Robert,

(a) (b)

7.28a and 7.28b ***The Godfather: Part II*** (1974). A retrospective plot of a father's formation of his Mafia family is woven into a contemporary tale of the son's later destruction of it.

an unsuccessful Hollywood director during the Depression, is on trial. The unexplained scene creates a mysterious suspense that is not resolved until much later in the film.

Other nonlinear chronological orders might interweave past, present, and future events in less predictable or logical patterns. In *Eternal Sunshine of the Spotless Mind* (2004), the two main characters, Joel and Clementine, struggle to resurrect a romantic past that has been intentionally erased from their memories. The flashbacks here appear not as natural remembrances but as dramatic struggles to re-create a part of the personal narrative they have lost [**Figure 7.29**]. *Hiroshima mon amour* (1959) mixes documentary photos of the nuclear destruction of Hiroshima at the end of World War II, a modern story of a love affair between a French actress and a Japanese architect, and flashback images of the woman growing up in France during the war, when she had a relationship with a German soldier [**Figure 7.30**]. Gradually, and not in chronological order, the story of her past is revealed. Conversations with her lover and images of Japan during World War II seem to provoke leaps in her memory. As the film narrative follows these flashbacks, we become involved in the difficulty of memory as it attempts to reconstruct an identity across a historical trauma. When a narrative violates linear chronology in these ways, the film may be demonstrating how subjective memories interact with the real world. At other times, as with *Hiroshima mon amour*, these violations may be ways of questioning the very notion of linear progress in life and civilization.

The Deadline Structure

One of the most common temporal schemes in narrative films is the **deadline structure** – a narrative structured around a central event or action that must be accomplished by a certain time. This structure adds to the tension and excitement of a plot by accelerating the action toward that certain moment, hour, day, or year. These narrative rhythms can create suspense and anticipation that define the entire narrative and the characters who motivate it. In *The Graduate* (1967), Benjamin must race to the church in time to declare his love for Elaine and stop her from marrying his rival. In the German film *Run Lola Run* (1998), Lola has twenty minutes to find 100,000 deutsche marks to save her boyfriend. This tight deadline results in three different versions of the same race across town

7.29 *Eternal Sunshine of the Spotless Mind* (2004). The film's chronology attempts to recover what has been lost from the couple's story.

7.30 *Hiroshima mon amour* (1959). The nonlinear mix of past and present engages us in the main character's attempt to reconstruct an identity across a historical trauma.

VIEWING CUE

LaunchPad Solo

How is time shaped in this clip from *Shutter Island* (2010)? What especially important elements of narrative's time scheme can you point to?

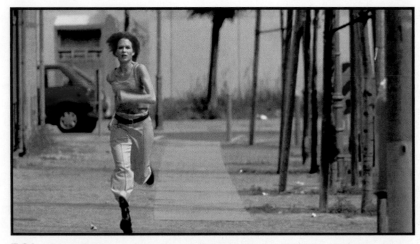

7.31 ***Run Lola Run*** (1998). In three different versions of the same race against time, Lola is forced to make different choices.

7.32 ***Ocean's Eleven*** (2001). The weaving together of the plot to rob a casino and a love story creates thematic and formal connections.

in which, like a game, Lola's rapid-fire choices result in three different conclusions **[Figure 7.31]**.

Parallel Plots

The deadline structure points to another common temporal pattern in film narrative—the doubled or parallel plotline. In parallel plots, there is an implied simultaneity of or connection between two different plotlines, usually with their intersection at one or more points. Many movies alternate between actions or subplots that take place at roughly the same time and that may be bound together in some way, such as by the relationship of two or more characters. One standard formula in a parallel plot is to intertwine a private story with a public story. *Jerry Maguire* (1996) develops the story of Jerry's efforts to succeed as an agent in the cutthroat world of professional sports, and concurrently it follows the ups and downs of his romance with Dorothy, a single mother, and his bond with her son, Ray. In some crime or caper films, such as *Ocean's Eleven* (2001), a murder or heist plot (in this case, involving a complicated casino robbery) parallels and entwines with an equally complicated love story (here between Danny and Tess Ocean) **[Figure 7.32]**. In addition to recognizing parallel plots, we need to consider the relationship between them.

Narrative Duration and Frequency

Movie narratives also rely on various other temporal patterns through which events in a story are constructed according to different time schemes. Not surprisingly, these narrative temporalities overlap with and rely on similar temporal patterns developed as editing strategies. **Narrative duration** refers to the length of time used to present an event or action in a plot. *Die Hard: With a Vengeance* (1995) features a now-standard digital countdown for a bomb that threatens to blow up New York City. The narrative suspense is, in large part, the amount of time the plot spends on this scene, dwelling on the bomb mechanism. The drawn-out time devoted to defusing the bomb, much longer than thirty real seconds, shows how the temporal duration can represent not simply a real but also an extended, in this case psychological, time.

At the other end of the spectrum, a plot may include only a temporal flash of an action that really endures for a much longer period. In *Secretariat* (2010), a rapid montage of images condenses many months of victories during which the renowned racehorse of the title rises to fame. Instead of representing the many details that extend an actual duration of one or more events, the plot condenses these actions into a much shorter temporal sequence. Both examples call attention to the difference between story time and plot time. Story events that take years—such as a

character growing up—may be condensed into a brief montage in a film's plot.

In a linear plot, each event occurs once. But **narrative frequency**—the number of times a plot element is repeated throughout a narrative—can be manipulated as an important storytelling tool. For example, in the narrative of an investigation, a crime may be depicted many times as more pieces of the story are put together.

Narrative Space

Along with narrative patterns of time, plot constructions also involve a variety of spatial schemes constructed through the course of the narrative. These narrative

7.33 Amour (2012). The film takes place in an apartment where the confined space intensifies the residents' memories, experiences, emotions, and decisions.

locations—indoors, outdoors, natural spaces, artificial spaces, outer space—define more than just the background for stories. Stories and their characters explore these spaces, contrast them, conquer them, inhabit them, leave them, build on them, and transform them. As a consequence, both the characters and the stories usually change and develop not only as part of the formal shape of these places but also as part of their cultural and social significance and connotations. Michael Haneke's *Amour* (2012) takes place almost exclusively in the apartment where a couple in their eighties have spent their married life [**Figure 7.33**]. After Anne suffers a stroke, the drama of this single mise-en-scène generates layers and layers of shared emotions and memories as the husband and wife struggle with the climactic crisis they now face. The complex temporality of *Interstellar*'s (2014) science fiction plot—involving wormholes and characters traveling in space who age at different rates than people on earth—is stabilized to some extent by its narrative spaces, which depict vivid planetary environments. A fundamental narrative of betrayal is set on a frozen planet with a toxic atmosphere [**Figure 7.34**].

In conjunction with narrative action and characters, the cultural and social resonances of narrative spaces may be developed in four different ways—historically, ideologically, psychologically, and symbolically. Whether actual or constructed, the **historical location**—the recognized marker of a historical setting that can carry meanings and connotations important to the narrative—abounds in film narratives. For example, in *Roman Holiday* (1953), a character visits the monuments of

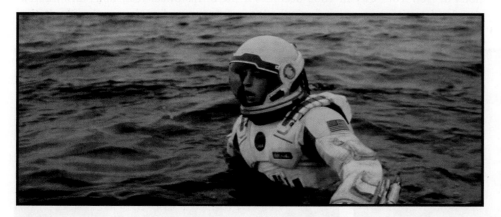

7.34 Interstellar (2014). The temporal abstractions of outer space are countered by human struggles that occur in planetary spaces.

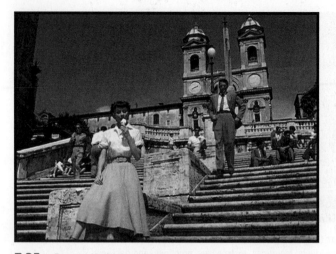

7.35 Roman Holiday (1953). During a character's exploration of Rome, a sense of human history emerges.

7.36 Walk the Line (2005). When Johnny Cash bonds with the inmates, the ideological significance of Folsom State Prison emerges.

Rome, where she discovers a sense of human history and a romantic glory missing from her own life [**Figure 7.35**]. Films from *Ben-Hur* (1925) to *Gladiator* (2000) use the historical connotations of Rome to infuse the narrative with grandeur and wonder.

An **ideological location** is a space or place inscribed with distinctive social values or ideologies in a narrative. Sometimes these narrative spaces have unmistakable political or philosophical significance, such as Folsom State Prison, where Johnny Cash bonds with prisoners in *Walk the Line* (2005) [**Figure 7.36**], or the oppressive grandeur of the czar's palace in Eisenstein's *October* (1927). The politics of gender also can underpin the locations of a film narrative in crucial ideological ways. In *9 to 5* (1980), the plot focuses on the ways that three working women transform the patriarchal office space of their jobs into a place where the needs of women are met [**Figure 7.37**].

Psychological location in a film narrative suggests an important correlation between a character's state of mind and the physical place he or she inhabits in the story. In Sofia Coppola's *Lost in Translation* (2003), an American actor (played by Bill Murray) experiences confusion and communication difficulties while visiting contemporary Tokyo. These, along with his isolation in an expensive hotel, connect to deeper feelings of disaffection and disillusionment with his life back home [**Figure 7.38**]. Less common, **symbolic space** is a space transformed through spiritual or other abstract means related to the narrative. In different versions of the Robinson Crusoe story—from Luis Buñuel's *The Adventures of Robinson Crusoe* (1954) to *Robinson Crusoe on Mars* (1964) and *Cast Away* (2000)—the space of an island might become emblematic of the providential ways of life or of the absurdity of the human condition [**Figure 7.39**].

Complex narratives often develop and transform the significance of one or more locations, making this transformation of specific places central to the meaning of the movie. In Martin Scorsese's *Gangs of New York* (2002), the Five Points neighborhood of New York City in 1863 becomes a site of historical realism as an infamous gangland territory, a psychological place of terror and violence, the ideological

7.37 9 to 5 (1980). Three women transform the gendered politics of office space.

7.38 Lost in Translation (2003). The isolation of an American actor in Tokyo suggests a disaffected psychological space.

7.39 *Cast Away* (2000). The island as symbolic space becomes emblematic of the absurdity of the human condition.

7.40 *Mystery Train* (1989). Japanese tourists, the ghost of Elvis, and bungling drifters transform the space of a run-down Memphis hotel into an offbeat carnival of loss and desire.

location of emerging American social classes, and a symbol of American culture. In Jim Jarmusch's anthology film *Mystery Train* (1989), the narrative interweaves the stories of two Japanese tourists, an Italian woman on her way home to bury her husband, and three drifters who hold up a liquor store **[Figure 7.40]**. All happen to seek refuge in a run-down Memphis hotel. Although they never meet, they infuse the narrative location of the hotel with the meanings of their individual dramas. For the Japanese couple, the hotel becomes a place of historical nostalgia for 1950s America and blues music; for the Italian woman, a comically ritualistic and spiritual location where she eventually meets Elvis Presley's ghost; and for the three drifters, a weird debating hall where they discuss contemporary social violence.

Narrative Perspectives

Plots are organized by the perspectives that inform them. Whether this perspective is explicit or implicit, we refer to this dimension of narrative as **narration** – the telling of a story or description of a situation. It is the emotional, physical, or intellectual perspective through which the characters, events, and action of the plot are conveyed. It shapes how plot materials appear and what is or is not revealed about them. Narration carries and creates attitudes, values, and aims that are central to understanding any movie. A **narrator** is a character or other person whose voice and perspective describe the action of a film, either in voiceover or through a particular point of view. It may be clearly designated in a film by direct address to the viewer. However, the term *narration* is not restricted to a single character or to verbalization within a movie about the plot but also can refer to how movies organize plot elements. The most common narrative perspectives are first-person, omniscient, and restricted. One tactic for drawing us into a story is a narrative frame. Frames and other devices direct the arrangement of the plot and indicate certain cultural, social, or psychological perspectives on the events of the story.

First-Person Narrative and Narrative Frames

Signaled by the pronoun *I* in written or spoken texts, a **first-person narration** in film may be attributed to a single character using voiceover commentary or to camera techniques and optical effects that mark an individual's perspective. However, movie images can usually only approximate a subjective point of view, in which the film frame re-creates what a single character sees for a limited period without appearing contrived. *Lady in the Lake* (1947), filmed from the point of view of detective Philip Marlowe, is a famous instance of cinematic first person and is considered by many to be a failed experiment.

Appearing at the beginning and end of a film, a **narrative frame** designates a context or person positioned outside the principal narrative of a film, such as

VIEWING CUE

LaunchPad Solo

From what point of view is the narration of this clip from *The Royal Tenenbaums* (2001)? If not controlled by an individual, how might the narration reveal certain attitudes about the story's logic?

7.41 *The Ice Storm* (1997). When a storm stops his train, a young man's thoughts on his past become the film's narrative frame.

bracketing scenes in which a character in the story's present begins to relate events of the past and later concludes her or his tale. This kind of narrative frame can help define a film's terms and meaning. Sometimes signaled by a voiceover, this frame may indicate the story's audience, the social context, or the period from which the story is understood. The frame may, for instance, indicate that the story is a tale for children, as in *The Blue Bird* (1940); that it is being told to a detective in a police station, as in *The Usual Suspects* (1995); or that it is the memory of a elderly woman, as in *Titanic* (1997). In each case, the film's frame indicates the crucial perspective and logic that define the narration.

In *Sunset Boulevard* (1950), the presence of the narrator is announced through the voiceover of the screenwriter-protagonist who introduces the setting and circumstances of the story. His voice and death become the frame for the story. Throughout the course of the film, his voiceover disappears and reappears, but we are aware from the start that the story is a product of his perspective.

Ang Lee's *The Ice Storm* (1997) also uses a narrative frame. In this case, the perspective of the frame is that of a young man whose commuter train has stopped en route to his home because of a heavy ice storm [**Figure 7.41**]. The film begins as he waits in the night for the tracks to be cleared of ice and debris and reflects on his family. This isolated moment and compartment frame the flashback that follows. Although he, too, disappears as a narrator until we return to the train and his voice at the end of the movie, his role makes clear that this tale of a dysfunctional family in the 1970s is about this young man at a turning point in his life. Indeed, both these examples suggest a question to ask about narrators: does it make a difference if they are seen as part of the story?

Third-Person Narrative: Omniscient and Restricted

The perspective of a film may adopt **third-person narration**—a narration that assumes an objective and detached stance toward the plot and characters by describing events from outside the story. With third-person narratives like *Gravity* (2013), it still may be possible to describe a specific kind of attitude or point of view. Far from being staid and detached, the organizing perspective of this film is forceful and dynamic, with camera movements that observe the main character's plight [**Figure 7.42**].

7.42 *Gravity* (2013). Although third-person narratives maintain objectivity, they also can create dynamic characters and action.

The standard form of classical movies is **omniscient narration**—narration that presents all elements of the plot, exceeding the perspective of any one character (a version of third-person narration). All elements of the plot are presented from many or all potential angles. An omniscient perspective knows all, knows what is important, and knows how to arrange events to reveal the truth about a life or a history. Although the four films in the *Bourne* series (2002–2016), for example, employ omniscient perspectives that follow Jason Bourne's flight through multiple cities around the world, the story itself contrasts the attempt of a covert American agency's surveillance mechanism to approximate that omniscient perspective in its pursuit of Bourne, while he constantly attempts to escape it.

A limited third-person perspective, or **restricted narration**—a narrative in which our knowledge is limited to that of a particular character—organizes stories by focusing on one or two characters. Even though this perspective on a story also assumes objectivity and is able to present events and characters outside the range of those primary characters, it confines itself largely to the experiences and thoughts of the major characters.

7.43 *The General* (1927). Restricted narration limits the plot to the experiences of the main character, Johnny Gray, as he rescues his locomotive and his girlfriend from the Union army during the Civil War.

The historical source of restricted narration is the novel and short story. Its emphasis on one or two individuals reflects a relatively modern view of the world that is concerned mostly with the progress of individuals. Limiting the narration in this way allows the movie to attend to large historical events and actions (battles or family meetings, for instance) while also prioritizing the main character's problems and desires. Buster Keaton's *The General* (1927), set in Georgia and Tennessee during the Civil War, follows this pattern. Johnny Gray's ingenuity becomes apparent and seems much more honorable, and funny, than the grand epic of war that stays in the background of the narrative **[Figure 7.43]**. With these and other restricted narratives, some characters receive more or less attention from the limited narrative point of view.

Reflexive, Unreliable, and Multiple Narration

Omniscient narration and restricted narration are the most common kinds of classical narration, but some films use variations on these models. **Reflexive narration** is a mode of narration that calls attention to the narrative point of view of the story in order to complicate or subvert the movie's narrative authority as an objective perspective on the world. Robert Wiene's *The Cabinet of Dr. Caligari* (1920) is a well-known early example of reflexive narration that fractures the veracity and reliability of its point of view when, at the film's conclusion, we discover that the narrator is a madman. In *About a Boy* (2002), the main character often comments reflexively on his own behavior as he pretends to be a father in order to meet women.

Contemporary and experimental films commonly question the very process of narration at the same time that they construct the narrative. **Unreliable narration** is a type of narration that raises questions about the truth of the story being told (it is sometimes called *manipulative narration*). In *Fight Club* (1999), the bottom falls out of the narration when, toward the conclusion of the film, it becomes clear that the first-person narrator has been hallucinating

text continued on page 274 ▶

7.48 *Fight Club* (1999). This is a dramatic example of a film whose narration suddenly appears to be the questionable fantasy of the film's narrator.

7.49 *Babel* (2006). Overlapping multiple narratives are woven together in a film about the search for a common humanity.

![icon] **VIEWING CUE**

What narrative perspective features most prominently in the film you just viewed? If the narration is omniscient or restricted, how does it determine the meaning of the story?

the entire existence of a central character around whom the plot develops **[Figure 7.48]**.

Multiple narrations are found in films that use several different narrative perspectives for a single story or for different stories in a movie that loosely fits these perspectives together. The 1916 movie *Intolerance* weaves four stories about prejudice and hate from different historical periods ("the modern story," "the Judean story," "the French story," and "the Babylonian story") and could be considered a precursor to the tradition of multiple narration. Woody Allen's comedy *Zelig* (1983) parodies the objectivity proposed by many narratives by presenting the life of Leonard Zelig in the 1920s and 1930s through the onscreen narrations of numerous fictional and real persons (such as Saul Bellow and Susan Sontag). Contemporary films like *Crash* (2004) and *Babel* (2006) weave together different stories from around a city or even the world, coincidentally linked by major events in the characters' lives **[Figure 7.49]**.

Compilation films (also called **anthology films**) are films comprised of various segments, often by different filmmakers—such as *Germany in Autumn* (1978), *Two Evil Eyes* (1990), *Four Rooms* (1995), and *Paris, je t'aime* (2006). They are more extreme versions of multiple narratives. Although the stories may share a common theme or issue—a political crisis in Germany, adaptations of Edgar Allan Poe stories, or zany guests staying in a decaying hotel—they intentionally replace a singular narrative perspective with smaller narratives that establish their own distinctive perspectives.

Making Sense of Film Narrative

In their reflections of time, change, and loss, film narratives engage viewers in ways that make time meaningful. From historical epics like *The Birth of a Nation* (1915) to the less plot-driven drama of teenage life on the run *American Honey* (2016), narrative movies have been prized as both public and private histories—as records of celebrated events, personal memories, and daily routines. Film, video, and computer narratives today saturate our lives with flashes of insight or events repeated again and again from different angles and at different speeds. Film narratives are thus significant for two reasons: they describe the different temporal experiences of individuals, and they reflect and reveal the shapes and patterns of larger social histories of nations, communities, and cultures.

The significance of film narrative never functions independently of histori-cal, cultural, and industrial issues. Many narratives in Western cultures are more inward, centering on individuals, their fates, and their self-knowledge. Individual heroes are frequently male, with female characters participating in their quest or growth primarily through marriage—a pervasive form of narrative resolution.

Moreover, Western narrative models, such as the Judeo-Christian one that assumes a progressive movement from a fall to redemption, reflect a basic cultural belief in individual and social development. Certainly, cultural alternatives to this popular logic of progression and forward movement exist, and in some cultures individual characters may be less central to the story than the give-and-take move-ments of the community or the passing of the seasons. In *Xala* (1975), for instance, by Senegalese filmmaker Ousmane Sembène, the narration is influenced by oral tradition, and the central character's plight—he has been placed under a curse of impotence—is linked to a whole community. This tradition is associated with the griot, the storyteller in some West African cultures who recounts at public gather-ings the many tales that bind the community together.

Shaping Memory, Making History

Film narratives shape memory by describing individual temporal experiences. In other words, they commonly portray the changes in a day, a year, or the life of a character or community. These narratives are not necessarily actual real-time experiences, as is partly the case in the single-shot film *Russian Ark* (2002). How-ever, they do aim to approximate the patterns through which different individuals experience and shape time—time as endurance, time as growth, time as loss. In *Lee Daniels' The Butler* (2013), the narrative describes the life of Cecil Gaines, the butler for eight U.S. presidents, and intertwines his personal struggles and achievements as a White House servant and the major historical events surrounding him, such as the civil rights movement and the Vietnam War. The often strained interac-tions between his personal experiences and public events celebrate how individual memory participates in the shape of history. In the virtually dialogue-free Italian film *Le Quattro Volte* (*The Four Times*) (2010), time is refracted in four episodes showing interrelated cycles of human, plant, and animal life **[Figure 7.50]**.

Through their reflections on and revelations of social history, film narratives make history. Narratives order the various dimensions of time—past, present, and future events—in ways that are similar to models of history used by nations or other communities. Consequently, narratives create public percep-tions of and ways of understand-ing those histories. The extent to which narratives and public histories are bound together can be seen by noting how many his-torical events—such as the U.S. civil rights movement or the first landing on the moon—become the subject for narrative films. But narrative films also can reveal public history in smaller events, where personal crisis or success becomes representative of a larger national or world history. The tale of a heroic African Ameri-can Union army regiment, *Glory*

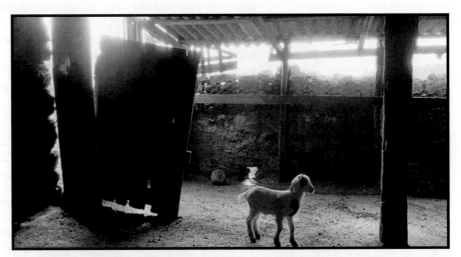

7.50 *Le Quattro Volte (The Four Times)* (2010). One narrative told in this contemplative and often funny film is shaped by the observations of a baby goat.

7.51 *Glory* (1989). A narrative of the heroic African American Union army regiment that fought during the Civil War tells a different history of that war.

(1989) **[Figure 7.51]** tells a history of the Civil War left out of narratives like *The Birth of a Nation* (1915) and *Gone with the Wind* (1939). By concentrating on the personal life of Mark Zuckerberg during his college years, *The Social Network* (2010) also reveals key dimensions of the social networking site Facebook and the cultural history of the digital revolution **[Figure 7.52]**. In these cases, film narratives are about cultural origins, historical losses, and national myths.

Narrative Traditions

Based on how movies can both shape memory and make history, two prominent styles of film narrative have emerged. The classical film narrative usually presents a close relationship between individual lives and social history, whereas the alternative film narrative often dramatizes the disjunction between how individuals live their lives according to personal temporal patterns and how those patterns conflict with those of the social history that intersects with their lives.

VIEWING CUE

For the film you will watch next in class, what type of history is being depicted? What does the narrative say about the meaning of time and change in the lives of the characters? What events are presented as most important, and why?

Classical Film Narrative

Three primary features characterize the classical film narrative:

- It centers on one or more central characters who propel the plot with a cause-and-effect logic, whereby an action generates a reaction.
- Its plots develop with linear chronologies directed at certain goals, even when flashbacks are integrated into that linearity.
- It employs an omniscient or a restricted narration that suggests some degree of realism.

Classical narrative often appears as a three-part structure: (1) a situation or circumstance is presented; (2) the situation is disrupted, often with a crisis or confrontation; and (3) the disruption is resolved. Its narrative point of view is usually objective and realistic, including most information necessary to understand the characters and their world.

Since the 1910s, most U.S. films have followed the **classical Hollywood narrative**—the dominant form of classical film narrative associated with the Hollywood studio system from the end of the 1910s to the end of the 1950s—but there have been many historical and cultural variations on this narrative model. Both the 1925 and 1959 films of *Ben-Hur* develop their plots around the heroic motivations of the title character and follow his struggles and triumphs as a former citizen who becomes a slave, rebel, and gladiator, fighting against the cruelties of the Roman empire. Both movies spent great amounts of money on large casts of characters and on details and locations that attempt to seem as realistic as possible. Yet even if both these Hollywood films can be classified as classical

7.52 *The Social Network* (2010). Here the personal history of the founder of Facebook reflects a much broader transformation in the social history of technology.

narratives, they also can be distinguished by their variations on this narrative formula. Besides some differences in the details of the story, the first version attends more to grand spectacles (such as sea battles) and places greater emphasis on the plight of the Jews as a social group. The second version concentrates significantly more on the individual drama of Charlton Heston as Ben-Hur, on his search to find his lost family, and on Christian salvation through personal faith [Figure 7.53].

An important variation on the classical narrative tradition is the **postclassical narrative** – the form and content of films after the decline of the Hollywood studio system around 1960, including formerly taboo subject matter and narratives and formal techniques influenced by European cinema. This global body of films began to appear in the decades after World War II and remains visible to the present day. The postclassical model frequently undermines the power of a protagonist to control and drive the narrative forward in a clear direction. As a postclassical narrative, Martin Scorsese's *Taxi Driver* (1976) works with a plot much like that of *The Searchers* (1956), in which an alienated and troubled Civil War veteran searches the frontier for a lost girl, but in Travis Bickle's strange quest to rescue a

7.53 ***Ben-Hur*** (1959). As the different versions of this film demonstrate, classical Hollywood narrative can vary significantly through history—even when the story is fundamentally the same.

7.54 ***Taxi Driver*** (1976). Robert De Niro's character erupts into senseless violence and seems bent on his own destruction, significantly challenging classical narrative codes.

New York City prostitute from her pimp, he wanders with even less direction, identity, and control than his predecessor, Ethan. Bickle, a dark hero, becomes lost in his own fantasies (see the Film in Focus feature on this film in Chapter 2) [Figure 7.54].

Alternative Film Narrative

Foreign and independent films may reveal information or perspectives traditionally excluded from classical narratives in order to unsettle audience expectations, provoke new thinking, or differentiate themselves from more common narrative structures. Generally, the **alternative film narrative** deviates from or challenges the linearity of classical film narrative, often undermining the centrality of the main character, the continuity of the plot, or the verisimilitude of the narration.

Both the predominance and motivational control of characters in moving a plot come into question with alternative films. Instead of the one or two central characters we see in classical narratives, alternative films may put a multitude of characters into play, and their stories may not even be connected. In Jean-Luc Godard's *La Chinoise* (1967), the narrative shifts among three young people – a student, an economist, a philosopher – whose tales appear like a series of debates about politics and revolution in the streets of Paris.

A visually stunning film from Iran, Abbas Kiarostami's *Taste of Cherry* (1997) contains only the shadow of a story and plot: the middle-aged Mr. Badii wishes to commit suicide for no clear reason. After witnessing a series of random encounters and requests, we remain uncertain about his fate at the conclusion. Freed of the determining motivations of classical characters, the plots of alternative film narratives tend

 VIEWING CUE

View the clip of the opening of *Midnight Cowboy* (1969), and consider how it refers to the classical narrative tradition. What features signal that this film is a postclassical narrative?

text continued on page 280 ▶

FILM IN FOCUS

FILM IN FOCUS
LaunchPad Solo

To watch a clip of *Mildred Pierce* (1945) and *Daughters of the Dust* (1991), see the *Film Experience* LaunchPad.

Classical and Alternative Traditions in *Mildred Pierce* (1945) and *Daughters of the Dust* (1991)

See also: *Rebecca* (1940); *All About Eve* (1950); *Jeanne Dielman, 23 Quai du Commerce, 1080 Bruxelles* (1975); *Vagabond* (1985)

Very much a part of the classical movie tradition, the narrative of Michael Curtiz's *Mildred Pierce* (1945) is an extended flashback covering many years—from Mildred's troubled marriage and divorce, to her rise as a self-sufficient and enterprising businesswoman, and finally to her disastrous affair with the playboy Monty. After the opening murder and the accusation of Mildred, the narrative returns to her humble beginnings with two daughters and an irritating husband who soon divorces her. Left on her own, Mildred works determinedly to become a financial success and support her daughters. Despite her material triumphs, her youngest daughter, Kay, dies tragically, and her other daughter, Veda, rejects her and falls in love with Mildred's lover, Monty. The temporal and linear progressions in Mildred's material life are thus ironically offset in the narrative by the loss of her emotional and spiritual life.

In *Mildred Pierce*, we find all three cornerstones of classical film form. The title character, through her need and determination to survive and succeed, drives the main story. The narrative uses a flashback frame that, after the opening murder, proceeds linearly—from Mildred's life as an obsequious housewife and then a wealthy and vivacious socialite to her awareness of her tragic family life. Finally, the restricted narration follows her development as an objective record of those past events.

Set in the 1940s with little mention of World War II, *Mildred Pierce* is not a narrative located explicitly in public history, yet it is a historical tale that visibly embraces a crisis in the public narrative of America. While focused on Mildred's personal confusion, the film delineates a critical period in U.S. history. In the years after World War II, the U.S. nuclear family came under intense pressure as independent women with more freedom and power faced changing social structures. *Mildred Pierce* describes this

7.55 *Mildred Pierce* (1945). Mildred's story reflects a larger national story about gender and labor.

public history in terms of personal experience; but like other classical narratives, the events, people, and logic of Mildred's story reflect a national story in which a new politics of gender must be admitted and then incorporated into a tradition centered on the patriarchal family. *Mildred Pierce* aims directly at the incorporation of the private life (of Mildred) into a patriarchal public history (of the law, the community, and the nation). Mildred presumably recognizes the error of her independence and ambition and, through the guidance of the police, is restored to her former husband, strikingly and perhaps ironically summarized in the final image of the film in which two laboring working women visually counterpoint the reunited couple **[Figure 7.55]**.

As a very different kind of narrative, Julie Dash's *Daughters of the Dust* (1991) recounts a period of a few

7.56 *Daughters of the Dust* (1991). Like this mysterious floating statue that appears and reappears through the film, the narrative drifts between past and present, merging history, memory, and mythology.

7.57 *Daughters of the Dust* (1991). Rather than focus on a single character, the narrative incorporates the perspectives of several Peazant family members.

days in 1902 when members of an African American community prepare to move north from Ibo Landing, an island off the coast of South Carolina. The members of the Peazant family meld into a community whose place in time oscillates between their memories of their African heritage (as a kind of cyclical history) and their anticipation of a future on the U.S. mainland (where time progresses in a linear fashion) **[Figure 7.56]**.

Daughters of the Dust avoids concentrating on the motivations of a single character. Instead, it drifts among the perspectives of many members of the Peazant family—grandmother Nana, Haagar, Viola, Yellow Mary, the troubled married couple Eula and Eli, and even their unborn child.

For many viewers, the difficulty of following this film is related to its nontraditional narrative, which does not move its characters forward in the usual sense but instead depicts individuals who live in a time that seems more about communal rhythms than personal progress, where the distinction between private and public life makes little sense **[Figure 7.57]**.

A fundamental question or problem appears quietly at the beginning of the film: will the Peazant family's move to the U.S. mainland remove them from their roots and African heritage? Yet the film is more about presentation and reflection than about any drama or crisis emerging from that question. Eventually, that question may be answered when some of the characters move to the mainland, where they presumably will be recast in a narrative more like that of *Mildred Pierce*. But for now, in this narrative, they and the film embrace different temporal values.

In *Daughters of the Dust*, the shifting voices and perspectives of the narration have little interest in a unified or objective perspective on events **[Figure 7.58]**. Besides voiceovers by Nana and Eula, the narrative point of view appears through Unborn Child, a mysterious figure who is usually invisible to the other characters and who narrates as the voice of the future. Interweaving different subjective voices and experiences, the film's narration disperses time into the communal space of its island world, an orchestration of nonlinear rhythms. A public history is being mapped in this alternative film, but it is one commonly ignored by most other American narratives and classical films. Especially with its explicit reflections on the slave trade that once passed through Ibo, *Daughters of the Dust* maps a part of African American history perhaps best told through the wandering narrative patterns inherited from the traditions and styles of African storytellers.

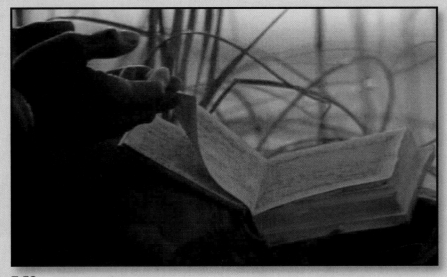

7.58 *Daughters of the Dust* (1991). As a story narrated in many voices, the film resists a unified perspective on events.

7.59 *Rashomon* (1950). Four different narrative perspectives tell a grisly tale that brings into question the possibility of narrative objectivity, especially when recounted by people deeply, and differently, affected by events.

to break apart, omit links in a cause-and-effect logic, or proliferate plotlines well beyond the classical parallel plot.

Many alternative film narratives question, in various ways, the classical narrative assumptions about an objective narrative point of view and about the power of a narrative to reflect universally true experiences. In *Rashomon* (1950), four people, including the ghost of a dead man, recount a tale of robbery, murder, and rape in four different ways, as four different narratives [**Figure 7.59**]. Ultimately, the group that hears these tales (as the frame of the narrative) realizes that it is impossible to know the true story.

By employing one or more of their defining characteristics, alternative film narratives also have fostered more specific cultural variations and traditions, including non-Western narratives and new wave narratives. Alternative, non-Western narratives swerve from classical Western narrative by drawing on indigenous forms of storytelling with culturally distinctive themes, characters, plots, and narrative points of view. Indian filmmaker Satyajit Ray, for example, adapts a famous work of Bengali fiction for his 1955 *Pather Panchali* and its sequels, *Aparajito* (1956) and *The World of Apu* (1959), to render the story of a boy named Apu and his impoverished family. Although Ray was influenced by European filmmakers—he served as assistant to Jean Renoir on *The River* (1951), filmed in India—his work is suffused with the symbols and slow-paced plot of the original novel and of village life, as it rediscovers Indian history from inside India [**Figures 7.60a and 7.60b**].

New wave narratives describe the proliferation of narrative forms that have appeared around the world since the 1950s. Often experimental and disorienting, these narratives interrogate the political assumptions of classical narratives by overturning their formal assumptions. Italian New Wave director Bernardo Bertolucci's *The Conformist* (1970) is an example. It creates a sensually vague

(a)

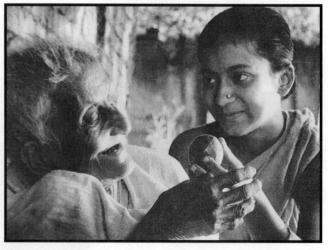

(b)

7.60 Alternative film narratives. (a) Jean Renoir's *The River* (1951) influenced the work of Satyajit Ray, but **(b)** Ray's *Pather Panchali* (1955), an adaptation of a famous Bengali novel, is suffused with the symbols and slow-paced plot that are indicative of the original work and Indian culture.

and dreamy landscape where reality and nightmares overlap. Through the mixed-up motivations of its central character, Marcello Clerici, the film explores the historical roots of Italian fascism, a viciously decadent world of sex and politics rarely depicted in the histories of classical narrative **[Figure 7.61]**.

Both these broad categories draw on many narrative cultures that differ sharply from each other, and both suggest not so much a complete opposition to classical narrative as much as a dialogue with that tradition. In this context, Indian film narratives are very different from African film narratives, and the new waves of Greece and Spain represent divergent issues and narrative strategies. All, however, might be said to confront, in one way or another, the classical narrative paradigm.

7.61 *The Conformist* (1970). In this film by Italian New Wave director Bernardo Bertolucci, the historical roots of Italian fascism are imagined in an alternative narrative set within a dreamy landscape where reality and nightmares overlap.

CONCEPTS AT WORK

From *The Wizard of Oz* to *Daughters of the Dust*, narratives are the heart of our moviegoing experience as we seek out good films with interesting characters, plots, and narrative styles. In these and other films, characters range across a myriad of roles and functions, from coherent characters to collective characters, who can develop in many different and meaningful ways. The narrative perspective of a film may provide an omniscient view of the world or one restricted to the point of view of a single character while a film's narration may organize the diegetic materials of a film according to various plots and patterns of time and space. Although many film narratives follow a classical pattern of linear development and parallel plots, many others deviate from those patterns and explore different ways of constructing a story and of infusing a film narrative with a larger significance. Whereas Dorothy might be a classically coherent character whose linear journey follows the yellow brick road to her home, the characters in *Daughters of the Dust* have a significantly more collective profile whose journey circles backward into their past. In all cases, film narratives allow us to explore and think about how time and history can be shaped as a meaningful experience. Recall a few of these key points and questions as a way to examine a narrative film in class:

- What might be some of the historical practices or foundations that inform this film narrative? Are the narrative innovations related to changes in technology (as in superhero movies) or to changes in social roles (as in *Mildred Pierce*)?
- How does the film construct its plot to arrange the events of a story in a way that creates meaning? Does it follow the linear plot found in many classical narratives from *The General* to *Trainwreck*? Or does it structure its story in a nonlinear fashion as in *Eternal Sunshine of the Spotless Mind*?
- Identify some character types in the film, and explain how they motivate actions in a story. Are they singular and realistic as in *Lincoln* (2012) or more figurative as in the *Pirates of the Caribbean* series?
- In films as different as *Hiroshima mon amour* and *Gravity*, consider the way the plots construct different temporal and spatial schemes and use of patterns of duration and frequency.
- Try to describe the narration or narrative point of view of the film you are discussing and show how it might determine our understanding of a story. Have you seen other films that use a first-person or restricted narration as does *Gone Girl*? How does that narration determine the story?
- Is the film you are examining best described as part of a classical or an alternative narrative tradition? Why?

⧈ LaunchPad Solo

Visit the LaunchPad Solo for *The Film Experience* to view movie clips, read additional Film in Focus pieces, and learn more about your film experiences.

DOCUMENTARY FILMS
Representing the Real

Alex Gibney's 2016 film *Zero Days* is a stunning example of the many critical and pro-
vocative topics and strategies available to documentary cinema. Since John Grierson first
described documentaries in 1926 as "the creative treatment of actuality," this particular
film practice has continually explored those different actualities and realities in new and
imaginative ways. The actuality of *Zero Days* focuses on Stuxnet, a self-perpetuating com-
puter malware worm developed by Israel, the United Kingdom, and the United States and
used to attack the Iranian nuclear centrifuges and disappear without a source. Part sus-
pense thriller, part espionage plot, and part political exposé, the film's montage of politi-
cal and scientific talking heads, elaborate computer graphics, and reenactments make
this documentary resemble a science-fiction film, exploring the new global terrain where
the wars of the twenty-first century will be fought.

For most of us, the film experience is primarily about elements like suspense, humor, or intense emotions. Yet that experience also can include the desire to be better informed about a person or an event, to engage with new and challenging ideas, or to learn more about what happens in other parts of the world. A nonfiction film that presents real objects, people, and events is commonly referred to as a **documentary**. John Grierson first used the term to describe a Robert Flaherty picture called *Moana* (1926) and its "visual account of events in the daily life of a Polynesian youth and his family." Broadly speaking, a documentary film is a visual and auditory representation of the presumed facts, real experiences, and actual events of the world. Documentary films usually employ and emphasize strategies and organizations that differ from those that define narrative cinema, such as plot and narration. Later Flaherty teamed up with German filmmaker F. W. Murnau to integrate the documentary world of *Moana* into the narrative film *Tabu: A Story of the South Seas* (1931) **[Figure 8.1]**, and this hybrid film raises key questions: How are documentary films different from narrative ones? What attracts us to them? How do they organize their material? What makes them popular, useful, and uniquely illuminating?

Narrative films are prominently about memory and the shaping of time, but documentary movies are about insight and learning—expanding what we can know, feel, and see. Narratives can enlarge and intensify the world for us in these ways as well, but because documentary movies do not have the primary task of telling a story, they can concentrate on leading our intellectual activities down new paths—in newsreels, theatrical films, PBS television broadcasts, and specials on cable TV or Internet streaming services. Entertainment and artistry are not excluded from documentary films. In *Searching for Sugar Man* (2012), two South Africans take their cameras and iPhones on a search for Sixto Rodriguez, a Detroit musician from the 1960s and 1970s who, unbeknownst to him, had achieved cult status in South Africa. This investigative quest discovers a lost hero who is presumed dead and returns him to a country where people celebrate him and his music in ways he had never experienced or imagined. Like the filmmakers and Rodriguez himself, we discover new human depths and new cultural geographies **[Figure 8.2]**.

Although narrative films are at the heart of commercial entertainment,

8.1 *Tabu: A Story of the South Seas* (1931). Following the documentary breakthrough of Robert Flaherty's earlier *Moana* (1926), Flaherty and F. W. Murnau's new project combines a tragic love story with documentary images of Polynesian life. Courtesy Everett Collection

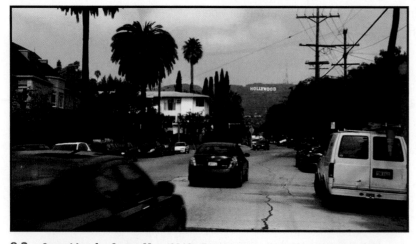

8.2 *Searching for Sugar Man* (2012). Entertainment and artistry intermingle in this quest for a lost reality that binds two cultures.

views of Jerusalem or Niagara Falls. When these early films captured or sometimes re-created historical or newsworthy events, they were referred to as **topicals**, suggesting the kind of cultural, historical, or political relevance usually found in newspapers. Around 1898, for example, the ongoing Spanish-American War figured in a number of topicals, often with battle scenes depicting the sinking in that year of the American ship USS *Maine*, which was re-created through miniatures. These factual and fabricated images of the war attracted large audiences **[Figure 8.5]**.

The 1920s: Robert Flaherty and the Soviet Documentaries

8.5 *The Motion Picture Camera Goes to War* (1898). Many topicals produced between 1898 and 1901 depicted the ongoing Spanish-American War. Library of Congress Motion Picture, Broadcasting and Recorded Sound Division [98500970]

Footage of distant lands continued to interest moviemakers and audiences even after narrative film became the norm around 1910. American adventurers Martin and Osa Johnson documented their travels in Africa and the South Seas in such popular films as *Jungle Adventures* (1921) and *Simba* (1928) **[Figure 8.6]**. But it was Robert Flaherty, often referred to as "the father of documentary cinema," who significantly expanded the powers and popularity of nonfiction film in the 1920s, most famously with his early works *Nanook of the North* (1922) and *Moana* (1926). Blending a romantic fascination with nature and an anthropological desire to document and record other civilizations, Flaherty identified new possibilities for funding these noncommercial films (largely through corporations) and, with the success of *Nanook*, identified new audiences interested in realistic films that were exciting even without stories and stars.

At the same time, a very different kind of documentary was taking shape in Soviet cinema. Filmmakers such as Dziga Vertov and Esfir Shub saw timely political potential in creating documentary films with strong ideological messages conveyed through the formal technique of montage. In *The Fall of the Romanov Dynasty* (1927), Shub compiles and edits existing footage to show the historical conflicts between the aristocracy and the workers. In *Man with a Movie Camera* (1929), which became one of the most renowned "city symphony" documentaries, Vertov re-creates and celebrates the energy of the everyday people and the activities of a modern city.

1930-1945: The Politics and Propaganda of Documentary

Perhaps more so than for other film practices, the introduction of **optical sound recording**—the process that converts sound waves into electrical impulses (which then control how a light beam is projected onto film) and that enables a soundtrack to be recorded alongside the image for simultaneous projection—catapulted documentary films forward in 1927. It made possible the addition of educational or social commentary to accompany images in newsreels, documentaries, and propaganda films. In the 1930s and 1940s, public institutions (such as the General

8.6 *Simba* (1928). Early documentaries took the shape of explorations of new lands and cultures, frequently transforming those worlds into strange and exotic objects. Here American adventurers Martin and Osa Johnson documented their travels in Africa and the South Seas. Courtesy of Milestone Film and Video

(a) **(b)**

8.7 Propaganda films. Films like these—**(a)** *Triumph of the Will* (1935) and **(b)** *Japanese Relocation* (1943)—represent the disturbing propagandistic power of documentaries that are controlled and supported by governments and other institutional agents. Photofest, Inc.

Post Office in England, President Franklin D. Roosevelt's Resettlement Administration, and the National Film Board of Canada) as well as private groups (such as New York City's Film and Photo League) unhesitatingly supported documentary practices. These institutions prefigure the more contemporary supporters of documentary film, including the Public Broadcasting Service (PBS) in the United States, the British Broadcasting Corporation (BBC), and Zweites Deutsches Fernsehen (ZDF) in Germany.

Documentary film history can never really be divorced from these critical sources of funding and distribution. Perhaps the most prominent figure to forge and develop a relationship between documentary filmmakers and those institutions that eventually funded them was British filmmaker John Grierson. From the late 1920s through the 1940s, as the first head of the National Film Board of Canada, Grierson promoted documentaries that dealt with social issues and established the institutional foundations that for years funded and distributed them. Government and institutional support for documentary cinema proceeded in a more troubling direction in the 1930s and 1940s in the form of **propaganda films** — political documentaries that visibly support and intend to sway viewers toward a particular social or political issue or group. Two famous examples are Leni Riefenstahl's *Triumph of the Will* (1935), commemorating the 1934 annual Nazi party rally in Nuremberg, and *Japanese Relocation* (1943), a U.S. film justifying the internment of Japanese Americans on the West Coast [**Figures 8.7a and 8.7b**].

1950s–1970s: New Technologies and the Arrival of Television

In the 1950s, changes in documentary practices followed the technological development of lightweight 16mm cameras, which allowed filmmakers a new kind of spontaneity and inventiveness when capturing reality. Most dramatic was **cinéma vérité** (a French term meaning "cinema truth") — a style of documentary filmmaking first practiced in France in the late 1950s and early 1960s that used unobtrusive, lightweight cameras and sound equipment to capture real-life situations. Documentary filmmakers like Jean Rouch, with films like *Moi un noir* (*I, a Black*) (1958), could now participate more directly and provocatively in the reality they filmed. This new mobile and independent method of documentary filmmaking advanced again in the late 1950s with the development of portable magnetic sync-sound recorders and then again

in 1968 with the introduction of Portapak video equipment. Armed with a lightweight camera and the ability to record direct sound, filmmakers could now document actions and events that previously remained hidden or at a distance. Rouch's later film, *Chronicle of a Summer* (1961), has become a classic example of these new cinéma vérité possibilities, featuring random encounters with people on the streets of Paris, who answer questions and give their opinions on happiness, war, politics, love, and work.

Sometimes referred to as the golden age of television documentary, this period also brought a rapid expansion of documentaries aimed at a new television audience. Merging older documentary traditions with television news reportage, these programs often were noted for their tough honesty and social commitment. The work of television journalist Edward R. Murrow, who critiqued Senator Joseph McCarthy's unfair accusations of treason against people working in government, entertainment, education, and unions, set a new benchmark for news reporting.

8.8 *Primary* (1960). This documentary about John F. Kennedy's presidential campaign took advantage of the mobility and immediacy produced by new camera and sound equipment.

Perhaps the best-known example of the convergence of new technology, a more mobile style, and television reportage is Robert Drew's *Primary*, a 1960 film about the Democratic presidential primary election in Wisconsin between John F. Kennedy and Hubert H. Humphrey **[Figure 8.8]**. This documentary was produced for the series *ABC Close-Up!* (1960–1985) by Drew Associates, the organization that trained many of the documentary filmmakers associated with **direct cinema** — a documentary style originating in the United States in the 1960s that aims to capture unfolding events as unobtrusively as possible.

1980s–Present: Digital Cinema, Cable, and Reality TV

In the 1980s, the consumer video camera was taken up by artists and activists, such as the AIDS collective called Testing the Limits, which used **activist videos** — confrontational political documentaries that use low-cost video equipment — as part of the democratization of the documentary that continued with the rapid shift to digital formats. After the introduction in the late 1980s of Avid's nonlinear digital editing process, which made editing much easier and less expensive, the documentary **shooting ratio** — the relationship between the overall amount or length of film shot and the amount used in the finished project — increased exponentially. This led to the growth of personal documentaries, which eventually achieved theatrical exposure in such films as Morgan Spurlock's quirky tale of his fast-food consumption quest, *Super Size Me* (2004) **[Figure 8.9]**. During this period, changes in the distribution and exhibition of documentaries significantly affected the availability and popularity of these films.

8.9 *Super Size Me* (2004). Morgan Spurlock had regular medical checkups in this personal documentary on fast-food diets and their effects on American obesity.

8.10 *Chimpanzee* (2012). Although relatively few documentaries receive wide national releases, Disney has seen success in recent years with its series of nature films. *Chimpanzee* remains one of the highest-grossing documentaries of recent years.

In addition to increased festival and theatrical exposure and the expanding video rental market, cable and satellite television networks provide more and more opportunities for documentary projects. Under Sheila Nevins, HBO's documentary division has sponsored numerous powerful and acclaimed films, including *Born into Brothels* (2004) and *If God Is Willing and da Creek Don't Rise* (2010). *Planet Earth* (2006), the eleven-part TV nature series coproduced by the BBC and Discovery Channel, garnered awards, critical praise, and wide audiences for its state-of-the-art, high-definition cinematography and conservation message, echoed in a successful series of theatrically released documentaries from the DisneyNature label **[Figure 8.10]**. Although public television and cable networks provide more venues for independently produced documentaries that otherwise may have limited distribution, the relatively low production costs of nonfiction programming have encouraged many channels to fill their schedules with reality television. From *Pawn Stars* (2009–2017) to *Top Chef* (2006–2017), these formats feature real people in situations that blur the lines between actual events, theatrical performances, and reenactments **[Figures 8.11a and 8.11b]**.

(a) (b)

8.11 **Reality television shows.** Two examples of reality television shows—**(a)** *Pawn Stars* (2009–2017) and **(b)** *Top Chef* (2006–2017)—blur the boundaries between what is real and what is performed. Courtesy Everett Collection, Inc.

The Elements of Documentary Films

The documentary film shares elements of cinematic form with narrative and experimental films, but it organizes its material, constitutes its authority, and engages the audience in a distinct fashion. The following section outlines the modes of discourse, organizational patterns, and methods of presenting a point of view typical of the documentary film.

Nonfiction and Non-Narrative

Two cornerstones of documentary films—nonfiction and non-narrative—are key concepts that are often debated. Although documentary films and experimental films (see Chapter 9) can be described as non-narrative, nonfiction has primarily been associated with documentary films. **Nonfiction films**—films presenting factual descriptions of actual events, persons, or places rather than their fictional or invented re-creation. Attempts to make a hard-and-fast distinction between "factual descriptions" and "fictional re-creations" have provoked heated debates throughout film history because facts are arguably malleable. Nonetheless, a fundamental distinction can be made between, say, a PBS documentary about the life of Elizabeth II of the United Kingdom and Stephen Frears's feature film *The Queen* (2006) about the same person. The first film uses the accounts of journalists, news media, and historians to show the facts and complex issues in the life of one of the great women of history. The second film uses some of the same information about the same woman but focuses on events immediately following the death of Princess Diana and the queen's relationship with Prime Minister Tony Blair in order to re-create a dramatic and entertaining episode in her life.

Nonfiction can be used in a variety of creative ways. In *Going Clear: Scientology and the Prison of Belief* (2015), Alex Gibney pursues a nonfictional, behind-the-scenes investigation of the scientology movement as it attracts, manipulates, and often threatens individuals ranging from movie stars to Internal Revenue Service agents **[Figure 8.12]**. In contrast, in *Of Great Events and Ordinary People* (1979), Raoul Ruiz turns an assignment to conduct nonfictional interviews in a Paris neighborhood into a complex and humorous reflection on the impossibility of revealing any truth or honesty through the interview process.

Non-narrative films—films organized in a variety of ways besides storytelling—eschew or deemphasize stories and narratives and instead employ other forms (like lists, repetition, or contrasts) as their organizational structure. For example, a non-narrative film might create a visual list (of objects found in an old house, for instance), repeat a single image as an organizing pattern (returning to an ancient carving on the front door of the house), or alternate between objects in a way that suggests fundamental differences (contrasting the rooms, clothing, and tools used by the men and the women in a house).

A non-narrative movie may embed stories within its organization, but those stories usually become secondary to the

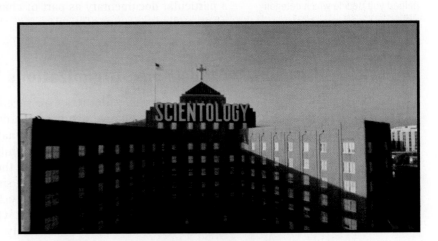

8.12 *Going Clear: Scientology and the Prison of Belief* (2015). This film, from the prolific Alex Gibney, is a nonfiction investigation of the scientology movement, which has attracted a number of prominent actors and other celebrities.

8.13 *Koyaanisqatsi* (1983). A non-narrative catalog of images contrasts America's beauty and decay.

non-narrative pattern. In *Koyaanisqatsi* (1983), slow-motion and time-lapse photography capture the open vistas of an American landscape and their destruction—pristine fields and mountains, rusty towns, and garbage-strewn highways—set against the drifting tones of Philip Glass's music [**Figure 8.13**]. Through these images, one may detect traces of a story about the collapse of America in what the Hopi Indian title declares is "a life out of balance," but that simple and vague narrative is not nearly as powerful as the emotional force of the film's accumulating visual repetitions and contrasts. Diane Keaton's *Heaven* (1987) intersperses clips from old movies with angels and other images of heaven and presents a litany of faces and voices to answer such questions as "Does heaven exist?" and "Is there sex in heaven?" Although we may sense a religious mystery tale behind these questions and answers, this movie is better understood as a playful list of unpredictable reactions to the possibility of a life hereafter.

Nonfiction and non-narrative approaches suggest distinctive ways of seeing the world. Although they often overlap in documentary films, one form of presentation does not necessarily imply the other. A non-narrative film may be entirely or partly fictional; conversely, a nonfiction film can be constructed as a narrative. Complicating these distinctions is the fact that both kinds of practices can become less a function of the intentions of the film than of viewers' perception. What may seem nonfictional or non-narrative in one context may not seem so in another. For example, audiences in the 1920s mostly assumed that *Nanook of the North* (1922) was a nonfictional account of an Inuit tribesman and his family. Now, most viewers recognize that some of the central events and actions were fabricated for the documentary. Similarly, for some viewers, *The Cove* (2009) is a non-narrative exposé of the capture and slaughter of dolphins by Japanese fishermen, while for others it is a dramatic narrative about a group of activists on a rescue mission. The different meanings of nonfiction and non-narrative can shift historically and perceptually, however, which makes the categories useful in judging the strategies of a particular documentary as part of changing cultural contexts and as a reflection of an audience's point of view.

VIEWING CUE

Is the film you have just seen in class best described as nonfiction or non-narrative? What elements helped you decide which categorization was more appropriate?

Expositions: Organizations That Show or Describe

Although narrative film relies on specific patterns to shape the material realities of life into imaginative histories, the documentary employs strategies and forms that resemble scientific and educational methods. For example, the 2015 feature film *The Walk* is a narrative about Phillippe Petit, a French high-wire artist who in 1974 walked between the tops of the two World Trade Center buildings on a thin wire. Replete with chronological suspense, intrigue, special effects, and even romance, this narrative moves crisply forward to culminate in a heroic conclusion, cheered on by the New Yorkers who watch the walk [**Figure 8.14**]. The 2008 documentary *Man on Wire*, conversely, develops in a nonlinear fashion, presents actual footage of the walk, has Petit himself explain much of his planning, interjects commentary by other participants in the event, and inserts home movies of his training.

8.14 **The Walk** (2015). This narrative feature film tells the same story as the 2008 documentary *Man on Wire*, with cutting edge 3-D cinematography in place of *Man on Wire*'s actual footage.

The formal expositional strategies used in documentary movies are known as "documentary organizations." These organizations show or describe experiences in a way that differs from narrative films—that is, without the temporal logic of narrative and without a presiding focus on how a central character motivates and moves events forward. Traditional documentaries tend to observe the facts of life from a distance and organize their observations as objectively as possible to suggest some definition of the subject through the exposition itself.

Here we discuss three distinctive organizations of documentary films—cumulative, contrastive, and developmental. These organizations may appear in different films or may be used in some combination in the same film. Then we explore how the use of these organizational patterns is often governed by the perspective—or rhetorical position—from which a film's observations are made.

8.15 **Rain** (1929). The accumulation of images of different kinds of rain showers gradually creates a poetic documentary of various shapes and textures.

Cumulative Organizations

Cumulative organizations present a catalog of images or sounds throughout the course of the film. It may be a simple series with no recognizable logic connecting the images. Joris Ivens's *Rain* (1929) presents images from a rainstorm in Amsterdam, showing the rain falling in a multitude of different ways and from many different angles **[Figure 8.15]**. We do not sense that we are watching this downpour from beginning to end but instead see this rain as the accumulation of its seemingly infinite variety of shapes, movements, and textures. Another example of cumulative organization is *Thirty-two Short Films About Glenn Gould* (1993). Although some viewers may expect a biography of the renowned pianist Gould, the film intentionally fragments his life into numerical episodes focused on his playing, on his acquaintances discussing him, and on reenactments of moments in his life **[Figure 8.16]**.

8.16 **Thirty-two Short Films About Glenn Gould** (1993). As an expositional organization, the film offers a glimpse into the life of the notoriously elusive genius through snippets of performance footage intermixed with reenactments of moments in his life. Telefilm Canada/REX/Shutterstock

FILM IN FOCUS

FILM IN FOCUS

LaunchPad Solo

To watch a video about *Man of Aran* (1934), see the *Film Experience* LaunchPad.

Nonfiction and Non-Narrative in *Man of Aran* (1934)

See also: *Nanook of the North* (1922); *Sunless* (1982); *Atanarjuat: The Fast Runner* (2001)

Robert Flaherty's documentary film *Man of Aran* (1934) is an early, incisive example of how films employ, albeit in different ways, both nonfictional and non-narrative practices. *Man of Aran*, a documentary about a small community living on an island off the coast of western Ireland, does not identify the characters or explain their motivations. Instead, it lists and describes the activities that make up their daily lives and records the hardships of living on a barren, isolated island. The members of this seemingly primitive community cart soil to grow potatoes on their rocky plots and struggle against the ferocious sea to fish and survive. The film is a historical and cultural record: it documents the routines of the residents' existence without the drama of a narrative beginning, climax, or conclusion. Adding to the distant atmosphere of a place that seems newly discovered by this film, the characters are not named, and the force of the sea constantly overwhelms their attempts to create order and meaning in their lives **[Figure 8.17]**. Well beyond learning about the customs of a distant way of life, audiences find in *Man of Aran* a dignity of living far removed from most viewers' experiences and knowledge.

Stories and narratives are not the primary organizational feature in *Man of Aran*. Instead, the film mostly accumulates, repeats, and contrasts images. The brutal lifestyle on the island is presented by contrasting human activities with natural forces. Images of people preparing meals, planting a garden, and repairing fishing nets alternate with images of crashing waves, barren rocky coasts, and empty horizons.

Yet traces of fiction and narrative are visible in the film, even if they are subsumed under alternative organizational patterns. Some situations are, in fact, fabricated, such as the episode in which the men are nearly lost at sea in the hunt for a basking shark. Two

8.17 *Man of Aran* (1934). Inhabiting Irish islands unknown to many viewers, nameless individuals fight for survival against a barren and harsh world.

generations earlier, shark hunts were a part of life, but by 1934, they no longer took place on the Aran Islands. The episode thus relies on the dramatic suspense that drives any good adventure story.

Innovative and distinctive as this film is, it also reminds us of its cultural heritage. Although explicitly working out of the tradition of an anthropological report, *Man of Aran* also adapts the tradition of the travel essay or travelogue that is found in the works of writers from Henry James (1843–1916) to Bruce Chatwin (1940–1989). James describes the sights and sounds of his visits to Venice, Chatwin writes about his encounters in Patagonia, and Flaherty's film shows us a culture on the far reaches of the emerging modern civilizations of the twentieth century.

Contrastive Organizations

As a variation on cumulative organization, contrastive organizations present a series of contrasts or oppositions that indicate different points of view on its subject. Thus, a film may alternate between images of war and peace or between contrasting skylines of different cities. Sometimes these contrasts may be evaluative, distinguishing positive and negative events. At other times, contrastive exposition may suggest a more complicated relationship between objects or individuals. Among the most ambitious versions of this technique is a group of films by Michael Apted, beginning with his documentary *7 Up* (1964) and followed by successive films made every seven years. The eight films in the *Up* series (1964–2012) track the changing attitudes and social situations of a group of children as they grow into the adults of *56 Up* (2012). With a new film appearing every seven years, these films contrast the differences among developing individuals in terms of class, gender, and family life and in their changing outlooks as they grow older. This emphasis on the contrasting shapes of these developments differs significantly from the fiction film *Boyhood* (2014), where the use of the same actor as he matures over a decade emphasizes the coherence of the development.

8.18 *Night Mail* (1936). Within the journey of mail from London to Scotland, a poetry of the everyday develops and progresses as the film follows the tasks of sorting mail, picking up that mail by trains, and eventually delivering it at the end of the line. BFI National Archive

Developmental Organizations

With developmental organizations, places, objects, individuals, or experiences are presented through a pattern that has a non-narrative logic or structure but still follows a logic of change or progression. For example, an individual may be presented as growing from small to large, as changing from a passive to an active personality, or as moving from the physical to the spiritual. With a script by W. H. Auden, *Night Mail* (1936) describes the journey of the mail train from London to Scotland, documenting and celebrating the many precisely coordinated tasks that make up this nightly civil service. With music from composer Benjamin Britten and poetry by Auden, the movement of this journey re-creates the rhythms of the train wheels as they accelerate, steady, and then slow in their developing path across England **[Figure 8.18]**. More recently, the 2007 *The King of Kong: A Fistful of Quarters* follows gamer Steve Wiebe in his attempt to break the record score of Donkey Kong champion Billy Mitchell. The film documents his progressive movement toward that goal and the showdown that threatens to derail it **[Figure 8.19]**.

VIEWING CUE

🔖 LaunchPad Solo

Examine carefully the organization of this clip from *The Cove* (2009). Does it follow a clear formal strategy? Explain.

Rhetorical Positions

Just as narrative cinema uses different types of narrators and narration to tell stories from a certain angle, documentary and experimental films employ

8.19 *The King of Kong: A Fistful of Quarters* (2007). Gaming becomes a world of ever-rising scores, new records, and conquests as we follow Steve Wiebe's journey from playing Donkey Kong in his garage to playing at the Funspot Arcade in Laconia, New Hampshire, where he performs a live high score to prove his ability and legitimacy.

8.20 *Hearts and Minds* (1974). A documentary explores the realities of the Vietnam War and tries to convince its audience of the misguided decisions that led to the disaster the war became.

their own rhetorical positions—or organizational points of view—that shape their formal practices according to certain perspectives and attitudes. Sometimes these films might assume the neutral stance of the uninvolved observer—referred to as the "voice of God" because of its assumed authority and objectivity. At other times, the point of view of the documentary assumes a more limited or even personal perspective. Whether clearly visible and heard, omniscient or personal, or merely implied by the film's organization, the rhetorical positions of documentary films generally articulate their attitudes and positions according to four principal frameworks:

- To explore the world and its peoples
- To interrogate or analyze an event or a problem
- To persuade the audience of a certain truth or point of view
- To reflect the presence and activity of the filmmaking process or the filmmaker

Sometimes these frameworks overlap in a single film. For example, the voice of Peter Davis's *Hearts and Minds* (1974) is both explorative and polemical as it uses strategically placed interviews and newsreel footage to tear apart the myths supporting the Vietnam War **[Figure 8.20]**. *Where to Invade Next* (2015), a film that centers on director Michael Moore's perspective on how other countries compare to the United States, offers an often exaggerated performance as a clearly argumentative perspective meant to incite and arouse audiences and to sway opinion on social and economic programs.

Explorative Positions

Explorative positions announce or suggest that the film's driving perspective is a scientific search into particular social, psychological, or physical phenomena.

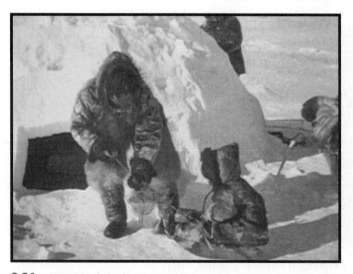

8.21 *Nanook of the North* (1922). Many documentaries mimic the anthropologist's project of exploring other cultures—in this case, the rituals and daily routines of an Inuit family.

Informed by this position, a documentary assumes the perspective of a traveler, an explorer, or an investigator who encounters new worlds, facts, or experiences and aims to present and describe these straightforwardly, often as a witness. Travel films have existed since the first days of cinema, when filmmakers offered short records of exotic locations such as Niagara Falls or the Great Wall of China. The first feature-length documentaries extended that explorative curiosity, positioning the travel film somewhere between the anthropologist's urge to show different civilizations and peoples, as in Flaherty's *Nanook of the North* (1922) **[Figure 8.21]**, and the tourist's pleasure of visiting novel sites and locations, as in Jean Vigo's tongue-in-cheek wanderings through a French resort town in *Apropos of Nice* (1930). More recently, Werner Herzog's *Cave of Forgotten Dreams* (2010) mobilizes 3-D technology to explore the Chauvet cave drawings in southern France, offering a stunning commentary on these

prehistoric paintings and their anticipation of cinematic movement [**Figure 8.22**].

Interrogative Positions

Interrogative or analytical positions rhetorically structure a movie in a way that identifies the subject as being under investigation—either through an implicit or explicit question-and-answer format or by other, more subtle techniques. Commonly condensed in the interview format found in many documentary films, interrogative techniques also can employ a voiceover or an on-camera voice that asks questions of individuals or objects that may or may not respond to the questioning. Frank Capra's *Why We Fight* series (1943–1945) explicitly formulates itself as an inquisition

8.22 *Cave of Forgotten Dreams* (2010). Werner Herzog's 3-D images of the Chauvet cave in southern France allow him to explore the space of prehistoric drawings in ways never before possible.

into the motivations for the U.S. involvement in World War II, whereas in Trinh T. Minh-ha's *Surname Viet Given Name Nam* (1989), a question or problem may only be implied, and succeeding images may either resolve the problem or not. Errol Morris's *Fog of War* (2003) creates a visually and musically complex forum, filmed with an innovative camera device he called the "Interrotron," through which he elicits strained explanations about the catastrophe of the Vietnam War from Robert McNamara, the former secretary of defense. One of the most profound and subtlest examples of the interrogative or analytical form is Alain Resnais's *Night and Fog* (1955), which offers images without answers [**Figures 8.23a and 8.23b**]. In short, interrogative and analytical forms may lead to more knowledge or may simply raise more questions than they answer.

Persuasive Positions

The use of interrogation and analysis in a documentary film often (but not always) is intended to convince or persuade a viewer about certain facts or truths. Persuasive

(a) **(b)**

8.23a and 8.23b *Night and Fog* (1955). As images of liberated survivors of the Nazi concentration camps alternate with contemporary images of the same empty camps, the complex organizational refrain of the film becomes, "Who is responsible?"

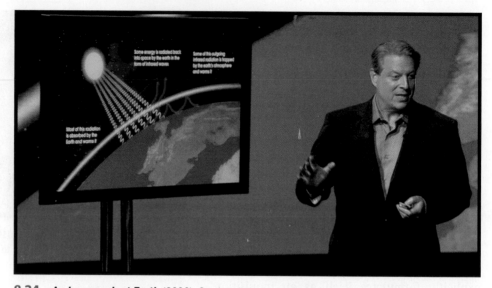

8.24 *An Inconvenient Truth* (2006). Graphs, charts, and expert opinion help to persuade an audience of the dangers of global warming.

VIEWING CUE

Watch this clip from *He Named Me Malala* (2015). Describe the presiding voice or attitude with as much detail as possible. How does the dominant rhetorical argument position the subject it addresses? Can you imagine another way of filming this subject? Explain.

positions articulate a perspective that expresses a personal or social position using emotions or beliefs and aim to persuade viewers to feel and see in a certain way. Some films do so through voices and interviews that attempt to convince viewers of a particular cause. In *An Inconvenient Truth* (2006), former vice president Al Gore positions himself like a professor before charts, graphs, and images in a sustained argument about the dangers of global warming **[Figure 8.24]**. Other movies may downplay the presence of the personal perspective and instead use images and sounds to influence viewers through argument or emotional appeal, as in propagandistic movies that urge certain political or social views. Leni Riefenstahl's infamous *Triumph of the Will* (1935) allows grandiose compositions of images to convince viewers of the glorious powers of the Nazi party. In *Pussy Riot: A Punk Prayer* (2013), the dramatic protests of three young Russian women against the repressions in Russian society are presented, as are their subsequent three-year prison sentences, and the pounding and energetic rhythms of the music and the absurdities of the trial persuasively expose the Russian church's support of a repressive government.

Persuasive forms also can rely solely on the power of documentary images themselves. Frederick Wiseman's *Titicut Follies* (1967), for example, exposes the substandard treatment of criminally insane men and women at a large hospital and influences attitudes about their care without any overt argumentation **[Figure 8.25]**. With such movies, what we are being persuaded to do or think may not be immediately evident, yet it usually is obvious that we are engaged in a rhetorical argument that involves visual facts, intellectual statements, and sometimes emotional manipulation.

Reflexive and Performative Positions

Reflexive and performative positions call attention to the filmmaking process or perspective of the filmmaker in determining or shaping the documentary material being presented. Often this means calling attention to the making of the documentary or the process of watching a film itself. Certain films—like Laleen Jayamanne's *A Song of Ceylon* (1985), which references the classical documentary *Song of Ceylon* (1934) through its meditation on colonialism and gender in Sri Lanka—aim to remind viewers that documentary reality and history are always mediated by the film image and that documentary films do not necessarily offer an easy access to truth. This focus can shift from the filmmaking process to the

8.25 *Titicut Follies* (1967). Much of the film's power resides in shocking images of the institutional abuses of the criminally insane prisoners. Bridgewater Film Company, Inc., permission granted by Zipporah Films, Inc.

8.26 *Sherman's March* (1986). A personal documentary about the filmmaker's attempt to make a historical film that becomes a reflexive performance about love, women, and making movies.

filmmaker, thus emphasizing the participation of that individual as a kind of performer of reality.

A classic example of a reflexive and performative documentary, Orson Welles's *F for Fake* (1974) wittily meditates on powers of illusion that bind filmmaking, art forgery, fraud, and the illusions of magicians. In Ross McElwee's *Sherman's March* (1986), the filmmaker sets out on a journey to document General William Tecumseh Sherman's conquest of the South during the Civil War. Along the way, however, this witty film becomes more about the filmmaker's own failed attempts to start or maintain a romantic relationship with the many women he meets **[Figure 8.26]**.

Making Sense of Documentary Films

Although moviegoers have always been attracted to a film's entertainment value, audiences also appreciated the cultural and educational values of nonfiction movies produced as early as the 1890s. These films presented sporting events, political speeches, and dramatic presentations of Shakespeare. In 1896, for instance, the Lumière brothers took audiences on an educational railway trip with the "phantom ride" of *Leaving Jerusalem by Railway* **[Figure 8.27]**. According to these practices, the documentary presumably could offer unmediated truths or factual insights that were unavailable through strictly narrative experiences. Regardless of how this basic view of the documentary may have changed since then, presenting presumed social, historical, or cultural truths or facts remains the foundation on which documentary films are built.

Perhaps more than narrative cinema, documentary films expand and complicate how we understand the world. The relationship between documentary films and the cultural and historical expectations of viewers thus plays a large part in how these movies are understood. Luis Buñuel's *Land Without Bread* (1933) might seem

8.27 *Leaving Jerusalem by Railway* (1896). Early films allowed audiences to experience the pleasure and education of visiting new lands and vistas.

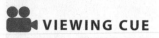

VIEWING CUE

What makes a documentary film
you have recently seen meaningful?
How does it achieve its aims and
make its values apparent?

to be a kind of travelogue about a remote region of Spain—Las Hurdes—but its bitingly ironic soundtrack commentary, which flatly understates the brutal misery, poverty, and degradation in the region, makes the film a searing political commentary on the failure of the state and church to care adequately for the people who live there. So unmistakable was the message of this film, in fact, that the Spanish government repressed it. Without its cultural context, this film might seem odd or confusing to some viewers today, reminding us that in order to locate the significance of a film, we often must understand the historical, social, and cultural contexts in which it was made.

Throughout the history of documentaries, viewers have found these films most significant in their ability to reveal new or ignored realities not typically seen in narrative films and to confront assumptions and alter opinions.

Revealing New or Ignored Realities

Because narrative movies dominate the cinematic scene, documentary films commonly have a differential value: successful documentary films offer different kinds of truth from narrative movies. Often this means revealing new or ignored realities by showing people, events, or levels of reality we have not seen before because they have been excluded either from our social experience or from our experiences of narrative films. To achieve these kinds of fresh insight, documentaries often question the basic terms of narratives—such as the centrality of characters, the importance of a cause-and-effect chronology, or the necessity of a narrative point of view—or they draw on perspectives or techniques that would seem out of place in a narrative movie.

By showing us an object or a place from angles and points of view beyond the realistic range of human vision, such films place us closer to a newly discovered reality. We see the bottom of a deep ocean through the power of an underwater camera or the flight of migrating birds from their perspectives in the skies. Perhaps the object will be presented for an inordinately long amount of time, showing minute changes rarely seen in our usual experiences. One movie condenses the gestation of a child in the womb, and another shows the dread and boredom that a homeless person experiences over one long night in Miami. David and Albert Maysles's *Grey Gardens* (1975) portrays the quirky extremes of a mother and daughter, relatives of Jacqueline Kennedy Onassis, who live in a dilapidated mansion in East Hampton, Long Island. Slowly, by following their daily routines and dwelling on the incidentals in their lives, the film develops our capacity to see two individuals whose unique personalities and habits become less and less strange [**Figure 8.28**].

Confronting Assumptions, Altering Opinions

Documentary films may present a familiar or well-known subject and attempt to make us comprehend it in a new way. Some documentaries are openly polemical when presenting a subject. As an obvious example, documentaries about a political figure or a controversial event may confront viewers' assumptions or attempt to alter currently held opinions about the person or event. Other films may ask us to rethink a moment in history or our feelings about what once seemed like a simple exercise, as in *Wordplay* (2006), a documentary about

8.28 *Grey Gardens* (1975). The relationship between two quirky and unusual women becomes a touching and entertaining documentary about individualism and humanity.

crossword puzzles and how they inspire intellectual activity [Figure 8.29].

With any and all of the formal and organizational tools available to a documentary, these films attempt to persuade viewers of certain facts, attack other points of view, argue with other films, or motivate viewers to act on social problems or concerns. An especially explicit example is Michael Moore's *Sicko* (2007), which visibly and tendentiously argues that the health care system in the United States is antiquated and destructive and needs to be changed. Released the same year, the documentary *Manufacturing Dissent: Uncovering Michael Moore* (2007) takes Moore and his many films to task for fudging or misrepresenting facts. Such polemic is central to this tradition of documentary cinema, which is always about which reality we wish to accept.

8.29 *Wordplay* (2006). This documentary presents viewers with new perspectives, such as that of Merl Reagle, longtime crossword constructor, on the seemingly ordinary subject of crossword puzzles.

Serving as a Social, Cultural, and Personal Lens

From the two primary agendas discussed above come two traditions of documentary cinema—the social documentary and the ethnographic film. These two traditions encompass some of the main frameworks for understanding many documentary films throughout the twentieth century.

The Social Documentary

Social documentaries examine issues, people, and cultures in a social context. Using a variety of organizational practices, this tradition emphasizes one or both of the following goals—authenticity (in representing how people live and interact) and discovery (in representing unknown environments and cultures). Considered by some scholars and filmmakers as the father of documentary, John Grierson made his first film, *Drifters* (1929), about North Sea herring fishermen. Another early British filmmaker, Humphrey Jennings, continued this tradition with *Listen to Britain* (1942), a twenty-minute panorama of British society at war—from soldiers in the fields to women in factories. Indeed, the social documentary tradition is long and varied, stretching from Pare Lorentz's *The River* (1937), made for the U.S. Department of Agriculture about the importance of the Mississippi River, to *Waste Land* (2010), about artist Vik Muniz's encounter with a community of people who live in and off the world's largest landfill on the outskirts of Rio de Janeiro. Two important spin-offs from the social documentary tradition are the political documentary and the historical documentary.

The Political Documentary. Partially as a result of the social crisis of the Great Depression in the United States and the more general economic crises that occurred in most other countries after World War I, political documentaries have aimed to investigate and to celebrate the political activities of men and women as they appear within the struggles of small and large social spheres. Contrasting themselves with the lavish Hollywood films of the times, these early documentary films sought to balance aesthetic objectivity and political purpose. Preceded by the films of Dziga Vertov and the Soviet cinema of the 1920s, such as *Man with a Movie Camera* (1929), political documentaries from the mid-twentieth century tend to take analytical or persuasive positions, hoping to provoke or move viewers with the will

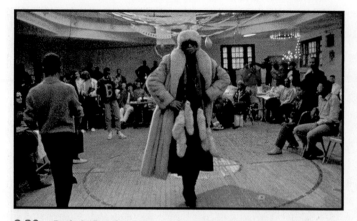

8.30 *Paris Is Burning* (1990). A sympathetic and witty portrayal of the subculture of drag balls in New York City.

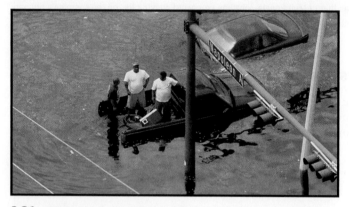

8.31 *When the Levees Broke: A Requiem in Four Acts* (2006). Spike Lee's HBO documentary uses the medium as a powerful tool for political statements.

8.32 *Atomic Cafe* (1982). By employing archival footage and conventional documentary devices, this film satirizes the paranoia of 1950s culture.

to reform social systems. Narrated by Ernest Hemingway, Joris Ivens's *The Spanish Earth* (1937) presents, for example, the heroic resistance of the "Loyalists" as they fight valiantly against the brutal forces of a fascist government. Although political documentaries such as these can sometimes be labeled propaganda films because of their visible efforts to support a particular social or political issue or group, they frequently use more complex arguments and more subtle tactics than bluntly manipulative documentaries.

Since World War II, political documentaries have grown more varied and occasionally more militant. In 1968, Argentine filmmakers Fernando Solanas and Octavio Getino produced *The Hour of the Furnaces*, a three-hour-long examination of the colonial exploitation of Argentina's culture and resources that inspired heated political discussions and even demonstrations in the street. In recent decades, feminist documentaries, gay and lesbian documentaries, and documentaries about race have explored political issues and identities that traditionally have not been addressed. The variety of these films indicates the power and purpose of this tradition. *American Revolutionary: The Evolution of Grace Lee Boggs* (2013) examines the life and work of a Detroit activist who continued, at age ninety-seven, to work for social change at a grassroots level. Robert Epstein and Richard Schmiechen's *The Times of Harvey Milk* (1984) describes the assassinations of San Francisco mayor George Moscone and Harvey Milk, an activist who was the first gay supervisor elected in the city, and Jennie Livingston's *Paris Is Burning* (1990) documents the Harlem drag ball scene **[Figure 8.30]**. Spike Lee's HBO documentary *When the Levees Broke: A Requiem in Four Acts* (2006), about the government's mishandling of the Hurricane Katrina disaster, is a worthy heir to a long tradition of documentaries that make the politics of race the centerpiece of the politics of the nation **[Figure 8.31]**.

The Historical Documentary. Another form related to social documentary is the historical documentary, a type of film that concentrates largely on recovering and representing events or figures in history. Depending on the topic, these films are often compilations of materials, relying on old film footage or other materials such as letters, testimonials by historians, or photographs. Whatever the materials and tactics, however, historical documentaries have moved in two broad directions.

Conventional documentary histories assume that the facts and realities of a past history can be more or less recovered and accurately represented. *Atomic Cafe* (1982), although a rather satirical documentary, uses media and government footage to describe the paranoia and hysteria of the nuclear arms race during the Cold War **[Figure 8.32]**. The films of Ken Burns—including the PBS series *The Civil War* (1990),

Baseball (1996), and *The War* (2007)—use a range of materials, techniques, and voices to re-create the layered dynamics of major historical and cultural events.

Reflexive documentary histories, in contrast, adopt a dual point of view. Alongside the work to describe an event (such as a historical trauma like the Holocaust or the nuclear bombing of Hiroshima) is the awareness that film or other discourses and materials will never be able to retrieve the full reality of that lost history. Despite their vastly different topics (the Nazi death camps and the racist murder of a Chinese American automotive engineer), Claude Lanzmann's *Shoah* (1985) and Christine Choy and Renee Tajima's *Who Killed Vincent Chin?* (1987) engage specific historical and cultural atrocities and simultaneously reflect on the difficulty, if not impossibility, of fully and accurately documenting the truth of those events and experiences **[Figure 8.33]**.

8.33 *Who Killed Vincent Chin?* (1987). This film documents a local hate crime that resonates in larger historical terms. At the same time, it reflects on the difficulty of communicating the full historical truth. Courtesy of Filmmakers Library, an imprint of Alexander Street Press

Ethnographic Cinema

Ethnographic documentaries—films that record the practices, rituals, and people of a culture—have roots in early cinema and are a second major tradition in documentary film. Although social documentaries tend to emphasize the political and historical significance of certain events and figures, ethnographic films are typically about cultural revelations and present specific peoples, rituals, or communities that may have been marginalized by or invisible to the mainstream culture. Here we highlight two practices within the ethnographic tradition—anthropological films and cinéma vérité.

Anthropological Films. Anthropological films explore different global cultures and peoples, both living and extinct. In the first part of the twentieth century, these films often sought out exotic and endangered communities to reveal them to viewers who had little or no experience of them. Such documentaries generally aim to reveal cultures and peoples authentically, without imposing the filmmaker's interpretations, but in fact they often are implicitly shaped by the perspectives of their makers. In the 1940s and 1950s, such works as Jean Rouch's *The Magicians of Wanzerbe* (1949) transformed film into an extension of anthropology, searching out the social rituals and cultural habits that distinguish the people of particular, often primitive, societies. Robert Gardner's *Dead Birds* (1965) examines the war rituals of the Dani tribe in New Guinea, maintaining a scientific distance that draws out what is most unique and different about the people **[Figure 8.34]**.

The scope and subject matter of ethnographic documentaries have expanded considerably over the years, sometimes finding lost cultures in the West's own backyard. This contemporary revision of anthropological cinema investigates the rituals, values, and social patterns of families or subcultures, such as the skateboard clan of *Dogtown and Z-Boys* (2001), rather than directing its attention to cultures or communities

8.34 *Dead Birds* (1965). This remarkable ethnographic film provides audiences with a glimpse of life in the Dani tribe in New Guinea, focusing on Weyak, a farmer and warrior, and Pua, a young swineherd. Courtesy of Documentary Educational Resources from *Dead Birds* by Robert Gardner

HISTORY CLOSE UP

Indigenous Media

Like the Kayapo and Waipai Indians (see "Indigenous Cinema," below), the indigenous people of Canada also left behind their legacy as objects of ethnographic film and campaigned for self-representation. Organized activism resulted in the licensing of the Inuit Broadcasting Network in 1982, featuring programming by, for, and about native Canadians. Years later, a new phase of indigenous media making was marked by the historic release of *Atanarjuat: The Fast Runner* (2001, right). Shot in digital video, this extraordinary film, directed by Inuit filmmaker Zacharias Kunuk, deploys the genre of epic to explore a people's past. But it portrays a cultural legend, not a factual past. Although at first it resembles an ethnographic film, *Atanarjuat* is set a millennium ago. By setting its depiction of the traditional way of life in the mythic past, the film represents an Inuit claim to self-representation on several levels. The film's use of amateur actors lends an "authenticity" to the scripted scenes, and its script represents the longest text ever written in the Inuit language. Its images also implicitly acknowledge and respond to the beauty as well as the problems of a film like *Nanook of the North* (1922). Two subsequent films made in 2006 and 2009 complete the *Fast Runner* trilogy.

that are "foreign" to its producers. Using found footage or archival prints of home movies made before 1950, Karen Shopsowitz's *My Father's Camera* (2001) argues that reality is sometimes best revealed by amateur filmmakers capturing everyday life though home movies and snapshots. One of the most ambitious films in movie history, Chris Marker's *Sans soleil* (*Sunless*) (1983) shuffles and experiments with many of the structures and tropes of ethnographic documentaries as it follows a cameraman's letters as he travels the world between Japan and Africa or, as the film puts it, between "the two extreme poles of survival."

Cinéma Vérité and Direct Cinema. One of the most important and influential documentary schools related to ethnographic cinema is cinéma vérité (French for "cinema truth"). Related to Dziga Vertov's *Kino-Pravda* (Russian for "cinema truth") of the 1920s, cinéma vérité films real objects, people, and events in a confrontational way so that the reality of the subject continually acknowledges the reality of the camera recording it. This film movement arose in the late 1950s and 1960s in Canada and France before quickly spreading to film cultures in the United States and other parts of the world.

Aided by the development of lightweight cameras and portable sound equipment, filmmakers like Jean Rouch created in their images a jerky immediacy to suggest the filmmakers' participation and absorption in the events they were recording. Rouch's *Moi un noir* (*I, a Black*) (1958), filmed in Treichville, a neighborhood in Ivory Coast's capital city, portrays the everyday life of a group of young Africans accompanied by the voiceover narration of one who refers to himself as Edward G. Robinson (after the "tough guy" actor in American films of the 1930s). In this version of cinéma vérité, rules of continuity and character development are willfully ignored. Here reality is not just what objectively appears. Reality is also the fictions and fantasies that these individuals create for and about themselves

and the acknowledged involvement of the filmmaker as interlocutor. Moreover, unlike its American counterpart, French cinéma vérité draws attention to the subjective perspective of the camera's rhetorical position. In Rouch's film, the voiceover frequently makes ironic remarks about what is being shown.

The North American version of cinéma vérité, referred to as *direct cinema*, is more observational and less confrontational than the French practice. Its landmark film, *Primary* (1960), follows Democratic candidates John F. Kennedy and Hubert H. Humphrey through the Wisconsin state presidential primary election. D. A. Pennebaker and the Maysles brothers, who were all involved in the making of *Primary*, continued to work in this tradition, gravitating toward social topics in which the identity of the subjects is inseparable from their role as performers. Pennebaker made numerous cinéma vérité–like films such as *Dont Look Back* (1967) **[Figure 8.35]**, a portrait of the young

8.35 *Dont Look Back* (1967). Direct cinema contemplates the inside of the celebrity world of Bob Dylan.

Bob Dylan, and *The War Room* (1993), about the 1992 presidential campaign of Bill Clinton. In addition to *Grey Gardens* (1975), Albert and David Maysles made many films in direct cinema style, including *Salesman* (1968), about itinerant Bible salesmen, and *Gimme Shelter* (1970), a powerful and troubling record of the 1969 Rolling Stones tour across the United States.

Indigenous Cinema. Indigenous cinema involves direct representation of native cultures and their ability to assert power through the control of the image. Film can record rituals in a way that written ethnographies cannot. Cameras can never grant complete access to a cultural context, especially in a culture that does not use a camera, where equipment can hardly remain invisible or neutral, even when filming interviews that capture the subject's own words and gestures. But film's ability to capture conversations, gestures, sounds, settings, time, and space can give a strong impression of documenting a culture despite such mediations. Widely considered the first feature-length documentary film and certainly one of the most influential movies ever made, Robert Flaherty's *Nanook of the North* (1922) is a record of the lives and customs of the Inuit people of the Canadian Arctic. Shortly afterward, Ernest B. Schoedsack and Merian C. Cooper made *Grass* (1925), a record of an Iranian migration (and in 1933, they made the not unrelated feature film *King Kong*).

Nowhere do claims of film as an impartial record become more loaded than in the filming of indigenous people by outside observers, and not until recently have indigenous groups been able to appropriate video and film technology to tell their own stories. Deploying a technology like the movies in such a cultural encounter means claiming the power to represent others and their history. The camera conveys a profound feeling of presence that also puts the viewer in the place of the observer or "expert."

The recent introduction of video technology to indigenous people, such as the Kayapo and Waipai Indians in the Amazon Basin of Brazil, has resulted in considerable output that has several empowering uses **[Figure 8.36]**. These include the preservation of traditional culture for

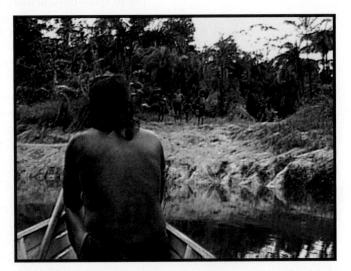

8.36 *The Spirit of TV* (1990). Amazon Indians, such as the Waipai, have used video to record their culture and assert their rights. Courtesy of Documentary Educational Resources from the Video in the Villages Series by Vincent Carelli

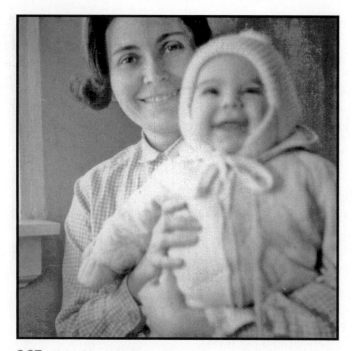

8.37 *A Healthy Baby Girl* (1996). Some documentaries, such as this one about the filmmaker and her mother, entwine a personal story with larger issues—here a breach of medical ethics. Courtesy Women Make Movies, www.wmm.com

future generations, video activism for land rights and the environment, and a new form of visual expression in a culture that has always relied on pictorial communication. Although the Kayapo are entering a new historical moment by employing this technology, the video work's primary purpose is to preserve the past.

Personal Documentaries, Reenactments, and Mockumentaries

Three specific strategies or tendencies have come to the foreground in recent years to define contemporary traditions in documentaries. As the line between social documentaries and ethnographic films has wavered and as filmmaking equipment becomes more widely available, **personal** or **subjective documentaries**—documentary formats that emphasize the personal perspective or involvement of the filmmaker, often making the films resemble autobiographies or diaries—have become more common. This subgenre has roots in earlier films. In *Lost, Lost, Lost* (1976), Jonas Mekas portrays his fears and hopes in a diary film about his growing up as an immigrant in New York. He counterpoints home movies, journal entries, and a fragmented style that resembles a diary, and the rhythmic interjections of the commentator-poet express feelings ranging from angst to delight. In *A Healthy Baby Girl* (1996), filmmaker Judith Helfland explores the causes of her cancer diagnosis in her mother's use during pregnancy of the drug diethylstilbestrol (DES), which was prescribed to prevent miscarriage. Although the film exposes and indicts this breach of medical ethics and its effects on women's health, its primary focus is on the personal journey of the filmmaker and her family [**Figure 8.37**].

Questions about the truth and honesty of documentaries have shadowed this practice since Flaherty's reconstruction of "typical" events for the camera in *Nanook of the North* (1922) and his other films in the 1920s. Recently, more and more documentaries have seized on the question of the veracity of the camera in order to complicate or to spoof documentary practices. Increasingly visible and debated today, documentary **reenactments** reenact presumably real events within the context of a documentary. An early example of this blurring of boundaries, *The Battle of Algiers* (1966) depicts the Algerian revolt against the French occupation (1954–1962) as a re-creation—a film about a real historical event that uses documentary techniques while developing the story with a script and actors (some playing themselves). Indeed, an opening caption announces that no documentary footage is used in the film.

Errol Morris's *The Thin Blue Line* (1988) is a documentary about Randall Adams, a man wrongly convicted of killing a Dallas police officer in 1976, but it also becomes a mystery drama about discovering the real murderer. Although it uses the many expository techniques of documentary film, such as close-ups of evidence and talking-head interviews, *The Thin Blue Line* alternates these with staged reenactments of the murder evening, invented dialogue, an eerie Philip Glass soundtrack, courtroom drawings, and even clips from old movies [**Figure 8.38**]. The debates and questions

8.38 *The Thin Blue Line* (1988). Reenacting a crime as a part of a documentary investigation, Errol Morris's film set the stage for more experimental documentary formats.

surrounding the practice of reenactment are explored in *Manufacturing Dissent: Uncovering Michael Moore* (2007), Rick Caine and Debbie Melnyk's documentary on Michael Moore's use of reenactments in his films.

At the other end of the spectrum, **mockumentaries**—films that use a documentary style and structure to present and stage fictional (sometimes ludicrous) subjects—take a humorous approach to the question of truth and fact. The mockumentary is an extreme example of how documentaries can generate different experiences and responses depending on viewing context and one's knowledge of the traditions and aims of such films. For example, with the initial release of *This Is Spinal Tap* (1984), some viewers saw and understood it as a straightforward rock-music documentary (or "rockumentary"), while most recognized it as a spoof on that documentary tradition **[Figure 8.39]**. The popular and controversial *Borat* (2006) integrates a similar mockumentary style by following a fictional Kazakh television talking head as he travels "the greatest country in the world" in search of celebrities, cowboys, and the "cultural learning" found on the streets of America. Actor Sacha Baron Cohen mixes his impersonation of the character Borat with interviews of people who accept his persona as genuine. As such, the film raises questions about the boundary between a parody of viewers' assumptions about the truth and a dangerous distortion of the integrity of documentary values **[Figure 8.40]**.

Closely related to the mockumentary but with more serious aims is the fake documentary, a tradition that includes Luis Buñuel's *Land Without Bread* (1933) and Orson Welles's *F for Fake* (1974), a movie that looks at real charlatans and forgers while itself questioning the possibilities of documentary truth. A more recent film, Cheryl Dunye's *The Watermelon Woman* (1996), is a fictional account of an African American lesbian documentary filmmaker researching a black actress from the 1930s. The archive of photos and film footage she assembles for the fake documentary within the film represents a lovingly fabricated work by the film's creative team—an imagining of a history that has not survived **[Figure 8.41]**.

As we have seen, documentary films create movie experiences markedly different from those of narrative cinema. Although some of these experiences are non-narrative portraits that envision individuals in ways quite unlike the narrative histories of the same people,

8.39 *This Is Spinal Tap* (1984). Mockumentaries like this cult film remind us that the authenticity of cinematic documentaries relies on the experiences and expectations of their audiences.

8.40 *Borat* (2006). Some of the most important assumptions about documentary integrity are violated in this film, perhaps as a way to satirize the pretensions of those assumptions.

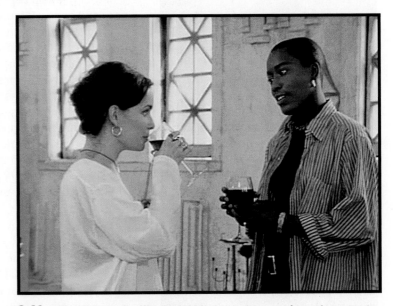

8.41 *The Watermelon Woman* (1996). As a serious use of a mockumentary tradition, this film suggests a history that has not survived—or perhaps not yet arrived.

text continued on page 309 ▶

LISA SIMONE KELLY

8.42

8.43

8.44

March 25, 1965
Montgomery, Alabama

8.45

8.46

FORM IN ACTION

The Contemporary Documentary: *What Happened, Miss Simone?* (2015)

Contemporary documentaries engage a wide variety of subjects and topics—from politics and war to the natural environment and science—but some of the most popular have involved musicians and music events. Since the coming of sound in 1927 through landmark documentaries like *Dont Look Back* (1967), about Bob Dylan's first tour of England, and *Searching for Sugar Man* (2012), about the lost 1970s rock musician Sixto Rodriguez, music docs have proliferated through their own tactics and conventions.

The recent *What Happened, Miss Simone?* (2015) is a dexterous and incisive example that tells the complex story of the extraordinary musician and performer Nina Simone through a series of layers and connections common to the best of these types of documentaries. With different musical performances as the connecting fabric throughout the film, it presents a retrospective development of Simone's life and career from childhood to adulthood, along the way including voiceover commentaries from friends, family members, music professionals, and other celebrities **[Figure 8.42]**. Often using archival footage, the performances themselves create a moving collage through her career of small club engagements, large theatrical events, and a variety of television appearances, in each case capturing her singular exuberance and energy **[Figure 8.43]**.

A distinctive technique of this music documentary is how the film weaves the abuse Simone suffered into the passion and poignancy of her singing, so that the music becomes, in her words, a measure of and outlet for her rage and anger about the mistreatments in her personal life **[Figure 8.44]**. Perhaps even more disturbing is how her remarkable musical abilities turn into political activism. At one point, she asks, "How can you be an artist and not reflect the times?" This question leads into one of the most extraordinary sequences in the film—the performance of "Backlash Blues" **[Figure 8.45]**, her song about institutional racism, intercut with archival footage of racial violence against African Americans during the civil rights protests of the 1960s **[Figure 8.46]**. In a few minutes, the movie conveys the depth of Simone's gifts.

 FORM IN ACTION

LaunchPad Solo

To watch a video about *What Happened, Miss Simone?* (2015), see the *Film Experience* LaunchPad.

others are about the truth of events. Narrative movies encourage us to enjoy, imagine, and think about our temporal and historical relationships with the world and to consider when those plots and narratives seem adequate according to our experiences. Documentary movies remind us, however, that we have many other kinds of relationships with the world that involve us in many other insightful ways—through debate, exploration, and analysis.

CONCEPTS AT WORK

As different as they are, *Zero Days*, *Man of Aran*, *What Happened, Miss Simone?* and the other documentaries discussed in this chapter provoke similar analytical and conceptual questions. All these films have developed their own strategies and formal features—expositional organizations that contrast, accumulate, or develop facts and figures and rhetorical positions that work to explore, analyze, persuade, or even "perform" the world. *What Happened, Miss Simone?* might be said to accumulate images of its subject through a perspective that at once performs and analyzes, while *Man of Aran* develops its explorative survey of life on the Aran Islands through images that span a day. What we often value about films like *Zero Days* is their ability to reveal that world to us in new ways and to provoke us to see it with fresh eyes, outcomes that have generated numerous and complex traditions from the many types of social documentaries to the many kinds of ethnographic films and personal documentaries. For the documentary film you are considering in class, reflect carefully on the following questions:

- Can the film be characterized as primarily nonfiction or primarily non-narrative?
- How would you describe the organizational strategies of the film?
- Is there a clear rhetorical strategy for the film as in *Man of Aran*?
- How do you make sense of the values and traditions that inform the film? Does it aim primarily to alter opinions, to investigate a different cultural world, or to do both?

LaunchPad Solo
Visit the LaunchPad Solo for *The Film Experience* to view movie clips, read additional pieces, and learn more about your film experiences.

and loyal fan base to engage with abstract language and imagery, visual references to antebellum Southern history, African diasporan culture, and feminist critique. As the critical and commercial success of *Lemonade* shows, new media platforms and consumption practices are reactivating the potential of experimental film techniques and opening them up to new voices and audiences.

Narrative films are often likened to prose: they relate to the human desire to see and understand society and history through fictional and nonfictional stories. The non-narrative, non-realist practices explored in experimental film, video, and other audiovisual media, on the other hand, are likened to poetry: they relate to our desire for insight into other aspects of human experience — emotions, memories, dreams, sensory states, and intellectual puzzles. This analogy to poetry underscores the lyrical impulse that often drives experimental work and also captures something of its economic marginality. Experimental work is made by individual artists rather than by large crews or studios, and its audiences have generally been composed of those few who seek out and are motivated to engage with alternative filmic strategies. But this mode of engagement with aesthetics and expression eventually influences film form and thus reaches all viewers.

Experimentation with form and abstract imagery has occurred consistently over film history. Adventurous filmmakers have used film to go outside the bounds of traditional narrative and documentary forms, combining images and sounds of the mundane, the unusual, and even the bizarre in order to address and challenge their audiences in fascinating ways. For example, the cryptic imagery and structure of a surrealist classic like *The Seashell and the Clergyman* (1928) are echoed in the form of music videos. In Michel Gondry's video for Björk's "Human Behavior" (1993), the singer inhabits a fairy-tale world in which animals and humans are no longer distinct and music allows us to transcend physical limits **[Figure 9.1]**. Experimental cinema also engages with medium and form in ways that comment on and bridge technological changes. This chapter explores experimental audiovisual media from its origins to the present day, giving you the necessary tools to watch and discuss some of screen history's most complex, challenging, and rewarding endeavors.

The word *cinema* is derived from *kinema*, the Greek word for "movement." Arguably, neither the storytelling ability of the medium nor its capacity to reveal the world is as basic to cinema as is the simple rendering of movement. Narrative film defines the commercial industry and much of viewers' experience of the movies, documentary film builds on viewers' assumptions about the camera's truth-telling function, and experimental film focuses on the basic properties of film as images in motion. Historically, various terms have been used to denote the works we discuss in this

9.1 **"Human Behavior"** (1993). Contemporary music videos are indebted to experimental film traditions such as surrealism. This video by Michel Gondry combines pop culture and the avant-garde, as does singer Björk's music.

chapter. Most notable is **avant-garde cinema**—aesthetically challenging, noncommercial films that experiment with film forms. Avant-garde was originally a military term for advance guard or vanguard; we use the more general term experimental to describe innovation in film form. It encompasses experiments with elements of film form for aesthetic expression or technical innovation that may not be tied to specific avant-garde movements.

Experimental films—noncommercial, often non-narrative films that explore film form—reflect upon the film medium itself and the conditions in which it is experienced by audiences. These conditions include such basic elements as film stock, sprocket holes, light, figure movement, editing patterns, and projection before an audience. Changes in technology bring changes in the forms and objects of these reflections. For example, filmmakers working in an amateur format like Super 8 may scratch directly on the film emulsion, as Su Friedrich does in *Gently Down the Stream* (1981). Video artist Joan Jonas sets the video monitor to display a rolling image to explore the medium of television in *Vertical Roll* (1972) **[Figure 9.2]**. The resources of artists working in moving-image media were greatly expanded by the introduction of portable video equipment in the late 1960s, the shift to digital formats in the 1990s, and the convergence and multiplication of media platforms in the 2000s, encouraging more medium-specific experimentation.

9.2 *Vertical Roll* (1972). Video artist Joan Jonas's piece takes its name from a television malfunction in which the unstable video image appears to roll. Here her face appears as if trapped in the monitor. Image copyright of the artist, courtesy of Video Data Bank, www.vdb.org, School of the Art Institute of Chicago

Although this chapter primarily discusses the body of work and history of experimental film in general, we also attempt to show how its histories and preoccupations are related to those of **video art** (artists' use of the medium of video in installations and gallery exhibitions, beginning in the late 1960s) and **new media** (technologies that include the Internet, digital technologies, video game consoles, cell phones, and wireless devices and the software applications and imaginative creations they support). Just as artists in the early twentieth century explored cinema's form and its place in modern life, many artists today use new media technologies to reflect on life in the information age. Experimental films that were often difficult to see outside of urban arts or university contexts are now accessible through the Internet, bringing a renewed energy to the realm of experimental moving-image media.

KEY OBJECTIVES

- Describe experimental film and media as cultural practices.
- Explain how experimental works make and draw on aesthetic histories.
- Point out how these works explore the formal properties of their media.
- Discuss how experimental media can both challenge and become part of dominant film forms and institutions.
- Examine some of the common organizations, styles, and perspectives in experimental media.
- Prepare viewers to watch and appreciate experimental works.
- Explain dimensions of the film experience made possible by experimental media.

A Short History of Experimental Film and Media Practices

Experimental films and the vision they express have their roots in the wider technological and social changes associated with **modernity**—a term designating the period of history from the end of the medieval era to the present as well as the period's attitude of confidence in progress and science centered on the human capacity to shape history **[Figure 9.3]**.

As modern society embraced progress and knowledge, some individuals rejected the scientific and utilitarian bias of the quest for facts. In "A Defence of Poetry" (1819), Romantic poet Percy Bysshe Shelley proclaimed that poets were the unacknowledged legislators of the world. Walter Pater, in *The Renaissance* (1873), argued for the power of art to reveal the importance of the human imagination and create experiences unavailable in commerce and science. Pre-Raphaelite paintings like those of Dante Gabriel Rossetti and the glimmering Impressionist paintings of Claude Monet expressed aesthetic commitments to sensibility, creativity, and perception over factual observation **[Figure 9.4]**. Romantic aesthetic traditions later influenced the emphasis on individual expressivity that is central to much experimental film practice **[Figure 9.5]**.

The early twentieth century, when motion-picture technology was perfected, saw rapid industrial and cultural changes that were mirrored and questioned in developments in the arts. Modernist forms of painting, music, design, and architecture captured new experiences of accelerated and disjunctive time, spatial juxtapositions,

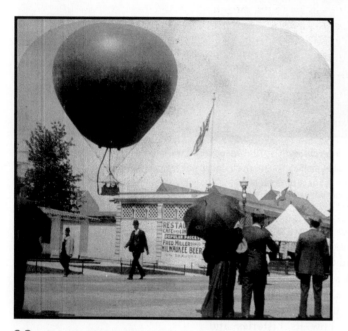

9.3 Chicago World's Fair (1893). Spectacles of nineteenth-century modernity celebrated visuality and technology, anticipating cinema's ways of seeing. Hulton Archive/Getty Images

9.4 Claude Monet, *Water Lilies* (c. 1916–1920). This panel from Monet's triptych anticipated experimental film in its energetic depiction of light. Claude Monet (1840–1926), Water Lilies, 1914–1926. Oil on canvas, three panels, each 6' 6¾" × 13' 11¼" (200 × 424.8 cm), overall 6' 6¾" × 41' 10⅜" (200 × 1276 cm), Mrs. Simon Guggenheim Fund, (666.1959.a–c), The Museum of Modern Art, New York, NY USA. Digital Image © The Museum of Modern Art/Licensed by SCALA/Art Resource, NY

9.5 *The Garden of Earthly Delights* (1981). The work of prolific experimental filmmaker Stan Brakhage is indebted to nineteenth-century Romanticism and its conception of artistic insight. This two-minute film was made by pressing actual flowers and leaves between strips of film and optically printing the images.

and fragmentation enabled by technologies like the railroad, the telegraph, and electricity. Because cinema is made with machines, the medium was considered a central art of modernism. Experiments with space and time emerged early in the medium's history, and film attracted experimental artists from other media.

1910s–1920s: European Avant-Garde Movements

In the silent film era, experimental film practices and movements emerged in a number of countries and were often linked to other innovations in art. In Germany in the 1920s, Dada artists Hans Richter and Viking Eggeling began experiments in abstraction that they called **absolute film** [**Figure 9.6**], and the expressionist painters in the group Der Sturm worked on the set designs of *The Cabinet of Dr. Caligari* (1920). In 1920s France, avant-garde filmmakers such as Jean Epstein and Germaine Dulac drew on impressionism in painting as well as new musical forms in their work. At the same time, film artists explored cinematography and editing to develop the cinema as a unique art form. In *Ballet mécanique* (1924), French cubist painter Fernand Léger collaborated with American director Dudley Murphy in a celebration of machine-age aesthetics originally intended as a visual accompaniment to American composer George Antheil's musical piece of the same name (see the Film in Focus feature on this film later in this chapter).

One of the most significant experimental film movements in history occurred in the Soviet Union after the Russian Revolution in 1917. Vladimir Lenin considered cinema the most important of the arts for the new society. Soviet constructivism celebrated machine-age art that served a social purpose, influencing painting, theater, poetry, graphic design, and photomontage as well as filmmaking. Avant-garde filmmaking in the silent era was international in spirit. In the United States, Germany, as well as the Soviet Union, filmmakers paid tribute to the modern metropolis in the "city symphony" genre. Charles Sheeler and photographer Paul Strand documented New York City scenes in *Manhatta* (1921) [**Figure 9.7**]. Filmic impressions of Berlin are orchestrated in Walter Ruttmann's *Berlin: Symphony of a Great City* (1927), and Dziga Vertov's *Man with a Movie Camera* (1929) shows the dynamism of modern Soviet life. In Britain, internationalism was advocated by writers and artists Kenneth Macpherson, Bryher, and the American poet h.d. through their translation of writings by Soviet filmmaker Sergei Eisenstein in their

VIEWING CUE

What historical precedents in the arts might have shaped the strategies used in the film you just viewed? Does aligning the film with a historical precedent shed light on its aims? Explain.

9.6 *Rhythmus 21* (1921). German artist Hans Richter claimed that this exploration of shapes in motion was the first abstract film.

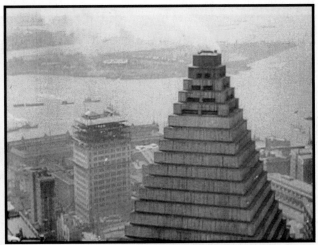

9.7 *Manhatta* (1921). One of the first avant-garde films made in the United States, this tribute to the metropolis is echoed in European "city symphony" films.

9.8 *Borderline* (1930). The editors of the British film journal *Close Up* put their modernist ideas into practice in this experimental narrative featuring the American actor Paul Robeson.

journal *Close Up* and in their strange and unique film, *Borderline* (1930). Featuring the politically outspoken African American actor Paul Robeson and his wife, Eslanda, *Borderline* engaged themes of race, sexuality, and Freudian psychoanalysis [**Figure 9.8**].

1930s–1940s: Sound and Vision

The international spirit of avant-garde cinema was challenged in the 1930s by the language barriers accompanying the introduction of sound and by the rise of fascism in Europe. Although many experimental filmmakers resisted the incorporation of synchronized sound and continued to produce silent films long after sound's introduction at the end of the 1920s, some were immediately attracted to the formal possibilities of the soundtrack. Dziga Vertov incorporated his interest in radio and industrial sounds in *Enthusiasm* (1931). German animator Oskar Fischinger composed abstract visual music in films such as *Allegretto* (1936), which he produced in the United States [**Figure 9.9**]. American ethnomusicologist Harry Smith produced dozens of short films to be accompanied by musical performances, records, or radio, and artist Joseph Cornell reedited a Hollywood B movie to make *Rose Hobart* (1936) and played a samba record to accompany its projection. Playwright Jean Cocteau began making his influential poetic, surrealist films in 1930 with *The Blood of a Poet*, which combines lyric imagery with music by French composer Georges Auric [**Figure 9.10**].

Most historians consider *Meshes of the Afternoon* (1943) by Russian-born Maya Deren and her Czech husband, Alexander Hammid, the beginning of the American avant-garde's historical prominence (see the Film in Focus feature about this film later in this chapter). Lightweight 16mm cameras, introduced as an amateur format and widely used during World War II for reportage, appealed to Deren and other midcentury artists seeking more personal film expression. The striking imagery and structure of Deren's films and her tireless advocacy for experimental

9.9 *Allegretto* (1936). The films of animator Oskar Fischinger are designed as visual music.

9.10 *The Blood of a Poet* (1930). Jean Cocteau's first poetic experiment on film remains one of the best-known avant-garde films.

film as a writer and lecturer shaped the conditions for, and aesthetics of, American "visionary film," the term coined by scholar P. Adams Sitney for this experimental film movement.

1950s–1960s: The Postwar Avant-Garde in America

Stan Brakhage, a protégé of Deren, is the most influential of the next generation of American avant-garde filmmakers, with four hundred 16mm and 8mm films, mostly silent, produced in a career spanning almost half a century. Although most of his films arrange imagery in sensual, abstract patterns, they also rely on very personal subject matter, such as the intimate images of his wife Jane giving birth in *Window Water Baby Moving* (1959) [**Figure 9.11**]. Working with the film stock itself—painting, scratching, and even taping moth wings to celluloid in *Mothlight* (1963)—Brakhage emphasized the materiality of film and the direct creative process of the filmmaker.

The American experimental film community established its own alternative exhibition circuit, including New York's Cinema 16 and the Anthology Film Archives (established in 1969 and cofounded by filmmaker Jonas Mekas), as well as distribution cooperatives such as the Film-Makers' Cooperative and Canyon Cinema. The exchanges fostered among artists and audiences profoundly influenced later generations of filmmakers working with film as personal expression.

The countercultural impulses of many midcentury U.S. filmmakers were reflected in their preferred term **underground film**—nonmainstream film associated particularly with the experimental film culture of 1960s and 1970s New York and San Francisco. In New York, pop artist Andy Warhol definitively shaped the underground film movement. He explored the properties of cinema as a time-based medium in his eight-hour view of the Empire State Building, *Empire* (1964), the five-hour *Sleep* (1963), and other films. He also created his own version of the Hollywood studio system at the Factory, whose "superstars"—underground male and female devotees of glamour such as Viva, Mario Montez, and Holly Woodlawn—were featured in films he either directed or produced, including *Chelsea Girls* (1966) and *Flesh* (1968), respectively [**Figure 9.12**]. A legendary figure in this gay underground film scene, New York filmmaker Jack Smith incorporated his

text continued on page 320 ▶

9.11 *Window Water Baby Moving* (1959). The visceral effects of images of childbirth are tempered by silence and the lyrical play of light and water.

9.12 *Chelsea Girls* (1966). The singer and Warhol "superstar" Nico appears in this Andy Warhol and Paul Morrissey film. Composed of vignettes filmed in New York's Chelsea Hotel, the film was projected on two screens arranged side by side.

9.16 *Flaming Creatures* (1963). Perhaps the most famous (and most notorious) of Jack Smith's works, this film, which featured several surreal and disturbing sex scenes, was seized by the police during its premiere and banned for being "obscene."

9.17 *Symbiopsychotaxiplasm* (1968). A hybrid of fiction and documentary, William Greaves's film about making a film in Central Park in 1968 is a fascinating record of the counterculture.

sublime and campy films and slides into erratically timed live performances in his downtown loft. In one notorious incident, a screening of Smith's *Flaming Creatures* (1963) was shut down by the police for the film's provocative content [Figure 9.16].

Maya Deren's role in the New York avant-garde also opened up space for women filmmakers. Shirley Clarke made abstract films like *Bridges-Go-Round* (1958) (see the Form in Action feature on this film later in this chapter) and the remarkable interview film *Portrait of Jason* (1967) and cofounded the influential Film-Makers' Cooperative of New York. Yoko Ono pursued filmmaking in addition to music and other areas of artistic expression, producing the humorous *Film No. 4 (Bottoms)* (1966) and the harrowing *Rape* (1969). By the late 1960s and early 1970s, an explicitly feminist avant-garde movement emerged with artists and filmmakers like Carolee Schneemann, who filmed herself and her husband making love in *Fuses* (1967).

The underground film movement frankly explored gender and sexual politics, and the political radicalism of the late 1960s was addressed at the border between documentary and experimental practice. African American actor, independent filmmaker, and documentarian William Greaves investigated the power relations observed on a film shoot in his feature-length *Symbiopsychotaxiplasm* (1968) made in Central Park [Figure 9.17]. Thirty-seven years later, Greaves incorporated footage from the summer of 1968 with new scenes featuring the same actors in a sequel called *Symbiopsychotaxiplasm: Take 2 1/2* (2005), produced with the assistance of independent film stalwarts Steven Soderbergh and Steve Buscemi.

Experimental filmmaking also flourished outside of New York. San Francisco, the heart of the counterculture and gay and lesbian rights movements, hosted its own vibrant avant-garde film scene, exemplified in the work of poet and filmmaker James Broughton and the prolific lesbian experimental filmmaker Barbara Hammer, who began her career in the Bay Area with short explorations of nature and the female body, such as *Multiple Orgasm* (1976). Canadian filmmaker Michael Snow explores space, time, and the capacity of the camera to transcend human perception in works identified as **structural film**—an experimental film movement that emerged in North America in the 1960s, in which films were organized around structural principles. In Snow's *La région centrale* (1971), a camera mounted on a specially built apparatus pans, swoops, and swings to provide an unprecedented

view of the mountainous Quebec region named in the film's title [**Figure 9.18**]. The avant-garde tradition is rich in Canada; some of its significant practitioners include Joyce Wieland, notable for films such as *Rat Life and Diet in North America* (1968), and in the next generation, Bruce Elder, whose forty-two-hour cycle of films collectively titled *The Book of All the Dead* was completed in installments from 1975 to 1994.

1968–1980: Politics and Experimental Cinema

Outside North America, experimental film impulses have often been incorporated into narrative filmmaking and theatrical exhibition rather than confined exclusively to autonomous avant-garde circles. During the postwar period in Europe, Asia, and Latin America, innovative new wave cinemas challenged and energized commercial cinemas with their visions and techniques. Such experimentation was spurred by student unrest, decolonialization and independence movements, and opposition to the American war in Vietnam.

Radical content and formal rigor characterized the films of Jean-Luc Godard and Chris Marker in France, Alexander Kluge in Germany, and Peter Wollen and Laura Mulvey in Britain. The massive traffic jam depicted in *Weekend* (1967) foregrounds Godard's revolutionary critique of consumerist culture through the consistent use of lateral tracking shots that are intended to hold viewers at arm's length [**Figure 9.19**]. Kluge, a central figure in the New German Cinema, addressed the Nazi legacy through experimental means in films like *The Patriot* (1979), in which a history teacher literally digs for the past with a spade. The influential theoretical writings of Peter Wollen and Laura Mulvey critiqued cinematic illusionism and narrative as complicit with the capitalist culture of individualism. These topics are made part of their critique of the conventional representation of women's bodies in their collaborative film *Riddles of the Sphinx* (1977).

Feminist exploration of cinematic tools and traditions came into its own in the 1970s and 1980s, and although much of this movement used documentary to tell previously untold stories, there was also a strong commitment to questioning form. Yvonne Rainer incorporated her work as an avant-garde dancer and choreographer, as well as experiments with language and text, in the feature-length *Film about a Woman Who ...* (1974). Barbara Hammer continued to use experimental film language to explore lesbian identity, eroticism, and other questions of representation, making more than eighty short films. Much of this work—as well as that of experimental feminist filmmakers outside the United States, including Belgium's Chantal Akerman, England's Sally Potter, and France's Marguerite Duras—was analyzed in and fostered by the galvanizing critical work by Mulvey and other feminist film theorists in the 1970s and 1980s.

9.18 *La région centrale* (1971). Michael Snow's 16mm camera moves wildly on a special mount, rendering the landscape abstractly through mechanized vision. Courtesy of Michael Snow

9.19 *Weekend* (1967). Jean-Luc Godard's blistering critique of middle-class values is a famous example of the European avant-garde or countercultural cinema.

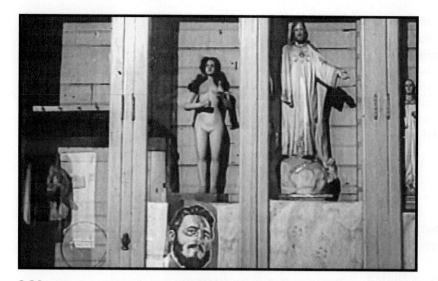

9.20 ***Memories of Underdevelopment*** (1968). Documentary footage interrupts the musings of an alienated intellectual in postrevolutionary Cuba in this commonly cited example of Third Cinema.

Cinema in the postrevolutionary and postcolonial periods of countries like Algeria, Cuba, and Senegal was also very concerned with the politics of representation. However, limited means and populist intentions meant that experimental techniques were used in conjunction with realist filmmaking strategies. Under the political repression of a military dictatorship, Argentine filmmakers Fernando Solanas and Octavio Getino called for a **Third Cinema**—a term coined in the late 1960s in Latin America to echo the phrase and concept "Third World." This cinema opposed commercial and auteurist cinemas with a political, populist aesthetic and united films from a number of countries and contexts. Solanas and Getino's epic documentary film *The Hour of the Furnaces* (1968) was made to engage audiences directly in the ongoing revolutionary struggles in Latin America. Cuban filmmaker Tomás Gutiérrez Alea's *Memories of Underdevelopment* (1968) uses experimental techniques such as the incorporation of documentary footage and self-reflexive voiceover in its narrative of a European-identified intellectual's sense of displacement in the aftermath of the Cuban revolution **[Figure 9.20]**.

The first feature film made in sub-Saharan Africa—Ousmane Sembène's *Black Girl* (1966), about an African domestic worker's alienation in France—makes an aesthetic virtue of economic necessity, notably in its use of postsynchronized sound. Sembène shot the film silent and added the voiceover later, a device that adds to our perception of the heroine's isolation. In *Perfumed Nightmare* (1978), Filipino filmmaker Kidlat Tahimik creates a witty parable of the clash between the "developed" world and the village of his birth by using a home movie aesthetic that incorporates cheap props and found footage.

Boundaries between experimental and documentary forms also began to blur during this period. In essay films by such filmmakers as Chris Marker in France, Kluge and Harun Farocki in Germany, and Jonas Mekas and Jill Godmilow in the United States, the "truth" of documentary is questioned. Self-reflexive techniques foreground experimental film's ability to see referential imagery in new ways. These richly interactive traditions are an important legacy for later video and digital-based media.

1980s–Present: New Technologies and New Media

Although filmmakers continued to experiment using Super 8 and 16mm (and Super 16) formats, a radical shift to use and interrogate new technologies was driven by the introduction of consumer video formats. With the Sony Portapak in the late 1960s, electronic video technology became available to artists for the first time. Video art pioneer Nam June Paik brought television into confrontation with the art world in video works that also were often works of installation art. During the 1980s, the advent of inexpensive consumer video formats spurred growth in activist videos and video art. Exemplary of both is Marlon Riggs's *Tongues Untied* (1989), a personal and poetic depiction of black gay men and HIV **[Figure 9.21]**. On the other end of the commercial spectrum, the launch of the MTV cable television channel

in 1981 brought many previously experimental techniques—such as rapid montage, use of handheld cameras, breaking of continuity rules, and juxtaposition of different film stocks—into the mainstream, where they were quickly incorporated into commercials, television shows, and movies. Spike Jonze, for instance, developed the nonlinear narratives and inventive visuals of his commercial and music video work in his feature film *Being John Malkovich* (1999).

The integration of computers and digital video in the 1990s blurred the lines between capturing on video and on film. In the independent and experimental sector of filmmaking, these media had distinct histories, cultures, and aesthetics. Commercial filmmakers used digital effects, like the credit sequence of *Se7en* (1995) that paid homage to Stan Brakhage, and video artists found new theatrical audiences for grassroots and gallery-based work by transferring it to film. At the same time, new media artists drew on mass media in computer-based work like **machinima**—a new media form that modifies videogame engines to create computer animation. The development of the Internet revolutionized the potential for interactive art, allowing users to participate actively and determine their experience of the artwork. Web series became a platform for artists to explore serial form. Finally, widespread access to computer technology has blurred the boundaries between artists and viewers, democratizing experiments with media forms and technologies.

9.21 *Tongues Untied* (1989). Poet Essex Hemphill appears in Marlon Riggs's *Tongues Untied*, one of the best known of the many experimental video works exploring issues of politics and identity that were facilitated by the availability of camcorders in the 1980s.

Formalist Strategies

A common understanding of the origins of cinema is that the Lumière brothers' short scenes of everyday life and scenic views represent the beginnings of the documentary tradition and that Georges Méliès's trick films represent the beginnings of narrative film. But as film scholar Tom Gunning has pointed out, both types of film had a common objective—to solicit the viewer's desire simply to *see* something. Gunning suggests that early cinema's "Look at me!" quality not only shapes key components of dominant traditions (such as special effects, musical numbers, and comedy skits) but also prefigures avant-garde cinema, which demands that viewers see with fresh eyes. Gunning's framework also implies that both documentary and narrative elements can be included in experimental practice. From Émile Cohl's *Automatic Moving Company* (1910), which uses animation to show spoons and other household items magically packing themselves away, to Douglas Gordon's *24-Hour Psycho* (1993), which slows down Alfred Hitchcock's 1960 film *Psycho* to play around the clock in a museum installation, experimental media forms have intrigued, delighted, and challenged viewers.

Film, video, and multimedia have been embraced as means of artistic expression that are distinct from but that draw on other arts such as photography, music, and theater. Commonalities include the properties of camera lenses shared with photography, the unfolding in time shared with music, and the configuration of audience and spectacle shared with theater. And like avant-garde movements in these other arts, experimental films often explore formal questions specific to the medium. Indeed, a great many experimental films are exercises in **formalism**—a critical approach to cinema that emphasizes formal properties of the text or medium over content. Many different experimental practices are motivated by

formal explorations of the qualities of light, the poetry of motion, and the juxtaposition of sound and image and by phenomenological inquiries into our ways of seeing. These practices include cameraless film (made by exposing film stock), video pastiche (made by reediting television shows), and computer art (which often depends on the user to determine the work's final form). Two primary formalist strategies are abstraction and narrative experimentation.

Abstraction

Abstract films are formal experiments that are also nonrepresentational. They use color, shape, and line to create patterns and rhythms that are abstracted from real actions and objects. Just as an abstract painting might foreground the texture of paint and the shape of the canvas, an abstract film might explore the specificities of film as a time-based medium by alternating forms rhythmically. Tony Conrad's *The Flicker* (1965) rigorously uses the editing of black-and-white frames to produce a phenomenological experience—the flicker effect that the audience is subjected to when the film is projected. Len Lye also uses black leader in *Free Radicals*, scratching patterns and lines directly on the stock. Begun in 1958, the four-minute film was not released until 1979. Abstraction has been embraced by a range of movements—from the 1920s absolute cinema of Richter and Eggeling, to the 1960s psychedelic films such as Storm De Hirsch's *Third Eye Butterfly* (1968) **[Figure 9.22]**, to current-day motion graphics.

Narrative Experimentation

Many experimental films are non-narrative in that they lack well-defined characters or logical plots (see Chapter 7). But it is hard to avoid narrative completely in a time-based medium because its basics are implied in the sequence of beginning, middle, and end. For some viewers, Alain Resnais's *Last Year at Marienbad* (1961) seems primarily a non-narrative study in the structural repetition and geometry of the rooms, hallways, and gardens of a baroque estate. For others, the film's formalism holds clues to an elusive plot about a man's sinister pursuit of a woman **[Figure 9.23]**. Chantal Akerman's films are just as formally interested in time, but their experimental techniques are more minimalist. In her most widely praised film,

VIEWING CUE

Consider how abstraction is achieved and used in a film screened for class. How do repetition and variation contribute to the film's shape?

9.22 *Third Eye Butterfly* (1968). Patterns emerge from natural and spiritual imagery in Storm De Hirsch's abstract film. Courtesy of Anthology Film Archives, all rights reserved

9.23 *Last Year at Marienbad* (1961). Characters and mise-en-scène suggest a narrative, but formal patterns disrupt linear time and coherent space.

9.24 *An Oversimplification of Her Beauty* (2012). Animated interludes punctuate live-action sequences in a recursive tale of romance narrated in the second person.

Jeanne Dielman, 23 Quai du Commerce, 1080 Bruxelles (1975), Akerman's consistent use of a stationary long take to frame images as flat planes make the viewer's attention oscillate between narrative and formal figures of space and time.

Often new technological capabilities encourage speculation on the relationship between narrative and form. A dreamlike, collage aesthetic builds on a simple narrative premise in Terence Nance's inventive *An Oversimplification of Her Beauty* (2012). A voiceover sets up a scenario: you have come home from work and found that the woman you planned to spend the evening with has canceled, and then asks, "How would you feel?" Possible responses are played out through animated sequences, narrative asides, voiceover variations, and replays with different camera formats and effects **[Figure 9.24]**. Narrative becomes a vehicle for experimenting through game-like play and a way of anchoring more fanciful sounds and images for the viewer. Immersive experiences designed for virtual reality technologies also explore narrative as both universal hook and individual perspective. In Milica Sec's *Giant* (2016), a family is trapped in a war zone, and the two parents distract their young daughter by making up a story in which bomb blasts are the footsteps of a giant.

Experimental Organizations: Associative, Structural, and Participatory

Although mainstream narrative films have predictable patterns of enigma and resolution and documentaries follow one of a number of expository practices, experimental works organize experiences either in ways that defy realism and rational logic or in patterns that follow strict formal principles. Whether experimental forms are abstract or representational and whether or not they draw on narrative, we can think of their organizations in the following ways—associative, structural, or participatory.

Associative Organizations

Sigmund Freud used free association with his patients to uncover the unconscious logic of their symptoms and dreams. Associative organizations create psychological or formal resonances, giving these films a dreamlike quality that engages viewers' emotions and curiosity. Associative organizations can be abstract, such as in musicologist Harry Smith's films that relate shapes in succession or create resonances

 VIEWING CUE

What is the principle of organization of the next experimental film you see in class? Identify the most representative shot or sequence, and discuss its meaning.

text continued on page 328 ▶

FILM IN FOCUS

FILM IN FOCUS

LaunchPad Solo

To watch a clip from *Ballet mécanique* (1924), see the *Film Experience* LaunchPad.

Formal Play in *Ballet mécanique* (1924)

See also: *Anemic Cinema* (1926)

9.25 *Ballet mécanique* (1924). Movement proliferates onscreen through refracted images of machine parts in motion.

Painter Fernand Léger collaborated with filmmaker Dudley Murphy on *Ballet mécanique* (1924), a film designed to accompany George Antheil's musical composition of the same title, which called for player pianos and airplane propellers, among other instruments. Cubist painters broke from realism in order to present the process of perception in their work, transforming the flat canvas with angular shapes and lines. Léger's paintings borrowed from cubism and from futurism's celebration of the machine age. His distinctive elongated shapes and thick black outlines suggest mechanical dynamism. His film explores related principles, literally setting geometrical shapes in motion. Quick cuts transform a circle to a triangle and back again. Léger was among the first of many modernist visual artists in the 1920s who saw cinema as a perfect medium to explore dynamism—one of the primary properties of the new art and the new age.

Circles and triangles are introduced in *Ballet mécanique* by abstracted photographic images. A straw hat filmed from above is echoed in the circle, and the back-and-forth arc of a woman on a swing traces a triangular shape. Rather than referencing reality or building a story, these recognizable images become part of a rhythmic chain. Photographic images of moving parts are even less identifiable. Not only are they filmed in motion and moved onscreen and offscreen by the editing that associates one moving part with the next, but they are also refracted, mirrorlike, by optical printing techniques so that they are repeated in multiple sectors within the frame itself **[Figure 9.25]**. The title's suggestion of a mechanized dance is clearly figured in these groups of images.

The film's title also implies that cinema could be regarded as a mechanization of what we know to be a human activity—ballet. As in all visual arts, the human form onscreen has a special attraction to the viewer. It orients us and invites our identification and narrative expectations: who is the woman on the swing, and what does she want? Many modernist artists use the human figure in a notably different way—as an object rather than a subject, as an element like any other in the frame, or as part of a machine. The swinging woman is the first image of the film, and we might think of the images that follow as her daydream, an interpretation supported by the final image of her smelling a flower. But we are also encouraged to abstract her image into one among many in a pattern of shapes and movements, as when the same footage of her swinging is shown upside down.

Indeed, one of the most notable ways that avant-garde art of the 1920s explored the connection between the human form and the machine was through fragmented images of modern women. In *Ballet mécanique*, a second female form appears—at first, simply as a pair

9.26 *Ballet mécanique* (1924). The fragmentation and abstraction of the female form is a common practice in modernist art.

of lips sharply outlined in lipstick (cosmetics were widely popularized during this period) and isolated in the frame by a black mask over the rest of the face **[Figure 9.26]**. The lips smile and relax, intercut with the image of the straw hat. The same woman also becomes part of the patterns of the film. In a later shot, her plucked eyebrows echo the curved shape of her eyes so that a quick cut of the eyes upside down goes by almost undetected. We do eventually see the woman's full head in profile, but the bobbed hair and stylized pose make her a sculptural image rather than a character to identify with.

A later "dance" of alternating images of mannequin legs adorned with garters is at the same time a delightful visual joke and a disturbing evocation of dismemberment. The male form is treated differently in the film: a male head appears at the center of the refracted frame, perhaps signifying mind instead of body. Yet this image's closest visual rhyme is with a parrot framed in the same way, a surreal association that prevents us from reading him as a guiding consciousness behind the film's succession of images.

Approaching an abstract film or any experimental media work is made easier by close description of its formal elements, identification of its patterns, and synthesizing of its themes, as we have attempted here. An intriguing clue to the formal concerns of *Ballet mécanique* lies in the image that appears before the title: Hollywood silent film comedian Charlie Chaplin is rendered in a fragmented form very reminiscent of Léger's paintings. The film, the credit says, is presented by "Charlot," the French name for Chaplin. At the end of the film, the image does a little animated dance of its own, a mechanized ballet **[Figure 9.27]**. An actor's iconic film image is thus first paid tribute to by a painter in a graphic form and then enfolded into the last of the film's sequence of everyday objects set in motion, demonstrating the vibrant exchange between cinema and the other arts in this period of modernist experimentation.

9.27 *Ballet mécanique* (1924). Charlie Chaplin's iconic image is animated by Fernand Léger.

9.28 *Film Number 7* (1951). Famous for his collections of American folk music, Harry Smith also made inventive animations in which found objects are organized in abstract associative patterns.

9.29 *Decasia* (2002). Patterns created by decaying nitrate film stock emerge on the surface of found footage, the layering suggesting impermanence and loss.

9.30 *The Hand* (1965). The hand symbolizes a figure of tyrannical power in this puppet film from eastern Europe.

between objects and shapes or colors [**Figure 9.28**]. They also can be representational, like in music videos, whose narratives may follow a dreamlike logic of psychological patterns or violent juxtaposition.

Metaphoric Associations. Metaphoric associations link different objects, images, events, or individuals in order to generate a new perception, emotion, or idea. In a film, this might be done by indicating a connection between two objects or figures by a cut or a compositional association or by creating metaphors in the voiceover commentary as it responds to and anticipates images in the film. Juxtaposing images of workers being shot and a slaughtered bull, as Sergei Eisenstein does in *Strike* (1925), metaphorically evokes the brutal dehumanization of the workers. Derek Jarman's *Blue* (1993) — perhaps best described as an experimental autobiography — is a metaphoric meditation on the color blue and its chain of associations in the life of the filmmaker, who died of AIDS in 1994. Accompanying one single blue image, a voice meditates: blue becomes associated with the "blue funk" created by a doctor's news, the "slow blue love on a delphinium day," and "the universal love in which all men bathe." Bill Morrison's *Decasia* (2002) edits together old films whose nitrate stock has deteriorated so that recognizable images and spaces blend into abstract splotches and blobs [**Figure 9.29**]. Metaphorical associations emerge in the dance of fleeting shapes, edited juxtapositions, and imagery called forth by Michael Gordon's symphonic soundtrack.

Symbolic Associations. Unlike the concrete associations that bind metaphoric images, symbolic associations isolate discrete objects or singular images that can generate or be assigned abstract meanings — either meanings already given to those objects or images by a culture or meanings created by the film itself. The symbolic significance may be spiritual (as with the Christian cross) or political (such as the flag of a particular country), or it may be tied to some other concept that has been culturally and historically grafted onto the meaning of a person, an event, or a thing. For example, in Czech filmmaker Jiří Trnka's experimental film *The Hand* (1965), a puppet struggles against the domination of a single, live-action hand that demands he make only other hands and not flowerpots [**Figure 9.30**]. The hand is a chillingly effective symbol of totalitarian regimes in eastern Europe at that time.

Author William Wees refers to the avant-garde film tradition as "light moving in time" and notes that the three elements of light, motion, and time are shared with human vision. Kenneth Anger's *Lucifer Rising* (completed in 1972 and released in 1980) is a richly imagistic film about esoteric ritual that uses natural and Egyptian symbols in an exploration of the principle of light.

Structural Organizations

Experimental films that employ structural organizations engage the audience through a formal principle rather than a narrative or chain of associations. Such films may focus on the material of the film itself, such as its grain, sprockets, and passage through a projector. This organization, which may follow a particular editing logic or image content, informs a wide variety of media artworks, including the stationary camera films of Andy Warhol, the video works of artist Bruce Nauman, and digital artworks generated by algorithms.

Artist Christian Marclay's *The Clock* (2010) is a widely acclaimed example of a structural film. This twenty-four-hour film is compiled entirely of clips from films and television shows that include clocks or other timepieces referencing the real time of viewing. The museum installation is both conceptual and experiential. The viewer can tell the time from the artwork itself and also engage in the pleasure of an extended "mash-up" of thousands of time-related scenes.

Some filmmakers weave images, framings, camera movements, or other formal dimensions into patterns and structures that engage the viewer perceptually and often intellectually. Michael Snow's *Wavelength* (1967) is a forty-five-minute image that slowly moves across a room in an extended zoom-in and ends with a close-up of a picture of ocean waves pinned to the wall **[Figure 9.31]**. Punctuated with vague references to a murder mystery and accompanied by a high-pitched sound that explores another meaning of "wavelength," this movie is an almost pure investigation of the vibrant textures of space—as flat, as colored, as empty, and most of all, as geometrically tense. In a sly nod to the new temporal capacities of digital media, Snow superimposed the film on itself to make a new version: *WVLNT (or Wavelength for Those Who Don't Have the Time* (2003).

Other films central to the structural film movement in the United States include Ernie Gehr's *Serene Velocity* (1970) and Hollis Frampton's *Zorns Lemma* (1970). *Serene Velocity* consists of images of the same hallway taken with structured variations in the camera's focal length, creating a hypnotic, rhythmic experience of lines and squares. In *Zorns Lemma*, a repeated sequence of one-second images of words on signs and storefronts arranged in alphabetical order creates a fascinating puzzle as they are replaced one by one with a set of consistent, though arbitrary, images **[Figure 9.32]**. The viewer learns to associate the images with their place in the cycle, in a sense relearning a picture alphabet. Such structural principles are fascinating intellectually, but Frampton's films, like the most effective structural films, also work on the viewer's senses.

9.31 **Filmstrip showing frames of *Wavelength*** (1967). An extended zoom-in for the duration of the film creates suspense through its formal structure. Courtesy of Michael Snow

9.32 ***Zorns Lemma*** (1970). Hollis Frampton's films are often organized around structural principles, as in this film's central sequence of images corresponding to cycles of the alphabet. Courtesy of Anthology Film Archives, All Rights Reserved

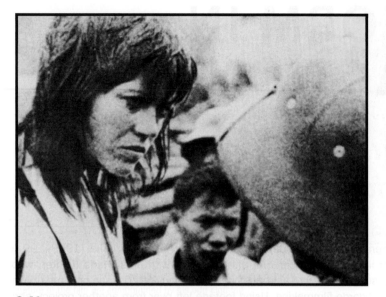

9.41 *Letter to Jane* (1972). Jean-Luc Godard and Jean-Pierre Gorin critique a photograph of American actress Jane Fonda for the liberal—rather than radical—politics it represents. Although prescient in its scrutiny of celebrity culture, the film can be seen as misogynist and even cruel in its confrontational style.

Counter Cinema. The European avant-gardes of the 1920s became a conscious model for filmmakers like Jean-Luc Godard. His films in the 1960s were partly experimental, challenging commercial film conventions through unusual sound and image juxtapositions or by having actors go in and out of character. But as the critical and political environment of this period became more intense, the confrontational impulse of what became known as counter cinema went deeper. Godard and his collaborators started making consciously noncommercial films like *British Sounds* (1970) under the name Dziga Vertov Group. In 1972, Godard and his partner, Jean-Pierre Gorin, made a film called *Letter to Jane* that scrutinizes a still photograph of liberal American actress Jane Fonda listening sympathetically on a visit to Vietnam. In voiceover, Godard and Gorin critique this image for its political naiveté **[Figure 9.41]**. The radicalism of this period was hard to sustain, but the confrontational impulse informs all of Godard's work. For example, the intricate image and sound montages of the multipart *Histoire(s) du cinéma* (1988–1998) ask viewers to look at all the meanings that images accumulate over time.

Many critical and confrontational techniques are associated with political or theoretical positions that dismantle the assumed relationship between a word or an image and the thing it represents, encouraging audiences to participate in the experiments at hand. Such modernist aesthetic strategies are rooted in the social critiques of the late 1960s. One of the most interesting and influential approaches to the image-oriented society of consumer capitalism was advanced by Guy Debord in a book and film called *The Society of the Spectacle* (1967 and 1973, respectively). Debord argued that images themselves—taken out of context through a process called *détournement* or diversion—were the only way to transform the image-oriented society. Feminist filmmakers like Yvonne Rainer, Laura Mulvey, and Peter Wollen used critical techniques to question the representation of women in film. In the 1980s, video artists extended this critical function toward mainstream media, and new media works today often demand that viewers question *how* they are looking at something as well as *what* they are looking at.

Filmmakers of color have embraced experimental strategies alongside documentary's potential as counter cinema. From Britain, Sankofa's *Passion of Remembrance* (1986) combines political debate with newsreel footage and dramatic sequences, and the Black Audio Film Collective's *Handsworth Songs* (1986) juxtaposes footage of rioting and West Indian carnival traditions with a voiceover that analyzes colonial history and the reasons for current racial unrest. In *Night Cries: A Rural Tragedy* (1989), Australian Aboriginal artist Tracey Moffatt uses stylized sets and sounds and disjunctive editing to tell a story about the mid-twentieth-century assimilation policies that forced single Aboriginal mothers to have their babies adopted by married white couples **[Figure 9.42]**.

In the 1980s, activist videos—particularly those inspired by government indifference to the AIDS crisis—employed a confrontational style. Although based in documentary in its presentation of information, activist media also used experimental techniques of editing, design elements drawn from advertising and

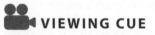

VIEWING CUE

Watch a clip from *The Future* (2011) online. What aspects of the clip employ a traditional narrative style? What aspects of this narrative film bring to mind experimental film techniques?

9.42 *Night Cries: A Rural Tragedy* (1989). The fraught relationship between a grown Aboriginal daughter and the elderly white mother who adopted her as a child is conveyed without dialogue through the film's innovative sets, lush 35mm cinematography, and sound work. Courtesy of the artist and Roslyn Oxley 9 Gallery, Sydney

9.43 *They Are Lost to Vision Altogether* (1989). Artist Tom Kalin conveyed competing impulses of mourning and militancy in response to the AIDS crisis in the elegiac imagery of this videotape.

propaganda, and self-conscious voiceover and personal reflection. Tom Kalin's *They Are Lost to Vision Altogether* (1989) combines elegiac imagery with footage of marches, portraying strategies of mourning and militancy employed by AIDS activists **[Figure 9.43]**. Online activist media takes many different forms, from deflecting the messages of mainstream media through reediting to citizen journalism.

CONCEPTS AT WORK

Experimentation is part of the film experience: the words share the same root. The dream logic of a film like *Meshes of the Afternoon* is readily understood by the viewer without requiring rational explanation. Film form reflects modern ways of seeing through abstract pattern in *Ballet mécanique* and lyrical camera movement in *Bridges-Go-Round*. We encounter experimental techniques in the work of the most innovative contemporary filmmakers, such as the complex storytelling and whimsy of Miranda July's *The Future* (2011) or the conceptual nature of Lars von Trier's *Melancholia* (2011). Today, with our pervasive self-consciousness about the presence of media in our lives, a popular work like *Lemonade* is able to mobilize experimental aesthetics to make a strong social statement.

- Look at how editing works within a fragment of *Lemonade*. Be sure to count the shots. How might the same scene look if it were edited in continuity style?
- Explore moving-image media in a museum setting. How are space and time explored?
- Find the structural patterns in *Zorns Lemma*, and consider the aftereffects of viewing this film. Do you continue to seek such patterns?
- Identify experimental practices in a mainstream film. Do they affect narrative coherence or aesthetic impact?

LaunchPad Solo

Visit the LaunchPad Solo for *The Film Experience* to view movie clips, read additional Film in Focus pieces, and learn more about your film experiences.

10.7 **Star Trek Beyond** (2016). Sequels and franchises cash in on the repetitive pleasures of genre formulas.

10.8 **Devdas** (2002). Internationally successful, *Devdas* illustrates the successful globalization of national genres.

familiar entertainment **[Figure 10.7]**. Franchises such as the live-action *Spider-Man* films (2002–2007, 2012–2014, 2017) spread genre elements into other platforms, such as video games.

Increasingly, the commercial movie business centered not only on Hollywood. Hong Kong action films like John Woo's *The Killer* (1989) established a worldwide fan base by combining the successful national and regional genre of martial arts films with formulas of Hollywood action films, and they proved that films made outside Hollywood could be globally profitable. Bollywood films, characterized by their extravagant song-and-dance sequences and megastars, deepened their popularity beyond the Indian subcontinent and South Asian communities abroad by relying on the Internet and DVD distribution. *Devdas* (2002), a spectacular romance about two young soul mates separated when young and doomed to live lives of unfulfilled love, became widely distributed and popular, especially in the United Kingdom and the United States **[Figure 10.8]**.

History renews some genres but also demands the invention of new ones. Because genre is always a historical negotiation, an awareness of the vicissitudes of cultural history makes movie genres more vital and meaningful. Recognizing those vicissitudes, however, also requires an understanding of the formal elements that define a particular genre.

The Elements of Film Genre

Genres identify group, social, or community activities and seem opposed to the individual creativity we associate with many art forms, including experimental films. A film may work creatively and individually within its genre, but the work must begin within the framework of acknowledged conventions and formulas that audiences expect. Our recognition of these formulas represents a bond between filmmakers and audiences, determining a large part of how we see and understand a film. Film genres thus describe a kind of social contract that allows us to see a film as part of both a historical evolution and a cultural community. For instance, the western, recognizable by scenes of open plains and lone cowboys, engages audiences' common knowledge of and interest in U.S. history and "how the West was won" in different ways and to different ends over time **[Figures 10.9a and 10.9b]**.

VIEWING CUE

For a movie you have recently watched, identify the genre, and describe three conventions typically associated with this genre.

Conventions

The most conspicuous dimensions of film genres are the conventions, formulas, and expectations through which we identify certain genres and distinguish

(a) **(b)**

10.9 **The western film genre: (a)** *My Darling Clementine* (1946) and **(b)** *Johnny Guitar* (1954).
Genres represent a bond between filmmakers and audiences that must be renegotiated by each genre film.
One western may meet expectations about cowboys in gunfights, and another may realign those expectations
by placing women at the center of the story's action.

them from others. Generic conventions are properties or features that identify a
genre, such as character types, settings, props, or events that are repeated from
film to film. In westerns, cowboys often travel alone; in crime films, a seductive
woman often foils the hard-boiled detective. Generic conventions also include
iconography – images or image patterns with specific connotations or meanings.
Dark alleys and smoky bars are staple images in crime movies. The world of the
theater and entertainment industry is frequently the setting for musicals, as in *Rock
of Ages* (2012) **[Figure 10.10]**.

These conventions and iconographies sometimes acquire larger meanings and
connotations that align them with other social and cultural **archetypes** – that is,
spiritual, psychological, or cultural models expressing certain virtues, values, or
timeless realities. For example, a flood is an archetype used in some disaster films
to represent the end of a corrupt life and the beginning of a new spiritual life, such
as in Peter Weir's *The Last Wave* (1977), with its ominous visions of a tidal wave
that will destroy Australia, according to the Aborigines who predict it, as part of a
spiritual process **[Figure 10.11]**.

10.10 *Rock of Ages* (2012). Much of the film revolves around and
takes place in a sleazy 1980s rock club.

10.11 *The Last Wave* (1977). Archetypal imagery, such as the tidal
wave shown here, underpins generic conventions.

10.12 *The Shining* (1980). Jack Nicholson is a writer who suffers a mental breakdown within the walls of a deceptively peaceful Colorado hotel.

Formulas and Myths

When generic conventions are put in motion as part of a plot, they become generic formulas, the patterns for developing stories in a particular genre. Generic formulas suggest that individual conventions used in a particular film can be arranged in a standard way or in a variation on the standard. With horror films, such as Stanley Kubrick's *The Shining* (1980), we immediately recognize the beginning of one of these formulas: a couple decides to live alone with their child in a large, mysterious hotel in the mountains of Colorado and is snowed in during the long winter [**Figure 10.12**]. The rest of the formula proceeds as follows: strange and disturbing events indicate that the house/hotel is haunted, and the haunting possesses the husband/father, leads to frightening visions, and begins to destroy the characters, who flee into the night.

In some cases, these generic formulas also become associated with myths—spiritual and cultural stories that describe a defining action or event for a group of people or an entire community. All cultures have important myths that help secure a shared cultural identity. One culture may celebrate a national event associated with a particular holiday, such as the Fourth of July, and another may see the birth and rise of a great hero from the past as the key to its cultural history. From *Patton* (1970) to *Malcolm X* (1992), historical epics often re-create an actual historical figure as a cultural myth in which the character's actions determine a national identity. In these cases, a U.S. army commander turns the tide of World War II, and a black American Muslim minister serves as spokesperson of the Nation of Islam and as a central figure in the black power movement in the United States [**Figures 10.13a and 10.13b**].

(a)

(b)

10.13 **Historical epics: (a)** *Patton* (1970) and **(b)** *Malcolm X* (1992). Historical epics often use a heroic figure to build a national myth.

The narrative formulas of science fiction films also can relate to broader myths, such as the Faustian myth of selling one's soul for knowledge and power or the story of Adam and Eve's eating from the tree of knowledge and their subsequent punishment. Science fiction films, such as Stanley Kubrick's *2001: A Space Odyssey* (1968), frequently recount explorations or inventions that violate the laws of nature or the spiritual world.

Audience Expectations

Triggered by a film's promotion or by the film itself, generic expectations inform a viewer's experience while watching a

film, helping him or her anticipate the meaning of the movie's conventions and formulas. Thus a narrative's beginning, characters, or setting can cue certain expectations about the genre that the film then satisfies or frustrates. The beginning of *Jaws* (1975), in which an unidentified young woman swims alone at night in a dark and ominous ocean, leads viewers to anticipate shock and danger, participate in the unfolding of the genre, and respond to any surprises this particular film may offer. In *Jaws*, much of the ensuing plot takes place on a sunny beach and open ocean, rather than in the darkened, confined houses of the usual horror film, which is a clever variation that keeps the formula fresh and viewers' expectations attentive.

10.14 *Viridiana* (1961). Reactions to Luis Buñuel's film, which employs a particular Spanish genre to satirize the Catholic Church, vary according to audience members' familiarity with the genre of religious films it attacks.

Indeed, generic expectations underscore the important role played by viewers in determining a genre and the ways that this role connects genres to a specific social, cultural, or national environment. Partly because of Hollywood's global reach and the extensive group of genre films it has produced, most audiences around the world will, for instance, quickly recognize the cues for a horror film or a western. Other non-Hollywood genres may not generate such clear expectations outside their native culture. Generic expectations triggered by a martial arts film are likely to be more sophisticated in China than in the United States. Hence, although *Crouching Tiger, Hidden Dragon* introduced the flying martial arts scenes of "wuxia" to widespread American audiences in 2000, these scenes were a commonly recognized generic figure in Asia well before that date. Likewise, the religious films, or *cine de sacerdotes*, of the 1940s and 1950s were well known in Spain, but their conventions and formulas may not be recognized by viewers from other cultures **[Figure 10.14]**.

Even within a culture, the popularity of certain genres depends on shifting audience tastes and expectations over time. Movie producers' beliefs about which films audiences will want to pay to see reflect historical and social conditions and also a genre's ability to assimilate those conditions. For example, musicals proliferated in the 1930s because they offered audiences an easy escape from the anxieties of the Depression. Film noir crime films flourished in the 1940s and early 1950s during and in the wake of the social upheavals of World War II. U.S. science fiction films had their heyday in the 1950s, when films like *The Day the Earth Stood Still* (1951) packaged and mythologized fears about political and other invasions as concrete aliens and monsters that could be confronted and understood **[Figure 10.15]**. Audience expectations signal the social vitality of a particular genre, but that vitality changes as genres move from culture to culture or between historical periods within a single culture. In this sense, genres can tell us a great deal about community or national identity.

VIEWING CUE

Reflect on a film trailer you recently saw. Based on the generic expectations triggered by the trailer, what conventions or narrative formulas could you expect in the film itself?

10.15 *The Day the Earth Stood Still* (1951). Science fiction films were popular in the Cold War era.

Six Movie Genres

■■ **VIEWING CUE**

Think back to a film you recently watched. Can you identify it as a particular hybrid or subgenre?

From their first days, movies were organized as genres according to subject matter—films about a famous person, panoramic views, and so on. As movies became more sophisticated, however, genres grew into more complex narrative organizations with recognizable formal conventions.

Assembling a list of movie genres can be more daunting and uncertain than it appears. Genres are a product of a perspective that groups together individual movies, sometimes in many different ways. For some scholars or viewers, for instance, film noir is an important movie genre that surfaced in the 1940s, whereas for others, it is less a film genre than a style that appears in multiple genres of the period. Moreover, a particular genre designation may encompass too much or too little: comedies might appear too grand a category for some critics, and screwball comedies may seem too limited a group to be termed a genre. Two terms are helpful when trying to understand the multiple combinations and subdivisions of genres. **Hybrid genres** are mixed forms created through the interaction of different genres to produce fusions, such as musical horror films like *The Rocky Horror Picture Show* (1975) **[Figure 10.16]**. Subgenres are specific versions of a genre denoted by an adjective—for example, the spaghetti western (produced in Italy) or the slapstick comedy. The idea of genres as constellations suggests how genres, as distinctive patterns, can overlap and shift their shape depending on their relation to other genres or as extensions of a primary field. *Blazing Saddles* (1974), for example, belongs both to the subgenre of comedic western and to the hybrid genre of western comedy. Seeing that film from one perspective or the other can make a difference in how we appreciate it **[Figure 10.17]**.

10.16 *The Rocky Horror Picture Show* (1975). A hybrid of horror film and musical comedy genres, this film also shares characteristics with other cult films.

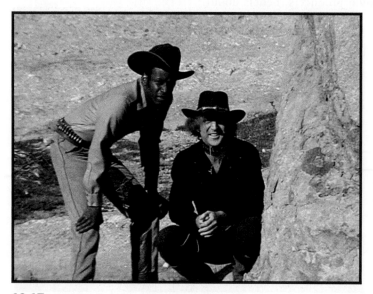

10.17 *Blazing Saddles* (1974). Comedic western or western comedy?

Hybrid genres and subgenres show the complexity of genres as constellations, but it is also helpful to demarcate major genres. Here we focus on six important groupings of films that are generally talked about as genres—comedies, westerns, melodramas, musicals, horror films, and crime films. We aim to define each genre as it has appeared in different cultures and at different points in history and as its social contract changes with different audiences. We also highlight a selection of defining characteristics for each genre, including the following:

■ the distinguishing features of the characters, narrative, and visual style
■ the reflection of social rituals in the genre
■ the production of certain historical hybrids or subgenres out of the generic paradigm

Although these generic blueprints inevitably will be reductive and the generic distinctions will overlap, mapping each of these paradigms can guide our explorations of specific films and how they engage their audiences.

Comedies

Film **comedies** have flourished since the invention of cinema in 1895, as comic actors took their talents to the screen where they could be appreciated even without synchronized sound. This film genre celebrates the harmony and resiliency of social life, typically with a narrative that ends happily and an emphasis on episodes or "gags" over plot continuity. Rooted in the *commedia dell'arte*, Punch and Judy, and the vaudeville stage acts that produced Buster Keaton and a host of other early comedians, film comedy is one of the first and most enduring of film genres. Its many variations can be condensed into these main traits:

- central characters who often are defined by distinctive physical features, such as body shape and size, costuming, or manner of speaking
- narratives that emphasize episodes or "gags" more than plot continuity or progression and that usually conclude happily
- theatrical acting styles in which characters physically and playfully interact with the mise-en-scène that surrounds them

From the 1920s comedies of producer Mack Sennett to the awkward and stumbling Woody Allen as Alvy Singer in *Annie Hall* (1977), comic figures stand out physically because of their body type, facial expressions, and characteristic gestures. Although comedies can develop intricate plots, their focus is usually on individual vignettes. In Sennett's *Saturday Afternoon* (1926), Harry Langdon balances between moving cars and hangs from telephone poles **[Figure 10.18]**. In *Annie Hall*, Alvy jumps around a kitchen chasing lobsters and later squirms at a family dinner table where he imagines himself perceived by others as a Hasidic Jew. In these episodic encounters, the comic world becomes a stage full of unpredictable gags and theatrical possibilities.

Comedies celebrate the harmony and resiliency of social life. Although many viewers associate comedies with laughs and humor, comedy is more fundamentally about social reconciliation and the triumph of the physical over the intellectual. In comic narratives, obstacles or antagonists—in homes, marriages, communities, and nations—are overcome or dismissed by the physical dexterity or verbal wit of a character or perhaps by luck, good timing, or magic. In *Bringing Up Baby* (1938), Katharine Hepburn is a flighty socialite who moves and talks so fast that she bewilders the verbally and physically bumbling paleontologist Cary Grant, who forsakes his scientific priorities for the joys of an improbable romance with her. In *Groundhog Day* (1993), Bill Murray plays a weatherman with many social and professional flaws who falls into a magical world where he relives the day again and again, with the ability to correct his previous errors and romantic blunders. In *Bridesmaids* (2011), anxieties and conflicts between two women friends erupt around the impending marriage of one of them, but after a series of

10.18 *Saturday Afternoon* (1926). Classic silent comedies, such as this Mack Sennett film, depend on physical gags.

10.19 *Bridesmaids* (2011). Within the tensions and transitions of an upcoming wedding, Annie and Lillian remake themselves and their relationship as a comedic reconciliation.

10.20 *The Proposal* (2009). Comic resiliency ultimately brings a seemingly mismatched couple together.

slapstick misunderstandings and fallouts, they rediscover their bond and learn how to integrate it into their romantic relationships with men **[Figure 10.19]**.

Perhaps the most obvious convention in comedies is the happy ending, in which couples or individuals are united in the form of a family unit or the promise of one to come. Traditional comedies often begin with some discord or disruption in social life or in the relationship between two people (lovers are separated or angry, for instance), but after various trials or misunderstandings, harmony is restored and individuals are united. In *The Proposal* (2009), for example, a demanding boss asks her assistant to marry her so she can avoid deportation back to Canada. Despite their mutual annoyance with the arrangement, they visit his family home in Alaska where they comically struggle to maintain the sham engagement, only to fall in love in the end **[Figure 10.20]**.

Historically, as the Hollywood film comedy responded to audience expectations in changing contexts, the genre itself endured numerous permutations and structural changes. Three salient subgenres emerged as a result—slapstick comedies, screwball comedies, and romantic comedies.

Slapstick Comedies

Slapstick comedies, marked by their physical humor and stunts, comprised some of the first narrative films. In the 1910s, the initial versions of this subgenre used printed intertitles rather than spoken dialogue and ran from a few minutes to about fifteen minutes in length. Early films like those of Mack Sennett's Keystone Kops revolved around physical stunts set within fairly restricted social spaces.

By the 1920s, comedy had integrated its gags and physical actions into feature-length films with more elaborate narratives. Still, the slapstick moments stand out, like the scene in *The General* (1927) when Buster Keaton misfires the cannon vertically into the air and manages to avoid disaster when the cannonball fortuitously misses him and just happens to destroy an enemy bridge. Slapstick comedies reemerged in the 1980s with films such as *Porky's* (1982) and *Police Academy* (1984). The ingenuity of physical comedy gave way to scatological and sexual jokes in these films targeted at young male audiences. In *Monty Python's The Meaning of Life* (1983) **[Figure 10.21]**

10.21 *Monty Python's The Meaning of Life* (1983). This birthing scene is an example of the slapstick that fills this social satire.

and *Monty Python and the Holy Grail* (1975), slapstick becomes an ingredient of nonstop social satire. Today the genre is popular again, featuring comic stars such as Will Ferrell in *Daddy's Home* (2015) and Melissa McCarthy in *Spy* (2015) [**Figure 10.22**] and *The Boss* (2016).

Screwball Comedies

In the 1930s and 1940s, **screwball comedies** transformed the humor of the physical into fast-talking verbal gymnastics and

10.22 *Spy* (2015). Slapstick comedy has reinvented itself for new audiences, often through exaggerated physical humor and bizarre dialogue.

unpredictable action, arguably displacing sexual energy with barbed verbal exchanges between men and women when the Production Code barred more direct expression. In effect, these films usually redirected the comic focus from the individual clown to the confused heterosexual couple. *It Happened One Night* (1934), *Bringing Up Baby* (1938), *His Girl Friday* (1940), and *The Philadelphia Story* (1940) are among the best-known examples of screwball comedies. Each features independent women who resist, mock, and challenge the crusty rules of their social worlds. When the right man arrives or returns—one who can match these women in charm and physical and verbal skills—confrontation leads to love. Focused on the nonstop chatter and quirkiness of its heroine, *Miss Pettigrew Lives for a Day* (2008) revives some elements of this formula and its pleasures.

Romantic Comedies

In **romantic comedies**, humor takes second place to the happy ending, typically focusing on the emotional attraction of a couple in a lighthearted way. Popular since the 1930s and 1940s, romantic comedies like *Small Town Girl* (1936), *The Shop Around the Corner* (1940), and *Adam's Rib* (1949) concentrate on the emotional attraction of a couple in a consistently lighthearted manner. This subgenre draws attention to a peculiar or awkward social predicament (in *Adam's Rib*, for example, the husband and wife lawyers oppose each other in the courtroom) that eventually will be overcome by romance on the way to a

happy ending. More recent examples of the "rom-com," as its recent exemplars have come to be known, include Nora Ephron's *You've Got Mail* (a 1998 remake of Ernst Lubitsch's *The Shop Around the Corner*), where the comic predicaments have contemporary twists—email and instant messaging replace the letters of the first version—but the formula and conventions remain fairly consistent. Stephen Frears's romantic comedy *My Beautiful Laundrette* (1985), however, suggests the range of possibilities in the creative (and here political) reworking of any genre. In this case, the social complications include a wildly dysfunctional Pakistani family in London and the romance that blossoms between the entrepreneurial son and a white man who is his childhood friend and a former right-wing punk [**Figure 10.23**].

10.23 *My Beautiful Laundrette* (1985). Director Stephen Frears and writer Hanif Kureishi update the romantic comedy genre to tell an interracial gay love story.

10.24 *Buffalo Bill's Wild West* (1899). At the end of the nineteenth century, William Cody's adventures as an army scout were reenacted in dime novels, stage melodramas, and his wildly popular show, establishing cowboy iconography for movie westerns to build on. MPI/Getty Images

Westerns

Like film comedies, westerns are a staple of Hollywood, although their popularity has waxed and waned in different historical eras. These films are set in the American West and typically feature rugged, independent male characters on a quest or dramatize frontier life. This genre grew out of late-nineteenth-century stories, dime novels, and journalistic accounts of the wild American West **[Figure 10.24]**. The film western began to take shape in the first years of the movie industry as a kind of travelogue of a recent but now-lost historical period. From *The Great Train Robbery* (1903) to *The Revenant* (2015), the western has grown over one hundred years into a surprisingly complex genre while also retaining its fundamental elements:

- characters, almost always male, whose physical and mental toughness separate them from the crowds of modern civilization
- narratives that follow some version of a quest into the natural world
- a stylistic emphasis on open, natural spaces and settings, such as the western frontier regions of the United States

John Wayne as the Ringo Kid in *Stagecoach* (1939) has a physical energy and determination that is echoed by Paul Newman and Robert Redford as *Butch Cassidy and the Sundance Kid* (1969) **[Figure 10.25]**. Never at ease with the law or the restrictions of civilization, these men find themselves on vague searches for justice, peace, adventure, freedom, and perhaps treasure, which would offer them all these rewards. Quests through wide-open canyons and deserts seem at once to threaten, inspire, and humble these western heroes.

10.25 *Butch Cassidy and the Sundance Kid* (1969). Paul Newman and Robert Redford incarnate western heroes for audiences in the 1960s.

Through the trials of a lone protagonist, rugged individualism becomes the measure of any social relationship and of the values of most western communities. Even when they are part of a gang, as in *The Magnificent Seven* (1960), these individuals are usually loners or mavericks rather than representative leaders. More than in historical epics, violent confrontations are central to these narratives, and this violence is measured primarily by the ability and will of the individual rather than the mass, nation, or community, even when it is directed against Native Americans. In *High Plains Drifter* (1973), the moody Clint Eastwood must protect a frightened town from the vengeance of outlaws **[Figure 10.26]**. When a violent showdown concerns two groups—as in the gunfight at the OK Corral between the Earps and

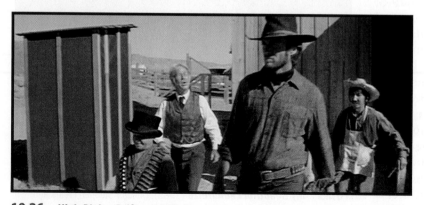

10.26 *High Plains Drifter* (1973). The western hero is often a loner for whom violence comes naturally.

the Clantons in John Ford's *My Darling Clementine*—the battle is often about individual justice or revenge (of sons and brothers) or about who has the rightful claims to the frontier.

Like most film genres, westerns have responded to changing audiences. During the early twentieth century, they were popular among the mass audiences of early cinema and associated with popular forms such as Wild West shows. With a few exceptions, westerns were not a particularly respected genre in the 1920s and early 1930s. Since then, however, three hybrids or subgenres have distinguished the western—the epic western, the existential western, and the political western.

Epic Westerns

The **epic western** concentrates on action and movement and develops a heroic character whose quests and battles serve to define the nation and its origins. With its roots in literature and epic paintings, this genre appears early and often in film history, foregrounding the spectacle of open land and beautiful scenery. An early instance of the epic, *The Covered Wagon* (1923), follows a wagon train of settlers into the harsh but breathtaking frontier, where their fortitude and determination establish the expanding spirit of America. Years later, *Dances with Wolves* (1990) describes a more complex struggle for national identity as a traumatized Civil War veteran allies himself with Native Americans [**Figure 10.27**].

10.27 *Dances with Wolves* (1990). Kevin Costner plays a sympathetic Civil War veteran who commiserates with Native Americans in this modern epic western.

Existential Westerns

In the 1950s, one of the most interesting decades for westerns, the **existential western** took shape. In this introspective subgenre, the traditional western hero is troubled by his changing social status and his self-doubts, often as the frontier becomes more populated and civilized. *The Searchers* (1956), *The Furies* (1950), *Johnny Guitar* (1954), *Shane* (1953), and *The Left-Handed Gun* (1958) are existential westerns with protagonists who are troubled in their sense of purpose. The traditionally male domain of the West is now contested by women, evil is harder to locate and usually more insidious, and the encroachment of society complicates life and suggests the end of the cowboy lifestyle. Even during the 1990s, this subgenre endured, most notably with *Unforgiven* (1992): here the formerly unbendable Clint Eastwood is now financially strapped, somewhat hypocritical, and disturbingly aware that killing is an ugly business.

Political Westerns

By the 1960s and 1970s, the **political western** had evolved out of the existential western, foregrounding ideology and politics and questioning the individual independence and use of violence featured in epic westerns. In *The Man Who Shot Liberty Valance* (1962), the heroic myth of the American West is exposed as a lie. With only communities rather than frontiers to conquer in *The Wild Bunch* (1969), aging cowboys are less interested in justice and freedom than in indiscriminate and grotesque killing. More recently, the western genre has remained visible in a variety of contemporary films, such as *There Will Be Blood* (2007) and *No Country for Old Men* (2007), where many of the conventional motifs and icons of violence

10.28 *There Will Be Blood* (2007). Contemporary films incorporate traditional western conventions and formulas like frontiers and violent conquests—but often in more grotesque and unsettling ways, such as the often brutal and unexpected violence in this film.

and conquest reappear in more horrifying and exaggerated forms than ever before [**Figure 10.28**], and *Hell or High Water* (2016), which addresses modern economic concerns.

Melodramas

Movie **melodramas** (with clearly identifiable moral types, coincidences, reversals of fortune, and music that underscores the action) are one of the more difficult genres to define because melodramatic characters and actions can be part of many other kinds of movies. The word itself indicates a combination of the intensities of music (*melos*) and the interaction of human conflicts (*drama*). Indebted to a nineteenth-century theatrical heritage in which social and domestic oppression created heightened emotional dramas, film melodramas arrived virtually simultaneously with the first developments in film narrative. Although the word *melodrama* was used in different ways by early film critics, the contemporary definition developed by film scholars includes these fundamental formulas and conventions:

- characters who are defined by their situation or basic traits rather than their deeds and who struggle, often desperately, to express their feelings or emotions
- narratives that rely on coincidences and reversals and build toward emotional or physical climaxes
- a visual style that emphasizes emotion or elemental struggles, whether in interior scenes and close-ups or in action tableaux

From D. W. Griffith's *Way Down East* (1920) to Kimberly Peirce's *Boys Don't Cry* (1999), the central character is restrained, repressed, or victimized by more powerful forces of society. These forces may pit a dominating masculinity against a weaker femininity. In Griffith's film, a city villain threatens an innocent virgin, and in *Boys Don't Cry*, Nebraska country boys assault and murder Brandon Teena when they discover that he was born female (named Teena Brandon) and has been living as a male. In the first film, claustrophobic rooms dramatize this victimization [**Figure 10.29**], until a climactic chase over a frozen river brings the conflict between good and evil outside for the world to witness. In the second, medium shots and close-ups of the protagonist emphasize the strains and contradictions of identity [**Figure 10.30**]. In each of these films, true to the conventions of melodrama, the story reaches a breaking point with the threat of death: one character almost drifts away on ice floes, and the other is senselessly shot and killed.

As with westerns, individualism and private life anchor this genre, but the drama is not about conquering a frontier and finding a home but is about feeling emotional strains and

10.29 *Way Down East* (1920). Claustrophobic interiors represent the melodramatic heroine's victimization.

often failing to act or speak out within an already established home, family, or community. Melodramas thus develop a conflict between interior emotions and exterior restrictions, between yearning or loss and satisfaction or renewal. One or more women are typically at the center of melodrama, illustrating how women historically have been excluded from or limited in their access to public powers of expression.

Mise-en-scène and narrative space also play a major stylistic role in melodrama. For example, in Griffith's films, individuals, usually female, retreat into smaller and smaller private spaces while some obvious or implied hostile force, often male, threatens and drives them

10.30 *Boys Don't Cry* (1999). Melodrama relies on close-ups to tell stories of contested identity—here the protagonist's expression of gender.

further into a desperate internal sanctuary. These rituals are often graphically acted out. In Elia Kazan's film version of *A Streetcar Named Desire* (1951), Blanche and Stella, confined in a run-down, claustrophobic apartment in New Orleans, also confine and repress their memories of a lost family history; their desires to escape are channeled through their sexuality. For Stella, that means accepting her husband Stanley's violent control of her; for Blanche, it means becoming a victim of Stanley's power and, after he rapes her, retreating into madness.

Early melodramas depicted female distress and entrapment in time and space, but those formulas have grown subtler, or at least more realistic, over the years. Three subgenres of melodramas that usually overlap and rarely appear in complete isolation from one another can be distinguished—physical, family, and social melodramas.

Physical Melodramas

Physical melodramas focus on the material conditions that control the protagonist's desires and emotions. These physical restrictions may be related to the places and people that surround that person or may simply be a product of the person's physical size or color. One of the first great film melodramas, D. W. Griffith's *Broken Blossoms* (1919), is also one of the most grisly. In an atmosphere of drugs, violence, and poverty, a brutal boxer, Battling Burrows, hounds and physically terrifies his unwanted and frail daughter, Lucy, who is sheltered by a kind Chinese man who falls in love with her. Although most melodramas do not definitively emphasize the physical plight of the heroine, viewers can recognize this generic focus on bodily or material strain in melodramas such as *Dark Victory* (1939), about a woman with a terminal brain illness, and *Magnificent Obsession* (1954), about a blind woman whose vision is ultimately restored. Even a film like *Black Swan* (2010) might be best understood as a contemporary variation on a melodrama about sexual identity, bodily restraint, and the eruption of violence [**Figure 10.31**].

10.31 *Black Swan* (2010). Although ostensibly about the world of ballet, this film is perhaps best understood as a melodrama about physical and sexual repression, as Nina battles pressures from her mother, her director, and herself to become the "perfect" Swan Queen.

10.32 *Captain Fantastic* (2016). A family of extraordinary outsiders must reshape itself under the pressures of a different "normal" world.

Family Melodramas

Although physical arrangements play a part in them, **family melodramas** focus on the psychological and gendered forces restricting individuals within the family. For many viewers, this is the quintessential form of melodrama, in which women and young people, especially, must struggle against patriarchal authority, economic dependency, and confining gender roles. In Douglas Sirk's *Written on the Wind* (1956), a Texas millionaire marries a beautiful but naive secretary and then tortures himself wondering whether the baby they are expecting is his or his best friend's—the man she should have married. The corruption and confusion of this household grow more intense and manic through the constant baiting and manipulations of a sister whose restlessness is expressed as sexual promiscuity.

The family melodrama came to prominence in the postwar period as gender and familial roles were being redefined. In *Ordinary People* (1980), an outwardly prosperous family is emotionally crippled by the loss of one son, the mother's withdrawal of affection from the other, and the father's powerlessness. In Matt Ross's *Captain Fantastic* (2016), the melodrama occurs at the odd intersections of a survivalist family whose father must deal with the death of the children's mother and the crisis of the family adapting to a world outside the Oregon woods **[Figure 10.32]**.

Social Melodramas

Social melodramas extend the crises of the family to include larger historical, community, and economic issues. In these films, the losses, sufferings, and frustrations of the protagonist are visibly part of social or national politics. Earlier melodramas fit this subgenre. For example, John Stahl's *Imitation of Life* (1934), remade by Douglas Sirk in 1959, makes the family melodrama inseparable from larger issues of racism as a black daughter passes for white. Contemporary melodramas also commonly explore social and political dimensions of personal conflicts. When a father is kidnapped in Steve McQueen's *12 Years a Slave* (2013), the harmony and happiness of an African American family from Saratoga, New York, are shattered by and intimately linked to the brutality and horrors of slavery in mid-nineteenth-century America **[Figure 10.33]**. In *Brokeback Mountain* (2005), male lovers are kept apart by social conventions as well as possibly generic ones, as cowboys are not usually shown falling in love with each other **[Figure 10.34]**.

10.33 *12 Years a Slave* (2013). This searing melodrama about a father snatched from his family becomes an emotional and personal depiction of the brutalities of slavery in the nineteenth century.

10.34 *Brokeback Mountain* (2005). This political melodrama depicts homosexual lovers kept apart by social and generic conventions.

Musicals

As noted in Chapter 5, when synchronous sound came to the cinema in 1927, the film industry quickly embraced the new technology and moved to integrate music and song into the stories. Precedents for film **musicals** range from traditional opera to vaudeville and musical theater, in which songs either supported or punctuated the story. Since the first musicals, the following have been their most common components:

10.35 *The Sound of Music* (1965). The Nazi threat cannot dampen the spirit expressed through song.

- characters who act out and express their emotions and thoughts through song and dance
- plots interrupted or moved forward by musical numbers
- spectacular sets and settings (such as Broadway theaters, fairs, and dramatic social or grand natural backgrounds) or animated environments

In *Gold Diggers of 1933* (1933) and *The Sound of Music* (1965), groups of characters escape the complexities of Depression-era society and Nazi encroachment into Austria by breaking into song **[Figure 10.35]**. Whether on a Broadway stage or against the beauty of an Alpine setting, characters in musicals speak their hearts and minds most articulately through music and dance.

As social markers, musicals are the flip side of melodramas, highlighting the joy of expression rather than the pain of repression. With musicals, the tearful cries of melodrama give way to the beautiful articulations of music. Both focus on personal emotions, but in musicals, song and dance become the longed-for vehicles for the repressed and inexpressible emotions of the melodrama. There are romantic crises, social problems, and physical dangers in the narrative, but in most cases, difficulties can be remedied or at least put into perspective by the immediacy of song, music, and dance. With more plot than most musicals, *West Side Story* (1961) features all the tragedy and violence found in Shakespeare's *Romeo and Juliet* (on which it is based) and a social commentary on Puerto Rican and white relationships in New York: gangs fight, lovers are separated, and horrible deaths happen. But even during the most troubling situations, song and dance transform battle cries into gaiety ("The Jet Song") **[Figure 10.36]**, patriotic idealism into comic satire ("America"), and even a tragic death into a peaceful vision

10.36 *West Side Story* (1961). Social antagonisms are expressed through song and dance.

10.37 *Across the Universe* (2007). Beatles songs are reimagined as wild production numbers with a music-video influence.

10.38 *42nd Street* (1933). The "Shuffle Off to Buffalo" number is presented as part of a Broadway show, which acts as the central mise-en-scène of the narrative.

10.39 *God Help the Girl* (2014). This modern musical is set in the indie music scene rather than backstage at a theatrical musical, and instead of production numbers, the musical sections more closely resemble homemade music videos, fading in and out of fantasy.

("Somewhere"). Julie Taymor's *Across the Universe* (2007) **[Figure 10.37]**, similarly rich with plot and narrative, weaves together the stories of several characters living in New York City during the turbulent 1960s. Musical enactments of Beatles songs express the "free love" spirit and the darker, politically charged moments of the decade.

After the first feature-length musical, *The Jazz Singer* (1927), musicals adapted to reflect different cultural predicaments. Of the many types of musicals, we can identify three subgenres—theatrical, integrated, and animated musicals. Many examples of each subgenre are adaptations of Broadway musicals or other theatrical sources.

Theatrical Musicals

No doubt the best known films of the musical genre are **theatrical musicals**, which situate the musical convention onstage or "backstage." Here it is unmistakable that the fantasy and art of the theater supersede the reality of the street. One of the finest early musicals is *42nd Street* (1933), which is partly about the complicated love lives of its characters—a Broadway director who wants one last hit play; the starlet Dorothy Brock, who juggles lovers offstage; and the chorus girl Peggy Sawyer, who substitutes for the star and saves the show. What ultimately gathers together all these hopes and conflicts is the musical show itself. Through the remarkable choreography of Busby Berkeley and hit tunes like "Shuffle Off to Buffalo," jealousies and doubts turn into a spectacular celebration of life on Broadway **[Figure 10.38]**.

Although theatrical musicals later waned in popularity, *All That Jazz* (1979) resurrected this subgenre as an exaggerated and even self-indulgent staging of the autobiography of choreographer Bob Fosse. The more recent *Dreamgirls* (2006) dramatizes the story of Motown, while smaller-scale musicals like *God Help the Girl* (2014) **[Figure 10.39]** and *Sing Street* (2016) apply theatrical techniques to stories about young people in rock bands, blurring the line between theatrical musicals and more everyday settings.

Integrated Musicals

When musicals began to integrate musical numbers into the film's narrative, they became **integrated musicals.** Here the idyllic and redemptive moments of song and dance are part of the common situations and realistic actions of the characters' everyday lives. In *My Fair Lady* (1964), the grueling transformation of a street girl into a glamorous aristocrat is described by song, and with numbers like "The Rain in Spain," songs actually assist that transformation. *Dancer in the Dark* (2000) and *Pennies from Heaven* (1981) are more ironic versions of this subgenre. In both films, musical interludes allow the characters (a blind woman accused of murder and a sheet-music salesman during the Depression, respectively) to transcend the tragedies and traumas of life. More recently, *Les Misérables* (2012) **[Figure 10.40]** weaves its operatic songs of love and rebellion into its famous tale of Jean Valjean in nineteenth-century France.

10.40 *Les Misérables* (2012). The long-running Broadway hit was finally translated into an integrated movie musical in 2012.

Animated Musicals

Beginning with *Snow White and the Seven Dwarfs* (1937) and increasing in popularity and frequency within the last decades, **animated musicals** use cartoon figures and stories to present songs and music. Moving in the opposite direction of integrated musicals, these films—including *Fantasia* (1940) and *Yellow Submarine* (1968), Disney features like *Beauty and the Beast* (1991) **[Figure 10.41]** and *Frozen* (2013), and offbeat versions such as Tim Burton's *The Nightmare Before Christmas* (1993) and Sylvain Chomet's *The Triplets of Belleville* (2003)—fully embrace the fantastic and utopian possibilities of music to make animals human, nature magical, or human life, as Mary Poppins says, "practically perfect in every way."

Horror Films

Horror has been a popular literary and artistic theme at least since Sophocles's account of Oedipus's terrifying realization of his fate, the horrifying suicide of

VIEWING CUE

LaunchPad Solo

Watch a clip of a musical number from the musical *La La Land* (2016). Does this appear to be an integrated musical, a theatrical/ backstage musical, or something else entirely? What cues hint at its musical subgenre?

10.41 *The Little Mermaid* (1989). The resurgence of the animated musical highlights the utopian impulse of film genres, through which songs link the characters to fantasies and fantasy worlds.

10.42 *The Golem* (1920). Horror takes monstrous physical form in this German expressionist film.

10.43 *Alien* (1979). Suspense and terror build as the grotesque creature lurks on the fringes of the visible, until finally bursting into view.

10.44 *28 Days Later* (2002). The social and physical world crumbles in a horror film about a zombie-creating virus.

his mother, and his ghastly self-blinding. The supernatural mysteries of Gothic novels such as *The Monk* (1796) were followed in the nineteenth century by tales of monsters and murder, such as *Frankenstein* (1818) and *Dracula* (1897). Occasionally overlapping with science fiction, **horror films** have crossed cultures and appeared in various forms throughout film history. The fundamental elements of horror films include

- characters with physical, psychological, or spiritual deformities
- narratives built on suspense, surprise, and shock
- visual compositions that move between the dread of not seeing and the horror of seeing

In Carl Boese and Paul Wegener's *The Golem* (1920) **[Figure 10.42]** and Ridley Scott's *Alien* (1979) **[Figure 10.43]**, monstrous characters terrify the humans around them with their grotesque shapes and actions, lurking on the fringes of the visible world. Each film is infused with a nervous tension at the mere prospect of seeing a horror that exists just out of sight, a suspense that explodes when the creatures suddenly appear.

Horror films are about fear—physical fear, psychological fear, sexual fear, even social fear. The social repercussions of dramatizing what we fear are often debated, but regardless of whether showing horror on film has any effect on society, the genre's widespread popularity suggests that it is a central cultural ritual. Like scary stories around a campfire, horror films dramatize our personal and social terrors in their different forms, in effect allowing us to admit them and attempt to deal with them in an imaginary way and as part of a communal experience. Horror films make terror visible and, potentially, manageable. An eerie tale about alien invaders taking over human bodies in an American town, *Invasion of the Body Snatchers* (1956) acts out the prevalent fears in the 1950s about military and ideological invasion. The frightening story of a high school misfit with telekinetic powers, the 1976 *Carrie* and its 2013 remake unveil all the anxiety and anger of female adolescence, and *28 Days Later* (2002) unleashes hordes of zombies, the product of a scientific experiment on a dangerous virus **[Figure 10.44]**.

Within this genre, horror and fear have taken many shapes in many different cultures over the past century, addressing audiences in specific historical terms. Here we call attention to three subgenres characterized by dominant elements—supernatural, psychological, and physical horror films.

Supernatural Horror Films

In **supernatural horror films**, a spiritual evil erupts in the human realm to avenge a wrong or for no explainable reason. This subgenre includes movies such as the aforementioned *The Golem* (1920); the Japanese film *Kwaidan* (1964), which features four tales based on the writings of Lafcadio Hearn about samurai, monks, and spirits; and *The Sixth Sense* (1999), about a boy able to see the dead. In *The Exorcist* (1973), Satan possesses a young girl's body, deforming it into a twisted, obscenity-spewing nightmare **[Figure 10.45]**. *The Exorcist* is typical of supernatural horror in that the how and why this evil has invaded the life of this

10.45 *The Exorcist* (1973). Satan possesses a young girl in this 1970s masterpiece of supernatural horror.

modern and affluent family are never made entirely clear. Japanese horror films made in the aftermath of nuclear destruction featured ostensibly supernatural figures like Godzilla, while the contemporary Korean horror film *The Host* (2006) taps into political relations with the United States as well as into environmental issues. Alongside more mainstream supernatural horror hits like the *Conjuring* series (2013–2016), smaller movies like *It Follows* (2015) **[Figure 10.46]** use supernatural horror to evoke a variety of contemporary anxieties.

Psychological Horror Films

Another variation on the threat to modern life, **psychological horror films** locate the dangers that threaten normal life in the minds of bizarre and deranged individuals. German expressionist films like *The Cabinet of Dr. Caligari* (1920) dealt with psychological themes, and many modern films—including *Psycho* (1960), *Whatever Happened to Baby Jane?* (1962), *Don't Look Now* (1973), *The Stepfather* (1987), *The Hand That Rocks the Cradle* (1992), and *Funny Games* (2007)—participate in this subgenre. *The Silence of the Lambs* (1991) is characteristic: although it features scenes of nauseating physical violence, Hannibal Lecter's diabolically brilliant mind and his empathetic bond with the protagonist, Clarice Starling, make this film mentally, rather than physically, horrifying.

Physical Horror Films

Films in which the psychology of the characters takes second place to the depiction of graphic violence are examples of **physical horror films**, a subgenre with a long pedigree and a consistent place in every cycle of horror film. Tod Browning's *Freaks* (1932) testifies to both the longevity and the more intelligent potential of physical horror. Cut and banned in many countries, *Freaks* tells a morality tale of rejection and revenge. It features performers from actual carnival sideshows who, despite their shocking appearance and the repulsive revenge they perpetrate, ultimately act in more generous and humane ways than the physically "normal" villains.

10.46 *It Follows* (2015). An acclaimed recent horror film uses a mysterious supernatural force to represent teenage anxieties about sex, aging, and death.

10.47 ***The Texas Chain Saw Massacre*** (1974). This classic slasher film goes to extremes—cannibalism.

Psycho is an originator of the contemporary horror films known as **slasher films,** which depict serial killers. Other grisly films that belong in this subgenre include *The Texas Chain Saw Massacre* (1974) **[Figure 10.47],** the story of a cannibalistic Texas family that attacks lost travelers; *Halloween* (1978), the first of a sequence of films about ghastly serial killings that spawned many imitators, including *Saw* (2004), which creates a gruesome mise-en-scène fashioned by a twisted mind to test and torture two captives competing to survive.

Crime Films

Like other genres, **crime films** represent a large category that describes a wide variety of films. These films typically feature criminals and individuals dedicated to crime detection and plots that involve criminal acts. Crime novels and short stories—from the mysteries of Edgar Allan Poe and the tales of Sherlock Holmes to the pulp fiction of the 1920s, such as Dashiell Hammett's *Red Harvest* (1929), and Walter Mosley's ongoing *Easy Rawlins* series—have been a staple of modern culture. When early movies searched for good plots, criminal dramas that contained physical action and relied on keen observation were recognized as a genre made for the cinema, where movement and vision are central. A crime film's chief characteristics include

- characters who live on the edge of a mysterious or violent society, either criminals or individuals dedicated to crime detection
- plots of crime, increasing mystery, and often ambiguous resolution
- urban, often dark and shadowy, settings

From *Underworld* (1927) to *The French Connection* (1971), the principal characters of crime movies are usually either criminals or individuals pursuing criminals. In *Underworld*, gangster Bull Weed flees and then faces his relentless police pursuers in the mean streets of Chicago. In *The French Connection*, detective Popeye Doyle becomes entangled in New York's narcotics underworld. In the first film, the law triumphs, but the tantalizing attraction of underworld life remains. In the second, legal victory is only partial, and the glamour of the international drug market far outshines the tattered life of a New York cop **[Figure 10.48].**

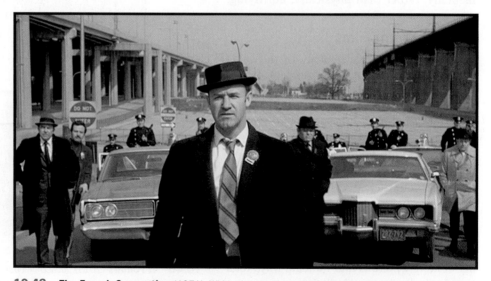

10.48 ***The French Connection*** (1971). Within the complex web of an international drug cartel, a determined New York detective relentlessly pursues its multiple and mysterious agents.

If the outsider characters in horror films represent what we as a society most physically and psychologically fear and repress, then the outsider characters in crime films describe what we as upholders of the status quo socially reject. Perhaps the foundation for this fascination with illegal behaviors is that most people are capable of both social and antisocial inclinations at one time or another. Two of the most gripping and socially complex crime movies in film history, *The Godfather* (1972) and *The Godfather: Part II* (1974), offer a picture of twentieth-century America that culminates in the transformation of Michael Corleone from a respectable son and war hero into a ruthless mob boss willing and able to destroy any enemies or competitors **[Figure 10.49]**. The films reveal both sides of the Mafia cult—its familial dedication and loyalty and its vicious thirst for power at any cost. Echoing this duality, these films suggest that U.S. society has grown from a struggling immigrant community into a rich and intimidating nation.

The different incarnations of crime films, from the 1920s to the present, include three prominent and popular subgenres—the gangster film, the hard-boiled detective film, and the stylistically distinctive film noir.

Gangster Films

Gangster films are set in the world of organized crime and its violent criminals. *Scarface* (1932) depicts a vicious mob war in which rivals coolly manipulate and shoot each other **[Figure 10.50a]**, and *The Public Enemy* (1931) follows Tom Powers's rise from a juvenile delinquent to a bootlegging killer who terrorizes Chicago. Both films were made and set in the 1930s, when crime thrived in defiance of Prohibition. More recent versions of gangster films—the remake *Scarface* (1983) **[Figure 10.50b]**, *Goodfellas* (1990), *Road to Perdition* (2002), and *The Departed* (2006), for example—tend to escalate the violence and explore the peculiar personalities of the criminals or the strained rituals that define them as a subculture.

The original gangster formula has been adapted in other cultures. The urban milieu of hip-hop and so-called gangsta rap characterizes a cycle of African American crime films of the early 1990s, including *Boyz N the Hood* (1991), *New Jack City* (1991), and *Juice* (1992), in which the codes of loyalty and family are strained by the lure of fame, drugs, and cash. Japanese actor-director Takeshi Kitano has received wide acclaim for his reworking of the traditional Japanese gangster, or *yakuza*, film in *Hana-bi* (1997) and other films, while two Hong Kong films—Johnnie To's

10.49 *The Godfather: Part II* (1974). Michael Corleone balances a life of organized crime and power with familial dedication and loyalty.

(a)

(b)

10.50a and 10.50b *Scarface* (1932 and 1983). A classic gangster film from the genre's heyday in the 1930s was later remade as the 1983 *Scarface* with Al Pacino. Photofest, Inc.

10.51 *Exiled* (2006). Hong Kong gangster films such as this one are influencing recent Hollywood genre films.

Exiled (2006) **[Figure 10.51]** and Andrew Lau and Alan Mak's *Infernal Affairs* (2002; remade in 2006 as Martin Scorsese's *The Departed*)—demonstrate both the global reach of this genre and its ability to return from abroad to reshape Hollywood films.

Detective Films

On the other side of this generic crime coin, **detective films** focus on a protagonist who represents the law or an ambiguous version of it, such as a private investigator. Usually these individuals must battle a criminal element (and sometimes the police) to solve a mystery or resolve a crime. In one of the most renowned films of this type, *The Maltese Falcon* (1941), detective Sam Spade pursues both a mysterious treasure (the falcon statue) and the murderers of his partner (killed for the statue). Suspected by the police, Spade embarks on a personal quest not so much for the treasure but, through his loyalty to his partner, for truth and integrity. Reinterpreted and reinvented in different cultures and with protagonists other than white males, this subgenre remains visible in unusual movies such as Jean-Luc Godard's meditation on crime detection, *Détective* (1985), and Lizzie Borden's feminist story of a sex crimes investigation in Georgia, *Love Crimes* (1992).

Film Noir

Although regularly discussed as a film style of shades and shadows, **film noir** can be considered a subgenre of crime films that emerged in the 1940s and one that distinctly elevates the legal, moral, and atmospheric ambiguity and confusion found in early examples of the genre. No longer simply about law versus crime or the ethical toughness of a detective, these films, such as the 1944 *Double Indemnity*, uncover darkness and corruption in virtually all their characters that never seem fully resolved. Film noir suggests a visual style that emphasizes darkness and shadows that, in turn, reflect the shady moral universes common in these films. Protagonists waver between the law and lawlessness, and relationships commonly appear determined by violence and sexuality, characterized notably in the femmes fatales who surround the male protagonist. Orson Welles's *Touch of Evil* (1958) is one of the most powerful examples of film noir. Arriving in a Mexican town wild with drugs, prostitution, and murders, lawman Mike Vargas searches the dark alleys and filthy canals in pursuit of the solution to a murder mystery. He discovers that at the heart of the corruption is Hank Quinlan, "a good detective but a lousy cop" **[Figure 10.52]**. In recent decades, neo-noir films, such as the 1981 *Body Heat* and the 2005 *Sin City*, represent a more self-conscious awareness of the generic conventions of film noir and often create characters and crimes far more confused and corrupt than their historical prototypes.

10.52 *Touch of Evil* (1958). Orson Welles plays Hank Quinlan, rotten with corruption in this classic example of film noir.

Since the beginning of the twentieth century, when chase films were an international fashion, the economics of the film industry were tied to the standardized formulas of film genre. Fashioned in accordance with the assembly-line productions of other industrialized businesses, these formulas were meant to increase efficiency and became the foundation for movie studios as they emerged in the 1920s. These studios came to define themselves through the predictable scripts, sets, and actors of one or more genres. Gradually audiences learned what to expect from these genres and their associated studios. Although film genres have changed and spread considerably since the 1930s, they remain a critical measure of audience expectations as well as of the film's ability to satisfy or disappoint and surprise or bore the movie viewer.

Film genres describe, in short, a social contract between filmmakers and their audiences, a contract in which each side recognizes a common language of conventions, formulas, and expectations. Because genres typically reflect historical and cultural contexts, these contracts give rise to different genres at different times and in different places. From comedies to crime films, film genres act out, mediate, and elaborate the pertinent myths and rituals that often inform our lives.

VIEWING CUE

LaunchPad Solo

Watch a clip from *The Searchers* (1956) online. Which characteristics of this genre are most apparent in its iconography? How does this sequence use these generic elements in its own way?

Making Sense of Film Genres

Although specific film genres vary and evolve in different ways, viewers make sense of those genres according to their developing and expanding experience of genre. As viewers see and think about how genre films are enjoyed and understood, certain conceptual frameworks shape, consciously or unconsciously, the experience of film genres. Two broad frameworks for understanding film genres are a prescriptive approach and a descriptive approach. Within these frameworks, viewers can see genres as part of a classical tradition (which might emphasize the historical origin or structural ideal of a genre) or as part of a revisionist tradition (which might understand genres as adapting to different cultures and different historical periods). Finally, genres can be considered in spatial terms as local and global genres.

Prescriptive and Descriptive Approaches

Viewers and filmmakers alike classify a movie according to their experience and understanding of a genre. A viewer who has seen and considers *Touch of Evil* (1958) the gold standard of film noir may have less patience accepting *Drive* (2011) in the same category, whereas a different viewer may have a more flexible view of the genre. The first viewer would hold a prescriptive approach that assumes a preexisting model for any particular film in the same category. In the case of *Drive*, a viewer with a prescriptive approach might ask "Is this protagonist the classically conflicted hero?," "Is Hollywood a seedy underworld?," and "Is there an adequately dark, traumatic crime in this film?" This viewer believes that a successful genre film deviates as little as possible from the prescribed model and that a viewer can and should be objective in determining a genre.

A second viewer might respond with a descriptive approach, one that assumes a genre changes over time by building on older films and developing in new ways. This viewer prizes genres for different reasons and accepts that viewers' subjectivity can help determine a genre. In the case of a contemporary film noir, *Black Swan* (2010), the heroine Nina (played by Natalie Portman) walks a precarious line between sanity and madness and between darkness and light in the competitive world of professional ballet. Nina's uncertain hold on reality lends to the ambiguous atmosphere, and the fact that she may or may not have been seduced by her

text continued on page 368 ▶

FILM IN FOCUS

◄ FILM IN FOCUS

🖸 LaunchPad Solo

To watch a video about *Chinatown* (1974),
see the *Film Experience* LaunchPad.

Crime Film Conventions and Formulas: *Chinatown* (1974)

See also: *The Maltese Falcon* (1941); *The Big Sleep* (1946); *L.A. Confidential* (1997)

Set in the 1930s Los Angeles of crime writers Dashiell Hammett and Raymond Chandler, Roman Polanski's *Chinatown* (1974) is a crime film that features elements of the gangster film, film noir, and especially the hard-boiled detective film. It opens in the offices of private investigator J. J. (Jake) Gittes, a location and a character that immediately recall classics of the crime film genre like *The Maltese Falcon* (1941) and *The Big Sleep* (1946). The room is scattered with light and shaded by partially closed venetian blinds, and the tough but cool Gittes (Jack Nicholson), wearing a white suit, controls the scene in every way as he presents pictures of an unfaithful wife to the distraught husband who has hired him **[Figure 10.53]**. A former police officer who worked the Chinatown district of Los Angeles, Gittes now operates between the legitimate law and the underworld, seeking out the seedy, dark side of human nature and exposing "other people's dirty laundry."

Familiar conventions and formulas are everywhere in this modern version of the crime film plot. Gittes takes what he believes is an everyday assignment and follows Los Angeles water commissioner Hollis Mulwray, who is suspected of having a sexual affair. However, Gittes soon becomes entangled in events that are more complicated and devious than he can understand. The woman who hires him to spy on Mulwray turns out to be an imposter, and the real Evelyn Mulwray becomes the foil that both attracts Gittes and makes it clear that, in this case, he is no longer in control.

Like other crime film detectives who survive with their independent moral vision, Gittes gradually and painfully uncovers the twisted and complicated truth that underlies this plot: Noah Cross, Mulwray's father-in-law and former partner, has killed Mulwray as part of a vast scheme to exploit the water shortage in Los Angeles. Indeed, it slowly becomes clear that the cryptic title of the movie refers to a section of urban life—and by extension, to all of life in this film—where conventional law and order have little meaning and where, in Gittes's words, "You can't always tell what's going on."

10.53 *Chinatown* (1974). Jack Nicholson plays Jake Gittes, the classic bitter, smart, and handsome hard-boiled detective.

Shades and shadows, specialties of classic film noir, line the faces and spaces in this unclear world, and the addition of rich yellows, reds, and browns to the Los Angeles urbanscape creates a sickly, rather than sunny and natural, climate.

As in other crime films, the shadowy haze of corruption and violence appears also as a sexual darkness. However, unlike the aggressive sexuality of femmes fatales in older crime films, the sexual danger and disorder in *Chinatown* are far more horrifying. Here Evelyn's sexuality poses little threat compared to the reality that Gittes discovers behind it—that she was raped by her father, Noah Cross, and that her daughter, the mysterious "other woman" involved with Hollis Mulwray, is also her sister **[Figure 10.54]**. These facts are climactically revealed in the dark streets of Chinatown when Evelyn is killed trying to flee with her daughter/sister.

The powerful and malevolent Cross walks away with his daughter/granddaughter, the police stand idly by, and Gittes is told, "Forget it, Jake. It's Chinatown." Although tentative and sometimes personal solutions to crime and corruption are a convention of crime films, the ambiguity is considerably darker and seamier in *Chinatown*.

Like the ending to *Chinatown*, many of the variations in these crime film formulas may be the product of changing times. With the Great Depression, Prohibition, and urban crowding and unrest, the crime film of the 1930s acted out social instabilities through the marginal success of a marginal detective, like Sam Spade and others. In the 1970s, after the government corruption of the Watergate break-in and cover-up, the moral ambiguities of the Vietnam War, and the confused sexual legacy of the 1960s, the genre returned with a new relevancy. In *Chinatown*, hard-boiled detectives are less confident than before, femmes fatales are more neurotic, and corruption is more sickly and widespread.

10.54 *Chinatown* (1974). Not your typical femme fatale: Evelyn's dark backstory proves to be much more dangerous than her sexuality.

(a)

(b)

(c)

10.55a–10.55c Approaches to melodrama: (a) *All That Heaven Allows* (1955), **(b)** *Ali: Fear Eats the Soul* (1974), **(c)** *Far from Heaven* (2002). Melodrama's generic characteristics are both foregrounded and modified in loose remakes of Douglas Sirk's original by filmmakers Rainer Werner Fassbinder and Todd Haynes.

rival, Lily (played by Mila Kunis), serves as a contemporary twist on the film noir themes of sexuality, masculinity, and the femme fatale.

A filmgoer looking at genre descriptively might survey the history of melodrama and deduce how its chief characteristics have altered through time. Admitting that such an exercise will necessarily depend on a person's particular perspective and knowledge (such as which films she has access to and the assumption that a particular genre exists), this viewer will value specific films for how they develop, change, and innovate within a generic pattern.

From this perspective, a film like Rainer Werner Fassbinder's *Ali: Fear Eats the Soul* (1974), about the social prejudices that hound the relationship between a young Arab migrant worker and an older German woman, may be a remarkable variation on the melodramatic formula, which in the different cultural context of the 1950s produced Douglas Sirk's *All That Heaven Allows* (1955), an earlier version of *Ali*'s story in which a gardener and a wealthy socialite fall in love. With Fassbinder's "remake" in mind, Todd Haynes's *Far from Heaven* (2002) then reshapes and develops that same basic story and generic formula into a contemporary film in which the melodramatic crisis turns on a married man's discovery of his gay identity and his wife's potential interracial affair with their gardener **[Figures 10.55a–10.55c]**.

Both prescriptive and descriptive approaches can point viewers to particular readings of films. A studio or journalist may, for instance, reference a particular genre as the framework for how a specific movie should be seen and evaluated. A studio may promote *Nebraska* (2013), a film about an aging father's stressful relationship with his family, as an offbeat melodrama, whereas a journalist may urge audiences to see it as a road movie. Following one or the other of those prescribed genres will most likely result in different understandings of the film.

Conversely, a movie historian may examine a number of similar films in order to describe the basic formulas of a genre (say, science fiction), but if the films that generate her description are limited to Hollywood movies since 1950, the model will emphasize and overlook generic features that a wider survey, one including silent or Asian films, for example, might not. In both instances, the resulting model of a film genre reflects the prescriptive or descriptive approach used and generates meanings that limit, expand, or focus a viewer's understanding accordingly.

Classical and Revisionist Traditions

The significance of a particular film's engagement with genre conventions also is shaped by its situation within classical or revisionist traditions. Classical genre traditions are aligned with prescriptive approaches that place a film in relation to

a paradigm that remains the same over time and that a genre film either successfully follows or does not. Classical generic traditions establish relatively fixed sets of formulas and conventions, associated with certain films or with a specific place in history.

Stemming from descriptive approaches, revisionist genre traditions see a film as a function of changing historical and cultural contexts that modify the conventions and formulas of that genre. A particular western, for example, will be understood differently from a classical perspective than from a revisionist one. Together these two traditions identify one of the central paradoxes of any genre—that genres can appear to be at once timeless and time bound and can both create patterns that transcend history and be extremely sensitive measures of history.

10.56 *Nosferatu* (1922). This film is a historical paradigm for horror films.

Historical Paradigms

Classical traditions can be viewed as both historical and structural paradigms. A historical paradigm presumes that a genre evolved to a point of perfection at some point in history and that one or more films at that point describe the generic ideal. For film critic André Bazin, John Ford's *Stagecoach* is the historical paradigm for the western that reached its pinnacle in the United States in 1939. For others, F. W. Murnau's *Nosferatu* (1922) is the historical paradigm for the horror film, achieving its essential qualities in the climate of 1920s Germany **[Figure 10.56]**.

Structural Paradigms

A structural paradigm relies less on historical precedent than on a formal or structural ideal that may or may not be actually seen, in a complete or pure form, in any specific film. For example, regardless of the many variations on science fiction films, a viewer familiar with the genre may develop a structural paradigm for the classic science fiction film. After viewing a wide spectrum of films—from *The Day the Earth Stood Still* (1951) to *The Man Who Fell to Earth* (1976) and

◀ VIEWING CUE

LaunchPad Solo

Watch a sequence from *Unforgiven* (1992) online, and identify those features that align it with a classical Western and those features that suggest a revisionist perspective.

10.57 *Nosferatu the Vampyre* (1979). As an example of generic reflexivity, Werner Herzog's film recreates and manipulates the conventions and formulas of a horror film classic, specifically referencing images and themes from F. W. Murnau's 1922 *Nosferatu*.

HISTORY CLOSE UP

John Waters and Midnight Movies

The term *midnight movies* describes a somewhat peculiar version of a film genre. Less a product of certain generic conventions and formulas, it refers to movies that historically were featured in the late-night screenings of small art or local cinemas. Often low-budget films, like *Plan 9 from Outer Space* (1953), or cult classics from lost eras, like Tod Browning's *Freaks* (1932), they share offbeat styles and stories, sometimes with uncensored sex or exaggerated violence, and they implicitly celebrate their position outside mainstream cinema. Their lack of Hollywood polish helps them appeal to audiences that often have been ignored or marginalized in the past. The films of John Waters have become especially popular versions of this practice. His recurrent star, the physically extravagant Divine, appears in films such as *Pink Flamingos* (1972, right) and *Female Trouble* (1974), forming, with *Desperate Living* (1977), what Waters has referred to as his Trash Trilogy. In these and other films, Waters gleefully embraces campy humor, excessive characters, subversive sexuality, and often grotesque actions. In more recent years, no longer associated with late-night screenings, Waters films like *Hairspray* (1988) and *Cecil B. Demented* (2000) have moved him closer to the mainstream of cinema culture. But they still represent a genre that thrives on challenging and overturning traditional expectations.

Pacific Rim (2013) — a viewer may understand that the paradigm for the genre requires a visual and dramatic conflict between earth and outer space, the centrality of special effects, and a deadline plot structure. Some films then fit this paradigm easily, whereas others — such as the frolicking *Repo Man* (1984), about teenage angst, the repossessing of cars, and a mad scientist — may seem less convincing participants in the genre.

Generic Revisionism

In contrast, generic revisionism assumes that a genre is subject to historical and cultural flux, continually changing as part of a dialogue with films of the same genre. Films within a genre adapt their conventions and formulas to reflect different times and places. From this perspective, Fred Schepisi's *Barbarosa* (1982) is as much a western as *Stagecoach* (1939), but it is adapted to a contemporary climate that sees outlaws and their myths in a more fantastic light.

More modern films may demonstrate **generic reflexivity** — that is, the quality of movies displaying unusual self-consciousness about generic identity. These films clearly and visibly comment on the generic paradigms. *Young Frankenstein* (1974) and *L.A. Confidential* (1997) fit this model — the first a goofy look at one of the most famous models for a horror film and the second a serious self-conscious reworking of the crime film. Less obviously, perhaps, Werner Herzog's *Nosferatu the Vampyre* (1979) does not simply re-create the original *Nosferatu* (1922) but also returns to many of its conventions and icons as a way of commenting on the continuing relevance of the vampire myth and the ways that it still reveals much about contemporary society **[Figure 10.57]**.

10.58a

10.58b

10.58c

10.58d

10.58e

FORM IN ACTION

Melodrama and *In the Mood for Love* (2000)

We can think of revisionist genres as a map of the history of film. They show how filmmakers regularly rethink and re-create generic formulas and conventions to reflect changing times and cultures. Especially in recent decades, older genres have reappeared in contemporary guises, have moved between different cultures around the world, and have adapted those formulas to different places and times. In this regard, melodrama has been one of the more flexible and mobile of revised genres, and one exceptionally complex, stylized, and self-conscious example is Wong Kar-wai's *In the Mood for Love* (2000).

Set in 1960s Hong Kong among displaced former residents of Shanghai and other global citizens, the film describes the coincidental meeting of a man and woman who rent rooms in the same boarding house and whose growing relationship bears all the marks of an intense melodrama. Bristling with the emotions that they slowly develop for each other, the drama foregrounds many of the primary features of traditional melodramas, most prominently the characters' emotional struggle to express themselves in a repressive situation and a narrative constructed around coincidences and reversals. Stylistically, *In the Mood for Love* reflects those themes through powerful close-ups and two-shots **[Figure 10.58a]**, a tightly framed and claustrophic mise-en-scène **[Figure 10.58b]**, and romantically longing music that suggests what the characters cannot say aloud **[Figure 10.58c]**.

This revisionist melodrama, however, is more than simply a re-creation of melodramatic codes. In a manner common to many contemporary revisionist genre films, *In the Mood for Love* self-consciously adapts and highlights those generic conventions and calls attention to them as cinematic conventions and forms. Like a dance, the characters' movements frequently follow the slow, languid rhythms of the soundtrack. Games, rituals, and even the writing of a generic martial arts story become the needed vehicles for their displaced emotions **[Figure 10.58d]**. The couple regularly rehearses a possible confrontation with their unfaithful spouses (coincidentally having an affair with each other) at the same time **[Figure 10.58e]**. With this self-conscious generic layering, the couple seems trapped in the very melodrama they are acting out in a modern global space.

FORM IN ACTION

LaunchPad Solo

To watch a clip from *In the Mood for Love* (2000), see the *Film Experience* LaunchPad.

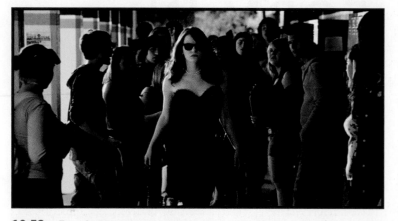

10.59 *Easy A* (2010). This film about a teenage girl using rumors about her promiscuity to elevate her social standing is part of the cycle of local teen films prevalent since the 1980s.

Local and Global Genres

Although major Hollywood genres may be the most recognizable, we also notice generic patterns in films connected to more specific times, places, events, and cultures — what we might call "local" genres. Modern American teen films — such as *The Breakfast Club* (1985), *Heathers* (1988), *Clueless* (1995), *Bring It On* (2000), and *Easy A* (2010) — can be considered examples of a genre that relates in very particular ways to the characters, crises, and rituals of contemporary American youth **[Figure 10.59]**.

In a sense, all genres are local because they first take shape to reflect the interests and traditions of a particular community or nation. Westerns are essentially an American genre, although they have traveled successfully around the world to Australia, Italy, Spain, and many other countries. Although horror is now a global genre, horror films may have their roots in the expressionistic cinema of Germany around 1920.

Of the many local genres that have appeared around the world, two clearly stress the connection between genre and a particular culture — the Japanese *jidai-geki* films and the Austrian and German Heimat films. Popular since the 1920s, the Japanese *jidai-geki* films are period films or costume dramas set before 1868, when feudal Japan entered the modern Meiji period. Movies such as *Revere the Emperor* (1927) and *A Diary of Chuji's Travels* (1927) work as historical travelogues to resurrect the customs and glory of times long past. Like most nations' relationship to their preindustrial past, the Japanese view this period with curiosity, nostalgia, and pride, often seeing in these early films a kind of cultural purity that was lost in the twentieth century. Through the years, however, this genre, like all successful genres, has assimilated current affairs into its conventions and formulas. Besides feudal courts and sword battles, *jidai-geki* films develop plots about class unrest and social rebellion. Akira Kurosawa's *Ran* (1985) is an interesting engagement with this essentially Japanese genre. This feudal Japanese costume drama is replete with many of the *jidai-geki* conventions. It is adapted from Shakespeare's *King Lear* and, ultimately, describes the end of an ancient world **[Figure 10.60]**.

Set in idyllic countryside locales, Austrian and German **Heimat films** depict a world of traditional folk values in which love and family triumph over virtually any social evil, communities gather around maypoles, and townspeople sing traditional German folk songs. Hailed by Austrian and German audiences throughout the first half of the twentieth century, this genre thrived in those countries with films such as *The Priest from Kirchfeld* (1914), *Heimat* (1938), and *The Trapp Family* (1956). As German filmmakers became more self-conscious about their historical background and the connection between this political history and the movies, modern films resurrected the Heimat genre, now reinterpreted as complicit in the social

10.60 *Ran* (1985). The classical Shakespearean story of King Lear is retold in this essentially Japanese genre film.

history of Germany. Peter Fleischmann's *Hunting Scenes from Bavaria* (1969), Volker Schlöndorff's *The Sudden Wealth of the Poor People of Kombach* (1971), Edgar Reitz's sixteen-hour *Heimat* (1984) **[Figure 10.61]**, and Stefan Ruzowitzky's *The Inheritors* (1998) are all explicit attacks on the mythology of this genre or reexaminations of its social meaning and power.

Recognizing film genres is a key part of the film experience, but understanding and evaluating those genres as part of larger historical, cultural, and conceptual frameworks enriches and broadens both our pleasure in and knowledge of what a specific film achieves. Identifying the prescriptive or descriptive model that informs your point of view and placing a film in a specific generic tradition give that film layers and resonances that can add considerably to our film experience.

10.61 *Heimat* (1984). The traditional values of German home life are subjected to the conditions of postwar occupation.

CONCEPTS AT WORK

The six genres examined in the central section of this chapter are broad but not all-encompassing. Each genre draws on specific conventions, formulas, and audience expectations, and hybrid genres and subgenres extend the possibilities to the limits of those generic paradigms. Comedies can become more precisely slapstick comedies like *22 Jump Street* (2014) or screwball comedies like *His Girl Friday*. Classical westerns evolve into political westerns such as *No Country for Old Men*. The family melodrama *Written on the Wind* can be distinguished from the social melodrama *Brokeback Mountain*. And horror films run the gamut from the supernatural horror of *The Exorcist* to the grisly physical horror of *Saw*. Identifying films by their genre helps place them in their historical context by connecting them to similar generic movies; to the plays, books, and works of art that have come before; and to the cultural and historical contexts that help define them. Because a film is a generic dialogue or social contract between filmmaker and audience, the genre is an unspoken agreement on the language of that dialogue, one that often is announced in a film's opening frames.

For the next genre film you examine, ask these key questions:

- Which generic expectations are created by the film, and through which recognizable conventions and formulas does it create them? Through a setting, as with the theatrical sets of *Dreamgirls* or the opening of *The Shining*?
- How does a film like *Gravity* (2013) engage and transform the conventions and formulas of science fiction found in films such as *2001: A Space Odyssey* or another classic science fiction film?
- Does the film fit a specific genre or subgenre, as does the integrated musical *Les Misérables* or the gangster crime film *The Departed*?
- Consider your approach to genre. Are you working with a classical model that might read a film like *Chinatown* next to precedents like *The Maltese Falcon* and *The Big Sleep*? Or are you evaluating the film according to the ways it revises its generic tradition?

LaunchPad Solo

Visit the LaunchPad Solo for *The Film Experience* to view movie clips, read additional Film in Focus pieces, and learn more about your film experiences.

READING ABOUT FILM
Critical Theories and Methods

Buster Keaton's 1925 film *Sherlock, Jr.* opens with a warning never to do two things at once. Its protagonist is a motion-picture projectionist who plays detective in order to prove his romantic rival is a thief. Soon he becomes literally split in two, as he falls asleep in the projection booth and his dreaming self enters the fictional film on screen. His surrogate solves the crime and gets the girl, but not before the film explores other characteristics of the cinematic illusion beyond narrative and its components of identification, genre, and closure. As Keaton begins to sit on a bench, the film breaks verisimilitude, cutting to a street scene where the actor completes his action, only to fall down in traffic. Several additional cuts match his pratfalls while changing backgrounds—a mountaintop, a lion-infested jungle, a desert where he narrowly avoids being struck by a freight train. Such bodily vulnerability to the speed and machinery of the early twentieth century is explored in many of Keaton's films, while viewers remain safe in our seats. The film touches on many preoccupations of film theory, including the specific characteristics of the medium, the place of realism, the syntax of storytelling, and the way the movie viewer is always doing two things at once—believing in an illusion and appreciating its craft.

Audiovisual technologies are now more prevalent and more integrated with our lives than ever before. Each time a new technology is introduced – television, home video, the Internet – predictions abound that moviegoing will be eclipsed by the new leisure forms. However, these pronouncements on the death of cinema have been premature. What is it about the film experience that resonates so meaningfully with modern life? This question, which emerged with the first projected moving images, continues to drive our thinking about mediated experiences today. Such reflection on the nature and significance of the medium is the province of film theory. The books and essays written by theorists in this field explore the specificity of the medium, the features of individual films or categories of films, and the interactions between viewers and films. In this chapter, we introduce the theoretical study of film through specific terms, histories, and positions.

Because cinema is accessible and familiar, some viewers are skeptical about the need to theorize the medium. Yet the knowledge that comes with avid moviegoing can itself be the foundation of a theoretical position. Every time we go to the movies, we evaluate elements about the film beforehand. When we choose drama or comedy, we invoke genre; if we buy a ticket for the new Wes Anderson film, we draw on auteur theory; and if we elect, while acknowledging the dismissive quality of the term, a "chick flick," we invoke some understanding of reception theory, which focuses on how different kinds of audiences relate to different kinds of films. When we speak of the fictional world of *The Godfather* (1972) **[Figure 11.1]** as if it were real, we invoke the concept of verisimilitude ("having the quality of truth"), and when we discuss the improbabilities of a comic book movie, we recognize the "willing suspension of disbelief" required of consumers of fictional stories, plays, and movies. Even when we select a seat at the movie theater, implicit in our choice is an ideal vantage point from which the film illusion will be most complete.

As these examples suggest, every theoretical approach to cinema foregrounds some elements and relegates others to the background. Besides looking at different aspects of the experience, film theories vary in their level of analysis and in the features that they address. Some theories regard the cinema as a mass phenomenon that needs to be approached on the institutional level (from the industry to the broad-based reception of films), and others are concerned only with formal principles. It may be helpful to think of each theory introduced in this chapter as part of the tool kit of the cultural critic. The toolbox metaphor implies that different theories are needed to address different questions and that theoretical inquiry helps us not only to take something apart but also to build models and connections. This brief overview cannot fully survey the diverse field of film theory; we encourage you to read these thinkers' own words so that you can share in their perspectives on the field's major debates.

11.1 *The Godfather* (1972). When audiences evaluate the verisimilitude of the world of the Corleone crime family, they are deploying a theoretical concept in an experiential way.

The Evolution of Film Theory

Before we present an overview of the history and key debates of film theory, we address two issues that are at the heart of the discipline and yet seemingly at odds with each other. First, the medium of film has elements that make it a distinct aesthetic form or mode of communication that demands its own analytical approach. Second, because film combines elements of other art forms and represents various commercial, artistic, and social interests, it must also be considered from an interdisciplinary perspective by drawing on art history, literary theory, sociology, and other disciplines. The excitement of studying film theory lies in the challenge of illuminating these two seemingly contradictory dimensions. Sustained critical interrogations—such as the writings by filmmakers, philosophers, and academics examined here—help us see cinema both as an aesthetic form and as a social institution that shares commonalities with other arts and cultural experiences.

Theories of an artistic medium often begin by trying to define their object—the nature of its being or **ontology**. How does cinema differ from painting or photography, for example? All use pictorial imagery, but film differs from painting because it is composed of photographic images captured with a camera, and it differs from photography in that its images are displayed to give the illusion of motion. As a storytelling medium, cinema borrows from the novel, yet the way it associates images with emotions resembles poetry. Like music, film is a time-based performance. Television borrows audiovisual and narrative language from film, yet its consumption is driven by different patterns of flow and interruption, contexts of space and time, and serial storytelling. Each of these comparisons can and has been extended. Theorists hope that from ever more precise statements of the properties of cinema, they can develop shared terms and inquiries.

Questions of cinema's **medium specificity**—its properties that are unique to the medium—and its interdisciplinary links are especially pertinent in light of today's technological developments. Breakthroughs like computer-generated imagery (CGI) and new forms of distribution and display raise interesting ontological questions about cinema. No longer is the film image a trace of the physical contact between light and an object that is chemically registered on film stock. Instead, the properties of the digital image are digitally coded and thus mutable. A computer-generated image does not have a real-world referent; in a sense the image *is* the thing **[Figure 11.2]**. Past work in the fields of film theory and history can help us make sense of the unique properties of digital media, and new approaches like cognitive science, data analysis, and game theory can contribute to the study of contemporary film and media.

While there are no clear chronological or intellectual boundaries to the field of film theory, we can contextualize important thinkers and understand how key principles and terms have been defined and debated over time. Film theory and the related theories that address new and emerging audiovisual media undoubtedly will take on different questions in the future. Yet these concerns will be shaped by a long and complex intellectual history.

VIEWING CUE

Compare a scene from a film you have viewed either in class or on your own with a passage from the book from which it was adapted. What elements are specific to the film?

11.2 *The Jungle Book* (2016). Is the nature or ontology of the film challenged by the combination of computer-generated imagery (CGI) and photography?

- Explain the concept of cinematic specificity and introduce the method of formal analysis.
- Describe the interdisciplinary nature of film and media studies.
- Outline the major positions in classical film theory, from Soviet montage theory to realism.
- Demonstrate knowledge about the key schools of thought within contemporary film theory, including semiotics and structuralism; psychoanalysis and apparatus theory; feminist, queer, and critical race theory; cultural studies; film philosophy; postmodernism and media convergence.

Early and Classical Film Theory

In this section, we begin with the earliest reflections on film that occurred not long after the first public exhibitions by Thomas Edison and the Lumière brothers. We then consider the body of work designated as **classical film theory**—writing on the fundamental questions of cinema produced in the first half of the twentieth century. This body of commentary emerged with the maturity of the medium in the 1920s and finds a convenient endpoint with the publication of Siegfried Kracauer's major work *Theory of Film* in 1960.

Early Film Theory

"Last night I was in the Kingdom of Shadows. If you only knew how strange it is to be there," wrote the Russian novelist Maxim Gorky after attending a film screening in 1896. When movies were new, observers searched for metaphors to describe the experience of seeing them. Struck by movies' magical properties, viewers attempted to pinpoint what was distinctive about the medium. Some early critics approached moviegoing as a social phenomenon, a new form of urban entertainment characteristic of the dawning twentieth century. Others viewed the cinema in aesthetic terms, heralding it as the "seventh art."

Although today film theory is considered part of an academic discipline, earlier writers on the topic came from many contexts and traditions outside the university, making any overview of the history of film theory a disjunctive one. A few early theorists wrote books, yet equally important theoretical contributions were made in journals, essays, and other forms. Some early writers on film were critics of other art forms or scholars in other disciplines, and others were filmmakers who shared their ideas and excitement about the developing medium with each other in specialized publications. Film theorists since the inception of the medium have examined the following questions:

- Is cinema an art form? How does it relate to photography, painting, theater, music, and other art forms?
- Does film resemble language or have a language of its own?
- Is film's primary responsibility to tell a story?
- Is film by nature a "realist" medium?
- What is the place of film in the modern world that fostered its development?

Two noteworthy books on movies appeared in the United States as early as the 1910s. Poet Vachel Lindsay's *The Art of the Moving Picture* (1915) responded enthusiastically to the novelty and the democratizing potential of the medium. "I am the one poet who has a right to claim for his muses Blanche Sweet, Mary Pickford,

and Mae Marsh," he stated, invoking the popular movie stars of the day. In his idiosyncratic but suggestive book, Lindsay likened film language to hieroglyphics. This metaphor of picture writing reflected cinema's promise of universality, which excited many early observers.

A more systematic elaboration of ideas about cinema was contributed by Harvard University psychologist Hugo Münsterberg in *The Photoplay: A Psychological Study* (1916). For Münsterberg, viewing films was linked to the subjective process of thinking. The properties of cinema that distinguished it from the physical reality to which its images referred made it interesting aesthetically and psychologically. Unlike watching a play, watching movies requires specific mental activities to make sense of cues of movement and depth. "The photoplay tells us the human story by overcoming the forms of the outer world, namely, space, time, and causality, and by adjusting the events to the forms of the inner world, namely, attention, memory, imagination, and emotion," wrote Münsterberg. His ideas thus emphasize the viewer's mental interaction with the medium. Decades later, theories of spectatorship did the same. Lindsay's work praised specific films, but Münsterberg referred to the photoplay in general. In a sense, their works mark the division between criticism, which reflects on a given aesthetic object, and theory, which is broader and sometimes more abstract.

Outside the United States, much early writing about cinema came from filmmakers themselves. Although movies immediately became commercialized, they emerged and flourished in the context of modernist experimentation in the arts—music, writing, theater, painting, architecture, and photography. Because film was based on new technology, many considered it an exemplary art for the machine age. Film influenced new approaches to established media, such as cubism in painting and the "automatic writing" of the surrealists. In turn, filmmakers adopted avant-garde practices, and painters like Hans Richter took up filmmaking to explore graphic and rhythmic possibilities. Modernist intellectuals debated cinema's aesthetic status and its relationship to the other arts.

French impressionist cinema—a 1920s avant-garde film movement that aimed to destabilize familiar or objective ways of seeing and to revitalize the dynamics of human perception—was fostered by groups known as ciné clubs and by journals dedicated to the new medium. In *Cinéma*, Louis Delluc coined the term **photogénie** to refer to a particular quality that distinguishes the filmed object from its everyday reality. Jean Epstein elaborated on this elusive concept in poetic writings such as "Bonjour Cinéma" and in his film adaptation of Edgar Allan Poe's story *The Fall of the House of Usher* (1928) **[Figure 11.3]**. Another key filmmaker of the period, Germaine Dulac, compared film to music in her extensive writings and lectures. Film theory and practice began to flourish jointly during this time and continued to develop in tandem in the period between the world wars.

Classical Film Theories: Formalism and Realism

Intellectual interest in the medium of film and its relation to contemporary times intensified as its technological and industrial organization, social role, and dominant styles solidified in the 1920s. Art historians like Rudolf Arnheim and Erwin Panofsky and film practitioners produced significant essays and full-length books on film theory. Although

11.3 *The Fall of the House of Usher* (1928). Jean Epstein's interest in the poetic quality of an object when filmed shares affinities with the writing of Edgar Allan Poe, whose short story he adapted in this impressionist film.

11.4 *Arrival of a Train at La Ciotat* (1896). Whether a truthful account or a myth, audiences were said to be so frightened by the image of a life-sized train coming directly at them that they screamed and ran from their seats. Association Freres Lumiere/Contributor/Getty Images

many film theorists sought to define the formal elements of film and their effects, both for practical reasons and to enter into debate with traditional theories of aesthetics, others held that the medium's appeal to realism was fundamental. Traditionally these positions are opposed to each other as **formalism**, a critical approach to cinema that emphasizes formal properties of the text or medium over content or context, and **realism**, the connection or quality of resemblance to the natural world.

Stories about the presentation of the Lumière brothers' film at the Grand Café in Paris invariably describe audiences that shrank from the arriving train or feared they would be splashed by ocean waves [**Figure 11.4**]. Such stories characterize cinema as realist and lacking the aesthetic distance of the other arts.

As we shall see, for realist theorists such as André Bazin and Siegfried Kracauer, film, like photography, was distinct because of its referential quality—its ability to refer to the world through images that resemble and record the presence of objects and sources of sounds. For formalists like Sergei Eisenstein and Béla Balázs, cinema is an art. Editing and close-ups are the basis of film's meanings and effects; realism is only a style that uses form in a particular way. Another approach to form can be found in the work of Walter Benjamin, who was interested in the way that film affects the sensory perception of the viewer. Although the debates between these positions became quite polemical, neither prevailed. The tension between the formal and realist properties of the medium remains at the heart of film theory.

Formalist Theories

Although some theorists might postulate that cinema is defined by some ineffable essence, most would characterize it by its form. In classical film theory, formalists looked to unique capabilities of cinema—such as camera movement and distance and shot duration and rhythm—to find meaning in the work itself. Some correlated aspects of film like editing to the fragmented experiences of modern life. Much of this work is indebted to influential theorist-filmmakers like Sergei Eisenstein.

Soviet Montage Theory. As is shown in the discussion of editing in Chapter 5, the montage theory of Eisenstein and other Soviet filmmakers of the 1920s has shaped both film practice and film theory. The 1917 Russian Revolution catalyzed a group of artist-intellectuals to develop formal means to express a new social order. Stylistic innovations in graphic and set design, painting, and sculpture were synthesized in the new medium of cinema, which, with its technological base and populist reach, was celebrated as a perfect expression of communist modernization. Lev Kuleshov's teaching at the state film school, where Vsevolod Pudovkin and Sergei Eisenstein were his students, put the theory of montage at the center of Soviet filmmaking. In *Mother* (1926) [**Figure 11.5**] and other films, Pudovkin used montage to break down a scene to direct the spectator's look and understanding. In contrast, Eisenstein's theory of montage, outlined in one of the most significant bodies of writing in film theory, emphasized the effects of collision between shots. Soviet filmmaker Dziga Vertov also contributed to film theory

in the form of manifestos signed by the Kinoki, or "cinema-eye" group. Vertov's avant-garde writings emphasized the new way of seeing made possible by the movie camera's ability to overcome the limitations of the human eye. He rejected the fiction film in favor of "life caught unawares" and was an early experimenter with the possibilities of sound.

Film Aesthetics. Like the Soviet montage theorists, Béla Balázs and Rudolf Arnheim championed formalist theories of film. Balázs, best known for his *Theory of the Film* (1952), was a Hungarian screenwriter and film critic who also worked in the Soviet Union and published his first book of film theory in 1924. Balázs argues that film broke with the theater and the other arts by allowing for viewer identification. In watching a movie, he writes, "we look up to Juliet's balcony with Romeo's eyes and look down on Romeo with Juliet's." In particular, Balázs wrote eloquently on the power of the close-up, an element of film art impossible to approximate on stage: "by means of the close-up the camera in the days of the silent film revealed also the hidden main-springs of a life which we had thought we already knew so well" **[Figure 11.6]**.

11.5 *Mother* (1926). Like other Soviet filmmakers, Vsevolod Pudovkin emphasized the power of montage. But although Eisenstein favored dissonant effects, Pudovkin pioneered the orchestration of emotion through cutting, as in this powerful adaptation of Maxim Gorky's novel.

German art historian Rudolf Arnheim argued even more strongly for a formalist position in his 1933 study *Film*, which was later revised for English publication as *Film as Art* (1957). For Arnheim, the quest for film realism is a betrayal of the unique aesthetic properties of the medium that allow it to transcend the imitation of nature. He set out to "refute the assertion that film is nothing but the feeble mechanical reproduction of real life." For example, his assertion that "film pictures are at once plane and solid" was not a limitation but an aesthetic parameter to be exploited by filmmakers and recognized by theorists. Like Münsterberg, Arnheim was interested in the psychology of perception and did not value the quality of resemblance above other responses to images.

Film and Modernity. The theorist Walter Benjamin was particularly interested in how cinema participated in the transformation of human perception. Benjamin wrote about cinema as well as photography in his famous 1935 essay, "The Work of Art in the Age of Its Technological Reproducibility." For Benjamin, the comparison of photography and film with painting does not hinge on their relative artistic value. Rather, they differ because these new art forms do not produce unique objects with the "aura" of an original artwork. Instead, film captures, in multiple widely circulating copies, the sense of accelerated time and effortlessly traversed space typical of contemporary urban

11.6 **Asta Nielsen as** *Hamlet* (1921). Theorist Béla Balázs believed the close-up could reveal the soul onscreen and wrote eloquently about Danish silent film star Asta Nielsen's face in close-up.

◀ **VIEWING CUE**

LaunchPad Solo

In this clip from *M* (1931), con-
sider how elements of form such
as the close-up, theorized by Béla
Balázs, and the two-dimensionality
of the screen, emphasized by
Rudolf Arnheim, direct the viewer's
interpretation.

◀ **VIEWING CUE**

Analyze a recent film you viewed
from a realist position. Can you
identify a scene that might support
André Bazin's ideas about the long
take or Siegfried Kracauer's ideas
about photography's power to cap-
ture the everyday?

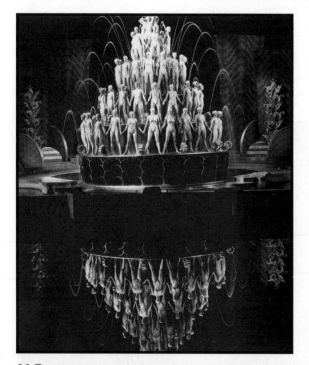

11.7 *Footlight Parade* (1933). In his writings of the 1920s
and early 1930s, Siegfried Kracauer cites the almost abstract pat-
terns of chorus girls in performance as examples of what he calls
"mass ornament."

life. Benjamin regarded the distracted state of the film viewer as both a response to
its formal properties and characteristic of the historical moment.

Realism

Formalist positions dominated in the 1920s, but the question of realism emerged
soon after as the central debate of classical film theory. The momentous technical
development of synchronized sound was accompanied by new speculation on the
nature of the medium: does sound allow film to fulfill a mission to reproduce the
world as it is, or does sound hinder cinema's visual expression? Realism, generally
speaking, serves the aim of **mimesis**, or imitation of reality, in the arts. The mimetic
quality has been valued in the Western artistic tradition since ancient Greece. If
the formalists saw the film screen as akin to a picture frame, the realists saw it as
a window.

During and after World War II, a reconsideration of realism was prompted by
political events as well as by technical innovations and new filmmaking move-
ments. One of the most prominent film critics and theorists of the 1950s and 1960s,
André Bazin, saw film as quintessentially realist, a medium "in which the image is
evaluated not according to what it adds to reality but what it reveals of it." Bazin
responded directly to the formalists who preceded him, and he serves as an impor-
tant predecessor of contemporary film studies in turn (Bazin's influence through
Cahiers du cinéma is discussed later in this chapter).

In his essay "The Evolution of the Language of Cinema" (1950–1955), Bazin
expresses the view that cinema's essence lies in its ability to capture a space and
event in real time. Montage interferes with this vocation, he argues, by alter-
ing spatial and temporal relationships. He advocates instead for scenes conveyed
through composition in depth, made possible by deep-focus
cinematography using wide-angle lenses. If all planes of the
image can be kept in view, cutting between shots taken from
different distances is less necessary. For Bazin, a filmmaker
like Jean Renoir, who staged scenes in depth using long takes,
conveys "respect for the continuity of dramatic space and, of
course, of its duration." Bazin sees the image as a reference
to both reality and the viewer's presence — and ultimately as a
means of transcending time.

Another formidable thinker on film, Siegfried Kracauer,
is, like Bazin, best known for his strong advocacy of real-
ism, although Kracauer's position evolved over time. In the
1920s, he began writing newspaper essays in Weimar Ger-
many amid modernist experimentation with film form. In
"The Mass Ornament" (1927), Kracauer explores the aesthet-
ics of mass culture and the new rhythms of life it inspired
[Figure 11.7], and in 1947 he published *From Caligari to
Hitler,* an influential study he called "a psychological his-
tory of the German film." In 1960, he elaborated his views
on film's capacity for realism in his major work, *Theory
of Film: The Redemption of Physical Reality.* In this work,
Kracauer argues that the cinematic medium "is uniquely
equipped to record and reveal physical reality." Not only
does film provide a window on the phenomenal world, but
more important for Kracauer, film also preserves what oth-
erwise would be destroyed — the momentary, the everyday,
the random.

Postwar Film Culture and Criticism

Film theorists' interest in cinematic realism was shaped by the devastating events of World War II and its aftermath. Kracauer's experience as a German Jewish refugee influenced his views on cinema as a kind of historical evidence. Bazin, an activist Catholic and member of the French Resistance, invested film with similar redemptive properties. For example, Bazin valued the postwar Italian neorealist movement—exemplified in films like *Germany Year Zero* (1948) with its amateur actors showing the hardships of postwar existence in actual locations **[Figure 11.8]**—because it demonstrates what Bazin calls "faith in reality."

In the period of recovery from the trauma and destruction of the war, neorealism led a vigorous resurgence of international film culture. Art cinema was supported by a network of new film festivals and journals. Film theory could not have taken hold without the flurry of filmmaking and lively debates of this period.

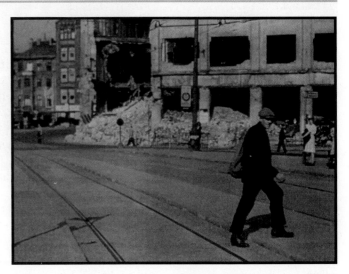

11.8 *Germany Year Zero* (1948). For André Bazin, Roberto Rossellini's film, set on location in postwar Berlin, puts its "faith in reality."

Film Journals

Perhaps the most famous postwar film journal, *Cahiers du cinéma*, was cofounded by Bazin in 1951 **[Figure 11.9]**. Under Bazin's mentorship, the magazine published the criticism of the young cineastes—François Truffaut, Jean-Luc Godard **[Figure 11.10]**, Eric Rohmer, Jacques Rivette, and Claude Chabrol—who shaped the French New Wave (see Chapter 2). These writers were getting much of their film education at the Cinémathèque Française, where Henri Langlois screened an eclectic menu of world film—including the hundreds of American studio films that could not be released in France during the Vichy period. The writings of

11.9 *Polyester* (1981). In cinephile John Waters's film, Divine reads an issue of the French film journal that introduced auteur theory in the 1950s.

11.10 Jean-Luc Godard in *Histoire(s) du cinéma* (1988–1998). From his feature debut *Breathless* (1960) to his cryptic experiment in 3-D, *Good-Bye to Language* (2014), Jean-Luc Godard as a filmmaker exemplifies the concept of auteur that he helped shape as a critic.

the *Cahiers* critics and the films that they made energized world film culture and lay the groundwork for the emergence of the discipline of film studies in universities.

Rival journals in France, *Positif* and *Cinéthique*, also flourished, and the polemics among them catalyzed film enthusiasts. Publications like *Movie* in England and the English-language *Cahiers du cinéma*, edited by Andrew Sarris in New York, disseminated French criticism and the auteur theory. In the United States, *Film Culture* was at the heart of the avant-garde New American cinema movement in the 1950s and 1960s, and the University of California's *Film Quarterly*, published under that title since 1958, introduced many key ideas of film theory.

After the cultural upheavals provoked by general strikes in France in May 1968, *Cahiers du cinéma* became both more political and more theoretical, with collectively written editorials and in-depth analyses of ideology and form in films like *Young Mr. Lincoln* (1939). In the 1970s, writers for the British journal *Screen* introduced the Marxist, semiotic, and psychoanalytic language and ideas from France that permeated Anglo-American cinema studies for more than a decade. Writing on film was not limited to periodicals. Monographs and series on individual directors, national cinemas, and genres proliferated. Many of these low-cost, portable "little books" combined the popular and the scholarly and encouraged the development of academic publishing in the field.

Auteur Theory

The ideas cultivated in these publications informed both popular criticism and academic theory. **Auteur theory** is an approach to cinema first proposed in *Cahiers du cinéma* that emphasizes the director as the expressive force behind a film and sees a director's body of work as united by common themes or formal strategies. It emerged in the 1950s when specific directors were vocally championed by the French critics. The retention of the French word *auteur* in English marks this origin. *Cahiers du cinéma* promoted what its writers called *la politique des auteurs*—a "policy" (or doctrine) of authors—singling out for praise filmmakers such as Orson Welles, Fritz Lang, Samuel Fuller, and Robert Bresson, whose distinct styles made their films immediately identifiable. European art cinema was in its ascendance, with figures like Ingmar Bergman and Michelangelo Antonioni fitting the definition of an auteur as an autonomous writer-director. Yet *Cahiers du cinéma*'s concept of authorship was also applied to a group of filmmakers for whom the idea of such conscious and consistent creative artistry seemed less appropriate—directors working in the heyday of the Hollywood studio system.

Critics argued that Hollywood auteurs such as Raoul Walsh and Howard Hawks left their signature on their films in the form of characteristic motifs or striking compositions, defying studio constraints on artistic autonomy in favor of market considerations. Debates arose over whether a particular director should be classified a true auteur or a mere **metteur en scène**, the French term

for director that here denotes a mere "stager" or stylist whose technical competence is not marked by the strong individual vision of the auteur. In America, *la politique des auteurs* was popularized by Andrew Sarris in *Film Culture*, the *Village Voice* and his 1968 collection *The American Cinema: Directors and Directions, 1929–1968*. Sarris includes Hawks, Chaplin, Welles, and John Ford in what he calls his "pantheon," while deflating the reputations of Academy Award-winners like William Wyler. In Sarris's hierarchy of Hollywood talent, the judgment of the critic prevails in assigning relative status to a wide array of directors based on their personal vision. Like that of the French critics, Sarris's work depends on a deep **cinephilia**, or love of cinema, and an almost exhaustive knowledge of the major and minor films released throughout the previous several decades. Sarris's rendering of the phrase *la politique des auteurs* as "auteur theory" in English is somewhat misleading. It is less a fully worked-out theory than a critical method, and any political connotation is lost in translation.

The auteurist approach tends to minimize the fact that cinema is a collaborative, commercial, and highly technologically mediated form. Making a film is not as personal as authoring a poem, and because so many individuals contribute to a film, it can be hard to assign credit to a single authorial vision, especially in studio-produced work. Critic Pauline Kael spoke out against Sarris's ideas and argued that writer Herman Mankiewicz rather than Orson Welles should be credited for coming up with *Citizen Kane*'s (1941) original structure and that cinematographer Gregg Toland's work distinguishes the film's look. In commercial cinema, a producer, studio, or franchise may be more important than a director. Today a director credit such as "a J. J. Abrams film" may be a matter of contractual obligations and financial arrangements. Film theorist Timothy Corrigan discusses the contemporary use of the director as brand as "the commerce of auteurism."

Genre Theory

In film, genre criticism, like auteur theory, was invigorated by the film culture of post–World War II France when American films that had not been released during that country's occupation by Germany were finally exhibited all at once, making commonalities easy to identify. Like auteur criticism, genre criticism also depends on cinephilia. Making generalizations based on only a few films would be imprudent. Sometimes genre criticism was considered to be at odds with auteurism. Geniuses could not make run-of-the-mill, formulaic films—or if they did, it was an exception in their oeuvre. But auteurist approaches essentially developed in tandem with genre perspectives. It can be argued that the mark of the auteur on a genre is what distinguishes his or her work. This is certainly the case with John Ford and the western.

Auteur criticism might also praise the handling of disparate genres by a particularly gifted auteur. Critic Robin Wood looks at the elaboration of Hawksian themes in both Howard Hawks's male adventure films and his screwball comedies and finds them to be related to the same concerns [**Figure 11.11**]. Similarly, a contemporary auteur such as Quentin Tarantino is known for

11.11 *His Girl Friday* (1940). Howard Hawks made classics in disparate genres, including westerns, musicals, adventure films, and comedies such as this one.

11.12 *Blade Runner* (1982). The convergence of auteurist and genre criticism is apparent in assessments of Ridley Scott's science fiction film.

his self-conscious use of martial arts, blaxploitation, and crime film genres, and Ridley Scott made an original film in *Blade Runner* (1982) while respecting the conventions of the science fiction genre **[Figure 11.12]**. Thus the positive critical response to popular cinema, especially Hollywood movies, that auteurism began to promote in the 1950s was carried on through genre criticism more directly.

Because different genres work out different cultural questions or problems, they tend to emerge and decline in particular periods. Critic Thomas Schatz, in his 1981 book *Hollywood Genres*, for example, sees musicals as celebrating cultural integration, often symbolized by the couple coming together, whereas westerns require the establishment of a home, one that the wandering hero cannot himself enjoy.

American philosopher Stanley Cavell used genre to frame his arguments about film as a form of thinking. In *Pursuits of Happiness,* he understood the remarriage plot common in screwball comedies as a way of posing central questions about what it means to be human; in *Contesting Tears,* he argued that similar questions posed by melodrama received different answers in the figure of the "unknown woman."

Contemporary Film Theory

By the 1970s, film studies had become an established discipline, with strong footholds in English and art history programs as well as its own academic departments, societies, and journals. During this time, the vocabulary of film theory became very specialized. Theorists became interested in a more systematic approach to cinema than was offered by the often subjective and impressionistic legacy of film criticism. Eventually, online journals, blogs, and streaming sites helped to democratize film theory, reflecting a greater engagement between the public and the scholarly film community and reconnecting with the discipline's origins in a wider film culture.

The following overview of contemporary film theory is organized according to major critical schools within the discipline. There are important interrelationships among these schools, and often one set of questions grows out of another. For example, when feminist film theory looks at our unconscious identification with characters onscreen, it overlaps with psychoanalytic theory. When it looks at how some genres are associated with female viewers, it overlaps with cultural studies. However, establishing the evolution of and broad outlines for each area of contemporary film theory is a useful way to raise questions for further study.

Structuralism and Semiotics

In a 1968 essay, French literary critic Roland Barthes declared "the death of the author," arguing that the artist's conscious intention and biography should be set aside in favor of an analysis of the formal qualities of the text itself. Auteur theory had extended the cultural prestige of the literary author to filmmakers, and now literary critics were calling into question the traditional notion of authorial genius. These new perspectives had their roots in **structuralism,** an approach to linguistics and anthropology that, when extended to literary and filmic narratives, looks for common structures rather than originality.

The origins of structuralism lie in the structural linguistics of Ferdinand de Saussure in the early part of the twentieth century, and the approach was widely influential in French thought in the 1960s. Because of this linguistic influence, film theorists, like thinkers in other disciplines, compared the medium to language. For Saussure, linguistics was the most exemplary case of a new science of signs he called semiology, which included pictures, gestures, and many other systems of communication. Semiology or **semiotics** is the study of signs and signification. It posits that meaning is constructed and communicated through the selection, ordering, and interpretation of signs. A **sign** is something that signifies something else, whether the connection is causal, conventional, or based on resemblance. For Saussure, a sign is composed of a **signifier** (a spoken or written word, picture, or gesture) and a **signified** (the mental concept evoked by a signifier). Together, the signifier *c-a-t* and the signified mental image of a domesticated feline form a sign, and the two parts cannot be imagined without each other. In a particular instance, the sign *cat* might refer to a specific feline, which would be its **referent**, the thing for which a sign stands. The analyst looks at the gap between the referent and the sign and the distinction between the signifier and the signified in order to isolate general rules or **codes** that apply to specific instances of communication or **messages**. The code of language, for example, allows English speakers and listeners to share the meaning of the word *winter* as one of four seasons, its **denotation** (the literal meaning of a word). Cultural codes, however, are responsible for the **connotations** of cold and snow, the associations connected with a word or sign.

For C. S. Peirce, the American philosopher who in the late nineteenth century coined the term semiotics, there are three varieties of signs—**symbol, icon,** and **index**. A symbolic sign (such as a word) has an arbitrary relationship to its referent that is assigned by language, which originates in culture. An iconic sign (such as a photograph or film) signifies its referents through a relationship of resemblance. Finally, an indexical sign (such as a footprint that indicates a person walked on a path or a weathervane that points in the direction the wind blows) has a direct causal relationship with the object depicted. This relationship can be likened to pointing or indicating, which is implied by the word index. An indexical sign like a photographic image is a product of a process in which light is reflected from an object and produces an image that is fixed by the chemical emulsion on film.

Pictures, especially photographs and film or video images (which are iconic and indexical signs), are often identified more strongly with their referents than are words (symbolic signs), which are connected to what they designate by convention only. In his famous painting *The Treachery of Images* (1929), René Magritte painted the words "*Ceci n'est pas une pipe*" ("This is not a pipe") under the image of a pipe. At first glance, the words seem absurd because they seem to refer to what is unmistakably a picture of a pipe. But a picture of a pipe is not a real pipe you would hold and use to smoke tobacco; it is merely its iconic sign. No essential nature of an object is captured in a sign, of whatever kind. Semiotics stresses language as a human invention and social convention, and the ways that these conventions have been described by linguistics' scientific methodology have allowed theorists to approach cinema systematically rather than subjectively (which might entail evaluating beauty and truth). Semiotic methods of formal analysis are based on these systematic attempts at understanding. Theorists identify how cinematic codes (such as camera movements and lighting) create meaningful patterns in specific films and across genres.

The legacy of linguistics has also been felt in theories of film narrative. Building on Saussure's structural linguistics, French anthropologist Claude Lévi-Strauss titled his important 1957 work *Structural Anthropology*. Lévi-Strauss

11.13 ***Star Wars: Episode IV—A New Hope*** (1977). George Lucas acknowledged that mythologist Joseph Campbell influence him in creating the plot of the first *Star Wars* (1977) movie. Narratologists would recognize the *dramatis personae* of the hero, the helper, and the princess in the film's main characters.

studied thousands of myths and discovered that they share basic structures that help shape cultural life. Russian folklorist Vladimir Propp noticed a similar unity in his study of hundreds of folktales. He found that many different plots had in common a limited number of characters performing a limited number of functions in the same order. These basic elements are echoed in many other narrative forms.

Narratology—the study of narrative forms—is a branch of structuralism that encompasses stories of all kinds, including films. Are there a limited number of basic plot elements available to filmmakers? Are genres like myths? Because movies are so formulaic and so strikingly similar to myths and folktales even when not explicitly based on them, narratological studies had fruitful results. The characters in the *Star Wars* series (1977–2015), for example, closely match the heroes, antiheroes, magical helpers, princesses, and witches of the folktales Propp studied **[Figure 11.13]**.

The linguists known as the Russian formalists, contemporaries of Sergei Eisenstein and Vladimir Propp, contributed the important distinction between plot and story (addressed in Chapter 7) to the study of narrative. In their terms, *syuzhet* (plot) refers to the way events are selected and arranged in the actual tale or film, and *fabula* (story) refers to the chronologically ordered sequence of events as we rationally reconstruct it. For example, a detective story's *syuzhet* follows the detective's progress through the investigation. Its *fabula* commences with the circumstances leading up to the committing of the crime.

Structuralist theorists reduce narrative to its most basic form: an opening situation is disrupted, a hero takes action as a result, and a new equilibrium is reached at the end. The novel, the distinctive middle-class cultural form of the nineteenth century, gave the hero psychological depth within a realistic field of action. These novelistic qualities were adopted by motion pictures, whose realist capacity reinforced them as norms. Film theorists drew on structuralism, semiotics, and the formalist positions of classical film theory to identify the conventions of classical narrative form and realism as a dominant, but not inevitable, form of cinema.

Ideological Critique

Influenced by Marxist theory, contemporary film theory used structuralism and semiotics as tools to critique ideologies seen to be underlying both the content and the dominant form of motion pictures. For example, a structuralist reading of the musical *Singin' in the Rain* (1952) that is critical of its ideological message would show that the technology and labor involved in making a Hollywood film are subordinated to the film's romance plot. Marxism is most immediately understood as a political and economic discourse that looks at history and society in terms of unequal class relations. But French thought—catalyzed by the radical social disruptions, political protests, and intellectual currents of the late 1960s—brought Marxism to bear on cultural forms like film.

Louis Althusser approached the traditional Marxist question of the nature of **ideology**—a systematic set of beliefs that are not necessarily conscious or acknowledged—with a new explanation of how people come to accept ideas and conditions that are contrary to their interests. Althusser defined ideology as "the imaginary representation of the real relations in which we live." According to him, real relations (such as paid work that contributes to the profits of others) disempower working people in the interests of the ruling class, and our imaginary representations (that this is the way things are supposed to be, according to narratives such as the evening news and Hollywood genre films) make this powerlessness seem inevitable and tolerable.

For the critics at *Cahiers du cinéma*, film became an important test of Althusser's theories about ideology because it affects viewers' beliefs on an unconscious level. In their 1969 editorial for the journal, Jean-Louis Comolli and Jean Narboni examined varieties of film practice and classified films in seven categories (from a to g) according to their relationship with the "dominant ideology." "Category a" films are those Comolli and Narboni perceived as most politically and formally consistent with the dominant ideology. "Category b" films include those that break with the dominant ideology on the level of content (for example, films that portrayed decolonization and the conflict over U.S. involvement in Vietnam) and on the level of form (for example, experimental films that disturb easy viewing processes).

But Comolli and Narboni's editorial set an even more lasting agenda for film theory in their practice of ideological critique. They used "category e" to designate Hollywood films that seem to uphold the status quo but that present formal excesses or internal contradictions that register the stresses and strains of trying to make the dominant ideology seem inevitable. Careful viewers can read these codes and see the film as a representation of or argument about the social world rather than as an unchangeable reality. Soon, other critics followed Comolli and Narboni's lead in reading films in this way. In these readings, critics found the films of studio-era auteur Douglas Sirk's 1950s melodramas—*All That Heaven Allows* (1955), for example—to be too color-coordinated, his characters too hysterical, and their environments too crammed with artificial commodities to be taken at face value [**Figure 11.14**]. These glossy surfaces were seen to be cracking under the brittle hypocrisies—anti-Communist

11.14 *All That Heaven Allows* (1955). Critics regarded Douglas Sirk's melodramas as "progressive texts" whose formal excesses and improbable situations showed the cracks in Eisenhower-era America's facade of prosperity and social consensus.

VIEWING CUE

Does the film you are watching put forth a clear ideological position? Are there ways to see conflicting positions in it?

hysteria, repression of the civil rights of African Americans, and the enforcement of restrictive gender roles and sexual codes that had been challenged during the war—of the prosperous, Eisenhower-era America they depicted. Sirk's films are what these critics called "progressive texts." They leave us with an uneasy feeling that can be taken as a critique of dominant ideology. This subtle and sometimes wishful approach is known as "symptomatic reading" and is a fruitful legacy of Althusser's ideological critique in contemporary film theory.

Poststructuralism

As the term implies, **poststructuralism** was an intellectual development that challenged the methodology and fixed definitions of structuralism. It did so by emphasizing the place of subjectivity, the unreliability of language, and the construction of social power. It included many distinct areas of thought, including psychoanalytic, postcolonial, and feminist theory. Poststructuralism asked us to reconsider the truths and hierarchies we take for granted. For example, our implicit standard that a satisfying film ties up all its loose ends is a structuralist position that posits closure as a basic narrative element. Poststructuralism countered that closure is a relative quality and stresses the open-endedness of stories. What happens if we daydream about the characters we have been introduced to or pick up on the relationship between a film and topical events?

As an intellectual movement, poststructuralism was a great deal messier than structuralism. Whereas structuralism attempted to be systematic by looking for transhistorical common patterns into which specific data could fit, poststructuralism questioned structuralism's assumption of objectivity and its disregard for cultural and historical context. A shorthand definition might be "structuralism + subjectivity = poststructuralism." Much of contemporary film theory remains poststructuralist in orientation because it explores the intersection of subjectivity with film structures. This is primarily done through drawing on the insights of psychoanalytic theory.

Psychoanalysis

Psychoanalytic theory comes into play in describing the psychic processes we undergo when experiencing the film illusion. When we watch films in a movie theater, we are immobile and surrounded in darkness and become absorbed in a larger-than-life image. Identification, desire, and disavowal of the illusory quality of the image are some of the processes that are activated as we watch a film.

Film theory was greatly affected by the ways French psychoanalyst Jacques Lacan described human subjectivity. Images were central to his account. In his teachings from the 1950s through his death in 1981, Lacan spoke of three domains of psychic experience: the "imaginary realm" deals in images, the "symbolic realm" is the domain of language, and the "real" is experienced as a trauma that cannot be directly represented. For Lacanian film theorists, people relate to pictures (the imaginary) in a powerful way that is rooted in one of the earliest images to leave an impression on us—our own reflection in the mirror. In the mirror stage, the infant comes to recognize himself or herself as a human individual, but this recognition is also a "misrecognition" because it is routed through an image that is an illusion.

Lacanian film theorists like Jean-Louis Baudry and Christian Metz likened this early sense of self, which is both powerful and illusory, to the experience of viewing a film and "believing" in its world. This sense of power in enhanced by the way that films portray stars and characters with physical powers superior to ours

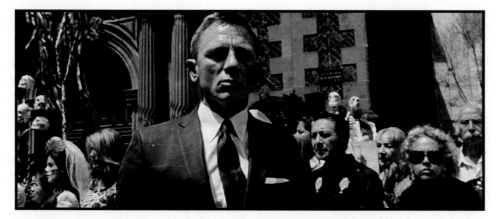

11.15 *Spectre* (2015). Daniel Craig's character, James Bond, represents an idealized object of identification — an aspect of spectatorship highlighted in psychoanalytic film theory.

and with whom we identify [**Figure 11.15**]. Although the symbolic and the real also come into play in our encounters with movies, the imaginary accounts for their power. This dimension of the film experience was elaborated by analogy with the viewing process itself.

Apparatus Theory

In Plato's parable of the cave, people are chained underground watching shadows on the wall and do not know that what they see is not real. Film theorist Jean-Louis Baudry saw the cinema as similar to the cave — as an ideological mechanism that is based in a physical set of technologies that has the power to convince us that an illusion is real. He uses Althusser's term "apparatus" to argue that the arrangement of movie equipment (such as the hidden projector and the illuminated screen) influences our unconscious receptivity to the image and to ideology — as if we, too, are trapped in Plato's cave.

Apparatus theory argues that the very mechanics upon which film is based, including cameras, projectors, and screens, were developed according to certain ideologies that then are reproduced in the viewing experience. It explores the values built into film technologies through the context of the medium's historical development. The camera's monocular (single-eyed) perspective is based on the values of human-scaled Renaissance art, in which the viewer stands at the point where perspective lines converge. Apparatus theory asserts that this position is not neutral but embodies Western cultural values — like anthropocentrism (human-centeredness), individualism, possessiveness, and the elevation of the visual over other senses. A culture that did not put the possessive individual at the center of representation — a culture that equally valued animals and people, for example, or senses other than sight in the arts — might never have developed the technology of photography.

The film viewer is in the same perspectival position as the camera that filmed the image and can thus imagine himself or herself as the originator or possessor of the illusion on the screen. This sense of one's self is double-edged. According to poststructuralism, an individual who stands in front of a Renaissance painting or watches a classical Hollywood movie is "subjected" to the apparatus's positioning and is granted his or her "subjectivity" or sense of self only in these predetermined conditions.

Theorists argue that subjects are constituted through language or through other acts of signification (meaning making), such as film. For example, the word *I* has no definite meaning until it is used by someone in a conversation, and its

meaning shifts as each speaker in the conversation uses *I* to refer to himself or herself. Because viewers cannot "talk back" when they watch a movie (as they can with video games, Web sites, and interactive films), they can be said to be constituted only as the object of the film's address: they are meant to laugh, cry, or put together clues as the film unfolds.

Spectatorship

How audiences interact with films and with the cinematic apparatus is addressed through the theory of **spectatorship** — the process of film viewing. Spectatorship has been a concern in film theory since Münsterberg, who used psychology to explain the mind's role in making sense of movies. In the poststructuralist theory of the 1970s, spectatorship stood at the convergence of theories of language, subjectivity, psychoanalysis, and ideology.

Christian Metz was one of the most prolific and influential contemporary promoters of spectatorship theory. In his book *The Imaginary Signifier* (1977), he argues that film's strong perceptual presence — giant images projected in a dark room with immersive sound — makes it an almost hallucinatory experience. Going to the movies gratifies our voyeurism (looking without being seen ourselves) and plays to our unconscious self-image of power. It is as if what is shown on the screen is made possible by our presence. The work of Metz and other French theorists appeared in translation in the influential English journal *Screen* in the early 1970s, and the great influence of what is sometimes known as "Screen theory" on the field led to the specialized use of the term "spectatorship" to indicate these psychoanalytically informed theories.

Theories of Gender and Sexuality

The poststructuralist account of spectatorship and subjectivity remains abstract if given only in general terms. In psychoanalytic theory, subjectivity is constructed as gendered. Theories of gender and sexuality have been integral to film theory's exploration of how subjectivity is engaged by and constructed in cinema.

Feminist Film Theory

As feminism began to have wide social and intellectual currency in the 1970s, commentators noted ways that female and male images were treated differently in film. In advertising, pornography, and painting, the objectification of the female image seemed to solicit a possessive, implicitly male gaze. In film, feminist critics noted, the spectator was envisioned in a similarly gendered way. "Is the gaze male?" asked E. Ann Kaplan in a 1983 essay of the same title, noting that vision in our culture is often associated with traits of ownership and power that are typically seen as male.

British theorist and filmmaker Laura Mulvey's "Visual Pleasure and Narrative Cinema," published in *Screen* in 1975, is considered by many to be the most important essay in contemporary film theory. Arguing that psychoanalysis offers a compelling account of how the differences between the sexes are culturally determined, Mulvey applied this account to cinema as a cultural institution enforcing such differences. She observes that the glamorous and desirable female image in film is also a potentially threatening vision of difference, or otherness, for male viewers **[Figure 11.16]**. Hollywood films repeat a pattern of visual mastery of the woman as "other" by attributing the onscreen gaze to a male character who can cover for the camera's voyeurism — its capacity for looking without being seen — and stand in for the male viewer. Film narratives also

VIEWING CUE

Consider your experience as a spectator of the film screened most recently for class. Did you relate to the point of view of a particular character, or was your perspective more omniscient? Were you aware of the apparatus (camera, projector, screen)?

tend to domesticate or otherwise tame the woman, Mulvey showed, offering analyses of Alfred Hitchcock's *Vertigo* (1958) and *Rear Window* (1954), whose stories are driven by voyeurism and require female makeovers. Essentially, Mulvey argues that the standard dichotomy in Hollywood film is "woman as image/man as bearer of the look."

In her essay, Mulvey championed "a political use of psychoanalysis" and a style of filmmaking that would "free the look of the camera into its materiality in time and space" so that it cannot be ignored through

11.16 *And God Created Woman* (1956). Brigitte Bardot's character exemplifies what Laura Mulvey calls woman's "to-be-looked-at-ness."

assimilation to the viewer's or characters' perspective. In their film *Riddles of the Sphinx* (1977), Mulvey and Peter Wollen used 360-degree pans, with the camera positioned at about waist level, to emulate the circularity of a young mother's rhythms of work and to avoid objectifying her body in a centered, still image **[Figure 11.17]**. The film deliberately set out to destroy conventional visual pleasure and narrative satisfaction. Like many theorists of this period, Mulvey and Wollen believed that making spectators think about what they were seeing would lead them to critique the dominant ideology.

Building on Mulvey's provocative argument, other feminist critics have raised the question of female spectatorship. If narrative cinema successfully positions the viewer to take up a male gaze, why are women historically often the most enthusiastic film viewers? One way to approach this question is to consider films produced with a female audience in mind. During Hollywood's heyday, "women's pictures" featured female stars like Bette Davis and Joan Crawford, who had a strong appeal to women. At first glance, women's pleasure in these films seems self-defeating: what these heroines seem to do best is suffer. However, feminists argued that a film like *Now, Voyager* (1942) enables female spectators to explore their own dissatisfaction with their lives by fantasizing a more fulfilling version of that existence. The movie shows Davis as a dowdy spinster taking control of her life—through psychoanalytic treatment, romance, and new clothes.

Today's commercial films aimed at women are not that different from those of the 1940s. Many feminist critics argue that women's pleasure in these complicated, mixed-message movies should be taken seriously. Because film is a mass medium, it will never radically challenge existing power relations, but if it speaks to women's dilemmas, it is doing more than much official culture does. Sometimes filmmakers succeed in evoking these emotions and mass cultural traditions in more reflexive and satisfying ways, such as in Pedro Almodóvar's revisiting of maternal melodramas in *All About My Mother* (1999) and *Volver* (2006) **[Figure 11.18]**.

Overall, feminism has affected the relatively young discipline of film theory more than it has affected more established

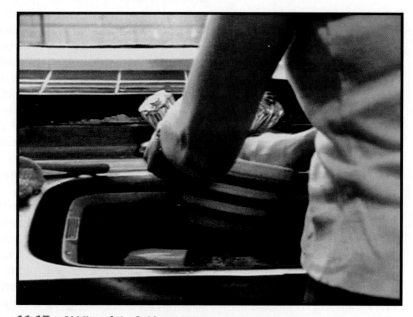

11.17 *Riddles of the Sphinx* (1977). Laura Mulvey puts her own theories about images of women into practice in a film made with Peter Wollen.

11.18 ***Volver*** (2006). Pedro Almodóvar revisits the Hollywood genre of the maternal melodrama in this family story, empowering his female characters.

ones. Arguably, gender in film cannot be ignored. As Mulvey's work suggests, cinema—certainly entertainment film but also the avant-garde—depends on stylized images of women for its appeal. Moreover, the cinema, because it is part of the fabric of daily life, necessarily comments on the everyday, private sphere of gender relations. Feminism's significant inroads in film theory have laid the groundwork for related, though not always parallel, critiques of cinema's deployment of sexuality, race, and national identity.

Queer Theory

Feminist theory and psychoanalytic theory stress that unconscious processes (such as desire and identification) are at play when we go to the movies. Like cinema itself, however, psychoanalysis historically concentrates on heterosexual scenarios (such as the Oedipus complex) and pathologizes gays and lesbians (as cases of "arrested development," for example). Queer film theory critiques and supplements feminist and psychoanalytic approaches, allowing for more flexible ways of seeing and experiencing visual pleasure than are accounted for by the binary opposites—of male versus female, seeing versus seen, and being versus desiring—that are the basis of Mulvey's influential model of spectatorship.

Queer theory challenges Mulvey's assumption that the desiring position is male and the desired one is female, which essentially equates gender difference with sexual desire. The gender of a member of the audience need not correspond with that of the character he or she finds most absorbing or most alluring. Mulvey cites Marlene Dietrich as an example of a "fetish" or mask for the male spectator's desire, but Mulvey does not remark on the lesbian connotations of the star's image. Dietrich cross-dressed for songs in many films and even kissed a woman on the lips in her first American movie, *Morocco* (1930) **[Figure 11.19]**. Dietrich's gender bending needs to be confronted in terms that go beyond psychoanalytic theory. Her onscreen style borrowed directly from the fashions of the lesbian and gay subculture of Weimar-era Germany, where her career began. Dietrich thus appealed on many different levels to lesbian and gay viewers, as well as to heterosexual women and men. In fact, this multiplicity could be seen more generally as a key to cinema's mass appeal. The theory of gender performativity—the idea that there is no essential content to gender, only a set of cues and codes that must be repeatedly enacted and can be changed—is illustrated in Dietrich's persona.

Although movies tend to conform to the dominant values of a society (in this case, to heterosexuality as the norm), they also make unconscious appeals to our fantasies, which may not be as conformist, and the term *queer* captures this antinormative potential. Moreover, films leave room for viewers' own interpretations and appropriations, such as when fan writers continue the adventures of particular mainstream characters or celebrities and share them on the

11.19 ***Morocco*** (1930). Queer theorists interpret Marlene Dietrich—here kissing a woman—in a different way than feminist theorist Laura Mulvey does in her influential essay "Visual Pleasure and Narrative Cinema."

Internet. Spectators positioned at the margins, such as gay men and lesbians, often "read against the grain" for cues of performance or mise-en-scène that suggest a story that is different from the one onscreen and has more relevance to their lives. An interest in stars may extend beyond any particular film they are cast in and ignore the film's required romantic outcomes. Queer theory allows for interpretations that value style over content and ambiguity over certainty.

Cultural Studies

Cultural studies is a set of approaches drawn from the humanities and social sciences that considers cultural phenomena in conjunction with processes of production and consumption. This approach scrutinizes aspects of cinema embedded in the everyday lives of individuals or groups at particular historical junctures and in particular social contexts. It does not analyze individual texts in isolation or theorize about spectatorship in the abstract. An interest in audience members' experience of cultural forms builds upon Marxist approaches like that of Theodor Adorno and Max Horkheimer, whose essay "The Culture Industry: Enlightenment as Mass Deception" (1944) argues that mass culture dupes its viewers by churning out movies in the same manner as new cars or brands of toothpaste, with only superficial differences among the products. A useful way of understanding the fresh approach that cultural studies takes lies in a shift in the definition of "culture." Instead of defining culture as great works produced by transcendent artists and appreciated by knowledgeable patrons, cultural studies defines the term anthropologically as "a way of life, including social structures and habits." In other words, cultural studies scholars are interested in how movies are encountered, understood, and "used" in daily experience. We look at a few key approaches within cultural studies—reception theory, star studies, and race and representation.

Reception Theory

Reception theory—a theoretical approach to the ways different kinds of audiences regard different kinds of films—focuses on how a film is received by audiences rather than on who made a film or what its thematic content or formal features are. Proponents of this approach focus on a work's meaning only as it is achieved in its reception. This implies a theory of audiences as active rather than passive. One obvious example is participatory viewing practices, including the costumes and call-and-response of fans in *The Rocky Horror Picture Show* (1975) viewings [**Figure 11.20**].

Reception theory also recognizes that films from the past may be received by today's audiences in entirely new ways. They might root for Native Americans rather than cowboys or might enjoy a supporting character's subversive wit more than the romance of a pair of bland leads.

Beyond the idiosyncrasies of personal history and circumstances, aspects of each viewer's cultural identity (for instance, age, ethnicity, and educational background) can predispose us toward particular kinds of reception. The homoerotic subtext of *Rebel Without a Cause* (1955) may be more salient to an audience knowledgeable about gay subcultural interest in actors James Dean and Sal

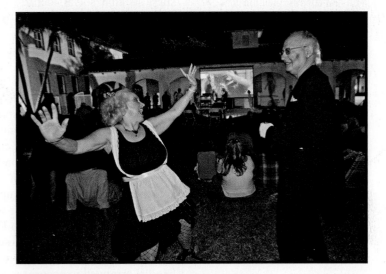

11.20 *The Rocky Horror Picture Show* (1975). Scholars of reception theory study participatory audiences and repeat viewers. © Allen Eyestone/*Palm Beach Post*/Zuma Press

11.21 Rebel Without a Cause (1955). Subcultural knowledge about actor Sal Mineo's gay identity reinforces the film's homoerotic subtext about Plato's feelings for Jim Stark, played by James Dean.

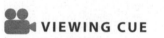

VIEWING CUE

Conduct a reception study of the film you just viewed by surveying your classmates about which characters and situations they responded to most favorably. Compare and contrast their opinions with those of film reviewers.

Mineo **[Figure 11.21]**. Such an audience can be understood as an **interpretive community**—group members who share particular knowledge or cultural competence through which a film could be experienced and interpreted. Such responses are sometimes called "situated responses."

The distinctive West African-derived hairstyles in *Daughters of the Dust* (1991) are more likely to be recognized and enjoyed by black women than by other audience members. Indeed, filmmaker Julie Dash intended this special gratification as part of the movie's address, its vision of its ideal audience. The citation of these images in *Lemonade* (2016) addresses those familiar with the independent film as well as new black female viewers. Theorists see these multiple ways of interacting with a text as confirmation that individuals actively make meaning even in response to otherwise homogeneous mass media.

The methodologies associated with reception theory include comparing and contrasting reviews drawn from different periodicals, countries, or decades; conducting detailed interviews with viewers; tracking commodity tie-ins (the goods that are marketed with the "brand name" of a particular film or characters); and studying fan activity on the Internet. Given the multitude of possible approaches, reception studies has a wide scope.

Reception studies differs from theories of spectatorship in that it deals with actual audiences rather than a hypothetical subject constructed by the text. Unlike spectatorship, which is concerned with the unconscious patterns evoked by a particular text or by the process of film viewing in the abstract, reception studies addresses actual responses to movies and the behavior of groups. British cultural studies scholar Stuart Hall argued that groups respond to mass culture from their different positions of social empowerment—with a dominant reading, by reacting from the position that the text slots them into; with a negotiated reading, by accommodating different realities; or with an oppositional reading, by rejecting the framework within which a dominant message is conveyed. Reception studies thus suggests that social identity considerably complicates the picture of subjectivity offered in poststructuralist film theory.

Star Studies

An important component of reception is our response to stars—performers who become recognizable through their films or who bring celebrity to their roles. In addition to analyzing how a star's image is composed, theorists are interested in how audience reception helps define a star's cultural meaning. Although they are one of the most pervasive aspects of cinema, stars may seem like unlikely topics to be considered in a theoretical approach. After all, stars are the province of entertainment news, tabloid journalism, fan Web sites, and online chats. But these familiar and ephemeral sources have an important place in cultural studies. Viewers understand a film in relationship to what they know of its stars outside the world of the film's fiction. From Judy Garland to Lindsay Lohan, stars with troubled offscreen lives are perceived differently in wholesome onscreen roles **[Figures 11.22a and 11.22b]**.

Richard Dyer details how multiple discourses about stars—including promotion (studio-arranged exposure such as Web sites and television appearances), publicity (romances, scandals, and political involvement), commentary (critical evaluations and awards), and their appearances in films—help construct their images. Star

images become texts that can be read in their own right. Even when a particular star is billed as an "ordinary guy," like Tom Hanks, or "the girl next door," like Doris Day was in the 1950s, this image is carefully orchestrated.

Analysis of a star image enriches understanding of a particular film as well as film culture. Viola Davis became a star later in her career, appearing in mass-market fantasy/action movies like *Suicide Squad* (2016) and *Ender's Game* (2013); receiving Academy Award nominations for her work in more prestigious films like *Doubt* (2008), *The Help* (2011) and an Oscar for *Fences* (2016); and crossing media by starring in the television series *How to Get Away with Murder* (2014–2017). She tends to play serious, formidable characters and has complemented her work with a series of heartfelt awards show speeches, that acknowledge her own struggles and those of women of color in Hollywood. Her performances and public appearances combine for a persona that carries connotations of "authenticity" **[Figure 11.23]**.

Audiences will never have access to the star as a real person. Instead, we experience his or her constructed image in relation to cultural codes (including age, race, class, gender, religion, fashion, and more) and according to filmic codes (genre, acting, and even lighting). For example, the silent film star Lillian Gish was sometimes lit from above as she stood on a white sheet. The reflected light enhanced her pallor and the radiance of her blond hair, connoting a virginal whiteness that was an important component of her star image in films directed by the white supremacist D. W. Griffith. Stars are often considered the embodiment of types. For example, John Wayne connotes rugged individualism; Sandra Bullock, spunky decency; Morgan Freeman, quiet dignity; Will Ferrell, manic mayhem. Heath Ledger's star image gained new dimensions from his performance as the Joker in *The Dark Knight* (2008) and his tragic premature death before that film's release.

We also construct our own identities and communities through stars whom we will never know, and this is not necessarily a negative aspect of the phenomenon. Young girls who patterned themselves after plucky singing star Deanna Durbin in the 1940s, Madonna in the 1980s, or Idina Menzel's characters incorporated the quality of independence these stars embodied and identified themselves in solidarity, rather than in competition, with other girls who shared their appreciation. According to Dyer, a basic conflict between the ordinary and the extraordinary is at the root of the star phenomenon. Stars are not better people than the rest of us, which facilitates our identification with them. And yet they remain a breed apart.

Star discourse is a particularly revealing and useful critical approach to cinema because it is based in our everyday experience as fans. We have many immediate and unexamined responses to stars, from crushes to antipathies. But we also appreciate stars in nuanced ways that yield considerable critical understanding. Cultural studies of stars often begin with viewer testimonials, not taking them at face value but using them as a starting point for a sociological analysis. What ethnic groups are represented in a nation's

(a)

(b)

11.22a and 11.22b **Lindsay Lohan's wholesome character in *Mean Girls*** (2004). The wholesome onscreen role contrasts with contemporary viewers' knowledge of the actress's troubled offscreen life.
(b) Jean Baptiste Lacroix/Getty Images

David Bordwell, one of the most prolific and well-respected contemporary film scholars, advocates a cognitivist approach that understands our response to film in terms of rational evaluation of visual and narrative cues that characterize film styles prevalent in particular places at particular historical junctures. **Cognitivism** draws on psychology and neuroscience to understand how the mind responds to narrative and aesthetic information in film. Rejecting analysis that invokes unconscious fantasy or employs idiosyncratic interpretation, cognitivism claims that we respond to the moving image with the same perceptual processes we use to respond to visual stimuli in the world — by adjusting film images for lack of depth and perceiving the identity of objects that are moving and changing in time. Not simply a backlash against the obscure terminology and French-influenced syntax of poststructuralist theory, analytic philosophy and cognitivist film theory argue for a less metaphorical, more scientific and historically verifiable definition and practice of film studies.

Phenomenology — a philosophical approach postulating that any act of perception involves a mutuality of the viewer and what is viewed — has also influenced film theory. Jacques Lacan and Christian Metz derived their emphasis on the gaze from phenomenologists, but the psychoanalytic concept of the unconscious diverged from the more embodied consciousness that phenomenology described. Vivian Sobchack uses the phenomenology of perception to account for the film experience as a reciprocal relationship between viewer and screen, also distinguishing between the different phenomenologies of film and television viewing.

French philosopher Gilles Deleuze made a distinctive contribution to contemporary film theory by building on the semiotics of C. S. Peirce and the work of philosopher Henri Bergson on time and duration. More than the writings of almost any other film theorist, Deleuze's work must be studied on its own terms because of the way he develops concepts through specific terminology. In his two books on cinema, Deleuze distinguishes between two types of cinema that correspond roughly to two historical periods.

The **movement image** — a practice of filmmaking in which editing emphasizes cause and effect — was prevalent in the cinema of the first half of the twentieth century. The physical comedy of Buster Keaton and the collision at the heart of Sergei Eisenstein's montage provoke a particular response in the viewer. In contrast, the **time image** — an open-ended image or film that lacks clear signals of spatial connection or logical sequence — is displayed in postwar films. The neorealist works of Roberto Rossellini and the more metaphorical studies of Michelangelo Antonioni, both made in the context of the disillusionment and uncertainty of postwar Italy, do not orient the viewer to a particular expectation or response. Instead of imposing an interpretation on time by representing it through sequence or movement, such films offer a "direct image of time" as the intersection of the potentiality of both past and future **[Figure 11.29]**.

Deleuze's philosophy of film goes beyond the specific films and directors he uses as examples to suggest new ways of imagining the relationship between images and thought. Referentiality — the idea that filmic images refer to actual objects, events, or phenomena — is no longer a basic tenet of film theory. For Deleuze, the film image is not a representation of the world; it is an experience of movement or time itself. For other

11.29 *L'Avventura* (1960). According to philosopher Gilles Deleuze, this classic art film presents "a direct image of time," in part through its unpredictable editing patterns.

thinkers, referentiality is no longer a tenet of film theory because neither film nor the world is what it used to be.

Postmodernism and New Media

Film is not the only medium that organizes our audiovisual experience, and the photographic basis of film has been largely replaced by digital capture and generation. At least since the late 1940s, when television was rapidly adopted into U.S. homes, other moving-image media have challenged cinema's dominance. However, film has so thoroughly transformed our overall experience that it has prepared us for the integration of digital imaging in our lives. Rather than defining film more narrowly in the digital era, we can think of it more broadly.

This predominance of media is characteristic of the culture of **postmodernism**. As we have mentioned, the term modernism refers both to a group of artistic movements (including atonal music, cubist painting, and montage filmmaking) and to the period in which those movements emerged and to which they responded (generally, the first half of the twentieth century). Postmodernism also has two primary definitions:

- In architecture, art, music, and film, postmodernism incorporates many other styles through fragments or references in a practice known as pastiche.
- Historically postmodernism is the cultural period in which political, cultural, and economic shifts challenged the tenets of modernism, including its belief in the possibility of critiquing the world through art, the division of high and low culture, and the genius and independent identity of the artist.

The most important thinkers on postmodernism have addressed both aspects of this definition. Fredric Jameson defines postmodernism historically as "the cultural logic of late capitalism"—referring to the period in post–World War II economic history when advertising and consumerism, multinational conglomerates, and globalization of financing and services took over from industrial production and circulation of goods. Stylistically, postmodern cinema represents history as nostalgia, as if the past were nothing more than a movie style.

For Jean Baudrillard, the triumph of the image in our cultural age is so complete that we live in a simulacrum, a copy without an original, of which Disneyland is one of his most illuminating examples. In *The Matrix* (1999) and its sequels, the characters' belief that they live in the "real world" is mistaken: the city, food, intimate relationships, and physical struggles are all computer-generated [**Figure 11.30**]. This lack of referentiality is frightening in that it represents the absence of any

11.30 *The Matrix* (1999). "What is the matrix?" the film's ad campaign asked. Postmodern theorist Jean Baudrillard is quoted in the film.

overarching certainty to ground postmodern fragmentation. But on the hopeful side, the "real" is now open to change. When *The Matrix* shows a (fake) book written by Jean Baudrillard, the film is both making an in-joke and illustrating postmodernism's tenet that there is nothing new in the world.

It is no accident that the postmodern world is vividly presented in a movie because movies themselves are simulations. Film theorist Anne Friedberg notes that the way we consume film images can be generalized to a society characterized by image consumption and mobility. The variety of "looks" one finds by window shopping, internet surfing, or identifying with other characters at the movies has a positive side. The postmodern breakdown of singular identity has as its corollary a recognition of identities formerly relegated to the margins. Postmodernism also recognizes the changes wrought by globalization. New technologies make the flow of images even easier—from Hollywood to the rest of the world, of course, but also from formerly peripheral sources to U.S. audiences and between local cultures. The acceleration of media convergence in the digital era allows access to these flows through different technological means and according to different habits of organizing time and experiencing both space and interface.

Our survey of the history of contemporary film theory evokes the auspicious institutional climate of the academic discipline of film studies in Anglo-American universities, which has consolidated and developed ideas from France and elsewhere since the late 1960s. This story of the origins of contemporary film theory can be told fairly smoothly, and that should make us suspicious. Fields of knowledge advance by active questioning and dissent. As we have noted, cultural studies and cognitivism have challenged the orthodoxies that began to emerge in film theory by the 1970s, and their pluralism and skepticism add a welcome perspective on ideas that might otherwise become rote and ossified and simply "applied" to new cases.

The challenges posed by the digital image to film since the 1990s go beyond technological and economic ones: they are also intellectual. Cinematic specificity is no longer defined by the photographic image, and the interdisciplinarity of cinema studies has accordingly expanded to include computer science, engineering, and design. Although in some ways new technology can be seen as merely enhancing the film experience as we have known it (for example, the return of 3-D technologies), in other ways it alters both the medium and our experience of it (for example, the puzzles, interactivity, and spatial innovations of video games). Scholars continue to draw on the legacies of previous inquiries in film theory in order to identify the salient questions our contemporary audiovisual experience raises and to develop tools with which to address those questions.

CONCEPTS AT WORK

This chapter has aimed to demystify the field of film theory, which is not to imply that readers will not have to struggle to understand film on a more abstract plane. In reading and picking apart theorists' work, it is important to recall that on some level theory always relates to practice. In reviewing Stuart Hall's approach to reception theory or Fredric Jameson's definition of postmodernism, we look at concrete responses to intellectual challenges. The term theory is a useful, shorthand way to refer to a body of knowledge and a set of questions. We study this corpus to gain historical perspective (on how realist theory grew from the effects of World War II, for example), to acquire tools for decoding our experiences of particular films (like the close analysis of formalism),

and above all to comprehend the hold that movies have on our imaginations and social lives.

- Consider whether cinematic specificity is affected by watching films across platforms.
- Think of insights from other academic disciplines or artistic pursuits that seem to be missing from this account of film theory, and consider what we might learn from these new approaches.
- How might the formalist and realist film theorists debate the return of 3-D technology?
- Consider how debates about race and representation raised by a film like *The Birth of a Nation* (2016) could be illuminated by drawing on concepts in film theory.

LaunchPad Solo

Visit the LaunchPad Solo for *The Film Experience* to view movie clips, read additional Film in Focus pieces, and learn more about your film experiences.

ct: cut	la: low angle	nds: nondiegetic sound
cu: close-up	ls: long shot	ps: pan shot
ds: diegetic sound	mcu: medium close-up	trs: tracking shot
es: establishing shot	mls: medium long shot	vo: voiceover
ha: high angle		

More specific camera movements and directions can often be re-created with arrows and lines that graph the actions or directions. The following drawings suggest the movements of the camera:

low camera angle ↗ high camera angle ↙ tracking shot ∿

For example, part of the jailhouse sequence in *Bringing Up Baby* [**Figures 12.9 and 12.10**] might be annotated as follows to indicate cuts, camera movements, or angles.

mcu of constable and Susan through bars
ct mcu David

Later, these notes would be filled in, perhaps by again reviewing the sequence for more details—for example, pieces of the hilarious monologue of "Swinging Door Susie." Drawings of shots can supplement such details. Critical comments or observations might also be added—for instance, about how the organization of the shot composition and editing provides the contrast between the officious and tongue-tied sheriff and the zany and loquacious Susan.

Selecting a Topic

After taking and reviewing your notes on the film, you need to choose the topic for the paper. Because there are many dimensions of a film to write about—character, story, music, editing—selecting a manageable topic can prove daunting. Even a lengthy essay will suffer if it attempts to address too many issues. Narrowing your topic will allow you to investigate the issues fully and carefully, resulting in better writing. In a five- or six-page essay, a topic such as "fast-talking comedy in *Bringing Up Baby*" would probably need to rely on generalities and large claims, whereas "gender, order, and disorder in the jailhouse" would be a more focused

12.9 *Bringing Up Baby* (1938). "Swinging Door Susie" engages the sheriff . . .

12.10 *Bringing Up Baby* (1938). . . . and baffles her cellmate, David.

and manageable topic. Although good critical analysis usually considers different features of a film, we can distinguish two sets of topics for writing about film—formal and contextual. Formal topics concentrate on forms and ideas within a film, including character analysis, narrative analysis, and stylistic analysis. Contextual topics, which relate a film to other films or to surrounding issues, include comparative analysis and historical or cultural analysis.

Formal Topics

In general, there are three types of formal topics: a **character analysis** focuses its argument on a single character or on the interactions between two or more characters, a **narrative analysis** concentrates on the story and its construction, and a **stylistic analysis** focuses on form (such as shot composition, editing, and the use of sound).

Although writing a character analysis may appear easier to do than other kinds of analyses, a good essay about a character requires subtlety and eloquence. Rather than write about a central character, like Susan in *Bringing Up Baby* or the singer Johnny Cash in *Walk the Line* (2005) **[Figure 12.11]**, an essay might concentrate on a minor character, such as Susan's aristocratic aunt or Cash's first wife Vivian.

Similarly, a narrative analysis should usually be refined so that the paper addresses, for instance, the relationship between the beginning and the end of a film or the way a voiceover comments on and directs the story. In *The Shawshank Redemption* (1994), the narrative concentrates largely on Andy Dufresne, condemned to prison for murdering his wife and her lover, but the complexity of his story becomes richer and more nuanced as it is filtered through the voiceover commentary of his prison comrade "Red" Redding. The relationship of the two creates, in effect, a second narrative line that interacts with the prison story.

A paper that deals with a stylistic topic will be more controllable and incisive if, for instance, it isolates a particular group of shots or identifies a single sound motif that recurs in the film. One student may find a topic for a paper by examining the role of the various narrators in Terrence Malick's *The Thin Red Line* (1998). Another student may choose to look carefully at repeated editing patterns in *Battleship Potemkin* (1925) or at the use of framing in Yasujiro Ozu's *Tokyo Story* (1953). Any one of these topics will grow more interesting and insightful if you continue to ask questions during the writing process: How is the character David in *Bringing Up Baby* shaped by costuming or shot composition? How do the various narrators in *The Thin Red Line* reflect different attitudes about war?

12.11 *Walk the Line* (2005). Character analysis of a primary role, the tormented musician Johnny Cash (played by Joaquin Phoenix), risks describing the obvious.

FILM IN FOCUS

FILM IN FOCUS
LaunchPad Solo
To watch a clip from *Minority Report* (2002), see the *Film Experience* LaunchPad.

Analysis, Audience, and *Minority Report* (2002)

See also: *A.I.* (2001); *Blade Runner* (1982); *Inception* (2010)

Minority Report (2002) initially attracted audiences through the reputation of one of the most prolific and acclaimed directors in the world, Steven Spielberg, and one of the most popular stars in the world, Tom Cruise. Some viewers may enjoy the film because it recalls and elaborates on themes from other Spielberg films or because it features a successful and complex performance by Cruise. Others may be intrigued by its variations on the sci-fi thriller genre. Any of these pathways could be developed into a provocative essay about the film but only if those perspectives and ideas can be substantiated or proven useful, true, and important—that is, only if they can be shown to have objective accuracy.

One student decides to write a review of *Minority Report* for his college newspaper in anticipation of the film's upcoming appearance at the college art house. Because the film is more than ten years old, the writer presumes that many of his potential readers have not yet seen it and need both information and balanced opinions. He proceeds with a clear sense of what his readers already know, do not know, and need to know about the film.

Background information on the director and film helps provide context for readers.

Minority Report (2002) probably is not one of the best-known or most commonly discussed films by celebrity director Steven Spielberg. Most of us likely associate Spielberg with well-known popular thrillers like *Jaws* (1975) and *Jurassic Park* (1993) or historical blockbusters such as *Saving Private Ryan* (1998) and *Lincoln* (2012). Although *Minority Report* features megastar Tom Cruise, it is a quirkier and edgier movie than most of Spielberg's other films. Based on a novel by Philip K. Dick and part of a sci-fi heritage that extends from *Blade Runner* (1982) through *Inception* (2010), this futuristic story, set in 2054, is perhaps Spielberg's darkest and most complex effort.

Reviews should have a point of view.

Here the writer argues that the film engages viewers through the drama of its futuristic technology.

Although some of you may dash out to see this 2002 movie for the big-screen projection of Cruise as John Anderton, the real star of the film is the depiction of future technology and the ways that it may change our world. Anderton is a police officer whose unit oversees three human "pre-cogs" linked to advanced computer technologies that allow the Pre-Crime Division to foresee and stop future murders. Everyone assumes this technological surveillance system is flawless and foolproof because it has kept Washington, D.C., free of all crime for several years. With an ingenious variation on the wrongly accused protagonist, however, Anderton discovers that he has himself been identified as a future murderer, which is when the plot suddenly takes off. Pursued by and pursuing the technological forces that define this future world (including

A review usually features more plot summary than an analytical essay.

mechanical spiders that invade any space and identify people by reading their eyes), Anderton weaves his way through a society that moves at incredible technological speeds and leaves no place to hide from its new powers to see into seemingly every corner of the world and individual minds.

Like the *Bourne* movies of this same period, *Minority Report* is a fast-paced thriller in which Cruise as Anderton is both criminal and detective. More than portraying his flight to discover the truth about a crime and to redeem himself, however, the film provides a timely reflection on new technologies and our perhaps misguided trust of them. The danger in this Spielberg world is not sharks, German soldiers, or stubborn congressmen but the powerful technologies that can control our lives today.

The same writer later chooses to compose the following critical essay about *Minority Report* for a film history course. In this case, his readers are his professor and the other students in the class, readers who are familiar with the film and have read other material about it. Note this student's inclusion of images from the film. These images do not serve merely as a visual embellishment for the paper but as concrete and precise evidence that supports his argument.

In the critical essays and reviews about *Minority Report*, viewers regularly praise the ingenious and elaborate plot and stunning cinematography that captures the blue tints of futuristic film noir. John Anderton, an officer in the Pre-Crime Division of Washington, D.C., in the year 2054, orchestrates the visions of three "pre-cogs" through a complex computer system that foresees murders and thereby allows the police to stop them. When this seemingly infallible network accuses Anderton of a future crime, the system splits open, launching Anderton on a mission to save himself and to find the truth about lost "minority reports" that can expose the fallibility of the system. A surveillance film about sight and seeing with cutting-edge technologies and new media velocities **[Figure MR.1]**, *Minority Report* remains nonetheless Spielberg's typical family melodrama with its narrative of finding a way back home.

> The writer concentrates on one or two scenes to analyze in detail.

At the heart of the film is an anxious and often excruciating drama about sight and seeing. The "pre-cogs" threesome foresees the future as a dramatic indication of how sight can now overcome conventional boundaries of time, and the surveillance technologies that suffuse the society describe astonishing ways that boundaries of space dissolve before the new technologies for seeing. In the midst of his flight, for example, Anderton hides in a decrepit apartment building, where the pursuing police release mechanical "identification spiders." At the start of the sequence, a precisely edited series of images reveals the various private spaces in the building, the release of the spiders, and their eerily rapid invasion of the different apartments. After they are inside, they open the most sensitive human interior, methodically lifting

MR.1 *Minority Report* (2002). A thesis identifies an argument about sight, new technologies, and lost families.

auteur theory: An approach to cinema first proposed in the French film journal *Cahiers du cinéma* that emphasizes the director as the expressive force behind a film and sees a director's body of work as united by common themes or formal strategies; also referred to as *auteurism*.

automated dialogue replacement (ADR): A process during which actors watch the film footage and re-record their lines to be dubbed into the soundtrack. See looping.

avant-garde cinema: Aesthetically challenging, noncommercial films that experiment with film forms.

average shot length: The average duration of time (usually measured in seconds) of individual shots in a particular movie.

axis of action: An imaginary line bisecting a scene corresponding to the 180-degree rule in continuity editing.

backlighting: A highlighting technique that illuminates the person or object from behind, tending to silhouette the subject; sometimes called *edgelighting*.

below-the-line expenses: The technical and material costs — costumes, sets, transportation, and so on — involved in the actual making of a film.

benshi: Storytellers who narrated and interpreted silent films in Japan.

blaxploitation: A genre of low-budget films made in the early 1970s targeting urban, African American audiences and featuring streetwise African American protagonists. Several black directors made a creative mark in a genre that was primarily intended to make money for its producers.

block booking: A practice in which movie theaters had to exhibit whatever a studio/distributor packaged with its more popular and desirable movies; declared an unfair business practice in 1948.

blockbuster: A big-budget film, intended for wide release, whose large investment in stars, special effects, and advertising attracts large audiences and big profits.

blocking: The arrangement and movement of actors in relation to each other within the physical space of the mise-en-scène.

Bollywood: A commonly used name for the popular Hindi-language film industry based in Mumbai, India, sometimes used to refer to the entire Indian film industry, the world's largest.

boom: A long pole used to hold a microphone above the actors to capture sound while remaining outside the frame, handled by a *boom operator*.

B picture: A low-budget, nonprestigious movie that usually played on the bottom half of a double bill. B pictures were often produced by the smaller studios referred to as Hollywood's Poverty Row. See A picture.

camera height: The level at which the camera is placed.

camera lens: A piece of curved glass that focuses light rays in order to form an image on film.

camera movement: See mobile frame.

camera operator: A member of the film crew in charge of physically manipulating the camera, overseen by the cinematographer.

canon: An accepted list of essential great works in a field of study.

canted frame: Framing that is not level, creating an unbalanced appearance.

casting director: The individual responsible for identifying and selecting which actors would work best in particular roles.

cels: A transparent sheet of celluloid on which individual images are drawn or painted in traditional animation. These drawings are then photographed onto single frames of film.

character: An individual who motivates the events and performs the actions of the story.

character actor: A recognizable actor associated with particular character types, often humorous or sinister, and often cast in minor parts.

character analysis: An argument focusing on a single character or on the interactions between two or more characters.

character coherence: The consistency and coherence of a character.

character depth: The pattern of psychological and social features that distinguish characters as rounded and complex in a way that approximates realistic human personalities.

character development: The patterns through which characters in a film move from one mental, physical, or social state to another.

characters: Individuals who motivate the events and perform the actions of the story.

character type: A conventional character (such as a hard-boiled detective or femme fatale) typically portrayed by actors cast because of their physical features, their acting style, or the history of other roles they have played. See stereotype.

chiaroscuro lighting: Dramatic, high-contrast lighting that emphasizes shadows and the contrast between light and dark; frequently used in German expressionist cinema and film noir.

chronology: The order according to which shots or scenes convey the temporal sequence of the story's events.

chronophotography: A sequence of still photographs that record incremental movement, such as those depicting human or animal motion produced by Eadweard Muybridge and Étienne-Jules Marey.

Cinema Novo: A film movement (1960s–1970s) in Brazil that emphasized social equality and intellectualism and broke with studio gloss.

cinematographer: The member of the film crew who selects the cameras, film stock, lighting, and lenses to be used as well as the camera setup or position; also known as the *director of photography* (D.P.).

cinematography: Motion-picture photography, literally "writing in movement."

cinéma vérité: A French term meaning "cinema truth"; a style of documentary filmmaking first practiced in France in the late 1950s and early 1960s that used unobtrusive, lightweight cameras and sound equipment to capture real-life situations. See direct cinema (the parallel U.S. movement).

cinephilia: A love of cinema; a film lover is a *cinephile*.

clapboard: A slate that is marked to identify each scene and the take and is snapped to synchronize sound recordings and camera images.

classical film narrative: A style of narrative filmmaking centered on one or more central characters who propel the plot with a cause-and-effect logic. Normally plots are developed with linear chronologies directed at definite goals, and the film employs an omniscient or a restricted third-person narration that suggests some degree of verisimilitude.

classical film theory: Writings on the fundamental questions of cinema produced in the first half of the twentieth century. Important classical film theorists include Sergei Eisenstein, Rudolf Arnheim, André Bazin, and Siegfried Kracauer.

classical Hollywood narrative: The dominant form of classical film narrative associated with the Hollywood studio system from the end of the 1910s to the end of the 1950s.

claymation: A process that uses stop-motion photography with clay figures to create the illusion of movement.

close-up: Framing that shows details of a person or an object, such as a character's face.

code: A term used in linguistics and semiotics for conventions governing a communication act. Senders and receivers must share a code for the message to be understood (for example, traffic signals use a color code). Film analysts isolate various codes (including codes of camera movement, framing, lighting, and acting) that determine the specific form of a particular shot, scene, film, or genre.

cognition: The aspects of comprehension that make up our rational reactions and thought processes, also contributing to our pleasure in watching movies.

cognitivism: An approach to film that draws on psychology and neuroscience to understand how the mind responds to narrative and aesthetic information.

color balance: The adjustment of particular parts of the color spectrum to create realistic or unrealistic palettes.

color filter: A device fitted to the camera lens to change the tones of the filmed image.

color grading: The process of altering the image after capture, either digitally or photochemically.

comedy: A film genre that celebrates the harmony and resiliency of social life, typically with a narrative that ends happily and an emphasis on episodes or "gags" over plot continuity.

comparative analysis: An analysis evaluating features or elements of two or more different films or perhaps a film and its literary source.

compilation films: Films comprised of footage taken from different sources; also sometimes used to mean anthology films.

computer animation: A digital version of traditional animation.

computer-generated imagery (CGI): Still or animated images created through digital computer technology. First introduced in the 1970s, CGI was used to create feature-length films by the mid-1990s and is widely used for visual effects.

connotation: The association connected with a word or sign. See denotation.

continuity editing: Hollywood editing that uses cuts and other transitions to establish verisimilitude, to construct a coherent time and space, and to tell stories clearly and efficiently. Continuity editing follows the basic principle that each shot has a continuous relationship to the next shot; sometimes called *invisible editing*.

continuity style: An approach to filmmaking associated with classical Hollywood cinema that uses a broad array of technical choices (from continuity editing to scoring) that efface technique in order to emphasize human agency and narrative clarity.

contrapuntal sound: Sound that is unexpected considering the image that is displayed onscreen.

costume designer: An individual who plans and prepares how actors will be dressed for parts.

counterpoint: Using sound to indicate a different meaning or association than the image.

coverage: Filming many takes, often using different set-ups, in order to have options during editing.

crane shot: A shot taken from a camera mounted on a crane that can vary distance, height, and angle.

credits: A list of all the personnel involved in a film production, including cast, crew, and executives.

crime film: A film genre that typically features criminals and individuals dedicated to crime detection and plots that involve criminal acts.

critical objectivity: Writing with a detached response that offers judgments based on facts and evidence with which others would or could agree.

crosscutting: An editing technique that cuts back and forth between actions in separate spaces, often implying simultaneity. See parallel editing.

cue: A visual or aural signal that indicates the beginning of an action, line of dialogue, or piece of music.

cultural analysis: An interpretation of the relationship of a film to its place in history, society, or culture.

cultural studies: A set of approaches drawn from the humanities and social sciences that considers cultural phenomena like film in conjunction with processes of production and consumption and aspects of everyday life.

cut: In the editing process, the join or splice between two pieces of film; in the finished film, an editing transition between two separate shots or scenes achieved without optical effects. Also used to describe a version of the edited film, as in *rough* cut or *director's* cut. See final cut.

cutaway: A shot that interrupts an action to "cut away" to another image or action, often to abridge time, before returning to the first shot or scene at a point further along in time.

Czech New Wave: A film movement that came to prominence in 1960s Czechoslovakia and used absurdist humor, nonprofessional actors, and improvised dialogue to express political dissent. It ended with the Soviet invasion in 1969.

dailies: The footage shot on a single day of filming.

day-and-date release: A simultaneous release strategy across different media and venues, such as a theatrical release and a DVD release.

deadline structure: A narrative structured around a central event or action that must be accomplished by a certain time.

deep focus: A camera technique using a large depth of field in which multiple planes in the shot are all in focus simultaneously, usually with a special lens. See wide-angle lens.

denotation: The literal meaning of a word. See connotation.

depth of field: The range or distance before and behind the main focus of a shot within which objects remain relatively sharp and clear.

detective film: A genre of the crime film focusing on a protagonist who represents the law or an ambiguous version of it, such as a private investigator.

dialectical montage: Sergei Eisenstein's term for the cutting together of conflicting or unrelated images to generate an idea or emotion in the viewer.

diegesis: The world of the film's story (its characters, places, and events), including what is shown and what is implied to have taken place. It comes from the Greek word meaning "narration." See *mimesis*.

diegetic sound: Sound that has its source in the narrative world of the film, whose characters are presumed to be able to hear it.

digital cinema package (DCP): A collection of digital files that stores and projects audio, image, and data streams.

digital cinematography: Shooting with a camera that records and stores visual information electronically as digital code.

digital compositing: The process of digitally assembling images to make a final image.

digital intermediate (DI): A digitized version of a film that allows it to be manipulated.

digital sound: Recording and reproducing sound through technologies that encode and decode it as digital information.

direct cinema: A documentary style originating in the United States in the 1960s that aims to observe an unfolding situation as unobtrusively as possible; related to cinéma vérité.

directional lighting: Lighting coming from a single direction.

director: The chief creative presence or the primary manager in film production, responsible for overseeing virtually all the work of making a movie.

direct sound: Sound captured directly from its source.

disjunctive editing: Editing practices that call attention to the cut through spatial tension, temporal jumps, or rhythmic or graphic patterns.

dissolve: An optical effect that briefly superimposes one shot over the next, which takes its place: one image fades out as another image fades in.

distanciation: Derived from the work and theories of Bertolt Brecht, an artistic practice intended to create an intellectual distance between the viewer and work of art in order to reflect on the work's production or the various ideas and issues that it raises.

distribution: The means through which a distributor delivers movies to theaters, video stores, television and Internet networks, and other venues.

distributor: A company or an agency that acquires the rights to a movie from the filmmakers or producers (sometimes by contributing to the costs of producing the film) and makes the movie available to audiences by renting, selling, or licensing it to theaters or other exhibition outlets.

documentary: A nonfiction film that presents real objects, people, and events.

documentary animation: Animation that tells true stories with enhanced moving images.

dolly shot: A shot in which the camera is moved on a wheeled dolly that follows a determined course.

dolly zoom: A shot in which the camera is moved to keep the object the same size.

early cinema: The period of rapid change in how films were made and seen that stretches from 1895 to the rise of the feature film form in around 1915.

edgelighting: See backlighting.

editing: The process of selecting and joining film footage and shots into a finished film with a distinctive style and rhythm. The individual responsible for this process is the *editor*.

ellipsis: An abridgment in time in the narrative implied by editing.

epic western: A subgenre of the western concentrating on action and movement and developing a heroic character whose quests and battles serve to define the nation and its origins.

establishing shot: An initial long shot that establishes the location and setting and that orients the viewer in space to a clear view of the action.

ethnographic documentaries: Films that record the practices, rituals, and people of a culture.

evidence: Concrete details that convince readers of the validity of a writer's interpretation.

exclusive release: A movie that premieres in restricted locations initially.

executive producer: A producer who finances or facilitates a film deal and who usually has little creative or technical involvement.

exhibition: The part of the film industry that shows films to a paying public, usually in movie theaters. See exhibitor.

exhibitor: The owner of individual theaters or theater chains who makes decisions about programming and local promotion. See exhibition.

existential western: A subgenre of the western whose introspective hero is troubled by his changing social status and his self-doubts, often as the frontier becomes more populated and civilized.

expanded cinema: Installation or performance-based experimental film practices.

experiential circumstances: The material conditions that define our identity at a certain time and in a certain place.

experiential histories: The personal and social encounters through which we develop our identities over time.

experimental film: A noncommercial, often non-narrative film that makes expressive use of film form.

exploitation film: A cheaply made genre film that exploits sensational or topical subject matter or genre conventions for profit.

extra: An actor without speaking parts who appears in the background and in crowd scenes.

extreme close-up: A shot that is framed comparatively tighter than a close-up, singling out, for instance, a person's eyes.

extreme long shot: A shot framed from a comparatively greater distance than a long shot, in which the surrounding space dominates human figures.

eyeline match: A cut that follows a shot of a character looking offscreen with a shot of a subject whose screen position matches the gaze of the character in the first shot.

fade-in: An optical effect in which a black screen gradually brightens to a full picture; often used after a fade-out to create a transition between scenes.

fade-out: An optical effect in which an image gradually darkens to black, often ending a scene or a film. See fade-in.

family melodrama: A subgenre of the melodrama that focuses on the psychological and gendered forces restricting individuals within the family.

fast motion: A special effect that makes the action move at faster-than-normal speeds, achieved by filming the action at a slow speed and then projecting it at standard speeds. See slow motion.

feature film: Running typically ninety to 120 minutes in length, a narrative film that is the primary attraction for audiences.

fill lighting: A lighting technique using secondary fill lights to balance the key lighting by removing shadows or to emphasize other spaces and objects in the scene.

film culture: The practices, institutions, and communities surrounding film production, publicity, and appreciation that shape our expectations, ideas, and understanding of movies.

film gauge: The width of the film stock—such as 8mm, 16mm, 35mm, and 70mm.

film noir: The French term for "black film"; a style of Hollywood films of the 1940s and 1950s, generally shot using stylized black and white cinematography in nighttime urban settings and featuring morally ambiguous protagonists, corrupt institutions, dangerous women, and convoluted plots.

film review: A short essay that describes the plot of a movie, provides useful background information, and pronounces a clear evaluation of the film to guide its readers.

film shoot: The weeks or months of actual shooting, on set or on location.

film speed: The rate at which moving images are recorded and later projected, standardized for 35mm sound film at twenty-four frames per second (fps); also, a measure of film stock's sensitivity to light.

film stock: Unexposed film consisting of a flexible backing or base and a light-sensitive emulsion.

film studies: A discipline that reflects critically on the nature and history of movies and the place of film in culture.

filters: Transparent sheets of glass or gels placed in front of the lens to create various effects.

final cut: The final edited version of a film. See cut.

first-person narration: Narration that is identified with a single individual, usually a character in the film.

first-run theater: A theater that shows recently released movies.

flare: A spot or flash of white light created by directing strong light directly at the lens.

flashback: A sequence that follows an image set in the present with an image set in the past.

flashforward: A sequence that connects an image set in the present with one or more future images.

focal length: The distance from the center of the lens to the point where light rays meet in sharp focus.

focus: The point or area in the image toward which the viewer's attention is directed; the point at which light rays refracted through the lens converge.

foley artist: A member of the sound crew who generates live synchronized sound effects while watching the projected film; named after the inventor, Jack Foley.

following shots: A pan, tilt, or tracking shot that follows a moving individual or object.

forced perspective: An optical effect produced in-camera by positioning the camera to create illusions of scale.

formalism: A critical approach to cinema that emphasizes formal properties of the text or medium over content or context.

frame: A still image from a movie.

framing: The portion of the filmed subject that appears within the borders of the frame. It correlates with camera distance — such as long shot or medium close-up.

French impressionist cinema: A 1920s avant-garde film movement that aimed to destabilize familiar or objective ways of seeing and to revitalize the dynamics of human perception.

French New Wave: A film movement that came to prominence in the late 1950s and 1960s in France in opposition to the conventional studio system. The films were often made with low budgets and young actors, were shot on location, used unconventional sound and editing patterns, and addressed the struggle for personal expression. Also called *Nouvelle Vague*.

frontal lighting: Techniques used to illuminate the subject from the front. See sidelighting, underlighting, and top lighting.

gangster films: A genre of the crime film about the world of organized crime and its violent criminals. An early cycle was set in the United States during Prohibition in the 1930s.

generic reflexivity: The quality of movies displaying unusual self-consciousness about generic identity.

genre: A category or classification of films that share similar subject matter, settings, iconography, and narrative and stylistic patterns.

German expressionist cinema: A German film movement (1918–1929) that veered away from the movies' realism by representing irrational forces through lighting, sets, and costume design. Expressionism (in film, theater, painting, and other arts) turned away from realist representation and toward the unconscious and irrational sides of human experience.

graphic match: An edit in which a dominant shape or line in one shot provides a visual transition to a similar shape or line in the next shot.

green-screen technology: A technique for creating visual effects in which actors, objects, or figures are filmed in front of a green screen and later superimposed onto a computer-generated or filmed background. See computer-generated imagery (CGI).

grip: A crew member who installs lighting and dollies.

handheld camera: A lightweight camera that can be carried by the operator rather than mounted on a tripod. Small-gauge handheld formats like 8mm and 16mm, as well as many digital cameras, allow for greater mobility, lower production costs, and encourage location shooting.

handheld shot: An often unsteady film image produced by an individual carrying the camera.

hard-boiled detective film: A subgenre of the crime film featuring a flawed or morally ambiguous detective protagonist battling a criminal element to solve a mystery or resolve a crime.

hard lighting: A high-contrast lighting style that creates hard edges, distinctive shadows, and a harsh effect, especially when filming people.

Heimat films: Films set in idyllic countryside locales of Germany and Austria that depict a world of traditional folk values.

high angle: A shot directed at a downward angle on individuals or a scene.

high concept: A short phrase that attempts to sell a movie by identifying its main marketing features, such as its stars, genre, or some other easily identifiable connection.

high-key lighting: Lighting where the main source of light creates little contrast between light and dark.

highlighting: The use of different lighting sources to emphasize certain characters or objects.

historical location: A recognized marker of a historical setting that can carry meanings and connotations important to a narrative.

historiography: The writing of history; the study of the methods and principles through which the past is viewed according to certain perspectives and priorities.

horror film: A film genre with origins in Gothic literature that seeks to frighten the viewer though supernatural or predator characters.

hue: Color discerned by detecting light of a particular wavelength.

hybrid genres: Mixed forms created through the interaction of different genres to produce fusions, such as musical horror films.

iconography: Images or image patterns with specific connotations or meanings.

identification: The complex process through which we empathize with or project feeling onto a character or an action.

ideological location: A space or place inscribed with distinctive social values or ideologies in a narrative.

ideology: A systematic set of beliefs that are not necessarily conscious or acknowledged.

IMAX: A large-format film system that is projected horizontally rather than vertically to produce an image approximately ten times larger than the standard 35mm frame.

independent films: Films that are produced without initial studio financing, typically with much lower budgets. They include feature-length narratives, documentaries, and shorts.

insert: A brief shot, often a close-up, that points out details significant to the action or interpretation.

integrated musical: A subgenre of the musical that integrates musical numbers into the film's narrative, rather than setting them off as performances.

intellectual montage: A process of meaning generation through editing that occurs when a viewer forms an independent idea after seeing two or more images that are rich in cultural, political, or symbolic history.

intensity: Brightness or dullness of color.

intercutting: Interposing shots of two or more actions or locations.

interpretive community: Members of an audience who share particular knowledge, or cultural competence, through which a film is experienced and interpreted.

intertextuality: A critical approach that holds that a text depends on other, related texts for its full meaning.

intertitle: Printed text inserted between film images, typically used in silent films to indicate dialogue and exposition and in contemporary films to indicate time and place or other transitions.

invisible editing: See continuity editing.

iris: A shot in which the corners of the frame are masked in a black, usually circular, form. An *iris-out* is a transition that gradually obscures the image by moving in; an *iris-in* expands to reveal the entire image.

Italian neorealism: A film movement that began in Italy during World War II and lasted until approximately 1952, depicting everyday social realities using location shooting and amateur actors, in opposition to glossy studio formulas.

***jidai-geki* films:** Period films or costume dramas set before 1868, when feudal Japan entered the modern Meiji period.

jump cut: An edit that interrupts a particular action and intentionally or unintentionally creates discontinuities in the spatial or temporal development of shots.

key lighting: The main source of non-natural lighting in a scene. See high-key lighting and low-key lighting.

leading actors: The two or three actors, often stars, who represent the central characters in a narrative.

lead room: The space in front and in the direction of an object being filmed.

letterbox: An effect, usually seen on home video or television, where the top and bottom strips of a frame are blacked out to accommodate a widescreen image.

lighting: Sources of illumination—both natural light and electrical lamps—used to present, shade, and accentuate figures, objects, and spaces in the mise-en-scène. Lighting is primarily the responsibility of the *director of photography* and the *lighting crew*. See key lighting, fill lighting, and highlighting.

limited release: The practice of initially distributing a film only to major cities and expanding distribution according to its success or failure.

linear chronology: The arrangement of plot events and actions that follow each other in time.

line producer: The individual in charge of the daily business of tracking costs and maintaining the production schedule of a film.

live action movie: A film that uses photographic images.

location scout: An individual who determines and secures places that provide the most suitable environment for shooting different movie scenes.

long shot: A shot that places considerable distance between the camera and the scene, object, or person being filmed so that the object or person is recognizable but defined by the large space and background. See establishing shot.

long take: A shot of relatively long duration.

looping: Recording an image or sound on a loop of film to be replayed or to replace previously recorded dialogue.

low angle: A shot from a position lower than its subject.

low-key lighting: Lighting where the main source of light creates a stark contrast between light and dark.

machinima: A new media form that modifies video game engines to create computer animation.

magic lantern: A device developed in the seventeenth century for using a lens and a light source to project an image from a slide; a precursor of motion pictures.

marketing: The process of identifying an audience and bringing a product such as a movie to its attention for consumption.

masks: Attachments to the camera or devices added optically that cut off portions of the frame so that part of the image is black.

match on action: A cut between two shots continuing a visual action.

matte shot: A process shot that joins two pieces of film, one with the central action or object and the other with a painted or digitally produced background that would be difficult to create physically for the shot.

mechanical effects: Techniques that are produced on set—often with sets, props, costumes, and make-up—and that include pyrotechnics, weather effects, and scaled models.

media convergence: The process by which formerly distinct media (such as cinema, television, the Internet, and video games) and viewing platforms (such as television, computers, and cell phones) become interdependent.

medium close-up: A shot that frames a person from the shoulders up; typically used during conversation sequences.

medium long shot: A shot that increases the distance between the camera and the subject compared with a medium shot; shows most of an individual's body.

medium shot: A middle-ground framing in which we see the body of a person from approximately the waist up.

medium specificity: A theory that says that a successful artwork fulfills the promise of its medium's unique physical properties.

melodrama: A sensational narrative mode with clearly identifiable moral types, coincidences, and reversals of fortune, and music (*melos*) that underscores the action.

metteur-en-scène: French term for "director" (particularly a theater director); in auteur theory, a director who conveys technical competence without a strong streak of individual vision, in contrast to an auteur.

mickey-mousing: Overillustrating the action through the musical score, drawn from the conventions of composing for cartoons.

mimesis: Imitation of reality in the arts. See *diegesis*.

miniature model: A small-scale model constructed for use during the filming process to stage special effects sequences and complex backgrounds.

minor character: A character who surrounds, contrasts with, and supports a film's protagonists and antagonists and who usually is associated with specific character groups. Also called *secondary character*.

mise-en-scène: All the elements of a movie scene that are organized, often by the director, to be filmed and that are later visible onscreen; includes actors, lighting, sets, costumes, make-up, and other features of the image that exist independently of the camera and the processes of filming and editing.

mix: The combination by the sound mixer of separate soundtracks into a single master track that will be transferred onto the film print together with the image track to which it is synchronized.

mobile frame: A property of a shot in which the camera moves or the borders of the image are altered by a change in the focal length of the camera lens to follow an action or explore a space.

mockumentary: A film that uses a documentary style and structure to present and stage fictional (sometimes ludicrous) subjects.

modernism: An artistic movement in painting, music, design, architecture, and literature beginning in the 1920s that rendered a fragmented vision of human subjectivity through strategies such as the foregrounding of style, experiments with space and time, and open-ended narratives.

modernity: A term designating the period of history stretching from the end of the medieval era to the present, as well as the period's attitude of confidence in progress and science centered on the human capacity to shape history.

montage: A term for editing most frequently used for a style that emphasizes the dynamic relationship between images, following Soviet silent-era filmmakers' use of the term; also designates rapid sequences in Hollywood films used for descriptive purposes or to show the rapid passage of time.

montage sequence: A series of thematically linked shots, or shots meant to show the passage of time, joined by quick cuts or other devices, such as dissolves, wipes, and superimpositions.

motion-capture technology: A visual effects technology used to incorporate an actor's movements into those of a computer-generated character. See computer-generated imagery (CGI).

movement image: Philosopher Gilles Deleuze's term for filmmaking that reflects a cause-and-effect view of time.

movie palaces: Lavish movie theaters built between the 1920s and 1940s with ornate architecture and sumptuous seating for thousands.

multiple narrations: Several different narrative perspectives for a single story or for different stories in a movie that loosely fit together.

multiplex: A movie theater complex with many screens. Initially found in suburbs and connected to malls, they are now common in cities.

musical: A genre popular since the introduction of synchronous sound that features characters who act out and express their emotions through song and dance.

music supervisor: The individual who selects and secures the rights for songs to be used in films.

narration: The telling of a story or description of a situation; the emotional, physical, or intellectual perspective through which the characters, events, and action of the plot are conveyed. In film, narration is most explicit when provided as asynchronous verbal commentary on the action or images, but it can also designate the storytelling function of the camera, the editing, and verbal and other soundtracks.

narrative: A story with a particular plot and point of view told by a narrator or conveyed by a narrational point of view. See plot and story.

narrative analysis: A critical approach that concentrates on the story and its construction.

narrative cueing: The ways that sound tells viewers what is happening in the plot.

narrative duration: The length of time used to present an event or action in a plot.

narrative frame: A context or person positioned outside the principal narrative of a film, such as bracketing scenes in which a character in the story's present begins to relate events of the past and later concludes her or his tale.

narrative frequency: The number of times a plot element is repeated throughout a narrative.

narratology: The study of narrative forms; Russian narratology introduced the distinction between the terms *fabula* (story), all the events included in a tale or imagined by the reader or viewer in the order in which they are assumed to have occurred, and *syuzhet* (plot), the ordering of narrative events in the particular narrative.

narrator: A character or other person whose voice and perspective describe the action of a film, either in voiceover or through a particular point of view.

native aspect ratio: The original size and shape of a frame shot by the filmmaker, sometimes altered for presentation on other platforms.

natural lighting: Light derived from a natural source in a scene or setting, such as the illumination of the sun or firelight.

New German Cinema: A film movement launched in West Germany in 1962 by a group of young filmmakers known for their confrontation with Germany's Nazi and postwar past.

new media: Technologies that include the Internet, digital technologies, video game consoles, cell phones, and wireless devices and the software applications and imaginative creations they support.

nickelodeons: Storefront theaters and arcade spaces where short films were shown continuously for a five-cent admission price to audiences passing in and out. They were prominent until the rise of the feature film in the 1910s.

nitrate: The highly flammable chemical base of 35mm film stock used until 1951.

Nollywood: The contemporary Nigerian film industry.

nondiegetic insert: An insert that depicts an action, an object, or a title originating outside of the space and time of the narrative world.

nondiegetic sound: Sound (such as a musical score) that does not have an identifiable source in the characters' world. See diegetic sound and semidiegetic sound.

nonfiction films: Films presenting factual descriptions of actual events, persons, or places, rather than their fictional or invented re-creation.

non-narrative films: Films organized in a variety of ways besides storytelling.

objective point of view: A point of view that does not associate the perspective of the camera with that of a specific character.

offscreen space: The implied space or world that exists outside the film frame.

omniscient narration: Narration that presents all elements of the plot, exceeding the perspective of any one character. See third-person narration.

180-degree rule: A central convention of continuity editing that restricts possible camera setups to the 180-degree area on one side of an imaginary line (the axis of action) drawn between the characters or figures of a scene. If the camera were to cross the line to film from within the 180-degree field on the other side, onscreen figure positions would be reversed.

onscreen space: The space visible within the frame of the image.

ontology: The branch of philosophy that deals with nature of being.

optical effects: Special effects produced with the use of an optical printer, including visual transitions between shots such as dissolves, fade-outs, and wipes, or process shots that combine figures and backgrounds through the use of matte shots.

optical sound recording: The process that converts sound waves into electrical impulses (which then control how a light beam is projected onto film) and that enables a soundtrack to be recorded alongside the image for simultaneous projection.

orphan films: Films that do not have copyright holders, including amateur films, training films, documentaries, censored materials, commercials, and newsreels.

overhead shot: A shot that depicts the action from above, generally looking directly down on the subject from a crane, helicopter, or drone.

overlapping dialogue: Mixing characters' speech to imitate the rhythm of speech; also may refer to dialogue that overlaps two scenes to effect a transition between them.

overlapping editing: An edited sequence that presents two or more shots of the same action across several cuts.

over-the-shoulder shots: Frame compositions where the camera is positioned slightly behind and over the shoulder of one character, focusing on another character or object; often used when alternating between speaking characters.

pace: The tempo at which the film seems to move, influenced by the duration of individual shots and the style of editing.

package-unit approach: An approach to film production established in the mid-1950s whereby the agent, producer, and casting director assembled a script, stars, and other major personnel as a key first step in a major production.

pan: A left or right rotation of the camera, whose tripod or mount remains in a fixed position; produces a horizontal movement onscreen.

pan-and-scan process: The process used to transfer a widescreen-format film to the 4:3 television aspect ratio. A computer-controlled scanner determines the most important action in the image and then crops peripheral action and space or presents the original frame as two separate images.

panchromatic: A property of film stock that responds to a full spectrum of colors, rendering them as shades of gray, and became the standard for black-and-white movies after 1926.

parallel editing: An editing technique that alternates back and forth between actions in separate locations, often implying simultaneity. See crosscutting.

parallel sound: Sound that reinforces the image, such as synchronized dialogue or sound effects or a voiceover that is consistent with what is displayed onscreen. See counterpoint.

performance: An actor's use of language, physical expression, and gesture to bring a character to life and to communicate important dimensions of that character to the audience.

performance-capture technology: A technique for generating computer models from data gathered from an actor's performance.

periodization: A method of organizing film history by groups of years that are defined by historical events or that produced movies that share thematic and stylistic concerns.

personal or **subjective documentaries:** Documentary formats that emphasize the personal perspective or involvement of the filmmaker, often making the films resemble autobiographies or diaries.

perspective: The manner in which the distance and spatial relationships among objects are represented on a two-dimensional surface. In painting, parallel and converging lines give the illusion of distance and depth; in film, perspective can also be manipulated by changes in the focal length of camera lenses.

phenomenological image: A film image that approximates the way we experience the physical world.

phenomenology: A theory that any act of perception involves a mutuality of the viewer and what is viewed.

photogénie: A term, coined by Louis Delluc, referring to a particular quality that distinguishes the filmed object from its everyday reality.

physical horror films: A subgenre of the horror film in which the psychology of the characters takes second place to the depiction of graphic violence.

physical melodrama: A subgenre of the melodrama that focuses on the material conditions that control the protagonist's desires and emotions.

piracy: The unauthorized duplication and circulation of copyrighted material.

pixilation: A type of animation that employs stop-motion photography to transform movement into rapid jerky gestures; the disintegration of the electronic image.

platforming: The distribution strategy of releasing a film in gradually widening markets to build its reputation through reviews and word of mouth.

plot: The narrative ordering of the events of the story as they appear in the actual work, selected and arranged according to particular temporal, spatial, generic, causal, or other patterns; in narratology, also known by the Russian word *syuzhet*.

plot time: The length of time a movie depicts when telling its story. See narrative duration.

poetic realism: A film movement in 1930s France that incorporated a lyrical style and a fatalistic view of life.

point of view: The position from which a person, an event, or an object is seen or filmed; in narrative form, the perspective through which events are narrated.

point-of-view (POV) shot: A subjective shot that reproduces a character's optical point of view, often preceded or followed by shots of the character looking.

political western: A subgenre of the western that evolved from the existential western, foregrounding ideology and politics and questioning the individual independence and use of violence featured in epic westerns.

postclassical narrative: The form and content of films after the decline of the Hollywood studio system around 1960, including formerly taboo subject matter and narratives and formal techniques influenced by European cinema.

postmodernism: An artistic style in architecture, art, literature, music, and film that incorporates fragments of or references to other styles; or the cultural period in which political, cultural, and economic shifts engendered challenges to the tenets of modernism, including its belief in the possibility of critiquing the world through art, the division of high and low culture, and the genius and independent identity of the artist.

postproduction: The period in the filmmaking process that occurs after principal photography has been completed; usually consists of editing, sound, and visual effects work.

postproduction sound: Sound recorded and added to a film in the postproduction phase.

poststructuralism: An intellectual development that challenged the methodology and fixed definitions of structuralism by emphasizing the place of subjectivity, the unreliability of language, and the construction of social power.

postsynchronous sound: Sound recorded after the actual filming and then synchronized with onscreen sources.

premiere: A red carpet event celebrating the opening night of a film.

preproduction: The phase when a film project is in development, involving preparing the script, financing the project, casting, hiring crew, and securing locations.

prerecorded music: Previously recorded music that is added to a film's soundtrack.

primary research sources: Original sources in formats such as 16mm films, videotapes, DVDs, and film scripts; documents from the time of the film's production; and new research data.

principal photography: The majority of footage filmed for a project during the shoot.

process shot: A special effect that combines two or more images as a single shot, such as filming an actor in front of a projected background.

producer: The person or persons who oversee each step of a film project, especially the financial aspects, from development to postproduction and a distribution deal.

production: The industrial stages that contribute to the making of a finished movie, from the financing and scripting of a film to its final edit; more specifically, the actual shooting of a film after preproduction and before postproduction.

production designer: The person in charge of the film's overall look.

production sound mixer: The sound engineer on the production set; also called a *sound recordist*.

production values: An evaluative term about the quality of the film images and sounds that reflects the investment expenses.

promotion: The aspect of the movie industry through which audiences are exposed to and encouraged to see a particular film; promotion includes advertisements, trailers, publicity appearances, and product tie-ins.

prop: An object that functions as a part of the set or as a tool used by the actors.

propaganda films: Political documentaries that visibly support and intend to sway viewers toward a particular social or political issue or group.

prosthetics: Artificial facial features or body parts used to alter actors' appearances.

protagonist: A character identified as the positive force in a film. See antagonist.

psychoanalysis: The therapeutic method innovated by Sigmund Freud based on his attribution of unconscious motives to human actions, desires, and symptoms; theoretical tenets developed by literary and film critics to facilitate the cultural study of texts and the interaction between viewers and texts.

psychological horror film: A subgenre of the horror film that locates the dangers that threaten normal life in the minds of bizarre and deranged individuals.

psychological image: A film image that reflects a state of mind or emotion.

psychological location: An important correlation between a character's state of mind and the physical place he or she inhabits in a story.

race movies: Early-twentieth-century films that featured all–African American casts and were circulated to African American audiences in the North and South.

rack focus (or pulled focus): A dramatic change in focus from one object to another.

reaction shot: A shot that depicts a character's response to something shown in a previous shot.

realism: An artwork's quality of conveying a truthful picture of a society, person, or some other dimension of everyday life; an artistic movement that aims to achieve verisimilitude.

rear projection: A technique that projects an image onto a screen behind the actors.

reception: The process through which individual viewers or groups make sense of a film.

reception theory: A theoretical approach to the ways different kinds of audiences regard different kinds of films.

reenactment: A re-creation of presumably real events within the context of a documentary.

reestablishing shot: A shot that reestablishes the space in which an edited sequence unfolds, orienting the spectator to changes in figure location and restoring an objective view of the action.

referent: In semiotics, the object to which a sign refers.

reflected sound: Recorded sound that is captured as it bounces from the walls and sets. It is usually used to give a sense of space. See direct sound.

reflexive narration: A mode of narration that calls attention to the narrative point of view of the story in order to complicate or subvert its own narrative authority as an objective perspective on the world.

reflexivity: Referencing the film's own process of storytelling or cinematic technique.

reframing: The process of moving the frame from one position to another within a single continuous shot.

restricted narration: A narrative in which our knowledge is limited to that of a particular character.

retrospective plot: A plot that tells of past events from the perspective of the present or future.

rhythmic editing: The organization of editing according to different paces or tempos determined by how quickly cuts are made.

road movie: A film genre that depicts characters on a journey, usually following a linear chronology.

romantic comedy: A subgenre of comedy in which humor takes second place to the happy ending, typically focusing on the emotional attraction of a couple in a lighthearted way.

room tone: The aural properties of a location that are recorded and then mixed in with dialogue and other tracks to achieve a more realistic sound.

rotoscoping: A technique using recorded real figures and action on video as a basis for painting individual animation frames digitally.

rule of thirds: A technique that imagines the frame divided horizontally and vertically into thirds and places objects along these lines for maximum visual interest.

safety film: Acetate-based film stock that replaced the highly flammable nitrate film base in 1952.

saturation booking: The distribution strategy of releasing a film simultaneously in as many locations as possible, widely implemented with the advent of the blockbuster in the 1970s. Also called *saturated release*.

scale: The relative size of the image within the frame.

scene: One or more shots that depict a continuous space and time.

scenic realism: The physical, cultural, and historical accuracy of the background, objects, and other figures in a film.

scenics: Early nonfiction films that offered exotic or remarkable images of nature or foreign lands.

score: Music composed to accompany a completed film.

screenplay: The text from which a movie is made, including dialogue and information about action, settings, shots, and transitions; developed from a treatment. Also known as a *script*.

screen time: The actual length of time that a movie takes to unfold.

screenwriter: A writer of a film's screenplay; the screenwriter may begin with an original treatment and develop the plot structure and dialogue over the span of several versions; also called a *scriptwriter*.

screwball comedy: A comic subgenre of the 1930s and 1940s known for fast talking and unpredictable action.

script: A blueprint for the story of a film that includes scene descriptions, dialogue, and other directions.

script doctor: An uncredited individual called in to do rewrites on a screenplay.

segmentation: The process of dividing a film into large narrative units for the purposes of analysis.

selects: The director's chosen takes to use in editing a scene.

semidiegetic sound: Sound that is neither strictly diegetic nor nondiegetic, such as certain voiceovers that can be construed as the thoughts of a character and thus as arising from the story world; also called *internal diegetic sound*.

semiotics: The study of signs and signification; posits that meaning is constructed and communicated through the selection, ordering, and interpretation of signs and sign systems, including words, gestures, images, symbols, or virtually anything that can be meaningfully codified. Also called *semiology*.

sequence: Any number of shots or scenes that are unified as a coherent action or an identifiable motif, regardless of changes in space and time.

sequence shot: A shot in which an entire scene is played out in one continuous take.

set: A constructed setting, often on a studio soundstage, on which filming takes place; can combine natural and constructed elements.

set director: The individual who completes the look of a set with the details of props and furnishings.

set lighting: The distribution of an evenly diffused illumination through a scene as a kind of lighting base.

setting: A fictional or real place where the action and events of the film occur.

shallow focus: A shot in which only a narrow range of the field is in focus.

shock cut: A cut that juxtaposes two images whose dramatic difference creates a jarring visual effect.

shooting ratio: The relationship between the overall amount or length of film shot and the amount used in the finished project.

shot: A continuous point of view (or continuously exposed piece of film) between two edits.

shot/reverse shot: An editing pattern that begins with a shot of one character looking offscreen in one direction, followed by a shot of a second character, who appears to be looking back. The first shot is taken from an angle at one end of the axis of action, the second from the "reverse" angle at the other end of the line; often used in conversations; also called *shot/countershot*.

sidelighting: Used to illuminate the subject from the side.

sign: A term used in semiotics for something that signifies something else, whether the connection is causal, conventional, or based on resemblance. As defined by Ferdinand de Saussure, a sign is composed of a signifier and a signified.

signified: The mental concept evoked by a signifier.

signifier: A spoken or written word, picture, or gesture.

slapstick comedy: Films known for physical humor and stunts; some of the first films were slapstick comedies.

slasher films: A subgenre of the horror film depicting serial killers, often considered to have originated with *Psycho* (1960).

slow cinema: Movies, often in contemporary international art films, where shots are sustained for what can seem an inordinate amount of time.

slow motion: A special effect that makes the action move at slower-than-normal speeds, achieved by filming the action at a high speed and then projecting it at standard speeds. See fast motion.

social documentaries: Documentaries that examine issues, peoples, and cultures in a social context.

social melodrama: A subgenre of the melodrama that extends the crises of the family to include larger historical, community, and economic issues.

soft lighting: Diffused, low-contrast lighting that reduces or eliminates hard edges and shadows and can be more flattering when filming people.

sound bridge: Sound that is carried over a picture transition or that belongs to the coming scene but is played before the image changes.

sound continuity: The process of furthering the aims of the narrative through scoring, sound recording, mixing, and playback processes that strive for the unification of meaning and experience.

sound designer: The individual responsible for planning and directing the overall sound of a film through to the final mix.

sound editing: Combining music, dialogue, and effects tracks to interact with the image track; performed by a *sound editor.*

sound mixing: The process by which all the elements of the soundtrack, including music, effects, and dialogue, are combined and adjusted to their final levels; also called *re-recording.*

sound montage: The collision or overlapping of disjunctive sounds in a film.

sound perspective: The apparent location and distance of a sound source.

sound recording: The recording of dialogue and other sound that may take place simultaneously with the filming of a scene.

sound reproduction: Sound playback during a film's exhibition.

soundstage: A large soundproofed building designed to house the construction and movement of sets and props and effectively capture sound and dialogue during filming.

soundtrack: Audio recorded to synchronize with a moving image, including dialogue, music, and sound effects; the physical portion of the film used for recorded sound.

source music: Diegetic music; music whose source is visible onscreen.

special effects: Techniques that enhance a film's realism or surpass realism with spectacle. They may be prepared in preproduction (such as building futuristic sets), generated in production (with camera filters or setups) or on set (such as pyrotechnics) or added in postproduction.

spectatorship: The process of film viewing; the conscious and unconscious interaction of viewers and films as a topic of interest to film theorists.

spotting: The process of determining where music and effects will be added to a film.

star system: The practice of a studio system or a national film industry of promoting films and organizing audience expectation through the casting and cultivation of distinctive and well-known performers.

Steadicam: A camera stabilization system introduced in 1976 that allows a camera operator to film a continuous and steady shot without a dolly or other device.

stereophonic sound: The recording, mixing, and playback of sound on multiple channels to create audio perspective.

stereotype: A character type that simplifies and standardizes perceptions that one group holds about another, often less numerous, powerful, or privileged group.

stinger: Sound that forces the audience to notice the significance of something onscreen, such as the ominous chord struck when the villain's presence is made known.

stop-motion photography: A process that records inanimate objects or actual human figures in different positions in separate frames and then synthesizes them on film to create the illusion of motion and action.

story: The raw material of a narrative; *fabula.*

storyboard: A shot-by-shot graphic representation of how a film or a film sequence will unfold.

story time: The sequence of events inferred during the telling of a film story.

structural film: An experimental film movement that emerged in North America in the 1960s, in which films followed a predetermined structure.

structuralism: An approach to linguistics and anthropology that, when extended to literary and filmic narratives, looks for common structures rather than originality.

studio system: The industrial practices of the large production companies responsible for filmmaking in Hollywood or other national film industries. During the Hollywood *studio era* extending from the late 1920s through the 1950s, the five major studios were MGM, Paramount, RKO, Twentieth Century Fox, and Warner Bros.

stylistic analysis: A critical approach focusing on form, such as shot composition, editing, and the use of sound.

subgenre: A specific version of a genre denoted by an adjective, such as the spaghetti western or the slapstick comedy.

subjective point of view: A point of view that re-creates the perspective of a character as seen through the camera.

supernatural horror film: A subgenre of the horror film in which a spiritual evil erupts in the human realm to avenge a wrong or for no explainable reason.

supporting actors: Actors who play secondary characters in a film, serving as foils or companions to the central characters.

surrealist cinema: An influential avant-garde movement of the 1920s that manipulated time, space, and material objects according to a dreamlike logic.

symbolic space: A space transformed through spiritual or other abstract means related to the narrative.

synchronous sound: Sound that is recorded during a scene or is synchronized with the filmed images and has a visible onscreen source; also referred to as *onscreen sound.*

take: A single filmed version of a scene during production or a single shot onscreen.

talking heads: An on-camera interview that typically shows the speaker from the shoulders up, hence "talking head."

Technicolor: Patented color processing that uses three strips of film to transfer red, green, and blue directly onto a single image; developed between 1926 and 1932 and widely used until the 1950s.

telephoto lens: A lens that has a focal length of at least 75mm and is capable of magnifying and flattening distant objects. See zoom lens.

theatrical musical: A subgenre of the musical that is set in a theatrical milieu.

theatrical release window: The period of time before a film's availability on home video, video on demand, or television platforms, during which it plays in movie theaters.

theatrical trailer: A promotional preview of an upcoming release presented before the main feature or as a television commercial.

thesis statement: A short statement (often a single sentence) that succinctly describes and anticipates each stage of an essay's argument. A *working thesis* is a rough version of a thesis used to draft an essay.

Third Cinema: A term coined in the late 1960s in Latin America to echo the phrase and concept "Third World," Third Cinema opposed commercial and auteurist cinemas with a political, populist aesthetic and united films from a number of countries and contexts.

third-person narration: A narration that assumes an objective and detached stance toward the plot and characters by describing events from outside the story.

30-degree rule: A cinematography and editing rule that specifies that a shot should be followed by another shot taken from a position greater than 30 degrees from that of the first.

three-point lighting: A lighting technique common in Hollywood that combines key lighting, backlighting, and fill lighting to blend the distribution of light in a scene.

tie-ins: Ancillary products (such as T-shirts, CD soundtracks, toys, and other gimmicks made available at stores and restaurants) that advertise and promote a movie.

tilt: An upward or downward rotation of the camera, whose tripod or mount remains in a fixed position, producing a vertical movement onscreen.

time image: Philosopher Gilles Deleuze's term for filmmaking that represents the open-endedness of time without giving clear signals of spatial connection or logical sequence.

tone: The shading, intensification, or saturation of colors (such as metallic blues, soft greens, or deep reds) in order to sharpen, mute, or balance them for certain effects.

topicals: Early films that captured or sometimes re-created historical or newsworthy events.

topic sentence: A sentence (usually the first sentence of a paragraph) that announces the central idea to which all other sentences within the paragraph are related.

top lighting: Used to illuminate the subject from above.

tracking shot: A shot that changes the position of the point of view by moving forward, backward, or around the subject, usually on tracks that have been constructed in advance; also called a *traveling shot*. See dolly shot.

traditional animation: Moving images drawn or painted on transparent sheets of celluloid known as cels, which are then photographed into single frames of film.

trailer: A form of promotional advertising that previews edited images and scenes from a film in theaters before the main feature film or on a television commercial or Web site.

treatment: A short prose description of the action of a film and major characters written before the screenplay or script.

two-shot: A shot depicting two characters.

underground film: Nonmainstream film, associated particularly with the experimental film culture of 1960s and 1970s New York and San Francisco.

underlighting: Used to illuminate the subject from below.

underscoring: A film's background music; contrasts with source music.

unit production manager: A member of a film's production team responsible for reporting and managing the details of receipts and purchases.

unreliable narration: A type of narration that raises questions about the truth of the story being told; also called *manipulative narration.*

value: Degree of lightness or darkness.

verisimilitude: The quality of fictional representation that allows readers or viewers to accept a constructed world—its events, its characters, and their actions—as plausible (literally, "having the appearance of truth").

video: Analog or digital electronic medium that captures, records, stores, displays, and transmits moving images.

video art: Artists' use of the medium of video in installations and gallery exhibitions, beginning in the late 1960s.

video on demand (VOD): The distribution of films through cable or online services that allow consumers to purchase and view movies on computers and home video screens.

viral marketing: The process of advertising that relies on existing social networks to spread a marketing message by word of mouth, electronic messaging, or other means.

virtual cinematography: The process of image capture in a computer environment, which may be incorporated into live-action cinematography or other computer-generated imagery.

visible editing: See disjunctive editing.

visual effects (VFX): Special effects created in postproduction through digital imaging.

voice-off: A voice that originates from a speaker who can be inferred to be present in the scene but is not visible onscreen.

voiceover: A voice whose source is neither visible in the frame nor implied to be offscreen and typically narrates the film's images, such as in a flashback or the commentary in a documentary film.

walla: A nonsense word spoken by extras in a film to approximate the sound of a crowd during sound dubbing.

western: A film genre set in the American West, typically featuring rugged, independent male characters on a quest or dramatizing frontier life.

wide-angle lens: A lens with a short focal length (typically less than 35mm) that allows cinematographers to explore a depth of field that can simultaneously show foreground and background objects or events in focus.

wide release: The premiere of a movie at many locations simultaneously.

widescreen processes: Any of a number of systems introduced in the 1950s that widened the image's aspect ratio and the dimensions of the movie screen.

widescreen ratio: The wider, rectangular aspect ratio of typically 1.85:1 or 2.35:1; see academy ratio.

wipe: A transition used to join two shots by moving a vertical, horizontal, or sometimes diagonal line across one image to replace it with a second image that follows the line across the frame.

women's picture: A category of films produced in the 1930s to 1950s, featuring female stars in romances or melodramas and marketed primarily to women.

Works Cited: List of sources cited in an essay, positioned on a separate page immediately after the last page of the essay text.

Works Consulted: Optional list of sources that have been consulted but not cited in the text or notes of an essay; appears on a separate page after the Works Cited list.

zoom-in: The act of changing the lens's focal length to narrow the field of view of a distant object, magnifying and reframing it, often in close-up, while the camera remains stationary; see zoom-out.

zooming: Rapidly changing focal length of a camera to move the image closer or farther away.

zoom lens: A lens with variable focal length.

zoom-out: Reversing the action of a zoom-in so that objects that appear close initially are distanced and reframed as small figures.